DIGITAL
MEDIA

Library of Congress Cataloging-in-Publication Data

Digital media: transformations in human communication /
edited by Paul Messaris, Lee Humphreys.
p. cm.
Includes bibliographical references and index.
1. Multimedia systems. 2. Digital media. 3. Human-machine systems.
I. Messaris, Paul. II. Humphreys, Lee.
QA76.575.D5383 302.23'1—dc22 2005022905
ISBN 978-0-8204-7840-1

Bibliographic information published by **Die Deutsche Bibliothek**.
Die Deutsche Bibliothek lists this publication in the "Deutsche
Nationalbibliografie"; detailed bibliographic data is available
on the Internet at http://dnb.ddb.de/.

Cover design by Lisa Barfield
Cover art Adam Finkelstein

The paper in this book meets the guidelines for permanence and durability
of the Committee on Production Guidelines for Book Longevity
of the Council of Library Resources.

*This book is dedicated
to Kathleen Hall Jamieson
with gratitude and admiration.*

Table of Contents

Figures and Tables

Acknowledgments

About half of the chapters in this book originated as papers presented at the Conference on Digital Media in Communication, held in Philadelphia on October 31 and November 1, 2003, under the sponsorship of the Annenberg Public Policy Center of the University of Pennsylvania. It is a pleasure to thank the Center's Director, Kathleen Hall Jamieson, to whom this book is dedicated. We also welcome the opportunity to express our gratitude to the Dean of the Annenberg School for Communication, Michael Delli Carpini, as well as all the many members of the staffs of the Annenberg Center and Annenberg School who contributed to the success of the conference: Richard Cardona, Kyle Cassidy, Lizz Cooper, Aaron Simmons, Michael Olsen, Hermon Mebrahtu, Deb Porter, Debby Stinnett, and Debra Williams. Paul Messaris would also like to acknowledge the contributions of his two assistants, Susan Haas and Jason Tocci. The process of editing this book was made much easier than it could have been by the encouragement and enthusiasm of Damon Zucca of Peter Lang Publishing. The book's cover illustration was graciously contributed by Adam Finkelstein. Finally, the editors are deeply grateful to their respective spouses, Carla Sarett and Jeffrey Niederdeppe, for their patience and support.

Paul Messaris & Lee Humphreys | # Introduction

The defining ingredient of digital media is the use of computers in the creation, transmission, and/or reception of human symbols. More simply, digital media involve computers in the process of human meaning-making. Digital media are often referred to as "new media." Is it time to retire that term? Computers and digital processes have been playing important roles in a variety of media for twenty years or more. The impact of digital imaging on photography first became a public issue as long ago as 1982, when a computer was used to shift the position of a pyramid in a *National Geographic* cover photo. (Adobe Photoshop followed in 1990.) Nineteen eighty-two was also the year in which digital imaging was first applied on a large scale to movies, in Disney's *Tron*, which featured some fifteen minutes of computer-generated imagery (Rausch 2004, 213–214). The first computer-game production company to achieve substantial commercial success, Nolan Bushnell's Atari, was formed in 1972, and Atari's Pong, released that same year, marked the beginning of arcade gaming.

The widespread adoption of digital computers for the creation of music also dates from the 1970s and early 1980s. Two significant milestones in that development were the 1977 inauguration of the Paris-based IRCAM (Institut de Recherche et de Coordination Acoustique/Musique), a government-sponsored institute dedicated to the study and creation of electronic music; and the 1983 introduction of the Yamaha DX-7, the first viable digital synthesizer (with sales of more than 200,000 units), which had followed the development of the MIDI standard for linking musical instruments to digital computers (Prendergast 2000, 66 and 87). Finally, it has been twenty-five years since the 1979 debut of the first commercially successful word-processing program, Micropro International's Wordstar, which inaugurated what Paul Levinson has called a "revolution in media production" (1997, 116).

As these dates suggest, computer-mediated communication has been with us in various forms for more than two decades. Does all of this mean that digital media are now "old media"? In strictly chronological terms, they are no

longer very new. However, from a different perspective, not only are they new now, but they will also most likely remain new for quite some time. If we look at the future instead of the past, we can make some reasonable guesses about where digital media are headed—or, at least, where today's developers and users would *like* them to be headed— and it seems quite likely that it's going to take them a very substantial amount of time to get there. Measured by the yardstick of those future goals, the digital media of today still seem quite "young": they have a long way to go, and they are changing rapidly. What exactly are the goals that digital media are moving towards? Judging from the comments and practices of present-day users and producers of digital media, at least four broad trends are discernable.

One implicit aim in the evolution of digital media, especially when they involve images, is that of **complete simulation**—the ability to reproduce our real-world sense impressions so completely as to fool us into thinking that we are witnessing raw reality (see Packer and Jordan 2001, part iv, for a history of this idea). This aim is present in the development of video games as well as movies and photographs. Some components of this overall trend (e.g., the creation of full-motion, photo-realistic images) have been achieved fairly well by movies, although not yet by video games. Other components, such as convincing voice synthesis, are not as fully approximated in any medium. Moreover, whereas the past development of simulation has focused almost entirely on the distal senses—vision and hearing—the future seems to be leading toward a confrontation with the considerably trickier issue of virtual touch.

A second major goal of digital media creators and users is **complete interactivity.** Right now, digital media do a fairly good job of representing people or places (whether real or imaginary), but they don't do half as good a job of allowing their users to interact with those people or places. At present, for instance, our entry into the world of video games is confined to a limited range of physical activities: pressing buttons, turning knobs or wheels, even typing. In prognostications about the future of digital media, it is almost axiomatic that we should one day be able to interact with virtual worlds more naturally, using a broader repertoire of actions and communicative modalities, such as eye movements or voice commands (Paul 2003, 214). For example, Claudia Springer has pointed-ed out that the early development of virtual reality was often accompanied by expectations of virtual sex (Springer 1996, 82; see also Dertouzos 1997, 142–148).

A third driving force in the development of digital media is the goal of **total connectivity**–the ability to access all information, in all places, at all times. In a rhapsodic forecast about the future of information flow, David Gelernter (2003) describes a world that "will be dense with computers. They will hang around everywhere in lush growths, like Spanish moss" (160). In this future world, information will spread through the landscape "like a breeze through tall grass" (157). This is the dream of digital omniscience. Cell phones and other portable Web-access devices have given us an early glimpse of the reality that this dream may lead to. At present, though, devices that try to do much more than that can be quite cumbersome. For example, an early version of an "augmented reality" system—a pair of glasses that superimpose informative data on the user's field of vision— required the user to wear some 26 pounds of auxiliary equipment, including "a shoulder-perching flying saucer-shaped antenna" (Ditlea 2002, 38).

Ten years ago, Nicholas Negroponte complained about how needlessly complicat-ed computers were: "Why is 'being digital' so hard?" (Negroponte 1995, 89) The kinds of routine tasks that Negroponte was referring to may have become easier in the ensu-

ing decade, but the attainment of **complete transparency**—perhaps best thought of as a situation in which computers adapt to humans instead of the other way around—is still a distant prospect (cf. Dertouzos 2001). This disparity between goal and attainment is probably felt most keenly by the growing numbers of people who use digital media for creative purposes, rather than just as consumers. The development of digital editing and sound-mixing has given large numbers of film-makers and musicians a set of tools that were previously confined mostly to the world of big-budget media (cf. Fox 2004, 14). But the continuing lack of transparency of many of those tools can sometimes create more problems than the tools solve (Wenocur 2004). As one musician puts it, "The whole digital music thing is being shaped by the technology and not the people. All you are hearing is presets [i.e., the automatic settings that come with the software][12]. This is not right!" (Andrew McKenzie, cited in England 2004, 29).

This list is not meant to be comprehensive, nor could it be. The digital media of tomorrow will exhibit all the variety that has always characterized the evolution of culture. Nor is our description of these trends intended as a prophesy about an actual end-state in the evolution of digital media. Rather, the aim is to underscore our broader point: Because the present-day development of digital media is motivated by goals whose attainment seems distant and elusive, the transformations associated with digital media today are still in their early phase. This book is a collective attempt to examine some of those transformations, as they appear to us at the present moment.

Scholarly interest in digital media often focuses on cyberculture and the Internet, and there are several excellent books on those topics. This book's aims are different. While the Web is, of course, a major theme in many of its chapters, the book also deals with a variety of other media whose development may intersect with that of the Web but should not be conflated with it. Such media as digital photography, techno music, console video games, and—least glamorous but by no means least important—desk-top publishing have each made their own contributions to the culture of digital media, and those contributions have retained their distinctive qualities even as the Internet has taken over from previous forms of distribution. The organization of this book is a reflection of these considerations. Because of the breadth and diversity of digital media, only one of the book's five sections—the section on video games—is devoted to an individual medium. Aside from being one of the oldest digital media in purely chronological terms, video games are also, arguably, the medium that played the most distinctive role in shaping the experiences of the first generation of people growing up in the digital age. The book's other four sections are all devoted to broader groupings of diverse digital media. Sections One, Two, and Three are organized around the three major modes of distal communication, namely, images, music, and verbal language (cf. Barthes 1977, Gross 1973). Within these groupings, individual chapters explore the variety of ways in which each of these modes has been transformed by the advent of digital processes; for instance, the effects of digital imaging technology on still photography as well as movies, the impact of computers on the composition as well as the distribution of music, and the consequences of digital mediation for the spoken as well as the written word. The book's concluding section, devoted to emerging digital media, takes a look at what lies beyond distal communication—namely, the move from virtual experience (pictures, sounds, words) to proximal communication (touch) and the direct transformation of physical reality by computers (wired architecture, ubiquitous computing, and communicative humanoid robots).

Outline of Contents

The book's opening section, composed of five chapters on **digital imaging**, reflects the increasing attention that communication scholars have been paying to visual studies in recent years. The first three essays in this section are all concerned, in one way or another, with the role of digital-effects tools in the creation and manipulation of visual images. Julianne Newton, photographer and author of a book on photographic truth (Newton 2000), addresses one of the central questions of visual scholarship in the digital age—viz., how digital manipulation has affected our sense of the documentary value of images. The discussion of digital manipulation continues in the next two chapters, which are devoted to movies. Paul Messaris attempts to assess how viewers react to special effects. Stephen Prince dissects the pervasive use of digital processing in "non-effects" scenes, and argues that this routine application of digital tools has had a more profound impact on the nature of big-budget cinema.

The remaining two chapters in this section of the book both deal with ways in which digital media have affected the production and distribution of nonprofessional pictures. Lee Humphreys' chapter, based on a study of online dating, analyses the use of personal photographs in the member profiles of a major dating service. David Perlmutter has previously written about the political effects of "high-impact" news images (Perlmutter 1998, 1999). Here he discusses pictures from the Iraq War, and examines how the power of controversial images has been affected by the ubiquity of digital cameras and Web access.

The book's next section is devoted to the relationship between **computers and music**. With a few important exceptions, music has not received as much attention from communication scholars as images or words have, and it is therefore our hope that this book might make a small contribution toward reversing that tendency. This section's opening chapter, by Lemi Baruh, deals with the impact of digital media on the distribution and consumption of music. Baruh's specific concern has to do with the regulation of online music sites and file-sharing, and he provides a detailed analysis of how that process may affect users' privacy rights. The other four essays in this part of the book are concerned more directly with the way in which music itself—its creation, its performance, its appreciation, its role in culture—is being affected by digital technologies.

To introduce this set of essays, we invited Rodney Whittenberg, an Emmy Award-winning composer, to describe his own experiences with digital music-making for movies and TV shows. Broadly speaking, the three chapters that follow are all concerned with the extent to which digital music represents a radical break with the musical past. Tim Taylor, a musicologist whose previous work had examined the evolution of musical culture from a global perspective (Taylor 2002), argues that digital media have indeed wrought fundamental changes in people's relationships to music. However, both Jonathan Sterne and Mark Butler give more skeptical accounts of those changes. Sterne's essay is a dissection of the many ways in which analog and digital are bound up with each other, while Butler, drawing on ethnographic research with DJs, documents the presence of considerable ambivalence towards digital technology among creators of dance music.

Although the recent scholarly focus on visual images has not been matched by a corresponding clustering of scholarship around the concept of verbal communication (perhaps because communication research has traditionally taken language for granted as the primary object of investigation), it seems appropriate in the context of this book to devote a section to the **electronic word**. This section's first two chapters deal with spo-

ken language, while the remaining three chapters deal with writing. The section begins with Paul Levinson's discussion of cell phones, based in part on his recent book on the same topic (Levinson 2004). Here he comments on the ways in which cell phones are restructuring our rules of social interaction and our expectations of privacy. Kwan Min Lee's chapter, based on previous studies of people's reactions to synthesized speech, is an attempt to provide a theoretical synthesis of those studies.

A middle chapter in this section, by Barbara Warnick, examines discourse on the Web, asking how the opportunities and constraints of a new medium have shaped the rhetorical practices of its users (cf. Warnick 2002). The two final chapters both look at electronic publishing, in terms of its impact on paper-based publishing and its acceptance by readers. Sidney Berger draws upon experiences that include running his own handpress, while Alex Humphreys' chapter reflects his involvement in a scholarly e-book initiative funded by the Mellon Foundation.

For younger readers of this book, **video games** may be the most characteristic symbol of the digital age in which they grew up. This section of the book contains six essays on the uses and consequences of gaming. The section begins with a discussion of the educational implications of video-game structure. Here James Gee provides a synopsis of a more extended argument developed in his book on gaming (Gee 2003), namely, that successful games embody a wealth of principles for effective teaching. Gee's chapter is followed by Mark Wolf's overview of the history and future of gaming (Wolf 2001; Wolf and Perron 2003), which includes a classification of basic game types.

The remaining four chapters are all concerned with the motivations and consequences of gaming. In their ethnographic study of The Sims Online, Jenny Stromer-Galley and Rosa Leslie Mikeal examine the experiences of female gamers in an environment that echoes traditional notions of "playing house." Shawn Green and Daphne Bavelier report the results of research on the cognitive effects of gaming, including their own experimental finding that certain kinds of games can sharpen users' attentional skills. John Sherry discusses the effects of games on aggression, and this part of the book concludes with Annie Lang's theory of the basic motivational system that drives users' reactions to the gaming environment,

The book's final section, titled **"new digital media: from virtual to real,"** takes a look at new digital media, i.e., forms of communication that are still in an experimental phase or have not yet moved beyond the stage of early adoption. The opening pair of chapters describes research on virtual reality. Jeremy Bailenson introduces the topic of VR and provides a summary of studies on its applications. Margaret McLaughlin's research on VR includes the implementation of virtual touch (McLaughlin et al. 2002). These discussions of virtual environments are followed by an exploration of the merging of virtual and real, in Jeffrey Huang's Swisshouse project. Designed as a means for fostering virtual interaction between scientists in Switzerland and the United States, the Swisshouse is a blend of digital interfaces and real architectural spaces.

Geri Gay's research on ubiquitous computing, described in the next chapter, can also be characterized as an exploration of the merging of digital media and real spaces. Finally, in this section's last pair of chapters, the discussion turns to the topic of communication between humans and "real" digital entities. The type of humanoid robot featured in these two chapters can be considered a virtual human, but it is also a physical "creature" inhabiting real space. Cory Kidd discusses a range of studies on human-robot communication, and the book concludes with a detailed investigation, by Sherry Turkle and her colleagues, of encounters between robots and children.

REFERENCES

Barthes, R. 1977. *Image–music–text.* Translated by S. Heath. New York: Hill and Wang.

Dertouzos, M. 1997. *What will be: How the new world of information will change our lives.* San Francisco: HarperEdge.

Dertouzos, M. 2001. *The unfinished revolution: How to make technology work for us — instead of the other way around.* New York: Perennial.

Ditlea, S. 2002. Believe it or not. . . . *Popular Science,* February:36–43.

England, P. 2004. Three is the magic number: The Hafler trio. *The Wire: Adventures in Modern Music,* 243:26–31.

Fox, B. 2004. Rethinking the amateur: Acts of media production in the digital age. *Spectator,* 24 (1):5–16.

Gee, J. P. 2003. *What video games have to teach us about learning and literacy.* New York: Palgrave Macmillan.

Gelernter, D. 2003. The second coming — a manifesto. In *The new humanists: Science at the edge.* Edited by J. Brockman. New York: Barnes & Noble, 157–167.

Gross, L. 1973. Modes of communication and the acquisition of symbolic competence. In *Communication technology and social policy.* Edited by G. Gerbner, L. Gross and W. Melody. New York: Wiley.

Levinson, P. 1997. *The soft edge: A natural history and future of the information revolution.* New York: Routledge.

Levinson, P. 2004. *Cellphone: The story of the world's most mobile medium and how it has transformed everything!.* Palgrave Macmillan.

McLaughlin, M., J. P. Hespanha, and G. S. Sukhatme. 2002. *Touch in virtual environments: Haptics and the design of interactive systems.* Prentice Hall.

Negroponte, N. 1995. *Being digital.* New York: Vintage Books.

Newton, J. H. 2000. *The burden of visual truth: The role of photojournalism in mediating reality.* Erlbaum.

Packer, R., and K. Jordan. 2001. *Multimedia: From Wagner to virtual reality.* New York: W. W. Norton & Company.

Paul, C. 2003. *Digital art.* New York: Thames & Hudson.

Perlmutter, D. D. 1998. *Photojournalism and foreign policy: Framing icons of outrage in international crises.* Westport, CT: Greenwood.

Perlmutter, D. D. 1999. *Visions of war: Picturing warfare from the stone age to the cyberage.* St. Martin's.

Prendergast, M. 2000. *The ambient century: From Mahler to Moby–the evolution of sound in the electronic age.* New York: Bloomsbury.

Rausch, A. J. 2004. *Turning points in film history.* New York: Citadel Press.

Springer, C. 1996. *Electronic eros: Bodies and desire in the postindustrial age.* Austin: University of Texas Press.

Taylor, T. 2002. *Strange sounds: Music, technology, and culture.* New York: Routledge.

Warnick, B. 2002. *Critical literacy in a digital era: Technology, rhetoric, and the public interest.* Mahwah, NJ: Erlbaum.

Wenocur, E. 2004. Why aren't my picture and sound in sync? The coming crisis in technical knowledge. *Spectator,* 24 (1):80–85.

Wolf, M. J. P. 2001. *The medium of the video game.* Austin: University of Texas Press.

Wolf, M. J. P, and B. Perron. 2003. *The video game theory reader.* New York: Routledge.

DIGITAL IMAGES

Julianne H. Newton

Influences of Digital Imaging on the Concept of Photographic Truth

The development of digital photography has been accompanied by intensified scrutiny of the concept of visual truth. Have digital images fulfilled early predictions by killing any hope of learning about the world through photography? Or has digital-imaging technology become a grand teacher of the complexities of visual truth by demonstrating the ease with which we all control what and how we see? This essay will explore the intersection of technology and reality perception manifested in the realm of photojournalism. Using visual reportage as a catalyst for discussion, the chapter will outline approaches to visual truth, concluding with recommendations for future research and theory building about digital imaging and photographic truth.

Through history, people have always felt threatened when faced with new technologies and the changes that they bring about. Indeed,I think we should embrace such changes with caution, but not to the extent that caution hampers our capacity to expand our horizons.

Pedro Meyer 1995

If pixels be the vehicle that realizes our dreams, be it so.

Shahidul Alam (cited in Meyer 1995, 14)

Truth and photography have a long and shared history. Before the birth of "light writing" almost two centuries ago, image creators hungered for a way to meet the challenges of representing the real world on a two-dimensional surface. The realism movement in painting and drawing had whetted the appetites of those who wanted to copy the natural world in fine detail and without the intermediary of a human hand put to canvas or paper.

Painters had mastered techniques for conveying the illusion of three-dimensional perspective within the confines of a two-dimensional frame four hundred years before light writing was discovered. The camera obscura, literally a dark room equipped for transcrib-

ing the world as it leaked through a tiny opening in a wall, had advanced to the point of a portable, table-top camera, complete with interchangeable lenses. The camera lucida, a device that channeled light rays from the real world through a prism onto a piece of paper for tracing, also helped increase the realism of hand-drawn images. What was missing was a way to record the patterns of light and shadow reflected from the real world, without having to draw them by hand. Solving that problem—it was thought at the time— would solve the dilemma of trying to see clearly through human interpretive filters.

Yet nothing could prepare the world for the revolution set in motion by the discovery of chemical processes for holding an image directly created by light itself. Similarly, nothing could prepare the world for the unsettling challenges to our understanding of truth, reality, and our ways of knowing that would follow our grand experiment with the "pencil of nature."

This chapter explores the human quest for truth by examining certain ideas about visual truth that are commonly associated with photography. In particular, I will discuss the impact of digital imaging on the content of photographs and on our understanding of their truthfulness. Most important, I will discuss my conviction that the most significant gifts of photography—from its beginning through the present age of digital imaging—are the lessons it teaches about the subjective nature of perception and our ways of knowing. This is true regardless of the type of instrument used to make a photograph or to discern what is true. In fact, the rise of the digital age has not weakened the cause of visual truth, but rather, has deepened our understanding of the complexities of truth precisely because digital imaging so clearly demonstrates both the fluidity and the profundity of visual truth.

I will explore three factors to help define the issues: tools, behavior, and perception. Along the way, I will offer context through examples of important moments in the history of photography as well as through discussion of new, as well as familiar, examples of how the issues play out in everyday contemporary media. Finally, I will suggest ways to address the challenges of discerning reasonable visual truths as our diverse global culture continues to produce new "technologies of seeing."

The Tool Itself

One of the most important principles to recognize about any kind of communication, whether visual, verbal or aural, is the effect of the communication tool—the technology itself—on the way the message is conveyed and understood. Consider, for example, the difference between a water color and an oil painting. Depending on the style of the artist, a watercolor may convey a sense of transparent depth bound by the slightest edge created by the stroke of a brush as the water dries on the paper. An oil painting, on the other hand, may convey a sense of the texture of the brush's bristles as they layer paint on the surface of a canvas.

In the last chapter of *The Transfiguration of the Commonplace*, art critic Arthur Danto (1981) discusses the etymology of the *stylus*:

> It is as an instrument of representation that the stylus has an interest for us and, beyond that, its interesting property of depositing something of its own character on the surfaces it scores. I am referring to the palpable qualities of differing lines made with differing orders of styluses: the toothed quality of pencil grains on paper, the granular quality of crayon against stone, the furred line thrown up as the drypoint needle leaves its wake of metal shavings, the variegated lines left by brushes, the churned lines made by sticks through viscous pigment, the cast lines made by paint dripped violently off the end of another stick. *It is as if, in addition to representing whatever it does repre-*

sent, the instrument of representation imparts and impresses something of its own character in the act of representing it, so that in addition to knowing what it is of, the practiced eye will know how it was done [emphasis added]. (197)

In many ways, the same is true in photography. The process, materials, and equipment that image makers use affect the way their vision comes across in their photographs.

It is easier for us to discern and accept the visual "poetic license" of a hand artist because we know he was "drawing by hand." It is harder to discern the sun's "poetic license" when we look at what is considered to be the world's first surviving photograph (circa 1826). When Josef Nicèphore Nièpce used his new heliographic process (first used in 1816), he had to wait at least eight hours for the sunlight to burn an image into a chemically coated pewter plate. Ironically, the surviving image looks more like a framed mirror than a permanent "Image from Nature" (HRC 2004). The image is so faint that its 20th-century inheritors thought it had faded into invisibility until an astute photohistorian, Helmut Gernsheim, detected its shadowy "light writing." "I had not expected a looking glass, nor an Empire frame in which the pewter plate lay like a painting," Gernsheim wrote in retelling his 1952 discovery. "I went to the window, held the plate at an angle to the light, as one does with daguerreotypes. No image was to be seen. Then I increased the angle—and suddenly the entire courtyard scene unfolded before my eyes" (HRC 2004).

Isn't it interesting that in its first appearance, the form of imaging we would—for a while—think of as rendering the most accurate representation of reality possible would have to be viewed at a certain angle in order to be seen at all?

Yet it is not simply a matter of the material base of the image that hampers our viewing of Nièpce's capture of his 19th-century courtyard. Nièpce's image of "Le Gras" shows shadows on both sides of the courtyard, shadows made possible only by the passage of time as the earth turned in relation to the sun, changing the light reflected off structures during the eight to ten hours of the image's recording.

Photography would undergo no fewer than 150 different processes, ranging from light-sensitive coatings on paper, metal, or glass, to silver-based celluloid film, resin-coated paper, and, now, digitization on silicon wafers. Each process inscribes light in its own way, revealing an image through nuances of chemistry, electromagnetism, material, and physics.

In one of the first images of a human being—a daguerreotype of a man having his shoes shined—the man's image was recorded because he was standing still during the 20-minute exposure. We cannot see the people and horses passing by on the street beside the man because they moved faster than could be recorded with exposures of the time.

In addition, the work of media photographers goes through other processes of being converted into dot patterns for offset printing: 0s and 1s for a camera's computer chip, energy for travel through the Internet, pixels for display on a computer monitor, or electrical signals that will rebuild as lines on a screen for television.

With each new process invented for photography has come changes in the ways images are made and conveyed—and, ultimately, in the realities communicated, perceived, and mediated.

Human Behavior: Beyond the Tool

Not all illusions in early imaging were related to unavoidable effects of technological processes. Even more influential than the characteristics of a technology is the

vision, which includes the intentions and actions, of the person using the tool. When William Cheselden used a camera obscura to make drawings and then engravings to print the first realistically illustrated book (1713) on human anatomy, the images brought a level of accuracy to the study of medicine never before achieved. Yet Cheselden had a point of view, depicting some of the skeletons in his later *Anatomy of the Bones* (1733) in evocative poses, such as on their knees praying.

Especially relevant to our discussion of photographic truth are such images as Hippolyte Bayard's "Self Portrait of a Drowned Man" (1840), in which Bayard posed as dead in order to make a statement about how his early experiments with photography had been ignored. By the 1850s, such photographers as Oscar Gustave Rejlander were combining separate images of models into staged narratives. Each early photographer wrestled with, mastered, and, to varying extents, manipulated the technical capacity and limitations of his tools in order to convey his vision.

As photographic media shifted and matured, so did the aesthetic styles of the photographers. Most people realize the influence an artist's style can have on a work of hand art. Consider the difference between a Monet and a Warhol. Not only did each artist focus on different subject matter, but his choice of colors and styles of representing subjects and colors were vastly different. Similar kinds of differences can apply to photographic artists. A portrait by the late Richard Avedon (1985) manifests his style of posing a person in front of a white background with controlled lighting, exposing a large negative through a view camera, and making exquisitely detailed, giant enlargements to hang on museum walls. A portrait by Sebastão Salgado (1993), on the other hand, manifests his style of documenting a person in his own environment, using available light and an unobtrusive camera, and publishing the image in the press or in a photographic book. The difference between hand art and photography is that people usually think of a photograph as something that is made mechanically as a trace of the real world (Bazin 1961), rather than as an artist's vision. This is one reason people not accustomed to having their photographs made (and there are still such people in our world) feel that something is being taken from them—in some cases their souls.

Yet there is more to human visual behavior, which I define as all the ways people image and use images, including gesture, dreaming, visualizing, using poetic words, photographing, wearing clothing, performing, and posing. In photography, human behavior encompasses the actions not only of the photographer, but also of the subjects, editors or curators, and viewers.

Consider, for example, a photograph most people have in their memory galleries—the World War II image of U.S. Marines raising the flag on Iwo Jima. Although some people have said the image was staged, I believe the photograph documents an authentic, unstaged event. I trust Jay Rosenthal's description of what happened when he made the picture. Rosenthal vividly remembered the moment on February 23, 1945, when he glimpsed the flag-raising out of the corner of his eye and swung his Speed-Graphic into place to make a 1/400 second exposure (Rosenthal, 1998). The Marines had raised a smaller flag earlier in the day, then fetched a larger flag. They lowered the first flag, and Rosenthal saw them just in time to record the second flag-raising—and to make an image that many Americans believe is the most signifacant icon of the twentieth century. Further complicating the story of the picture is what happened afterward. The moment was so fleeting that Rosenthal "didn't know what he had taken" (Landsberg, 2005). As a back-up, he asked the Marines at the top of Mount Suribachi to pose "for a jubilant shot

under the flag" (Landsberg, 2005). He then sent his exposed film, along with the captions, to a press center for processing, editing and radio transmission. Two days later, Rosenthal's inspiring image ran on Sunday front pages throughoutthe U.S. When Rosenthal received a congratulatory wire, he did not know which photo had received the attention. Then when Rosenthal was asked if he posted the photo, and, "assuming this was a reference to the 'gung-ho shot,' he said, 'Sure'" (Landsberg, 2005). Controversy ensued, and, though allegations were retracted, accusations that Rosenthal set up the Pulitzer-winning image still plague the photographer for 50 years later."

Human behavior—Rosenthal's and the Marines',' as well as subsequent editing, publication, and translation through time and memory into iconic status—affects our responses to any form of the Iwo Jima image, whether it be in an editorial cartoon, in a Washington, D.C., monument, or reenacted for real and in the press after the collapse of the World Trade Center towers.

However, we do not always fully comprehend the potential influence of human behavior on what and how we see. For example, editors at *National Geographic* would use the then state-of-the-art Scitex to move one pyramid closer to the other in order to make a better vertical image for the cover. *TV Guide* would put Oprah Winfree's head on Ann-Margret's body.

Texas Monthly used digital manipulation to put then-Governor Ann Richards' head on the body of a model dressed in a white Elvis costume and riding a white Harley-Davidson (July 1992). The magazine compounded its ethical blunder by labeling the cover image a photograph, rather than a photo-illustration, in the cover credits. The cover was sparked by an actual event in which Harley-Davidson presented a motorcycle to the Governor in a ceremony in the rotunda of the Texas Capitol (see Figure 1.1).

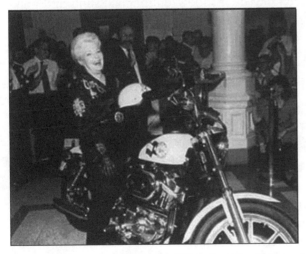

Figure 1.1: Texas Governor Ann Richards (1991–1995) receives a motorcycle from Harley-Davidson after she proclaimed May Motorcycle Safety Month. May 15, 1992. Photograph by Susan Gaetz. Used with permission.

Some cases of digital manipulation manifest the quirky way some people deal with horrible events. The image of a tourist supposedly atop a World Trade Center tower seconds before one of the planes crashed into the building below him was simply too hard to believe—though many initially did believe the image somehow survived in a camera found in the rubble of the WTC.

According to "Tourist Guy," the original photograph was taken when he visited the observation deck of the World Trade Center in 1997 (Benner 2001). Peter, a 25-year-old Hungarian, who wants his last name kept private, said he pasted an image of a plane into the photo and emailed it to friends as a joke. Now there's a web site called TouristofDeath.com that showcases more than 1,600 images of Peter pasted into such scenes as Abraham Lincoln's assassination and the explosion of the Hindenburg, as well as into more recent scenes of presidential campaigning, hurricanes, and even Abu Ghraib.

In the case of the Ann Richards photograph, the image projected by the cover illustration put Richards in a favorable light, showing her as tough, hip, and daring. The

Governor could not have staged better publicity, though the original presentation of the Harley was popular, as well. The Tourist Guy image manifested a form of escape for Internet users seeking dark humor as a way to deal with a horrific event. Other cases of digital manipulation are not so benign.

Consider the case of the image that was supposed to prove presidential candidate Senator John Kerry was closely associated with Vietnam war protestor and actress Jane Fonda. In a *Washington Post* article about the faked photograph, famed photojournalist Ken Light (2004) wrote,

> It's not that photographic imagery was ever unquestionable in its veracity; as long as pictures have been made from photographic film, people have known how to alter images by cropping. But what I've been trying to teach my students about how easy and professional-looking these distortions of truth have become in the age of Photoshop—and how harmful the results can be—had never hit me so personally as the day I found out somebody had pulled my Kerry picture off my agency's Web site, stuck Fonda at his side, and then used the massive, unedited reach of the Internet to distribute it all over the world.
>
> I've spent a lot of time answering questions about this in the past couple of weeks, and this time, as far as I can tell, the Internet has come as close as it gets to a correction. If you use a search engine to look for my Kerry picture now, you'll find the hoax explanations before you see the photo itself. So what do I do now about the conspiratorial Web site that's trying to convince its readers that my original picture was the hoax—that Fonda really was at that podium with Kerry, and somebody edited "Hanoi Jane" out? All I can do is pull Roll 68 out of the file cabinet again. It's my visual record, my unretouched truth.

The lack of a physical record such as film is one of the most troubling aspects of digital photojournalism. Archivists struggle to protect their digital records, yet longevity estimates for a compact disk range from three to seven years, requiring repeated transfer of digital files to new media. In addition, photojournalists can easily delete files in their cameras while making quick edits at the scenes of their shoots, culling bad shots and making room to shoot more.

In another incident involving a *Los Angeles Times* photographer, digital imaging had nothing to do with creating a visual lie. A poignant image of a fatigued fire fighter splashing water on his face was nominated for a Pulitzer Prize. As a result, the *Times* began its usual investigation to authenticate the photograph. The trail led to the fire fighter himself, who reported that the photographer had instructed him to splash water on his face. The staged photograph was removed from the Pulitzer nomination pool and the photographer was disciplined (personal communication).

Some manipulations are detected only by the astute and careful eyes of experienced picture editors. Consider the case of Brian Walski, the *Los Angeles Times* photographer who combined two photographs he took in Iraq into one image because it made a more aesthetically appealing and dramatic image. The photographer, a respected photojournalist who had been on the front lines in Iraq for weeks, was subsequently fired.

How do these examples differ from the 2004 uproar when CBS unknowingly used forged documents as proof that President Bush had received special treatment while in the National Guard? In principle, the incidents are similar, even though the Kerry and Iraq examples involved photographs and the Bush example involved words. Both relied on manipulated visual evidence to establish authenticity. But there is one fundamental difference that underscores the significance of lying with pictures: we notice, believe, and remember pictures better than we do words—even if we know the images may not be true.

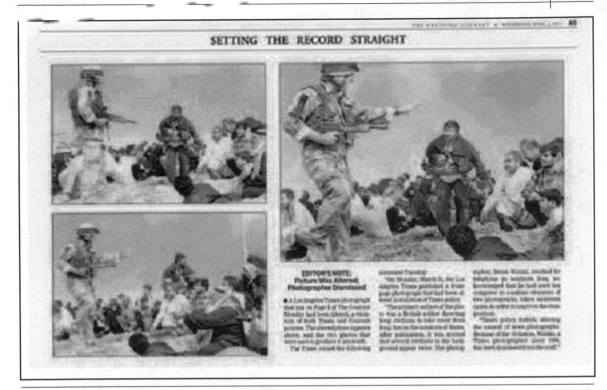

Figure 1.2: Correction spread by *Los Angeles Times* sister newspaper *The Hartford Courant,* April 2, 2003. Used with permission.

Further complicating the issue is the fact that no one has to manipulate photographs—either during their creation through framing or posing, or digitally after they are made—in order to manipulate the perceived and remembered meaning of photographs.

In fact, in at least one instance, technology actually resolved a behavioral error leading to misinformation. The now-famous photograph of astronaut Christa McAuliffe's family watching the launch of the space shuttle Challenger raises another set of issues complicated by erroneous words that have led to erroneous public memory of the image. Photojournalist Keith Meyers took the photograph while covering the fateful January 1986 launch and explosion, which killed McAuliffe and her fellow crewmembers. The next day, *The New York Times* ran the photo along with a caption erroneously stating that the image caught McAuliffe's sister, mother, and father reacting in horror at the moment of the explosion.

Ironically, another form of photography—videotape—would establish the truth of the image. Another photojournalist, Arthur Pollock of the *Boston Herald*, made a photograph of McAuliffe's family at the same moment Meyers did but submitted the photo with its correct caption for publication because he knew it was not at the moment of the explosion (personal communication). The *Herald* ran an Associated Press version of the photograph—and Pollock's editor asked him why he had missed the shot. So Pollock and Edward Dooks, who covered the Challenger launch for WBZ-TV, studied Dooks' videotape of the family viewing the launch. "Using the time code on the tape," Dooks (2004) recalls, "we determined *The New York Times* photo and the AP photo were taken within moments of each other at nine seconds after lift off while the announcer was telling the shuttle was clear of the tower." The booster rocket for the Challenger did not explode for another 64 seconds.

In June 1986, the *Herald* set the record straight with a story headlined "The photo that fooled the world." *The New York Times* issued a correction and embargoed the photo from future publication. *News Photographer* magazine ran a story about the inaccurate caption in the September 1986 issue. Yet years later, *Life* magazine would run Meyers' photo with the same misleading caption material, and scholars would publish the image—again with erroneous words framing its meaning—in *Visual Communication Quarterly* in 2004 (Hariman and Lucaites). Once again, retractions were published—in the July 2004 issue of *News Photographer*, through which *VCQ* was distributed, and in the Summer-Autumn 2004 *Visual Communication Quarterly* (Dooks 2004; Hariman and Lucaites 2004; and Newton 2004).

In an article discussing recent photo fakeries, Bruce Goldfarb writes,

> If the history of print images is any indication, the emergence of real-time digital video manipulation is particularly troubling. Computers are a force for the democratization of global communication, and a powerful tool of propaganda. Sooner or later some clever person will figure out how to game the system and make the public believe they witnessed something on live television that never really happened (npn).

Furthermore, the prevailing trend toward publishing images from such staged events as President George Bush's flying a fighter jet onto an aircraft carrier or serving a plastic turkey to soldiers in Iraq on Thanksgiving make real, unmanipulated photographs of manipulated events into front-page "news."

Perception: On Seeing and Remembering

Unfortunately, research indicates that once people get a picture in their minds and think of it in a certain way—as with the McAuliffe family photograph—that is how they are likely to remember it, regardless of learning of information to the contrary (Zillmann and Gibson 1999). Research also indicates that the viewing public may be more concerned about substantial manipulations of visual truth than they are about such violations as removing a distracting item from a picture. In one recent study, Jennifer Greer and Joe Gosen (2002) asked people their opinions of digital manipulations ranging from the removal of a piece of trash from a photo to removing a background person from a photo. Interestingly, Greer and Gosen also determined that when people know more about digital imaging, they are more tolerant of alterations—up to the point where people are removed.

The bottom line is that some people lie and some people try to tell the truth. People manipulate facts for different reasons, ranging from good to bad intentions. They conveniently omit details, take things out of context, exaggerate descriptions, and make things up. People lie with numbers, with words, and with pictures. It especially bothers us, however, when people lie with pictures because our minds, as part of our bodies, are programmed to believe what we see. The living organism that is the human body has evolved first, to believe what the eyes see; second, to react to what they see; and, third (a somewhat distant third that sometimes never happens), to reflect consciously on what they have seen and how they reacted.

What may be most important to our discussion of visual truth is how we perceive truth—how we determine whether something is true. People tend to perceive photographs—whether created through chemical or digital means—as true. On the one hand, this has more to do with visual perception than it does with technology. On the other hand, technology is at the heart of the matter. We both trust and distrust technology.

Technology makes it easier to make and transmit images so that we can know what is going on in the world. But technology also makes it easier to alter images and to stage scenarios that look real to us in images. Reason says we can trust usually reliable news media to tell us the truth. Intuition tells us we can only trust ourselves. In terms of primal perception, that means trusting our own eyes, our own senses. Reason returns to argue that our senses do not always perceive everything accurately—that we know our eyes can be fooled. Yet, carrying on the endless dialectic of perception, we still depend upon our eyes to connect the external world to our internal worlds at speeds that are faster than reason.

We rely on sight for our survival and to help us understand and negotiate the world. If we see a snake on the path before us, for example, most of us will take sudden notice—and action, such as freezing in fright, fighting it off, or fleeing. Only those who have learned through past experiences will recognize whether the snake is dangerous or harmless. Even people without physical sight have a form of vision, through which they form images of the world through their senses of touch, sound, and smell. That should tell us something—read it again: all people create pictures in their minds to help them survive and navigate the world, even the blind.

Furthermore, our so-called direct vision is not really so direct. Neuroscientists now know that what we really "see" are actually copies, rough schemata, of the images our minds create by organizing patterns of light and color as they enter the eye and are transmitted to other parts of the brain. There is a 300 to 500-millisecond delay between the perception of a visual stimulus, the routing and organizing of the visual information, creation of a copy of the interpreted image, and our conscious awareness that we have seen something.

This means that, no matter what we do or how hard we try, the best that we will ever see anything is in a representational form. That is why the invention of photography was so exciting for us. For at least two millennia, philosophers, artists, and scientists had been trying to figure out how we see. Photography suddenly gave us a way to preserve at least a few fleeting moments from real life, to hold those moments in our hands or put them on our walls. Furthermore, the moments were recorded by a machine, not by a person's artistry. Our trust in the neutrality of machines underscored our tendency to believe cameras could not lie.

The Special Case of Digital Truth

A number of innovations for protecting images from the special case of digital manipulation are taking place. One researcher, for example, has developed a method for determining whether individual pixels—the tiny units that make up a digital image—have been altered from the original. Another scholar suggested putting quotation marks around images to indicate that they had not been altered, in keeping with journalism's practice of putting quotations marks around the exact words of a speaker. Still another group has devised a carefully considered policy for determining and labeling authentic photographs. News-picture editors tend to favor the practice of labeling an image that has been altered a "photo-illustration," rather than a photograph. Many picture editors refuse to run photo-illustrations unless the alteration would be obvious to the average person viewing the image. Many news-photograph operations have developed meticulous systems for tracking even standard manipulations, such as lightening or darkening a photograph for better reproduction purposes, by requiring every person who deals with the

image in any way to sign a log sheet indicating what he or she did.

Photography is a double-edged sword. When we look through the viewfinder, make images, and view images—regardless of the behavior of the persons involved, the type of camera, the technical process, or the medium of distribution—we have an opportunity to learn about the world, to learn about how people behave, and to learn about how other people interpret the world. Photography can communicate a reasonable truth—the best truth humans can achieve—when the photographers, sources and publishers are credible—just as when words are credible. The alternative is not to look, not to see, not to know at all.

Photography has given us a means by which we can indeed capture moments of history for the albums of memory. The images of planes hitting the World Trade Center on September 11, 2001, recorded light reflected from the explosions in full, horrific truth. Digital cameras made possible the taking and transmission of photographs of events occurring in Abu Ghraib prison that few would have believed had there not been a photographic record. Photographs are so powerful that the U.S. government does not want newspapers to publish images of coffins bearing U.S. dead for fear seeing the images will diminish support for the war in Iraq. And photography is part of life rituals, recording precious moments of births (and now even fetuses in utero), birthdays, weddings, and other important events in our lives.

The viewfinder can be turned toward us to monitor our behavior—for good or for bad intentions. And just as words can be manipulated to shade the truth, or even lie, so can photographs be manipulated, either during the act of making an image, or afterward. Digital photography has made manipulations and lying easier to do and harder to detect, but the biggest threat to truth is not the potential of digital photography. The biggest threat to truth is two-fold 1) in those who choose to lie and manipulate, and 2) in public and individual denial that the responsibility for determining what is true rests with us all—photographers, editors, and most of all, viewers and readers.

What Can You and I Do?

A number of websites, such as Alias.com (2004), test viewers' abilities to detect photo manipulation. *National Geographic*, one of the earliest to cause a public stir through digital manipulation of a cover photograph, has started a website aimed at teaching children to detect photo manipulations. Called "Photo Foolery: Can you believe your own eyes? Not always!" (2004), the site warns, "Computerized photo manipulation can make anything seem real. With a few clicks of the mouse, you can switch people's faces, create a mob out of one person, even show an elephant catching air on a skateboard. As long as photos have existed, people have faked or manipulated them to fool others." The site offers several images for children to test their detection skills, along with such tips for spotting "photo fakes" as examining shadows, looking for jagged edges and repetitions, and using common sense.

The Newseum, a Washington, D.C., museum of news funded by the Freedom Forum, offers an 18-minute video and curriculum package for teachers of middle and secondary schools. Called "Is Seeing Believing . . . How Can We Tell What's Real?," the materials examine photo manipulations ranging from cropping through digital alteration. The Cyber Newseum (2004) features an online exhibition of photographs used in the Soviet Union between 1929 and 1953. Some of the alterations, which ranged from removing objects to removing people, were done well enough to make detection unlike-

ly, though others, such as a photomontage of Politburo members mourning the body of Stalin, are obvious.

Ethics scholar Tom Wheeler offers guidelines for evaluating digital manipulation practices in his book, *Phototruth or Photofiction* (2002). Wheeler suggests that news media should honor a reader's and viewer's Qualified Expectation of Reality (QER).

The key to photographic truth is to think—about the source of the image, about the reason the image was made, about why the image is being published, about whether the words accompanying the image are likely to be fair and forthright, about whether other sources corroborate the event and the image documents, about whether the image stands the test of time and continues to be interpreted in terms of the literal meaning of the moment in which it was taken.

In the end, what we all want is to see and know what is going on in the world. We may not be able to determine Absolute Truth through any means, but we can determine a Reasonable Truth—the best truth humans can discern, given the limits of individual perception and our means of representing the world. Photography's most significant gifts to humankind are not the means for establishing THE TRUTH, but rather a means for exploring the world in all its complexity.

The true revolution is not about digital photography. The true revolution is the maturation of human perception of reality. The fact that we know and understand that digital images are only groups of pixels mirrors our increased understanding of the multitude of particles composing the world—and even our bodies. Digital imaging has clarified—brought into clear focus, if you will—the fluidity of truth. We have more tools, greater understanding, and greater capacity for experiencing the continuum of truth through the creativity of virtual reality than we ever had via silver gelatin prints. Are the greatest truths to be found in the silver grains of continuous-tone prints, or in the pixels of a computer screen? The greatest truths are to be found inside our hearts and minds—if we exercise them.

Interestingly, film scholar Laura Marks (1999) argues that "even the digital image remains a physical object" because it

> relies for its existence on the fundamental interconnectedness of subatomic particles. Electronic images, like all of us, owe their material being to electrons and their associated waveforms. We are physically implicated in the virtual realms we inhabit, and far from divorcing ourselves from the world when we enter electronic spaces, we may be more connected than we imagine. (npn).

REFERENCES

Alias.com 2004. Fake or foto? http://www.alias.com/eng/etc/fakeorfoto/ (accessed on October 4, 2004).

Avedon, R. 1985. *In the American west.* New York: Abrams.

Bazin, A. 1961. On the ontology of the photographic image. In *What is cinema?*, translated by H. Gray. Berkeley: University of California Press.

Benner, J. 2001. He's the real tourist guy. *Wired News,* November 20, 2001. http://www.wired.com/news/culture/0,1284,48397,00.html (accessed on October 4, 2004).

Cheselden, W. 1733. Osteographia or the anatomy of the bones. Historical Anatomies on the Web, National Library of Medicine. http://www.nlm.nih.gov/exhibition/historicalanatomies/home.html (accessed on October 3, 2004).

Cyber Newseum. 2004. Commissar vanishes, the falsification of photographs in Stalin's Russia, Newseum, the Interactive Museum of News. http://www.newseum.org/berlinwall/commissar_vanishes/index.htm (accessed on October 4, 2004).

Danto, A. 1981. *The transfiguration of the commonplace: A philosophy of art.* Cambridge: Harvard University Press.

Dooks, E. 2004. Letter to the editor. *Visual Communication Quarterly* 11,3(4).

Goldfarb, B. 2004. Digital deception: The cultural and historical context of Larry's face. http://larrysface.com/deception.htm (accessed on October 4, 2004).

Greer, J. D., and Gosen, J.D. 2002. How much is too much? Assessing levels of digital alteration as factors in public perception of news media credibility. *Visual Communication Quarterly*, 9(3):4–13.

Hariman, R., and Lucaites, J. 2004. Modernity's gamble. *Visual Communication Quarterly*, 11 (1–2):4–16

Hariman, R., and J. Lucaities. 2004. Correction to photo of McAuliffe family. *Visual Communication Quarterly* 11 (3–4):26–27.

Landsberg, M. 2005. Fifty years later, Iwo Jimo photographer fights his own battle. Associated Press, http://www.ap.org/pages/about/pulizter/rosenthal.html (accessed on September 27, 2005).

Light, K. 2004. Fonda, Kerry and photo fakery. *The Washington Post*, Feb. 28, 2004. http://www.washingtonpost.com/ac2/wp-dyn?pagename=article&contentId=A13810–2004Feb27¬Found=true (accessed on October 4, 2004).

Marks, L. U. 1999. How electrons remember. *Millennium Film Journal*. 34 (Fall) http://mfj-online.org/journalPages/MFJ34/LUMframeset_horiz.html (accessed on September 25, 2004).

Meyer, P. 1995. Expanding memory: An interview with Pedro Meyer. *Truths & fictions: A journey from documentary to digital photography.* New York: Aperture.

Mikkelson, B., and D. P. Mikkelson. 2001. The accidental tourist. Urban Legends Reference Pages, November 20, 2001. http://www.snopes2.com/rumors/crash.htm (accessed on October 4, 2004).

Newton, J.H. 2001. *The burden of visual truth: The role of photojournalism in mediating reality.* Mahweh, N.J.: Lawrence Erlbaum Associates.

Newton, J.H. 2004. Commentary. *Visual Communication Quarterly*, 11, 3(4).

HRC Online Exhibition 2004. The first photograph. http://www.hrc.utexas.edu/exhibitions/permanent/wfp/ (accessed on October 4, 2004).

National Geographic 2004. Photo Foolery: Can you believe your own eyes? Not always! http://www.nationalgeographic.com/ngkids/0104/foolery/index.html (accessed on October 4, 2004)

Rosenthal, J. 1998. Associated Press video presentation by Hal Buell. University of Texas at Austin.

Salgado, S. 1993. Workers: An archaeology of the Industrial Age. New York: Aperture in association with Philadelphia Museum of Art.

Tourist of Death.com. 2004. http://www.touristofdeath.com/ (accessed on October 4, 2004).

Wheeler, T. 2002. *Phototruth or photofiction?: Ethics and media imagery in the digital age.* Mahwah, N.J.: Lawrence Erlbaum Assocates.

Zillmann, D., and R. Gibson. 1999. Effects of photographs in news-magazine reception on issue perception. *Media Psychology* 1:207–228.

Paul Messaris

Viewers' Awareness of Digital F/X in Movies

Big-budget movies are often promoted on the basis of digital special effects. Are viewers therefore more aware of special effects as they watch these movies? And, if so, does this awareness come at the expense of attention to story line? Is there a need to revise traditional conceptions of spectatorship?

In an interview about the making of the *Charlie's Angels* movies, director McG says that audiences can immediately spot the use of digital special effects. He calls this ability a "built-in CG detector." Fearful of setting that detector off, McG says he limited the amount of computer-generated imagery in his movies' stunt scenes (quoted in Corliss 2003, 3). If he had been asked to explain *why* the audiences' CG-detector had to be evaded, McG would probably have been nonplussed. Isn't it self-evident that audiences shouldn't be reminded of the trickery that goes on behind the scenes of a movie? Isn't it bad for viewers to be thinking of how the movie was made, instead of simply enjoying the story?

In academic film scholarship, the idea that movies should not draw attention to technique has often been seen as a basic ingredient of Hollywood filmmaking, and Hollywood movies have often been said to have an "invisible style." As Robert Ray has put it, the essence of this style is the concealment of the activities of the filmmakers. When a Hollywood movie is working properly, the viewer should become totally immersed in the world of the movie's story line. Succumbing to the movie's illusion of reality, the viewer should lose sight of the fact that that world is actually an artificial construction. By extension, Ray speculates, Hollywood audiences may further lose sight of the fact that any movie's ideological premises are also, in a sense, a construction (Ray 1985, 55; see also Bordwell 1997, 96).

As McG's comment about digital effects may suggest, academic theorizing about Hollywood's invisible style is amply supported by the statements and actions of filmmakers themselves. Moreover, it should be emphasized that the invisible style is not just a matter of concealing those elements of filmmaking that are explicitly designed to fool the eye (such as special effects). Indeed, as Ray points out, the invisible style is mostly about

such routine things as "camera placement, lighting, focus, casting, . . . framing (the components of *mise en scene*); [and] editing" (Ray 1985, 32).

A paradigmatic illustration of this aspect of the invisible style is contained in Ronald Davis's account of the making of John Ford's *The Quiet Man*. Ford and Charles FitzSimmons (a producer) were standing on a bridge overlooking a railroad station, the setting for an upcoming shoot. FitzSimmons was struck by the view, and suggested to Ford that this was an excellent opportunity for an overhead shot. But Ford objected that such a shot would look too unnatural and obtrusive. Instead, he would film the action at eye level, as it would appear to someone in the scene itself. In FitzSimmons's recollection of the incident, Ford said to him: "Charlie, when you talk to somebody, do you climb up on a ladder and look down at them. Or do you lie on the ground and look up at them? Or do you look at them right between the eyes?" FitzSimmons had to agree that you look at them right between the eyes. "That's how I shoot motion pictures," Ford concluded (Davis 1995, 252).

But things have been changing in the world of big-budget moviemaking. In seeming contradiction of the kind of concern voiced by McG, critics now often argue that the advent of computer-generated imagery has encouraged filmmakers to abandon unobtrusive narration in favor of showy F/X scenes that call attention to themselves and disrupt the coherence of the story. Reviewing a recent (non-Hollywood) example of this trend in filmmaking, David Kehr complains that "The details become the discourse—a constant flow of visual (and aural) stimulation in place of the traditional development of plot, character, and theme. . . . This is an art that does not possess the organic wholeness that we have for so long admired and continue to admire in film" (Kehr 2004, 74). As another critic puts it, "It may be true that computer graphics, the new lingua franca of commercial cinema, have long since altered how we perceive and appreciate film form, dating cherished theories about spatial and temporal reality. . . ." (Pipolo 2004, 63).

Aside from the content of the films themselves, two major developments in the distribution and marketing of movies have contributed to the style of spectatorship that is adumbrated in Pipolo's comment. First, the marketing of big-budget movies often focuses on digital effects as such. In advance of the second installment of the *Matrix* trilogy, there was extensive publicity about two specific scenes: the car/motorcycle/truck chase and the fight scene in which the bad guy keeps bringing in multiple copies of himself as reinforcements. These scenes' technical innovations were explained in some detail in the popular press, as well as more technical publications. Not surprisingly, perhaps, both scenes are the main focus of the very first review of *The Matrix Reloaded* that one encounters on the "User Comments" section of imdb.com (by IAN-Cinemaniac, posted 8 May 2003).

A much more compact example of F/X-focused marketing is described in Dade Hayes and Jonathan Bing's account of the way in which the third *Terminator* movie was promoted at the 2003 Cannes Film Festival. After a large crowd of journalists and onlookers had been entertained by the movie's theme music and a procession of animatronic robots, Arnold Schwarzenegger himself made an appearance. In the pronouncements that are quoted by Hayes and Bing, Arnold repeatedly emphasizes two points: first, the movie's complete title (*Terminator 3: Rise of the Machines*), and second, the movie's stunts and effects: "We have the best stunts, and visual effects that you have never seen before," "It has incredible stunts that are absolutely gigantic" (quoted in Hayes & Bing 2004, 218).

It is also worth noting that F/X are a major component of many big-budget movie trailers, and that trailers still appear to be the most important single source of influence on moviegoers' theatrical ticket purchases (see Wasko 2003, 198, regarding the latter point). However, DVD rentals and sales are now rivaling theatre receipts as a source of movie-industry revenue, and the emergence of DVDs is a second major factor shaping the way in which movies are viewed. Faced with a medium that is explicitly designed to allow viewers to skip to specific scenes, how likely is it that audiences will keep watching movies in the kind of story-driven manner envisioned by invisible-style theory? A friend of mine says that, when he rented the DVD of *Star Wars II: Attack of the Clones* (which he had not previously seen in a movie theater), the only thing he wanted to watch was Yoda's fight, an impressive effects scene that occurs at the very end of the movie. This may be an extreme case of lack of interest in a movie's story line, but selective viewing per se is surely quite typical.

There seems to be a need, then, for a modified conception of spectatorship that better reflects the piecemeal, scene-focused way in which many movies are actually viewed. Moreover, as others have noted (Pierson 2002, 118ff; see also Bukatman 2003, Klein 2004, Ndalianis 2004), it needs to be emphasized that, while digital effects may have increased its prevalence, this way of viewing movies does have a long history. In Hollywood cinema, the closest parallels to the F/X-laden movies of the past decade can probably be found in the religious epics of the 1950s. Between 1949 and 1959, almost every other year featured a big-budget, religiously themed movie at the top of the box-office charts. Any number of commentators have pointed out that some of the most popular recent sci-fi and fantasy series (*Star Wars, The Matrix*, and *The Lord of the Rings*) are permeated with religious themes (e.g., Anker 2004, chapter 8; Jones 2004). However, for our purposes, it is the formal structure of these movies that provides the most interesting point of comparison with their religious predecessors of the 1950s. Both sets of movies contain relatively slow dialogue scenes punctuated by extended, rapidly paced, spectacular action scenes featuring state-of-the-art special effects. Moreover, then as now, the effects scenes were advertised as such, and the movies' publicity campaigns included details about the creation of these effects, as well as their cost (cf. Pierson 1999, 41). For example, in connection with *Samson and Delilah* (1949), the *New York Times* carried an article describing the construction and expenses of the vast scale model that was used for the movie's climactic scene, in which Samson destroys the temple of his idol-worshipping foes (Affron & Affron 1995, 108–109). Commenting on this scene, Charles and Mirella Affron note that "this noisy and visually arresting finale is a triumph not of narrative closure but of production values. The true heroes are the art and special effects departments. . . . Here décor . . . is the principal actor" (109).

One more brief comment about the movies of the past may be in order. In 1950, one year after the release of *Samson and Delilah*, its director, Cecil B. DeMille, made an appearance as himself in *Sunset Boulevard*, in a scene in which that movie's protagonists visit the set of *Samson and Delilah*. This is a small example of a much larger phenomenon that we should not lose sight of, namely, that "behind-the-scenes" looks at the film-making process have a history that long predates today's "making-of" videos. As far as special effects are concerned, perhaps the most notable example from the past is the Lon Chaney bio-pic *The Man of a Thousand Faces* (1957), which gave a fictionalized account of how an actor working with rudimentary prosthetics and makeup was able to transform himself into such characters as the Hunchback of Notre Dame or the Phantom of the

Opera (Blake 1993). This kind of lifting of the veil of special effects has been a part of the movie industry for a long time, and it doesn't seem to square very well with the idea that technique should be invisible.

But back to the present, and the effects of today. Most digital movie F/X involve one of two general processes (or both): compositing and animation. In principle, compositing includes any kind of combination of two or more images, including superimposition, split-screen, etc. In practice, however, the most characteristic form of special-effects compositing involves the use of blue-screen or green-screen as a way of superimposing a foreground character on a background scene shot separately. For example, in *Star Wars II*, there is a spectacular aerial car chase through the dense traffic of a crowded city. As in most chase scenes, the protagonists of this scene were shot by themselves, in their vehicles, against blue backgrounds, and those backgrounds were then filled in digitally with the images of the cityscape whizzing by. Impressive though the results may be, compositing in itself is not the element that most sharply distinguishes the effects of today from those of the past. Long before the advent of electronic compositing, filmmakers were able to create effective composite scenes through the (admittedly quite cumbersome) technique of optical printing. In the hands of a meticulous director (such as Stanley Kubrick in *2001: A Space Odyssey* [1968]), this form of compositing was capable of yielding image combinations that were as precise as any blue-screen composite in today's movies.

What is most radically new about digital special effects is their capacity for animation. No matter how formidably proficient some of Hollywood's hand-animators may have been, nothing in their repertoire of skills could even come close to the following four achievements of computer-based animation as it exists today (to say nothing of the future): first, its ability to represent changes in the appearance of a three-dimensional object as it moves through space; second, its ability to model the surface textures of a wide variety of natural and manufactured objects; third, its ability to model the way in which the surfaces of objects change appearance as a result of the reflection or refraction of light; and fourth, its ability to represent changes in the appearance of three-dimensional objects and spaces as a spectator moves by them or through them. And there's more. This general list does not include a number of more specialized applications, such as the water effects of *Finding Nemo* (light traveling through an undulating surface) or the use of artificial intelligence to model the growth of trees and their appearance in different seasons (Johnson 2004; Pinteau 2004).

Such technical details are useful background information for a discussion of how viewers react to effects, but a more pertinent classification for this purpose is outlined by Mitchell (2004), who describes three different situations in which effects are used: first, to create "something that does not exist, nor could exist" (as in much science fiction and fantasy); second, to depict scenes that, while physically possible, may be too difficult to film "live," because of danger to actors or other reasons; and third, to make relatively minor alterations in the appearance of objects (e.g., removing a sound boom from a shot, or modern elements such as a TV antenna from old buildings) (Mitchell 2004, 9–10). This classification system may not be completely airtight. For instance, it isn't entirely clear how it would treat science fiction that isn't currently true but might plausibly become true in the future. However, the system provides a productive starting point for thinking about how we react to special effects, especially if we recognize that there is a middle ground of effects that are clearly fantastic but could still, in principle at least, involve "live" action. The chase scene in *The Matrix Reloaded* is a good example of this middle ground. On the one hand, much of this scene (e.g., morphing "agents" or Neo

flying through the air) falls squarely into the realm of fantasy. On the other hand, however, the scene contains substantial amounts of action (such as Trinity riding a motorcycle) that were reportedly filmed with the real actress riding a real motorcycle at high speed on a real set (Fordham 2003).

Fantasy

Although dinosaurs did once exist, let's take their resurrected descendents of *Jurassic Park* as our first example of fantasy, since the movie's portrayal of retrospective cloning is largely imaginary. In discussing this and other F/X movies, I will occasionally cite the results of an informal survey of students in one of my undergraduate courses. Although the course's topic was visual communication, most of the students were enrolled in it because it fulfilled general major requirements, and very few were actually planning careers in visual media production. So it is reasonable to assume that, on the whole, their responses do not represent a markedly different level of visual sophistication from what one might find in any group of educated young people. For example, one student added the following footnote to her survey: "I do not ever think of special effects when watching movies. I don't watch a lot of movies in general. I haven't even seen *Forrest Gump!*" In response to questions about F/X movies they had enjoyed and the specific effect (if any) that they would consider the best of all time, eight students mentioned *Jurassic Park*, placing it in a select group of movies that received more than one or two nominations. Although it is not always clear from the students' comments whether they were thinking of the original *Jurassic Park* or its sequels, one student specifically mentioned *Jurassic Park 3*, adding the following comment about why he had chosen to see it: "I knew it would suck, but there might be cool special effects."

This example reinforces the idea that special effects can sell a movie by themselves, at least to some viewers. Indeed, the promise of digital dinosaurs was especially important in promoting the original *Jurassic Park*, which is considered the first big-budget movie in which computer-animated creatures were successfully composited into live-action footage. Explaining why he picked this movie as the best special-effects spectacle of all time, one of my students wrote that "All scenes with CGI dinosaurs were very well done, and the entire success of the film hinged on this. Also, one of the few movies I can watch today and still think it looks good and not dated." In contrast to the previous quotation, this one has nothing bad to say about the other elements of the movie, so we can perhaps assume that he enjoyed the story line and characters as well. Still, as his comments suggest and as the movie's promotion would lead us to expect, his attention while watching the movie was probably split between the story and the effects. Must we assume that his awareness of the latter undermined his immersion in the former? Does a digital dinosaur's violation of the invisible style lead a viewer to disengage from the rest of the movie?

The idea of the invisible style is based on an either-or conception of how people react to performances—especially when those performances have to do with strong emotions, as most fiction movies do. Supposedly, we can either react to the performance as performance (in other words, with an awareness of style and technique), or react to the emotional content that the performance represents (in other words, without thinking of style and technique), but we can't do both at the same time. This notion may seem logical on the face of it, but we should not take it for granted that the workings of our minds actually conform to such logic. Indeed, as anyone who has seen a filmmaker react to her/his own

movie may suspect, it may sometimes even be true that awareness of what went into a production actually enhances our experience of the production's emotional content. Admiration for the skill that created digital dinos may have intensified some viewers' reactions to the drama of the dinos' scenes.

Does this mean that digital effects should deliberately draw attention to their artificiality? In the introduction to his autobiography, Ray Harryhausen—probably the most respected figure in the history of pre-digital special effects—says he would not have wanted to be involved with *Jurassic Park,* because, "for all the wonderful achievements of the computer, the process creates creatures that are too realistic" (Harryhausen & Dalton 2004, 8). Instead, Harryhausen argues in favor of the stop-motion animation that was used in *King Kong* and in Harryhausen's own movies. As he points out, the movement produced by this technique has an air of unreality to it, no matter how skillfully it is executed, and in his view that makes stop-motion better suited to fantasy than computers are. It certainly seems true that Harryhausen's movies (*Jason and the Argonauts, The Seventh Voyage of Sinbad,* etc.) appear to have been as captivating to the viewers of their day as anything produced today. However, what is missing from his argument is an acknowledgement that, at the time they were created, the animation in his movies was as realistic as effects could get. For a viewer watching a Harryhausen creature in the sixties, there was no sense of a deliberate withdrawal from realism.

For a present-day application of Harryhausen's principle, we can turn to the *Hulk.* In the published version of the movie's screenplay, visual effects supervisor Dennis Muren presents a short summary of his artistic philosophy: "Nobody wanted this movie to be about computer tricks; I have no interest in doing anything like that. . . . I am interested in telling a story and I care about the actors. . . . The technology should be invisible" (Muren 2003, 16). And yet, the most notable thing about the movie's special effects was probably the decision to make the Hulk less-than 100% realistic, so as to preserve some of the cartoonish quality of the original. In explaining this decision, director Ang Lee argues that the story of the Hulk "is a weird combination of pop culture and realistic drama. . . . How much should be realistic? If it's too realistic, how can you believe in a green giant . . . ?" (Lee 2003, 7)

This line of reasoning sounds quite similar to Harryhausen's. However, although the movie received considerable praise for some of its other aspects, the Hulk's unreal look was a frequent source of complaint, as in this comment by *Slate* reviewer David Edelstein: "Well before The Hulk (Universal) was screened for the press, I heard the computer-generated title character described as 'Shrek on steroids,' and I only wish he were so lifelike. . . . the creature's quizzical eye rolls are hardly more credible than those of Willis H. O'Brien's stop-motion ape in the original King Kong (1933)" (Edelstein 2003). Even praise for the Hulk's appearance was sometimes preceded by the kind of defensive statement included in this user's comment from imdb.com: "It seems that I'm in the select minority of people that thought this movie was awesome. I've talked to a lot of different people about this movie, and it seems like I get the same complaint every time: 'The CGI looked fake!' . . . I loved the way this movie was done." The review is titled, "Why does everybody hate on this movie???" (posted November 16, 2004, by effedup).

Of course, much of this commentary begs an important question: What is the meaning of "realistic" when one is dealing with a fantastic creature? An answer to that question is provided by the character of Gollum in the *Lord of the Rings* trilogy. Gollum is in some ways the same kind of entity that the Hulk is: a distorted, humanoid monster produced through the transformation of a normal person (although, in the case of Gollum,

the normal person is a hobbit). At the time that *Lord of the Rings* was made, Gollum represented the most advanced use of motion capture as a basis for an animated character's facial expressions. (The technique was subsequently taken a step further in Robert Zemeckis's *Polar Express.*) Andy Serkis, the same actor who portrayed Gollum's pre-transformation character (a hobbit named Smeagol), performed Gollum's actions and expressions in front of a bank of cameras (while wearing a suit covered in reflective dots, which were also pasted on his face), and this record of his performance was used as the basis for the movements of the animated Gollum. Moreover, the animation of Gollum's muscles and bones was derived from research on real human anatomy. Perhaps most importantly, though, the appearance of Gollum's skin was modeled according to the principles of "subsurface scattering," i.e., the way in which light reflects off semi-translucent surfaces in the real world (see Johnson 2004, 25). As a result, a single, motionless image of Gollum still has the look of a real creature, whereas a single image of the Hulk looks more like a painting.

In my classroom survey of student opinions about special effects, seven students chose Gollum himself (i.e., independently of the other effects in the *Lord of the Rings* trilogy) as their top effect of all time. One student (an aspiring animator) wrote that "To create a completely digital character and make it believable is an outstanding achievement," while another described Gollum as "incredible CGI, unparalleled in history." Did Gollum's realistic appearance mean that, while the students were watching him, they lost sight of the fact that he was animated? If anything, the comments that address this topic suggest that awareness of the animation was part and parcel of their enjoyment of the movies: "I had a better appreciation of Gollum when I saw Return of the King after learning about how it was done," "The Gollum guy is clearly special effect and it made me like the movie even more . . . so did the Elefunt." Extrapolating from these reactions, we would have to say that there isn't much support here for Ray Harryhausen's views about computer-generated fantasy creatures. When realism is evidence of artistic achievement, deliberate departures from realism are risky.

But there is more to be said about Gollum, and about Harryhausen's theory. The near-human quality of much of Gollum's appearance makes him a potential example of the "Masahiro Mori" effect. Mori is a roboticist who has speculated about an interesting phenomenon that may take place as humanoid entities (robots, animations, etc.) become increasingly anthropomorphic. Up to a certain point, closer approximations to human-like appearance make the entity more attractive to human viewers. But then, as the robot or animated character becomes almost indistinguishable from a human, small deviations from human appearance begin to unsettle the viewer, who is now repelled instead of attracted by the anthropomorphic appearance. This putative plunge in attractiveness (followed by a renewed increase once full anthropomorphism has been achieved) is commonly referred to as the "uncanny valley" by roboticists and animators (Reichardt 1978). The uncanny valley is usually viewed as a potential pitfall of too-realistic animation. In other words, the fear is that near-human characters will appear creepy instead of engaging. However, a character who is already supposed to be creepy (such as Gollum) can only benefit from this effect, if indeed it exists.

From Fantasy to Reality

Quite apart from the Mori effect, there is good reason to believe that our brains are attuned to pay special attention to slight deviations from human form in humanoid

objects. Gollum's overall structure is too distant from anthropomorphism to satisfy this criterion. However, animated characters who are supposed to be human, and to appear in scenes with real humans, certainly do satisfy it. This brings us to that middle ground of scenes that, while essentially fantastic, include actions that could, in principle, be filmed with live actors or stunt persons. There were several references to such scenes in the comments of my students, and some of those references came in response to a question about special effects that had diminished their enjoyment of a movie. Here are three examples of such references (from three different students):

> "The 2nd *Matrix* where Neo is fighting 100 Smiths, sometimes it shows his face and it looks completely digital. I didn't like that. But the fact that he was fighting 100 of them didn't affect me."
>
> "The 3rd *Matrix*, they got carried away and you could tell that 'Neo' when flying was not actually Keanu Reeves."
>
> "In *LOTR I*, in the tomb scene in Moria, Legolas jumps down from the troll's head and he is *clearly* CGI. That totally broke me out of the LOTR world."

Although these students were not alone in their objections to scenes from *The Matrix* and *Lord of the Rings* trilogies, the overwhelming responses to both sets of movies were positive, and there were many of them. Judging from this survey, it seems fair to say that, in the eyes of this group of students as a whole, *The Matrix* and *LOTR* trilogies represent the state of the art in computer effects. That being the case, the three comments cited above raise a question: Why should the imperfections of state-of-the-art animation be bothersome in these scenes and not in any of Gollum's scenes or, indeed, in any of the dinosaur scenes from the *Jurassic Park* movies? The obvious answer is that, unlike Gollum and the dinos, the animated characters in these scenes are human (or near human, depending on what exactly an elf is). But there may be a less obvious reason as well. In an earlier period in the history of special effects, these scenes would have been filmed entirely with live actors or stunt doubles, using harnesses, wires, and a lot of compositing. In fact, when analyzing *The Matrix Reloaded* fight scene in class, I have noticed that many students seem surprised to hear that, beyond a certain point in the action, they are no longer watching real humans. Substituting an animated character in place of a live-action star or stunt person is not simply a (potential) loss of humanlike appearance. It is also a sacrifice of the admiration that can be evoked by skillful stuntwork.

As the U.S. box-office success of Hong Kong–style action movies demonstrates, live stunt-work counts for a lot as a promotional tool. For example, Jackie Chan's movies routinely include outtakes that illustrate how difficult and dangerous his stunts are. Indeed, the original *Matrix* was itself a showcase for live stunts, and all three of its stars received martial-arts training to prepare for them. This emphasis on having the actors do their own stunts was an implicit acknowledgement of a broader point: The physical demands of executing a special effect may often be a major part of its appeal, and, when that is true, a movie may benefit from *not* having a completely invisible style. When silent comedian Harold Lloyd climbed up the side of a twelve-story building in *Safety Last*, did audiences simply enjoy the fictional thrill of the scene or were they also mindful of the fact that the real Harold Lloyd, not a stunt double, was hanging over the streets of Los Angeles without much evidence of a safety net? One of the most incisive illustrations of this distinction comes from an essay by the film critic and theorist Andre Bazin, recounting his own reactions to a scene of a lion stalking a family of humans (including a child). At first, the scene entailed a series of alternating close-ups in which the lion and the family were shown separately. Then, unexpectedly, there was a cut to a wider shot of all of them together. As Bazin recalls, this transition gave him a jolt. He suddenly realized that a real

lion and a real child were in the same physical space, and that realization added a distinctly sharper edge to his reaction to the scene (Bazin 1967, 49–50).

The appeal of physically challenging effects may extend beyond the area of stunts. In a discussion of blockbusters, Julian Stringer points out that big-budget movies have often been advertised on the basis of the effort that went into the construction of their sets. He cites the comments of Ken Adam, production designer for the James Bond movie *You Only Live Twice* (1967), who called the movie's huge set a "nightmare," the result of "suddenly realizing that you have designed something that has never been done before in films, that is bigger than any set ever used before" (quoted in Stringer 2003, 5). The sheer difficulty of shooting on location has also been a traditional ingredient of movie publicity. When David Lean insisted on shooting a scene of a shipwreck in *Ryan's Daughter* (1970) during an actual storm (instead of using wind machines, scale models, etc.), the movie's press book was careful to emphasize that fact: "Lean and his crew filmed 12 hours a day for four days in winds gusting up to 90 m.p.h., so strong in fact that staying on their feet was a major effort. Lean's amazing physical stamina, which he proved in the jungles of Ceylon for 'Kwai,' and in the Jordanian desert for 'Lawrence,' was again the key factor in getting on screen what must be one of the most awesome storms ever filmed" (*Ryan's Daughter* Press Book 1970, 2; see also Young 1999, 130–131).

To the extent that viewers have such considerations in mind when watching action scenes or other kinds of spectacles that could have been shot "real" (wholly or even partially), the use of digital effects may come as a disappointment, no matter how convincing those effects may be. As one of my students said about the fight scenes in *Lord of the Rings*: "I feel like it's somehow cheating to include special effects." The importance of the real physical details of a movie's production is highlighted in another student's comments about *Titanic*. Responding to a question about effects that had diminished her enjoyment of a scene in a movie, she mentioned that her prior knowledge about the making of the movie had lessened her appreciation of the scenes that were shot in water. Although the digital effects in these scenes are not particularly obtrusive, what lessened the scene's impact for her was the knowledge that "they really weren't in cold water, they were in warm water while filming." Similar concerns may have motivated the negative comments that some students made about fights, stunts, or scenes of danger in such movies as *Lara Croft* ('hang gliding scene"), *Gladiator* ("the computer-generated tiger"), *Little Women* ("fake ice breaking on ice rink"), or *The Jackal* (Bruce Willis's character is chasing Richard Gere and Gere gets trapped between 2 moving trains").

In his discussion of realism in animation, Ray Harryhausen mentions a piece of advice that he received from Willis O'Brien, the creator of King Kong: "Never attempt to create what you can photograph in real life" (Harryhausen 2004, 8). We have just examined one reason for such caution: if the real life that one could have photographed involves physical feats that would have been impressive in their own right, viewers may feel cheated by the substitution of animated representations of those feats. But there is also a second, more subtle way in which digital substitutes of real things may run into trouble. This aspect of the matter is illustrated very tellingly in the movie *S1m0ne*. Movies in general may not be the best place to look for accurate forecasts of the future, but, as far as the future of digital F/X is concerned, the scenario presented in *S1m0ne* is technologically well-informed and psychologically convincing. The movie's protagonist is a beleaguered film director (played by Al Pacino), who is being harassed by the extremely temperamental and demanding star (Winona Ryder) of his current production. (As the

movie opens, we see him sorting out red jelly beans for the supply she keeps in her trailer—a story detail that was most likely copied from the real-life behavior of a famous rock star who couldn't abide brown M&Ms.) Eventually she walks out on him, and it looks as if his career is over. But then he acquires a revolutionary new type of animation software, which allows him to create a completely photorealistic actress (a "synthespian"). He composites this actress into his movie, and all is well again. His movie becomes a big hit, and the actress becomes a big star. The only problem is that he hasn't revealed the fact that this amazing new star is actually a digital animation, and now the media and the movie fans want to know more about the "real" S1m0ne.

As depicted in *S1m0ne*, the future of animation software is a more advanced form of motion capture, in which the director sits down in front of the camera and computer screen, performs the actions himself, and gets an immediate playback of those actions with S1m0ne substituted for his own face and body. This futuristic apparatus seems like a plausible portrayal of the kind of animation set-up that many filmmakers would love to own. It produces instant results, and it doesn't appear to require any technical skills! Moreover, the movie paints a convincing (and not overly exaggerated) picture of one of the major motivations for switching from human stars to CGI. Even the most powerful directors can sometimes feel overwhelmed by the pressures of dealing with high-maintenance movie stars, not to mention all the other hassles that typically crop up in any real-world shoot. As George Lucas put it—in 1983, after he had directed what was then the most lucrative movie of all time—"I dislike directing. I hate the constant dealing with volatile personalities. Directing is emotional frustration, anger, and tremendous hard work—seven days a week, twelve to sixteen hours a day." Earlier, Lucas has also said that directing is "like fighting a fifteen round heavyweight bout with a new opponent everyday" (both quotations cited in Kline 1999, xi). Not surprisingly, Mark Hamill, the star of "Star Wars," is quoted as saying, "I have a sneaking suspicion that if there were a way to make movies without actors, George would do it" (in Kline 1999, 202).

In fact, something very close to the kind of movie envisioned by Hamill—a completely animated movie with photorealistic digital actors—has already been made. Unfortunately, that movie—*Final Fantasy*—was not very successful at the box office, and it actually ended up being included in a *Premiere* magazine list of "The 50 Most Disturbing Moments in Movie History." This inclusion was explained by noting that the movie "was supposed to usher in the era of the 'synthespian,' a CGI uberform that would take over Hollywood" but instead achieved a net loss of $105 million on a price tag of $137 million (Borgeson et. al. 2004, 90). But it would probably be wrong to attribute the movie's box-office misfortunes to its animation style, and to assume that the outcome of this experiment tells us very much about the likely future of synthespians. If anything, the animation appears to have generated widespread admiration for the movie, despite the ungenerous comment in *Premiere*, and its failure to make money seems to be a straightforward case of an unsatisfactory story line. The most recent user comment on imdb.com (posted by Kat on November 26, 2004) says that "This movie definitely broke the boundaries for computer animation" and is "quite possibly the best computer animated movie of all times," but adds that "If you can't sit through an extensively complex plot line that most Americans can't appreciate, then don't bother. Yet if you enjoy sitting and playing a Final Fantasy game and attempting to understand the plot line, then you're set."

All the same, Willis O'Brien's admonition to Ray Harryhausen does point to a potential pitfall of all synthespian-based movies, and not just those that involve the kinds of

stunts or derring-do discussed earlier. This pitfall is actually prefigured very astutely in *S1m0ne*'s scenes of the show-biz media clamoring for info about the new movie star. When we watch a real movie star on the screen, our reactions are undoubtedly colored by everything we know (or think we know) about who that star is in real life. It could be argued that getting us to think that way is one of the major goals of the movie industry's publicity system, and it certainly seems possible that many movie goers have spent more time watching movie stars in publicity appearances (on talk shows, award ceremonies, publicity interviews, and the like) than in the actual movies in which those stars appear. All of that dense network of real-world associations is lost when humans are replaced by computer-generated actors. It seems reasonable to speculate that viewers' capacity for emotional engagement with such characters may suffer as a result.

And yet, we also need to keep in mind that animated cartoon characters have no trouble engaging the emotions of children (and some adults) despite the fact that, traditionally, their only link to real-life performers has been their voice. Moreover, if synthespians are indeed animated in the way envisioned in *S1m0ne*, or even through more traditional motion capture, the director or actor who supplied the underlying performance may live on in viewers' minds, and thus attach the associations of her/his own real-world persona to the animated character. That was the explicit intention of *Polar Express*, which used "performance capture" to translate Tom Hanks into several different CGI characters, although the movie as a whole is still closer to the realm of children's cartoons than to fully photorealistic synthespians. Finally, we should not take it for granted that synthetic characters are completely incapable of acquiring their own "off-screen" personas in our minds (cf. Reeves and Nass 1996). There is already at least one talent agency for digital actresses (available for commercials and other promotional work as well as movies), and the entrepreneur who started it has organized an all-digital beauty contest as a way of creating publicity for his talent roster. Candidates for this agency are screened for their past performances, and digital actresses who have appeared in pornographic works are turned away (Lam 2004).

Conclusions

I began this chapter with a discussion of the traditional notion of an "invisible style" of filmmaking, which masks its technique in order to encourage viewers' immersion in the story. As the filmmakers I have cited suggest, invisibility of technique remains a major concern among people engaged in making big-budget entertainment movies. But those movies are also the most likely to feature computer-generated effects, which have come to be seen as potential threats to stylistic invisibility. The user comments that I have cited make it clear that many viewers are indeed frequently aware of digital effects. But, rather than assume that the traditional concerns of film analysts and critics (as well as filmmakers and their audiences)—namely, narrative and character—are necessarily becoming irrelevant, I have suggested that it may be appropriate to change our ideas about the consequences of stylistic *visibility*.

Suppose that viewers *do* commonly think about digital effects while watching movies. What difference does that make to their engagement with character and narrative? I have argued that the answer depends to a considerable extent on whether the effect is being used for pure fantasy or for a scene that could have been shot at least partly live. In the former case, at least, we may need to modify our notions of spectatorship to encompass the following possibility: Awareness of technique may actually strengthen our emotion-

al response to its use, instead of diminishing it. But things get more complicated when digital effects replace live performances, because awareness of the effect may also bring with it a sense of lack (no off-screen person) or of an inferior substitute (no stunt, no effort, no danger, etc.). Since I do think it likely that human performers will increasingly give way to digital substitutes, a big question for the future is how exactly these issues will be resolved in the minds of tomorrow's movie viewers.

REFERENCES

Affron, C., and M. J. Affron. 1995. *Sets in motion: Art direction and film narrative.* New Brunswick, NJ: Rutgers University Press.

Anker, R. M. 2004. *Catching light: Looking for God in the movies.* Grand Rapids, MI: Eerdmans.

Bazin, A. 1967. *What is cinema?* translated by H. Gray. Berkeley: University of California Press.

Blake, M. F. 1993. *Lon Chaney: The man behind the thousand faces.* New York: Vestal Press.

Bordwell, D. 1997. *On the history of film style.* Cambridge, MA: Harvard University Press.

Borgeson, K., et al. 2004. The 50 most disturbing moments in movie history. *Premiere* November: 88–94.

Bukatman, S. 2003. *Matters of gravity: Special effects and Supermen in the 20th century.* Durham, NC: Duke University Press.

Corliss, R. 2003. Summer of vroooom. *Time* Online Edition, June 16, 2003. www.time.com

Davis, R. L. 1995. *John Ford: Hollywood's old master.* Norman, OK: University of Oklahoma Press.

Edelstein, D. 2003. Hulk B-a-a-a-d: Ang Lee's green monster never comes to life. Slate. Posted Thursday, June 19, 2003, at slate.com.

Fordham, J. 2003. Neo Realism. Cinefex 95: 84–127.

Harryhausen, R., and T. Dalton. 2004. An animated life. New York: Billboard Books.

Johnson, S. 2004. Paint the light fantastic. Discover 25 (4):24–25.

Hayes, D., & J. Bing. 2004. Open wide: How Hollywood box office became a national obsession. New York: Hyperion.

Jones, R. R. 2004. Religion, community, and revitalization: Why cinematic myth resonates. In Jacking in to the Matrix franchise: Cultural reception and interpretation, edited by M. Kapell and W. G. Doty. New York: Continuum.

Kehr, J. 2004. A very long engagement. Film Comment 40 (6):73–74.

Klein, N. M. 2004. The Vatican to Vegas: A history of special effects. New York: The New Press.

Kline, S. 1999. George Lucas interviews. Jackson, MS: University Press of Mississippi.

Lam, B. 2004. Don't hate me because I'm digital. Wired November: 198–203.

Lee, A. 2003. Walking a constant tightrope. In Hulk: The illustrated screenplay. New York: Newmarket Press.

Mitchell, M. 2004. Visual effects for film and television. New York: Focal Press.

Muren, D. 2003. Invisible technology. In Hulk: The illustrated screenplay. New York: Newmarket Press.

Ndalianis, A. 2004. Neo-baroque aesthetics and contemporary entertainment. Cambridge, MA: The MIT Press.

Pierson, M. 1999. No longer state-of-the-art: Crafting a future for CGI. Wide Angle 21 (1):28–47.

Pierson, M. 2002. Special effects: Still in search of wonder. New York: Columbia University Press.

Pinteau, P. 2004. Special effects: An oral history. translated by L. Hirsch. New York: Harry N. Abrams.

Pipolo, T. 2004. House of flying auteurs. Film Comment 40 (6):62–63.

Ray, R.B. 1985. A certain tendency of the Hollywood cinema, 1930–1980. Princeton, NJ: Princeton University Press.

Reeves, B., and C. Nass. 1996. The media equation: How people treat computers, television, and new media like real people and places. New York: Cambridge University Press.

Reichardt, J. 1978. *Robots: Fact, fiction, and prediction.* New York: Penguin Books.

Ryan's Daughter Press Book. 1970. Warner Studios.

Stringer, J. 2003. Movie blockbusters. New York: Routledge.

Wasko, J. 2003. How Hollywood works. Thousand Oaks, CA: Sage Publications.

Young, F. 1999. Seventy light years: A life in the movies. London: Faber and Faber.

Stephen Prince

The End of Digital Special Effects

This chapter examines changes in contemporary cinema that are taking digital special effects from showcase exhibits to a more pervasive presence in the aesthetics of cinema, its production-exhibition context, and the viewer's own understanding of the nature of a moving image. Using prominent examples from recent movies, the chapter discusses the routine and pervasive manipulation of the visual quality of movie images, including such aspects as color, contrast, tonal quality, etc.

Special effects currently provide the clearest, most explicit application of digital imaging in contemporary cinema. When Spider-Man swings through the canyons of Manhattan, or the Hulk rampages through the hilly streets of San Francisco, moviegoers are fully aware that these are digital creations. Indeed, these effects provide a chief reason for seeing the films, and the ability of filmmakers today to create more convincing and more flamboyant effects helps to explain why there has been such an upsurge of comic-book characters in the movies. In addition to those now out, we can look forward to new appearances by Catwoman, Wonder Woman, the Fantastic Four, Iron Man, and the Sub-Mariner (Brodesser 2003). As an editor at Fantagraphics, a comic publisher, remarked, "Who wants to look at a static image of the Hulk on the printed page when you can watch a film by Ang Lee of the Hulk kicking butt?" (Carlson 2003).

Indeed, digital effects have become so popular with audiences that the industry now regards them as an essential part of mainstream studio movies, even films like *Legally Blonde* 2 that don't seem to be effects oriented. The shops that create these effects are now so overbooked that many cannot take on new projects for at least a year. Studios that wanted to add additional efx, late in postproduction, to such summer 2003 pictures as *Terminator 3*, *Pirates of the Caribbean*, and *The League of Extraordinary Gentlemen* were unable to find shops able to take on the work (Graser 2002, 1).

Because of the marketing hype that surrounds these pictures, and the attention given to digital effects in popular media, moviegoers may assume that digital imaging technologies have made inroads into cinema primarily in this area and that digital effects are something that is inserted into a film that may otherwise be quite traditional in its production methods. In fact, special effects are merely the most visible aspect of

what is a much larger, more extensive digital transformation of cinema. I want to focus on some of the perhaps less apparent, but, in my view, more significant aspects of this transformation, ways that digital imaging technologies are altering the nature of cinema, as it has traditionally existed in terms of a photo-chemical medium. These transformations have been proceeding rather more quietly, behind the scenes, even as special effects provide the big sales tool for digital imaging to the public.

First, though, I want to make a few more remarks about digital effects by way of responding to the interesting suggestion put forth by Lev Manovich (1995) that digital imaging is moving cinema away from its photo-realist heritage and taking it into the realm of animated images.

Manovich (1995) suggests, "The manual construction of images in digital cinema represents a return to nineteenth century pre-cinematic practices, when images were hand-painted and hand-animated. At the turn of the twentieth century, cinema was to delegate these manual techniques to animation and define itself as a recording medium. As cinema enters the digital age, these techniques are again becoming the commonplace in the filmmaking process. Consequently, cinema can no longer be clearly distinguished from animation. It is no longer an indexical media technology but, rather, a sub-genre of painting."

This is an interesting and suggestive idea, and it does correspond with a quality that I have often experienced when watching elaborate digital-effects sequences, like those that open *The Mummy* and its sequel *The Scorpion King*, namely, a feeling that I *am* watching a cartoon. Indeed, in *The Matrix Reloaded*, the transitions between what looks like live-action footage and digital animation is sometimes so abrupt as to be visually jarring.

At some level, I remain a Bazinian realist, committed to the idea that a viewer does feel a difference between an image that is photographically real and one that is a digital fabrication. In *Ran*, for example, director Akira Kurosawa burns down a huge castle set and places his actors in front of the real fire, and viewers of the film hopefully experience this in a different fashion than they would a digital creation of the corresponding scene.

However, this attitude may be overly nostalgic, and, in any event, the opposition in it, and in Manovich's perspective, between digital and non-digital images tends to overlook the important ways in which the boundaries between photo-realist and special-effects images have always been blurred and which digital images are now replicating. A photo-realist image is created in-camera, whereas an effects image, whether traditional or digital, is composited—that is, it is the result of image elements that are created separately and then layered together.

But for the special effect to be convincing, it has to mimic qualities of photographic or sonic realism, actual attributes of our physical world that can be captured by the camera or sound-recording equipment. I have elsewhere referred to this process as the provision by special-effects imagery of perceptual realism (Prince 1996). Even if the image is referentially fictional, showing us something that does not or cannot exist as a photographable reality, like the Hulk, its credibility requires that it seem perceptually realistic.

To make the Hulk credible, that film's cinematographer, Frederick Elmes, lit his shots as if the Hulk were present, putting green bounce light on other characters, for example, and he gave Industrial Light & Magic very detailed information about his lighting schemes—whether the light was hard or soft, the location of the sources, their relative intensities and colors, etc. ILM incorporated all of this information into its computer work.

ILM's effects supervisor, Dennis Muren, pointed out that this often included very subtle information. "Sometimes Fred would say he was doing something interesting with the lighting, such as using two different colored gels on the fluorescents, one slightly warm and one slightly cool. The overall lighting looked the same, but when you looked into the shadows you could see that the highlights were two colors. I made sure we grabbed all of that info and incorporated it into our effects shots" (Magid 2003).

These lighting cues work to conjoin the realms of live action and digital imagery, making it seem as if the Hulk is co-present with the in-camera elements of the scene. Except for films of all-digital animation, like *Shrek*, most effects work involves this kind of live action and digital compositing. Making the effect credible requires making it seem as if the digital and non-digital elements are part of the same screen world, and effects artists do this by adding perceptually realistic information to the digitally animated object. To provide another example, the dinosaurs in *Jurassic Park* 3 look more convincing than those in the first film because the digital animators are able to convey the movement of muscles and tendons below the skin, whereas in the first film all we have is skin texture and joint rotation.

Thus, although we may be in the realm of animation, we haven't entirely left the realm of photographically derived realism. The widespread application of digital effects in contemporary film is not likely to alter the basic mode of cinema in the way that Manovich has suggested. Yes, there is more animated footage in live-action films than ever before, but the standards of credibility are still furnished by the kind of perceptually realistic information that live action has always provided, even if the characters in question may have super powers or other unreal abilities.

In this sense, the logic of special effects, whereby effects artists create unreal images and make them credible, has remained relatively unchanged by the transition from traditional tools to digital ones. In other areas of cinema, however, the effects of the digital revolution are more significant and substantial. Indeed, digital-imaging technologies are changing all phases of film production and are re-configuring the production process. Sound design, sound editing, film editing, set design, pre-visualization of cinematography and sets are all accomplished today using digital means. One of the newest digital-imaging tools available to filmmakers is a process called digital grading, which is quickly becoming a standard tool of post-production image processing and one that has significant implications for the art of cinematography. Indeed, its application is changing the nature of the production process, when things get done and by whom.

Digital grading enables filmmakers to run their footage through a very powerful image editor, enabling them to make alterations and corrections in a huge number of image elements, including color, contrast, filtration, gamma, brightness, and others. To do this, filmmakers create a digital intermediate by scanning the film footage, frame by frame, into a digital-video format. Once the alterations and corrections are made, the digital file is then scanned back out to film.

This is a very expensive and relatively slow process. The first American feature film to undergo it was *Pleasantville* in 1998: scanned at 2K resolution, 1920 pixels x 1,440 lines, 11 megs per frame, 163,000 frames of film at around two seconds per frame (Fisher 1998). Since then, scanners have gotten faster and with better resolution. 4K scanners now operate at 6–8 frames per second. Still, it's a slow and costly process, which is why, to date, only around 18 films have been scanned in their entirety. But many more have used digital grading on particular shots and scenes.

An example is *Frida*, directed by Julie Taymor, about Mexican artist Frida Kahlo. Taymor wanted a sequence where Kahlo visits Paris to have the look of early hand-tinted postcards or motion pictures. Using a digital intermediate, the film's cinematographer, Rodrigo Prieto, gave the images a maroonish-brown hue, de-saturated skin tones, and reduced the color in a stained-glass window in the ceiling of a hotel set (Bosley 2002). Digital grading enabled Prieto to work selectively on all of these image elements, a selective focus that traditional photo-mechanical methods of color correction did not permit.

This is a key point accounting for the attraction that digital grading holds for contemporary filmmakers. Traditional methods of image processing give filmmakers only a gross level of control by essentially manipulating all of the image at once. Color timing of the footage in the lab, for example, involves adjusting the timing lights in ways that can affect the overall color balance, but a cinematographer using this method would be unable to concentrate only on skin tones or the stained-glass ceiling while leaving all the rest of the image unaffected.

Because lab timing is a relatively blunt process, in recent years cinematographers had turned to additional photo-chemical processes as a way of altering color and contrast. Bleach bypass and ENR are silver-retention processes that leave some silver halides in the negative that ordinarily are removed during processing. The result is an increase in contrast, de-saturation of color, accentuation of edge details, and an exaggeration of the reflective properties of shiny glass or metal surfaces. Steven Spielberg and his cinematographer Janusz Kaminski have been prominent proponents of ENR, using it in *Saving Private Ryan*, *A.I.*, and *Minority Report*.

Flashing is an older technique and involves introducing a uniform amount of light to either the camera negative or to a positive. This reduces contrast and pulls detail out of shadow areas. Flashing the negative will affect the black areas more than the highlights, whereas flashing the positive will mute the whites and leave the blacks relatively unaffected. Cinematographer Vilmos Zsigmond was the industry's great proponent of flashing, first using it in several key Robert Altman films of the 1970s, *McCabe and Mrs. Miller* and *The Long Goodbye*.

Cross-processing takes reversal stock (as the camera negative) and processes it like a color negative, something that it was not designed to do. As used in pictures like *Clockers*, *U-Turn*, and *Get on the Bus*, it makes primary colors more intense and vibrant while enhancing contrast and intensifying grain.

All of these methods are compatible with cinema's traditional photo-chemical heritage and can be seen as efforts by filmmakers to subject their images to a process of grading that would supplement and modify the characteristics of contrast and color that were established during production by decisions about lights and gels, costumes and sets, and the film stocks used in camera. Flashing, ENR, and cross-processing give filmmakers an additional point at which the aesthetic effects of these decisions can be modified, providing more tools for image manipulation in post-production. Digital grading, by contrast, supersedes cinema's photo-chemical heritage, and it better fulfills the ideal that these earlier processes collectively aimed at: enabling filmmakers to continue manipulating the image beyond the point of filming.

As such, it gives filmmakers infinitely finer control over the image, and many now opt for digital grading over these more traditional processes. On *Frida*, director Taymor and cinematographer Prieto considered using bleach bypass to reduce contrast in a hospital scene but opted to go with digital grading because it "enabled us to control just how

far we wanted to push the contrast" (Bosley 2002, 46). Cinematographer Roger Deakins was one of the industry's great pioneers of bleach bypass, using it to striking effect on *1984*. He considered using it to create the brown dustbowl look needed for *O Brother, Where Art Thou?* but, in the end, rejected it and decided to use digital grading for its flexibility and power.

The advent of digital grading takes filmmaking closer to the fine-grain visual aesthetics of an art like painting because it enables filmmakers to approach the painter's level of control over the elements of image creation. This is something rather new in the history of cinema because hitherto filmmakers have been relatively constrained by their images once the footage has been processed. Image creation really was the province of production, not post-production. Directing and cinematography during production created an essentially finished image, though it was a latent one on the negative. And, as a result, neither directing nor cinematography extended much into post-production. This is one reason that montage has played such an aggressive role in some traditions of cinema aesthetics. A careful edit of the footage enables moviemakers to impose a new order of meaning on the image values as created during filming. The Soviet filmmaker Sergei Eisenstein was quite explicit about this. For him, montage was a way of overcoming what he felt was the brute reality of the shot.

In contrast to this traditional method of production, digital grading makes cinematography into a post-production process in a way it never was before. Cinematographers, like Deakins and Prieto, oversee the digital intermediate process, spending weeks in consultation with the production houses handling the intermediate. In turn, this means that directing and cinematography during the phase of production are better defined as *image capture* processes rather than as *image creation* processes, which is what they had always been until the advent of digital grading. The image is captured with the goal of subjecting it in post-production to its essential modifications and final creation.

Digital grading, then, is altering the nature of film direction and cinematography and the traditional place these have occupied in the production process. And it is doing this in a kind of subliminal way, as far as the moviegoing audience is concerned. In contrast to gaudy special effects, which tend to advertise themselves as such, the digitally graded image need not sacrifice a naturalistic context. The audience need not be aware that the photographic images they are seeing ever underwent a process of digital alteration.

As I have mentioned, the process is expensive because of the need to convert celluloid to digital video. This expense places filmmakers in a position where they must negotiate with their studio or other source of production financing for special permission to create a digital intermediate. It is precisely because of this costly conversion process—from film to video and then back to film again for theatrical release—that George Lucas has advocated making the shift from traditional production methods using celluloid to all digital ones. Because the second of his recent *Star Wars* films was shot on digital video, Lucas claimed a significant cost saving despite the fact that it had more effects shots than its predecessor.

In 2002, Lucas invited a group of prominent Hollywood directors to Skywalker Ranch, his production facility, and tried to sell them on the advantages of filmmaking using digital video rather than celluloid. The discussions became intense, and Roger Ebert, who was there, reported that Oliver Stone objected at one point that *film*making is what they all did and loved doing, and Stone cautioned Lucas that he could become known as the man who destroyed cinema.

This is perhaps unfair. Lucas is merely the most visible proponent of a digital cinema, and, in any event, digital production and post-production methods have been making steady inroads for two decades. In many of its components, filmmaking has already become a digital process. Despite that, the appearance of tradition has continued in the sense that films are still shot on celluloid and exhibited that way theatrically. But powerful and seemingly irreversible economic trends are working against the celluloid tradition.

For one thing, the active life of a film on celluloid is relatively brief. Film on film exists only at the point of production and then into theatrical release, but after that the electronic formats take over, as the movie goes into its ancillary life of distribution in home video, cable television, Internet and video game outlets. Far more viewers see the film in these markets than they do in theaters, and studios earn far more from them than they do from theatrical.

And the revenue window from theatrical is closing. Expensive movies today earn most of their theatrical revenue during their first week, and revenue then falls of precipitously. On average, films released in summer 2003 saw revenue declines of 56% in their second week, compared to 44% the previous year. In its second week, *The Hulk* was off 70% and *The Matrix Reloaded* 60% (Bing and Hayes 2003). Second week declines are the pattern for nearly all films in release today.

The exploding costs of making films — in 2002 the average cost of producing and marketing a film was $90 million (U.S. Entertainment Industry 2002) — coupled with the very short time frame in which theatrical is viable have made the ancillary markets, where films morph into their electronic versions, ever more critical. Of these markets, DVD is the most important, with revenues in 2002 of $15 billion (Hettrick 2003).

This complex of factors is exerting significant pressure on the industry to move in the direction that George Lucas has advocated. Shifting from celluloid to digital video would eliminate the costs associated with a format whose revenue-generating life span is steadily diminishing. And there are small but important signs that this process is underway. Digital exhibition, for example, is a growing presence in the industry. The number of digital screens has climbed impressively in a three-year period, going from twelve screens in 1999, to 31 in 2000, 45 in 2001, and to 124 in 2002 (U.S. Entertainment Industry 2002).

Star Wars Episode II: Attack of the Clones screened at a mixture of digital and conventional theaters in the U.S. and Canada, and 20th Century Fox, the distributor, reported that business was more sustained at the digital locales (*Variety* 2002). Within recent years, numerous films have been exhibited in both formats, including *Planet of the Apes, Spirit: Stallion of the Cimarron, Scooby-Doo,* and *Minority Report,* and executives at the major studios have confirmed their intention to supply pictures for digital exhibition.

The potential for digital exhibition, coupled with nonlinear systems of picture and sound editing and the industry's swift adoption of digital grading, create an increasingly strong rationale for capturing images in a digital format. And, indeed, an increasing number of feature films are being shot on digital video. The most high profile of these is *Attack of the Clones,* but their number also includes the Inuit epic *Atanarjuat: The Fast Runner,* Barbet Schroeder's *Our Lady of the Assassins, Session 9, The Anniversary Party, Tadpole,* and others. These films may be exhibited digitally or converted to celluloid for conventional exhibition.

Shooting on digital video yields an image with significantly different properties than the celluloid image, and these differences present interesting implications for the nature of cinema and the ways that viewers perceive it. Since the inception of cinema, the visual characteristics of its images have been a function of its celluloid base. In particular, the special vividness of the film image owes much to the constantly changing grain pattern, which is never the same from frame to frame, giving each a relatively unique display of light information. Over the decades, manufacturers of motion-picture stock have consistently improved grain structure, mainly by making it ever finer and more light sensitive. Contemporary films display little obvious grain in their projected images, whereas films of the 1970s are more coarsely-grained. But across these changes, the special luminosity and vividness of the cinema image has remained tied to an unchanging attribute of celluloid, its grain structure that makes each frame a relatively unique visual experience for the viewer.

Other medium-specific characteristics of celluloid include the ability of film to pull a lot of information out of the high end of the light curve. It can finely discriminate highlights, such as snow, a white shirt, or bright sunlight. By contrast, it doesn't see as well into shadows, which is why the technique of flashing emerged, as a means of pulling more detail out of these areas. And, with film, one has a great deal of control over depth of field, and various aesthetic traditions in cinema involve the manner in which filmmakers treat depth of field, from those like Kurosawa, who minimize it, to those like Jacques Tati or Orson Welles, who maximize it. Indeed, French theorist Andre Bazin suggested that film history can be understood in terms of the ongoing aesthetic tension between these creative alternatives.

Shooting on digital video changes these characteristics of the celluloid based image. Unlike film, DV doesn't see very well into the highlights. Fire, sunlight, and other bright areas in the frame tend to bleach or burn out—to be so overexposed that they lose detail. This is a constant problem that cinematographers working in DV have to worry about, and a film, like the Inuit epic, *Atanarjuat: The Fast Runner* (2002), suffers a bit from being shot on DV, which drops a lot of visual information from the snowy landscapes. Working on the horror film *Session 9*, the cinematographer felt that "the highlights were a dead giveaway that it was video" because they kept blowing out (Thomson 2001, 68).

Digital video also tends to produce a wide-angle look as a kind of auto-default, and cinematographers have to work very hard to keep this from becoming too prominent because it has come to be regarded as a kind of video look. John Bailey, who shot *The Anniversary Party* (2001) on DV, kept his cameras back from the action in order to minimize the wide-angle look. Andre Bazin famously argued that deep-focus filmmaking tended toward greater realism because it reproduced the spatial complexity of the actual visible world, and there was an ethical constituent to his position. By *choosing* to work in deep focus, a filmmaker was restoring a measure of autonomy to the viewer, granting them a degree of perceptual freedom to look where they liked within the deep-focus image. The significance that Bazin gave to this was predicated on its being a departure from cinema's dominant tradition of shallow-focus cinematography, and one wonders how Bazin would have incorporated DV into his theoretical outlook. DV privileges a wide-angle look, but by doing so it encourages many filmmakers working in digital video to avoid this look.

In contrast to the inherent grain structure of film, DV offers a clean, crisp, shiny, clear look. It's sharper than film because it lacks grain but the downside is a kind of flatness

to the image, a lack of change that the shifting grain structure gives to film. The DV image is crisp and clean but doesn't approach the vividness of celluloid. Currently, many filmmakers working in DV strive for a film look. The head of research and development at Swiss Effects, a digital-transfer facility that takes DV projects to film, points out, "Almost nobody wants the clarity of digital projection—they want more grain," (Argy 2001, 78). To accomplish this, they can use a software program to add fake grain to the video image or transfer a DV project onto film for exhibition, allowing the grain in the transfer stock to emerge and provide a celluloid look.

These differences between the mediums are very apparent on Hollywood films that have been restored for release on DVD. The DVDs can look extremely good but they are converting the look of film into that of video, mainly by scrubbing out much or all of the visible grain structure of the film original. Robert Harris (2002), the restoration expert who worked on *Lawrence of Arabia* and *Vertigo*, points out, "*Citizen Kane* and *North by Northwest* have been digitally cleaned to a point where the film grain has been removed, yielding an almost shiny, grainless image. I'm not saying that these transfers are bad. They're not. It's just that they're different, and not representative of the actual film. They are, for all intents and purposes, a modification of the film into a fully digital, video product."

We are in a transitional era. Digital video is making incursions into all areas of filmmaking and into film viewing via DVD. It is difficult to see what the final outcome of this transition will be, in what manner celluloid film will remain a part of what we presently call "motion pictures." Some say that celluloid will not survive at all, and that is certainly possible.

But what does seem clear is that, at a perceptual level, the nature and meaning of cinema is being transformed because the information in light—its color and contrast range, black values, highlights, and other variables—is undergoing change, as numerous forces act to pull images away from celluloid characteristics and toward digital video ones. It's not simply a question of changing the image-capture devices or the means of film production and exhibition. It also involves changing the viewer, and I believe that in future years viewers will find the visual characteristics of DV imagery to provide the normative basis of their experience of cinema, just as many older viewers today may find the warmer and slightly hazier look of film to be more subliminally agreeable.

There are already indications that this is happening. On the Internet, DVD discussion forums commonly register complaints from viewers of older films about the grainy look of their images. Grain is being superseded historically by the grainlessness of the digital world, along with its attendant image characteristics. As this occurs, the nature of the cinema image is being redefined in terms of the norms that viewers look for and are comfortable with. As a celluloid-based medium, cinema is receding on numerous fronts as digital imaging makes inroads in production and exhibition, and one of the most important and decisive areas of change is here, in the way that cinema is transforming within the perceptual experience of the viewer, as the patterns of light information that define the medium shift from one array of characteristics to another.

In respect of these changes, the title of this paper derives from a claim made by a director of digital special effects who goes by the sole name of Pitof and whose work appears in *Alien: Resurrection, The City of Lost Children,* and *Delicatessen.* Pitof predicts, "In the coming years, my speciality, digital special effects will disappear," (Bergery 2002, 194). By that, he means that the computer will become so integrated in all phases of filmmaking that the notion of a separate area of efx will become obsolete, as set designers,

cinematographers, and others routinely use digital tools to process their images. We seem to be moving, then, from the present era, in which digital special effects are celebrated in the media and taken as the most important manifestation of cinema's digital turn, to a time when they vanish because they are everywhere, both inside and outside the image, in the aesthetics of cinema, in its production-exhibition context, and in the viewer's own understanding of the nature of a moving image.

REFERENCES

Argy, S. 2001. Striking "Digital Prints" *American Cinematographer* April: 78.

Bergery, B. 2002. *Reflections: Twenty-one cinematographers at work.* Hollywood, CA: ASC Press.

Bosley, R. K. 2002. A dynamic portrait. *American Cinematographer* October: 46.

Bing, J., and D. Hayes. 2003. B.O. is blockbusted. *Variety* July 14–20: 1, 56.

Brodesser, C. 2003. Marvel faces rivalry from Catwoman & co. *Variety* July 14–20: 7.

Carlson, C. 2003. Hollywood's digital revolution. *Videography* February 1.

Fisher, B. 1998. Black-and-white in color. *American Cinematographer* November: 60–67.

Graser, M. 2002. F/X gridlock seizes studios. *Variety* June 30–July 13: 1.

Harris, R. 2002. Vinegar syndrome is a gas, gas, gas. http://www.thedigitalbits.com/articles/robertharris/harris071702.html (accessed August 2002).

Hettrick, S. 2003. Home video industry bounds past $20 billion mark. http://www.videobusiness.com/article.asp?articleID=4622 (accessed October 2003).

Magid, R. 2003. Growing pains. *American Cinematographer* July: 51.

Manovich, L. 1995. *What is digital cinema?* http://www.manovich.net/TEXT/digital-cinema.html (accessed June 2003).

Prince, S. 1996. True lies: Perceptual realism, digital images and film theory. *Film Quarterly* 49 (3): 27–37.

Thomson, P. 2001. Horror in hi-def. *American Cinematographer* April: 68.

U.S. Entertainment Industry: 2002 MPA Market Statistics, www.mpa.org.

Variety. 2002. June 24–30, 14.

Lee Humphreys

Photographs and the Presentation of Self through Online Dating Services

In contrast to newspaper and magazine personals, online dating sites make it easy for their users to accompany text with visual images. In fact, some online dating services strongly encourage their members to post photos as a means of increasing their chances of finding a match. This study examines how members of an online dating service use photographs to represent themselves to potential mates. The study analyzed the photos posted on a random sample of 60 male and 60 female member profiles on a major online dating service. The study discusses trends in the formal properties of the photographs, and it explores differences in photograph usage by gender, age, and self-reported body type.

The definition of online dating is that it begins outside any context—historical, temporal, physical . . . online personals are a natural outcropping of our historical and technological landscape—one more proof of the fact that time and space are ceding their primacy as organizers of our experience.
The New York Times, 2003

Online dating services have become increasingly popular over the past few years. These sites allow people to post personal ads as well as to browse thousands of others' ads across varying zip codes, ages, ethnicities, hobbies, religions, smoking habits, and incomes, among many other characteristics. Services vary in size from small sites catering to niche ethnic, religious, or hobby groups to large international sites with more than 12 million users. Regardless of size, these sites offer to bring people together for friendship, casual sex, or long-term relationships.

According to comScore (Mudd 2003), Americans spent $214.3 million on personals and dating sites in the first half of 2003. Accounting for nearly 30% of all paid content spending online, dating services/personals lead the paid content category, ahead of both business/investment and entertainment/lifestyles content. In August 2003, 40 million Americans visited at least one online dating site (Egan 2003). As with other interpersonal communication technologies, the value of these services grows as their membership increases.

These services and their popularity present researchers with an opportunity to study gender roles, courtship characteristics, and mating strategies of men and women. Online dating sites provide a forum for people to act out normative expectations for desirable characteristics of men and women in courtship. Online dating services offer a new mediated channel for courtship as well as several other technological changes such as photographs for mating strategies. This study explores how members of an online dating service use photographs in their quest to find a match. It is important, however, to situate online personals within a much longer history of impression management and personal ads in general.

Literature Review

Goffman (1959) writes that one tries to control the impression that others have of one through one's performance. He defines performance as "all the activity of an individual which occurs during a period marked by his continuous presence before a particular set of observers and which has some influence on the observers" (22). Of course when referring to online dating, this presence is virtual, but a presence nonetheless. Goffman suggests that "front" is the part of one's performance that one uses to express and define the situation. Goffman describes three standard parts of front: setting, manner, and appearance, all of which have relevance to understanding online personal ads. The setting of a front refers to the scenery and stage props on and with which human performances are played out. In the case of online dating, this would refer to the profile webpage one sets up for oneself. The setting can extend to different channels for communication such as e-mail, instant messaging, or phones. In the case of mediated interaction, the mode of communication can refer to the setting of one's performance.

In addition to setting, "manner" is also an important component to front. Goffman defines manner as "those stimuli which function at the time to warn us of the interaction role the performer will expect to play in the oncoming situation" (24). Another way to think about manner is that the personality characteristics or mood that a person presents will affect his overall behavior within an interaction. Similar to manner, "appearance" refers to those stimuli that indicate a person's social status and state of activity; that is, whether someone is engaging in a socially formal or informal activity. Manner and appearance are important components to the presentation of oneself on online dating sites. Through answers to dating profiles, descriptions of who they are and what they are looking for, and the photos of themselves, people actively engage in impression management through the front they present.

"Exchange theory" (Cameron, Oskamp, and Sparks 1977) offers another means of understanding social interaction during courtship. The theory suggests that people try to maximize their profits in social situations by identifying those desired characteristics they offer and seek. Women traditionally offer physical attractiveness and fertility and seek financial security, while men offer financial resources and seek attractive partners. Both

partners bring a desired commodity to the social interaction and also gain from the other's desired characteristics. Personal ads create a forum for people to advertise their own desired commodity while also articulate those commodities they would like to exchange it for.

Personal Ads

Online dating sites are not entirely novel, but instead very much related to a long history of personal ads in newspapers and magazines. A number of studies have analyzed personal ads in order to better understand gender roles, courtship characteristics, and mating strategies of men and women. Several studies suggest that men look for physical attractiveness while women look for successful and financially secure men (Goode 1996; Thiessen and Ross 1990; Cameron, Oskamp, and Sparks 1977). While some men may still look for attractiveness and some women still look for security, Lance (1998) found that personality characteristics were the most often mentioned characteristics in his content analysis of personal ads. He suggests the changing social climate and gender roles are instrumental in these changes.

In a more recent experiment, Donald Strassberg and Stephen Holty (2003) placed four "female seeking male" ads on Internet bulletin boards. Contrary to prior research, Strassberg and Holty found the most popular (most responded to) ad was for a "financially independent . . . successful and ambitious" woman rather than the ad for the "lovely . . . attractive and slim" woman. The researchers suggest several explanations for their results. First, they note that unlike most of the earlier studies, they used Internet-based personal ads. Perhaps the men who use these sites are more ambitious and successful than those using traditional newspaper or magazine personals and are therefore looking for someone who shares these qualities. Second, the researchers point out that the "lovely and very attractive" ad did have the second highest number of responses, thus suggesting that male respondents still value these qualities. The researchers also propose that some men may have been turned off by a woman who describes herself as "very attractive," which may imply that she considers it one of her most important qualities. The researchers also point out that in addition to their medium choice (Internet vs. newspapers), the methodological difference from past personals studies (experimental vs. content analyses) also may have contributed to their different findings.

The Internet

Other researchers have examined the influence of the Internet on mediating relationship styles. Katelyn McKenna has examined the influence of the Internet on levels of disclosure of people's "true" selves. Two survey studies (McKenna, Green, and Gleason 2002) found that people who can better disclose their true selves over the Internet rather than in face-to-face interactions will be more likely to form close relationships online and that the majority of these Internet relationships were still together after several years. The researchers also conducted an experiment where one group of subjects met face-to-face and another group met online. The subjects were all then asked to evaluate their partners. Those subjects who had met online liked their partners more than those subjects who had met face-to-face. Another experiment found that people randomly assigned to interact via the Internet were better able to express their true-self qualities to their partners than those interacting face to face (Bargh, McKenna, and Fitzsimons 2002).

The researchers suggested that "gating features" such as physical appearance, stut-

tering, or visible shyness or social anxiety are not factors in online-relationship formation. Greater anonymity online also reduces risks of disclosure. Without such risks, disclosure may be higher, which can therefore lead to greater intimacy and closeness. McKenna et al. suggest that it's also relatively easy to find others who share similar interests online. As a result of greater ease of self-disclosure and the founding of relationships on more substantive bases, such as shared interests (as opposed to just physical attraction), online relationships may develop faster than off-line relationships. McKenna et al. argue that while socially adept people may have little need to express their true selves online, socially anxious or lonely people feel better able to express their true self online and may develop close and meaningful relationships. These relationships may start online, but many will be brought off-line as well.

Photographs

While online interactions do offer greater anonymity than face-to-face interactions, some online dating services offer members the ability to post photos to accompany their profiles or ads. This specific service is fairly particular to the medium. Unlike newspapers and magazines personals, online dating sites can easily offer such visual services. Some sites even highly recommend their members post photos as a means of increasing their chances of finding a match. For example, according to Match.com, "Guys are 14 times more likely to look at a profile with a photo; women are 8.5 times more likely to check out your profile if you have a photo; and members with photos get contacted seven times more often than members without." In addition to getting more people to see your profile, photos can also act as a safety measure. As part of ten safety tips for online dating, Match.com suggests to its members to ask for a photo of their potential date. "A photo will give you a good idea of the person's appearance, which may prove helpful in achieving a gut feeling. In fact, it's best to view several images of someone in various settings: casual, formal, indoor, and outdoors. If all you hear are excuses about why you can't see a photo, consider that he or she has something to hide. Since Match.com offers free scanning services to its members, there's no reason someone shouldn't be able to provide you a photo." In addition to text, photos provide a unique opportunity to explore how people present themselves through images.

Before we can analyze these photos as a means of self-expression on these sites, Goffman's *Gender Advertisements* (1979) provides us a helpful base with which to understand gender as represented in images. Goffman suggests that photographs in advertisements are ritual-like displays of gender norms. He observes several phenomena regarding gender roles in advertising. For example, when an advertisement depicts someone sitting or lying on a bed or a floor, that someone is almost always a child or a woman, hardly ever a man. Goffman also suggests that women, much more so than men, act childlike in these photographs and almost always have dazzling smiles. As Vivian Gornick points out in the introduction to the book,

> The most painful and perhaps the more important sentence in *Gender Advertisements* is this: "Although the pictures shown here cannot be taken as representative of gender behavior in real life . . . one can probably make a significant negative statement about them, namely, that as pictures they are not perceived as peculiar and unnatural" (ix).

While Goffman is specifically addressing photos in advertisements, his observations about gender norms may extend to personal ads where people are aware of these norms and may act them out in the photos they choose to post on their profile. By exhibiting

these gender displays in their profiles and photos, people may decrease their risk of offending other members and increase their chances of finding a match.

Methodology

In order to examine how members use photos in online personal ads, I examined 120 members' profiles on a major international Internet dating service website. I searched "woman seeking man" and "man seeking woman." For each gender, I searched three age categories: 18–29, 30–49, and 50+. In order to limit the results to relevant members, I searched only those profiles that had photos. No zip codes were entered in the search field so as to get a geographically diverse sample. The online dating service presents their findings 10 per page, with up to 50 pages for any one search. I searched pages 1, 6, 11, 16, etc., skipping those subjects who were not in the United States until I reached 20 subjects for each gender-age slot. The search results included international profiles, however, I wanted a more culturally homogenous group than an international search would have provided. Differences in the profiles may have been more cultural than social.

Each profile was coded for gender, age, location, ethnicity (self-identified), number of photos posted, number of photos smiling, number of photos looking into the camera, number of face shots, number of medium-range shots, number of long-range shots, number of photos in which the member was with someone or something else and who/what it was, and whether the photos were black-and-white or color. The number of photos that accentuated the member's body was also coded. A photo accentuating the body was defined as a man having his shirt off in a photo, a woman wearing a short skirt (mid-thigh or higher) or a shot in which a woman is revealing any amount of cleavage. There was one image of a man wearing a wetsuit that, while covering his whole body, was coded as accentuating his body due to its tightness. The activity and location of the person in each picture were also coded if available. Much of the time, the photos were so tightly cropped around the person that it was impossible to code for location or activity besides posing.

All members of this particular dating site are asked to fill out a member profile that includes a self-assessment of one's body type. The site offers six categories of body type to choose from: "slim," "athletic and toned," "about average," "a few extra pounds," "heavyset," and "other." Members are also asked to select the desired body type of a potential match. For this section, members can choose as many categories of body type as they want. In addition, an "any" category was included in the list of desired body types. Both the member's body type and the desired body type are noted in this study. Finally, each profile page included a section where members are asked to describe themselves and what they are looking for. This study analyzed the section of each profile where the member described what they were looking for.

Results

Overall, the average number of photos posted per profile was 1.09. This did vary significantly by gender (p<.05), but not by age cohort. Contrary to expectations, men posted more photos than did women. There were no women in this sample who posted more than three photos, however, there were seven men who did. No one posted more than five photos on their profile although the site allows members to post up to 25 photos for free.

Of the photos submitted, 40.8% included face shots, 69.2% included medium shots, and only 20.8% included long, or full-body shots. There were no significant trends

between the type of shot and gender or age cohort. However, there were differences between how the genders combined photo shots. Of the 15 men who posted full-body shots, 13 of them included at least one close-up or medium shot as well. Of the 15 women who posted full-body shots, 9 of them did not include any other medium or close-up shots. This gender difference is statistically significant (gamma = .714, p<.05). This suggests that for women, a full-body shot was more sufficient to represent themselves than it was for men. It might also imply that women feel a full-body shot of a woman is more important in evaluating potential mates than is a full body shot of a man.

A few of the photos appeared to be professionally taken. Five men and five women posted photos that seemed professionally done (coded either stylistically or because of a backdrop). These professional-looking photos can be broken down into two groups: glamour shots or formal shots. Glamour shots used a lot of lighting and sometimes makeup to make the subject look glamorous. Three women and two men included glamour shots in their profile. Formal shots included photos that were in front of a gray or blue backdrop. Three of these photos were shots of people in suits (two men and one woman), and two other photos looked like high school pictures for a yearbook (one man and one woman). In addition to professional-looking photos, images were noted as color or black-and-white (sepia tones were coded as black-and-white). Only 5% of men and 8.3% of women posted photos that were black-and-white. All of the women who posted black-and-white images of themselves also posted color images. All of men who posted black-and-white images did not include any color images. This gender difference is statistically significant (p<.05).

While some people had photos that appeared to be professionally done, most photos were amateur. Some posted photos had originally included other people or objects, which were obviously cropped out. In several of the photos, arms or hands of other people were still evident. There was one photo that seemed to be a professionally taken family portrait, which had been cropped to only include the male.

Not all members of this online dating service chose to crop images that included other people or things. Twenty-one people (17.5%) posted at least one photo in which they were posing with another person, animal, or large object (a car or boat). Of this group, women were more likely to include people or animals than objects. Men, however, were more likely to include animals than they were people or objects. Five women and three men posted *only* photos that included either another person or an animal or a large object, and did not include any photos of just themselves.

As expected, women were significantly more likely than men to both smile in their photos (gamma = 0.34, p<.001) and to look at the camera (p = .01).

Men were also more likely to be participating in an activity in the photos while women were likely to be passively posing in their photos (p<.01). There were significantly more photos of men engaging in an activity, such as working at a desk, playing a sport, talking on a phone, playing a musical instrument, hiking, driving, skiing, swimming, or at a bar with friends. When women were doing something active, they were seldom alone and shown either out with friends or talking to other people. In addition to differing activities, several men wore uniforms (specifically military or medical) in their photos, while no women included photos of themselves in such clothing.

There were also significant gender differences between posting photos that accentuated the body. Consistent with exchange theory, women were more likely to post photos revealing cleavage or wearing short skirts than men were to post photos with their shirts off (p<.05). The use of such revealing images did not significantly vary by age cohort. The

kinds of images women posted did range from fairly innocent to fairly provocative poses. Some women included pictures of themselves standing in a low-cut shirt, while others would pose very suggestively, for example, crawling across a bed. Of the 12 women who included photos accentuating their bodies, all but two also included photos that did not accentuate their bodies. An interesting aside, the only two people who mentioned in their profile wanting someone who was drug-free were two women who posted photos that accentuated their bodies.

The body types of the subjects were fairly similar between genders. There were slightly more "slender" women than men, while men were more likely to identify themselves as "athletic and toned." There were also similar numbers of men and women who identified themselves as "a few extra pounds" or "heavyset." All of the men answered this section of the profile, while there were four women who had "no answer" for body type on their profile. Based on the photos these women posted (which may be misleading), these four women could have fit into the body-type categories "about average" or "a few extra pounds."

One of the interesting things, however, about this and other online dating services is that it allows people to compare the self-identified body type with the photos that were posted. There were remarkable differences between people of similar self-identified body types of both men and women. There were also physical similarities between people in different body-type categories. For example, some men identified themselves as "a few extra pounds," but looked very similar to someone of the same height who identified himself as "heavy." This suggests that self-identified body type may be as much biological as it is psychological. It should be noted, however, that photos can be misleading. While a person may self-identify as and look athletic and toned in a picture, to meet them face-to-face might lead you to think they had a few extra pounds on them. In addition, there were 20 subjects who only posted close-up shots, which do not allow for much of a comparison between self-identified body type and photos. For the most part, peoples' self-identified body type did seem to correlate with their photos.

There were significant differences in the number of photos posted based on self-identified body type. Athletic and toned people posted the most number of photos (mean = 2.06), then average people (mean = 1.61), closely followed by slender people (mean = 1.60). Given that there were only two people who considered themselves "heavy," it is difficult to say much about them, though both of them did post more than one picture.

In addition to how people identified their own body type, the dating website also asked people to select their ideal or desired body type of their potential match. All of the subjects answered this, even the four women who did not identify their own body type. Of these four women, one said that "any" body type is ideal, one said "about average" is ideal, one said "athletic/toned" is ideal, and the last one said that both "about average" and "athletic/toned" are ideal.

Overall there were significant differences between how men and women described the body type of their ideal match. Women were much more likely than men to say that "any" body type would be acceptable in their ideal match (gamma = 8.5, p<.001). For men, 85% identified "slender" as a desired body type for a match while only 52% of women did (p<.001). This gender difference is not surprising given traditional gender norms of women as small and slender and men as strong and athletic. Men most often selected "athletic/toned" as the desired body type for their match(87%), while women

most often selected "about average" as their desired body type (88%). Women were significantly more likely to select "a few extra pounds" (p<.05) and "heavyset" (p<.001) as desired body types.

Additional gender differences are revealed through an analysis of the text of each profile, in which the member specifies what they are looking for in a potential mate. Overall, most people were interested in meeting others who had similar interests to their own. Several people just spoke about themselves and their own interests with a brief sentence about liking the same in a match or "if any of this has piqued your interest, please contact me." Each description was also analyzed for whether it identified any stereotypical female or male characteristics (good looks or attractiveness for women and strength, responsibility, or financial stability for men). Men were much more likely than women to mention good looks or attractiveness when describing what they were looking for in a match (gamma = .46, p<.05). Some examples of these are:

- "basically looking for a pretty girl who can carry on an intelligent conversation."
- "[am looking for] all the standards: honest, loyal, trustworthy, good looking, etc., etc."
- "I'm looking for a beautiful, fun, and outgoing young lady who's not afraid to try new things."
- "My ideal date would be a lady with a true smile, excitement in the eyes, that is a little shorter and smaller than me, that takes care of herself and others in her life, that loves the world and the people and things in it."
- "Looking for a trim, slender woman to share my life and enjoy life together, travel companion, someone to share life's experiences and pleasures."
- "She should be between 36 and 50. The only request that I have other than her age is that she not be obese. A few extra pounds in the right places is certainly acceptable! What's in her head and her heart is far more important than what's below." (Note: Although he says a few extra pounds is ok, he only marked slender, athletic/toned, and about average as the desired body type for his match.)

While 25% of women (n = 15) mentioned a stereotypical masculine characteristic in their description of what they are looking for in a match, a number of men did as well (15%, n = 9). When men did mention a stereotypical masculine characteristic when describing their female match, they most often used the terms "independent" and "strong." Only one man mentioned, "It would be nice if she had a good job." Often, when a man would identify a "masculine" characteristic, it would be followed up by a "feminine" characteristic such as, "A woman who is strong with/without her mate; however, her mate is the support which helps raise her to the next level in life," or "she would be strong and independent but attentive and receptive to romance."

Some examples of women using traditional gender displays to describe their perfect male match are:

- "Very secure and stable, someone that is confident but not stuck on himself"
- "I would like to meet a mature man with responsibilities."
- "A gentleman who knows how to treat a lady."
- "Someone that I can just look at and feel protected and secure."
- "I am looking for a tall, handsome man who is responsible and fun loving."
- "Confident, successful, warm, caring, intelligent gentleman would impress me."
- "Someone kind, witty, honest with at least a halfway decent job."

Despite these stereotypical characteristics, the majority of people described personality characteristics of their ideal mate. Similar to Lance's study (1998), members primarily sought matches with such characteristics as "nice," "honest," "caring," "having a good sense of humor," "trustworthy," "fun," "sincere," "understanding," "charismatic," "thoughtful," "happy," and "a good communicator." A number of subjects discussed wanting to do things with their match such as going out to dinner, cuddling on the couch while watching a movie, and traveling (especially the older men). Only one member actually posted pictures of himself out to dinner at a restaurant and traveling. Most of the photos do not depict or correlate with the descriptions people wrote.

Discussion

Unlike most newspapers and magazine personal sections, online dating services are not limited by time and space. They do not come out weekly, but can be constantly updated and changed. Profiles can be added, edited, or removed with ease. Even throughout the course of this study profiles were changed or removed (data and analyses were based on initial coding of profile and images). Because space on these websites is significantly larger than what newspapers or magazines can afford (in addition to what people would pay for their personal ads), more information about each member can be communicated.

In addition to the profiles that members fill out, and the descriptions written, people can and are encouraged to post photos. These photos did not vary much by age cohort, but did by gender. Following Goffman's observations of gender roles in advertisements, there were many gender displays in the photos posted by members of this online dating service. As stated earlier, women were more likely than men to look at the camera and smile in their photos, were more likely to diversify their photos choices based on style and format, and were also more likely than men to post photos of themselves that accentuate their bodies. These gender differences suggest that women are aware that their looks may be important to a potential match. This was confirmed by the desired body type for a match: women were much more likely than men to check that "any" body type would be desired.

Following Goffman's observations of gender advertisements, men were also more active in their photos than were women. At the same time, there was evidence to suggest that people do not entirely subscribe to the exchange theory and gender displays. There were men who were looking for strong, independent, and successful women and there were women who were looking for sensitive and attractive men. However, even some of these members would exhibit traditional, if subtle, gender displays in other sections of their profiles. This study demonstrates that gender roles and mating strategies are not entirely predefined, but continually constructed on both an individual and social level.

In addition to gender differences, there were also significant differences between how people of different body types used photos. People who identify themselves as athletic and toned posted more photos of themselves than any other body-type category. This is not surprising since people who are athletic usually work out or play sports to actively tone their bodies. Also, there is a certain amount of backlash against women who appear too skinny, with a general shift towards desiring a healthy and fit partner. It can also be suggested that slender people do not want others to think they are showing off their body and therefore do not post as many photos. Another possible explanation is that some members might not be slender and therefore do not want to post too many photos that might reveal their real body size.

One of the most interesting (and tangentially related) findings of this study is the promotion of images by the website itself. From safety tips to how to maximize your chances of finding a date, the site heavily promoted the use of images and even video for its members. While McKenna found that the anonymity of the web offered socially anxious people a means of expressing their true self, such visual technology may decrease this anonymity and change who uses these services and how. In addition to promoting photos, the site also promoted glamour-shot services. These services include professionally taken photographs as well as digitally enhanced photos (e.g., whitening of teeth, smoothing out of wrinkles). Such services raise questions about how photos represent the true self. Moving forward, the evolution of these services may greatly affect those who use online personals.

Important questions about how people think about the different elements of these services (text vs. photos, for instance) could reveal more about how people find matches. For example, what types of people constantly edit or update their profiles? Who uses the profile-matching services on these websites, and who scours the web profiles? What kinds of categories (such as ethnicity or relationship history) are most important to people? Who initiates communication between two members? What other kinds of gender roles are enacted in these mediated spaces? While this study did not address it, an analysis of who posts photos and who does not may lead to further understanding about anonymity and social anxiety, as well as the importance of the body and appearance in mating strategies. More analysis comparing face-to-face and online dating could also help us to understand how people construct their gender and identities when meeting potential matches. However people initiate communication, in the end the technology goes away and the ultimate goal is to find that special someone in our lives.

REFERENCES

Bargh, J., K. McKenna, and G. M. Fitzsimons. 2002. Can you see the real me? Activation and expression of the "true self" on the Internet. *Journal of Social Issues* 58 (1):33–48.

Cameron, C., S. Oskamp, and W. Sparks. 1977. Courtship American style: Newspaper ads. *Family Coordinator* 26:27–30.

Egan, J. 2003. Love in the time of no time. *The New York Times.* November 23, 2003.

Goffman, E. 1959. *The presentation of self in everyday life.* Garden City, NY: Doubleday Anchor Books.

———. 1979. *Gender advertisements.* New York, NY: Harper Colophone Books.

Goode, E. 1996. Gender and courtship entitlement: Responses to personal ads. *Sex Roles: A Journal of Research* 34 (3–4):141–170.

Lance, L. M. 1998. Gender difference in heterosexual dating: A content analysis of personal ads. *The Journal of Men's Studies* 6 (3):297–306.

McKenna, K. Y. A., A. S. Green, and M. E. J. Gleason. 2002. Relationship formation on the Internet: What's the big attraction? *Journal of Social Issues* 58 (1):9–31.

Mudd, G. 2003. U.S. consumer spending online. New York, NY: comScore.

Strassberg, D.S., and S. Holty. 2003. An experimental study of women's Internet personal ads. *Archives of Sexual Behavior* 32 (3):253–261.

Thiessen, D., and M. Ross. 1990. The use of a sociobiological questionnaire (SQ) for the assessment of sexual dimorphism. *Behavior Genetics* 20 (2):297–305.

APPENDIX: DESCRIPTION OF PROFILE GUESTIONNAIRE

On this website, subjects are requested to fill out a member profile that asks about height, eye/hair color, body type, how you would describe your sense of humor, what are your turn ons/offs, smoking habits, drinking habits, occupation, income, ethnicity, faith, education, political affiliation, languages spoken, number of children, past relationships, and what type of relationship the member is looking for. The website also asks members "who they are looking for." This section of the profile asks questions about gender, age, geographic location, height, eye/hair color, body type, ethnicity, faith, education, languages, profession, income, drinking and smoking habits, past relationship history, and if the person has children or wants them. For each of these categories, members are asked to rank the overall importance ("not very," "somewhat," and "absolutely"). The ranking of these categories are not public, but instead are used by the company to identify "matches" or make suggestions to members.

David Perlmutter

Hypericons

Famous News Images in the Internet-Digital-Satellite Age

Only recently in human history have visual images been transmitted instantly from the place of their creation to a global audience. This chapter explores how the characteristics of "big pictures"—images that become icons of photojournalism—are affected by their "live from ground zero" status. Taking examples from the Iraq War of the "Cargo of Flag-Draped Caskets" and the "Killing of American Civilian Contractors at Falluja" pictures, I argue that the speeded-up famous image, or hypericon, has both thwarted government attempts at controlling images and undermined some of the traditional mechanisms of icon making and shaping. Furthermore, since the news system puts such a premium on its dissemination, saturation, and then replacement, the icon itself may have lost its value as a transcendent marker of history. The hypericon may be but a blur, signifying a post-icon age to come.

The scientist, the engineer, the editor, and the cameraman are today linked in a united, and ever tireless, effort to speed the news photograph to the reader, so that when he scans the picture as he reads the accompanying story over his breakfast table, he can truthfully exclaim: "This picture age is marvelous!"

Ezickson 1938, 48

The Rise of the Hypericon

In writing of the "real-time" phenomenon of the first Gulf War, Barbie Zelizer noted, "Critical incidents are generally shaped by discourse about two features: technology and archetypal figures" (1992, 82). My goal here is to appraise the effect of the technological quality of "speed" of a communication act on archetypal pictures of news events. Specifically, I look at two recent famous news pictures and ask what the "time" element of their delivery signified for our interpretations of their meaning.

In perspective, in the pre-electronic past, people were reliant on transmitting images and words via media that could be transported only as fast as a horse or ship. The last half millennium, however, has seen a compression of the time from the moment a picture of news is "taken" to when it reaches its audience (see Table 5.1—Picture Transmission Chronology). The advent of printing on movable type in the 1500s facilitated the mass production and distribution of identical images. The invention of photography in the 1840s allowed the "capturing" of events with a mechanical device, although it was almost fifty years before "photojournalism" was regularly practiced (Carlebach 1992), and not until the 1930s that pictures were first regularly sent "over the wire" (Coopersmith 2000). Developments accelerated from the first black-and-white halftone used in "transferring" a photo to print (1880s) to radio-wireless transmissions of data (1895), the miniature still camera (1888), roll film (1889), commercial use of Leica (single lens reflex camera) (1925), and the widespread use of color photography (1950s). By the 1960s, critics and researchers were already talking about "living-room wars"—yet news-film stock took about a day to be flown from, say, Saigon, and then to be processed to appear on the evening news or in afternoon papers. The use of video (1970s), fiber-optic glass tubing (mid-1970s), the employment of satellite transmission (1962), the commercial Internet, digital photography, and commercial cell phones (1990s) further compressed the temporal distance between the pictured event and its audience, so that now pictures of the Iraq War are available to viewers worldwide seconds after they are taken, on television or on the Internet.

Questions about the effects of the content of images have an even more ancient heritage but also a modern provenance. In Plato's "Republic," the philosopher argues that most visual artists as well as vivid poets should be banned from the ideal state because painters and poets "too easily fool the senses, confusing reality with falsehood" (Plato 1987, 595c). In turn, the gullible public will be lured into following policies not because of their rational sense, as elucidated by the philosopher-rulers, but by spurious feelings. From the Vietnam era through the mid-1990s, television was typically cited as the most influential purveyor of such powerful images. As reporter Donald Shaw wrote, "Clear, dramatic pictures are the key to both 'good television' and to the impact a given story will have on viewers" (1992, A19).

Further, it is taken as a commonplace that such images affect what governments do and what the people think about an issue. For example, in the case of the 1992 decision of outgoing President George H. W. Bush to intervene in Somalia, media critic Tom Shales asserted that "shocking and heartbreaking" television pictures of starving children in Somalia helped motivate the American response (1992, G1). Concurring, one of America's most senior statesmen, George F. Kennan (1993), cited images as the driving force behind such a policy. Typically, policy-makers are unhappy that their deliberative processes are upset by images. Secretary of State Warren Christopher complained that "television images cannot be the North Star of America's foreign policy" (Urschel 1994, 10A). Yet political leaders often monitor television to find out "what's really happening."

When presidents and pundits speak of powerful pictures, notably they typically refer not simply to the herd of the news stream (many pictures), but to the select "icons" of photojournalism, that is, the canonical "big pictures"; those that not only become famous but are ascribed to be influential on the very events they portray (Domke et al. 2002; Hariman and Lucaites 2004; Perlmutter 1998, 2004a, 2004d; Perlmutter and Wagner 2004). These are the pictures that are printed and shown often in various media,

Date	Invention	Common Use
1450	Printing – Gutenberg	Multiple copies of a document
1663–1669	Drawing machines	Projected image traced on to semi-transparent paper and viewed through a fixed eye piece
1775–1804	Wood cut illustrations	Drawing traced onto polished surface and hand engraved by several workers onto separate plates
1837	Telegraph	Transmission of electronic signals by wire. Information that once took ten days now is received at 186,000 miles per second
1839	Photography	The capture of the visual image: daguerreotype
1867	Rotary press photogravure	Enables visual images to be printed along with text
1880	B&W halftone	Reduces process of visual replication from etchings of weeks to hours. First use of halftone in newsprint paper: January 21, 1897, the New York Tribune
1889	Roll film	Allows for capturing of fast-moving visuals (modern film)
1896	Radio	Wireless transmission of electronic data (limited distances) Marconi sends a message between two post-office buildings in London
1901	Radio/telegraph	First transatlantic telegraph message sent by radio
1907	Cathode ray tube receiver	Allows for electrons of light to be received and transformed into images
1925	Fax	Transmission of electronic images through wire
1935	Regular photo-by-wire service	Wirephoto introduced by AT&T, leads to AP Wire
1939	Television	Transmission of visual image via wireless technology. NBC officially inaugurated the nation's first regular television service on April 30 by sending broadcasting to an antenna atop the Empire State Building eight miles away.(Roughly 200 television sets existed in New York at this time.)
1946	Computer	Electronic Numerical Integrator and computer at Univ. of Penn. Digital compression of data allows for faster transmission of information with then-available vacuum tube technology.
1951	Network television	Coaxial cable and microwave relays allow for greater distance of television
1956	Transatlantic cable	Speed and quantity of news flow increased between nations
1956	Videotape	Capacity for high-speed scanning of imagery and the re-recording of information; instant replay not possible before video tape
1957	Sputnik satellite	
1962	Communication Satellite- Telestar	Instant transmission of electronic data across the globe
1965	Cell phone	Low-frequency transmissions of data that individual receivers can share and relay to a central tower
1969	E-mail	The first computer-to-computer message occurred in 1969 from UCLA to Stanford where two programmers sat at each end of a computer connected by phone wire.
1960s	Internet	ARPANET Sharing data over telephone lines and satellites, direct connection and instant data two-way transmission
1960s–1970s	Mainframe and minicomputer	Replication of process of data thousands and millions at a time on magnetic tape and disc
1970s	Fiber-optic cable	Telephone copper wire replaced by fiber-optic glass tubing allowing for greater capacity of digital information transfer two ways from one point to the next
1975	Electronic news gathering camera (ENG)	Before transistors in cameras, breaking news stories were filmed and there was a delay of an hour or more while the film was being returned to the studio and developed
1982	Sony Mavica digital camera	First electronic non-film still camera
1988	Portable transmitter	Allows for format, caption, and transmission of 35mm film images directly to computer or output printers
1996	30 million Internet users and growing by 15% a month	The number of people connected to the Internet grew at an exponential rate in the mid-1990s, a phenomenon called Metcalfe's Law, unseen or heard of in any technology, media, or business.
1997	Wireless application protocol (WAP)	Allows data to be sent in a roaming network and by satellite without wire
1998	Internet telephone	Nokia launches a telephone that enables users to connect to the Internet
2002	Satellite videophone	Allows camera to plug into cell phone with signal bounce off satellite; allows live footage in real time or completely edited tape fed back to station between 5 and 30 minutes transmission time.

Table 5.1: Picture Transmission Chronology

and then enter the pantheon of great historical images. Beyond celebrity, these pictures are employed in political struggles and serve as symbols of or "summing up" events, issues, and even whole eras of history. They become familiar to a generation of viewers and can be recalled by the mere mention of their subject matter: for example, Robert Capa's *Dying Spanish Militiaman* (1936), Eddie Adams's *Saigon Street Execution* (1968), Dorothea Lange's *Migrant Mother* (1936), Joe Rosenthal's *Old Glory Goes Up On Mt. Suribachi* (1945), the photo by an unknown Nazi photographer of a small boy emerging from the rubble of the Warsaw ghetto (1943), Alberto Korda's *Portrait of Che Guevara* (1960), Charles Moore's *Police Dogs Attacking Black Civil Rights Marchers in Birmingham, Alabama* (1963), Bob Jackson's *Jack Ruby Shooting Lee Harvey Oswald* (1963), John Paul Filo's *Girl Screaming over a Dead Body at Kent State* (1970), Huynh Cong Ut's *Naked Little Girl and Other Children Fleeing Napalm Strike* (1972), and *Man Standing Against the Tanks at Tiananmen* (various photographers). "The Fall of Saddam's Statue," "Abu Ghraib Prisoner Abuse," and "Cargo of Caskets" are more recent candidates for iconicity.

However, researchers tend to (or should) be somewhat skeptical about the "powerful" effects model for news icons. For example, Howard Bossen (1982) found that the widely held opinion that William Henry Jackson's magnificent western landscape photographs helped pass the protective Yellowstone Act of 1872 was plainly false, since the Jackson photos postdate the legislation. Studies in the anatomy of icons affirm that, while certifiably icons in their popularity and ubiquity, these images often have effects more complicated than generally surmised (Perlmutter 1998; Perlmutter and Wagner 2004). Often, in many famous cases, the ritual formula that develops is that a picture "drove" some big event, such as from war to an election, but the data to support this contention are a *fata morgana*, receding when one gets closer to the facts. In my study of the *Saigon Street Execution* image from Tet, 1968, for example, I found hundreds of assertions, coming from politicians, generals, and protesters, that this was "the picture that ended the war," but the public opinion data and the historical sequence of events simply did not support the hyperbole. It may be in fact that the most powerful effect of pictures is the generally held belief that they are powerful.

In response, I have suggested that visual icons be divided into two species. First, there are the singular, acute, or "discrete" icons, those images that we recognize as single famous "shots" taken at one time and place in relation to one event (such as *Girl Screaming over a Dead Body at Kent State*). Second, there are the chronic or "generic" icons that describe many images across time and space and events. The "starving child of Africa" is such a commonplace—a veritable visual cliché repeated over the last century in many African conflicts and disasters.[1]

We may further circumscribe the elements of the news icon into Celebrity (the degree of fame of the image as signaled by its winning awards such as the Pulitzer Prize or its citation in works such as this present study), Prominence (the relative status of its placement in media such as, for example, "above the fold" on the front page of the newspaper or as the lead-in of a newscast), Frequency (how often over time the image appears and reappears), Profit (how much money the picture earns in rights and sales), Transposability (how often and widely the picture is transposed into other media—for example, a photo appears on a T-shirt, or is morphed onto an editorial cartoon, or inspires a fiction film), Fame of Subjects (the notoriety of the people in the image), Importance of Events (the notoriety of the events of the image's provenance), Metonymy

(that the image is used to symbolize or stand for greater events and even eras), Primordiality and/or Cultural Resonance (the image seems to tie into greater or older cultural allusions: for example, *Man Against the Tanks at Tiananmen* is likened to Horatius at the bridge or David vs. Goliath); Striking Composition (the image seems to suspend dramatic events into what Cartier-Bresson called the "decisive moment," where "the subject and the compositional elements form a union" (Lester 1991, 7), and what Henry Grossman dubbed "revealing juxtapositions" (quoted in Clarke 1981, 28); and Emotionality (the ability to draw emotional reactions from viewers). Then, icons often are said to be powerful politically, driving public opinion, policy-making, even events themselves.

A final quality of icons is one that the modern technology has made possible: speed. Icons of yesteryear could certainly attain fame quickly: Benjamin West's *Death of General Wolfe* and Leonardo's *Mona Lisa*, for instance, were popular and profitable from their first showing. But, in contrast, Umberto Eco spoke of the "hyper reality" of the modern world: everything is faster, from food to our media. Elsewhere I have written that while we often accuse media representations of being unreal, or false, actually they are "inreal"—intensified versions of reality (Perlmutter 2000). For example, most television police officers engage in weekly violence, from car chases to shoot-outs. Many real-world police take part in the same activities, but at a much lower rate. Indeed, as Derek Bouse found, even the "documentary" wildlife film, in order to create drama and action, compresses activities of months into minutes so as to make the animals' lives televisually dramatic (2000).

Here, taking examples from the Iraq War and insurgency, I will argue that the famous news picture is now a sort of *hypericon*—instantly available, globally disseminated via the Web, and, perhaps, also fleeting in public consciousness. I will speculate on how we can assess the effects of this novel phenomenon. Does the speeded-up pace of the modern news picture affect how we appreciate it? Are today's icons affected by their quality of instantaneousness or being actually or virtually "live from ground zero"? What happens when icons are not subject to the filtration mechanism of the old news media? Speaking to Walter Benjamin's argument that the "work of art in the age of mechanical reproduction" has lost its status of uniqueness, can we think of "time" (and its compression) as one aspect of this erosion of the icon?

The Cargo of Caskets

Among the most common generic visual icons of war, both in news and in fictional portrayal, is the warrior's funeral. Some warriors are, of course, more famous than others and their rites of death were, in ages past, stock imagery. For example, the funerals of Patrocles, Hector, and Achilles were ubiquitous on ancient Greek pottery. In the case of the Greeks and Romans, the funeral scene typically comprised the body either being carried to a tower of immolation or on the pyre itself. In other cultures, the setting may be more stark. In Akira Kurosawa's *Seven Samurai* (1954), after the final battle, the graves of the four fallen Ronin heroes are featured. They are marked by a quartet of swords plunged into a large pile of earth, crested by the war banner of the seven samurai. Of course, grand funeral proceedings and imposing monuments are part of many other traditions, occidental and oriental (Coombs 1983). But in the American iconology of war, the soldier's funeral tends to have certain distinct visual features: the casket draped by the American flag is almost always the centerpiece of the frame. The coffin may be in the

foreground at the Arlington National Cemetery (Perlmutter 1998, 127 and 153), or being transported off a cargo plane.

The Iraq War photograph of the American soldiers' flag-covered caskets combined a receptacle as well as a symbol of death with the premier symbol of the nation. The picture and its elements are not naturally "anti-war" or "pro-war" but rather are filtered through the minds of the beholders. For example, an anti-war activist, opposed to the Iraq War whether out of pacifism or in antagonism to this particular conflict, could take such an image as indicative of the war's costs—the pointless deaths of America's valiant men and women. A supporter of the war may agree on the tragedy of the loss but see the flag-draped casket as a measure of sacrifice for the cause of defeating terrorism. The more personally involved observer will, of course, be aware of the body inside the box. Recently, a New Jersey mother of a serviceman killed in Iraq became instantly famous when she confronted First Lady Laura Bush at a campaign rally (Hedges 2004). Interviewed later by the *New York Times*, she lamented that she felt the body of her son had not been respected because, as an observant Jew, she had "asked that her son not be embalmed or undergo an autopsy," but the Army had conducted both procedures anyway.

During the Iraq War, the flag-covered caskets became controversial for another reason: whether to show them at all, since they were subject to military censorship. Notably, the first breaking of this ban was a case study in the hypericon. The narrative of the events is straightforward (see Table 5.2—Timeline of Cargo of Coffins Story). On April 7, 2004, Tami Silicio, of Edmonds, Washington, was working for Maytag Aircraft company in Kuwait. Among her duties was to assist in the loading of caskets of American servicemen killed in the Iraq War onto the company's transport planes (Kugiya 2004). The planes would then fly the caskets to Germany and then to the United States, or directly to the United States Dover Air Force base. Ms. Silicio was helping to load a 747 jumbo jet transport bound for Germany. Using a pocket digital camera, she took several photos of the casket-packed bay of the plane. She then sent the pictures, as an e-mail attachment, to a friend in Seattle. She later told reporters, "The photograph was supposed to show the respect. It was supposed to be a comfort" (Buncombe 2004). That much can be read in the picture, at least by this observer. When asked by a newspaper to write about my aesthetic judgment of the image I responded,

> The photographer in me acknowledges the fearful symmetry of the rectangular flags over the caskets. They look like railroad tracks receding into the horizon. Then, the blurred attendants are bent over, as if they offer reverence to the honored dead, although they may simply be adjusting straps or securing hinges. Finally, there is the anonymity of the mass, packed economically . . . (2004c).

These are images connoting veneration as well as a documentation of process, anti-war and pro-war considerations are imposed by the viewers.

But the picture did not remain in the private sphere. Ms. Silicio's friend provided the picture to the *Seattle Times*, which ran it and then put the photographer quickly in touch with a photo agency (Haldane 2004). The picture was picked up by print and electronic publications worldwide—"The Shot Seen Around The World," proclaimed London's *Independent* (Buncombe 2004). Meanwhile, Silicio and her husband were fired because, according to their employer, they "violated Department of Defense and company policies by working together" to take and pass on the images (*Los Angeles Times*, 2004). That policy had been formulated by the administration of former U.S. President George Bush senior. In 1996, media outlets lost an appeal for a lift on a ban on pictures (JB Pictures Inc. v. U.S. Department of Defense, 1996). But the policy had not been enforced until

Date	Event
January 1991	President Bush prohibits photos of coffins at Dover for Gulf War
1996	Media outlets lose appeal for lift of ban on pictures
November 2000	Military-wide ban against photographing coffins; prohibits families of killed from attending arrival of coffins
March 2003	Pentagon reiterates "no photograph" policy of deceased military personnel through Dover
April 7, 2004	Tami Silicio takes picture of coffins in cargo bay of plane at Kuwait headed for Dover
April 18, 2004	Seattle Times publishes coffin photo
April 21, 2004	Silicio is fired from Maytag Aircraft
May, 2004	Russ Kick of memoryhole.org receives and posts 288 photos of soldiers' coffins from the Air Force, including 73 of the Columbia astronauts killed. Print and electronic media apologize for publication of miscaptioned pictures.

Table 5.2: Timeline of Cargo of Coffins Story

November 2000, when the military enacted a ban against photographing caskets or the arrival of caskets. In April 2003, the Pentagon reiterated the "no photograph" policy of deceased military personnel through Dover (cf. Perlmutter 2004b). At one point, even the families of soldiers killed in war were not allowed to be at Dover when the caskets arrived, but that policy was revised on May 26, 2004, to ban only the taking of photographs (Penrod 2004). To add to the seeming contradictions, the DoD had allowed the dissemination of some pictures of flag-draped caskets from the Afghanistan war and others of bodies uncovered by American soldiers of enemies and civilians after battles in Iraq.

The publication of Silicio's picture unleashed a storm of controversy. The President, however, announced that he had been "moved" by the casket photos. Editorial opinion, not surprisingly, was strongly for a loosening or removal of the ban. A national poll asking, "Should the public be allowed to see pictures of the caskets arriving in the United States?" found 62% in favor, 27% opposed.

The story was complicated when many other flag-covered casket pictures began to appear in mainstream media, most sourced to memoryhole.org, a private website whose founder, Russ Kick, seeks out restricted information. In this case, Kick had filed a Freedom of Information request to get access to such photos from the U.S. Department of Defense. The DoD provided more than 300 pictures taken by military personnel but later announced that they had been released in error. Confusion ensued when NASA announced that some of the pictures were in fact the dead from the Columbia Space Shuttle. (Bloggers noted that NASA administrators are visible in a number of the photos (Cowing 2004).) In the end, the DoD maintained their policy on banning flag-casket photos and does so to the time of this writing (Kirschbaum 2004).

I argue that the flag-draped casket case challenges our traditional view of the icon in several ways, or rather creates complications and contradictions with the norms of "big pictures" and their outcomes. Of initial interest is the genesis of the photo. That an icon can be produced by an amateur, not even a hobbyist photographer, is not unusual. The *Screaming Woman at Kent State* and the *Oklahoma Firefighter Carrying a Baby* were both icons taken by ordinary people who happened to have a camera at the scene of an extraordinary event (although in the former case the photographer worked in the student photography lab of the university campus). Generally, however, the amateur has had to approach a media organization physically—that is, go to a nearby television station or

newspaper office to offer the photo.

Now, cheap digital cameras and e-mail attachments allow anyone to electronically mail a picture to any news outlet in the world. No longer must the photographer find a contact within the news industry. And if rejected by a "local" outlet, the amateur could try thousands of media outlets with websites. Note here how industry and fringe conflate: Once the picture is bought by an "acceptable" news outlet, then it can be distributed by traditional means over the "wire" (actually industrial computer networks and services like AP Photostream). Silicio's flag-casket photo, as stated, was e-mailed to a friend who in turn e-mailed it to a *Seattle Times* editor. Only *after* the paper printed the picture and then referred Silicio to a photo-rights agency did the image achieve wide distribution. In short, it was not exactly the case of an amateur creating her own venue for the image. Nor was the speed of delivery greater than what would have resulted from a professional photographer's production, in fact, it was a slower process from the taking of the picture to its appearance in print.

One element of hypericonicity, thus, is that the delivery of a news picture to a global audience is not yet at the point where we can determine contact to be direct between picture-maker and picture-viewing public on a wide scale. Certainly, a terrorist group can put a picture of some atrocity on the Web, but typically only after a widely recognized website publicizes the pictures (reposting them) and blogs provide the site's location can even the more technology savvy (and morbidly inclined) public actually see them. In fact, I have noted that by the time such images have been openly announced (and denounced), the Web links in question are down. In short, the mainstream media still play an important channeling, directing, and amplification role in the icon's rise to greatness; indeed, it is the speed of their transport systems that allows large audiences to take note of such icons.

But speed has another connotation here. Meyerowitz, in his book *No Sense of Place*, argued that mass-media events create a virtual public arena (or agora) where the public has less and less of a "sense of place" (1985, 145–147). Other writers have also asserted that improved communications technology can lessen locality, that is, suppress community ties driven by geographic propinquity (Kern 1983). Undoubtedly, we live in a society where we may be more in touch with the avatars of our comrades-in-arms in the online game Everquest (500,000 players nightly) whom we have never met face-to-face than our own next-door neighbors. The icon, however, still performs its function as a gathering place for eyeballs—and we can all talk about it with virtual as well as physical friends. It does so because in becoming an icon it tends to cross media boundaries (Internet, print, broadcast and cable television) and thus is available for any and all possible audiences. In this projection, we retain our sense of place of where we are and contrast it to where the "event" occurs, but at the same time share the act of making that contrast with others.

Control is another issue here. The history of war is also the history of warlords controlling its pictorial portrayal (Perlmutter 1999). Today, the traditional methods of censoring images seem to be stymied by technology. We are told that, for example, President George W. Bush "chastised his defense secretary, Donald H. Rumsfeld's, handling of a scandal over the American abuse of Iraqis" at Abu Ghraib prison; notably, no mention is made of the *events*, but rather the President was upset over "Mr. Rumsfeld's failure to tell Mr. Bush about *photographs* [emphasis mine] of the abuse, which have enraged the Arab world" (Bumiller and Stevenson 2004). A White House official was quoted as saying, "The president was not satisfied or happy about the way he was informed about the

pictures" (Bumiller and Stevenson 2004). Unsurprisingly, in later testimony to Congress, Rumsfeld specifically cited the uncontainable nature of digital photographs: "We're functioning with peacetime constraints, with legal requirements, in a wartime situation in the Information Age, where people are running around with digital cameras and taking these unbelievable photographs and then passing them off, against the law, to the media, to our surprise" (Plummer 2004). In sum, the "cargo of caskets" picture's genesis, provenance, and short-term outcome suggest that the news icon has altered to a degree from its traditional scope.

The Falluja Lynching

On March 31, 2004, Iraqi terrorists killed four American civilian contractors who were driving through the city of Falluja, Iraq. A mob of civilians quickly converged on the area and attacked the bodies with sticks, stones, even shoes. Many, including children, danced and chanted anti-American and pro-insurgent slogans. Some of the crowd hung two of the corpses from a nearby bridge that spans the Euphrates river. A number of local stringers and photographers arrived at the scene very soon after the initial attack. Within hours, photos and video of the event began appearing in print, on television, and on the Internet. As shown by a survey of major print publications, the pictures did not conflate around a single "defining icon" but rather displayed a range of shots showing a sequences of events, from Karim Sahib/Getty Images' *Iraqis Cheering with Burning SUV* to an AP photo of *Contractors Hanging on Bridge with Celebrating Iraqis in Foreground* to another Getty image, *Single Boy with "Falluja is the Cemetery of Americans" Sign in Front of Burning SUV* (Perlmutter and Major 2004). In addition, many news organizations chose not to show the pictures, edited them, or warned their audience as to the graphic nature of the content. The *Dallas Morning News*, for example, explained, "We didn't think it was appropriate to show bodies on Page One." Peter Jennings, during his newscast, introduced the images by cautioning, "Let us tell you in advance some of the pictures are pretty repugnant but they are the reality of war."

Like many icons, the Falluja photos exist in a public space that is linked with previous icons. The elements of jeering mob, desecrated bodies of Americans, and the proscenium of a Third World cityscape all reminded many observers of the icons of the American servicemen's bodies dragged through the streets of Mogadishu in Somalia in 1993 (Perlmutter 1998, 127–175). One commentator called it nearly a "Mogadishu moment" (Dyer 2004). On the other hand, a difference between the two events was that the Somalia images were unanticipated—that is, there were relatively few "bad pictures" coming out of Somalia before the Mogadishu disaster. In contrast, such pictures of carnage and at least the captioned knowledge that Americans were dying were coming from Iraq every day (Perlmutter 2004d).

For our purposes, however, the images raise further issues about the state of the icon in the era of new media technology. First, the pictures arrived quickly from on-site to satellite transmission. As the various modes of final presentation to the public showed, this rapidity posed a problem for editors. They needed to make, almost instantly, the gatekeeping and framing choices under their sovereignty. The print organizations, unlike in previous eras, had no more time for deliberation than their electronic peers. One newspaper editor I spoke to about her decision-making process remarked, "It's no longer the case that I have five hours until the presses roll. The pressure is high to get the scoop on the website first, as well." (The same is true even for weekly newsmagazines. The *Time*

magazine website posted pictures from the killings at about the same time as they began to appear on CNN.) So we can assume that the speed of delivery has not only compressed what used to be called the "news cycle" (for journalists as well as policy-makers) but fractured the process that once had set up time-oriented markers and deadlines. Certainly, for 24-hour cable news, every minute is a deadline, but we can project that this is increasingly the case with newspapers and even magazines as well.

The notion of speed of transmission, for the Falluja icons, implies yet another consideration. In the race for novelty, replacement rates of Web content are high (Perlmutter 2004a). There is no stable "page," rather, the website is updated frequently, in part or as a whole. We who study icons often assume that their longevity and their frequency of publication are linked: famous pictures are reprinted often, which in turn makes them even more famous. But what happens when the news-stream crowds out the old content with increasing rapidity?

In the summer of 2004, I asked two classes of some 200 mass communication undergraduates about their knowledge of the provenance of various past and contemporary icons, from the raising of the flag at Iwo Jima to several of the Falluja images. No more than 10% of the students recalled that the latter were pictures taken in Falluja, although most assumed they were from the Iraq War, roughly the same number recalled that the victims were "contractors." In short, the picture is vaguely familiar only because it looks like many generic images of carnage coming out of a war that packs our front pages and television screens with similar images daily. The images were icons for a few weeks, now they are footnotes for the visual researcher to study. I argue that "replacement rate" must be a factor here: so many similarly striking images are flooding out of Iraq that, unless we are students of such images, few have distinctive narrative or visual elements that make us recall them for longer than a news cycle.

Here we have an interesting fusion with research on how we remember events. Psychologists have studied the phenomenon of "flashbulb memory," that is, memory of particular scenes or events experienced physically or through media and important to an individual or group (Sierra and Berrios 1999). Past findings distinguish between event memory (of news about the event) and autobiographical memory (of news of one's own actions in relationship to the event) for any happening (Smith, Bibi, and Sheard 2001). There is a winnowing effect, in that memories of events coalesce into a set of selected details and images that come to define the event (Winningham, Hyman, and Dinnel 2000). These are not, notably, hard indelible engravings on the mind—they are subject to the biases of any other form of recollection and eyewitness testimony (Wright 1993). When masses of people view signature events, most often via media, they form a "collective historical memory" that is later interpolated via "the publicly presented past," in print media and television and film as well as more formally in "speeches and sermons, editorials and school textbooks, museum exhibitions, historic sites, and widely noticed historical art, ranging from oil paintings to public sculpture and commemorative monuments" (Kammen, cited in Laderman 2002). Finally, people tend to recall most strongly those events that occurred in the formative years of early adulthood; icons are often generation entities (Schuman, Belli, and Bischoping 1997).

A key factor in remembering an event via a photo-icon is how often that icon reappears and is publicly defined as the icon that symbolizes the event. Here replacement rate is even more important, since the hypericon does not have time to establish itself through long-term repetition because other quasi-icons replace it quickly. That said, we

must admit that this point is for future reference rather than present-day conclusion. In defining mental imagery, one researcher cautioned, "Another reason is that [mental images] are notoriously elusive—they can appear at one moment and quickly fade the next" (Finke 1989, 1). That fading, or blurring, is worth the attention of the visual researcher trying to understand the place of the news icon in our hyper-mediated world. For now, we can only say that images like the Falluja photos, which at the moment seem to be icons, may be crowded out of the immediate news stream. Indeed, as of this writing, in early December of 2004, my students are now primed by the word "Falluja" to call up a whole new set of icons from the recapture of the city from insurgents. The future months or years may bring a whole new set of pictures to attach to the name of the city.

The Falluja images raise a final question: Are they, as many contend, really shocking? Almost the entire slate of commentary on the images in the popular press noted this as one of their signature qualities. Indeed, when I was interviewed by almost a dozen journalists in response to the pictures, each began with some variation of a query on the shock value of the pictures' content. By "shock," the interviewers were referring to a reaction to several dimensions and degrees of grisliness: human beings killed in a terrible manner (burned to death), their bodies desecrated (beaten, hung), and civilians (especially children) jeering at the corpses. A political component was that, after all, these were the people that Americans had liberated from Saddam Hussein. Are their ferocity and subsequent elation not disturbing to us as Americans and as human beings? Does the speed of the pictures' arrival contribute anything to our sense of being shocked—a suddenness of impact?

A problem with such a direction of observation is that it fails to account for the relative value of human life as held by most humans. It surprises students, for example, that images that they think contain *objectively* shocking or "terrible" content were not viewed as such or through such a frame by the creators of the slaughter as well as the pictures. Two notorious historical examples suffice to elucidate this point. Most Holocaust pictures, displayed today as illustrations of the horrors of Nazi atrocities, were in fact taken by Nazis as trophy photos, souvenir snaps, or bureaucratic records: same pictures, different meanings. As well, we should recall that the many images of lynchings of African-Americans in the pre–Civil Rights era were taken by members of white lynch mobs. The images, appalling to our modern eye, were even employed as subjects for "scenic" postcards mailed to friends and family (Ginzburg 2000). Likewise the Falluja images, where reactions in the Arab world reportedly ranged from indifference to approval that the people of Iraq were striking back against their occupiers (Abdallah 2004; Khorshid 2004; Fandy 2004). In sum, shock and outrage, like any human reaction to any image, is in the mind of the beholder.

Conclusions: The Post-Icon Age?

A yet unwritten history of the "big picture," or news icon, might claim that it is a product of modern technology and mass psychology. Printing, then photography and the "wire," radio-transmission, followed by satellites and the Internet and e-mail, now allow any image to be distributed to anyone in her home with a brief (the speed of light!) delay from the time of the creation of the image. A fundamental question of icons is, Are they born or made? It is clear in many cases that there is "viral consensus" between photo editors, commentators, elites, and others that a picture has some sort of status beyond that of its millions of peers in the news stream. Perhaps that quality is aesthetic, or metonymic,

or possessing of a potential power to shape events in and of itself. Yet, at the same time, anyone who has sat at a monitor viewing AP Photostream software will note that many pictures are "great"—have all the qualities of amazing images—but they achieve no notoriety and now sit forgotten in archives or even have been erased for want of a buyer. Icons are partly born great, but mostly they have greatness thrust upon them. Visual researchers play a role in that process.

The news icon we know of depends on the maintenance of the elaborate system of newsgathering, gate-keeping, and dissemination that persists to this day. But cracks and contradictions are evident. The "handoff" of a picture from a reporter on the scene to a news page is no longer a predictable linear progression. Amateurs, outsiders, even antagonists to the news industry are becoming increasingly involved; some icons come from them. Consider the old ethical scenario once presented in journalism classes: Terrorists demand that their statement be read on television or they will kill a hostage: should the statement be broadcast? Today, the fanatics kill the hostage and upload the streaming video to their website, knowing the act will prompt media attention as effectively as the threat. In addition, a picture, once made, is no longer a controllable entity—by copyright or by holding it up to some nonexistent "negative." It is malleable, a *tabula rasa* for Photoshop, but also for anyone to make any point.

On the other hand, the "system" of news is still robust: the revolution is not yet here, or rather news elites are working very hard to co-opt it. No picture, for example, has become an "icon" in the traditional definition without at least in some manner going through the traditional process. The fact is that no homemade blog attracts as big an audience as MSNBC unless MSNBC tells us to look at it. Only when mainstream news picks up a picture does it get the mass circulation that makes it big news. We have yet to see an example of a "pure play" Internet icon.

But here is a problem for studying news icons: Our definition becomes tautological. If I say that a picture is not an icon because it has not attracted a mass audience, then are we insisting that there is only one class of icons, in terms of their reach? We live in a realm of niche marketing and audience segmentation (Turow 1997). A television show that would have been cancelled because of its low ratings in the 1960s now is classified a "hit" because its audience consists of thousands of teenage girls who can be lucratively sold to advertisers of acne medication, blue jeans, and Britney Spears CDs. So should we change our standard for an icon to that of inhabitants of such niches—icons for certain audiences for which no crossover can or should be possible? Further, the speed of the arrival of an icon puts a premium on its finding an audience quickly. This is the case with modern network programs that are cancelled in weeks if they do not "find an audience" as opposed to the many months allowed during the old "mass" audience era.

To conclude, speed, as I have said, implies an ephemeral quality. Icons blur past us, raising quivers of interest, then being replaced by an hourly Web page update to other pictures, more or less sensational. Again, I retain skepticism that we exist in a post-icon age. Yes, the era of the "big picture" seems ever more chaotic, unprogrammed, and jump-started, but icons will endure because the world desires them and even needs them. News icons have been, are, and will continue to be among the few objects that a world audience can share, if briefly, despite divergent interpretations. What is certainly the case, however, is that we are more aware than ever (or should be) that other people may not share our meanings for any picture. For example, we know more about what various groups in the Arab world think when considering an icon, and on a basic level what they

consider to be an icon, than was possible in a previous era. We can even share such cross-meanings instantly. But simple awareness, however useful, is hardly empathic understanding. We can share raw data, but can we share pain? The signal importance of icons in news and events has not been eclipsed, but new technology continues to force us to pose fundamental questions about their function in society.

NOTES

1 For discussions of the early use of icons and visual clichés in advertising, see Marchand 1985, 235-(84.

REFERENCES

Abdallah, S. 2004. Review of the Arab press. *United Press International Wire*. April 7, 2004. http://washingtontimes.com/upi-breaking/20040407–075123–6388r.htm.

Bossen, H. 1982. A tall tale retold: The influence of photographs of William Henry Jackson upon the passage of the Yellowstone Act of 1872. *Studies in Visual Communication*. 8 (1):8–109.

Bouse, D. 2000. *Wildlife films*. Philadelphia: University of Pennsylvania Press.

Bumiller, E., and R. Stevenson. 2004. Rumsfeld chastised by President for his handling of Iraq scandal. *The New York Times*, May 6, 2004.

Buncombe, A. 2004. The shot seen around the world; When Tami Silicio saw the caskets of U.S. servicemen. *The Independent*, May 6, 2004.

Carlebach, M. L. 1992. *The origins of photojournalism in America*. Washington, D.C.: Smithsonian Institution Press.

Clarke, G. 1981. Freezing moments in history. *Time*, December 28, 1981.

Coombs, R. B. 1983. *Before endeavors fade*. London: Battle of Britain International.

Coopersmith, J. 2000. From lemons to lemonade: The development of AP wirephoto. *American Journalism* 17 (4):55–72.

Cowing, K. 2004. DOD Misidentifies Photos of Columbia Crew Remains Arriving at Dover AFB as Being Iraq War Dead. April 23, 2004. http://www.spaceref.com/news/.

Domke, D., Perlmutter, D. D., and M. Spratt. 2002. The primes of our times? An examination of the "power" of visual images. *Journalism* 3 (2):131–159.

Dyer, G. 2004. Editorial. *Pittsburgh Post-Gazette*, April 4, 2004.

Ezickson, A. J. 1938. *Get that picture! The story of the news cameraman*. New York: National Library Press.

Fandy, M. 2004. Where's the Arab media's sense of outrage? *The Washington Post*, July 4, 2004.

Finke, R. A. 1989. *Principles of mental imagery*. Cambridge & London: The MIT Press.

Ginzburg, R. 2000. 100 years of lynchings. *Without sanctuary: Lynching photography in America*. Edited by J. Allen, A. Hilton, J. Lewis, and L. Litwack. Santa Fe, NM: Twin Palms.

Haldane, D. 2004. O.C. agency is at heart of casket photo debate; Zuma Press of Laguna Beach distributes the picture, and hears comments pro and con. *Los Angeles Times*, May 24, 2004.

Hariman R. and J. L. Lucaites 2004. Ritualizing modernity's gamble: The iconic photographs of the Hindenburg and Challenger explosions. *Visual Communication Quarterly* 11 (1 and 2): 4–17.

Hedges, C. 2004. Mourning the warrior and questioning the war. *New York Times*, September 22, 2004.

JB Pictures Inc. v. U.S. Department of Defense 86 F.3d 236 (D.C. Cir. 1996).

Kennan, G. 1993. Somalia, through a glass darkly. *New York Times*, September 30, 1993.

Kern, S. 1983. *The culture of time and space, 1880–1918*. Cambridge: Harvard University.

Khorshid, S. 2004. Pacify Falluja. *Islam Online*, November 4, 2004. http://www.islamonline.net/English/Views/2004/04/article02.shtml.

Kirschbaum, E. 2004. Military affirms TV cover ban on Iraq caskets. *The Independent*, April 26, 2004.

Kugiya, H. 2004. Lives altered by photo of coffins. *Newsday*, August 8, 2004.

Laderman, S. 2002. Shaping memory of the past: Discourse in travel guidebooks for Vietnam. *Mass Communication & Society* 5 (1):1520–5436.

Lester, P. 1991. *Photojournalism: An ethical approach*. Hillsdale, NJ: Lawrence Erlbaum.

Los Angeles Times. 2004. Correction Appended Home Edition, Foreign Desk. April 23, 2004.

Marchand, R. 1985. *Advertising the American dream: Making way for modernity, 1920?1940*. Berkeley: University of California Press.

Meyerowitz, J. 1985. *No sense of place: The impact of electronic media on social behavior*. New York: Oxford University Press.

Penrod, G. 2004. Letting loose the image of war. *The News Media and the Law* Summer: 7–9.

Perlmutter, D. D. 1998. *Photojournalism and foreign policy: Framing icons of outrage in international crises*. Westport, CT: Greenwood.

Perlmutter, D. D. 1999. *Visions of war: Picturing warfare from the stone age to the cyberage*. New York, NY: St. Martin's.

Perlmutter, D. D. 2000. *Policing the media: Street cops and public perceptions of law enforcement*. Beverly Hills: Sage.

Perlmutter, D. D. 2004a. The Internet: Big pictures and interactors. In *Image Ethics in the Digital Age, 2nd ed.*, edited by L. Gross, J. S. Katz, and J. Ruby. Minneapolis: University of Minnesota Press.

Perlmutter, D. D. 2004b. U.S. can't block coffin photos. *Newsday*, April 27, 2004:A37, A39.

Perlmutter, D. D. 2004c. Indelible images of caskets. *Indianapolis Star*, April 28, 2004.

Perlmutter, D. D. 2004d. Photojournalism and foreign affairs. *Orbis*, Winter, 49:1.

Perlmutter, D. D., and L. Hatley-Major. 2004. Images of horror from Falluja. *Nieman Reports* 58 (2):68–70.

Perlmutter, D. D., and G. L. Wagner. 2004. The anatomy of a photojournalistic icon: Marginalization of dissent in the selection and framing of a death in Genoa. *Visual Communication* 3(1):91–108.

Plato. 1987. *Republic, Part X, 595c, 2nd ed.*, translated by D. Lee. London: Penguin.

Plummer, R. 2004. U.S. powerless to halt Iraq net images. *BBC News Online*, May 8, 2004. http://news.bbc.co.uk/2/hi/americas/3695897.stm.

Schuman, H., R. F. Belli, and K. Bischoping. 1997. The generational basis of historical knowledge. In *Collective Memory of Political Events: Social Psychological Perspectives*, edited by J. W. Pennebaker, D. Paez, and R. Rimé. Mahway, NJ: Lawrence Erlbaum.

Shales, T. 1992. Television: On the tube, talk, talk, yak, yak: The new age of blah. *Washington Post*, December 27, 1992.

Shaw, D. 1992. News often has to be seen before it is heard. *Los Angeles Times*, October 26, 1992.

Sierra, M., and G. E. Berrios. 1999. Flashbulb memories and other repetitive images: A psychiatric perspective. *Comprehensive Psychiatry* 40(Mar–Apr):115–125.

Smith, M.C., Bibi, U., and D.E. Sheard. 2003. Evidence for the differential impact of time and emotion on personal event memories for September 11, 2001. *Applied Cognitive Psychology* 17(9): 1047–1055.

Turow, J. 1997. *Breaking up America*. Chicago: University of Chicago Press.

Urschel, J. 1994. Caution: Don't base policy on emotions. *USA Today*, February 10, 1994.

Winningham, R.G., Hyman, I.E., and D.L. Dinnell. 2000. Flashbulb memories? The effects of when the initial memory was obtained. *Memory* 8(4): 209–216.

Wright, D. B. 1993. Recall of the Hillsborough disaster over time—Systematic biases of flashbulb memories. *Applied Cognitive Psychology* 7 (2):129–138.

Zelizer, B. 1992. CNN, the Gulf War, and journalistic practice. *Journal of Communication* 42(1):66–81.

Computers
+ Music

Lemi Baruh

Music Of My Own?

The Transformation from Usage Rights to Usage Privileges in Digital Media

The digitization of music distribution has led to some important changes in the ways in which individuals consume music. Digital audio-encoding techniques such as MP3 not only make it very easy for individuals to copy, transport, and share music, but also increase their chances of becoming producers by resampling different pieces of music. However, despite this potential for creative democracy, the way the members of the recording industry have responded to the digitization of music tends to diminish the flexibility with which individuals use digital music. This chapter argues that the usage limits imposed by the changes in the legal and the technological infrastructure that governs use of digitized music creates an environment within which music enthusiasts will be stripped of their already limited ability to determine and/or anticipate which types of content use are "kosher." In the end, such a process may cultivate a permission culture where each content use is a potential "misuse" that needs explicit approval from corporate copyright holders.

Introduction: The Digital World of "You Could Possibly, but You Shouldn't"

In July 2004, RealNetworks, an online music store, started a publicity campaign around its Harmony music software. One of the main selling points of this campaign was "freedom of choice" for music consumers. With this Harmony software, RealNetworks customers became the first group of online music enthusiasts who would be able to listen to copy-protected tracks that they had purchased from other online music stores including iTunes (Borland 2004a). This publicity campaign is a clear symptom of the problems that music enthusiasts face in a digital world: The right to play a track you own in a device you own has "suddenly" transformed into being a privilege (and a marketing gimmick).

Many scholars have noted that the fast diffusion of technologies such as personal computers, music sampling devices, and digital camcorders, makes every individual a poten-

tial creator of content (Lessig 2004; Litman 2001; Vaidhyanathan 2001). Unfortunately, as digital technologies' potential to transform every end user into a potential creator expands, so do the copyright-rich media corporations' ability to control how individuals use content. With the advances in digital technology and the Internet, copyright law, which has traditionally regulated commercial publishing, started controlling an increasing number of cultural activities without discriminating between commercial and noncommercial uses of content (Lessig 2004). Copyright-rich media corporations justify this expansion in the scope of the copyright law by arguing that the unregulated uses of content before the rise of digital (and networked) media were due to certain loopholes in the copyright law and can be fixed by technology.[1] This chapter will focus on the changes in the legal and technological infrastructure that governs cultural products in order to argue that an important consequence of the expansion in the scope of copyright controls is the creation of a permission culture within which individuals continuously face the question of "Am I doing something wrong?."

Coping with Digital Copies of Songs: The Response from the Copyright-Rich

Legal Actions and Lobbying

Recently, consumption of music in digital media has become one of the hot issues that trigger extensive debates about the norms that should govern the use of digital content. The recording industry, represented by a very aggressive lobbying group called the Recording Industry Association of America (RIAA), has devised many different strategies, such as suing technology providers and individual users, lobbying for tougher laws, and creating technological protection systems to prevent individuals from using content in ways that the members of the industry consider as unfit (Yu 2004).

One of the strategies that the recording industry frequently utilizes is suing technology providers. First, the recording industry responded to the growing popularity of the mp3 format by suing a company called MP3.com. This site, in addition to offering an extensive library of music that belonged to artists without recording contracts and sharing the proceeds of the sales with the artists, created a service which in many ways resembles a digital locker room. Any individual who owned a music CD, after providing the id number of the CD as a proof of purchase, would be able to listen to the contents of the CD from any computer that could connect to www.mp3.com. Members of the recording industry sued the company by adopting the argument that every content use in digital media creates a digital copy and thereby requires the permission of the copyright holder (Information Infrastructure Task Force 1995). Accordingly, although mp3.com had acquired the licenses to broadcast the CDs, it had not acquired any license to copy them. In other words, mp3.com, by creating a digital copy every time it streamed music to a subscriber's computer, was allegedly infringing copyrights. After losing the lawsuit, mp3.com was acquired by one of the recording industry members, Vivendi Universal, and was sold to Roxio (Litman 2001, 2002; Yu 2004).

While websites such as mp3.com that either "pirated" or contributed to the "piracy" of others were the first target of the recording industry, peer-to-peer (p2p) networks rapidly replaced them. These p2p networks, rather than storing the music on their own servers, provided individuals with the ability to share what they had stored in their own personal computers. While many uses of these networks are now considered as illegal,

not all uses are illegal and not all illegal uses are harmful to the recording companies. For example, individuals may use these file-sharing networks in order to share content that is in the public domain (a legal use), share copyrighted content that is not in the market anymore (a use that is not legally protected but not harmful), and preview songs that they are planning to purchase (a use that is considered as illegal but may be beneficial to the recording companies) (Lessig 2004). However, the recording industry pursued a zero-tolerance policy of all or nothing: any p2p should be 100% piracy free or cease to exist.

The industry found its first high-profile target in a p2p network called Napster. Despite Napster's argument that its p2p network could be used for non-infringing purposes, the court agreed with the recording industry's argument that Napster was liable because it was contributing to the infringement of copyrights (Litman 2001). In this case, the court adopted a two-step test for determining contributory liability: 1) Are there substantial non-infringing uses? and 2) Does the defendant have actual knowledge of infringement going on? Napster, which maintained a centralized index of the content that resided on subscribers' shared folders, failed the second test, declared bankruptcy, and was subsequently sold (Miles 2004). It did not take long before different p2p networks, such as Grokster and Aimster, replaced Napster and became the target of lawsuits. However, not all lawsuits were as clear-cut as that of Napster. For example, Morpheus and Grokster were much more decentralized than Napster. They were able to show the actual non-infringing uses, such as sharing the works of Shakespeare, of their networks. More importantly, these networks did not index available songs and thereby were able to argue that they did not receive any specific information regarding infringement of copyrights (Metro-Goldwyn-Mayer Studios v. Grokster 2003; Miles 2004). Finally, the court used a "close-the-doors test" to explain that the architecture of Grokster would allow users to continue swapping files even if Grokster was found guilty and was forced to cease operations. Therefore, the court argued, Grokster was more like a VCR rather than Napster and could not be held liable for the infringement of its customers (Miles 2004).

Clearly, the cases against Napster, Aimster, and Grokster were not the first time that copyright holders utilized the argument of contributory infringement against technology providers. In as early as 1984, the Supreme Court decided that Sony Betamax VCRs were "capable of substantial noninfringing uses" (Sony Corporation of America et al. v. Universal City Studios, Inc., et al. 1984). Following this ruling, which limited the copyright industry's ability to influence the development of new technologies, copyright owners started lobbying for legislation that would protect their ability to develop technologies to control how content is used (Jackson 2001). The Audio Home Recording Act (AHRA) of 1992 is a case in point that shows how these lobbying efforts increasingly focused on consumers' ability to reproduce audio in digital format, without any significant loss in sound quality (O'Hara 2003; Sparkler 2004). By the end of the '80s, manufacturers like Sony and Phillips had produced the first Digital Audio Tapes (DAT) that could be used by consumers to create multiple digital copies of an audio track. The AHRA, lobbied for by the recording industry, required that every consumer-grade DAT include a Serial Copy Management System that would prevent these devices from making second (and later) generation copies. In other words, a consumer with a DAT recorder could copy as much as she wanted from an original album but could not make copies of the copy. This limitation, combined with the royalty fees that the DAT manufacturers were required to pay under the provisions of AHRA, prevented DATs from ful-

filling their potential and becoming a feasible option for consumers (Litman 2001; O'Hara 2003; Schulman 1999; Sparkler 2004).

The response of the copyright industry to p2p networks was very similar to its response to DAT recorders: kill it before it may possibly hurt. Following the ruling of the courts that the p2p network named Grokster was not liable for contributory infringement, the copyright industry started pushing for a legislation that would sidestep the notion that a device might have significant noninfringing uses. The resulting piece of legislation, known as the Induce Act, is the best example of how far the copyright industry is willing to go in order to fight against technologies that may threaten the way they do business. According to this bill, which died in the Senate on October 8, 2004, anyone who knowingly or consciously induces others to engage in infringement would be liable as infringers (Inducing Infringement of Copyrights Act 2004).

Until recently, due to the sheer difficulty of dealing with a large number of individuals, the copyright industry had refrained from pursuing legal actions against possible individual infringers. However, since 2002, and especially after the court rulings in favor of p2p networks such as Grokster, the copyright industry started suing individuals for infringement of copyrights. According to the RIAA, under section 512(h) of the Digital Millennium Copyright Act (DMCA) of 1998, copyright holders have the right to enforce a pre-litigation subpoena seeking the identity of an Internet subscriber who is suspected of infringing copyrights. Using the "safe harbor" clause of the DMCA, which mandates that any Internet service provider should provide assistance to copyright holders in order to avoid liability, the copyright industry started identifying possible infringers, reaching off-court settlements with some of them and suing many others. Since September 2003, the recording industry sued close to 4,000 individuals for using p2p networks, such as Kazaa, Grokster, and eDonkey, to exchange songs (Baruh 2004; Sparkler 2004).[2]

Digital Rights Management (DRM) Systems

As mentioned in the introduction to this chapter, members of the copyright industry argued that their past failure to control how individuals consume content was due to loopholes in the system. Such arguments go a long distance in justifying not only the legislations that the copyright industry has been lobbying for but also the digital-rights management technologies that they are developing (and using) to close these loopholes. The proponents of such technological fixes argue that in the digital age of flawless copies, the only way to provide authors with incentives to produce is to grant them sustained control over every use of their content (Litman 2002).

Digital-rights management systems usually have two functions. The first of these functions is assigning a unique identifier to a certain content file so that it can be recognizable and the source can be traced back if the content file circulates among different users. Two techniques that are frequently used to assign identifiers to content are fingerprints and watermarks. For example, any music file can be watermarked by inserting a sound bite that a human ear cannot hear. Similarly, any song can be fingerprinted by determining some key features of that song, such as the sequence of certain notes or words, which other songs would not have (Benoliel 2004; Godwin 2004; National Research Council 2002). These fingerprints that are assigned to a song are an important prerequisite for digital-rights management companies like Audible Magic to develop a database of copyrighted songs and block users from exchanging, downloading, or uploading these songs in specific networks (Borland 2003).

The second function of digital-rights management systems is to determine who can have access to a specific content file. These types of digital-rights management systems may encrypt a content file so that only those who own the access key can use a content file or may anchor a content file to a specific device (e.g., a computer) (Bell 1998; Benoliel 2004; Godwin 2004; National Research Council 2002). Many digital-content providers rely on a combination of these two systems to be able to "specify that a consumer could read a document but not print it, save an unencrypted copy, or e-mail a part . . . to a friend" (National Research Council 2002). This way, copyright holders can charge consumers for repeated use and can communicate to the electronic devices through which the content is used in order to create rules that specify the allowed uses of content.

As it can be seen from this brief summary of digital-rights management systems, technological fixes to "fight piracy" may impose important limitations on how individuals use a cultural product. The following section will discuss how these limitations that the copyright holders impose on content use in digital media may interfere with individuals' legally recognized rights.

Owning the Songs You Paid for: Technical Standards and Controlling Consumption

Not many people, and certainly not many people representing us, are seated on the tables that determine the technical standards that will rule how we can or cannot use a content that we purchase (Cohen 1996). Ironically, the behavior that these technical standards govern is our content-consumption behaviors, many of which are protected by copyright law, property law, and even the Constitution. As many scholars have noted, these technical standards, which tell the machines how we can or cannot use a specific content file, increasingly resemble laws, sometimes supplementing and more often supplanting the actual laws (Burk and Cohen 2001; Jackson 2001; Lessig 1999, 2004; O'Hara 2003; Reindenberg 1998). Given this power to supplant the laws that are created by a centralized government, copyright owners may use technological copyright-management systems not only for the purposes of preventing piracy but also to avoid the limitations that the law imposes on them in order to protect the rights of individuals who use their content (Jackson 2001; Lessig 1999).

Lessig (1999, 2004) argues that there are three possible uses of any cultural product. First, there are regulated uses such as republishing a copyrighted content or making copies of it for a commercial purpose. Second, there are unregulated uses that most often fall into the realm of personal use. For example, when an individual purchases a CD, how many times he/she listens to the album or a specific song within the album, how many times he reads the lyrics printed on the cover, and to whom he/she lends or sells the CD are unregulated. Finally, there are some uses, which, despite involving copying of the copyrighted content, are considered as fair uses and remain unregulated (Lessig 1999, 2004). For example, making a copy of a CD for using in the car or giving to a friend has, until recently, been considered as fair use.

However, as mentioned previously, the copyright industry frames these unregulated areas as loopholes or defects within the system. According to the copyright industry, digital-rights management systems are here to close these loopholes. Of course, one could also easily argue that these "loopholes" are in place to protect the fragile balance between copyright holders' limited rights over the content that they produce and the public's right to have access to information and cultural output (Vaidhyanathan 2001).

Given these two perspectives, let's take a look at what happens when technological fixes determine how we use the songs that we purchase. One doctrine of the copyright law that was designed to limit the rights granted to copyright holders is the first sales doctrine. According to this doctrine, once an individual purchases a cultural product such as a book or a recording, the copyright holder has no say over whether she can sell the copy she owns to a third party (Godwin 2004; Litman 2001; O'Hara 2003; Vaidhyanathan 2001). This doctrine was what George Hottelling had in mind when he attempted to auction on eBay a song that he purchased from iTunes. And there were many music enthusiasts who were willing to pay a hefty price, as high as $16,000, to satisfy their curiosity as to whether Mr. Hottelling could practice his right to sell the track he owned (Gilbert 2003; DRM Watch 2003). Eventually, eBay cancelled the auction on the grounds that the auction violated its regulations regarding the listing and sale of electronic content (Smith 2003).

Clearly, eBay's decision does not (and did not intend to) address the question of whether Mr. Hottelling could use his right to sell the songs he owned. However, his attempt was enough to show what kind of problems any person willing to engage in such a trade would face. The songs purchased by the customers of online music stores (e.g., iTunes, Napster, Connect) are anchored to an account that authorizes each customer to play the purchased songs on a limited number of computers. Such a system means that the only way one can sell a song that he/she purchased from an online music store is to transfer the whole account that contains the song to another person. In other words, if you want to sell a song that you purchased from an online store, the only way you can technically accomplish this deed is to sell all the songs you've purchased, unless you opened a separate account for every song you purchase.

Now let's assume that an individual decides to go ahead and sell his account, and all the songs that he purchased, to someone else. Is this possible? Initially, iTunes, the forerunner of the online music industry, was reluctant to answer this question (Hansen 2003). However, even before iTunes, there had been others who had responded to this question by saying that the first-sale doctrine does not apply to digital goods. The proponents of this point of view recite the argument that every single content use in digital environment creates a copy. Accordingly, because no one can guarantee that a person who has sold a copy of a copyrighted good has deleted every other digital copy he has made, the first-sale doctrine should apply only to physical distribution of content (U.S. Copyright Office 2001). This argument has recently been adopted by various online music stores. For example, the terms of use for both Napster and Connect.com clearly indicate that the rights granted to the customers are limited and non-exclusive. Moreover, the customer has no right to transfer his/her rights to any third party.[3] Given these limitations, the question that needs to be asked is whether a customer who has paid for the content actually owns the content. The answer to this question is provided clearly in the terms of service for Walmart's online music store. Paying the fee and downloading the song does not mean that the customer has any "right, title or interest in any downloaded products or software." As such, because products "are licensed to you and not sold," you can't sell the music that you downloaded.[4]

At this point, it is important to note that the limitations on music enthusiasts' rights to transfer the ownership of a song is only one of the many limitations that are imposed upon usage rights that are recognized by the existing copyright laws. For example, despite the fact that the Audio Home Recording Act of 1992 recognizes individuals' right

to make analog and digital copies of the content they own, most of the online music stores impose certain limits to the number of times one can copy a playlist (a specific group of songs) to a CD. Moreover, despite a long-standing tradition of a fair-use doctrine that allows various private uses of content, the online music stores strictly prohibit any act that would translate, adapt, combine, modify or transform the licensed content. Of course, even if an individual decided that the prohibition should not apply to the transformations that she is planning to make for her own purposes, the digital-protection technology usually prevents that person from transforming the song by using sampling or other types of music-creation software. For example, Acid Music 3.0, a loop-based music-creation software, does not recognize the AAC music format that iTunes uses to compress and digitally protect the songs it sells. Finally, when Congress enacted the first copyright law in 1790, it recognized the need to ensure that copyrighted content makes its way to the public domain. While the copyright industry has successfully lobbied for legislations that extend the period during which copyright holders enjoy exclusive rights over content before it transfers to public domain, the copyright law still recognizes the need to transfer cultural products to the public domain (Lessig 2004). However, none of the online music stores recognize this right by limiting the number of years during which a song will be protected by their digital-rights management systems.

Certainly, online music is not the only domain where the copyright industry plans to implement digital-rights management technologies. Recently, major music labels started experimenting with embedding digital-rights management technologies into audio CDs. These digital-rights management technologies may go as far as preventing individuals from making digital copies or from playing the CDs on certain consumer electronic devices including personal computers (Itworld.com 2002; O'Hara 2003). Another medium that has attracted the attention of the copyright industry is the upcoming digital-audio broadcasts that will significantly improve the audio quality of radio broadcasts. Arguing that any digital-audio player that is able to receive and record digital broadcasts will potentially allow individuals to copy songs with CD-quality sound and share them over p2p networks, the recording industry is lobbying for the implementation of digital-rights management systems that will allow individuals to record digital broadcasts but prevent them from editing them into smaller fractions and share it (Borland 2004b; Byrne 2004).

An important factor that significantly adds to the copyright industry's ability to impose technical limitations on individuals' legally recognized rights over cultural objects is the Digital Millennium Copyright Act (DMCA) of 1998. This law, enacted after an extensive lobbying effort by the copyright industry, essentially makes it illegal to circumvent any digital-copyright protection technology. According to the DMCA, manufacturing, importing, trafficking or marketing any device that is designed to circumvent a digital-rights protection technology is illegal (Jackson 2001; Litman 2002). As Lessig (2004) notes, circumvention technologies, just like a knife, can be used for both good and bad means to an end. On the one hand, they can be used to break a digital-rights management system and make millions of unauthorized copies of copyrighted music albums and sell them in developing markets. On the other hand, they can be used to circumvent a technology that prevents a computer from playing a music album. While the DMCA provides some exceptions to accommodate fair use, that the sales and marketing of any device that circumvents a digital-copyright technology is illegal makes it almost impossible for an individual to find and/or purchase the technology that will help

her to benefit from these exceptions (O'Hara 2003). Clearly, according to the recording industry's definition of fair use, an end-user's right to make copies of a cultural product she owns does not necessarily translate into a right to make a copy using the copying technique (e.g., copying to a CD) that she prefers (Universal Studios, Inc. v. Corley 2001). As such, if an individual is really keen on making a copy of a music album that is bundled with a copy protection system which prevents her from making digital copies, there isn't anyone stopping her from making an analog copy!

Opting In for a Worse Deal:
Contracts and Property Rights over Cultural Products

The Digital Millennium Copyright Act is not the first example of the government's use of its coercive power to enforce privately determined allocation of rights (Burk and Cohen 2001). In fact, critics of neoliberal politics often note that government's role is rapidly being reduced to that of enforcing contracts (Chomsky 1999). Given this role of the government, many commentators argue that digital-rights management systems are legitimately grounded not only on copyright law but also on contract law. Even before the fast diffusion of digital-rights management systems, private contracts and licenses were used to make users of cultural products waive their legally recognized rights (Lessig 1999). Accordingly, one can argue that if an individual consents to a license agreement (e.g., an online music store's terms of use) regarding the use of a copyrighted content, he has autonomously accepted the terms that may prescribe the use of digital-rights management systems that will leave him with fewer (or more) rights than what the copyright law provides him.[5]

This line of reasoning suffers from two important problems. The first of these problems is the assumption that the existence of a private contractual agreement will always justify the violation of existing policies (Burk and Cohen 2001). On the contrary, if the law does not permit the participants to engage in a specific action, contractual agreements cannot override existing laws and public policies (Lessig 1999; Reidenberg 1998). According to Burk and Cohen (2001), there is no reason why this rule should not apply to the use of digital-rights management systems that impose limits on individuals' rights to use cultural products. While the Constitution only incidentally recognizes the right to have access to intellectual products, legal interpretations of the First Amendment make it clear that the right to speak is predicated upon the right to receive cultural and intellectual products (Baruh 2004; Board of Education v. Pico 1982; Cohen 1996; Griswold et al. v. Connecticut 1965). That is why the limitations that the U.S. Constitution imposes on the government's ability to create exclusive property rights over intellectual products should be equally applicable to contracts and technologically imposed constraints if cultural products are to function as they are intended to (Burk and Cohen 2001).

The second shortcoming of the argument that the use of digital-rights management systems is grounded on contractual law pertains to the reason that justifies the use of contracts. Copyright holders contend that they need to have full control over how content is used in order to protect their property rights over cultural products in a digital environment of perfect duplications.[6] Accordingly, such full control can only be accomplished through the implementation of a property regime over content where digital-rights management systems will track and dictate how individuals use it (Information Infrastructure Task Force 1995). In other words, the copyright holders are demanding that owners of intellectual property are "accorded the same rights and protection resident in all other

property owners" (quoted in Lessig 2004, 117). However, this kind of a demand fails to recognize the property rights that end-users have both over content and over devices that they own in order to use that content (Cohen 2002).

When an individual purchases a CD, she makes that purchase with the reasonable expectation that she will be able to play that CD in different audio systems she owns. However, the way digital-rights management systems are designed may lead to incompatibility problems that may prevent older CD players from recognizing a new digital-rights management system (Godwin 2004). Regardless of whether these incompatibility problems were intended or not, the result is simple: the end-user cannot fully enjoy the property right she has over the device and the content she has purchased. Moreover, some CD manufacturers may deliberately add errors to a CD so that certain CD players can play the CD while others (including personal computers) cannot (Itworld.com 2002; Godwin 2004). Similarly, the digital-rights management systems that are used by online music stores are not compatible with portable audio systems (mp3 players) that are sold by competitors. While protection against piracy is the publicly accepted justification of such incompatibility between different companies' music formats, it is also a very easy method to prevent customers from shifting to competitors' online music stores or portable audio machines. In addition to determining whether certain devices can play an audio CD or a music file, certain digital-rights management systems may also strain the resources of a device in a way that potentially limits how one uses that device. A case in point is the digital-rights management systems that the copyright holders are proposing for digital-radio broadcasts. As mentioned above, these digital-rights management systems will be designed such that a person who records a digital-audio broadcast will not be able to divide the recording into smaller fractions. In other words, if an individual records an hour-long music program from a digital radio, she will not be able to get rid of the parts that she does not want to listen to anymore. Despite the growing storage capacity and processing speed of computers, compelling an individual to keep several gigabytes worth of programming so that she can listen to a small fraction of those several gigabytes is an unwarranted control over how that person will allocate the resources of her computer for different uses.

Conclusion: Regulating Behavior and Reasonable Expectations

As many commentators of intellectual property suggest, the growth of digital media has brought about important uncertainties regarding the norms that should govern the use of cultural products. In the short run, this uncertainty has negative effects on both copyright owners and end-users (Wagner 2004). However, what is important to notice is that only those with the legal, financial, and technological resources can capitalize on this kind of uncertainty in the long run. As this chapter has shown with respect to music in digital media, the copyright industry is far more willing and able than unorganized individuals to write the new rules of the game.

Clearly, digital-rights management technologies, which are solely based on the policy preferences of the copyright industry, and license agreements that utilize these technologies to control intellectual property are important tools for shaping these new rules. These tools not only regulate current content consumption behavior of individuals but also shape consumers' reasonable expectations about what they are and what they are not allowed to do. Every time an individual purchases a CD or downloads a song from a different online store, a new set of standards regarding appropriate uses of content are pre-

sented to her. Buying cultural products and buying software and hardware to consume cultural products increasingly resemble going through an airport security check when terror-alert level is orange. You never know what will prompt the alarms. As a result, every end-user will increasingly wonder whether she is doing something wrong (Benoliel 2004; Lessig 2004). As Litman (2002) argues, piracy used to be something that was associated with criminal organizations making and selling counterfeit copies. Nowadays, any unlicensed activity becomes a potential theft or piracy.

What further exacerbates this problem is that individuals do not have much say over how these digital-rights management systems will govern their content-consumption behavior. Before digital-rights management systems, an individual who allegedly infringed intellectual property would have the chance explain the justification of why her use should not be considered as an infringement. Then, a human judge, who could deliberate about the circumstances that lead to the alleged infringement, would either find guilt or open the way for an exception to the standards that are established by the law. Even with private contracts and licenses that are not enforced by digital-rights management systems, an individual has a slim chance of challenging a provision of the contract that might be inconsistent with the existing law (Lessig 1999). Nowadays, once a digital-rights management system is embedded in a song, an audio CD, or any form of content we purchase, it is impossible to negotiate with technologically imposed limitations, many of which are largely arbitrary.

NOTES

1. See Lessig (2004), Litman (2001), and Vaidhyanathan (2001) for a detailed summary and refutal of these arguments.

2. See also ZDnet.com (2004). While the music industry justifies this action by attributing the decline in CD sales to piracy, representatives of music consumers argue that the multi-year decline in CD sales is due to "bad" music rather than piracy.

3. See Napster LLC (2004) and Sony Connect Inc. (2004). These license agreements, as well as the license agreements for other online music companies such as that of iTunes, essentially create an increasingly detailed and often unchallengeable list of acceptable and unacceptable uses of content.

4. See Walmart.com Music Downloads (2004). With this statement, Walmart.com provides the most explicit answer to the question of whether consumers own the tracks that they pay for.

5. See Cohen (2003) for a detailed summary and refutal of this argument.

6 See Cohen (1996) and Litman (2001) for a detailed summary and refutal of this argument.

REFERENCES

Baruh, Lemi. 2004. Audience surveillance and the right to anonymous reading in interactive media. *Knowledge Technology and Policy* 17 (1):59–73.

Bell, Tom W. 1998. Fair use vs. fared use: The impact of automated rights management on copyright's fair use doctrine. *North Carolina Law Review* 76:557–617.

Benoliel, Daniel. 2004. Technological standards, inc.: Rethinking cyberspace regulatory epistemology. *California Law Review* 92:1069–1116.

Board of Education v. Pico. 457 U.S. 853 (1982).

Borland, John. 2003. Fingerprinting p2p pirates. *Cnet News.com*, August 18, 2004. http://news.com.com/Fingerprinting+P2P+pirates/2100–1023_3–985027.html.

———. 2004a. RealNetworks slashes song prices. *Cnet News.com*, October 21, 2004. http://news.com.com/RealNetworks+slashes+song+prices/2100–1027_3–5312143.html?tag=nl.

———. 2004b. Piracy battle begins over digital radio. *Cnet News.com*, October 17, 2004. http://news.com.com/Piracy+battle+begins+over+digital+radio/2100–1027_3–5236755.html

Burk, Dan L., and Julie E. Cohen. 2001. Fair use infrastructure for rights management systems. *Harvard Journal of Law & Technology* 15:41–83.

Byrne, Sean. 2004. RIAA's new issue: Digital radio = giant file sharing network. *CDFreaks.com*, October 17, 2004. http://www.cdfreaks.com/news2.php?ID=9901.

Chomsky, Noam. 1999. *Profit over people: Neoliberalism and global order.* New York: Seven Stories Press.

Cohen, Julie E. 1996. A right to read anonymously: A closer look at "copyright management" in cyberspace. *Connecticut Law Review* 28:981–1058.

———. 2002. Overcoming property: Does copyright trump privacy? *University of Illinois Journal of Law, Technology and Policy* (Fall):101–108.

———. 2003. DRM and privacy. *Berkeley Technology Law Journal* 18:575–616.

DRM Watch. 2003. Selling songs on eBay? October 22 2004. http://www.drmwatch.com/legal/article.php/3095241.

Gilbert, Alorie. 2003. iTunes auction treads murky legal ground. *Cnet News.com*, October 22, 2004. http://news.com.com/iTunes+auction+treads+murky+legal+ground/2100–1025_3–-5071108.html?tag=nl.

Godwin, Mike. 2004. What every citizen should know about DRM, a.k.a. "Digital rights management." Washington, DC: Public Knowledge & New America Foundation.

Griswold et al. v. Connecticut. 381 U.S. 479 (1965).

Hansen, Evan. 2003. eBay mutes iTunes song auction. *Cnet News.com*, October 15, 2004. http://news.com.com/2100–1027_3–5071566.html?tag=fd_top.

Inducing Infringement of Copyrights Act of 2004. S. 2560.108th Cong., 2nd Sess.

Information Infrastructure Task Force. 1995. Intellectual property and the national information infrastructure: The report of the working group on intellectual property rights. Washington, DC. Available from: http://www.uspto.gov/web/offices/com/doc/ipnii/ipnii.pdf.

Itworld.com. 2002. Big five labels sued over copy-protected CDs. October 5 2004. http://www.itworld.com/Man/2683/020619cdcopy/.

Jackson, Matt. 2001. Using technology to circumvent the law: The DMCA's push to privatize copyright. *Hastings Communication and Entertainment Law Journal* 23:607–646.

Lessig, Lawrence. 1999. *Code and other laws of cyberspace.* New York: Basic Books.

———. 2004. *Free culture: How big media uses technology and the law to lock down culture and control creativity.* New York: The Penguin Press.

Litman, Jessica. 2001. *Digital copyright.* Amherst: Prometheus Books.

———. 2002. Copyright law as communications policy: Convergence of paradigms and cultures: War stories. *Cardozo Arts and Entertainment Law Journal* 20:337–365.

Metro-Goldwyn-Mayer Studios v. Grokster. 259 F. Supp.2d 1029 (2003).

Miles, Elizabeth. 2004. In re Aimster & MGM, Inc. v. Grokster, Ltd.: Peer-to-peer and the Sony Doctrine. *Berkeley Technology Law Journal* 19:21–57.

Napster LLC. 2004. Napster terms and conditions. October 17, 2004. http://www.napster.com/terms.html.

National Research Council. 2002. *The digital dilemma: Intellectual property in the information age.* Washington, D.C: National Academy Press.

O'Hara, Rebekah. 2003. You say you want a revolution: Music & technology—evolution or destruction? *Gonzaga Law Review* 39:247–294.

Reidenberg, Joel R. 1998. Lex Informatica: The formulation of information policy rules through technology. *Texas Law Review* 76:553–593.

Schulman, Brendan M. 1999. The song heard 'round the world: The copyright implications of mp3s and the future of digital music. *Harvard Journal of Law & Technology* 12 (3):590–647.

Smith, Tony. 2003. eBay pulls iTunes song auction. *The Register*, October 10, 2004. http://www.theregister.co.uk/2003/09/05/ebay_pulls_itunes_song_auction/.

Sony Connect Inc. 2004. Connect store terms of service and end-user license agreement. October 17, 2004. http://www.connect.com/tos.html

Sony Corporation of America et al. v. Universal City Studios, Inc., et al. 464 U.S. 417 (1984).

Sparkler, Andrew. 2004. Senators, congressmen, please heed the call: Ensuring the advancement of digital technology through the twenty-first century. *Fordham Intellectual Property, Media & Entertainment Law Journal* 14:1137–1170.

Universal Studios, Inc. v. Corley. 273 F.3d 429 (2001).

U.S. Copyright Office. 2001. Digital Millennium Copyright Act Study. Washington, D.C.

Vaidhyanathan, Siva. 2001. *Copyrights and copywrongs: The rise of intellectual property and how it threatens creativity.* New York: New York University Press.

Wagner, Polk. 2004. Nuts & bytes: Fundamentals of fair use in the scholarly domains. Paper presented at the Knowledge Held Hostage Conference, Philadelphia, PA.

Walmart.com Music Downloads. 2004. End use license agreement. October 17, 2004. http://musicdownloads.walmart.com/catalog/servlet/EulaServlet;jsessionid=BlH49I1wg95heqQQWoyGfutDLE9yQnnyTLMkOtqnIiCK2HUpyWRy!-1607612612.

Yu, Peter K. 2004. The escalating copyright wars. *Hofstra Law Review* 32:907–951.

ZDnet.com. 2004. RIAA puts more "John Does" in the dock. August 26, 2004. http://news.zdnet.com/2102–3513_22–5323850.html.

Rodney Whittenberg

Using Computers to Create Music

This chapter discusses the uses of digital technology in the composition of music for film and television. I examine how the development of digital instruments, sampling, and soft synths have changed the way in which music is created, particularly in the area of movie production. I also discuss examples from my own experience as a composer.

In the Beginning

It was 1972. I was a nine-year-old kid growing up in Yeadon, Pennsylvania, a small suburb outside of Philadelphia. I would spend hours in the basement building analog oscillator circuits, designing the printed circuit boards with supplies from the local Radio Shack that I would buy with my allowance. Using capacitors, resistors, and rheostats, I created different tonal colors. Then I discovered by combining two oscillators together I could get a more a complex tonal color. I would record sounds with a *Superscope* by Marantz cassette deck to two old, gray, late-1950s model suitcase reel-to-reel tape recorders, the ones with the orange tube that shows the proper modulation. I would make up drumbeats using a Realistic microphone placed under old pillows and hit them with drumsticks while recording them. The more pillows the deeper the sound. Then I would play that recording back and record beeps and boops from a synthesizer that I had made using the case and keyboard for my Mattel *tote-a-tune* and a big wood box holding the oscillator circuit with a few potentiometers sticking out for tuning and glissandos. I would bounce that back to another tape deck and add some spacey electric guitar running through an Electroharmonix *Electric Mistress* flanger. I was making music that would have been perfect for a 1970s horror film or a cue from Stanley Kubrick's *The Shining* (1980). I dreamed that one day I would be a famous rock star and I

would have my own studio. I would compose music for television and film on the side.

Jump ahead 30 years. I did not make it as a famous rock star but I am an Emmy-winning composer. I have my own studio and compose music for film and television. I still live in the Philadelphia area. My studio is on the third floor of an old Victorian house in the Germantown section of Philadelphia. From there I compose music for independent films like writer/director Josh Olson's *Infested* or Anurag Mehta's *American Chai*, and television shows like *A Cook's Tour, Real Wedding from the Knot, The Jane Pauley Show,* and NASCAR. It is because of digital technology that I and every composer and music maker around the world can make music that sounds and feels real with a limited budget and resources but still achieve a big sound. I will spend this chapter taking you on a journey through some of my experiences—the highs and lows and a look at the future of digital technology for music production.

Digital vs. Analog

With an analog recording, sound is turned into electrical pulses usually by a microphone. The vibrations in the air vibrate a diaphragm that is connected to a coil of wire surrounding a magnet and the vibrations cause current to flow. The current is amplified and then sent to a tape head. The tape head is another form of an electromagnet. Tape passes across the head and the magnetic field created by sound vibration attaches itself to the metal particles on the tape. When that same area of tape is passed by the head, the whole process happens in reverse. The head reads the signal, it is sent to the amplifier, and then to a speaker.

With digital recording, the process starts out the same way but after the signal is amplified, the signal is converted to a series of number-by-circuits called digital to analogue converters. The string of numbers or bits of information are saved on some kind of storage device, just like your computer saves data to a hard drive or back-up tape. As you can imagine, having sound saved as digital information causes the manipulation of the sound to become as simple as a cut and paste.

The Quest for the Perfect Master

Musicians and recording engineers have always wanted to have a way to produce quality masters in their homes, to work in an environment that feels right to them, an environment that feels, well, like home. There are many stories of folk singers doing this. Pete Seger, " The Boss" Bruce Springsteen, and alt rocker PJ Harvey have all recorded albums in their homes. The Hip Hop and Techno revolution owes much to that home-grown genius Les Paul. Les Paul—born Lester Polfus on June 9, 1915, in Waukesha, Wisconsin—is a visionary inventor who developed the multi-track recorder (recording onto individual tracks, playing them back, and being able to record on additional tracks on the same machine). Originally he used flat discs to record to. He moved to using tape after a friend gave him a German-made analog tape recorder that the friend had brought back to the U.S. after World War II.

Paul's studio was in his home, originally in the barn, and later in the house. He started a revolution that continues today. Throughout the '50s, '60s, and '70s, engineers like Joe Meek, Tom Dowd, George Massenburg and a list of others have improved on Les Paul's ideas and the recording studio became an institution. The cost of the equipment, having a great sounding room to record in, and having multiple microphones made it impossible for the individual musician to produce a "master" without going into a stu-

dio. For example, a reel of 24-track two-inch tape in 1979 could cost as much as $150 for 15 minutes of recording time, not to mention the tape machine that everyday in the late 1970s needed maintenance and alignment, which could cost as much as $75,000, and a mixing console for $500,000. It was not until the 1980s eight-track reel-to-reels like the *Fostex Model 80* that the musician could begin to afford a multi-track recorder.

These tape machines, however, were noisy and a constant hiss could be heard in the background. A noise-reduction device had to be used to eliminate noise, but as a result you also ended up losing some of the higher frequencies. Four-track cassette decks were introduced, but they were even noisier. All of this was great for home-demo use but hardly anyone was making masters. (A few professional engineers and producers have claimed to have recorded albums this way but it wasn't widely used.) The less expensive recording equipment did help in the creation of Punk and Rap music. Given that both styles of music were raw, energetic, and homegrown, the Lo-fi (Lo fidelity) sound became part of the aesthetic of both of these styles of popular music.

As analog technology trickled down to the consumer, the professional technology kept on advancing. In 1978 Telarc Records released the first widely distributed digitally recorded LP of the Cleveland Orchestra Winds. In 1979 Fleetwood Mac digitally recorded the double album *Tusk* for the unheard of price of $1,000,000. Even though the album was not as successful as their previous recordings, the stage was set for the move to digital. By the mid 1980s, SSl automated mixing boards were becoming commonplace in recording studios and digital samplers like the *Fairlight* and the *Synclavier* were commonplace on records by Steve Wonder, Duran Duran, Peter Gabriel, and Frank Zappa.

For the consumer the digital revolution had arrived in full force in 1983 when Compact Disc Technology was introduced in the United States. In the spring, the Compact Disc Group formed to help market the CD, and CD-ROM prototypes were shown to the public. That year 30,000 CD players and 800,000 CDs were sold in the U.S.

By the early 90s, a small group of engineers and musicians set out to make a digital multi-track recorder that would change everything. The company was Alesis.

Their creation was the ADAT, an 8-track Digital Recorder that used S Video tape to record digital information. You could connect three of them together to get 24 tracks and there was a transport (a remote-control device that allows the engineer to control the ADAT functions) that looked like what the big studios use. The "list" price for a brand-new ADAT was around $2,500. The home-recording revolution had taken on new meaning.

As I stated earlier, when I was a nine years old the only way for me to record 8 tracks was to bounce tracks between tape recorders 8 times. Once bounced, I had no control of previously recorded tracks (this is the way the Beatles recorded "Sergeant Pepper," but in a very controlled environment on two 3-track machines). I could never deliver these tracks for professional use.

The ADAT with its CD-quality sound meant that multi-track recording was attainable. If you wanted a better quality digital-recording deck you could buy one of the Tascam DS series, which offered better digital-to-analog converters and recorded on Hi8 videotapes. The housing on the Hi8 tapes were also sturdier and more reliable. The DS-88 offered better reliability and better sound quality for around $4,500.

Mackie, a Seattle-based mixing-board company, began to develop mixers that rivaled the sound of the big studio mixer; they were good enough to produce quality production masters. Musicians went crazy. Everyone who could get one bought one and started mak-

ing digital master-quality recordings. This began to change music production and how music was created for media.

Let's take a minute to define digital master. The way it has worked for at least the last 40 years. A piece of music is recorded onto multiple tracks. Once the recording is completed it is then mixed from 24 or 48 tracks to a 2-track stereo or 6 tracks for a surround-sound mix. This master will then be sweetened or "mastered." When engineers first began cutting master discs used to produce vinyl records, they designed signal processors such as compressors, limiters, and equalizers (EQ) to prevent overloading the cutter head. They noticed that changing the settings could also have beneficial effects on the music, especially in Pop styles. Equipment and techniques were developed to further "sweeten" the sound. Since then, this has been considered the heart of the process, where clarity, smoothness, impact and "punch" are enhanced, depending on the needs of the music. The goal is to increase the emotional intensity. If the performance, arrangement, and recording quality are good to start with, then the final master sounds even better than the mix tapes, and even casual listeners can notice the difference. The files go to "stage," where it is mixed to the audio track of a film. It can also be sent to a video production house where it is mixed with the video image, or to a CD duplication plant where it is mass produced. In the modern age, the files can be uploaded to a website and downloaded into mp3 players or iPods. The ability to create a quality master allows musicians to make music that's ready for the world.

The Real World

In 1994 I started my company, Melodyvision, in a bedroom in a south Philadelphia apartment. I started with a Mackie mixer, a Fostex 8 track, an EPS 16 Plus sampler, and a Macintosh SE 30, running Mark of the Unicorn's *Performer* plus a few guitars and my imagination. The EPS is a sampler that digitally records a snippet of sound and allows playback of the sound. With the attached keyboard one has the ability to control aspects of the sound, pitch, attack, sustain, and release. You can make any sound musical. The Fostex we have already discussed. The Mark of the Unicorn's *Performer* is a computer-based sequencer. A sequencer allows a musician to record MIDI (Musical Instrument Digital Interface) information. In the early 1980s, manufacturers of electronic musical instruments came up with a language to communicate between instruments and, later, computers. The software *Performer* records this midi information like a piano roll recorded the pianist performance. Playback is an exact recreation of the original performance. The information takes up a minimal amount of space, but it needs the sound source to be connected in order to hear the sound. This was my studio in 1994.

I started composing music for dance even though I wanted to work in film. Philadelphia in 1994 was not a hotbed of film production and I had no proven track record, so I went to the Philadelphia Dance Community and said, "Use me." One of the pieces I composed showed off how digital-recording technology supports creativity and imagination. I was working with the dance department at Temple University. The choreographer's name was Sarah Lowing. She wanted to create a performance based around her dog and she wanted the music to sound like the early-1990s band Big Audio Dynamite featuring former Clash guitarist Mick Jones. But she wanted the sound of her dog, Longfellow, to be used somehow in the piece.

What comes to mind is the funny and cheesy recording of dogs barking jingle bells. That's not what I wanted to do, so I thought, "What if the dog could become one of the

instruments in the piece? " So I took my Sony Digital Tape recorder to her apartment and recorded about an hour's worth of Longfellow's barking, panting, howling, drinking, snorting, sniffing, licking, and, because Longfellow had lost his sight, bumping into the microphone. I took all of these sounds back to my studio, selected a few choice sounds, and, using my K200 sampling keyboard, I created four different instruments. One was of Longfellow licking or drinking water. I set each instrument to play at various speeds and pitches and then added Longfellow panting. I set them up across the keyboard and at different pitches, including Longfellow's moaning and, of course, barking.

At the time I was using a Macintosh 8600 running MOTU's Performer 2.5 as my sequencer. I used the natural tempo of Longfellow's licking to set the tempo of the piece of music. I then brought in his panting as if it were another percussion instrument, then added traditional percussion instruments around that to create the groove. There is a neat synth line that weaves about the piece. The piano and the barking dog trade off and on the melodic ascending hook. Sarah was very happy and we ended up creating a full-length piece a year later. The quality of the sounds and the recording were master quality. She has gone on to perform this piece in other venues and a review was written in the *Washington Post*, which commented on the unique use of the dog sounds. Without digital technology the whole process would have taken a week as opposed to a day. The time-consuming part was to dream up and compose the piece.

Another project that comes to mind is the Columbia Tri Star picture *Infested*, written and directed by Josh Olson. This was going to be a lot of fun. At the time Josh and I had been friends for 20 years and we both had talked about finding a project we could work on together with him in L.A. and me in Philadelphia. I have worked on a few other L.A. productions and every time there are hurdles to overcome. I think they exist mostly in the minds of those who run and work in Hollywood: How could you be any good if you're not in L.A.? You won't be able to meet the deliverables. So I had to convince the producer, Chuck Block, that I could handle the job, deliver on time and with no headaches. The thing that I was most struck by is how the business is so scattered in how it relates to technology. You can be working with a small mom-and-pop production company and they're on the cutting edge of the recording technology. Then you could be working with a major production company and they are not set up to FTP files and formats and computer platforms. This just adds to the confusion.

In Hollywood, most of the editing suites were connected via DSL. So I sent mp3 files to Josh. He would match the time code on a VHS tape to the start time of the cue that I sent to him. He would start both at the same time while talking to me on the phone and he could approve or make changes to them at the same time. There was an occasion where he was in an edit suite that was connected to the Internet. He and the editor were working on the opening of the film. He called me and asked if I could whip something up for the funeral scene. Twenty-five minutes later he was watching the cue in L.A. synched to the picture. We never replaced it with an AIFF file and that mp3 file is actually in the film.

In 1998 I worked on a short film for a small Philadelphia production company with one of my favorite editors, Geoff Richman. They had an Avid editing system hooked directly into a DSL or cable modem. As a result, I was able to send them cues as they were completed, and not as mp3 but as AIFF or Wave files. In 2002, working on *Eating Out Loud*, a special for the Food Network, I was able to FTP all the files to the production house, Radical Media.

This practice has become much more commonplace in 2004. Digidesign has developed a system for sending entire Pro-Tools (Pro-Tools is a software and hardware-based digital-recording program like Digital Performer) files over the web, allowing musicians to collaborate with other musicians all over the world wherever they have high-speed Internet access.

To create the score for *Infested* I wanted the music to sound as big and orchestral as possible and include lots of authentic-sounding percussion with a nod to '70s and '80s horror films. The budget was very small with no money for a real orchestra, in fact, no money for real anything. However, over the years I have created an extensive library of sounds for my K200 plus a pretty authentic digital-sound sample library. So I spent the first couple of days compiling and creating a pallet. I knew I wanted a tinkle of high piano in homage to the score for John Carpenter's *Halloween*, so I sampled my grand piano in my living room and then mixed that with a piano sound on the Alesis QS 8. It worked perfectly. I could not have done this in my house 20 years earlier. Digital technology has made it possible for me to live out a dream; it changed the way music for film and television is created. And made the 9-year-old in me very, very happy.

Where are We Now and Where are We Going

Things are not always great in the new frontier; there are some negative effects of this digital revolution. As I am putting the final touches on this chapter, I am in a panic because one of my terabyte drives has failed. It has about two months of work on it and, of course, is not backed up. The industry of data recovery is booming because it's not *if* a drive will fail but *when*. With files getting bigger and bigger and drives getting bigger and bigger, it's hard to have redundancy as a small business. But I am finding it's worth it to invest and back things up.

The economy of production has also changed. In the 70s and 80s you could get a decent budget for a low-budget TV show, but now with technology making it seem so easy to produce music, the budgets have gotten smaller. I can't tell you how many times I've heard a client say, "Hey, my kid uses *Acid* on a PC. How hard can it be?" (*Acid* is a loop-based program that allows you to manipulate loops and create your own music. Hence, no musical knowledge is necessary to make your own music.) You just have to shrug it off and let the client know that you are a professional with years of experience and training.

As to where this is going, at the time I am writing this the latest and newest craze are software-based sound modules *B4*, *Reason*, *Giga sampler*, and *Sample Tank*, which all allow you to have two full rooms of new and vintage gear in one computer. You will be able to have access to any sound and, believe it or not, with *plug-ins* (plug-ins are software that adds additional functionality on to a software program). I can then take that sound and place it in any room. They have figured out a way to sample how a sound will respond in a room and I can record that sound with any microphone.

Microphones can range from $100 to many thousands of dollars. It would be costly to have every mic on hand, but there are plug-ins that will model just about any mic. There is even a plug-in that will fix the intonation if your singer is slightly flat or sharp. *Anters auto tune* can get him or her back in tune. And the cost of all this seems to be coming down with every new release or new development. Last year Apple released *Garage Band*, which does approximately what *Digital Performer* and *Pro-Tools* do. Digital

Performer's list price is $795. You can get a basic *Pro-Tools* set-up for around $495 list price. Garage Band is part of Apple's iLife package that sells for $59.

A recent trip to L.A. sums up how digital technology has vastly changed music production. I edited a short promo film for a friend's company but when I got to L.A., I realized I didn't have the appropriate music for the piece. I had brought my laptop and a *Midi Man Oxygen USB* Midi keyboard with me. While sitting on the balcony overlooking a Mexican water fountain, I composed, played, and recorded the music for the promo film, mixed it and exported it to *Final Cut Pro*. I listened to the final mix before I uploaded the whole thing to the Internet. It would not have sounded any better if I were in my home studio with all my gear. I have seen the future and it is glorious.

Timothy D. Taylor

Music
+ Digital Culture

New Forms of Consumption and Commodification

This chapter examines the ways that digital forms of music distribution have changed the ways that people consume music, and argues that established modes of understanding consumption are inadequate to explain these new forms of music consumption: listeners are able to personalize their listening experiences as never before, and to make their own music more easily than ever before. Related to this development is the changing nature of music as a commodity. This essay argues that digital technology has brought a new regime of the commodification of music, following earlier regimes of commodification identified as: (1) "premodern," in which sound itself can be the commodity, (2) mechanical, referring to printing and publishing, which added a printed object to the realm of the music commodity, and (3) electronic. The much-discussed fetishism of commodities is inevitably altering as music as an object-commodity—especially the LP and CD—is becoming supplanted by computer files without cover artwork or other accompanying material. And these musical computer files can become raw material for the remixing skills of fans, constituting a new kind of relationship to the music commodity.

The rise of digital technologies in music since the 1980s has greatly altered every facet of music: production is vastly different, the range of equipment has expanded to outfit everything from extremely expensive professional studios to affordable home gear of unprecedentedly high quality, some musicians have lost work as new technologies have entered realms of musicking, and, what has received the most press, the distribution and thus consumption of music has been utterly transformed, to the extent that the nature of music as a commodity has been altered.

In this paper I want to talk about these new technologies of distribution, specifically, the new ways that music is consumed, and the changing shape of music as a commodity.

Consumption of Music[1]

Theorizing music consumption requires a brief survey of classic theories of consumption. I don't think it has always been noticed that arguments concerning consumption form the core of some of the most influential theories of mass and popular culture going back to the Frankfurt School and continuing to the present in various theories of postmodern culture. The main two positions historically have been essentially "top-down" and "bottom-up"; that is, the so-called culture industries promulgate their products on a public thought to accept them unquestioningly, or, that people are believed to make their meanings out of mass-produced and mass-mediated cultural forms. Thanks to the work of the so-called Birmingham School, in the realm of cultural studies there has been a rejection of the top-down notion of "mass culture"—a model mainly associated with Max Horkheimer and Theodor Adorno of the Frankfurt School—in favor of a more bottom-up notion of "popular culture," as if the first is entirely—totally—malevolent and the latter only salutary.[2] If forced to make a choice I would happily align myself with the Birmingham School rather than Horkheimer and Adorno, but their position is not wholly unusable. Horkheimer and Adorno's characterization of the "culture industry" doesn't mean that people can't make their own meanings out of the things they buy, even when they know that they might have been manipulated into buying them.

But there are arguments to be made on both sides—sometimes industries' desires prevail, sometimes people's do. In understanding the nature of the consumption of music, I think that it is more productive to view the Frankfurt and Birmingham Schools as representing two poles. While the Birmingham School model seemed to be more accurate for awhile, the rise of what we have come to call globalization, and new kinds of technologies such as satellite television, computers, and fax machines, has meant that cultural forms travel further and faster than ever before, a condition that in some quarters prompted a resurrection of arguments resembling those of the Frankfurt School. Jean Baudrillard, perhaps the most influential theorist of the contemporary moment, is in some sense a neo-Frankfurter with respect to consumption.[3] Baudrillard, like his earlier German colleagues, assumes a structure that dominates individuals. Rather than the culture industry, however, the dominating structure is the code, the system of signs that has replaced actual products (referents, or "finalities" in Baudrillard's language, which are thought of as having functions), which were once what people consumed. This system of signs structures reality itself, even produces it. Objects are no longer defined by their functions, by their relationships to people, but now are defined by their relationships to each other in the absence of the social that is assumed to have been effaced, and along with it, individual agency.

Yet, despite the influence of Baudrillard's work, it needs to be pointed out that his, and indeed, most studies of consumption have not been ethnographic.[4] Researchers who conduct ethnographies are not finding changes as dramatic (or pessimistic) as Baudrillard and others are. James G. Carrier and Josiah McC. Heyman argue that contemporary patterns of consumption in the U.S. are far more connected to household interests and needs, whereas the familiar "cultural studies" notion of consumers as individuals "who contemplate, desire and acquire commodities" describes a fairly small subset of con-

sumers and consumption patterns (Carrier and Heyman 1997, 368–9). They preface this empirical argument with a trenchant critique of the recent academic interest in consumption, a turn, they say, that suffers from its synchronic approach, resorts to psychocultural explanations (that is, explanations are concerned with what goes on in people's minds as reflections of collective values), and that the literature on consumption represents consumption and consumers unidimensionally.

Carrier and Heyman are not arguing that previous theorists of consumption are wrong, simply that, without an ethnography or at least attention to specific social groups in specific times and locations, a practice as broad and ubiquitous as consumption cannot be theorized totally as either Horkheimer and Adorno—and Baudrillard—on the one side, or Stuart Hall and the other Birmingham School representatives on the other.

Daniel Miller, another anthropologist of consumption, has written extensively about consumption and shopping, and similarly finds that, contrary to a Baudrillardian "top-down" argument, and, perhaps more surprisingly, also contrary to what Stuart Hall and others have said, people shop as "an expression of kinship and other relationships" (Miller 1998, 35).[5] This argument helps explain the massive popularity of the file-sharing of music. File-sharing programs such as KaZaa or LimeWire allow users to congregate in various chat rooms devoted to specific styles and genres of music and trade MP3s; they have access to your MP3s and you have access to theirs, effectively turning everyone's computer temporarily into a server. This means that MP3 distribution can be accomplished without any need for the music industry whatsoever, except the production of the distributed music. There is no need for a centralized distribution system, either physical or virtual (such as the website MP3.com).

Despite the work of Carrier and Heyman and other ethnographers, the two poles, represented by the Frankfurt School (essentially top-down) and Birmingham School (bottom-up), remain dominant. Now you are probably thinking I am about to propose some sort of middle ground between these two positions, but I am not. Let's face it. Sometimes some consumers in some places and times are duped, sometimes some industries in some places and times fail to fool their customers. Practices of marketing and consumption, from being either top-down or bottom-up, are instead caught up in a complex dynamic in which corporations try to figure out what consumers want and attempt to give it to them, even though consumer preferences can never be easily predicted.

Today, I believe that we are in a moment when the Birmingham School conceptualization of consumption is more accurate, at least with respect to music and digital culture. At the same time, however, we are also in a moment when the music industry is more consolidated than ever.

One of the ways the record industry sought to increase profits in the late 1990s was to greatly reduce the number of singles issued in an attempt to force consumers to purchase the whole CD. Now they don't have to. Digital modes of distribution permit listeners to share and download only those songs they want, or subscribe to a download service, or purchase songs individually through a download service.[6] Listeners are thus able to make their music collections more personal. They no longer have to purchase a prepackaged bunch of songs on CDs or cassettes, and instead can put together whatever combination they want, keeping the songs they like and omitting the ones they don't. According to the director of Apple Computer's popular music download site, iTunes, consumers "want to own their music. They want to have the flexibility to do what they want with it. They don't want to rent music" (Ryan 2003, 1).

Today's technology makes possible a greater degree of eclecticism in consumption of music, and other goods, than ever before because of purchases (or downloads) from the web of single tracks of recorded music.[7] While in the past a consumer with eclectic tastes might have cultivated an interest in several genres (it is easy to imagine the yuppie whose record collection boasts selections of jazz, blues, rock, and world music), it is now easy to acquire, cheaply or for no cost at all, just about any kind of music one might want from the Internet.

British Sociologists Scott Lash and John Urry employ the term "reflexive accumulation" to theorize new modes of consumption. A subcategory of this general term is of direct interest here: "reflexive consumption," a kind of consumption made possible by the decline of social forces that once influenced, even determined to a significant extent, a particular consumer's choice—family, corporate groups, and social class (Lash and Urry 1994, 61).

This degree of eclecticism, this notion of reflexive accumulation facilitated by the digital distribution of music, is related to the increasingly technologized economy. Today's music fan may not hang out physically with a group of fans with similar tastes, but instead can find fellow music lovers on the Internet by visiting websites devoted to particular musicians (some of those made by fans are incredibly detailed and complete); newsgroups devoted to particular bands, styles, regions, eras; or by joining similarly specialized mailing lists, which put e-mail messages in users' e-mail inboxes. I have seen many messages on the mailing lists to which I subscribe saying that the particular writer is alone in her tastes, how few of her friends are interested in whatever music to which the mailing list is devoted. But today's isolated fans can find like-minded friends all over the world, congregating on the Internet.

Fans are not simply accumulating reflexively, however—they have the power to alter the music they download, or purchase on CD. Until recently, music was pretty much used as manufactured—companies made recordings, consumers played them back. Playback situations can vary hugely, of course. But, whereas in the past only someone with a studio could alter recorded music—with the main, and important, exception of hip-hop musicians scratching their LPs—with digitally recorded music, and with inexpensive software or even free Internet websites, it is now possible for music fans to remake and remix somebody else's music (a remix is an altered version of a pre-existing track of music). One can play an MP3, or one can play with it, using any one of a number of available software packages, in which the listener can be a DJ, a remixer, a soundscape artist, and engineer. And much of the software that makes this possible is free or cheap (by which I mean under $100). Some of this software seems to be popular; I tried many times to download Visiosonic's PC DJ Phat, a free MP3 DJ application, but with no success (http://www.visiosonic.com).[8] After a week or so, I tried again and found that Visiosonic had added two servers to handle what seemed to be a far greater than anticipated demand. Their motto for this product is: "Don't just play, MIX with PCDJ!" There are other such applications, such as Virtual Turntables ($42), which emulates a DJ's pair of turntables (http://www.carrotinnovations.com/vtt_overview.shtml). One can remix using Mixman Studio ($19.95) or Mixman Studio Pro ($49.95), software applications that allow you to make your own remixes of prerecorded (available from Mixman) music and save them as MP3s (http://www.mixman.com).[9]

And DJs now take laptops to gigs, not because they hold a database of recordings in the DJ's collection, but because the music collection itself is in the computer and easily made available for DJ use. Some DJs appear simply with two Apple iPod MP3 players.

As a way of summing up this section, let me quote from the owner of a company that promotes bands, films, video games, and more to the youth market, who says:

> Look, the kids are so smart these days, they can find, retrieve, disseminate, produce any piece of music or technology now on the Internet. They can take a song, send it to a friend in North Africa, remix it how they want, make their own video for it and make it their own. And that technology makes them so powerful. It's not about the radio programmers anymore or promoters. It's about a kid in homeroom in Iowa now. Everything is different now (Boucher 2003, E1).

Music as a Commodity

I asserted at the outset of this paper that the nature of music as a commodity has been altered with the arrival of digital technologies, and in this last portion of the paper I want to flesh out that claim. Separating consumption and commodification, however, is a tricky business, and so this paper will conclude with an examination of how intertwined they are, at least with respect to digital music.

In discussing music as a commodity I am hampered by the fact that a thoroughgoing, theoretically sophisticated treatment of music as a commodity has yet to be written, besides a few assertions of music's commodity status (especially popular music) by none other than the Frankfurt School musicologist and philosopher Theodor Adorno.[10] So this discussion of music as a commodity is only the beginning of what will need to be a larger project on the subject.

As is well known, the nature of the commodity is one of the most slippery and difficult concepts in all of social theory, and time does not permit a thorough examination of music as a commodity here.[11] In the time that I do have I will begin by simply restating Arjun Appadurai's definition of a commodity as a starting point in the hope of clarifying the issue: a commodity, he writes, is *any thing intended for exchange* (Appadurai 1986, 9; emphasis in original).

It immediately becomes apparent, however, that music isn't a commodity like others: what kind of thing is it? Music can be commodified as an object, a recording in many formats, or instrument, or score; as an experience, whether pleasurable or educational; and music plays a role in commodifying and consuming practices and processes, such as broadcasting, shopping, dining out, travel (airports, airplanes), and more. Clearly, music as a commodity is not always a static object: all music moves through complex networks of commodifying, uncommodifying, and non-commodifying tendencies.

In Appadurai's sense, music has been a commodity for a long time, though one could argue with just when it became one. Music as sound has been commodified for centuries, as people with money paid performers to perform. The rise of music printing and publishing in the early 16th century heralded a new era, aided by music copyright beginning in the late 18th century. This era, not coincidentally, also gave birth to modern aesthetics, the idea of "art for art's sake," a necessary set of ideologies as composers were released from the patronage system and became freelancers in an open market. "The artist was born," writes Jacques Attali, "at the same time his work went on sale" (Attali 1985, 47).

After printing, later technologies shaped the commodification of music even more strongly: the invention of the phonograph in the 1870s, then radio and sound film in the 1920s, commodified music to the extent that most people in the industrialized world ceased making their own music and began buying it instead.

Let us call these periods, none of which supersedes another but commingle, (1) premodern, in which sound itself can be the commodity, (2) mechanical, referring to print-

ing and publishing, which adds a printed object to the realm of the music commodity, and (3) electronic—phonograph, radio, film, and television. Each of these shifts brought with it new processes of the commodification, distribution, and consumption of music.

Digital culture has given rise to a fourth regime of commodification and consumption. Practices such as sampling—the exact, digital copying of pre-existing music—and the distribution of music online are raising new questions about the commodification of music, and indeed, the very notion of music as a commodity.

And digital technology has brought about another mode of listening to—interacting with—music. I am less interested than Adorno (or other contemporary writers) in inventing new terms, but we have to call this new kind of listening something, so: digital listening. I talked about this kind of listening in my book *Strange Sounds*, but attributed it more to the methods of composition of two individuals: Toby Marks, whose "band" is called Banco de Gaia; and Bryn Jones, whose "band" is called Muslimgauze, who work, as many musicians now do, with computers (Taylor 2001).

Digital technology, and sampling in particular, have accomplished for music what writing did for language: it created a new category of information (Canaday n.d.). Sampling is music informationalized; not just sampled music, but all music becomes heard as something that can be sampled, redeployed, remixed (Virilio 1997). More generally, digitization informationalizes music, transforming it into just another downloadable entity, like an image, or text, or software. Paul Virilio, who first made the point about digitizing as information, doesn't make much of this as he might, but it matters. Whatever uniqueness music might posses as a cultural form is diminished as it becomes just another folder on the hard disk. The tactility of the CD is lost as it becomes simply a temporary vehicle by which music is transported from the CD store to the hard disk, iPod, and Internet. Music as concrete object—commodity—as CD, cassette, or vinyl LP, is gone, or of very limited use. There is only the MP3 player, either as software or hardware.

This means, of course, that music itself will change. The reason why the standard length of a popular music song is 3–4 minutes is because that's all the music that a 78rpm record could hold. With the rise of the LP after World War II, some popular artists began to think in terms of the "unified side," or even of an entire album of songs that had a common underlying theme. Now we are entering an era when the song is, once again, becoming a singular entity, atomized, just as its component parts are atomized digital bits.

And I think to some extent commodity fetishism of music will change, or even break down. People who collect LPs, or CDs are becoming rare connoisseurs: they collect old-fashioned music commodities as objects. Younger people collect MP3s, fashioning their own collections out of a huge variety of online sources. A commodity fetish-chain from music star to album to distributor to retailer to consumer is being disrupted as the distributor and retailer are excised.

Without the album, the photos of the star, the artwork, the liner notes—the physical manifestation of the music commodity—the link between the song and the star becomes increasingly abstract, even theoretical. And with the technological ability to manipulate music found in MP3s, the star's music may become less something to groove to, but raw material for the fan's remixing skills, the fan's own creativity, as we have seen.

It may be too romantic, or premature, to proclaim that we are entering an era of what Jacques Attali (1985) calls "composition," a time when people stop buying music and instead make it for themselves. But we are certainly in an era when new kinds of skills of sound production, from turntablism to software virtuosity, are increasingly prevalent, increasingly part of our everyday soundscape. And that, it seems to me, is a hopeful sign.

NOTES

1. This section is adapted and updated from Taylor 2001.

2. The Frankfurt School perspective is best represented in Horkheimer and Adorno 1991. For Birmingham School discussions that operate from a "bottom-up perspective," see Hall and Jefferson [1976] 1993; Hebdige [1979] 1991; and Willis 1981.

 Adorno's position is particularly disappointing given his participation in some quasi-ethnographic studies of music while working with Paul Lazarsfeld and others in their research into radio in the U.S. in the 1940s. Martin Jay writes that the methods of Lazarsfeld and others, involving questionnaires and interviews were inadequate in Adorno's view "because the opinions of the listeners themselves were unreliable. Not only were they incapable of overcoming the conformity of cultural norms, but even more fundamentally, their ability to hear had itself degenerated" (Jay [1973] 1996, 190). Jay writes in a later work that Adorno's hostility toward such empirical work later lessened (Jay 1984, 39).

3. See the essays contained in Baudrillard 1988.

4. I would be remiss not to mention two Birmingham School ethnographies: Hebdige [1979] 1991, and Willis 1981.

5. See also Miller 1995.

6. The music industry is now releasing more singles than ever, which is probably an attempt to lure back downloaders. See Dean 2003.

7. Johnson 1997, 204–5, also discusses eclecticism in music consumption facilitated by digital technology.

8. See Jones 1999.

9. For more on Mixman software, see "Music Made Easier" 1998.

10. There is Theodor Adorno. But his discussions of the commodified nature of music are usually the form of assertions and assumptions: popular music and jazz are commodities that are not "heard" or "listened to" by listeners, but are consumed (see Adorno 2002b). "Serious" music is generally exempt from this view but serious music, for Adorno, runs the risk of being commodified and fetishized through mass-media repetitions (see Adorno 2002a), or pedagogy that enshrines listening for surface details rather than structural ones (see Adorno 1994). For all his fulminating, Adorno never wrote a comprehensive analysis of the nature of the music commodity in a theoretical sense. There are moves in this direction, however, by Gramit (2002) and Klumpenhouwer (2002).

11. See, of course, Marx 1967.

REFERENCES

Adorno, T. 1994. Analytical Study of the NBC *Music Appreciation Hour*. *Musical Quarterly* 78 (summer): 325–77.

———. 2002a. On the Fetish Character in Music and the Regression of Listening. In *Essays on Music*, edited by R.Leppert. Translated by S. H. Gillespie. Berkeley: University of California Press.

———. 2002b. On the Social Situation of Music. In *Essays on Music*, edited by R. Leppert. Translated by S. H. Gillespie. Berkeley: University of California Press.

Appadurai, A. 1986. "Introduction." *The Social Life of Things*, edited by A. Appadurai. New York: Cambridge University Press.

Attali, J. 1985. *Noise: The Political Economy of Music*, translated by B. Massumi. Minneapolis: University of Minnesota Press.

Baudrillard, J. 1988. *Selected Writings*, edited by M. Poster. Stanford: Stanford University Press.

Boucher, G. 2003. Now Fans Call the Tune. *Los Angeles Times*, August 3, 2003.

Canaday, J. T. n.d. "Medieval Interpretive Authority and the Emergence of Modern Science and Literature." Photocopy.

Carrier, J. G., and J. McC. Heyman. 1997. Consumption and Political Economy. *Journal of the Royal Anthropological Institute*, n.s., 3 (June):355–73.

Dean, K. 2003. I'll Take My Music a la Carte. *Wired News*, September 4, 2003. http://www.wired.com/news/digiwood/0,1412,60282,00.html.

Gramit, D. 2002. Music scholarship, musical practice, and the act of listening. In *Music and Marx: Ideas, practice, politics*, edited by R. Burckhardt Qureshi. New York: Routledge.

Hall, S., and T. Jefferson, eds. [1976] 1993. *Resistance through rituals: Youth subcultures in post-war Britain*. New York: Routledge.

Hebdige, D. [1979] 1991. *Subculture: The meaning of style*. New York: Routledge.

Horkheimer, M., and T. Adorno. 1991. *Dialectic of enlightenment*, translated by J. Cumming. New York: Continuum.

Jay, M. 1984. *Adorno*. Cambridge, MA: Harvard University Press.

———. [1973] 1996. *The dialectical imagination: A history of the Frankfurt School and the Institute of Social Research, 1923–1950*. Berkeley: University of California Press.

Johnson, S. 1997. *Interface culture: How new technology transforms the way we create and communicate*. New York: HarperEdge.

Jones, C. 1999. Digital DJs Phatten Up. *Wired News*, November 27, 1999. http://www.wired.com/news/technology/0,1282,32705,00.html.

Klumpenhouwer, H. 2002. "Commodity-form, disavowal, and practices of music theory." In *Music and Marx: Ideas, practice, politics*, edited by R. Burckhardt Qureshi. New York: Routledge.

Lash, S., and J. Urry. 1994. *Economies of signs and space*. Newbury Park, CA: Sage.

Marx, K. 1967. *Capital: A critique of political economy*. Vol. 1, *The Process of Capitalist Production*. New York: International.

Miller, D. 1995. Consumption as the vanguard of history: A polemic by way of an introduction. In *Acknowledging consumption: A review of new studies*, edited by D. Miller. New York: Routledge.

———. 1998. *A theory of shopping*. Ithaca: Cornell University Press.

Music made easier; it's all in the mix. 1998. *New York Times*, October 8, 1998.

Ryan, M. 2003. Online music. *Chicago Tribune*, May 11, 2003.

Taylor, T. D. 2001. *Strange sounds: Music, technology and culture*. New York: Routledge.

Virilio, P. 1997. *Open sky*, translated by J. Rose. New York: Verso.

Willis, P. E. 1981. *Learning to labor: How working class kids get working class jobs*. New York: Columbia University Press.

WEBOGRAPHY

http://www.carrotinnovations.com/vtt_overview.shtml

http://www.mixman.com

http://www.visiosonic.com

Jonathan Sterne

What's Digital in Digital Music?[1]

This essay directly questions the meaning of "digital" in digital music by arguing that digital technologies are best understood as always bound up with a range of cultural practices and other—"analog"—technologies. It proceeds in four parts. The first section argues that, while digital audio technology is important, it must be understood in the context of contemporary sound culture, which is not purely or even mostly digital. Following this claim, the second section examines a range of creative technologies and practices like sampling and turntablism that can be lumped under the admittedly clumsy label "recombinant music." Much has been made of the role of digital technology in these practices. I offer a description of recombinant music that does not privilege digital technology, but does take it seriously as an element in a larger cultural formation. The third part of the essay explores changing relationships between professionals and amateurs in the recording industry, and again questions the centrality of digital technology to this transformation. Although the essay is deliberately speculative throughout, the final section ratchets up the speculation quotient to suggest some directions and orientations for future research.

I write in one of those weird moments in which scholars of contemporary culture constantly find themselves. There is a growing literature on various aspects of digital music. Yet, we don't even really know what digital music is. Is all music that comes into contact with a digital technology at some point during its production, distribution, and consumption "digital"? If so, is there any electronically reproduced music in existence today that cannot be called "digital" at some level? Digital is everywhere in the production-distribution-consumption-reappropriation cycle of musical culture, and it has moved from an esoteric dimension of studio technology to an array of mundane facts that lurk beneath the surface of so much contemporary musical experience. Not only are there digital instruments and studios, but compact discs were one of the first widely used digital media in American culture. Computer programs are essential to modern studio design

and computer modeling is largely responsible for the shape and sound of modern speaker systems, not to mention headphones. Digital modeling of physical spaces has also become a central part of the sound of modern recorded music as computers and stand-alone devices model physical spaces from bathrooms to cathedrals and devices from guitar amplifiers to microphones. Even power supplies for amplifiers in performance venues are now oftentimes digitally regulated. File-sharing depends on digital modeling of human psychoacoustic perception, so that mp3s can lose a good deal of data and still sound like the recordings from which they are condensed.

This essay directly questions the meaning of "digital" in digital music. It proceeds in four parts: the first section explores some basic issues in thinking about the relationship between digital technology and music. The second section examines a range of creative technologies and practices like sampling and turntablism that can be lumped under the admittedly clumsy label "recombinant music." Much has been made of the role of digital technology in these practices. I offer a description of recombinant music that does not privilege digital technology, but does take it seriously as an element in a larger cultural formation. The third part of the essay explores changing relationships between professionals and amateurs in the recording industry, and again questions the centrality of digital technology to this transformation. Although the essay will be deliberately speculative throughout, the final section of this essay ratchets up the speculation quotient to suggest some directions and orientations for future research. There is, of course, much more that could be said. There are only passing mentions of listening technologies, which I take to be centrally important and intend to explore elsewhere, or changing performance practices—for instance in the whole laptop movement. But I am hopeful that the explorations in this essay at least offer a sense of my approach to the question of music's interface with "the digital" and inspire you to ask new questions that I haven't yet considered.

Undefining "Digital"

Lurking beneath the question of digital music is the question of digital technology more generally. In his *Language of New Media* (2001), Lev Manovich rejects the term "digital" because it acts "as an umbrella term for three unrelated concepts—analog-to-digital conversion (digitization), a common representational code, and numerical representation [conversion to 0s and 1s]. Whenever we claim that some quality of new media is due to its digital status, we need to specify which of these three concepts is at work. For example, the fact that different media can be combined into a single digital file [unlike film or video, digital files don't exactly have a separate "soundtrack" and "imagetrack"] is due to the use of a common representational code, whereas the ability to copy media [for instance, burning a copy of a CD or copying an mp3] without introducing degradation is an effect of numerical representation" (Manovich 2001, 52). We could go even further if we think about the examples listed above. Numerical code, for instance, allows for easy copying, but it also allows for algorithmic processing: run a recorded sound through the right algorithm and you can change its pitch, its apparent ambient environment, and countless other factors. Manovich calls this dimension of digital processing "transcoding."

As he dissects the term "digital," Manovich objects to the use of the term because it is too blunt a conceptual instrument for his purposes. While his points are well-taken, his alternative term, "new" media, creates at least as many problems as it solves.

"Newness" carries with it a whole set of connotations in our consumer-capitalist socie-ty; we're used to advertisers who tell us that new, amazing products will change our lives; commercial culture brings with it a cult of youth to which ideas of the "new" are always tied; and the predisposition to dispose of our technologies—as in, literally, throwing them out—also fuels and is fueled by an ideology of "the new" (I discuss this point at greater length in a forthcoming essay that explores how digital equipment becomes garbage).

Manovich's periodization is also problematic, since by privileging cinema he pro-motes a very particular view of "new" and "old" in 20th-century media history. Put sim-ply, there is no simple, useful, "unproblematic" adjective that describes current changes in media technologies. We are stuck in a web of description and prescription. As follow-ers of French sociologist Pierre Bourdieu would note, we never have any other alterna-tive when we analyze society—we cannot simply describe a social phenomenon without invoking a prescriptive dimension in our prose—so take this as a cautionary statement, and not an apology (Bourdieu 1991).

Definitional problems aside, there is the more basic social theoretical question of how to study technology. A vast literature on technology exists, but regardless of whether one is a fan of the Science-Technology-Society (Bijker 1995; Bijker, Hughes, and Pinch 1987; Collins and Pinch 1998) approach or the older "philosophy of technology" (Ellul 1964; Heidegger 1977; Ihde 1993; Illich 1973; Mumford 1934; Winner 1986), they all pose the same central challenge for us: if we study the specifics of creation, listening, or other music-related practices that occur in the neighborhoods of digital technologies, then to what extent are we simply making too much of a coincidence between the practices and the technology? This essay largely considers practices normally grouped under the rubric of musical "production" as the creation and composition of music (and to a much lesser extent, distribution performance). In some senses, the approach isn't quite fair. A more holistic approach is really necessary because things start to look very differ-ent when we turn from what we normally think of as the production of music to its con-sumption. To anticipate a point I'll raise again in the conclusion, it's not at all clear that digital technology has affected or accompanied significant changes in listening practices.

Even in the realm of production and distribution, too much is often made of the "dig-ital" aspects of current practice. Take mp3s, for instance. If one reads the newspaper, it might seem on prima facie that the technological form of the mp3 changed the music industry. But in a broader historical and international context, the so-called crisis of the American recording industry doesn't look all that different from the "crises" of regional recording industries all over the world with the introduction of cassettes (Manuel 1993; Wallis and Malm 1984). There are some new twists to be sure: the obscene profit mar-gins and growth indices demanded by the conglomerates that own the major labels are certainly skewing business practice, as did their business strategy of the last couple decades, where profits sagged before the introduction of the compact disc. But CDs arti-ficially boosted sales, especially in back-catalogs, where baby boomers replaced their vinyl LP collections with CDs. As that boom ran out in the mid 1990s, the industry began to look elsewhere to maintain its inflated profit margins, despite the fact that profit margins on CDs are considerably higher *per unit* than on LPs because of improved mass-production techniques and cheaper raw materials (Negativland n.d.). On the distribu-tion side, it is certainly faster to share mp3s than tapes if you've got a high-speed Internet connection. While that describes a relative minority o f people, the industry is right that these people—college students and early adopters of new forms of consumer electron-

ics—are the people most likely to spend a good deal of money on records. This fact leads us to the consumption side and the latest twist in the mp3 saga: the recording industry is now suing potential customers (and implicitly threatens thousands or millions more with litigation) in order to get them to buy its product. That scenario is in equal parts comic, tragic, hilarious, and disgusting. But this too shall pass. The majors may or may not remain intact as they are now, but as long as capitalism exists, people will continue to create and perform music, and other people will find ways to profit from it.

The mp3 case is actually a good example of the issue: by reducing a complex social issue to its technological dimension, we elide the agency of both institutions and individuals in the scenario. This is not to argue for an instrumental theory of technology, that it is simply a neutral "means to an end"—far from it! But every technology exists in multiple systems: systems of social relationships, systems of technologies, and systems of physical or so-called natural phenomena. One could substitute "histories" for "systems" in the previous sentence and get just as far. We cannot directly assess the "impact" of digital music technology, because "impact" studies tend to steer us away from the larger questions of history and culture that are central to understanding musical practice—or any other social practice. In the mp3 case, it simultaneously steers us away from interrogating the current form of the music industry, the relationship of that technology to *other* reproduction technologies (cassettes, CDs), and actual practices among people who listen to or collect music. Indeed, talking with undergraduates who compulsively stockpile mp3s on their hard drives, I am reminded of Walter Benjamin's famous essay on unpacking his library (Benjamin 1968, 59–68): the acquisition is the aesthetic experience, and not the listening.

So much has already happened in the "digital "world that we need not set our sights on the future: the immediate past and present are powerful enough. Here, I follow Lev Manovich who says that instead of prognosticating about the future of new media, which was a major pastime of intellectuals in the 1990s, he would simply look at what had already happened and what practices had developed around and through new media (Manovich 2001, 6–8). I find his stance useful because I don't think we're ready to assess the impact of digital technology per se in music because we haven't even really yet gauged its nature or extent. Here I'm taking a slightly different position than Timothy Taylor, who argues that the "advent of digital technology in the early 1980s marks the beginning of what may be the most fundamental change in the history of Western music since the invention of music notation in the ninth century" (Taylor 2001, 3). Though Taylor goes on to specify and qualify his provocative claim, I'm less ready to take up that position, probably because I've written so much on the origins of sound-reproduction technologies like the phonograph, telephone, microphone and radio.

Partly, this is so because I'm still hung up on transducers. Technologies that change sound into something else, like electricity, and change it back into sound are called transducers. A microphone is a transducer, and so is a speaker. They define modern sound-reproduction devices, whether we are talking about studios, CD players, or telephones for that matter.[2] In *The Audible Past: Cultural Origins of Sound Reproduction* (Sterne 2003a), I argued that sound recording, radio, and telephony indexed a whole set of practices of acoustic modernity. I won't recite those details here, but in the conclusion, I wrote that the jury was still out on digital technology because in essence it was just another step between transducers (ibid., 335–339). For example: to record and play back a tuba

performance in a digital setup, the tuba player plays into a microphone, which transduces the sound vibrations into electricity. That electrical signal is then digitally sampled 44,100 times-per-second through an analog-to-digital converter, and stored as binary data. When you're ready to play the tuba solo back, the digital data goes through a digital-to-analog converter that turns the 44,100 samples-per-second back into an analog electrical signal, when then goes through a speaker or headphones that turn the electricity to sound. Technologically speaking, the digital conversion adds a step to the process of sound reproduction, it doesn't reorganize the process. You still need a speaker to hear the music, and in some cases you still need a microphone or pickup. From the standpoint of the history of sound-reproduction technology, digital audio makes the scenario more complicated, but it does not transform its most fundamental components. If we move outwards a bit from the technology to its function, digital audio devices are pretty similar to analog devices: we delegate the human powers of hearing and sounding to them in a manner very similar to the way that early users delegated their faculties of hearing and speech to 19th-century telephones and phonographs.

One could argue that synthesizers, both analog and digital, have dispensed with the microphone for the most part, and therefore have eliminated the first transducer in the process. Instead, they start with electrical signal that is eventually converted into sound. This is true in many cases. But even here, there are qualifications to be made. One look at advertisements for Korg's MS2000 and Microkorg synthesizers shows the continued importance of a transducer on the front end of the performance. The ads prominently feature microphones that are included with the synthesizers so that musicians can process their voices along with the synthesized sounds (Korg 2003). Another popular Korg product, the electribe, also includes an input feature so that any sound—once transduced into electricity—can be run through the synth.

So you can see why I argued that digital audio just added a step in the middle of the process of turning sound into electricity and turning electricity back into sound. In many ways, I think that claim holds. But in many other ways, that seems too quick and too glib. A more supple position requires a somewhat stretched definition of what counts as digital music and digital technology, and since those terms will remain in question for the rest of the essay, I will dispense with the annoying scare quotes.

Recombinant Music

Ask any musician about the role of digital technology, and he or she will quickly get to its power to edit, transform, mangle, and combine sounds down to the most basic waveforms. Digital editing allows people to easily change the pitch or pace of recorded music, and it allows them to easily alter the timbre of the sounds in a wide variety of ways. With even a basic sampler or audio-editing program, a person can change one sound into something completely different in a matter of seconds. Of course, much of this was possible with analog audio technologies as well, and in fact turntablism reappropriates an analog technology—the record player—to create new soundscapes. But it is difficult not to be struck by the vast proliferation of music that uses other recorded music or sound for its basic building block as digital technologies have become more widely available to musicians. Sample- and mix-based music has taken over many dance clubs: as a live form, it has superceded performance on more "traditional" instruments in venues all over the world; it has influenced a whole fleet of its own genres and mixed with many genres that once eschewed recombinant practice; and, in a truly bizarre way, it has more or

less obliterated more "traditional" forms of background music (the best-known American brand is Muzak) in Europe.

Why call this trend in music-making recombinant? I'm not really excited about biological metaphors for cultural phenomena, but if you talk to any DJ, the art in the music is in the combination and *recombination* of different elements to create new sonic textures. The art is in the choice of sound object, the way it is processed, and the musical mix into which it is put. I first came across this term in a scholarly context in an essay by James Hay on advertising (Hay 1989). His point was that advertising reorganizes cultural forms that exist outside the ads and puts them to new ends. So the "recombinant" metaphor is not necessarily an assessment of the impact or significance of digital technology—it may in fact simply be a cultural form that appeared in music at a time coincident with the introduction of digital audio equipment.

Sampling is a phenomenon that would, at first glance, appear to challenge my earlier thesis about the centrality of the transducer.[3] All samplers work on the premise that music has been recorded somewhere else and that the recording can be imported into the sampler for manipulation and reproduction. Samplers are a classic example in the recording world of a phenomenon that social theorist Ulrich Beck has termed "reflexive modernization" (Beck 1994; Beck, Giddens, and Lash 1995). Beck wrote about the environment, among other things, and used the concept of "reflexive modernization" to describe phenomena that were "the results of *the results of*" modernization. So, for instance, ozone depletion results from pollution, which results from industrialization. Like all good academics, I'm taking Beck's words and twisting them around for a completely different use—music, in this case. Let me explain. There is a common idea out there that recordings reproduce "live" performances, with more or less fidelity. But this is not exactly the case. Rather, "live" events are usually fabricated specifically for the purpose of recording or reproduction. Musicians who know they are going to be recorded perform differently—sometimes the performance is *radically* different from a live performance. Even something as simple as a telephone does not simply reproduce live conversation. People say specific things into phones so that they'll be transmitted over phone lines. While this seems like a small and obvious distinction, it is philosophically significant because standard academic appraisals compare recorded music to "live" music as if the former were a degraded version of the latter. As I argue, such comparisons are really of the "apples and oranges" variety because recording is a fundamentally different (though related) form of social practice from live performance.

So, in essence, when people invented recording, while the device was important,[4] the whole field of practices that go with sound recording made it what it became: studios (which were a new kind of musical space), new types of musicianship, new attitudes toward what music was and how it sounded, new ways of listening, and of course the whole recording industry itself (see Sterne 2003a, 215–86).

This is where sampling comes in. Sampling, along with turntablism (where the playback medium becomes a musical instrument), loop-based audio composition, and even most modern synthesizers, *presupposes and builds upon* this whole culture and economy of recorded music. To apply a geological metaphor to technological practice: as recording practices have formed an increasingly sedimented cultural layer, sampling and other recombinant practices are like a new layer settling on top of the recording layer. Of course the metaphor is not exact, since any historian of avant-garde sound art, most notably Douglas Kahn (1999), can point out the long history of messing with recordings

in the form of cut-up, musique concrete, and other artistic practices that took for grant-ed and played with the medium of recording. The difference between those earlier practices and the more recent explosion of recombinant music-making is a matter of degree, dissemination, and emphasis. Those early composers were somewhere between playing with and fighting with the medium.

Today, a thousand species of recombinant music-making thrive (including a few platy-puses), and a vast equipment industry accompanies each one. One can find specialist DJ turntables; samplers designed for recording, performance, or both; software packages designed to emulate DJ-style performance or hardware sampling; recording- and performance-oriented software packages that allow musicians to compose music from short, measure-length repetitive loops; and on and on. Even karaoke machines might fit this model.

All of these devices *presuppose* the culture and economy of sound recording. They exist on top of the massive archive of existing recordings and listener knowledge and expe-rience of those recordings. In this sense, Beck's "reflexive modernization" perfectly cap-tures the spirit of the recombinant musical enterprise. In fact, there is probably an essay to be written on sampling and the recombinant dimensions of cultural memory. Many authors (e.g., Dimitriadis 2001; Ramsey 2003; Rose 1994) have noted that hip-hop musi-cians, for instance, use sampling to index a particular moment, period, feeling or ideal by quoting other music. This point is already taken as gospel (and therefore is not worth another essay). But recombinant music-making goes even a step further than that—many DJs and mix artists purposely choose obscure music that their audiences *won't* remem-ber (and for which they are less likely to be sued). But all recorded music bears a tim-bral imprint of its place and moment, partly because of the room, techniques, and technology used to make the recording and partly because of the cultural sensibility from which the recording emanates. All recordings have a *sound* to them—and this sonic part of the sample, even if listeners don't know the exact recording, may be powerfully evoca-tive. One could imagine that a study of such a phenomenon might wind up arguing that this ability to index a moment or "feeling" might well be one of the most powerful affec-tive dimensions of recombinant music.

Although recombinant music seems to have built a giant edifice on top of the cul-tural archive of recorded music, there is an important way in which it dishonors that archive as much as it honors it. Recombinant music, at least the process through which it is created, elides the difference between ambient (a more accurate term than "live" in this particular case) sound and recorded sound. Since many digital devices and programs are able to record as well as reorganize sounds, musicians can use them to mix-and-match elements from the ambient environment and found recordings to create new or musi-cal sonic textures. In a certain sense, then, it doesn't matter if it's "live" or "recorded" because recombinant musicians do not—in this one sense—discriminate. Again, one could imagine the historian's objection. This practice goes at least as far back as multi-track recording. In the 1940s and 1950s, Les Paul played along with himself first on acetate recordings and later on audio tape. Though as Albin Zak has perceptively point-ed out, multitrack recording did not catch on until the second half of the 1960s (Zak 2001, 14–17). Once again, it is not the technology per se but practice that we are after. Digital technology is clearly a significant component: anyone who has used the new loop-based software must concede that it is a qualitatively new instrument for music-making. But as an instrument, it is no more or less central than any other musical instrument. Is the dig-

ital sampler or loop-based software a more important or fundamental innovation than the electric guitar or analog synthesizer? This seems to be a comparative-historical question, and one that requires us to move outside the narrow realm of the digital in order to truly understand both the agency of digital technology, and the larger system of power within which it operates.

The Digital (Home) Studio

In a manner homologous to the ways in which commentators have credited samplers and other digital tools for the rise of recombinant music, the rise of the "home studio" and the explosion of small, niche-based "project" recording studios has been widely attributed to the development of cheaper, digital versions of analog audio devices. Paul Theberge has written eloquently on the rise of the MIDI-based synthesizer home studio. At the end of his book, he notes the explosion of home- and mobile-recording with a modular multitrack digital-tape system called the ADAT, manufactured by the Alesis corporation (Theberge 1997, 248–51). ADATs were released in 1992, and by the late 1990s they were ubiquitous, both in professional recording studios and in smaller home or project studios. The device is an eight-track recorder (it can record sound from eight separate microphones or sources at once, which can later be mixed) and it is modular, which means that you can buy three ADATs, hook them up to run together, and record 24 tracks at once, which was the standard analog "track count" in professional studios when the ADAT came out. At the time of its release, the ADAT was also comparatively cheap because it used analog-to-digital converters and recorded its digital data onto VHS tape (instead of the expensive 2" tape reels used by analog machines). As a result, the ADAT became the best-selling multitrack recorder ever within a few years of its introduction.

ADATs were also symbolic of the democratization of audio recording and changes in the audio industry. But the ADAT shared its distinction with a relatively inexpensive mixer manufactured by another audio company—Mackie. Mackie mixers were less noisy and of higher quality than other sub-$1,000 mixers, and they were a very common choice for ADAT-based studios because of their low price, high build quality, and portability. Like the ADAT, they did impart a certain sonic character to the music.[5] And like the ADAT, it was the best-selling mixer of all time.

So, here is an innovative digital device paired with an innovative analog device, both were often sold together, and both sold well. As they sold, they gained a certain symbolic currency. Despite a host of economic and cultural factors, the ADAT/Mackie combination came to symbolize the rise of amateur recording and a whole "semiprofessional" realm of small studios, often located in homes, or other less-than-optimal acoustic spaces. These new studios lacked the lavish acoustic design and esoteric equipment of their more professional counterparts, but they charged a lot less (or provided musicians with the facilities to make their own recordings) and they were a current in the maelstrom of musical releases that began in the mid-1990s. As Paul Theberge (1997) has put it, musicians have become consumers of technology to a degree hitherto unknown. And while more people than ever can record themselves, it is no easier than before to actually make a living in the music industry. And for some music professionals, like recording engineers, it became more difficult to make a living.

Because the ADAT and Mackie were iconic of this broader trend, they were often singled out for derision by professional engineers. At the 1997 convention of the Audio

Engineer's Society, a trade show for people in the recording end of the music industry, a controversial sculpture appeared on the convention floor. Entitled "Shit on a Stick," it featured an ADAT recorder and a Mackie mixer impaled on a four-foot metal spike. Sydney Fletcher (who simply goes by Fletcher), proprietor of Mercenary Audio and creator of the sculpture, said that his sculpture was "about the fact that they have been telling us that digital audio is great since 1980. But it doesn't sound great. They've been lying to us. Some day it's going to sound great, but not yet. It's the emperor's new clothes. Things like ADATs are good writing tools. But no more than that. They're writing tools disguised as being acceptable for pro-audio use and they're putting studios out of business. Most of the [records] I listen to [are] low budget; but the ADATs and the Mackies have taken away the incentive to make good-sounding low-budget records. They make them sound tinny. You can have great playing but the record has no soul because of the equipment" (Daley 1997). The sculpture almost got Fletcher kicked out of the show, and certainly offended employees of Alesis, the ADAT's manufacturer. (An apocryphal story has it that once he was shown the sculpture, a more good-humored Greg Mackie claimed that his company's mixer would still work if someone were to pull it off the spike and plug it in.)

Though the ADAT has since been eclipsed by hard-disc recorders,[6] and Mackie has released two updates to its mixer design, the sculpture is still a powerful icon. The story illustrates the degree to which people in the industry—and not just academics—believe in the magical power of the technology. But in Fletcher's striking sculpture, an analog and a digital device are impaled *together*, just as thousands of people had purchased them together. And as I've suggested above, the ADAT/Mackie combination did, in fact, index a larger assault on the cultural and economic supremacy of the professional audio engineer in the music industry even if the combo didn't exactly *cause* it.

Audio engineering has a mystique to it. As Louise Meintjes has pointed out, metaphors of "magic" and "wizardry" are often used in recording studio talk, and they function, in part, to mystify or explain the engineer's talent and the relatively esoteric equipment that populates most studios (Meintjes 2003, 93–98). This mystique went hand in hand with the professional engineer's economic supremacy—prior to the rise of the home studio, if you wanted to record something, you needed to rent time in a studio and hire a professional engineer.

But the home studio was not simply an effect of cheaper technology. It had been a desire and a lauded goal of musicians for decades. Trevor Pinch and Frank Trocco report the ambitions of early Moog synthesizer owners in the 1960s and 1970s to create completely mobile or home-based recording studios (Pinch and Trocco 2002). Rock stars who were lucky enough to have the money and big enough homes, could routinely set up their own studios. The Rolling Stones, famously, had a studio on a truck that allowed rock musicians to record in nontraditional spaces. Home recording was also a frequent selling point of cylinder phonographs in the 1890s and the first two decades of the 20th century, and analog tape machines in the middle of the century.

In fact, to truly understand the significance of home recording, we would have to do a broader study of the changes in the cultural status of the middle-class home since the 1960s. Although the "home" in "home studio" is not exactly the "home" in "home office," both terms point to paired trends: 1) the explosion of consumer electronics for domestic use (fax machines and copiers, or cassette-based multitrack recorders and cheap microphones) that digital-equipment industries could pick up on, develop, and

exploit, and 2) the effectiveness of what Alice Crawford (2003) has called the e-topian fantasy of the totally enclosed middle-class home that can function as work space, private space, play space, and as a replacement for public space. This extended functionality of the home, which critics of architecture and urban design have noted for some time now (Colomina 1992; Jacobs 1961; Rowe 1991; Spain 1992), and these new appropriations of domesticity are an important ground for the figure of the home studio.[7]

We would also have to consider understandings of what it means to make your own music. Two towering trends in 20th-century music are especially worthy of consideration here: 1) the move from orchestras and "big bands" to ever-smaller groups of musicians in a wide range of popular music, and 2) the increasing centrality of recording to people's musical experience. An operation like a home studio presupposes both of these phenomena: it would be impossible to record an orchestra or big band in most private homes. The home or project studio is designed to accommodate a smaller band or even the lone singer-songwriter or artist and producer, depending on your chosen genre. Couple this to the idea that bands primarily exist through their recordings (since this is how most people experience most of the music they hear) and the drive to record one's own music becomes nothing more than an extension of the desire to pick up an instrument and make music in the first place. Many of the music genres of the second half of the 20th century are by and large *studio* genres, as critics of rock and rap have pointed out (Dimitriadis 2001; Gracyk 1996; Rose 1994; Zak 2001).

Another key factor is so obvious as to miss: the economic boom of the 1990s led to a great deal of disposable income for the upper echelons of the middle class and the upper class. Even *relatively* inexpensive studio equipment was still objectively expensive when compared with other consumer electronics. A 16-channel Mackie cost about $1,000 and an ADAT cost more than $2,000, and prices went up from there. Expensive studio toys were a new form of conspicuous consumption. One can simply do a search of the archives of Rec.Audio.Pro, read back issues of *Electronic Musician* or countless other magazines to see the degree of gear connoisseurship that developed as disposable income became available. Indeed, months can go by without a single negative equipment review in the glossy audio magazines. On Internet user groups, this is taken to the extreme, where people will recommend brands and models of sound-processing equipment that they've never actually heard, based on reputation alone. These are not professional audio engineers, who through years of experience have learned to detect subtle differences among specialized devices; these are people who wish to demonstrate their consumer knowledge to peers. One can hear echoes of Thorstein Veblen's "man of leisure" in the sniping gear-snobs of Internet audio groups: "In the process of gradual amelioration which takes place in the articles of his consumption, the motive principle and the proximate aim of innovation is no doubt the higher efficiency of the improved and more elaborate products for personal comfort and well-being [or good recording, in this case]. But that does not remain the sole purpose of their consumption. The canon of reputability is at hand and seizes upon such innovations as are, according to its standard, fit to survive. Since the consumption of these more excellent goods is an evidence of wealth, it becomes more honorific; and conversely, the failure to consume in due quantity and quality becomes a mark of inferiority and demerit" (Veblen [1899] 1953, 60). If the professionals had a legitimate gripe about a dwindling economic base (even if they misguidedly attacked the equipment rather than less-tangible but more-significant economic and cultural issues), the amateur connoisseur has no reason at all to disdain the ADATs and Mackies of the world, other

than to distinguish his (and only very occasionally her) self from the thousands of other amateur recordists.

Audio manufacturers also, of course, benefited from the explosion of disposable income. But even more, they benefited from a shift in the logic of audio-equipment replacement. Inasmuch as the forced obsolescence cycle for digital equipment of all types is much faster than that for analog, audio-equipment manufacturers have a much more robust revenue stream. Consider that the expected durability of most analog audio devices is on the order of decades, *at the very least*. And some instruments can last half-centuries or longer. Over the past ten years, audio manufacturers have managed to accustom musicians and engineers to replacement cycles on the order of years and occasionally months, rather than decades. If we are looking for a digital revolution, here it is. But it is not the digital character of the gear, but rather the culture of design and marketing that is revolutionary, insofar as it helps to constitute new social and economic relations. To borrow again from Theberge, musicians are now often in the position of *managing* their relationships to technology. While this means more creative control in the studio, it also makes music a more expensive hobby. And it can lead people (including me, to my embarrassment, on some occasions) to believe that an equipment purchase might shore up some deficiency in the recording or song when more practice might do just as well.

There is, of course, much more to be said about digital recording. Computers are now ubiquitous in professional and amateur studios, as are various kinds of hard-disc–based recording systems. While digital audio tape allows for numerical storage, which was one of its primary advantages over analog tape (along with cheapness), hard-disc recording allows for much easier access to the kinds of transcoding that people think of when they think of digital recording: cut-and-paste–style random-access editing, automatic pitch correction, wild transposition and filtering effects, and all manner of spatial and psychoacoustic processing. Does hard-disc recording better fit the impact story for digital recording than digital audio tape? Again, I would argue that its significance is primarily organological—as an instrument in music-making. And it is bound up with other phenomena.

Let's take perceived loudness of recordings, for instance. Put two different CDs into a stereo, leave all the other settings the same, play one and then the other and you may find that they are of a different overall volume. Or that the quiet parts are of a different volume but the loud parts are about the same. Dynamic range—the range of volumes between different beats, notes, and passages—is a central aspect of musical perception. But more recent recordings, especially in rock, pop, and hip hop have had less and less dynamic range. In other words, the quieter sounds are almost as loud as the louder sounds.

The explanation is a little technical, but please be patient with me. Before a recording is commercially released, it is "mastered." One thing a mastering engineer does is set the overall level of the recording. In digital audio, the highest possible level is 0db (db is short for decibel), with the lowest possible level being approximately–96db for a 16-bit recording (which is the CD standard). What this means in practice is that 0db is the loudest that your playback system will get at a certain volume. So, if your volume knob is set to "2," a sound at 0db would be as loud as your system could put out at "2." If you turn your stereo up to "3," a sound at 0db will sound louder, since 0db is now as loud as your system could put out at "3." So 0db—the upper limit of a CD's volume—is always relative to the maximum volume that your system will put out at a given setting. Historically, recorded music has had a fair amount of dynamic range. So if you listened

to an old recording on a record player, it might vary between 0db (at its very loudest passages) and, hypothetically,–12db at its very quietest passages. Modern, digitally mastered albums sometimes go very little below 0db for entire songs. This is because it is well known that all other things being equal, people tend to think something that is louder sounds better.

With digital mastering software and equipment, it has been possible to limit music to an unprecedented extent, but the reason for this "loudness" competition has very little to do with the fact that it's made possible by the technology. After all, it's also possible to have a 96db dynamic range with digital audio (assuming that the analog recording equipment and transducers are of high-enough quality to reproduce such a range), yet we don't get ever-quieter recordings. In fact, I don't know of a commercial recording that's used half that dynamic range.

Rather, there are two important forces at work. One is competition among songs on radio stations. The idea is that if a song playing on the radio is just a little louder than the song on the previous station, listeners will be more likely to tune in. The other force at work is competition among albums and songs. This was, in fact, possible to accomplish before digital mastering: most radio stations have very powerful limiters designed to "limit" dynamic range. In fact, some are set at such extreme levels that the "louder" parts of songs will actually sound quieter than the "quieter" parts of songs. You can hear this on many classic rock stations, for instance, when there is a song with a quieter electric or acoustic guitar on the verse and loud, distorted guitars on the chorus. This competitive mentality has now been extended to musicians and record executives, who don't want their CDs to be the quietest one on the CD changer.

But in radio stations' defense, it's not just a matter of competition for audience attention, it is also a matter of following FCC regulation. FCC regulations of signal strength and bandwidth are extremely stringent for radio stations, and so, in order to comply with the terms of their licenses, most stations *must* use some kind of limiting to insure that they broadcast a consistent signal out into the electromagnetic spectrum and on to our receivers. So, in the case of loudness, we have a broad cultural sensibility that is better enabled by digital technology, but that was fueled by the economic relationships between radio stations, their attention to habits of listening (listeners scanning the dial for a good song), a side effect of FCC regulation, and musicians' internalization of that aesthetic sensibility. And we haven't even discussed the degree to which the *sound* of compression and limiting has become an important part of 20th-century musical aesthetics. To offer but one example, compression has more or less defined the sound of recorded rock music (Zak 2001).

The Future of Digital Music Studies

In the examples above, it is impossible to tease out the precise "digital" dimensions of a musical practice, or even a technological system. To answer the question posed in my title: there's not much that's digital in digital music. Even in the *most* digital situations—where the music is completely composed and recorded on computers, reproduced electronically, and published on the Internet—most of the actual musical event still happens as sound in the nondigital parts of the social world. There may be a few select cases in the analysis of a digital technology that explains a practice, but in many more cases, the digital is one factor in a long line of other practical considerations.

In this paper, I have tried to focus on situations where people have argued for the clear

and compelling impact of digital technology on music-making. But as we move away from those examples, it becomes even more difficult to conceive of digital technology as having an impact all its own. To take a diminutive example, consider the new phenomenon of the mobile, hard-disc–based mp3 player (Creative Labs' Rio and Apple's iPod are the two best-known examples). Here is a digital device that is, functionally speaking, not very different from any other kind of portable, personal stereo (e.g., a Sony Walkman). And as Michael Bull (2000) has shown, understanding the personal stereo is really a matter of understanding listening and experience in urban life. Does it make a difference that people are listening to mp3s instead of tapes or CDs? The one obvious difference is the storage capacity of mp3 players; it is now possible to carry a whole music collection around with oneself, instead of just a few selections. But does this really change anything? That is, ultimately, an ethnographic question, and it would have to be posed in the context of the intertwined histories of portable music listening and the maintenance and transportation of music collections. If that weren't enough, we might well have to move outside the specific realm of musical practice to the larger culture of data storage and movement, and the burgeoning cult of consumer electronics as one of the new frontiers of consumerism.

The question of digital music itself poses further difficulties for media scholars because, strictly speaking, digital music isn't a medium. Music isn't a medium, but rather a phenomenon that occurs in many media. I've said little about television and film, for instance, much less video games, advertisements, telephones and radios. There's certainly a musical and a digital dimension to all those media, and the stories of how those vectors intersect have yet to be written. And even they will be plagued by the difficulty of defining "the digital." As Tim Taylor, Trevor Pinch, and Frank Trocco all point out, orchestras have largely been replaced by synthesizers on TV program and advertisement soundtracks (Pinch and Trocco 2002; Taylor 2001). But those were analog synthesizers. The role of the shift to digital music-making in the sound and feel of contemporary television and film is an essay or a book that has yet to be written.

Like the transducer before it, the fact of analog-to-digital-to-analog conversion of sound has a history, and carries with it a truckload of cultural baggage, but that "digital baggage" truck must be understood in the much larger traffic of culture and practice. This might sound like a grim or slim view of digital technology. But I think scholars of digital music should rejoice at this state of affairs. It means that we have the opportunity, once again, to ask some fundamental questions about creativity and culture, technology and humanity, power, effect, and meaning. By eschewing an exceptionalist stance, where we treat the digital as a revolutionary or prima facie determining factor, and instead consider it in the vast traffic of practices, we will be able to better understand the role and meaning of digital technologies. This is because we will be able to see them as they really are: bound up with countless other technologies, people, natural forces, and institutions in vast networks, to borrow a term from Bruno Latour (1993).

But if I am going to end with the French, I'd prefer Pierre Bourdieu and his collaborators (Bourdieu, Chamboredon, and Passeron 1991; Bourdieu and Wacquant 1993; see also Sterne 2003b), who say that the most important moment in social research is the "construction of the object," the moment when the researcher decides which questions he or she is going to ask. Our challenge as scholars of digital technology is ultimately to reformulate our questions to approach digital technology from its many exteriors. In this essay, I have offered some possible avenues for doing that, but the point is not to follow

my lead. Rather it is to use your own imagination. Leave aside the advertising hype, the "new amazing products" and the black boxes that are supposed to change our lives. Scholars, ask not what digital technology can do for you! Instead, approach it anew each time, and ask after the world of which it is and must be a part.

NOTES

1. The author would like to thank Carrie Rentschler for her reading of an earlier draft of this essay.

2. On the history and significance of transducers, see Sterne 2003a, 31–85.

3. Observers familiar with the workings of recently manufactured synthesizers will note that most synthesizers are, at this point, essentially samplers because they build sounds from sampled waveforms. But the distinction between synthesis and sampling still has heuristic value because it indexes different sets of musical practices, so I will live with it for now.

4. The most basic elements of sound reproduction technologies have a long history over the 18th and 19th centuries in a wide range of sonic and social practices. And by understanding those earlier histories (I do not think they are "prehistories," even though recording was not officially invented until 1877), we can better understand the genesis, roots, and meanings of practices that appear to "belong" to sound recording and its cousins when they finally are "invented" (in the narrow sense of the term). Sound—and sound reproduction—have a history that cannot be contained in a single lineage of devices.

5. Though in my own casual listening, I think the significance of the "sound" of ADATs and Mackies is overstated in the industry. Much more important is quality of the music recorded and the talent of the engineer.

6. In new sales only. ADATs are still in use all over the world.

7. There is a vexed gender component here as well, since domesticity has traditionally been coded as feminine, while office work (apart from secretarial activity) and audio recording have, in many cases, appeared as stereotypically more "male" pursuits. As Crawford (2003) points out, the e-topian fantasy of the wired home is often a specifically male fantasy. But at the realm of changing practice, and given the number of women in the workforce, I think it also speaks to the changing gender dynamics of the professional world.

REFERENCES

Beck, U. 1994. *Risk society*, translated by M. Ritter. Newbury Park: Sage.

Beck, U., A. Giddens, and S. Lash, (eds.). 1995. *Reflexive modernization: Politics, tradition and aesthetics in the modern social order*. Stanford: Stanford University Press.

Benjamin, W. 1968. *Illuminations*, translated by H. Zohn. New York: Schocken.

Bijker, W. 1995. *Of bicycle, bakelites, and bulbs: Toward a theory of sociotechnical change*. Cambridge: MIT Press.

Bijker, W., T. Hughes, and T. Pinch, (eds.). 1987. *The social construction of technological systems*. Cambridge: MIT Press.

Bourdieu, P. 1991. *Language and symbolic power*, translated by G. Raymond and M. Adamson. Cambridge: Harvard University Press.

Bourdieu, P., J.-C. Chamboredon, and J.-C. Passeron. 1991. *The craft of sociology: Epistemological preliminaries*, translated by R. Nice. New York: Walter de Gruyter.

Bourdieu, P., and L. J. D. Wacquant. 1993. *An invitation to reflexive sociology*. Chicago: University of Chicago Press.

Bull, M. 2000. *Sounding out the city: Personal stereos and everyday life*. New York: NYU Press.

Collins, H., and T. Pinch. 1998. *The Golem at large: What everyone should know about technology*. New York: Cambridge University Press.

Colomina, B., (ed.). 1992. *Sexuality and space*. New York: Princeton University Press.

Crawford, A. 2003. *The city in the future perfect: Information technology, utopianism, and urban Life*. Unpublished Ph.D. Dissertation, University of Pittsburgh: Pennsylvania.

Daley, D. 1997. *I don't know much about art, but I know what I like*. http://www.mercenary.com/idonknow-muca.html (accessed August 20, 2003).

Dimitriadis, G. 2001. *Performing identity/performing culture: Hip hop as text, pedagogy, and lived practice*. New York: Peter Lang.

Ellul, J. 1964. *The technological society*, translated by J. Wilkinson. New York: Vintage.

Gracyk, T. 1996. *Rhythm and noise: An aesthetics of rock*. Durham: Duke University Press.

Hay, J. 1989. Advertising as a cultural text (Rethinking message analysis in a recombinant culture). In *Rethinking communication*, edited by B. Dervin. London: Sage.

Heidegger, M. 1977. *The question concerning technology and other essays*, translated by W. Lovitt. New York: Harper and Row.

Ihde, D. 1993. *Philosophy of technology: An introduction*. New York: Paragon.

Illich, I. 1973. *Tools for conviviality*. New York: Harper and Row.

Jacobs, J. 1961. *The death and life of great American cities*. New York: Vintage.

Kahn, D. 1999. *Noise, water, meat: A history of sound in the arts*. Cambridge: MIT Press.

Korg. 2003. Macro/Macro. *Electronic Musician*, 19 September, 67.

Latour, B. 1993. *We have never been modern*, translated by C. Porter. Cambridge: Harvard University Press.

Manovich, L. 2001. *The language of new media*. Cambridge: MIT Press.

Manuel, P. 1993. *Cassette culture: Music and technology in North India*. Chicago: University of Chicago Press.

Meintjes, L. 2003. *Sound of Africa!: Making music Zulu in a South African studio*. Durham: Duke University Press.

Mumford, L. 1934. *Technics and civilization*. New York: Harcourt, Brace and Co.

Negativland. n.d. . *Shiny, aluminum, plastic and digital*. http://www.negativland.com/minidis.html (accessed August 20, 2003,)

Pinch, T., and F. Trocco. 2002. *Analog days: The invention and impact of the Moog Synthesizer*. Cambridge: Harvard University Press.

Ramsey, G. 2003. *Race music: Black music from bebop to hip hop*. Berkeley: University of California Press.

Rose, T. 1994. *Black noise: Rap music and contemporary culture in Black America*. Hanover: Wesleyan University Press.

Rowe, P. 1991. *Making a middle landscape*. Cambridge: MIT Press.

Spain, D. 1992. *Gendered spaces*. Chapel Hill: University of North Carolina Press.

Sterne, J. 2003a. *The audible past: Cultural origins of sound reproduction*. Durham: Duke University Press.

———. 2003b. Bourdieu, technique and technology. *Cultural Studies* 17 (3/4):367–389.

Taylor, T. 2001. *Strange sounds: Music, technology and culture*. New York: Routledge.

Theberge, P. 1997. *Any sound you can imagine: Making music/consuming technology*. Hanover: Wesleyan University Press.

Veblen, T. [1899] 1953. *The theory of the leisure class*. New York: Viking Press.

Wallis, R., and K. Malm. 1984. *Big sounds from small peoples: The record industry in small countries*. New York: Pendragon.

Winner, L. 1986. *The whale and the reactor: A search for limits in the age of high technology*. Chicago: University of Chicago Press.

Zak, A. J. 2001. *The poetics of rock: Cutting tracks, making records*. Berkeley: University of California Press.

Mark J. Butler

"Everybody Needs a 303, Everybody Loves a Filter"

Electronic Dance Music and the Aesthetics of Obsolescence

Electronic dance music, or "EDM," is often portrayed as "future music," as a cutting-edge genre that draws upon the latest advances in technology. Yet the relationship between EDM culture and technology is in fact considerably more problematic. This ambivalence is especially evident within the sphere of musical creation. On the one hand, EDM DJs and producers welcome new technological windows into music-making; recent years have seen the widespread promulgation of digital-editing software as well as the emergence of Final Scratch, a tool that enables the mixing of mp3 files. On the other hand, much of the equipment used to make EDM is decidedly obsolete, low-tech, and prone to malfunction; in particular, analog devices such as the Roland TB-303 bass line generator and the TR-808 drum machine, manufactured during the early 1980s, continue to play important roles in contemporary EDM studios. Ultimately, this paradoxical interplay of high- and low-tech approaches to music-making is representative of a broader dialectic between the mechanical and the human that has characterized EDM culture since its inception.

Techno is a music based in experimentation;
It is sacred to no one race; it has no definitive sound.
It is music for the future of the human race.
Without this music there will be no peace, no love, no vision.
By simply communicating through sound,
Techno has brought people of all different nationalities
Together under one roof to enjoy themselves.
Isn't it obvious that music and dance
Are the keys to the universe?
So called primitive animals and tribal humans
Have known this for thousands of years!
We urge all brothers and sisters of the underground
To create and transmit their tones and frequencies
No matter how so called primitive their equipment may be
Transmit these tones and wreak havoc on the programmers!

—Underground Resistance[1]

Electronic dance music, or EDM, is often portrayed as "future music," as a cutting-edge genre that draws upon the latest advances in technology. These characterizations abound in both popular and academic descriptions. For instance, Michiko Kakutani, writing in the *New York Times*, describes techno as "the most visible part of a digital subculture" (Kakutani 1997, 14), while Jon Savage, in an essay in the *Manchester Guardian*, speaks of its "machine aesthetic" (Savage 1993, 2.8). In the journal *Youth Studies Australia*, Susan Hopkins argues that "whereas punk's battle cry was 'no future,' techno celebrates a future which has already arrived. . . . Rave participants are drawn to a synthetic environment of digital animation and digital music where excess is ordinary" (Hopkins 1996, 15). Douglas Rushkoff, author of the virtual-reality manifesto *Cyberia*, takes this characterization to its logical extreme, going so far as to describe a real person whom he met at a rave as a "toon" (Rushkoff 1995, 133). Similar portrayals originate within EDM culture as well, as exemplified by Underground Resistance's description of techno as "music for the future of the human race." Perhaps the best-known statement epitomizing this future-oriented view of the connection between EDM and technology comes from Juan Atkins, one of the founding figures of Detroit techno, who is quoted in an influential piece of early journalism on EDM as follows: "Berry Gordy built the Motown sound on the same principles as the conveyor belt system at Ford's. Today their plants don't work that way—they use robots and computers to make the cars. I'm probably more interested in Ford's robots than in Berry Gordy's music" (Cosgrove 1988, 89).

Yet the relationship between EDM culture and technology is in fact considerably more problematic. Ambivalence is especially evident within the sphere of musical creation. On the one hand, DJs and producers have traditionally welcomed new technological windows into music-making; innovations such as the variable speed turntable and the digital sampler have had major impacts on the development of electronic dance music. On the other hand, much of the equipment used to make EDM is decidedly obsolete, low-tech, and prone to malfunction; in particular, analog technologies developed during the 1970s and early 1980s remain central within many contemporary electronic dance-music studios. This paper will explore this paradox, arguing that this interplay of high- and low-tech approaches to musical creation is representative of a broader dialectic between the mechanical and the human that has characterized EDM culture since its inception.

Although the most distinctive characteristic of EDM production is the pervasive use of electronic technologies, live performance remains essential to this repertory, and it is in this domain that EDM's most visible analog holdouts—the turntable and the twelve-inch vinyl record—can be found. Interacting in real time with a dancing audience, DJs use two or more turntables, along with headphones and a mixing board, to combine and manipulate different parts of records into new compositions that differ substantially from their source materials.[2] These technologies support an aesthetic of continuity in which there is never any silence between records, but instead records are overlaid, or "mixed," in a variety of ways. Most commonly, DJs overlap the end of one record with the beginning of the next. They also maintain a constant tempo from one record to the next through a process called "beat matching." To match the beats of record B with those of record A, the DJ listens through headphones to record B (or to the combination of A and B), while at the same time setting up the mixing board so that the audience only hears A. She then uses a slider to modify the tempo of record B so that the two records are moving at exactly the same speed. Once a common tempo is attained, she must also *synchronize* the beats, which she accomplishes by pushing the second record very slightly

forward or backward into alignment with the first. A third part of this process is the coordination of larger periodicities, such as four-beat measures and multimeasure patterns consisting of four, eight, or sixteen bars.

The virtuosity and precision involved in contemporary DJing have been facilitated in important ways by improvements in the construction and design of the turntable. The continuous tempo adjustment I have just described, for instance, is not possible on turntables intended for home listening, which play at speeds of either 33 or 45 rotations per minute. Most home turntables are also belt-driven, a method of control that affords less power and accuracy than the direct-drive motors found on DJ turntables. Yet these innovations are hardly recent; in fact, they began during the 1970s. In particular, they were codified in 1979 with the introduction of the Technics SL-1200, which remains the industry standard today. In the twenty-four years since the introduction of the SL-1200, however, the compact disc player and the mp3 file have almost completely superseded the turntable and the vinyl record in most musical domains. What are the reasons for the dogged persistence of these formats within the supposedly futuristic realm of electronic dance music?

While several answers to this question are possible, perhaps the most important factor is the hands-on nature of EDM DJing. DJs match beats and cue records by touching them directly with their hands, and advanced techniques such as scratching are even more dependent on manual interaction. In fact, it is only quite recently that audio companies have developed CD players that EDM DJs will actually use. These products, which include the Pioneer CDJ-1000 (introduced 2001) and the Technics SL-DZ1200 (introduced 2004), feature a flat, round interface that mimics the platter of an analog turntable, as well as a slider for adjusting the tempo. Although the CD enters through a slot on the front of the machine, the DJ can transform its sound in many different ways by physically manipulating the interface as if it were a record.[3] Another recent product, Final Scratch (released 2002), places old and new technologies in even starker opposition: it allows DJs to use analog turntables to mix digital files in formats such as mp3 and wav. Final Scratch works through software installed on a computer, which the DJ plugs into the mixing board, and specially adapted records (still made of vinyl), which the DJ uses to manipulate the files. The turntables and mixing board are standard; it is the software and records that allow the files to be manipulated.

These technologies respond to new forms of digital media by integrating them within the existing performance traditions of EDM—which, in spite of the increasing popularity of devices such as the CDJ-1000, continue to center around the analog turntable and the vinyl record. Analog equipment also pervades the studio technology with which this music is first created. In particular, vintage synthesizers and drum machines, created mostly during the 1980s, have been central to the genesis of EDM. At the forefront of this trend is a series of machines from Japan's Roland corporation—most notably, the TB-303 bass line generator and the TR-808 and 909 drum machines—which were manufactured in small, short-lived production runs during the early 1980s. Even at the time of their production, these machines were hardly cutting-edge. The 303 and the 808, for instance, predate MIDI, the "Musical Instrument Digital Interface." A digital drum machine, the Linn LM-1, had already been introduced in 1979. This machine, along with its successor the LinnDrum, were used much more widely in mainstream popular music due to their "realistic" drum sounds borrowed from samples of acoustic instruments. Furthermore, the first commercial digital synthesizer, the Yamaha DX-7, appeared

in 1983, leading, according to Samuel Pellman, "to the near extinction of analog synthesizers" (Pellman 1994, 264).

The analog species still thrives within electronic dance music, however; though only a few thousand 808s and 909s exist, they are constantly sold and resold on the second-hand market. As with the turntable, part of the continuing appeal of these antiquated technologies lies in their simple, hands-on interfaces. The layout of each drum machine, for instance, presents a direct physical correspondence with the rhythm of a 4/4 measure. A row of sixteen buttons runs along the bottom of each instrument. When the meter is defined as 4/4, each button represents a potential sixteenth-note attack. To create a rhythm, the producer selects a drum sound and then presses the button that corresponds to each attack's position in the measure. To program a bass-drum pattern consisting of four quarter notes per measure, for instance, one would choose the appropriate sound and press buttons 1, 5, 9, and 13. This rhythm will then repeat infinitely until "stop" is pressed.

In comparison to the essentially primitive equipment available at the time of the 909's creation, the technology available to the modern dance-music producer presents a wealth of possibilities. Computer programs such as Pro Tools, Sound Forge, and Logic offer powerful digital sound-processing capabilities at an affordable price, as well as "virtual" replicas of vintage synths and drum machines. Nevertheless, many producers continue to prefer simpler equipment that can be directly manipulated. For example, Adam Jay, a producer whom I interviewed as part of field research for my doctoral dissertation (Butler 2003), uses the Akai MPC-2000 as the centerpiece of his recording studio. This machine, released in 1997, has all the functions of a keyboard and a drum machine along with powerful sequencing and sampling capabilities. Due to its sixteen pads—the large buttons found on the bottom right of the machine—its interface is more intuitive than that of a computer, its main competition. Producers can use the pads, which are touch-sensitive to velocity and pressure, to play pitch and rhythm patterns in real time rather than programming them. For Adam Jay, this stripped-down studio approach fosters compositional freedom; in fact, he actually sold off much of his previous equipment when he chose to purchase the Akai:

> In terms of its interface, I've only got two knobs and a slider on here, whereas my Microwave XT had thirty-six knobs on it. And what are you gonna do with thirty-six knobs, when all that really matters is the notes you're putting into the back of it? . . . This helped me blossom as a songwriter, 'cause I got past the fascination with the fact that it was electronic sound generation and remembered that it's still music. Whereas before I had all these tools at my disposal, and it was up to me to be creative because the sky was the limit, I actually have a limit with this. It forces me to be creative. (Interview with the author, 22 March 2002)

In addition to relishing simple and often outdated machines, EDM producers have made a widespread practice of what might be called the "creative perversion" of technology (cf. Brewster and Broughton 2000, 315). They have frequently used machines in ways their makers never intended, and they have used them "incorrectly" in order to achieve surprising results. The most commonly cited example of this phenomenon is their use of the Roland TB-303 bass line generator. The TB-303 is an extremely basic analog synthesizer, designed specifically for the production of bass lines. It was marketed as a sort of portable accompanist: guitarists could use it in place of a live bassist when practicing or playing solo gigs. Produced in 1982, it was intended to be cheap and functional. The sound of a TB-303, however, does not resemble any bass guitar, either real or imaginary, and its interface is unreliable and difficult to use. The machine was never suc-

cessful in a rock context, and it was soon discontinued. Electronic dance musicians, however, were not concerned with reproducing the sound of "real" instruments. Entranced by the otherworldliness of its timbres, Chicago house musicians such as DJ Pierre used the 303's signal processing controls—the knobs running across the top of the machine—to modify parameters such as resonance and decay. The results, which sounded even *less* like a bass guitar, have been described with a variety of adjectives, some of the most common being "buzzy" and "squelchy."[4] Records that employed this sound became known as "acid tracks," and the overall style as "acid house." Acid house became hugely popular in England during the late 1980s, and the sounds of the 303 continue to pervade electronic dance music today. In fact, it is from one such contemporary 303-laden track that I derive the title of my paper: Fatboy Slim's "Everybody Needs a 303" (1997), subsequently released as a remix (also by Fatboy Slim) entitled "Everybody Loves a Filter."[5]

Another seemingly oxymoronic component of the 303's allure is its unpredictability: quite simply, it doesn't work very well, but its mistakes are viewed as surprising and interesting. This celebration of malfunction, a corollary to the creative perversion of technology, continues to be evident even when EDM producers use "cutting-edge" modern technology. In the late-90s trend known as glitch music, for instance, the "errors" associated with *digital* sound processing are taken as points of departure. Instead of eliminating phenomena such as distortion, aliasing, and clipping, glitch musicians deliberately incorporate them into musical compositions. One intriguing example of this phenomenon is the track "Maschine" by Esther Brinkmann,[6] which appears on *clicks_+_cuts 1*, a seminal compilation of glitch music released on the label Mille Plateaux in 2000. Soft distortion is audible throughout the entire track, along with periodic statements of the following phrase: "Ich will eine Maschine sein: Arme zu greifen, Beine zu gehen, kein Schmerz, kein Gedanke" ("I want to be a machine: arms to grasp, legs to walk, no pain, no thoughts"). In both musical and lyrical domains, therefore, this track thematizes the human/mechanical interplay that characterizes EDM more broadly. A second example, "Transfer" by Disc (a collaboration between producers Jay Lesser, Kid 606, and Matmos), is a record featuring 105 locked grooves, all of which include the sound of a CD skipping.[7] Released in 2000 on clear vinyl, "Transfer" is described on its record label's website as "an 'interactive' artifact that requires hands-on maintenance" (www.deluxerecs.com; cited 2 December 2004).

In light of these trends, it would seem that electronic dance music is hardly the digital utopia it has been made out to be. While EDM DJs and producers gladly avail themselves of new ways to make music, they do so within an aesthetic that cherishes obsolescence, simplicity, and technological error. While I have already suggested several practical reasons for the continuing endurance of this aesthetic—for example, the benefits offered by equipment that allows direct physical manipulation—I would like to speculate on the broader origins of EDM's relationship to technology as I conclude.

The ways in which modern electronic dance musicians interact with technology are part of a cultural tradition that dates back to the beginning of EDM. Two of the styles most central to the early development of electronic dance music, techno and house, began not in Europe but rather in two industrial cities in the American Midwest—namely, Detroit and Chicago, respectively. At the time of techno's genesis in the early 1980s, the legacy of industrialism had become particularly problematic for Detroit: the music industry, in the form of Motown, had left the city for L.A., while the auto industry—the core of the city's economy—had suffered disastrous financial downturns and begun to

relocate to the suburbs. While the city struggled to redefine its relationship to industry, techno musicians began to problematize the relationship between *music-making* and technology. Juan Atkins in particular was influenced by the writings of Alvin Toffler, who, in works such as *The Third Wave* (1980), prophesied a re-envisioning of the model of human-technological interaction set in place by the Industrial Revolution. The agents of this "third wave," whom Toffler called "the techno-rebels," were not opposed to technology, but they saw that it "need not be big, costly, or complex in order to be 'sophisticated'" (Toffler 1980, 152), a view that clearly resonates with EDM's mediation of the cutting-edge and the low-tech. At the same time, the optimism expressed by Detroit producers is often tempered with a note of wariness; Atkins, for instance, points out that "with technology, there's a lot of good things, but by the same token, it enables the powers that be to have more control" (Reynolds 1999, 19). Likewise, Underground Resistance exhort the "brothers and sisters of the underground" to "create and transmit their tones and frequencies," regardless of "how so called primitive their equipment may be"; in so doing, they will "wreak havoc on the programmers." These statements articulate a perspective in which technology is simply a fact of modern existence, and the music industry is no different than any other. By celebrating the errors of hi-tech machinery and deliberately provoking mechanical malfunction, musicians are able to recontextualize technological failure; their practices emphasize how we use technology rather than how it performs. According to Toffler (1980, 152), "the techno-rebels argue that either we control technology or it controls us." Through their constant exploration of the tension between these two possibilities, electronic dance musicians reveal a genre defined not so much by the machines with which it is made as by an ongoing commentary on the interaction of humans *with* these machines.

NOTES

1. Underground Resistance is a Detroit-based record label and collective of DJs and producers. This statement comes from a portion of their website entitled "Creed." See www.undergroundresistance.com (cited 21 June 2004).

2. See the "Online Resources" section at the end of the paper for links to further information about and photographs of all the electronic technologies described herein.

3. The dual CD players marketed toward club DJs prior to these innovations (e.g., the Citronic CD-1) are much more similar to home CD players: except for sliders allowing tempo adjustment, and in some cases small "jog wheels" enabling effects such as pitch bend, their primary method of control is through buttons. As a result, they do not offer the level of tactile control required by most EDM DJs and have not been able to compete with analog equipment.

4. Both terms are used in Shapiro 2000, 193. For instances of "squelch," see Sicko 1999, 104; Reynolds 1999, 32; and Brewster and Broughton 2000, 315.

5. Fatboy Slim's titles are in turn derived from the 1977 track "Everybody Needs Love" by soul singer Edwin Starr, a sample of which is featured in both mixes.

6. "Esther Brinkmann" is a recording name used by producer Thomas Brinkmann.

7. A "locked groove" is a pattern etched into a record in a way that allows it to repeat continuously. In performance, DJs use locked grooves as tools, combining them in a variety of ways with full-length tracks. Most locked grooves are quite short; on "Transfer," each lasts exactly 1.8 seconds and features a tempo of 133.33 beats per minute.

8. In addition to sources that are cited directly, this reference list includes other works pertinent to the topic that were consulted in preparing the article (Bradby 1993; Cummings 1994; Théberge 1997; Gilbert and Pearson 1999; Cascone 2000; Loubet 2000; Butler 2001; Taylor 2001).

PRINT REFERENCES[8]

Bradby, B. 1993. Sampling sexuality: Gender, technology, and the body in dance music. *Popular Music* 12 (2):155–76.

Brewster, B., and F. Broughton. 2000. *Last night a DJ saved my life: The history of the disc jockey.* New York: Grove Press.

Butler, M. J. 2001. Turning the beat around: Reinterpretation, metrical dissonance, and asymmetry in electronic dance music. *Music Theory Online* 7.6. Available from http://www.societymusictheory.org/mto/issues/mt0.01.7.6/toc.7.6.html.

———. 2003. Unlocking the groove: Rhythm, meter, and musical design in electronic dance music. Ph.D. diss., Indiana University.

Cascone, K. 2000. The aesthetics of failure: "Post-digital" tendencies in contemporary computer music. *Computer Music Journal* 24 (4):12–18.

Cosgrove, S. 1988. Seventh city techno. *The Face* 97:86–89.

Cummings, S. 1994. Welcome to the machine: The techno revolution comes to your town. *Rolling Stone* 679:15–17.

Gilbert, J., and E. Pearson. 1999. *Discographies: Dance music, culture, and the politics of sound.* New York: Routledge.

Hopkins, S. 1996. Synthetic ecstasy: The youth culture of techno music. *Youth Studies Australia* 15 (2):12–17.

Kakutani, M. 1997. Escape artists. *New York Times Magazine* 146(50845):14.

Loubet, E. 2000. Laptop performers, compact disc designers, and no-beat techno artists in Japan: Music from nowhere. *Computer Music Journal* 24 (4):19–32.

Pellman, S. 1994. *An introduction to the creation of electroacoustic music.* Belmont, Cal.: Wadsworth Publishing.

Reynolds, S. 1999. *Generation ecstasy: Into the world of techno and rave culture.* New York: Routledge.

Rushkoff, D. 1995. *Cyberia: Life in the trenches of hyperspace.* New York: HarperCollins Publishers.

Savage, J. 1993. The Sound Warp. *The Guardian*, October 22, 1993.

Shapiro, P., ed. 2000. *Modulations: A history of electronic music: Throbbing words on sound.* New York: Distributed Art Publishers.

Sicko, D. 1999. *Techno rebels: The renegades of electronic funk.* New York: Billboard Books.

Taylor, T. 2001. *Strange sounds: Music, technology, and culture.* New York: Routledge.

Théberge, P. 1997. *Any sound you can imagine: Making music/consuming technology.* Hanover, N.H.: Wesleyan University Press.

Toffler, A. 1980. *The third wave.* New York: Morrow.

ONLINE RESOURCES

Turntables and other DJ equipment:

www.1200s.com

www.citronic.com

www.panasonic.com/consumer_electronics/technics_dj/default.asp

www.pioneerprodj.com

Final Scratch:

www.finalscratch.com

Vintage synthesizers and drum machines; Akai MPC-2000:

www.synthmuseum.com

www.vintagesynth.org

www.tb-303.0rg

tr-808.com

Digital sound-production software:

www.apple.com/logic/

www.digidesign.com

mediasoftware.sonypictures.com

EDM musicians:

www.deluxerecs.com

www.undergroundresistance.com

DISCOGRAPHY

Disc. 2000. *Transfer* [twelve-inch vinyl]. Deluxe Records 0061p.

Esther Brinkmann. 2000. "Maschine." On *clicks_+_cuts 1* [compilation]. Mille Plateaux Records MP 79.

Fatboy Slim. 1997. "Everybody Loves a Filter." On *Everybody Needs a 303* [CD-single]. Skint Records 31xcd.

The Electronic Word

Paul Levinson

The Hazards of Always Being in Touch

A Walk on the Dark Side with the Cell Phone

Marshall McLuhan observed in an age prior to cell phones that the only place we could be alone—beyond reach of callers—was in our automobile. Now we are in reach everywhere, all the time. This essay explores some of the drawbacks of this development, including: the need to make excuses or lie about why we do not answer our cellphone, why the ringing phone is irresistible, how cameras in cellphones threaten unprecedented invasions of our privacy, and why "texting" can be a social kind of cheating. Nothwithstanding all of the above, however, this essay concludes with an explanation of what we can do to control these hazards and reap the substantial benefits of cellphonic life. While not a ringing endorsement, it puts the cellphone in the perspective of a media evolution towards imperfect but increasing satisfaction of human needs.

Back in ancient 1976, Marshall McLuhan observed that the automobile was the last place a North American could easily go to be alone. He was referring, of course, to the driver as the sole occupant of a car, and what he had in mind was that there was no way to be alone in a home with a telephone. Once upon a time, the home was truly a castle in terms of protection from unwanted access: the only information that got inside the home was what you brought through the front door. But the telephone changed that, and allowed voices of the world-at-large inside your home, every time the phone rang and you answered. Moreover, unlike the later media of radio and television, whose voices had no idea whether you were home when they entered, the telephone caller knew you were there as soon as you answered. The telephone thus obliged you not only to listen but respond.

With the home thus colonized by the outside world, the outside ironically became more private. Sometimes you went outside simply because you did not want to be reached. Car phones began changing that in the 1980s. The informational sanctity of the automobile cited by McLuhan barely survived his death. And now, thanks to the cellphone, that sanctity survives nowhere.

The Golden Age of the Little White Lie

What can you do when you do not want to be reached? The people who have your cellphone number can be limited, but if even one person has your number, sooner or later there will be a specific occasion when you will not be in the mood for a conversation with that person. You can adopt means of evasion. You hear your cellphone ring, but later claim that you did not hear it—that you were in a "pocket" in which service was spotty. You can say your cellphone was accidentally off, when it really was on. In other words, in addition to all of its benefits, the cellphone may have ushered in a golden age of deception about its use.

Teenagers are among the most affected by this double-edged sword. In the old days of only landline phones in the home, parents tried to restrict their kids from talking on the phone, because it could interfere with dinner or homework. Kids were not too thrilled about talking in front of their parents anyway, and thus at first welcomed the cell phone as a great means of talking to their friends in places that were out of parental earshot. That remains true, but kids—and parents—soon learned that the cell phone admirably served another purpose: keeping parents in touch with their kids, when the kids were out with their friends or for whatever reason not home. Leaving home without a cell phone has become a cardinal sin. Deliberately shutting your cell phone off when you are out—and thereby shutting out your parents—is almost as bad.

Adults have discovered similar unwanted strings attached to the wireless revolution. In bygone years, to be out of the office was to be beyond business reach. Computers and e-mail in the home began to change that, but the cell phone has eliminated business-free space almost entirely. To give someone your cell phone number is to render yourself accessible to that person anytime, anywhere. And the advent of publicly available cell phone directories, likely in the next few years or sooner (see, for example, Sappenfield 2004), means that everyone will have your number. Calling this your "cell number" is more than a pun—it will be the number of your imprisonment in a world in which you are omni-reachable, with no easy escape.

What would be the escape routes? Well, anyone could decide not to have a cell phone. But with landlines likely to shrivel as cell service increases, such a decision could mean doing with no personal phone service at all. And social pressure is already mounting on everyone to be cellular—who of you reading this is getting by with no cell phone? The other, last drastic escape plans entail pretending you did not receive certain calls, and lying later to those who tried to call you.

In addition to whatever qualms we might feel about deceiving others—even for the good reason of protecting our informational sanctity—there is a more profound impediment to the strategy of letting our phone ring and doing nothing about it. Most of us have an irresistible urge to answer the phone.

The Irresistible Calling

The ring of the phone was always irresistible. In the home, it commanded attention above all else—not only dinners and conversation with family, but television (a rival medium) and even lovemaking could all be suspended or interrupted by a phone call (media theorists call the latter, "telephonus interruptus"). The telephone trumped all.

The ring of the cell phone in any public place commands the similar attention of everyone who hears it. At the instant a cell phone rings anywhere in your vicinity, you think, "it could be mine." Personalization of rings, with every phone having its own lit-

tle melody, should help (see Fernandez 2004). Further identification, with every caller having his or her own little ditty or series of tones, should help even more.

But even in such an instantly identifiable world—perhaps especially so—the unlabelled, ambiguous ring will rivet our attention. Precisely because the incoming ring is off of our programmed radar, it blares forth the possibility that it could be the most important call of our lives. It could be from the person of our dreams, be they business or personal. Take me, for example (that is, as a receiver of phone calls). In addition to writing scholarly books and articles, I write science fiction. An incoming call from an unknown party on my phone might be from Steven Spielberg—who has picked up one of my novels at an airport, and decided it would make a great next movie. (See, I told you I write fiction . . .)

Ambiguous calls may thus be the most demanding. But calls coming in from people we know can be demanding as well, if we want to hear from them. Indeed, the only kinds of calls that improvement of ring tones and caller-IDs will save us from are those from people with whom we would rather not converse. Bill collectors and in-laws, then, may lose some of their access to us, but we will nonetheless be totally on the hook for everyone else.

Still, the advent of personalized ring tones is surely a step in the right direction, a good example of an improvement of the cell phone that helps us cope, or enjoy the benefits of the cell phone while reducing its disadvantages. Unfortunately, some recent cell phone add-ons are having just the opposite effect.

Pan-Optic Phones

Being forever on-call for conversation is not the only way the cell phone is keeping us always in touch. The recent outfitting of cell phones with cameras is keeping us in touch—or keeping others always in touch with us—in a different way: we can be photographed any place we may happen to be.

This kind of pan-optic view is, on at least one account, far more of an incursion on our privacy than the irresistible ring. We, after all, have made a decision to carry a cell phone, which makes us reachable by someone else's. But we have made no decision to allow someone else with a camera-phone to photograph us, other than just happening to be in the place in which the camera-phone is pointed.

Our faces (and bodies, with whatever clothing we might be wearing) are, of course, always available for snapshot, surreptitious or otherwise, whenever we happen to be in public, or indeed out of our homes or private offices. But prior to cell phones with built-in cameras—and notwithstanding the proliferation of small, digital cameras—there were just not that many cameras around to take our picture. The cell phone is well on its way to being in every pocket or purse, in contrast to stand-alone—or, maybe, carry-alone is a better word—cameras, which on their own have showed no sign of attaining such ubiquity. From the rapidly proliferating camera-in-a-cell phone's point of view, it is almost as if the camera has captured the cell phone, hitched a ride on its omnipresence, and therein has smuggled itself in, right under our very noses, every place that we may walk and sit, work, play, and relax.

The worst kind of such incursions are "up-skirts"—photos of unsuspecting women on trains and benches and department stores—as well as photographs of people unclothed in locker rooms and restrooms (see Kageyama 2003 for an early report). They are available on Internet porn-sites, and, though some may have been posed, if even some are of

truly unknowing subjects they are perhaps the most outrageous violation of privacy at the hands of a new medium in history. (A search on the terms "up-skirts" and "photos" yielded some 569,000 hits on Yahoo in November 2004.)

"Up-skirt" and similar cell-photographs would be outrageous even if they were taken for the private enjoyment of the cell-photographer. But the ease of transferring, copying, and disseminating anything digital on the Web means this invasion of privacy is not only instantly, but, for all intents and purposes, infinitely viewable. If anyone is able to take a photograph of us that gets under, up, or through our clothes, and immediately make this available to millions, we might as well be walking around nude.

Although it is a little early to say that cell phones with camera attachments are turning the whole world into a nudist colony, it is certainly reasonable to enact laws against these practices. And for photographs that do not invade our privacy, whether we may want our face online or not? That may be the price we have to pay for the cell phone's turning every eye into a camera.

The Seduction of Silent Text

The cell phone reaches out to us in another way that goes beyond spoken conversation. Like all of the drawbacks of communication everywhere and anywhere, texting—conversation on the cell phone via snippets of writing—also has undeniable and, in this case, enormous benefits. To text is to talk silently, which means the texter disturbs no one in the vicinity. The restaurant patron, the colleague at a conference around a table, the student in a large auditorium—each can carry on a conversation free of initial rings and continuing voice. But texting also has a dark side.

The student texting in the auditorium, to take the most obvious example, cannot be hearing or comprehending much of what the teacher is saying. The texter at any business meeting is cheating his or her colleagues, who think, wrongly, that they have the texter's attention. But they do not. The texter, while sitting around the same table as everyone else in the meeting, is in psychological fact miles, or even continents away. The texter is where the text is.

Like the camera in the cell phone, texting was not the first use of the phone freed from wires, which, of course, was for good old-fashioned speech. But the camera in the phone performs at the extreme, outer limit of how the cell phone can invade our privacy—it is clearly a use of the cell phone that has nothing to do with what the cell phone is intrinsically about. It is, instead, in its worst examples, a perversion of the cell phone and its purposes. In contrast, texting in many ways epitomizes what the cell phone was always intended to do: allow us to converse whenever we want, which, in the case of texting, now includes conversing in such a way that no one around us need know we are conversing. And if this pulls us away from the people at hand, from the place we inhabit at that moment, it is no more than what a regular, verbal exchange on the cell phone does.

The only difference is that texting can do this privately, secretly, in public.

There is an old Yiddish saying: "With one *tuchas* [backside], you can't dance at two weddings." The same is true of the cell phone. With one cell phone, you can't be in two places. Not really. Not fully. You can pretend to be, but it's mostly illusion. If you're talking verbally, you at least can be looking at one place, maybe even smiling or frowning or gesturing there, and talking in the other. But when you're texting, you're just a shell in the place you're not texting to. You're breathing there, you're existing there, but your mind is elsewhere. We might say that texting literally makes us absent-minded.

Bright Spots

The formidable drawbacks of always being in touch should not blind us to its impressive benefits. Texting may be socially disruptive to in-person events, but it connects us to others, and in a manner that may be heralding a renaissance of text, or the rescue of writing as a cool, popular, beloved mode of interpersonal communication.

And the cell phone shines through its clouds in other ways. We may be pulled out of a sunny afternoon on Fifth Avenue for a dark, depressing conversation we would rather not have, but there was a time, not that long ago, when we would have been obliged to have that same unwanted conversation in a dingy office with flickering fluorescent lights.

Portable media in general, and the cell phone in particular, have liberated us from a 20th century in which most long-distance communication required us to be stuck in a place, usually indoors. Jacques Ellul (1954/1964, 321) captured this predicament in a vivid passage written about halfway through the last century:

> Man was made to do his daily work with his muscles; but see him now like a fly on flypaper, seated for eight hours, motionless behind a desk. . . . The human being was made to breathe the good air of nature. . . . He was created for a living environment, but he dwells in a lunar world of asphalt, glass, cast iron, and steel. . . . Man was created to have room to move about in, to gaze into far distances. . . . See him now, enclosed by the rules and architectural necessities.

Ellul's bleak depiction was already being partially exploded as he wrote it, by transistor radios that allowed people to hear music and news on mountain trails and sandy beaches—or away from the "architectural necessities" of urban life and business. Indeed, the transistor, invented in 1948, was beginning to humanize cities themselves, by giving their denizens music of their choosing on streets and park benches. The transistor was tiny compared to the vacuum tube that radio had previously required. And as the twentieth century progressed, the replacement of transistors with thumbnail and smaller microchips sped this process along. Today, Palm Pilots and cell phones permit people to work and "gaze into far distances" at the same time. The phone booth, which rarely smelled sweet, has given way to the cell phone, which allows us to breathe "the good air of nature" when talking on the phone almost anytime we please. We have broken free of the flypaper. And this happened because, unlike the hapless fly, we can think our way out of problems—of our own creation or otherwise—and devise remedial media to take care of them. (Of course, remedial media, while reducing or removing some problems, may create new ones, which require remedies of their own. The camera-phone, discussed above, is a particularly vexing example. For more on remedial media, see Levinson 1988, 1997, and 2004.)

To what extent, then, have we only traded in the flypaper, severed the wires that bound us to rooms, for just a different kind of leash—an invisible leash that keeps us connected to people whether we like it or not? That is the ultimate question regarding the cell phone, the question we have been examining in this essay.

Its answer resides in choices.

Evolution and Options

The evolution of media—that is, the humanly directed evolution of media—has always been about increasing our choices in communication. We invented writing, and with it, the option of whether to speak our thoughts, or commend them to some near or distant place, some close or far future, via incisions or markings. The printing press gave

the writer the choice of keeping the markings more or less private, or making them massively public. A writer with an idea for a fictional story has the option today of writing it for publication, or turning it into screenplay for a movie or television show.

Those kinds of choices are all about production. But they also are enjoyed by consumers. If I want to learn more about a news event, do I look at a newspaper, a Web page, or a television screen? And, if television, at a 24/7 all-news cable station, or at a network newscast? Or, maybe I want to rest my eyes altogether, and get my news instead from radio.

So, the invention and dissemination of media is about the growth of choices. This is beneficial, insofar as we can tailor our communication with increasing precision to our needs. But the growth of choices does carry a burden: the more options we have, the more we are required to consider which is the best option. A world in which there was only one way to communicate would require no decisions at all about how to communicate.

As in so many other crucial aspects of media and their evolution, the cell phone epitomizes both this increase in choices, and their burden. It has literally opened up areas of life to communication where previously we had the company of only our own thoughts—including that last little piece of private space in the automobile. And the integration of digital media, the funneling of previously diverse modes of communication into what was originally a speaking device—a little mouthpiece and earphone—that we carry in our pocket means that not only the occasions for communication have greatly increased, but so have what and how we communicate on these ubiquitous occasions. Not only photographs, video clips, and written words now populate cell phones. So does radio, music, television, and the cornucopia of content available on the Web.

Do such drastic increases in the occasions and contents of our communication entail burdens and hazards? Yes. And some of the remedies for these problems bring dangers of their own. Would we be better off, then, without the cell phone?

Only in the sense that we would be better off being an amoeba, which has no communication, no perception, at all, other than what it happens to blindly bump into in the little patch of water it inhabits. We humans have always done better pushing the envelope, reaping the benefits, identifying the hazards, and doing what we can to amend them.

REFERENCES

Ellul, J., 1954. *The technological society*, translated by J. Wilkinson, 1964. New York: Knopf.

Fernandez, D. 2004. Racy rings may lead to ring tone ratings. *Palm Beach Post*, November 19, 2004.

Kageyama, Yuri. 2003. Camera-equipped phones spread mischief. *Associated Press*, July 9, 2003.

Levinson, P. 1988. *Mind at large: Knowing in the technological age*. Greenwich, CT: JAI Press.

Levinson, P. 1997. *The soft edge: A natural history and future of the information revolution*. New York & London: Routledge.

Levinson, P. 2004. *Cell phone: The story of the world's most mobile medium, and how it has transformed everything!* New York: Palgrave/Macmillan.

McLuhan, M. 1976. Inside on the outside, or the spaced-out American. *Journal of Communication* 76 (4):46–53.

Sappenfield, M. 2004. In cellular future, will privacy ebb? *The Christian Science Monitor*, June 2, 2004.

Kwan Min Lee

Phenomenological Understanding of Social Responses to Synthesized Speech

Computer-synthesized speech may be defined as "doubly disembodied" language not only because of the absence of an actual speaker at the moment of its interpretation—first-level disembodiment—but also because of the broken association between its paralinguistic cues and its source (the speaker): second-level disembodiment. This chapter provides a phenomenological analysis of computer-synthesized speech. Heidegger's concepts of ready-to-handness and present-at-handness are explained and applied to the analysis of people's social responses to doubly disembodied language. This analysis leads to a discussion of design implications for Speech User Interfaces, and the chapter concludes with a typology of language in the digital age: actually embodied, disembodied, doubly disembodied, and artificially embodied.

In recent years, there has been increasing interest in and use of computer-synthesized speech. This is due to several factors. First, there has been growing demand for Speech User Interfaces (SUIs). SUIs are needed as an alternative/complement to Graphical User Interfaces (GUIs), because GUIs have several limitations (Shneiderman 1997). For example, GUIs are not appropriate for hands-occupied or eyes-occupied situations such as driving (Sawhney and Schmandt 1997). GUIs also cannot be effectively implemented on technologies such as telephones or PDAs, because of screen-size limitations (James 1998).

Second, for some people, it is hard or even impossible to use GUI-based systems. For example, about 11 million people have some form of visual impairment and about 1.5 million are totally blind in the United States alone (James 1998). Computer-synthesized speech provides a new opportunity for the disabled to use the power of the computer and the Internet. In addition, computer-synthesized speech also makes it easier for the illiterate and/or the pre-literate (e.g., children) to use computers.

Third, call centers (e.g., customer-service call centers of almost all the major companies in the world) and voice portals (e.g., Tellme, BeVocal) rely heavily on computer-

synthesized speech for presenting textual information on telecommunication devices. This is because it is almost impossible to record constantly changing information, such as traffic conditions, news, and weather, via real human voice.

Finally, interface designers are increasingly using computer-synthesized speech to develop more human-like interfaces. The basic assumption is that by incorporating anthropomorphic indicators such as speech, users will feel more comfortable with computers and perceive them to be more intelligent.

Despite the increasing use of computer-synthesized speech in computers and other information devices, little is understood about how people make sense of this clearly artificial voice. The general objective of this chapter is to explain how and why people respond to computer-synthesized speech. Before turning to this question, we need to understand what computer-synthesized speech is, how it is psycholinguistically different from other types of languages, and why it deserves special attention.

Synthesized Speech: Technology of TTS (Text-to-Speech)

Synthesized speech is simulated speech that is created by computers or other electronic systems, instead of by natural means such as the human voice. A system used for this purpose is termed a speech synthesizer, which is often called a TTS (text-to-speech) engine/system, in reference to its ability to convert written text into audible speech.

There are two major categories of speech synthesis technologies: concatenated synthesis (synthesis from stored data) and formant synthesis (synthesis by rules) (Olive 1997; Weinschenk and Barker 2000). Concatenated synthesizers use computer assembly of segments of recorded human voice sounds to create meaningful speech output. The segments of recorded human voice sounds can be phonemes, diphones, demi-syllables, syllables, words, phrases, or even full sentences. A phoneme is a single distinctive unit of sound that can distinguish words. A change of one phoneme in a word can produce another word. A diphone is a unit of acoustic data comprised of two phonemes recorded from the center point of one phoneme to the center point of the next phoneme. A demi-syllable is the half of a syllable, either from the beginning to the center or from the center to the end of a syllable (for more phonetical details, see Olive 1997; Weinschenk and Barker 2000). In comparison to formant synthesis, concatenated synthesis produces more natural sounding speech. However, concatenated synthesis is often impractical for many applications because of the large data-storage space needed for recorded segments (e.g., there are approximately 15,000 syllables in English and different sound versions of a syllable need to be recorded for smooth connections among them [Olive 1997]), the high computational power needed for speech assembly, and the need to constantly update myriads of new speech segments required for natural sounding speech (i.e., new words are constantly being added to the language). For this reason, concateanted synthesis works best for domain-specific areas with limited speech output, such as transit schedule announcements or weather reports (Wikipedia Encyclopedia 2004).

Formant synthesis technology produces synthesized speech using a rule-based accoustic model. Rather than assembling pre-recorded human speech, this system creates truly artificial voice by controlling basic speech parameters like pitch (tone of voice), pitch range (variation of pitch), amplitude (loudness), and speech rate (Wikipedia Encyclopedia 2004). For this reason, speech produced through formant synthesis sounds very robotic and can hardly be mistaken for a real human speech (e.g., Digital's DECTalk used by noted physicist Stephen Hawking).

Despite its poor naturalness, formant synthesis is the focus of most speech-synthesis research. There are three reasons. First, unlike concatenated synthesis, formant synthesis can produce limitless speech without restriction from the database of speech segments (Weinschenk and Barker 2000). Thus, it can be used in embedding or ubiquitous computing situations where memory space and processing power are often scarce. Second, thanks to its full control of basic speech parameters, a wide variety of emotions and tones of voices can be manipulated. When coupled with artificial intelligence (AI) and natural language understanding (NLU) technologies, formant synthesis technology can create highly compelling voice characters (Olive 1997). Finally, formant synthesis is more reliable than concatenated synthesis, because it requires less computing power (Wikipedia Encyclopedia 2004). The reliability of a system is very important especially when high-speed real-time speech output is required. For this reason, formant synthesis is the dominant technology for TTS systems where rapid transformation of written text into speech output is critical (Weinschenk and Barker 2000).

Two major criteria for evaluating speech-synthesis systems are intelligibility and naturalness of the resulting speech (Beutnagel et al. 1999; Kamm, Walker, and Rabiner 1997). In terms of intelligibility, most systems produce highly intelligible speech with relatively little variations (Beutnagel et al. 1999; Lai, Wood, and Considine 2000). In fact, word-intelligibility scores for the best TTS systems are close to 97%, which is very similar to real human speech (Kamm, Walker, and Rabiner 1997). In contrast to the high-intelligibility scores, the naturalness scores for even the best TTS systems are in the poor-to-fair range (Kamm, Walker, and Rabiner 1997). This is because they lack the quality and prosody of natural human speech.

There are several reasons for the poor naturalness of synthesized speech. First and foremost, without true AI and NLU, a speech-synthesis system cannot understand what it is reading (Kurzweil 1997; Olive 1997). Therefore, it cannot change its vocal parameters according to the emotion and tone of a text it is reading. Inconsistency of emotional states between linguistic cues (i.e., text) and paralinguistic cues (e.g., voice) often results in very unnatural speech output. Second, for the same reason discussed above, a speech system cannot effectively partition "thought units" in a sentence, which is critical for natural sounding speech. Without true understanding of the meaning of a sentence, a rule-based approach to segmenting thought units eventually fails. Third, non-alphabetic characters (e.g., Mr., Dr., St.), numbers (e.g., 234–7654, 78, 8320985), and the mix of them ($1.5 million) make it very hard for a system to pronounce them correctly (Olive 1997). For example, how should a system read "st."? "Saint," "street," or "es tee dot"? Should a system read "$1 million" as "dollar one million" or "one million dollars"? Finally, constantly added new words make it very hard to put the right stresses on them. For example, where should a system put a stress to the newly invented word "google"?

Despite the above difficulties in producing truly natural synthesized speech, various companies and universities have made much progress. Systems such as AT&T Natural Voices TTS Engine (http://www.research.att.com/projects/tts/demo.html), Microsoft TTS Systems (https://research.microsoft.com/speech/engtts/default.asp), and CSLU Toolkit (http://cslu.cse.ogi.edu/) produce high-quality synthesized speech in real time.

Synthesized Speech as Doubly Disembodied Language

Disembodied language is "language that is not being produced by an actual speaker at the moment it is being interpreted" (Clark 1999, 1). Many kinds of mediated com-

munication utilize disembodied language—newspaper, traffic signs, pre-recorded speech, radio, films, TV, computers, etc. Because disembodied languages are so abundant in everyday life and people almost automatically understand it with little difficulty, we tend to think that its interpretation is a trivial process that does not require further investigation. It is, however, clearly a remarkable process that only humans can handle (Clark 1999). The hidden mechanism of its interpretation, thus, deserves serious investigation.

Based on the situational and experiential representation model of discourse, Clark (1999) argues that *imagination* plays a key role in the interpretation of disembodied language. Through imagination, people visualize *virtual speakers*, who supposedly wrote or uttered linguistic contents at hand. Disembodied language, in this sense, is no more than a representation of embodied language produced by virtual speakers and is understood in the same way as we understand natural embodied language, such as face-to-face conversation. In the context of literary interpretation, Bleich (1981) also argues that readers instinctively invent a human source when language is phenomenologically present without its author.

There are two forms of disembodied language: written language and pre-recorded human speech[1] (Clark 1999). The two forms are clearly distinct not only because their modalities are different (visual vs. auditory), but also because they yield two psychologically different imagination mechanisms.

For written language, imagining of virtual speakers is based on an internal visualization process, which occurs when people read a text. If the writer is unknown to a reader, linguistic cues in the writing (e.g., content style, word choice, verb-adjective ratio, certainty vs. uncertainty [Scherer 1979]) become the basis of the imagining process.[2]

For pre-recorded speech, both paralinguistic (e.g., loudness, pitch, and speech rate) and linguistic cues of the speech affect the mental formation of a virtual speaker. Because the judgment of paralinguistic cues is evolutionarily hard-wired (Cooper and Aslin 1990; Fernald 1992), paralinguistic cues are judged immediately (Debus 1978) and become more salient and influential in the mental formation of the unknown speaker (Lee and Nass 2005; Nass and Lee 2001). For example, the consistent use of strong words and expression of self-confidence in a speech could serve as a cue to mentally picture the speaker as an extrovert person (Isbister and Nass 2000; Moon and Nass 1996), but the image of the speaker as an extrovert person would be more vivid if the speech contains certain paralinguistic cues, such as loudness, higher pitch, and fast speech rate, that are typical to extrovert people (Pittam 1994; Scherer 1979).

When a computer synthesizes a voice and produces disembodied speech from a given text, the speech becomes a special case of disembodied language because it is from a source that is clearly not human.[3] In this chapter, I call this special type of disembodied language *doubly disembodied language*. Computer-synthesized speech is *doubly* disembodied because of the absence of an actual speaker at the moment of its interpretation (first-degree disembodiment) and the broken association between its paralinguistic cues and its source, i.e., the speaker (second-degree disembodiment). The doubly disembodied nature of synthesized speech provides a more serious challenge to its interpretation than the disembodied language of pre-recorded human speech. That is, the ontologically problematic computer-synthesized speech—a voice from a non-human source—blurs the distinction between two forms of disembodied language.

From one viewpoint, linguistic cues in synthesized speech should be the sole basis for listeners' imagining of a virtual speaker because the voice is synthesized from a pre-

determined algorithm and has nothing to do with the source of the speech. In other words, the obviously synthetic nature of synthesized speech should make the paralinguistic aspects of speech irrelevant to listeners' imagining of virtual speakers.

From another viewpoint, however, paralinguistic cues in synthesized speech would be as equally influential and powerful as those in real human speech because human brains are not evolved to respond to synthesized speech any differently from real speech (see Nass and Gong 2000, for a review of the evolutionary nature of voice recognition; for a similar claim, see Reeves and Nass 1996). Consequently, paralinguistic cues in synthesized speech will also be influential in people's imagining of virtual speakers, even though they no longer bear a survival value and have nothing to do with actual speakers (writers) whose identification should be judged solely by linguistic cues.

This chapter provides a phenomenological understanding of human responses to doubly disembodied language. Throughout the chapter, I have assumed that spoken language is employed as a tool for people's everyday communicative acts. Based on that assumption, I applied Heidegger's concepts of "ready-to-handness" and "present-at-handness" and their relationships in people's everyday understanding of doubly disembodied language.

"Ready-to-Handness" and "Present-at-Handness"

According to Heidegger (1977; 1996), people encounter objects and properties either as ready-to-hand or as present-at-hand. Various examples (e.g., hammer, car wheel, pen, etc.) have been shown in order to explain and differentiate those two ways of existence. For example, Winograd and Flores (1986, 36) exemplify "hammering" by stating that:

> To the person doing the hammering, the hammer as such does not exist. It is a part of the background of *readiness-to-hand* [italics in original] that is taken for granted without explicit recognition or identification as an object. . . . The hammer presents itself as a hammer only when there is some kind of breakdown or *unreadiness-to-hand* [italics in original]—in other words, *present-at-handness* [inserted by the current author]. Its "hammerness" emerges if it breaks or slips from grasp or mars the wood, or if there is a nail to be driven and the hammer cannot be found.

Heidegger's (1996) main point is that present-at-hand—a detached reflection on the external world—is not an object's primary mode of being in the world. He argues that things exist in ready-to-handness, which is hidden beneath our projection of the present-at-handness. In this sense, ready-to-handness precedes present-at-handness. Maturana (1975) supports Heidegger's argument by heavily criticizing the current way of science, which transforms things/objects from their ready-to-handness modes to present-at-handness ones in order to study them. Jacobs (1999) supports Maturana's criticism by providing a good example of what went wrong with the current medical science. He criticizes the way physicians study a living organ after they detach it from where it functions and lives in everyday normal life.[4] In order words, physicians examine dead bodies to study living ones. In this perspective, the fundamental problem of current cognitivism is the reflection and theorization about objects by transforming objects from its ready-to-handness to present-at-handness. According to Heidegger (1996; see also Winograd 1995), only the understanding of an object in its ready-to-handness can bring the true understanding of it. Even though Heidegger restricts the use of the word *Dasein* ("being") to human beings only, I am arguing here that the phenomenological understanding of human beings through their *Dasein* can be equally applicable to our understanding of complicated artifacts such as synthesized speech. Just like the *Dasein* of an individual is

not about what he/she is (his/her property) but is about what his/her existence and possibilities are (various ways of being), the *Dasein* of an object is not about its factual properties—technological components—but about its phenomenological interpretabilities—various way of its interpretation by its users—which can be acquired only through its ready-to-handness.

Psychological Processing of Doubly Disembodied Language in its Ready-to-Handness

In the previous section, I argued that tools are ready-to-hand first and therefore should be examined and understood in its ready-to-handness. If we regard doubly disembodied language as a tool for communicative acts, the logical conclusion is that doubly disembodied language would be understood by people in its ready-to-handness. Therefore, paralinguistic cues in doubly disembodied language would be equally influential in people's imagining of a virtual speaker and in their *social* responses to synthesized speech. By social responses, I mean people's use of social rules and heuristics that are usually directed at other people (see Nass and Moon 2000; Reeves and Nass 1996). Examples of social responses in the domain of speech acts are identification of a person by his/her voice, judgment of personality based on paralinguistic and linguistic characteristics of speech, and the application of subtle social heuristics such as not trusting a speech with unmatched speech cues (e.g., a strong claim with a very unstable voice). An interesting point in this conclusion is that this conclusion is drawn solely from the phenomenology of doubly disembodied language—especially ready-to-handness of doubly disembodied language—rather than evolutionary theories or psycholinguistic analyses. I will explain this observation, which is based on a series of studies done by me and my colleagues (Lee, Nass, and Brave 2000; Lee 2002; Lee and Nass 2002, 2004, 2005; Nass and Lee 2001).

A study by Nass and Lee (2001, see Experiment 1) shows the evidence that paralinguistic cues in synthesized speech do influence the image of a virtual speaker; when listening to book reviews on a book-buying website, participants who hear an extroverted machine voice that is characterized by higher fundamental frequency (F0), faster speech rate, and wider pitch ranges, judged the reviewer to be an extrovert, whereas participants who hear an introverted machine voice judged the personality of the reviewer to be introverted. At a first glance, this seems similar to a traditional embodied language situation in which a narrator delivers utterances of other people by varying his/her voice. The one-person narration, however, is totally different from the machine-voice situation in that the choice of paralinguistic cues in the one-person narration is a *conscious* activity of the narrator. The variation of the narrator's voice is a prop to help listeners imagine the actual sources of the utterances. The listeners' interpretation of paralinguistic props in the one-person narration is logically sound and natural in that, in order to appreciate a story, a joke, or a discourse more, they are imagining a virtual speaker in a way that is set by the narrator (Clark 1996). In a machine-voice situation, however, the influence of paralinguistic props on the mental formation of a virtual speaker is logically problematic since machines ontologically lack consciousness. The results, thus, are very surprising and provide evidence that our responses to synthesized speech are phenomenologically social and follow the same rule that we apply to other humans in our everyday lives. Synthesized speech is processed in its ready-to-handness until it breaks down, exposing its present-at-handness.

A more recent study by Lee and Nass (2004; also see Lee 2002) explicitly test the orientation of social responses to synthesized speech. In this study, the concept of social presence was operationalized in order to directly measure listeners' imagining of virtual speakers. "Social presence" is defined as technology users' feeling that other intelligent beings co-exist and interact with them when they use technologies (Biocca 1997; Heeter 1992; Lee 2004). In short, it is the mental simulation of other intelligences (Biocca 1997). Social presence occurs when technology users successfully imagine or simulate intelligent social actors (whether human or non-human intelligences) when they use media or simulation technologies. By applying this concept, Lee and Nass (2004) examined the most basic social responses to synthesized voice—*identification of speakers based on voices*—in an e-commerce situation where participants hear multiple product endorsements by multiple people. In one condition, the participants heard multiple endorsements narrated by multiple synthetic voices, whereas in the other condition the participants heard the same multiple endorsements narrated by a single synthetic voice. They hypothesized that if people's imagining of virtual speakers is influenced by paralinguistic cues of synthesized speech, one synthetic voice would manifest one virtual speaker and multiple synthetic voices would manifest multiple virtual speakers. Therefore, product endorsements narrated by multiple synthetic voices would have higher persuasive impacts than the same endorsements that are narrated by a single synthetic voice, even though the obviously artificial nature of the synthetic voice—i.e., present-at-handness of a synthetic voice—should hinder it from being used for speaker identification. In addition, they also hypothesized that if people's social responses to synthesized speech are oriented toward imagined virtual speakers, the possible positive impacts of multiple synthetic voices on persuasion would be mediated by listeners' feeling of social presence of multiple virtual speakers (i.e., an indirect effect of multiple voices on persuasion). If there are no mediating effects, multiple voice presentation will affect listeners' attitudes directly (i.e., only a direct effect of multiple voices on persuasion). The results confirmed both hypotheses. The confirmation of the second hypothesis is especially important, because it indicates that people's social responses to synthesized speech are oriented toward phenomenologically present virtual speakers. Present-at-handness of synthesized speech (i.e., simple judgment of the number of voices used for narration) does not produce social responses. It is the consequences of ready-to-handness of synthesized speech—as measured by the feeling of social presence—that cause the observed social responses.

In an attempt to eliminate two powerful alternative explanations for social responses to synthesized speech—"social responses to programmers or designers" and "social responses to mechanically distorted human speech"—Lee and Nass (2002, 2004) conducted two critical studies.

From the viewpoint of the first alternative explanation, social responses to synthesized speech come from listeners' desire to jointly pretend with programmers (or designers) who intentionally manipulate paralinguistic cues of synthesized speech. Therefore, social responses to synthesized speech are oriented toward people behind computers, rather than imagined virtual speakers. In order to eliminate this alternative explanation, Lee and Nass (2002) let participants freely choose either an extrovert or an introvert voice as the narrating voice of book reviews. The result shows that the participants exhibit the same social responses as discovered in the previous study (Nass and Lee 2001) even though it was they—not programmers—who had choices and were ultimately responsible for the synthetic voice that they heard. This result eliminates the first alternative explanation that

social responses to computer voices are nothing more than social responses to the intention of programmers or designers behind computers. All the participants in this experiment clearly recognized that only they were responsible for a specific type of voice that they heard, because they chose the voice. That is, there were no hidden designers or programmers to whom they should socially respond. This experiment also weakens the psycholinguistics-based explanation of people's social responses to doubly disembodied language. According to Clark's (1999) layering model of disembodied language, *joint pretense* between a user and a programmer is critical in our interpretation of doubly disembodied languages. Since pretending requires internationality, people cannot jointly pretend with objects that lack internationality. This experiment shows that joint pretense is not a prerequisite for people to respond socially to synthesized speech. People respond socially to synthesized speech, regardless of its ontological impossibility of having intentionality. More radically, the results also imply that computers can produce even embodied languages despite their ontological limitation of lacking intentionality, because they are phenomenologically present in its ready-to-handness in front of users.

The second alternative explanation for social responses to synthesized speech is the argument based on social responses to mechanically distorted human speech. This argument claims that participants in the previous studies (Experiment 1 in Lee and Nass 2004; Nass and Lee 2001) incorrectly believed that the synthetic voices they heard were actually pre-recorded human voices, or more convincingly, distorted versions of pre-recorded human voices. This erroneous belief could have arisen from peoples' ignorance of the potential of current TTS technologies. According to this alternative explanation, there is nothing unique about people's social responses to synthetic voices because people do not interpret the synthetic voices as *artificial*. Therefore, people will stop exhibiting social responses, as soon as they realize the ontological status of synthesized speech. To test the validity of this argument, Lee and Nass (2004, see Experiment 2) conducted an experiment in which participants were explicitly taught the technological details of speech synthesis before hearing synthesized speech. The participants were even instructed to generate different synthetic voices in order to clearly understand the purely artificial nature of synthesized speech. The results of the experiment showed that technological literacy did not preclude social responses to synthesized speech. That is, even when people clearly knew the artificial nature of synthetic voices, they nonetheless respond socially to synthetic voices. Therefore, this experiment effectively eliminates the alternative explanation that social responses to media and computer technologies simply come from people's ignorance of the artificial nature of technologies that they are using (the technological ignorance argument). Combined with results from Lee and Nass (2002), this experiment provides a strong evidence for the robustness of social responses to synthesized speech. No matter how clearly people know present-at-handness of synthesized speech (e.g., technological details and ontological limitations of synthesized speech), synthesized speech is processed in its ready-to-handness first before serious breakdowns expose its present-at-handness on the surface.

Phenomenology based explanation of social responses to synthesized speech even nicely explains phenomena that cannot be easily accounted by evolution-based theories (for evolution-based theories for social responses to computers and communication technologies, see Lee 2002; Reeves and Nass 1996). Nass and Lee (2001, see Experiment 2) found that people prefer to listen to a synthesized speech whose paralinguistic and linguistic cues provide a consistent personality type. When the personality of linguistic cues—manifested by writing style, contents, word choices, confidence level (e.g., extro-

verted people usually choose stronger words and show high levels of confidence in content)—matches the personality of paralinguistic cues, people in general trust the source of the speech and like the content and synthetic voices more than when those cues are mismatched to each other. This type of a consistency-attraction effect, which we usually see in our everyday social interaction with other people (e.g., people like to interact with other people whose verbal contents and non-verbal paralinguistic cues are consistent with each other), cannot be easily explained by evolution-based theories, since it's almost impossible to find evolutionary reasons for people's preferences for the consistency between linguistic and paralinguistic cues. That is, even though quickly detecting a trustworthy partner has a survival value and thus has a good reason to be gradually evolved, the specific skill of finding personality cues in linguistic cues and matching them to personality cues in paralinguistic cues cannot be evolutionary hardwired because those skills surely require a substantial amount of learning and later reinforcement. Present-at-handness of synthesized speech caused by phenomenological breakdown due to the inconsistency between linguistic and paralinguistic cues can nicely explain this phenomenon. That is, if a TTS engine transforms a text that clearly manifests strong extroversion of the writer, with a voice clearly manifesting strong introversion of the speaker, a phenomenological breakdown occurs due to the inconsistency between the writer and the speaker. In order to make sense of the phenomenologically broken synthesized speech, listeners need to divide the speech into linguistic and paralinguistic parts. Since spoken language is a tool that exists as a combination of both linguistic and paralinguistic cues, the separation of the cues hinders users from processing the given synthesized speech in its ready-to-handness. Tools constantly remind users its present-at-handness cannot reach its idealized way of being, and users cannot fully appreciate the tools. Likewise, synthesized speech with mismatched linguistic and paralinguistic cues cannot be easily processed in its ready-to-handness. This causes the disastrous effects of mismatched synthesized speech on persuasion. To sum up, the result of the second experiment in Nass and Lee (2001) demonstrates the explanatory power of the phenomenological understanding of social responses to synthesized speech.

Conclusions and Discussions on Languages in the Digital Age

Language settings of human communication have become incredibly diverse and complicated with the continuous introduction of new communication technologies. So far, we have witnessed three types of language settings—face-to-face communication, disembodied language, and doubly disembodied language. Below, I briefly explain the way each language setting is psychologically processed.

The most basic language setting of human communication is face-to-face communication mediated by spoken language (body language aside). Spoken language of face-to-face communication is embodied in its actual speaker who is physically present. Therefore, the processing of face-to-face communication is natural and does not require any special mental process to construct the source of the speech.

Language settings of human communication have become complicated with the invention of written language and electronic media. The introduction of written language and modern electronic media makes it possible for humans to communicate messages without physically embodying them.[5] As a result, written language and spoken language in mediated communications are disembodied from their actual sources. Then how do people make sense of these disembodied languages? The theory of disembodied language

(Clark 1999) explains that people mentally construct the source of disembodied language by imagination when they read written language or hear pre-recorded human speech. Therefore, the theory concludes that disembodied language is understood in the same way as face-to-face communication.

The development of voice-synthesis technology makes the language settings of human communication even more complicated. In addition to the first-degree disembodiment defined by the non-existence of an actual speaker at the moment of its interpretation, voice-synthesis technology creates a second-degree disembodiment by breaking the authentic link between paralinguistic cues of speech and its source. The term *doubly disembodied language* is coined and introduced in this chapter to explain this new type of disembodied language.

The results of the experiments reviewed in the current chapter indicate that people automatically construct the source of synthesized speech based on paralinguistic cues of doubly disembodied language, even though the paralinguistic cues have nothing to do with the actual source of the speech. These results imply that just as automatic imagination based on automatic perceptual responses to *real* human voice plays an important role in people's understanding of *disembodied* language, automatic imagination based on automatic perceptual responses to *synthetic* voices plays an important role in people's understanding of *doubly disembodied* language. Based on the results of a series of experiments, I conclude that doubly disembodied language is processed in its ready-to-handness, unless there is a major breakdown. Therefore, doubly disembodied language, disembodied language, and even face-to-face communications are phenomenologically equal as long as artifacts for disembodiment (e.g., synthetic speech, written languages, machine recording devices) exist in its ready-to-handness when they are being processed.

Even though the above categorization provides a useful theoretical framework for understanding modern human communication settings, it cannot explain a more advanced version of a 21st-century communication setting in which an artifact itself generates synthesized speech. As technologies such as CTS (concept-to-speech)—which produces synthesized speech based on machine-generated thoughts rather than given texts (see Olive 1997)—develop, it will be possible for computers or robots to generate their own speech. For example, at least in movies, a computer like HAL or a robot like C3P0 vary their synthetic voices based on their own *intentions* to effectively convey their own *thoughts* to others. In short, they have intentional stances (Denett 1987) when they communicate. I would define this futuristic type of language as *artificially embodied* language. Future studies should investigate how people respond to artificially embodied language. At least, directors of popular films such as *2001: A Space Odyssey* and *Star Wars* already provided hints that people will respond to artificially embodied spoken language uttered by HAL and/or C3PO in the same way as they would respond to real human speech. Again, Heidegger's (1996) observation that ready-to-handness of an artifact precedes its present-at-handness will still hold true.

NOTES

1. In his paper, Clark (1999) uses the term "mechanized speech" to refer to pre-recorded television shows, recorded telephone messages, books on tape, pre-recorded fire alarms. That is, he uses the term "mechanized" in the sense that real human speech is *recorded*. To eliminate possible confusion between his term, "mechanized speech," and my term, "computer-synthesized speech," the term "pre-recorded human speech" is used instead of Clark's "mechanized speech."

2. The mental formation of known speakers is a different topic. In the case of a known speaker, people automatically conjure up the image of the speaker previously stored in their brain. Paralinguistic cues become the immediate verification devices for checking the authenticity of the speaker. Linguistic cues become the source of authentication when no other cues exist.

3. Listeners almost automatically recognize the artificiality of synthesized speech, because even the best text-to-speech (TTS) systems have not yet achieved the quality and prosody of natural human speech (Kamm, Walker, and Rabiner 1997).

4. In this sense, medical science originating from China and other Asian countries provides phenomenologically attractive alternatives. For example, the study and practice of acupuncture is conducted without placing the patient in quasi-dead conditions (e.g., anesthesia).

5. I will not discuss the social implications of the introduction of new communication technologies here because they have been well discussed by communication historians such as Innis (1950, 1951) and McLuhan (1964a, 1964b).

REFERENCES

Beutnagel, M., A. Conkie, J. Schroeter, Y. Stylianou, and A. Syrdal. 1999. *The AT&T next-gen TTS system.* Paper presented at the joint meeting of ASA, EAA, and DAGA, March 14–19, in Berlin, Germany.

Biocca, F. 1997. The cyborg's dilemma: Progressive embodiment in virtual environments. *Journal of Computer-Mediated Communication*, 3 (2), http://www.ascusc.org/jcmc/vol3/issue2/ (accessed January 10, 2004).

Bleich, D. 1981. The individual language system. *ADE Bulletin* 68: 5–8.

Clark, H. 1996. *Using language.* New York: Cambridge University Press.

Clark, H. 1999. How do real people communicate with virtual partners?, in *Proceedings of 1999 AAAI Fall Symposium, Psychological Models of Communication in Collaborative Systems*, 43–47. North Falmouth, MA: AAAI.

Cooper, R. P., and R. N. Aslin. 1990. Preference for infant-directed speech in the first month after birth. *Child Development* 61:1584–1595.

Debus, G. 1978. *Über Wirkungen akustischer Reize mit unterschiedlicher emotionaler Valenz.* Meisenheim, Germany: Hain.

Denett, D. 1987. *The intentional stance.* Cambridge, MA: MIT Press.

Fernald, A. 1992. Human maternal vocalizations to infants as biologically relevant signals: An evolutionary perspective. In *The Adapted mind: Evolutionary psychology and the generation of culture*, edited by J. H. Barkow, L. Cosmides, and J. Tooby, New York: Oxford University Press.

Heeter, C. 1992. Being there: The subjective experience of presence. *Presence* 1:262–271.

Heidegger, M. [1927] 1996. *Being and time.* A translation of *Sein und zeit*, translated by J. Stambaugh, Albany, NY: SUNY Press.

Heidegger, M. [1954] 1977. The question concerning technology, translated by W. Lovitt. In W. Lovitt, *The question concerning technology and other essays.*

Innis, H. 1950. *Empire and communication.* Oxford: Clarendon Press.

Innis, H. 1951. *The bias of communication.* Toronto: University of Toronto Press.

Isbister, K., and C. Nass. 2000. Consistency of personality in interactive characters: Verbal cues, non-verbal cues, and user characteristics. *International Journal of Human-Computer Interaction* 53:251–267.

Jacobs, D. C. 1999. *The presocratics after Heidegger.* New York: SUNY Press.

James, F. 1998. *Representing structured information in audio interfaces: A framework for selecting audio marking techniques to represent document structures.* Ph. D. diss., Stanford University.

Kamm, C., M. Walker, and L. Rabiner. 1997. *The role of speech processing in human-computer intelligent communication.* Paper presented at NSF Workshop on human-centered systems: Information, interactivity, and intelligence, Arlington, VA.

Kurzweil, R. 1997. When will HAL understand what we are saying? Computer speech recognition and understanding. In *HAL's legacy: 2001's computer as dream and reality*, edited by D. Stork. Cambridge, MA: MIT Press.

Lai, J., D. Wood, and M. Considine. 2000. The effects of task conditions on the comprehensibility of synthetic speech. Proceedings of the CHI 2000 Conference, 321–328. New York: ACM.

Lee, E. J., C. Nass, and S. Brave. 2000. Can computer-generated speech have gender? An experimental test of gender stereotypes. In CHI 2000 Extended Abstracts, New York: ACM.

Lee, K. M. 2002. *Social responses to synthesized speech: Theory and application*. Ph. D. diss., Stanford University.

Lee, K. M. 2004. Presence, explicated. *Communication Theory* 14:27–50.

Lee, K. M., and C. Nass. 2002. *User choice and computer-synthesized speech*. Unpublished Document.

Lee, K. M., and C. Nass. 2004. The multiple source effect and synthesized speech: Doubly disembodied language as a conceptual framework. *Human Communication Research* 30:182–207.

Lee, K. M., and C. Nass. 2005. Social-psychological origins of feelings of presence: Creating social presence with machine-generated voices. *Media Psychology* 7, 31–45.

Maturana, H. R. 1975. The organization of the living: A theory of the living organization. *International Journal of Man-Machine Studies* 7:313–332

McLuhan, M. 1964a. *Understanding media: The extensions of man*. New York: McGraw Hill.

McLuhan, M. 1964b. *The Gutenberg galaxy: The making of typographic man*. New York: Mentor.

Moon, Y., and C. Nass. 1996. How "real" are computer personalities? Psychological responses to personality types in human-computer interaction. *Communication Research* 23:651–674.

Nass, C., and L. Gong. 2000. Speech interfaces from an evolutionary perspective. *Communications of the ACM*, 43(9): 36–43.

Nass, C., and K. M. Lee. 2001. Does computer-generated speech manifest personality?: Experimental test of recognition, similarity-attraction, and consistency-attraction. *Journal of Experimental Psychology, Applied* 7:171–181.

Nass, C., and Y. Moon 2000. Machines and mindlessness: Social responses to computers. *Journal of Social Issues* 56:81–103.

Olive, J. P. 1997. "The talking computer": Text to speech synthesis. In *HAL's legacy: 2001's computer as dream and reality*, edited by David Stork, Cambridge, MA: MIT Press.

Pittam, J. 1994. *Voice in social interaction: An interdisciplinary approach*. Thousand Oaks, CA: Sage.

Reeves, B., and C. Nass. 1996. *The media equation: How people treat computers, television, and new media like real people and places*. New York: Cambridge University Press.

Sawhney, N., and C. Schmandt. 1997. *Design of spatialized audio in nomadic environments*. Paper presented at the international conference on auditory display (ICAD '97), Palo Alto, CA.

Scherer, K. R. 1979. Personality markers in speech. In *Social markers in speech*, edited by K. Scherer and H. Giles, New York: Cambridge University Press.

Shneiderman, B. 1997. *Designing the user Interface: Strategies for effective HCI*. Reading, MA: Addison-Wesley.

Weinschenk, S., and D. T. Barker. 2000. *Designing effective speech interfaces*. New York: Wiley

Wikipedia Encyclopedia. 2004. *Speech synthesis*. http://en.wikipedia.org/wiki/Text_to_speech (accessed July 25, 2004).

Winograd, T. 1995. Heidegger and the design of computer systems. In *Technology and the politics of knowledge*, edited by A. Feenberg and A. Hannay. Bloomington, IN: Indiana University Press.

Winograd, T., and F. Flores. 1986. *Understanding computers and cognition: A new foundation for design*. Norwood, NJ: Ablex Publishing Corporation.

Barbara Warnick

Rhetoric on the Web[1]

Since the initial appearance of hypertext and Web-based communication, the study and practice of rhetoric have evolved to suit the new media environment. This chapter will consider how Web text has developed and changed over the last ten years, and it will describe how website authors and users have altered their writing and reading practices in the Web environment. After explaining why some aspects of traditional rhetorical theory are inadequate for studying persuasive discourse on the Web, the chapter provides some examples of how traditional theories of textual criticism have been adapted to the analysis of the distributed, networked, modular text found on the World Wide Web

Like other communication researchers, rhetorical theorists and critics have been challenged during the past decade by the rise of the World Wide Web and the new forms of communication found there. In the period since the public Web sphere began to take shape, hypertext, website structure, and the technologies of website construction have changed dramatically. Furthermore, the modalities in which people produce and consume media content on the Web have moved from the desktop computer and now include portable computers and cellular phones.

The present study will consider how the appearance of Web-based communication has encouraged use of new or altered models of rhetorical expression. By "rhetoric," I am referring to the forms of influence in communication and the ways in which audiences are addressed and respond to posted discourse. Because this essay is situated in a collection where other authors describe video and visual communication, I will focus primarily, but not exclusively, on verbal expression.

Early writers on hypertext emphasized its differences from conventional print-based expression. When it first took shape in the early 1990s, the public Web was highly disorganized, unstructured, and eclectic in its content. Users could enter the Web at any given point and choose their own pathways of narrative development, and authors were said to lose control over the narrative and their readers' point of view (Landow 1997; Warnick 1998). Rhetorical theory and criticism grounded in neoclassical rhetoric seemed

to be poorly suited to studying Web-based expression because classical theory often concerned itself with the author as the source of the message and with linear, monologic, stabilized forms of communication.

Another way to think of this would be to consider Roland Barthes' distinction between "the work" and "text." The Web is comprised of texts that are distributed in a linked network, produced through corporate authorship, constantly revised, often borrowed, and frequently parasitic on the other texts to which they are linked. In its intertextuality, performative forms, and indeterminacy, the Web text is more like an organism than like a "work." As Barthes noted, on this view "the metaphor of the Text is that of the *network*; if the Text extends itself, it is as the result of a combinatory systemic" (1977, 161).

The shift to thinking of what one finds on the Web as "text" rather than as "work" has implications for the study of both consumption and production. On the consumption side, website users appear to be less inclined to ponder dense, tightly structured, sequenced discourse. They tend to be restless (Farkas and Farkas 2002). Kaplan (2000) describes Web reading, not as deficient, but as *different* from reading print text. Since there is no predetermined next node in the reading process, readers must continually choose what to read next. Therefore, they proceed by weighing alternatives, constructing forecasts as they read, and then modifying their expectations. The link cue, then, is not simply "a local occurrence (or annoyance) but is a requisite part of a larger structural pattern, a pattern visible only as it emerges through each reader's successive acts of choosing" (Kaplan 2000, 228). Kaplan's view is that readers read Web text with heightened attention, partially because they are constantly making micro-decisions about where to go next and what to read next while they are reading.

Another implication of these reading patterns, of course, is that the Web text is decentered and, often having no point of origin in a particular author, becomes what Barthes calls a writerly text. If a Web text is not unitary, sequential, and locatable as a whole, then it emerges as the product of the reader's action. The Web text thus becomes "a multi-dimensional space in which a variety of writings, none of them original, blend and clash. The text is a tissue of quotations drawn from innumerable centres of culture" (Barthes 1977, 146). The reader becomes a scripter, creating the text she reads as she reads it. Thus, visitors to large websites usually each read a different text in a different order from other visitors to the site; the very idea of an identifiable or single meaning for a given "text" becomes hard to imagine. Furthermore, there is always the possibility of leaving the site entirely, or jumping between sites even to the point of disorientation. The frequent indeterminacy and variability of the texts that readers read has considerable implications for how persuasion and influence might occur on the Web as compared with how they usually occur in more structured, author-centered environments, and I will return to this later.

My promise to later return to an aforementioned topic presupposes that you, the reader, are reading this essay as a continuous document, so I can include a cross reference to later content here. This idea can lead us to consider the process of producing Web content. In regard to the verbal text, that means writing for the Web, and, like reading, it is often different on the Web than in many other writing contexts. In advice on Web writing, some suggestions are commonplace. For example, writers are advised to write for easy scanning, because website readers do not read word for word. Liberal use of white space, short sentences, conciseness, simple sentence structure, highlighting, bullets, and numbered lists are all recommended (Nielsen n.d.; Farkas and Farkas 2002). Readers are

advised to use a "pyramid scheme," and to place the most important content "above the fold" on a page, followed by content that is comparatively less important. Such placement is advised because users have been shown to be unlikely to scroll down on the page unless they become initially interested in site content (Lynch and Horton 2001). Furthermore, writers are encouraged to express content in "chunks" or independent modules that stand alone. Modular writing enables readers to access content at any point and still understand it without needing further context (Farkas and Farkas 2002). Finally, writers are discouraged from inserting "out links" into the middle of a narrative or discourse because they create the possibility that users will leave the site or get disoriented.

Having considered patterns of production and consumption called for in a nodal, networked discursive system, one might also note in contrast the extent to which the system itself has become progressively more structured and organized during the past ten years. As is the case in many instances of communication, there are tensions between centripetal and centrifugal forces in website texts. Centripetal (centralizing) forces are those forces that regularize and constrain speech diversity, whereas centrifugal forces are those that spin away from ordered, monologic speech (Bakhtin 1981). On the Web, centripetal forces can be thought of in terms of the pyramid scheme for content placement, prescribed conventions for page design, search-engine protocols, site maps, and writing guides such as those referenced in the preceding paragraph. Centripetal factors are at work alongside of and in tension with centrifugal forces that conduce to speech diversity. Centrifugal expression includes parody, punning, language play, graffiti, slang, and disordered speech. These forms tend to deconstruct hegemonic, ordered speech by exposing internal contradictions in text or behavior, violating speech norms, and providing commentary. Such forms are used in all language environments, but the Web is particularly well suited to their use.

As the Web has become more of a commercial platform, it has become more structured and more influenced by commercial forces. Consumers expect to be able to find what they need quickly and easily and to have their questions readily answered. The use of large search engines, Internet portals, advertising, networked links, hosting services and other resources has reintroduced hierarchy into the Internet environment. To work within the constraints of website structure and usability, authors must be strategic and deliberate in posting their sites, attracting visitors, and keeping them interested. The results of their efforts were well described by David Resnick when he said that websites are designed "to inform, influence, and persuade those who log onto them" (1997, 48).

The ways in which Web rhetoric works, then, are dependent on the purpose and context of the discourse in use. Verbal rhetoric on an advertising or commercial site might observe such conventions as making the most of the space above the fold on the home page, displaying visible, clearly formatted link tables, and strategic ad placement. But verbal rhetoric in an artistic or experimental environment may open with an intentionally disorienting but intriguing entry page that invites readers to linger and appreciate what is displayed. The commercial site thus promotes ease of use, rapid user response, and efficiency, while the artistic site encourages bricolage, experimentation, curiosity, and/or artistic appreciation. The artistic site presents texts that are dispersed and designed to be experienced rather than to provide closure. The extent to which centripetal and centrifugal forces shape user experience thus varies with the nature of the site itself.

Even as consumption and production of Web discourses have changed during the past decade, so have the critical models used to study Web-based rhetoric. Authors of pre-

Internet monologic and print-based messages often could assume that their listeners and readers would tolerate and even appreciate linear development, sustained argument, and carefully reasoned proofs. Rhetorical critics and argument theorists could therefore attend to how a speaker or writer advanced a thesis, sequenced the claims that supported it, used logical structures, and selected supporting evidence to build a case (Perelman and Olbrechts-Tyteca 1969; Eemeren, Grootendorst, and Henkemans 2002). Because the modularity and discontinuity of website texts now generally do not lend themselves to persuasion based on logical structure, rhetorical critics may need to focus on discursive structures that lie outside the realm of traditional logic.

New modes of textual appeal call for new forms of rhetorical critical analysis. Critics of online texts have studied how the affordances of new media have been used for rhetorical purposes. For example, devices such as "Web rings" and other forms of structural or content-oriented reciprocity can be studied to ascertain how web authors and readers establish credibility based on textual cues and how they construct and shape their audiences through strategic use of shared beliefs and premises (Mitra 1999). This form of criticism is partially predicated on the idea that "the glue that holds the Internet together is the text exchanged by different users of the Internet" (Mitra and Cohen 1999). Gurak (1997) studied forms of online group protests in a text-only environment where participants used message forwarding, group petitions, e-mails addressed to power agents, and other text-based actions to agitate for their cause. In a follow-up case study, Gurak and Logie (2003) reported on how group protest had migrated to the Web. Participants used their own Web pages to set up a linked network for resistive action, including a boycott of the offending agent, downloadable protest graphics, alteration of protest-created Web content, and use of the Web to attain offline media coverage to achieve their aims. Gurak and Logie's case study illustrated how rise of the Web has enhanced text-based protest, making it more immediate, efficient, and effective.

In many genres of online websites, the whole paradigm of rhetorical action has changed. As Lev Manovich has observed, user-centered design on the Web emphasizes drawing users into a site and encouraging return visits. He notes that "the goal of commercial Web design is to create 'stickiness' (a measure of how long an individual user stays on a particular Web site)" (2001, 161). In contrast to writing for a print-centric medium where authors can presume readers who will stay with the text and follow intricate chains of reasoning and linear development, the aim of much of the website text is to keep the reader on the site.

This desire to draw users into the site has also inspired producers to develop texts that work more like puzzles to be solved than like one-to-many appeals. Intertextuality, in which an already-familiar text is invoked or played upon in a new textual context, is a driving force on many parodic sites. The hypertextual environment, the ease of cut and paste, the potential for using someone else's html code, and other factors make it easy for website producers to play one text against another. In a recent study (Warnick 2002), I explained how Web parodists in the 2000 Bush/Gore campaign used various forms of intertextuality to carve out an "in the know" audience of return visitors. By juxtaposing parodic speech with candidates' original speech, altered sites with candidates' official sites, and candidate actions with candidate words, parodists made the experience of visiting their sites like playing a game or solving a puzzle. Their strategy was to create uncertainty and suspense, followed by play and excitement. This in itself was a rhetorical process with a rhetorical outcome—users who had learned about candidate foibles, personal histories, and backgrounds.

Like offline parody, intertextuality engages audiences because it calls upon them to supply the missing links or text and give meaning to what they are reading. By embedding subtle allusions recognizable only to readers who are savvy about a given topic, Web authors can deploy intertextuality very strategically to hold their audiences' attention and get their point across. They can, in effect, create an audience of repeat visitors by establishing background knowledge about the topic in question, circulating a stable of commonplaces (ideas and examples used as discursive resources), and then exploiting these through textual cross references and embedded hyperlinks. In so doing, they create a community of interest through and by means of the text itself. Frequently, these textual devices are complemented by other graphic and visual elements such as splash pages, altered images, multimedia downloads, blogs, and message boards that are likewise designed to keep the reader on the site or encourage him or her to return.

Designers and authors of online messages seek to appeal to the user both as a member of a group with a group identity and as an individual. The appeal to the individual has led to website customization and personalization in the form and content of Web communication (Burnett and Marshall 2003). The mass audience has been disaggregated. Design and content are often based on information about the user gleaned through use of cookies, click-through information, online registration forms, and other means. Different users see different displays of the same content: media adapted to user bandwidth, font and images controlled by user browser settings, and pages generated on the fly based on users' past inputs to the host site. On many commercial sites, careful analysis of user behavior, responses, and interests means that website content can be carefully and strategically tailored for maximum effect.

Another mode of appeal that can emanate from the verbal text grows out of text-based interactivity. Interactivity is a highly contested term in the research literature concerning online communication (Kiousis 2002; McMillan 2002). While it can be discussed in terms of the interaction between the user and the system (e.g., clicking on hyperlinks, customizing site features), user-to-document (e.g., user-contributed comments, discussion boards), or user-to-user (e.g., online chat, instant messaging), it can also be considered as a rhetorical dimension of the website text (Endres and Warnick 2004). Studies of online interactivity have understandably focused on interactive features unique to new media, but features of the text itself, such as the use of first person, active voice, first-name reference, and direct address, can engage users and increase their sense of the presence and immediacy of the message source. A recent, unpublished study of website users indicated that they stayed on political sites longer and had better recall of issue positions when candidate views were expressed in vivid, direct language accompanied by alt-tagged photographs than they did when candidate views were expressed impersonally with fewer unlabeled photographs (Warnick et al. 2004). These findings suggest that, when researchers analyze website characteristics such as site features, visual design, use of images, and multimedia downloads, they might consider as well the forms of verbal and stylistic expression found in the text itself.

A final area of traditional rhetorical theory, that can be retooled so as to cope with rhetoric in Web-based environments, is ethos, or source credibility. During the Web's early years, the conventional approach to online ethos was to advise users to judge the credibility of a site based on the expertise, credentials, and/or institutional affiliation of its author or the organization that created it (Fritch and Cromwell 2001; Schlein 2003). More recently, however, Web sources have become progressively less likely to identify the precise sources of their information, and to disclose information about authorship and

credentials.[2] Conventional rhetorical theory views ethos as emanating from the speaker or writer who produces the text and as a quality of the text that disposes audience members to believe and trust what is said. It thus becomes one of the available means of persuasion that a rhetor can use to gain acceptance for his or her message. As an author or speaker-centered construct, however, conventional ethos does not always transfer well to a distributed textual environment such as the Web. Furthermore, surveys and observation of Web users reveal that they rarely use authorship as the primary criterion for judging websites. Instead, they look to such factors as site design, ease of use, and whether the site offered what they were looking for (Fogg, Soohoo, and Danielson 2002).

In a recent essay (Warnick 2004), I suggested that, instead of looking to authorship credentials, users may look to a number of other factors, taken together, to make judgments about ethos. These can include recency of content, coincidence of information with other sources, site design and usability, mission statements, and information usefulness. I noted the significance of Nicholas Burbules' idea of "distributed credibility" for judging online content (Burbules 2001). Website users often do not judge texts as freestanding units, instead, they make field dependent, comparative judgments based on probability. They tend to view the credibility of any textual artifact as tied-in with the larger networked system of which it is a part. A rhetorical critic could therefore consider the credibility of an online site in terms of the knowledge system of which it is a part and the criteria that emanate from that knowledge system. In particular, the factors used to gauge reliability and believability of an online source within the field where the discourse is located should be drawn on, rather than consistently relying on authorship or expertise as the central means for judging ethos.

Much of the apparatuses of Eurocentric classical rhetorical theory—rhetorical logics, sequential disposition, and specific strategies for audience adaptation—were formulated as ancient Greek society moved from an oral to a literate culture. As Walter J. Ong observed, the era of electronic communication in the late 20th and early 21st centuries has returned us to a state of "secondary orality" (1982, 135), and online and other forms of mediated discourse have come to resemble the primary orality of preliterate cultures. These expressive forms enact orality in their participatory mystique, their fostering of a communal sense, their concentration on the present moment, and their use of textual formulae. Secondary orality is the most recent development in how influence processes change as their communication environments develop.

Like the communication technologies and contexts that preceded it, the WWW requires rhetorical practitioners and critics to consider how conventional modes of appeal can be adjusted to new forms of text and context. This chapter has noted Web-based challenges to conventional rhetorical expression, such as discontinuous reading by users, networked, episodic text, and dispersed authorship. In many cases, these environmental factors render conventional modes of print-centric composition, logic, and source credibility less suitable for the production and study of persuasion on the Web. The chapter has described some alternate means that Web authors have successfully used to meet these challenges. These include modular writing, strategic content placement, intertextual allusion, and personalization of the message to the user. The chapter has also suggested that Internet researchers should consider rhetorical dimensions of verbal expression as a form of interactivity, since language use and the creation of rhetorical presence appear to be factors in audience responses to Web-based messages. Finally, rhetorical critics might consider ethos as a distributed, field-dependent construct for evaluating

site interactivity rather than as one centered in the credentials and expertise of the message source. As mobile access to the Web and availability of immersive Web-based environments increase, communication researchers will continue to track how changes in the technological context affect the forms of rhetorical expression that occur within it. Rhetoric's malleability and ubiquity will nonetheless continue to make it a phenomenon of interest in the future.

NOTES

1. Portions of this essay are taken from the author's article "Looking to the Future: Electronic Texts and the Deepening Interface," to be published in Technical Communication Quarterly and are used with permission.

2. For example, a 2002 study of 460 websites in 13 countries by Consumers International found that 35% of health sites and 75% of finance sites failed to provide information about the authority and credentials of the people behind the site (Consumers International 2002). More than one-third of the sites in the study provided no address or phone number, and one-quarter provided no information about who owned them.

REFERENCES

Bakhtin, M. M. 1981. *The dialogic imagination: Four essays,* ed. by M. Holquist; trans. by C. Emerson and M. Holquist. Austin: University of Texas Press.

Barthes, R. 1977. *Image music text.* New York: Noonday Press.

Burbules, N. C. 2001. Paradoxes of the Web: The ethical dimensions of credibility. *Library Trends* 49 (3):441–454.

Burnett, R., and P. D. Marshall. 2003. *Web theory: An introduction.* New York: Routledge.

Consumers International. 2002. *Credibility on the Web: An international study of the credibility of consumer information on the Internet.* http://www.consumersinternational.org/documents_asp/searchdocument.asp?DocID=509®ionid=135&langid=1 (accessed December 5, 2004).

Eemeren, F. H. van, R. Grootendorst, and A. Francisca Snoeck Henkemans. 2002. *Argumentation: Analysis, evaluation, presentation.* Mahwah, NJ: Erlbaum.

Endres, D., and B. Warnick. 2004. Text-based interactivity in candidate campaign Web sites: A case study from the 2002 elections. *Western Journal of Communication* 68 (3):322–342.

Farkas, D. K., and J. B. Farkas. 2002. *Principles of Web design.* New York: Longman.

Fogg, B. J., C. Soohoo, D. Danielson. 2002. How do people evaluate a Web site's credibility? Results from a large study. http://www.consumerwebwatch.org/news/report3_credibilityresearch/stanfordPTL_abstract.htm (accessed December 5, 2004).

Fritch, J. W., and R. L. Cromwell. 2001. Evaluating Internet resources: Identity, affiliation, and cognitive authority in a networked world. *Journal of American Society for Information Science and Technology* 52 (6):499–507.

Gurak, L. J. 1997. *Persuasion and privacy in cyberspace: The online protests over Lotus MarketPlace and the clipper chip.* New Haven: Yale University Press.

Gurak, L. J., and J. Logie. 2003. Internet protests, from text to Web. In *Cyberactivism: Online activism in theory and practice,* edited by M. McCaughey and M. D. Ayers. New York: Routledge.

Kaplan, N. 2000. Literacy beyond books: Reading when all the world's a web. In *The World Wide Web and contemporary cultural theory,* edited by A. Herman and T. Swiss. New York: Routledge.

Kiousis, S. (2002). Interactivity: A concept explication. *New Media & Society, 4(3),* 355–383. Retrieved January 24, 2004, from the Ingenta database.

Landow, G. P. 1997. *Hypertext 2.0: The convergence of contemporary critical theory and technology.* Baltimore: The Johns Hopkins University Press.

Lynch, P. J., and S. Horton. 2001. *Web style guide*, 2nd ed. New Haven: Yale University Press.

Manovich, L. 2001. The language of new media. Cambridge: The MIT Press.

McMillan, S. J. 2002. Exploring models of interactivity from multiple research traditions: Users, documents, and systems. In *The handbook of new media*, edited by L. Lievrouw and S. Livingstone. Thousand Oaks, CA: Sage.

Mitra, A. 1999. Characteristics of the WWW text: Tracing discursive strategies. *Journal of Computer-Mediated Communication* 5(1). http://www.ascusc.org/jcmc/vol5/issue1/mitra.html (accessed December 5, 2004).

Mitra, A., and E. Cohen. 1999. Analyzing the Web: Directions and challenges. In *Doing Internet research: Critical issues and methods for examining the Net*. Thousand Oaks, CA: Sage.

Nielson, J. n. d. Writing for the Web. http://www.useit.com/papers/webwriting/ (accessed December 5, 2004).

Ong, W. J. 1982. *Orality and literacy: The technologizing of the word*. London: Methuen.

Perelman, C., and L. Olbrechts-Tyteca. 1969. *The new rhetoric: A treatise on argumentation*, translated by J. Wilkinson and P. Weaver. Notre Dame: University of Notre Dame Press.

Resnick, D. 1997. Politics on the Internet: The normalization of cyberspace. *New Political Science* 41–42 (1997):47–67

Schlein, A. M. 2003. *Find it online: The complete guide to online research*. Tempe, AZ: Facts on Demand Press.

Warnick, B. 1998. Rhetorical criticism of public discourse on the Internet: Theoretical implications. *Rhetoric Society Quarterly* 28:73–84.

Warnick, B. 2002. *Critical literacy in a digital era: Technology, rhetoric, and the public interest*. Mahwah, NJ: Erlbaum.

Warnick, B. 2004. From substantiation to representation: Ethos on the World Wide Web. Paper presented at the Rhetoric Society of America conference, in Austin, Texas.

Warnick, B., M. Xenos, D. Endres, and J. Gastil. (In Press). Effects of campaign-to-user and text-based interactivity in political candidate campaign Web sites. *Journal of Computer-Mediated Communication*.

Sidney E. Berger

The Future
of Publishing
in the Digital Age

In the fall of 1972, Bobby Fisher and Boris Spassky completed a titanic chess match for the world championship. The match lasted several months, and it was covered extensively in the media. The day after the match ended, Penguin published a hefty volume listing all the moves of every game, along with diagrams and commentary by the world's best chess grandmasters. It took about a day to get this volume into print and even into the bookstores, practically a miracle in those days. Today such a publishing feat would go by without a raised eyebrow. With the emergence and subsequent sophistication of computers, such "feats" are commonplace. Books—the physical objects—are easier to produce today than they ever were before. And even the notion of what a book is has evolved. There are predictions that these physical objects will eventually be replaced by digital texts, a direction we are clearly going in. But we should not take it for granted that new technology will always, necessarily drive out an old one. While digital technology, which allows instant, worldwide publishing of texts, has clearly affected print-based publishing, it is possible that they will both continue to exist in the same world, strongly influencing each other. The evolution of technology is one of many important issues that one must consider in the future of publishing.

The "microfiche book" is a development that has come to stay"
Teague 1980

Twenty-five years ago, S. John Teague, in an article titled "Microform Publication," commented on what he saw as the *ne plus ultra* of scholarship and technology. The development under scrutiny: microfiche publication. Necessity being the mother of invention, the microfiche was developed to satisfy what was perceived, rightly, to be a dual major need in the library and

archives world. The needs were diminishing space and proliferating titles. Additionally, the problems of cost and access pushed the inventors on.

Microfiche publication did solve several problems. It produced "books" (that is, texts) in a portable, inexpensive form, taking up only a fraction of space that books did, and yielding access through easy reproducibility, inexpensive shipping, and relatively low production costs. There were no paper, ink, printing, or binding costs. Publishers could take what was essentially "camera-ready" copy from the author and film it quickly and cheaply. Some companies even provided—free of charge—portable fiche readers. What more could one want? Prices for books would be slashed on both ends: for the publishers (in production and manufacture) and for the consumer. And publishers need not have warehoused large quantities of printed and bound volumes, these texts could be reproduced on demand from master copies. This was, indeed, "a development that ha[d] come to stay."

Where are they now, these "microfiche books"? Gone the way of mustache wax, high-button shoes, and the slide rule, the last of which is the perfect analogy for what has happened in many fields impacted by technology. With the emergence of any new technology—especially one that does more than the older one does (and does it better)—there are the predictable prognostications about the death of the older machinery or tools. Most people who have any insight into the world of publishing will recognize that new technologies need not necessarily drive out old ones. There are, of course, instances in which this *is* the case. Almost the minute pocket calculators appeared, slide rules plunged to extinction. But television did not replace radio. In fact, listenership to radio has been holding steady for decades. The reason for these contradictory developments is simple. If a new technology comes along that completely satisfies the user, that does all that the older technology did as well as or better than the older one, there is then no reason to maintain the older one (except maybe for nostalgia or a sense of antiquarian curiosity). The calculator not only did everything that the slide rule did, it did it better and faster.[1] But such total displacements are rare, especially if the older technology has great merit, if it has served a valuable function for a long time (decades, generations, centuries), if it is so familiar to its users that it is engrained in our brains as serifs are in typefaces, and if the new technology and the old are not mutually exclusive.

So it is with publishing. The obvious sub-topic to discuss under the title of "Publishing in the Digital Age" is explicitly stated in the word "digital." What this implies is that the new electronic media can disseminate information vastly more efficiently and ubiquitously than could any previous method of distribution. And in some respects, this is so. But efficiency and ubiquity are not the only traits in publishing that are desirable. There are other traits that militate for the perpetuation of the older forms of publishing.

Looked at generically, "publishing" has two interlinked but distinctly different meanings. First, there is the publishing that authors do. They get their word "into print," whether that "print" means in analog or digital form. They are making their texts public. Second, there are the efforts and products of publishers, the issuing of texts, also in analog or digital form. "I published my book" implies that the author has got her words out to the public. "We publish 25 books a year" says that a publisher takes the work (verbal, pictorial, auditory, tactile,[2] or a combination of these), usually of others, and packages it in such a way that others in the public can have access to it.

One line of thinking recently, with the emergence of the World Wide Web, is that the old method of getting things into print often yielded fairly reliable, authoritative texts. A publisher (of books, magazines, journals) would receive a text from an author (anachronistically termed a "manuscript," though produced on a typewriter or computer). The

editor at the publishing house would do a preliminary screening of the text and decide whether or not it was appropriate for her publication—in terms of topic, length, house guidelines, and so forth. The manuscript would then be sent out to one, two, or more readers who would vet the text, often with no author name affixed to the pages they were sent. The readers would review the piece and return it to the publisher with one of three recommendations: 1) publish as is, 2) publish with these revisions, 3) reject the text. With number 2, perhaps the most common verdict, the author would address the readers' concerns, revise appropriately, and return the manuscript to the editor, who would then assess the revisions and the new text as a whole.

If the author heeded the reviewers' advice, publication ensued, producing a text that was presumably reliable, authorial, and accurate. This so-called "peer review" was behind the release of most publications, and the reader had a sense that he was taking in worthwhile material. The old phrase spoken by the Doubting Thomas, "I'd like to see that in print," meant that if it was in print, it was believable, reliable.

But in the digital age, anyone with a computer and a link to the Internet can be a publisher. Anyone with a modicum of expertise can create a text and "publish" it by posting it on the Web, with a great deal of, little, or no vetting whatsoever. So behind the remarks that follow, that caveat must lurk.

This essay will examine three sets of major issues pertaining to the future of publishing in digital form: costs and space, speed and ubiquity of the dissemination of information, and preservation and the future of technology. The essay will also discuss a number of related topics, including digital publishing in the academic world, the demands of readers and their evolving willingness to accept non-paper-based reading, the kinds of texts that do best in digital form, desktop publishing, electronic 'zines, legal challenges, the Electronic Literature Organization, and book collecting.

Costs and Space

Paper-based publishing is expensive. Costs for the physical objects alone are high: paper, ink, presswork (black-and-white and color), design for the paper surface (for facing pages, title pages, tables of contents, and so forth), binding, marketing, and other expenses. According to Brian Baker of W.W. Norton, for a simple paperback with an average pressrun and no complications (no tip-ins, extensive color illustrations, and so forth), each unit should cost the publisher between $2 and $4. The cost of digital publishing is certainly a fraction of that. Libraries have limited budgets. There is no library in the world that can buy everything, especially with the proliferation of books (the physical objects) that we have seen in the last half century. In the last twenty years alone, the number of physical books produced only in the United States has risen from 692,462 (1985–86) to 1,879,250 (2002–04).[3] Astonishingly, for 2001–02—just a single year—230,354 *new titles* were issued in the U.S.[4] And in 2003–04, *Books in Print* listed 1,879,250 titles available in the U.S. All in book form. Obviously, no library in the world can keep up with this flood.

Digitally available texts bring down costs. And CDs and DVDs take up a small fraction of the space that books require. Also, distributors can offer massive numbers of texts online, so the libraries simply subscribe to the packages the distributors offer, and the library need not use any physical space at all. JSTOR is an example of this kind of "publishing." JSTOR has available 449 online journals among its offerings. Institutions essentially rent access to packages of these journals, paying a fee for online access. The

publishers get a royalty from JSTOR, so they are not losing anything to those institutions that no longer pay for subscriptions of paper-based copies. As of the date observed, the company had offerings in 36 different disciplines, with 110,773 issues of journals, and 1,171,300 full-length articles. Add in book reviews, editorials, and other texts beyond the articles, and the company's database contains 2,668,505 pieces available. Many of the journals still exist in paper form, but a good number exist only online, since this considerably reduces publishers' costs. One of the features publishers and libraries appreciate with this arrangement is that since there is not a single copy of a journal on the shelves, many users can read the same text concurrently. Access, in this regard, is increased.[5]

So, many publishers of journals no longer even print hard copy. Either way—paper-based or digital journals—the publishers now look at their industry from a new perspective. They are distributing their work through an intermediary. Since JSTOR packages its offerings under subject headings, libraries must purchase access to whole packages, even if they do not want some of the items in a particular package. This is one direction publishing is going, using the compression and ubiquity of electronic resources to get texts to readers, and to save clients money and space.

Concomitant issues with such "rental" services have to do with future access and library statistics. (For the latter of these see note 8 below.) What would happen if a library subscribing for, say, ten years to a package from an agency like JSTOR learns that the agency closes down for some reason? Does the library continue to have access to the texts they once rented, or are these texts gone for good? How does the library catch up on or replace the 10-years'-worth of texts that have just disappeared? Can they afford to do so? Also, will the agency have the wherewithal to continue to migrate the texts it rents out to newer platforms? A journal they get from a publisher in 1995 may be accessible on platform A. Then the publisher—itself keeping up with the evolution of technology (hardware and software)—begins issuing its texts on platform B, then C, and so on. The agency must keep pace. Can it keep all versions of the platforms, or must it migrate all past texts to the newer platforms? Is this possible to do, especially with the rapidity of technological change? And as I point out below, there is also an issue of the longevity of digital texts. The expenses to "keep up" may be too much for the agency, and it may need to continue to raise its prices (thus running the risk of losing customers or going out of business itself).

Speed and Ubiquity

If there are two features of publishing in the (present and) future that call for digital texts, they are speed and ubiquity. It could take months or years to get a book or an article in a paper-based journal or magazine into print. In the digital environment, it could take just seconds to do so after the piece is ready to go out to the world. For timely information, as with medical developments or other scientific publication, speed can save a life. And a text published in book form will get into the hands of only those in reach of a copy of the book. But digitally published material can be had in seconds from anywhere in the world where there are computers and access to the Web. So in certain fields, instant publishing in digital form is ideal.

Additionally, some publications that are timely may need updating: sports news, news about the military's progress (or regress) in the war in Iraq, statistics of various kinds, the progress of a person or event, traffic or weather news, stock-market prices, and other kinds of developing stories. Readers seek this kind of information daily, hourly, and even more

often. Putting it into print is simply illogical, unpractical, and even impracticable. But getting it out on the Web makes sense. Publishers now have the tools to get information to their readers instantly and ubiquitously. This is a trend that will not change.

In the library world, there has long been an elusive dream of Universal Bibliographic Control. That is, having a worldwide reference tool letting people know the location of every book and pamphlet, manuscript and piece of ephemera that scholars may wish to consult. It may be truly unattainable, but one form of publishing is working to make it a reality: the online publishing of bibliographic records and finding aids. Clearly, in the world of reference, there is no substitute for digital publishing. Beyond this, the dream reaches the impossible (at least for the foreseeable future): having full-text access to everything that is under that bibliographic control. Costs are absolutely prohibitive. So is the scope of such a massive undertaking. Texts—information—are being generated at such a fast rate than no person, group, corporation, or assembly of experts can keep up with them all, let alone capture what is currently "out there."

Further, even universal bibliographic control deals only at the finding-aid level. The giant bibliographic database may help one to locate a particular title under a particular subject, but that does not mean the item is accessible, or that it has been digitized and made available over the Web. Indeed, only a tiny fraction of extant texts are accessible in digitized form.

Preservation and the Evolution of Technology

A problem in the world of digital information has been with us since main-frame computers: will the information available to us now be available in ten years, two years, next month? Websites disappear. Companies go out of business. Technology evolves at an alarming rate. Today's state-of-the-art computer is tomorrow's obsolete piece of trash. And when I say "tomorrow," I may be speaking literally without much exaggeration. On November 10, 2004, the front page of the first section of the *New York Times* had an article by Katie Hafner, which begins, "The nation's 115 million home computers are brimming over with personal treasures—millions of photographs, music of every genre, college papers, the great American novel and, of course, mountains of e-mail messages. Yet no one has figured out how to preserve these electronic materials for the next decade, much less for the ages. Like junk e-mail, the problem of digital archiving, which seems straightforward, confounds even the experts." Not merely websites, but digital information in general cannot be preserved with present technology. Cybergeniuses are working on migration, emulation, robotics, and various other ways of preserving or lengthening the life of electronically stored materials, but digital-preservation solutions seem far off.

Serious publishers who value the texts they produce, who are not merely concerned about profits but are interested in the perpetuity of the works they publish, will not rely on digital media for the preservation of their texts. Content is medium neutral: it can be digital only, print and digital (hybrid), or simply commodified into a computer game, a movie, or a TV show. Publishers know this. And for a vast number of texts, the publishers are opting for analog presentation. This is a major factor behind the increasing figures I mentioned above, showing the number of *new* titles published in the U.S. yearly and the tremendous number of in-print books available. That does not mean that there is not also an increase in the number of texts available in digital form. It just shows that we are moving more and more into a hybrid world, with mixed-media texts and with a burgeoning amount of information available in all media[6], and with a recognition that

a good portion of that information is temporary (unless it is migrated to a more stable platform than digital texts reside on).

Related to preservation, the topic of academic publishing (see below) is central to the issuing of texts in digital form. Willis H. Walters says, "Long-term sustainability should be a primary concern of librarians deciding whether to replace print subscriptions with online journal resources." He distinguishes between "permanent subscriptions and supplementary resources," and shows that six criteria should help shape the acquisition of journals: "completeness, timeliness, reliability . . . [and] legal, economic, and organizational components" (Walters 2004, 300).

Interestingly, Walters cites Drexel University, which decided to cancel a large number of its analog subscriptions in favor of digital ones because "'archival storage . . . is not part of the mission of the Drexel Library'" (Walters 2004, 300). This statement, published in October 2000, recognized that digital does not equal preservation. We have come no further today to making that equation.

But as I have indicated, many libraries, facing financial and storage problems, look to the new medium as a lifesaver, and are canceling their paper subscriptions. Walters quotes Mark Rowse, who asserts that in the humanities and social sciences, subscribing to paper-based journals makes sense, but that is not the case in the sciences, where rapid updates in scholarship are crucial to scientific disciplines and must be published in as timely a manner as possible.

The fear is that too many librarians are simply burying their heads in the earth and opting for digital resources, thinking (or not giving a thought to the fact) that digital texts may have a remarkably short "shelf" life. Until a firm, reliable preservation method for digital materials is developed, it may be short-sighted of the publishing industry and those who patronize it to be willing to give up hard copy.[7]

Digital Publishing in the Academic World

Willis Regier, director of the University of Illinois Press, says that while there is a strong push within the publishing world—especially for non-profit publishers like university presses—to go digital with all of their publications, the authors are equally strongly demanding hard copy (2004). Authors want books, offprints, and physical artifacts to send to colleagues, to show to students and researchers, and to cite (where online resources do not guarantee any longevity for citation as books and analog journals do). Further, Regier says that Web publication offers practically no chance for cost recovery as does hard-copy publishing. At least with physical objects to sell, there could be some income, while digital publications cannot be secured and generally will not be remunerative. Additionally, analog materials can be archived more securely than can digital texts (Regier 2004).

Regier does point out that authors (and the presses themselves) wish for quick publication, and administrators and librarians look for the advantages that online publication can offer (including speed of publication and reduced costs when physical objects are not being produced). He adds, however, that there is the perceived "digital divide" in which the privileged will have access to digital materials while the less fortunate will not. He says that new technologies are being developed faster than most users (especially many libraries and the general populace) can handle or afford. And there is a copyright problem: who will own and control online texts? While many of these issues encourage the production of online texts, many militate for analog publication.

One other point worth making concerning the resistance of many scholars to online publication is that promotions are often tied to the publication of *books*, not online texts. Peter Monaghan, in "Presses Seek Fiscal Relief in Subsidies for Authors" (2004), notes that

the 90 or so university presses in the U.S. are being pressured from above (by administrators) to go digital or shut down operations, while they are being pressured from below (by faculty) to continue to publish books. The professors must "publish or perish," and book-form, paper-based publishing carries more weight with tenure committees (and scholarly book reviewers) than does digital publication. Many academic presses are losing money because of high-production costs and low sales, but they are constrained to continue to publish books.[8]

As I have mentioned, one solution that has been around for many years is that universities and other institutions that support academic research create a pool of money to provide subsidies for authors to help offset the costs of publishing. The university publishing world is at an impasse on these issues at present, but for the moment even most of the financially challenged university presses continue to publish books.

Another feature of academic publishing—and, in particular, the publication of textbooks—is bundling of print with digital materials. For the last, say, ten years some publishers have figured out a way to increase the cost of their textbooks by "bundling" a CD with the book. The CD may be useless (as it often is in the humanities, when instructors themselves are not interested in the contents on the disk). Some may be useful, containing a large amount of information in a compressed form. But CDs cost only a few cents to produce, and the added costs when they are included with books can be well beyond "cents."

Readers' Preferences

The received wisdom is that people prefer to read from paper rather than from computer monitors. Studies have shown that people prefer alphabets with serifs over sans-serif faces. Miles Tinker, one of the most prolific scholars on the *Legibility of Print*—he is credited with nearly 100 studies on the subject—says, "A serifless type . . . is read as rapidly as ordinary type, but readers do not prefer it," and he says that hundreds of years of conditioning, along with the extra "information" that the serifs impart, make us more comfortable with serifs than we are with non-serif typefaces," (1963, 64–66). As comfort with reading with serifs is inured in us, so are we accustomed to and comfortable with reading from paper surfaces. Since the advent of computers, say for the last 25 years, people have pretty much taken this as a truism. However, young folk from the Gen Z world have been born into a computer culture. Even the Gen X'ers had a balance between books and computers in their experience. Nowadays, the truism is challenged by the fact that millions of people seem to be perfectly comfortable reading digital texts.[9] So the so-called paper preference seems to be fading, and publishers seem to be less worried about whether their clientele want paper-based texts.

Texts that Do Best in Digital Form

For sustained reading, perhaps no medium matches the printed page (books, newspapers, magazines, journals, etc.) for ease, legibility, convenience, portability, and so forth. But some texts are destined to be (and already are being) published in digital form. Statistics that need to be updated, weather information, breaking news that cannot wait for print, reference guides of all kinds, any text that is in the process of being produced that would benefit from the input of others worldwide, texts with expensive visuals, and texts that do not require long-term preservation, are excellent candidates for digital publishing. If one needs to preserve the information for consultation, or to carry it with her

where carrying a computer is impractical and impracticable, or if one needs instant information that can be discarded once it has been used, digital publication makes sense. And if a scholar needs at his fingertips a vast number of facts, from many books and magazine texts, and needs them while traveling from place to place, having it all in digital form makes it all portable and accessible.

Further, the interactivity of the medium allows for many minds to have input in the creation of, and, in some cases, in the storage of the information. If a scholar needs to merge, juxtapose, or otherwise manipulate data or information, images and even sounds, digital format is ideal. Publishers with an ability to do market research know what their clientele need, and they will supply it if it is cost effective, remunerative, and practicable. If publishing in electronic form is the best choice, publishers will choose it.

Desktop Publishing

When we try to foresee "the future of publishing in the digital age," we must look equally at the development of related technologies. Publishing in analog form required a sizable infrastructure in which the publisher needed authors, editors, reviewers, printers, paper, ink, cloth, glue, type or some other way of transmitting the intellectual matter onto the physical matter, binders, advertising channels, distributors, and so forth. The technology of all of these has evolved, with each new development supposedly allowing for one of three things (and perhaps for two or even all three of them): lower cost, quicker production, higher quality. With digital publishing much of that infrastructure is done away with.

But with this evolution, production has become easier not only for traditional publishers, but also for each person. Perhaps starting with mimeograph machines that allowed science-fiction fan clubs to produce their own fanzines, and moving through early dry-copying machines (the Xerox® technology), to massive conglomerations like FedEx Kinko's, which centralizes all the technology one might need to get a text into print, the world of publishing has made it easier and easier for anyone to be a publisher.

While the notion of desktop publishing has long suggested the production of paper-based texts—anything from a broadside to a little pamphlet to a book to a multivolume set—the new technology expands that notion since we no longer need a physical object to contain the intellectual materials being made public. The old view mentioned above that a book was two different things—content and container—has evolved to a newer one in which the container is cyberspace, electronic impulses, a computer hard drive, the Internet, or some other ethereal phenomenon. Publishing is, after all, just getting materials out to the public, regardless of the way it is done.

'Zines

For more than eighty years, the phenomenon of 'zines (originally called 'fanzines' for 'fan magazines') has been a part of the underground publishing world. The earliest ones, mostly in the field of science fiction, were home-published items. Thousands of titles emanated from mimeograph machines all over the country, a good many containing the first and early publications of writers like Arthur C. Clarke, Isaac Asimov, Phillip K. Dick, and Ray Bradbury. These newsletters still exist, but are now joined by e-zines— Web-based texts with the potential for instant worldwide circulation. They are usually modeled after print-based magazines, and some can be had in both media, though most are in digital form only.

This is one of the branches of future publishing. And as with the issue of authenticity of print versus digital texts in books, there is no way to know how accurate or reliable anything in a 'zine is without fact checking or contacting the producer and learning of his sources, when that is possible. Since these do not rely on the traditional publishing infrastructure, they may have a life of their own, and will "sell" whether the book superstores exist or not. If someone wants a print copy, he may download it. If not, he may delete it, or store it temporarily in some digital form.

Budding authors do not have to go through the agony of the standard publishing channels to get their words into "print." They can be instantly published with a worldwide audience, and at minimal cost. The nature of the e-zines, thus far, is that most of them are of the peripheral kind, appealing to narrow niche audiences, so publication through a commercial firm is not practical, either for the author or for the publisher. So though these are proliferating, they will probably not have much impact on the future of "standard" publishing.

Legal Challenges

The e-zine phenomenon points out the extent to which the electronic world has entered the publishing industry. When there was only print, the field of copyright ownership was so complex and protean that a major industry of copyright law emerged to protect the rights of owners of text rights (publishers, authors, or their heirs). With court cases and legal analysis over the decades, the refinements of the copyright code now must be seen in huge texts, laying out the laws, practices, principles, and legal fine points. With the coming of the digital world, the topic has become hotter and more complicated. Who owns a picture, a musical composition, or a sentence on the Web? How can anything be controlled? With the ability to cut and paste, delete, move, augment, use Photoshop, and change sounds, pirates can appropriate anything on the Web and use it for their own purposes, usually without getting caught, or, if caught, with no penalty.

But with the expansion of Web-based publishing, it is clear that the problems of the digital presentation of texts have not been a deterrent to those wishing to be published. There seems to be a new attitude about much publishing, not at all with respect to profit, but more with respect to the desire to see one's texts published. With only a few exceptions, authors know they will make no money by publishing on the Web, but they do so anyway. The idea that someone can appropriate an author's text (visual, verbal, or aural) for his own use without much or any reprisal seems to have reduced the issue of the legal status of text ownership. In a few cases, as with the Disney empire, copyright is upheld, with the company pursuing illegal appropriations of its characters, plots, and images.[10] But it takes a great deal of money to do this, and few parties can afford such vigilance and the costs of prosecution.

The ELO

The Electronic Literature Organization, an international organization of authors that is based at UCLA, is dedicated to publishing texts only in electronic form. One significant feature of the literature they publish is that it is interactive: readers can interact with it, changing it, shaping it, and creating unique texts from what the author has published. The authors create in digital formats texts that are not fixed—not fixed even in their electronic forms. For instance, one poem might be written on several "layers" at once, and the reader selects a single layer to read, pausing at any given word by pressing a key that

transfers her to another level. The text then picks up at the other level, either at the beginning of that level or at the same point in that level at which she left the first level. The poem might also have links to other poems, prose pieces, or visuals, to yield an infinite number of possible "texts." Further, the texts can be linked to visuals or music or voice-overs. This is only one of incalculable possibilities for interactive literary texts. The question is: What is the *text?* Can a single version be captured and downloaded? Can hundreds upon hundreds be downloaded or replicated? One might say to a second reader, "I loved that poem. Go read it." It would be practically impossible for the second reader to recreate the experience of the first one. Preservation for such a protean phenomenon is equally challenging.[11]

What does the ELO offer? To begin with, its authors create texts that are interactive, unique, endless, and imaginative. Also, like digital publishing in general, the texts can be accessed anytime, from anywhere in the world. And equally thrilling is that they can be on several levels (three or more texts running parallel, above, or below, or even within each other) and with images and sound. For example, some have music and/or voices accompanying the written words. Publishing has always been seen as a multi-medium phenomenon, but now, with the advent of new technologies, several media can all be part of a single, ubiquitous text. When we talk about the future of publishing, such phenomena must be considered. It is a hybrid, unique form, but nonetheless, it yields what the criteria for "publishing" require: texts, in some accessible format, created by an author (or authors).

Collecting

As I have mentioned, profit is a driving force in publishing. Thousands of book collectors look forward to the next Tom Clancy novel or the next book on Oriental carpets. As with textbooks, publishers have niche markets that bring in money, and they are certainly unwilling to forego the income to be had from collectors of first editions or hundreds of other fields. Such a strong incentive will help to insure the perpetuation of analog book production.

Further, with modern technology being what it is, producing multiple variants of books is trivial. Recently in a large chain bookstore, I saw, just inside the main entrance, a cardboard rack of paperback books—the latest Stephen King novel. The rack held books five across, seven down, in little piles. And each file of books was bound in a different-color cover. Other than that, the books were identical. The publisher knew of the rapacity of the King collector, who would want at least one copy of every manifestation of the writer's books. This selling ploy practically guarantees the sale to many collectors of at least six copies of the book: the hardbound version and one each of the paperbacks. (Perhaps also a reading copy, since the maniacal collector would want the collected volumes to remain in pristine condition.) This kind of selling strategy underlies the idea that publishing in book form has a solid future.

[Inconclusive] Conclusion

Let me conclude optimistically (as I see it): 1) publishing has a strong future, both in analog and digital form, 2) digital publishing will certainly not displace or supersede analog publishing, 3) with two powerful media at work and prospering in their own ways, analog and digital publishing have become not only parallel but also intersecting phenomena that can coexist comfortably, 4) it will take perhaps fifty years to sort out the legal

ramifications of ownership of all kinds of texts published in digital form, 5) the longevity of print is more secure than is that of digital materials, and it may be necessary for the analog world to step in—at least for now—to help preserve that in digital form that needs preserving (and can practically be preserved), 6) with the coming of the digital age, the notion of publishing has evolved into something far more complex than anyone could have imagined thirty years ago, and 7) with the proliferation of technology, no one knows where we are headed or what publishing might look like—how it will be done—in the future.

NOTES

1. One example of this "nostalgia" is the return of the turntable and the use of "vinyl" records. On the issue of new versus old technologies, Paul Duguid (1996) discusses the notion of "supersession—the idea that each new technological type vanquishes or subsumes its predecessors." His analogy likening the book to the pencil and to the hinge is telling. All are devices superseded by other technologies, but they all survive because they *work*, and because, in many respects, they cannot be improved upon. He says that "claims of supersession are, above all else, a significant marketing ploy. Rapid technological development has increased pressure to sell the new on the heels of the old, no matter how durable the old. . . . The new, by implication, doesn't merely replace the old; it supersedes it." He says that this narrow view does not consider "the resilience of the old." See Duguid 1996, 135–44.

 The "new technology driving out the old" notion is sometimes so inured in people's minds that we find statements like that of Sven Birkets, paraphrased by Brigitte Frase in her "Cassandra Complex" (2000): "We've reached a critical juncture in the transition from print culture to the screen." This obviously begs the question, simply presupposing that the transition is under way and will be completed some time soon. It does not seem to allow for the possibility that this is not really a transition from one technology to another, but the emergence of one technology that will live peacefully *beside* another.

2. Under "tactile" we have not only children's books that teach about the sense of touch (the classic example is *Pat the Bunny*), but also books for the blind using Braille or some other method of raised text that can be read using the fingers.

3. Figures published in the front matter of the annual *Books in Print* (NJ: Bowker). The precision of this number is attested to by the fact that Bowker draws its data from the number of ISBNs assigned to new books each year.

4. Over that span of twenty years, the number of publishers in the U.S. has risen from 18,200 to 73,200. (Data from Bowker, *Books in Print.*)

5. As I will discuss below, such storage of information is delicate. Multiple access now is no guarantee of *any* access down the road.

6. How much of this information could or should be captured and saved, who will do it, at what costs, and at whose expense, and who will update the material, preserve it all, and make it accessible to the world of readers who need it? These and many other questions are beyond the scope of this chapter, but they are all part of the larger picture of publishing in the future.

7. One good article reviewing issues in the field of preservation is Linda L. Phillips' and Sara R. Williams' "Collection Development Embraces the Digital Age: A Review of the Literature, 1997–2003," *Library Resources & Technical Services* 48.4 (October 2004): 273–99.

8. One concomitant force is at work in maintaining book publishing. In the U.S., the Association of Research Libraries (ARL) yearly publishes statistics about the quality and ranking of libraries. About 124 libraries appear in the ranked listing, their place being determined by a number of forces. Under the category of "Collections" they list: Volumes Held, Volumes Added, Monographs Purchased, Serials Owned and Purchased, Total Current Serials, Microforms, Government Documents, Manuscripts and Archives, Cartographic Materials, Graphic, Audio and Audio-Visual Materials, Films, and Computer Files (which they define as "Physical items of media such as CD-ROMs, magnetic tapes, and magnetic disks that are designed to be processed by a computer"). Other categories are Personnel and Public Services, Expenditures, and other University Data having to do with faculty, staff, and student programs and degrees. To maintain a high ranking—and therefore to be able

to use that ranking as a draw for the best students—libraries want to "keep their numbers up." This means having high figures in the category of Collections. Just how databases and digital materials figure into this listing and how they affect ranking are unclear. But the acquisition of paper-based materials is quantifiable, so these analog items carry a good deal of weight in the ARL rankings. Such statistics drive institutions to maintain their budgets for analog purchases and are just one additional encouragement for publishers to continue to publish *books* (Association of Research Libraries).

9. In my own experience I see a transformation. I get an e-mail newsletter every week that I wish to keep a file of. So I download the four pages. While it is printing, I read the text on the screen. As soon as the printing is done, I take the sheets from the printer, clip them together, and read the rest of the text from the paper. But recently I have grabbed the printed text and continued to read the letter from the screen. My muscles (eyes, shoulders, neck) have evolved to such a degree that it is no longer physically uncomfortable to read from the screen, and the image on my monitor—scalable to a comfortable size for my aging eyes—is quite good.

10. Ironically, Disney got to be the empire that it is by expropriating public-domain content such as the Grimm fairy tales.

11. For the ELO website, consult http://www.eliterature.org. For electronic literary texts like those produced by those in the ELO, what is it that would be preserved? A single reading of one text, several readings, the ability to keep the entire range of possible texts available?

REFERENCES

Association of Research Libraries. 2004. http://www.arl.org/stats/arlstat/ddoc.html (accessed on November 15, 2004).

Baker, B. 2004. Telephone conversation with author.

Books in Print. 1975–2004. NJ: Bowker.

Duguid, P. 1996. Material matters: Aspects of the past and futurology of the book. In *The future of the book,* edited by G. Nunberg. Berkeley, CA: University of California Press. http://www2.parc.com/ops/memibers/brown/papers/mm.html (accessed July 2004).

Electronic Literature Organization. http://www.eliterature.org. (accessed November 2004).

Frase, B. 2000. *Cassandra complex.* http:dir.salon.com/books/feature/2000/03/30/birkets/index.html (accessed July 2004).

Hafner, K. 2004. *The New York Times,* November 10, 2004. http://www.nytimes.com/2004/11/10/technology/10archive.html (accessed November 15, 2004).

JSTOR. http://www.jstor.org (accessed November 11, 2004).

Monaghan, P. 2004. Presses seek fiscal relief in subsidies for authors. *The Chronicle of Higher Education,* August 14, 2004.

Phillips, L., and Williams, S. "Collection Development Embraces the Digital Age: A Review of the Literature, 1997–2003," *Library Resources & Technical Services* 48.4 (October 2004): 273–99.

Regier, W. 2004. Interview with author, July. Champaign, Illinois.

Teague, S. J. 1980. Microform publication. In *The Future of the Printed Word: The Impact and the Implications of the New Communications Technology,* edited by P. Hills. Westport, CT: Greenwood Press.

Tinker, M. 1963. *Legibility of Print.* Ames, Iowa: Iowa State University Press.

Walters, W. H. 2004. Notes on operations: Criteria for replacing print journals with online journal resources. *Library Resources & Technical Services* 48(4):300–04.

Alex Brymer Humphreys

The Past, Present, and Future of Immersive and Extractive E-books

In evaluating the success of e-book publishing, it is instructive to distinguish between two "types" of books: immersive (books one tends to read cover-to-cover) and extractive (books one tends to use as reference). Initial forays in online publishing focused on immersive books and were largely unsuccessful. Meanwhile, extractive books have proven well-suited for electronic publication. In this paper, I evaluate representative e-book efforts within the context of this distinction. Building on this analysis, I extrapolate the evolution of this immersive/extractive e-book front into the future.

My first job out of college was at Time Warner Electronic Publishing. Four months in, I was laid off along with much of the division when the company shut down its CD-ROM initiative. The history of the publishing industry's embrace of new e-publishing technologies is littered with similar examples of fits and failures. This should not be surprising or necessarily disappointing (unless perhaps you were laid off). When a new technology emerges, it invariably takes time for the market to understand it. The first e-book was published 30 years ago, and the Internet—the medium that has most impacted the industry—has matured in the past ten years. In that time a body of experience has arisen that approaches just such an understanding of e-publishing technology. Experiments are still being conducted, but enough results are in that an analysis can help to influence future developments.

The historical success of e-publishing initiatives can be analyzed along a number of axes. My purpose in this paper is to choose one particularly illustrative axis: to evaluate the success of e-book efforts within the context of the distinction between *immersive* and *extractive* books. This analysis will show that while immersive e-books have been largely unsuccessful, extractive e-books have been proven well-suited for electronic publishing. The reason for this, as we shall see, is extractive content's natural qualities of malleability and scalability, from which many e-book benefits flow.

Definitions

First, a definition of terms and description of boundaries. By e-book, I am referring to the content delivered electronically that would previously have been delivered in the form of a physical book. This definition is broad, as it includes everything from an Asimov science-fiction novel to the latest Zagat restaurant index. In my usage, the term does not refer to the physical device used to render the content, be it a personal computer, palmtop device, or e-ink enabled contraption, it instead refers to the content itself. I have chosen to focus on e-books specifically, rather than on the more general e-publishing, which would include content previously published in newspapers, magazines, journals and other formats. Many of the lessons from the one will be applicable across the others, but that application is here not my purpose.

Immersive books are ones that the reader tends to read cover-to-cover. The purest example of an immersive book is the trade-fiction title. The reader is looking to get lost within the book, and is likely to read for extended durations. Bill Hill, a print specialist who helped develop the Microsoft Reader, uses the phrase "ludic reading" to describe this sort of reading: "Ludic reading is an extreme case of reading, in which the process becomes so automatic that readers can immerse themselves in it for hours, often ignoring alternative activities such as eating or sleeping (and even working)"(Hill 1999, 38). During immersive reading, the content's delivery mechanism disappears. The reader doesn't think about page numbers, fonts, and tables of contents while reading *Harry Potter*, the reader is thinking about the story.

Extractive books, on the other hand, are ones from which the reader pulls information.[1] Dictionaries and other reference works are examples. As opposed to ludic or immersive reading, the reader is well aware of the content's delivery mechanism throughout the process. In fact, the reader makes use of the mechanism to find the desired content. In a physical reference book, the reader uses tables of contents, alphabetical structure, and indices to find the desired content. Extractive reading typically is performed for shorter durations than immersive.

As with many seemingly either-or distinctions, there are gradations between these two poles. A reader may choose to read an extractive book cover-to-cover.[2] Likewise, a researcher may choose to treat immersive texts in an extractive manner. She may, for example, extract and tally all words with Latin roots from Hemingway's novels and compare the results with those from Faulkner's. In this paper, I will consider these gradations where appropriate—most specifically with treating immersive books in an extractive manner—but will deal mostly with the distinctions in their most pure forms.

Last, in examining the story of immersive and extractive e-books, I will focus not on the production process that creates the e-book, but on the finished product and its success in the marketplace. The production process for the two types of content does differ in significant ways, and it is likely that these differences impact in some way on the success their respective initiatives will have in the market. I contend, however, that the more significant impact is felt from how the reader interacts with the produced content, and I will focus on this aspect of the publishing process.

With these terms and scope defined, let us now examine some e-book examples through the lens of this immersion/extraction distinction.

E-book Optimism

The early optimism for e-books is well-documented, and much of it begins with Stephen King. In March 2000, Mr. King released an e-book-only novella called *Riding the Bullet*. Curious readers could download it from many websites, most of which charged $2.50 (although some sites, such as amazon.com, offered it for free). Response was immediate and extraordinarily positive. In the following month of furious interest and clogged servers, over half-a-million copies were downloaded. A flurry of reports and articles followed, crying the demise of the printed word.

In 2000, PricewaterhouseCoopers forecasted that by 2004 the e-book market would balloon to $5.4 billion and would account for one-sixth of the publishing market. A contemporary but less sanguine report by Arthur Anderson predicts just over half that revenue and market share (Thompson 2005, Chapter 12). It is 2004 at this writing, and even the Arthur Anderson report appears ludicrously off. The Open eBook Forum, a trade and standards organization dedicated to electronic publishing, compiles sales statistics from numbers self-reported from e-book publishers and retailers. OEB reports total e-book revenue through the first two quarters of 2004 at $6,243,033 (Open eBook Forum 2004), less than one-fifth of one percent of what had been predicted just three years earlier.

What went wrong? First, Mr. King's great success was unique and may have distracted reporters from what was happening in the rest of the market. *Riding the Bullet* may have been downloaded 500,000 times, but its publisher, Simon & Schuster, reported that its second most popular title led to just 35,000 downloads (Burk 2001). A "successful" e-book would sell 1,000 copies. The fact that *Riding the Bullet* was available at prices ranging from free to a quarter of the price of trade paperback book played a role, too; the vast majority of e-books were priced similarly and, in some cases, higher than physical books.

Second, we should recognize the scope of these numbers: like the industry they report on, they focus on downloadable e-books. They do not include money received from subscriptions to a web-published content that previously had been published in a physical book. In short, they exclude important extractive e-book content.

This bias is consistent with the thinking at the time, which myopically focused on the immersive. In *Books in the Digital Age*, John Thompson quotes a managing director of a small publishing firm: "We have got Microsoft backing to convert some of our titles. . . . We deliberately chose books that were more on the trady side of the list because that was what Microsoft wanted. But they haven't done an awful lot—I think they generated less than $2,000 since last August [nine months previous], when they were put up there" (Thompson 2005, Chapter 12). When Random House shut down its e-book imprint, its spokesman said, "I think we did a great job of putting together a program that would have made good e-books available had people been buying e-books in any real numbers" (Kirkpatrick 2001, Chapter 14). Of course, the e-book titles the imprint had featured were almost exclusively immersive.

Barnes & Noble

The experience of Barnes & Noble's e-book initiative is particularly illustrative of these immersive biases and their impact. In 1999, B&N's Steve Riggio and Microsoft's Dick Brass agreed on an e-book partnership wherein Microsoft would create the technology and bn.com would implement the platform and provide a sales channel. In August 2000, the product launched, giving users the ability to download books in the

doclit format, which they would then be able to read in Microsoft's Reader desktop application. In October of the same year, bn.com gave its users the ability to download books in the Adobe format as well. They also had been distributing books in Gemstar's RocketBook format for some time. Negotiations with Palm were begun but never completed.

In 2001, particularly after September 11, it became apparent that the market for e-books sold in the B&N manner had been overestimated. The most successful e-book sold 10,000 in a year. The strongest sold in the hundreds or even up to 1,000 in a week, and then dropped off the list the following week. These numbers, however, were mere blips compared to store sales for B&N—hardly worth the effort to create them. The division began trimming down in 2001. In 2003, the last e-book employee was let go, and the division was shut down. The last e-book was downloaded on December 9th of that year. At the time Daniel Blackman, a bn.com vice president, said, "Sales did not take off as we and many others expected." He said that the lack of a user-friendly reading device was a major contributing factor in the failure and contrasted the e-book market with digital music after the success of the user-friendly iPod. He also pointed the finger at publishers for releasing too few, or too expensive e-books, saying that there needed to be "an incentive for customers to buy an e-book instead of a printed book." (Albanese 2003, S4)

Blackman's listed factors are a good place to start when analyzing the failure of B&N's e-book effort. His first, the lack of an iPod-like reading device, is a good point. The iPod revolutionized digital music because it overcame the hurdles inherent in other devices. Importantly, this list of hurdles includes those held by non-digital devices. The iPod was small and supremely portable. It could store far more content than competing products, both digital and analog. Its Digital Rights Management (DRM) model was relatively open and very easy to use. And it combined all these features into one elegant package. The contrast is stark between this and the e-book devices with which B&N was working. Most of the e-books downloaded from bn.com were eventually read on desktop or laptop computers, neither of which is as portable as a simple physical book. Computers—and in most cases, e-book devices like the RocketBook—can certainly store a large number of books, but acquiring the books was too cumbersome. The files (particularly for Adobe's format) were large and took a long time to download. There was no way, as there was with iPod's mp3s, for a reader to create their own e-book content from books they already own. The DRM model for e-books was very prohibitive. For Microsoft titles, it required the implementation of Microsoft's Passport system, which, at the time, was at its inception. In the words of one B&N e-book manager, this made the downloading of Microsoft e-books "a real pain in the ass." It is telling that Microsoft saw expanding the user base for Passport as more of a priority than eliminating hurdles for e-book users. Last, an e-book, once purchased, could not freely or easily be moved between a user's computers, in fact, this issue was the single most common issue sent to bn.com's e-book customer service. We will return to many of these issues later when we speculate what an "iPod for Reading" might look like.

Blackman's other factor contributing to the closing of B&N's e-book initiative is that publishers sold too few books at too expensive a price. This hints at but does not fully describe the problem with B&N's available content. The fundamental problem was that those deciding what content to include tried to apply bookstore reasoning to the new medium. This led to problems in what content they chose and what prices they set. B&N took what content was provided by publishers and Microsoft, who spent several million dollars to purchase copyrights and convert content to the doclit format. B&N made strong

recommendations regarding content, but these suggestions were neglected by both Microsoft and publishers. One B&N e-book manager told me: "We looked at sales and used a little common sense and recommended a lot of reference-based content, travel and business titles, general nonfiction stuff. Then Microsoft takes their several million dollars and goes off and we don't hear about it for six months until we find out they've licensed all of Michael Crichton's books. We just scratched our heads." The sales of e-books on bn.com supported these recommendations. The most successful titles were Susan Miller's astrology books. Customer service reported that users wanted content including travel, digested business content, pronunciation guides, guides to colleges (all extractive content). B&N would recommend these titles to publishers, and publishers continued to focus almost exclusively on trade-fiction titles and continued to set the prices as equal to, and in some cases higher than, the print-book price. It was clear, however, that customers saw an e-book as worth somewhat less than a physical book, and were not willing to pay the same price. In the end, immersive e-book content simply conveyed fewer benefits and more detriments over the physical book.

MLA Bibliography

This equation reverses with extractive content, such that the detriments of the physical book are overcome, and new benefits are added. Another extended example will help to understand this. The Modern Language Association (MLA) published the first *MLA International Bibliography* in 1922. The Bibliography catalogs all research done in literature, language, linguistics and folklore across the media of journals, books, and dissertations. Naturally, this resource began its existence as a physical book: a series of well-indexed books published yearly. The yearly collections would index a year's worth of scholarly activity. Due to the constraints set by typesetting, printing, and distribution, an article or book may take up to two years to be included in the physical version of the Bibliography.

In 1980, the MLA began to move its content onto computers in order to organize it. They created a new taxonomy called the Classified Indexing and Faceted Taxonomy, or CIFT, to assist them in organizing the content digitally. They sold the first digital version of the Bibliography—a mainframe database operating in Dialog—in 1981. In the early nineties, the Bibliography became available on CD. A few years later, it was first released on the Internet. It is currently available for purchase in book and CD form, and for subscription over the Web. A subscription to the Web version gives you all historic content along with the most recent updates. Ten updates to the Web content are released a year, keeping the site current with scholarly activity.

Revenues on MLA physical book sales are still substantial enough to financially justify its existence. The physical Bibliography market is primarily international, where Web access, particularly at public institutions like libraries, is slower and less reliable. While the MLA continues to profit from physical book sales, they now represent a tiny percentage of the revenue generated by the Bibliography. Not only have sales shifted from physical the electronic delivery, but electronic delivery has grown the market sufficiently to fund a 50% growth in Bibliography staff in the past five years. A manager at the MLA told me that they will cease printing the physical book and move completely to electronic delivery when the market tells them to.

A comparison of the experience in using the physical and the electronic Bibliography will illustrate why the market has so naturally moved toward the electronic. To work with

the physical book, a researcher must first locate and acquire the books. This usually means a trip to the local library, and a search through the library's stacks. Each year in the Bibliography has its own book, which means that a researcher must look up the same subject for every year they want their research to cover. This could mean repeating a search eighty times. Once the researcher has settled on a year, she must look up her subject in the heavy book. The first Bibliography, covering research done prior to 1922, made this a real challenge: it is organized by subject, but in a discursive text. Subsequent Bibliographies also organize by subject but use lists for easier browsing. Still, our researcher must hope that her classification of her subject matches the taxonomy of the editors. If she is lucky, the editors have provided a blind entry (e.g., "Protest Literature, See Literature of Protest"). If she is unlucky, she has to invent alternative subject classifications. Recent Bibliographies make this less arduous by indexing separately by Subject, Classification, and Author. This helps tremendously with finding a reference, but to save space the full bibliography is only provided in one of the three sections. If our researcher finds what might be a helpful article in the Subject index, she is referred to the Classification section using an internal identification number (e.g., "2–17932"). She must then look in another book for the complete bibliography. If, finally, after deciding that the journal is reputable and the article may indeed be worthwhile, she then has to begin a completely new search through the library to find the physical article to read. Throughout the process, the physical book assists her search in small ways (certainly it would be much harder for her if, for instance, the indexes weren't alphabetical), but more than anything the book is an obstacle to be overcome as she tries to access the content she wants.

The electronic Bibliography presents a very different scenario. First, our researcher needs only access to the website. For an academic associated with a research library, this can usually be done remotely from the researcher's home or office. Once in the site, she can search all the content at once, going back to 1963—the MLA is currently indexing pre-1963 content to bring it into the online product as well. The most extreme difference between the media, however, is in the search mechanism. She can search by a great many criteria, including keyword, author, chapter title, language, publisher, year and document type. What was handled by blind entries in the physical book is handled by an automatic search-engine thesaurus on the website, which means that our researcher needn't think about it. If she enters "Protest Literature" the search engine will automatically translate that to the appropriate keyword. She can also combine searches in a way that simply cannot be done in the book (e.g., "all peer-reviewed journal articles about 'masculinity' and 'Hemingway' published in English between 1993 and 1997 in journals that my library has full-text access to, sorted by Date"). The difference between the power of the physical books and that of the online search engine is the difference between a spark and a nuclear reactor. By helping her find references she might not have otherwise, the electronic medium increases the value of the Bibliography's content.

The benefits of the medium to our researcher do not stop there. Once she has identified an article as interesting, her access to the article itself is made much easier. There are links embedded in the bibliographic entry to help find the entry. She can, for example, click to read the article in JSTOR, an online journal archive. Or she can click to find it in the library's card catalog, wherein another click will bring her to the online resource or tell her where in the stacks to find the work. Because they make use of technical library standards such as Digital Object Identifiers (DOIs) and OpenURL, these links are

updated automatically based on the library's holdings. Last, our researcher gets access to the most recent content because the website is updated regularly.

Malleability

This discussion has already elucidated some of the benefits of e-publishing extractive content, and the detriments of immersive e-content. Further discussion will be helped by introducing the two aspects of extractive content that convey its e-publishing benefits: malleability and scalability. We will discuss malleability first. Extractive content is malleable in that it consists of multiple atomic elements, the presentation of one of which is not necessarily dependent on another. To understand the definition of *niblick*, for example, it is not necessary to know that it follows *nibble* in the dictionary. Spatial context is irrelevant. Contrast this with an immersive book: a specific paragraph in *Moby Dick* must necessarily be preceded and followed by particular other paragraphs. From this essential difference flow many e-book benefits.

Having multiple atomic elements in an extractive text gives publishers flexibility in defining business models. To understand that, let's look at the inflexibility of immersive content. Immersive texts are typically read once cover-to-cover (although a reader may choose to reread it whole or in part). From the reader's perspective, the value of the work is generally limited to one single event, the cover-to-cover read of the book. This makes the business proposition for publishers of immersive text very rigid: they've got one chance per reader to profit from the text. The primary way for a publisher to affect the numbers of immersive e-book sales is by changing the price. Surely one of the reasons that that *Riding the Bullet* found so many readers was that it was priced low, a lesson many publishers forgot when pricing trade fiction for Barnes & Noble.[3]

Extractive content has quite a different value to a reader: the value of recurrent use. This gives the publisher great flexibility in defining business models, which creates a more mature market. Subscriptions (as opposed to sales) for both institutions and individuals become successful with extractive content. While it makes little sense to subscribe to the latest Robert Ludlum, it makes perfect sense for a library or lexicographer to subscribe to the Oxford English Dictionary. The value of the subscription will be achieved over time, and if at any point its value decreases, the subscription can be ended. In a 2003 article discussing emerging trends in the library e-book market, Wallys Conhaim points out that "[b]usiness models range widely now. Due to market differentiation from niche to niche, they show few signs of standardizing. They include netLibrary's checkout model and ebrary's multiuser, simultaneous access to all holdings packaged into a searchable database" (Conhaim 2003, 41). This variability is tremendously valuable to the market, as it allows each publisher to find the business model that best suits their specific needs and content.

Publishers have other options with their malleable, extractive content. They can provide some content freely (for example, abstracts), with more in-depth content available to paying readers only. They can offer the first few atomic elements at one price (or no price), and then subsequent elements at another. They can offer pay-per-view. In addition, they can divide and subdivide access to the content that in a physical book must be provided in whole. An encyclopedia of art can be divided and sold along countless axes, such as Western versus Eastern and Ancient versus Modern. This can and certainly does occur in the print-book world as well, but the ease with which it occurs is far greater in the electronic medium. The ability to divide the content (and then to recombine) gives

the last real benefit regarding extractive business models: the ability to license certain elements to other electronic distributors. There are a number of aggregators of electronic content, such as OCLC and Proquest, to which a publisher can license its content. These aggregators effectively become distributors for the publisher; their value in the market is in providing either focus or volume. A publisher, meanwhile, can choose which content investments to leverage by selling to aggregators, and which licensing opportunities risk compromising the brand and quality. This flexibility is rooted in the malleability of the original content.

All of this flexibility leads to complications with the great unresolved issue of electronic media: copyright. Most copyrights—for both extractive and immersive content—do not specify explicit electronic rights, simply because the contracts were signed in an age when it was not yet conceived. The market and the law are still debating such fundamental electronic copyright issues as fair use. Undoubtedly, the inherent complexity of extractive content makes securing electronic rights more cumbersome for it than it does for immersive content. Not only are there usually more authors and rights holders than there are for the typical immersive book, but there is also greater likelihood of having to deal with embedded rights, such as those required for quoted text or images. The business models for extractive content discussed above provide ample incentive to overcome these copyright obstacles. One suboptimal solution to this challenge has been for publishers to exclude content for which they do not own the electronic rights, be it a specific article or an embedded picture.

The concept of friction can help to understand why extractive content has more incentive to overcome these obstacles than immersive content does. Dick Brass of Microsoft used the word "friction" to describe the physical constraints inherent in redistributing a printed book—the time, effort, and cost to photocopy a book simply isn't worth it. Brass calls the e-book world "frictionless" (Peters 2001). This frictionless-ness is of great concern to publishers—they fear a world in which they no longer control the distribution of their own content. The mistake that immersive publishers have made has been to try to recreate friction in an electronic world. They have done so by creating draconian DRM systems like Microsoft implemented with Barnes & Noble. This friction, however, is not natural, and readers know it. As Scott Adams points out in a *New York Times* article on November 5, 2001, "a pirated e-book is better than the original e-book because it's identical in function, free and you don't have to give anyone your personal and financial information."

The malleability of extractive content allows publishers not just to overcome the frictionless-ness of e-publishing but to embrace it. A physical book, naturally, can be in one location at a time. By embracing the fact that the same electronic text can be read by any number of people at once, publishers can embrace new markets and business models. A subscription can be sold to a library that can then provide unlimited access to its patrons. A publisher might decide to limit the subscription to "seats" or simultaneous users, or it might decide to set its price based on the size of the purchasing institution. Either way, there is great incentive to find a solution for electronic copyright issues, and that incentive is magnified because of the recurrent-use nature of extractive content.

The last benefit that malleability provides extractive content is that it allows publishers to provide greater value by creating in-depth metadata for its atomic elements. The value of immersive content is found in the content itself. Extractive content, as we have seen, elicits value as much from the content as from the means of finding the content. Metadata—elements that describe the content—is what makes this possible. Because

extractive content is composed of multiple atomic elements, each element can be assigned any number of metadata elements to describe it, and users can then use any combination of these metadata to find and organize the content. The description of the experience of researching with the print and electronic MLA Bibliography illustrates how the electronic medium encourages additional metadata. The relative cost of adding one more field by which to search is significantly lower; in a printed book, a completely new volume would need to be printed. In the electronic world, the data need only be collected (a not insignificant task, it should be said). The readers, in turn, have far greater flexibility in applying these metadata, often in ways that even the publisher didn't foresee.

Scalability

This search power leads us from the benefits conveyed by extractive content's malleability to those conveyed by its scalability. Extractive content is scalable in that, in general, the more there is of it, the greater benefit there is to the user. Immersive content has no such quality; a reader's experience does not change when she reads twenty books or one—there is simply more of the same experience. Extractive content is wholly different. A researcher's job is made easier if she has more content available to her. As is the case in both the physical and the electronic media, researchers have always sought more data on which to base their arguments. Where the two media depart is in electronic content's greater ability to sift through vast quantities of data. Michael Hart, the founder of Project Gutenberg, an effort to digitally publish public-domain books, discussed with me the benefits of electronic content's capacity to scale: "In just one second [a reader] can search the entire eBook for whatever quotation they are seeking. . . . [Y]ou could search all of Shakespeare for everything about wedding, marriage, husband, wife, troth, etc., and then write a paper on what Shakespeare thought about marriage knowing you had every possible reference, something that before would have taken an entire career. . . . Research papers used to be 90% research and 10% thought. Now they will be 10% research and 90% thought, a much better ratio." Our researcher's experience with the MLA Bibliography upholds his thesis.

The MLA Bibliography also demonstrated the other benefit of scalability: linking. The more content there is, the more there is to link to, a great boon to the user of extractive content. Linking provides little to no benefit to readers of immersive content. Some e-book software and devices provided certain linking functionality for use with immersive content. One common feature was the ability to highlight a word and link to that word's entry in a dictionary or encyclopedia. This was not a desired feature for immersive content, almost by definition: one reads an immersive text in order to lose oneself. In fact, a 2002 survey on electronic book features sponsored by the Open eBook Forum, listed such extractive features as text search and cross-book search as more important features than a linked dictionary (Henke 2002). Linking in extractive content, meanwhile, augments the value to the reader. Due to its nature, the content is enhanced by links to both internal and external locations. The electronic medium gives publishers the ability to maintain these links for users, ensuring that they provide maximum value. As the volume of available e-content scales, links can be automatically added to content already published.

Two relatively recent developments are taking the scalability of e-content to its logical extreme: Amazon.com's Search Inside the Book and Google Print (still in beta at the time of this writing). Both companies have digitized large numbers of books. Both allow

users to access formerly unavailable digitized book content in a limited manner for free. Both use books' content to augment a user's ability to find what she is looking for. Of the two, however, Google's initiative is likely to have the greater impact. Amazon's efforts are centered on giving a user the ability to find a book to purchase; this reinforces existing usage patterns. Google Print, on the other hand, focuses on a user's ability to access information, essentially turning all books into extractive resources (the rights-approach limits the user to reading just a few pages of a book, eliminating the possibility of immersive reading). The vast scale of content available will be a tremendous resource for researchers.

The Future

Given all of this experience, how will e-books evolve? How will our immersive/extractive axis change as technology progresses? Google Print points to one such development: ongoing added volume. It is safe to predict that content will continue to be digitized and made available. Because scalability benefits use of extractive content more, this additional volume will reinforce the usage patterns already set. Volume alone, however, may become stifling. The value that Google offers to a user looking for a website is that it very effectively sorts sites by relevance. As any Web user will tell you, all content is not created equal. For example, Google helps a user find the content that is most helpful to her. Google Print alone enhances this by adding volume. One area for further development is *context*. Currently, Web search engines return only publicly available content. Google has taken some steps in providing context-specific content with Google News (which limits the context of a search to news sources), Froogle (limited to e-commerce sites), and the new Google Scholar (currently in beta, Scholar limits its searches to indexed scholarly resources, some of which are pay-per-view). It is not a stretch to imagine Google or a similar service indexing content that is truly specific to a user. This would allow a user to include her personal library, her company's documents, and her library's subscribed-to resources. Amazon.com, for example, could notify Google when a user purchases a book, whereupon Google could automatically include that book's text in a user's indexed resources. Allowing institution-specific documents presents a possible new revenue stream for Google: selling these services to the institution (including governments).

Added context within massively scaled searches does not, however, alter the immersive/extractive landscape. What future developments might occur that would alter this landscape? Is it possible that the equivalent of an iPod for reading could arise that would dramatically shift the way readers interact with their immersive e-content?

Elegance plays an important part in the iPod's success. Its user interface is simple and intuitive. It is a small, portable, attractive product. An emerging technological development may play a role in our speculative iPod's elegance: e-ink. Electronic content is currently limited by its mechanism for display: computer monitors or LCD screens. While increased resolution and better electronic typography help with potential eyestrain, the displays are designed for interactivity. E-ink presents an alternative to this. The technology works with tiny beads placed between two thin leaves. The beads are magnetic with one side colored white and the other black. A tiny electronic charge through the covering leaves shifts each individual bead so that it displays either its black or white side. With one electronic pulse, all the beads are shifted according to a specific design, which creates a display similar to a page printed from a high-quality dot-matrix printer. Neither back-lit and nor requiring electricity (except to change display), the display is more natural to the eye. Because the display is very similar to paper, it is conceivable that readers won't

expect the same interactivity as they do with LCD screens. If the interface is truly elegant and allows for simple, intuitive browsing and reading, e-ink might enable a reader to immerse herself in an e-book the way she can with a physical book.

What other features would our speculative iPod need in order to make immersive content attractive electronically? It must easily store and manage vast quantities of content. Publishers must make a wide variety of content available for use. Most important, its DRM implementation must give users the flexibility and openness that they desire. It should allow them to digitize and upload their own content as well as to move content freely between a user's systems. Ideally, it should allow users to lend their books easily to friends. Sony's Librie, the first e-book device to make use of e-ink, has an incredibly restrictive DRM approach (after 60 days of "ownership," content disappears and must be re-purchased), which was justly pilloried by critics. To achieve the same level of success as the iPod, an e-book device can't make the same mistake. This will either require sophisticated DRM software, or it will require publishers to trust their readers to act within legal constraints in a frictionless environment. Either option appears very challenging.

If all these hurdles are overcome — if an elegant, e-ink-enabled design is combined with large storage capacity and a user-friendly DRM implementation — it is likely that our iPod for reading would impact, but not revolutionize, immersive reading. Certainly, people would use it, but incrementally it solves fewer problems for users than the iPod solved for music. The combination of portability and scalability is less compelling for immersive books. While a user conceivably might want quick access to all 1,000 albums she owns, she is unlikely to read more than a few immersive books at one time. She will use our speculative device occasionally, but physical books will remain a part of her life.

It is far easier to conceive of the sunset of printed extractive content. We have seen the benefits that flow from extractive e-books' malleability and scalability. As publishers and researchers realize these benefits, it is likely that more extractive content will be exclusively published online. The devices used to access the content may change, expanding from desktop and notebook computers to palmtops and other devices as they become more wired and powerful, but the patterns in effect now will only be reinforced.

Given this, it seems that our extractive/immersive axis will remain in place for some time yet, and is likely even to be reinforced over time. It has only been thirty years since the first e-book was published on Project Gutenberg, and it has been ten years since the Internet's emergence. There have been some fits and failures during that time, some of which I have documented here, but the publishing industry collectively has arrived at an approach to e-publishing within which extractive content has flourished. There will continue to be missteps along this axis as technologies and legal issues evolve, but it is all part of our inexorable march forward.

Which brings me to you. Are you reading this article extractively or immersively? Have you dived in and read it straight through? Or are you leaping from one use of the term "e-book" to the next, having found this article by a contextual Google Scholar search? That the content itself, like most content, supports both activities is a true strength of the publishing industry, and is a testament to our collective creativity.

NOTES

1. I first heard the specific terms "immersive" and "extractive" from Niko Pfund, Academic Publisher at Oxford University Press. While the terms may be his, many people have drawn the distinction between the two types of books and reading.

2. As demonstrated by the recent book *The Know-It-All: One Man's Humble Quest to Become the Smartest Person in the World*, in which the author reads all volumes of the *Encyclopedia Britannica*.

3. That publishers should price their e-books similarly to physical books is significant. It reflects the realization that, contrary to some early optimistic reports, e-publishing does not greatly impact the cost of developing, editing, marketing, and releasing a book. The fact that customers perceived the value of immersive e-book content as less than that of a physical book was largely irrelevant to publishers setting prices.

REFERENCES

Adams, S. 2001. A cartoonist's venture into the world of e-books. *The New York Times*, November 5, 2001.

Albanese, A. 2003. B&N Bows Out of E-books, but Publishers Upbeat. *Library Journal* 128 (17):S4.

Burk, R. 2001. E-book devices and the marketplace: In search of customers. *Library Hi Tech*, 19 (5):325–331.

Conhaim, W. W. 2003. E-books are not dead yet. *Information Today* 20 (1):40–41.

Henke, H. 2002. *Survey on electronic book features*. Sponsored by the Open eBook Forum, March 20.

Hill, B. 1999. *The Magic of Reading*. http://slate.msn.com/ebooks/magic.lit (accessed November 2004).

Kirkpatrick, D. D. 2001. Random House is dropping e-book imprint, but not e-books. *New York Times*, November 9, 2001.

Open eBook Forum. 2004. *Ebook Statistics: Quarter 2, 2004*.

Peters, T. A. 2001. Gutterdammerung (Twilight of the Gutter Margins): E-books and Libraries, *Library Hi Tech*, 19:1.

Thompson, J. B. 2005. Manuscript in progress. *Books in the digital age: The transformation of academic and higher education publishing in Britain and the United States, 1980 to the present*. Cambridge: Polity.

Video Games

James Paul Gee

Learning by Design

Good Video Games as Learning Machines

This essay argues that people interested in designing and using video games for learning, inside and outside classrooms, should pay close attention to commercial games. Such games already use good theories of learning and build good learning principles into their designs. They must. Good commercial games are long, hard, and complex. If players could not learn them and keep learning as they play, no one would buy them. This essay looks at the design for learning built into a few good commercial games, namely games like Full Spectrum Warrior, Rise of Nations, and The Elder Scrolls: Morrowind. I will then discuss the implications of these design issues for how we might change the ways in which we approach teaching and learning in schools, as well as how we can create new lifelong learning opportunities for everyone.

Many good computer and video games, games like *Deus Ex*, *The Elder Scrolls III: Morrowind*, or *Rise of Nations*, are long, complex, and difficult, especially for beginners (from now on I will simply use the term "video games" for both computer games and games on platforms like the *Playstation 2*, the *Xbox*, and the *Nintendo GameCube*). As we well know from school, young people are not always eager to do difficult things. When adults are faced with the challenge of getting them to do so, two choices are often available. We can force them, which is the main solution schools use. Or, a temptation when profit is at stake—though not unknown in school either—we can dumb down the product. Neither option is open to the game industry, at least for the moment. They can't force people to play and most avid gamers don't want their games short or easy. Indeed, game reviews regularly damn easy or short games.

For people interested in learning, this raises an interesting question. How do good game designers manage to get new players to learn their long, complex, and difficult games, and not only learn them, but pay to do so? It won't do simply to say games are "motivating." That just begs the question of "Why?":

Why is a long, complex, and difficult video game motivating? I believe it is something about how games are designed to trigger learning that makes them so deeply motivating.

So the question is: How do good game designers manage to get new players to learn long, complex, and difficult games? The answer, I believe, is this: the designers of many good games have hit on profoundly good methods of getting people to learn and to enjoy learning. They have had to, since games that were bad at getting themselves learned did not get played and the companies that made them lost money. Furthermore, it turns out that these learning methods are similar in many respects to cutting-edge principles being discovered in research on human learning (for details, see Gee 2003, 2004 and the references therein).

Good game designers are practical theoreticians of learning, since what makes games deep is that players are exercising their learning muscles, though often without knowing it and without having to pay overt attention to the matter. Under the right conditions, learning, like sex, is biologically motivating and pleasurable for humans (and other primates). It is a hook that game designers own to a greater degree—thanks to the interactivity of games—than do movies and books.

But the power of video games resides not just in their present instantiations, but in the promises for the future of the technologies by which they are made. Game designers can make worlds where people can have meaningful new experiences—experiences that their places in life would never allow them to have, or even experiences no human being has ever had before. These experiences have the potential to make people smarter and more thoughtful.

Good games already do this, and they will do it more and more in the future. *Star Wars: Knights of the Old Republic* immerses the player in issues of identity and responsibility: What responsibility do I bear for what an earlier, now transformed "me" did? *Deus Ex: Invisible War* asks the player to make choices about the role ability and equality will or won't play in society: If we were all truly equal in ability, would that mean we would finally have a true meritocracy? Would we want it? In these games, such thoughtful questions are not abstractions, they are part and parcel of the fun and interaction of playing.

I care about these matters both as a cognitive scientist and as a gamer. I believe that we can make school and workplace learning better if we pay attention to good computer and video games. This does not necessarily mean using game technologies in school and at work, though that is something I advocate. It means applying the fruitful principles of learning that good game designers have hit on, whether or not we use a game as a carrier of these principles. My book *What Video Games Have to Teach Us About Learning and Literacy* (2003) lists many of these principles. Science educator Andy diSessa's book *Changing Minds: Computers, Learning, and Literacy* (2000) offers many related principles without ever mentioning video games.

Learning in Good Games

There are many good principles of learning built into good computer and video games. These are all principles that could and should be applied to school learning tomorrow, though this is unlikely given the current trend for skill-and-drill, scripted instruction, and standardized multiple-choice testing. The principles are particularly important for so-called "at risk" learners, students who have come to school under-prepared, who have fallen behind, or who have little support for school-based literacy and language skills outside of school.

The principles are neither conservative nor liberal, neither traditionalist nor progressive. They adopt some of each side, reject some of each, and stake out a different space. If implemented in schools they would necessitate significant changes in the structure and nature of formal schooling as we have long known it; changes that may eventually be inevitable anyway given modern technologies.

I list a baker's dozen below. We can view this list as a checklist: The stronger any game is on more of the features on the list, the better its score for learning. The list is organized into three sections: (a) Empowered Learners, (b) Problem Solving, and (c) Understanding. Under each item on the list I first give a principle relevant to learning, then a comment on games in regard to that principle, as well as some example games that are strong on that principle. I then discuss the educational implications of the principle. Those interested in more ample citations to research that supports these principles and how they apply to learning things like science in school should consult the references cited in Gee (2003, 2004).

Empowered Learners

Co-design

Principle: Good learning requires that learners feel like active agents (producers), not just passive recipients (consumers).

Games: In a video game, players make things happen. They don't just consume what the "author" (game designer) has placed before them. Video games are interactive. The player does something and the game does something back that encourages the player to act again. In good games, players feel that their actions and decisions—and not just the designers' actions and decisions—are co-creating the world they are in and the experiences they are having. What the player does matters, and each player, based on his or her own decisions and actions, takes a different trajectory through the game world.

Example: *The Elder Scrolls: Morrowind* is an extreme example of a game where each decision the player makes changes the game in ways that ensure that each player's game is, in the end, different from any other player's. But at some level, this is true of most games. Players take different routes through *Castlevania: Symphony of the Night* and do different things in different ways in *Tony Hawk's Underground*.

Education: Co-design means ownership, buy-in, engaged participation. It is a key part of motivation. It also means learners must come to understand the design of the domain they are learning so that they can make good choices about how to affect that design. Do student decisions and actions make a difference in the classroom curriculum? Are students helping to design their own learning? If the answers are no, what gives students the feeling of being agents in their own learning? Forced and enforced group discussions are about as far as interactivity goes in most classrooms, if it goes that far. The whole curriculum should be shaped by learners' actions and react back on the learner in meaningful ways.

Customize

Principle: Different styles of learning work better for different people. People cannot be agents of their own learning if they cannot make decisions about how their learning will work. At the same time, they should be able (and encouraged) to try new styles.

Games: Good games achieve this goal in one (or both) of two ways. In some games,

players are able to customize the game play to fit their learning and playing styles. In others, the game is designed to allow different styles of learning and playing to work.

Example: *Rise of Nations* allows players to customize myriad aspects of the game play to their own styles, interests, and desires. *Deus Ex* and its sequel, *Deus Ex: Invisible War*, both allow quite different styles of play, and, therefore, learning to succeed.

Education: Classrooms adopting this principle would allow students to discover their favored learning styles and to try new ones without fear. In the act of customizing their own learning, students would learn a good deal not only about how and why they learn, but about learning and thinking themselves. Can students engage in such customization in the classroom? Do they get to reflect on the nature of their own learning and learning in general? Are there multiple ways to solve problems? Are students encouraged to try out different learning styles and different problem solutions without risking a bad grade?

Identity

Principle: Deep learning requires an extended commitment, and such a commitment is powerfully recruited when people take on a new identity they value and in which they become heavily invested—whether this be a child "being a scientist doing science" in a classroom or an adult taking on a new role at work.

Games: Good games offer players identities that trigger a deep investment on the part of the player. They achieve this goal in one of two ways. Some games offer a character so intriguing that players want to inhabit the character and can readily project their own fantasies, desires, and pleasures onto the character. Other games offer a relatively empty character whose traits the player must determine, but in such a way that the player can create a deep and consequential life history in the game world for the character.

Example: *Metal Solid Gear* offers a character (Solid Snake) that is so well developed that he is, though largely formed by the game's designers, a magnet for player projections. *Animal Crossing* and *The Elder Scrolls: Morrowind* offer, in different ways, blank-slate characters for which the player can build a deeply involving life and history. On the other hand, an otherwise good game like *Freedom Fighters* offer us characters that are both too anonymous and not changeable enough by the player to trigger deep investment.

Education: School is often built around the "content fetish," the idea that an academic area like biology or social science is constituted by some definitive list of facts or body of information that can be tested in a standardized way. But academic areas are not first and foremost bodies of facts; they are, rather, first and foremost, the activities and ways of knowing through which such facts are generated, defended, and modified. Such activities and ways of knowing are carried out by people who adopt certain sorts of identities—that is, adopt certain ways with words, actions, and interactions, as well as certain values, attitudes, and beliefs.

Learners need to know what the "rules of the game" are and who plays it. They need to know how to take on the identity of a certain sort of scientist, if they are doing science, and operate by a certain set of values, attitudes, and actions. Otherwise they have no deep understanding of a domain and surely never know why anyone would want to learn, and even spend a lifetime learning in, that domain in the first place.

Ironically, when learners adopt and practice such an identity and engage in the forms of talk and action connected to it, facts come free—they are learned as part and parcel of being a certain sort of person needing to do certain sorts of things for one's own pur-

poses and goals (Shaffer 2004). Out of the context of identity and activity, facts are hard to learn and last in the learner's mind a very short time, indeed.

Manipulation and Distributed Knowledge

Principle: Cognitive research suggests that for humans, perception and action are deeply interconnected (Barsalou 1999a, 1999b; Clark 1997; Glenberg 1997; Glenberg and Robertson 1999). Thus, fine-grained action at a distance—for example, when a person is manipulating a robot at a distance or watering a garden via a Web cam on the Internet—causes humans to feel as if their bodies and minds have stretched into a new space (Clark 2003). More generally, humans feel expanded and empowered when they can manipulate powerful tools in intricate ways that extend their area of effectiveness.

Games: Computer and video games inherently involve action at a (albeit virtual) distance. The more and better a player can manipulate a character, the more the player invests in the game world. Good games offer characters that the player can move intricately, effectively, and easily through the world. Beyond characters, good games offer the player intricate, effective, and easy manipulation of the world's objects—objects that become tools for carrying out the player's goals.

Example: *Tomb Raider, Tom Clancy's Splinter Cell*, and *ICO* allow such fine-grained and interesting manipulation of one's character that they achieve a strong effect of pulling the player into their worlds. *Rise of Nations* allows such effective control of buildings, landscapes, and whole armies as tools that the player feels like "god." *Prince of Persia* excels both in terms of character manipulation and in terms of everything in its environment serving as effective tools for player action.

One key feature of the virtual characters and objects that game players manipulate is that they are "smart tools." The character the player controls—Lara Croft, for example—knows things the player doesn't, for instance, how to climb ropes, leap chasms, and scale walls. The player knows things the character doesn't, like when, where, and why to climb, leap, or scale. The player and the character each have knowledge that must be integrated together to play the game successfully. This is an example of distributed knowledge, knowledge split between two things (here a person and a virtual character) that must be integrated.

A game like *Full Spectrum Warrior* takes this principle much further. In this game, the player controls two squads of four soldiers each. The soldiers know lots and lots of things about professional military practice, for example, how to take various formations under fire and how to engage in various types of group movements in going safely from cover to cover. The player need not know these things. The player must learn other aspects of professional military practice, namely what formations and movements to order, when, where, and why. The real actor in this game is the player and the soldiers blended together through their shared, distributed, and integrated knowledge.

Education: What allows a learner to feel that his or her body and mind have extended into the world being studied or investigated, into the world of biology or physics, for example? Part of what does this are "smart tools," that is, tools and technologies that allow the learner to manipulate that world in a fine-grained way. Such tools have their own built-in knowledge and skills that allow the learner much more power over the world being investigated than he or she has unaided by such tools.

Let me give one concrete example of what I am talking about. Galileo discovered the laws of the pendulum because he knew and applied geometry to the problem, not

because he played around with pendulums or saw a church chandelier swinging (as myth has it). Yet it is common for liberal educators to ask children innocent of geometry or any other such tool to play around with pendulums and discover for themselves the laws by which they work. This is actually a harder problem than the one Galileo confronted—geometry set possible solutions for him and led him to think about pendulums in certain ways and not others. Of course, today there are a great many technical tools available beyond geometry and algebra (though students usually don't even realize that geometry and algebra are smart tools, different from each other in the way they approach problems and the problems for which they are best suited).

Do students in the classroom share knowledge with smart tools? Do they become powerful actors by learning to integrate their own knowledge with the knowledge built into their tools? The real-world player and the virtual soldiers in *Full Spectrum Warrior* come to share a body of skills and knowledge that is constitutive of a certain type of professional practice. Do students engage in authentic professional practices in the classroom through such sharing? Professional practice is crucial here, because, remember, real learning in science, for example, is constituted by *being a type of scientist doing a type of science*, not reciting a fact you don't understand. It is thinking, acting, and valuing like a scientist of a certain sort. It is "playing by the rules" of a certain sort of science.

Problem Solving

Well-Ordered Problems

Principle: Given human creativity, if learners face problems early on that are too free-form or too complex, they often form creative hypotheses about how to solve these problems, but hypotheses that don't work well for later problems (even for simpler ones, let alone harder ones). They have been sent down a "garden path." The problems learners face early on are crucial and should be well-designed to lead them to hypotheses that work well, not just on these problems, but as aspects of the solutions of later, harder problems, as well.

Games: Problems in good games are well-ordered. In particular, early problems are designed to lead players to form good guesses about how to proceed when they face harder problems later on in the game. In this sense, earlier parts of a good game are always looking forward to later parts.

Example: *Return to Castle Wildenstein* and *Fatal Frame II: Crimson Butterfly*, though radically different games, each do a good job of offering players problems that send them down fruitful paths for what they will face later in the game. They each prepare the player to get better and better at the game and to face more difficult challenges later in the game.

Education: Work on connectionism and distributed parallel processing in cognitive science has shown that the order in which learners confront problems in a problem space is important (Clark 1989; Elman 1991a, 1991b). Confronting complex problems too early can lead to creative solutions, but approaches that won't work well for even simpler later problems. "Anything goes," "Just turn learners loose in rich environments," and "No need for teachers" are bad theories of learning, and are, in fact, the progressive counterpart of the traditionalists' skill-and-drill.

Learners are novices. Leaving them to float amidst rich experiences with no guidance only triggers human beings' great penchant for finding creative but spurious pat-

terns and generalizations that send learners down garden paths (Gee 1992, 2001). The fruitful patterns or generalizations in any domain are the ones that are best recognized by those who already know how to look at the domain, know how the complex variables at play in the domain relate and interrelate to each other. And this is precisely what the learner does not yet know. Problem spaces can be designed to enhance the trajectory through which the learner traverses them. This does not mean leading the learner by the hand in a linear way. It means designing the problem space well.

Pleasantly Frustrating

Principle: Learning works best when new challenges are pleasantly frustrating in the sense of being felt by learners to be at the outer edge of, but within, their "regime of competence." That is, these challenges feel hard, but doable. Furthermore, learners feel—and get evidence—that their effort is paying off in the sense that they can see, even when they fail, how and if they are making progress.

Games: Good games adjust challenges and give feedback in such a way that different players feel the game is challenging but doable and that their effort is paying off. Players get feedback that indicates whether they are on the right road for success later on and at the end of the game. When players lose to a boss, perhaps multiple times, they get feedback about the sort of progress they are making so that at least they know if and how they are moving in the right direction towards success.

Example: *Ratchet and Clank: Going Commando, Halo,* and *Zone of the Enders: The Second Runner* (which has different difficulty levels) manage to stay at a "doable," but challenging level for many different sorts of players. They also give good feedback about where the player's edge of competence is and how it is developing, as does *Sonic Adventure 2 Battle. Rise of Nations* allows the player to customize many aspects of the difficulty level and gain feedback of whether things are getting too easy or too hard for the player.

Education: School is often too easy for some kids and too hard for others, even when they are in the same classroom. Motivation for humans lies in challenges that feel challenging but doable, and in gaining continual feedback that lets them know what progress they are making. Learners should be able to adjust the difficulty level while being encouraged to stay at the outer edge of, but inside, their level of competence. They should gain insight into where this level is and how it is changing over time. Good games don't come in grade-levels that players must be "at." They realize that it doesn't matter when the player finishes or how he or she did in comparison to others—all that matters is that the player learns to play the game and comes to master it. Players who take longer and struggle longer at the beginning are sometimes the ones who, in the end, master the final boss most easily.

There are no "special" learners when it comes to video games. Even an old guy like me can wander the plains of Morrowind long enough to pick up the ropes and master the game. The world doesn't go away, I can enter any time, it gives me constant feedback, but never a final judgment that I am a failure, and the final exam—the final boss—is willing to wait until I am good enough to beat him.

Cycles of Expertise

Principle: Expertise is formed in any area by repeated cycles of learners practicing skills until they are nearly automatic, then having those skills fail in ways that cause the learners to have to think again and learn anew (Bereiter and Scardamalia 1993). Then

they practice this new skill set to an automatic level of mastery only to see it, too, eventually be challenged. In fact, this is the whole point of levels and bosses. Each level exposes the players to new challenges and allows them to get good at solving them. They are then confronted with a boss that makes them use these skills together with new ones they have to learn, and integrate with the old ones, to beat the boss. Then they move on to a new level and the process starts again.

Games: Good games create and support the cycle of expertise, with cycles of extended practice, tests of mastery of that practice, then a new challenge, and then new extended practice. This is, in fact, part of what constitutes good pacing in a game.

Example: *Ratchet and Clank: Going Commando, Final Fantasy X, Halo, Viewtiful Joe,* and *Pikmin* do a good job of alternating fruitful practice and new challenges such that players sense their own growing sophistication, almost as an incremental curve, as the game progresses.

Education: The cycle of expertise has been argued to be the very basis of expertise in any area. Experts routinize their skills and then challenge themselves with the new problems. These problems force them to open up their routinized skills to reflection, to learn new things, and then to integrate old and new. In turn, this new integrated package of skills—a higher level of mastery—will be routinized through much practice. Games let learners experience expertise, schools usually don't. The cycle of expertise allows learners to learn how to manage their own lifelong learning and to become skilled at learning to learn. It also creates a rhythm and flow between practice and new learning and between mastery and challenge. It creates, as well, a feeling of accumulating knowledge and skills, rather than standing in the same place all the time or always starting over again at the beginning.

Information "On Demand" and "Just in Time"

Principle: Human beings are quite poor at using verbal information (i.e., words) when given lots of it out of context and before they can see how it applies in actual situations. They use verbal information best when it is given "just in time" (when they can put it to use) and "on demand" (when they feel they need it).

Games: Good games give verbal information—for example, the sorts of information that is often in a manual—"just in time" and "on demand" in a game. Players don't need to read a manual to start, but can use the manual as a reference after they have played a while and the game has already made much of the verbal information in the manual concrete through the player's experiences in the game.

Example: *System Shock 2* spreads its manual out over the first few levels in little green kiosks that give players—if they want it—brief pieces of information that will soon thereafter be visually instantiated or put to use by the player. *Enter the Matrix* introduces new information into its "on demand" glossary when and as it becomes relevant and useable and marks it clearly as new. The first few levels of *Goblin Commander: Unleash the Hoard* allow the player to enact the information that would be in a manual, step by step, and then the game seamlessly moves into more challenging game play.

Education: If there is one thing we know, it is that humans are not good at learning through hearing or reading lots of words out of contexts of application that give these words situated or experiential meanings. Game manuals, just like science textbooks, make little sense if one tries to read them before having played the game. All one gets is lots of words that are confusing, have only quite general or vague meanings, and are quickly forgotten. After playing the game, the manual is lucid and clear because every word

in it now has a meaning related to an action-image and can be situated in different contexts of use for dialogue or action. The player even learns how to readjust (situate, customize) the meanings of game-related words for new game contexts. Now, of course, the player doesn't need to read the manual cover to cover, but can use it as reference work to facilitate his or her own goals and needs.

Lectures and textbooks are fine "on demand," used when learners are ready for them, not otherwise. Learners need to play the game a bit before they gets lots of verbal information and they need to be able to get such information "just in time" when and where they need it and can see how it actually applies in action and practice. Since schools rarely do this, we are all too familiar with the well-known phenomenon that students who earn A's because they can pass multiple-choice tests cannot apply their knowledge in practice.

Fish tanks

Principle: A fish tank can be a little simplified ecosystem that clearly displays some critical variables and their interactions that are otherwise obscured in the highly complex ecosystem in the real world. Using the term metaphorically, fish tanks are good for learning: if we create simplified systems, stressing a few key variables and their interactions, learners who would otherwise be overwhelmed by a complex system (e.g., Newton's Laws of Motion operating in the real world) get to see some basic relationships at work and take the first steps towards their eventual mastery of the real system (e.g., they begin to know to what to pay attention).

Games: Fish tanks are stripped down versions of the game. Good games offer players fish tanks, either as tutorials or as their first level or two. Otherwise, it can be difficult for newcomers to understand the game as a whole system, since they often can't see the forest because of the trees.

Example: *Rise of Nations'* tutorial scenarios (like "Alfred the Great" or "The 100 Years' War") are wonderful fish tanks, allowing the player to play scaled down versions of the game that render key elements and relationships salient.

Education: In traditional education, learners hear words and drill on skills out of any context of use. In progressive education, they are left to their own devices immersed in a sea of complex experience, for example, studying pond ecology. When confronted with complex systems, letting the learner see some of the basic variables and how they interact can be a good way into confronting more complex versions of the system later on. This follows from the same ideas that give rise to the well-ordered problems principle above. It allows learners to form good, strong, fruitful hypotheses and not go down garden paths by confronting too much complexity at the outset.

The real world is a complex place. Real scientists do not go out unaided to study it. Galileo showed up with geometry, ecologists show up with theories, models, and smart tools. Models are all simplifications of reality and initial models are usually fish tanks — simple systems that display the workings of some major variables. With today's capacity to build simulations, there is no excuse for the lack of fish tanks in schools (there aren't even many real fish tanks in classrooms studying ponds!).

Sandboxes

Principle: Sandboxes in the real world are safe havens for children, which still look and feel like the real world. Using the term metaphorically, sandboxes are good for learn-

ing: if learners are put into a situation that feels like the real thing, but with risks and dangers greatly mitigated, they can learn well and still feel a sense of authenticity and accomplishment.

Games: Sandboxes are game play much like the real game, but where things cannot go too wrong too quickly or, perhaps, even at all. Good games offer players sandboxes, either as tutorials or as their first level or two. You can't expect newcomers to learn if they feel too much pressure, understand too little, and feel like failures.

Example: *Rise of Nations'* "Quick Start" tutorial is an excellent sandbox. You feel much more of the complexity of the whole game than you do in a fish tank, but risks and consequences are mitigated compared to the "real" game. The first level of *System Shock* 2 is a great example of a sandbox—exciting play where, in this case, things can't go wrong at all. In many good games, the first level is a sandbox or close to it.

Education: Here we face one of the worst problems with school: it's too risky and punishing. There is nothing worse than a game that lets you save only after you have gone through a whole long, arduous level. You fail at the end and have to repeat everything, rather than being able to return to a save partway through the level. You end up playing perfectly the beginning of the level over and over again until you master the final bits. The cost of taking risks, trying out new hypotheses, is too high. The player sticks to the tried-and-true well-trodden road, because failing will mean boring repetition of what he or she already well knows.

Good games don't do this. They create sandboxes in the beginning that make the players feel competent when they are not ("performance before competence") and thereafter they put a moratorium on any failures that will kill joy, risk taking, hypothesizing, and learning. Players do fail, of course; they die and try again, but in a way that makes failure part of the fun and central to the learning.

In school, learners, especially so-called "at risk" learners, need what Stan Goto (2003) has called "horizontal learning"—that is, time to "play around," to explore the area they are about to learn, to see what is there and what the lay of the land is, before they are forced up the vertical learning ladder of ever-new skills. They need always to see failure as informative and part of the game, not as a final judgment or a device to forestall creativity, risk taking, and hypothesizing.

Skills as Strategies

Principle: There is a paradox involving skills: People don't like practicing skills out of context over and over again, since they find such skill practice meaningless, however, without lots of skill practice, they cannot really get any good at what they are trying to learn. People learn and practice skills best when they see a set of related skills as a strategy to accomplish goals they want to accomplish.

Games: In good games, players learn and practice skill packages as part and parcel of accomplishing things they need and want to accomplish. They see the skills first and foremost as a strategy for accomplishing a goal and only secondarily as a set of discrete skills.

Example: Games like *Rise of Nations, Goblin Commander: Unleash the Hoard,* and *Pikmin* all do a good job at getting players to learn skills while paying attention to the strategies these skills are used to pull off. *Rise of Nations* even has skill tests that package certain skills that go together, show clearly how they enact a strategy, and allow the player to practice them as a functional set. The training exercises (which are games in them-

selves) that come with the *Metal Gear Solid* and *Metal Gear Solid: Sons of Liberty* are excellent examples (and are great fish tanks, as well).

Education: We know very well that learning is a practice effect for human beings—the conservatives are right about that, we humans need practice and lots of it. But skills are best learned (often in sets) as strategies for carrying out meaningful functions that one wants and needs to carry out.

Sounding out letters, together with thinking of word families and looking for sub-patterns in words, work best when they are seen as functional devices to comprehend and use texts. It's not that one can't get reading tests passed by drilling isolated skills out of context—one certainly can. But what happens is that we then fuel the so-called "fourth-grade slump," the long-known phenomenon in which children seem to do all right learning to read (decode) in the early grades (at least in terms of passing tests), but then cannot handle the complex oral and written language they confront later in the content areas of school (e.g., science, math, social studies, etc.) (Chall, Jacobs, and Baldwin 1990; see the papers in the special issue of the *American Educator* 2003, devoted to what they call the "fourth-grade plunge").

These children aren't learning to "play the game"—and the game in school is ultimately using oral and written language to learn academic areas, each of which uses language far more complicated than our everyday vernacular forms of language. Learners need to know how skills translate into strategies for playing the game.

Understanding

System Thinking

Principle: People learn skills, strategies, and ideas best when they see how they fit into an overall larger system to which they give meaning. In fact, any experience is enhanced when we understand how it fits into a larger meaningful whole. Players cannot view games as "eye candy," but must learn to see each game (actually each genre of game) as a distinctive semiotic system affording and discouraging certain sorts of actions and interactions.

Games: Good games help players see and understand how each of the elements in the game fit into the overall system of the game and its genre (type). Players get a feel for the "rules of the game"—that is, what works and what doesn't, how things go or don't go in this type of world.

Example: Games like *Rise of Nations*, *Age of Mythology*, *Pikmin*, *Call of Duty*, and *Mafia* give players a good feel for the overall world and game system they are in. They allow players to develop good intuitions about what works and about how what they are doing at the present moment fits into the trajectory of the game as a whole. Players come to have a good feel for and understanding of the genre of the game they are playing (and in *Pikmin*'s case, this is a rather novel and hybrid genre). *Metal Gear Solid* and *Metal Gear Solid: Sons of Liberty* come with training exercises that strip away the pretty graphics to make clear how the player is meant to read the environment to enhance effective action and interaction in the game. If players stare at the pretty fish in the island paradise of *Far Cry*, they'll die in a minute. Players have to think of the environment they are in as a complex system that must be properly understood to plan effective action and anticipate unintended consequences of one's actions.

Education: We live, in today's high-tech, global world, amidst a myriad of complex systems; systems that interact with each other (Kelly 1994). In such a world, unintend-

ed consequences spread far and wide. In such a world, being unable to see the forest for the trees is potentially disastrous. In school, when students fail to have a feeling for the whole system that they are studying—when they fail to see it as a set of complex inter-actions and relationships—each fact and isolated element they memorize for their tests is meaningless. Further, there is no way they can use these facts and elements as lever-age for action, and we would hardly want them to, given that acting in complex systems with no understanding can lead to disasters. Citizens with such limited understandings are going to be dangers to themselves and others in the future.

Meaning As Action Image

Principle: Humans do not usually think through general definitions and logical principles. Rather, they think through experiences they have had and imaginative recon-structions of experience. You don't think and reason about weddings on the basis of gen-eralities, but in terms of the weddings you have been to and heard about and imaginative reconstructions of them. It's your experiences that give weddings and the word "wedding" meaning(s). Furthermore, for humans, words and concepts have their deepest meanings when they are clearly tied to perception and action in the world.

Games: This is, of course, the heart and soul of computer and video games (though it is amazing how many educational games violate this principle). Even barely adequate games make the meanings of words and concepts clear through experiences the player has and activities the player carries out, not through lectures, talking heads, or general-ities. Good games can achieve marvelous effects here, making even philosophical points concretely realized in image and action.

Example: Games like *Star Wars: Knights of the Old Republic*, *Freedom Fighters*, *Mafia*, *Metal of Honor: Allied Assault*, and *Operation Flashpoint: Cold War Crisis* do a very good job at making ideas (e.g., continuity with one's past self), ideologies (e.g., free-dom fighters vs. terrorists), identities (e.g., being a soldier), or events (e.g., the Normandy Invasion) concrete and deeply embedded in experience and activity.

Education: This principle is clearly related to the "Information 'just in time' and 'on demand'" principle above. For human beings, the comprehension of texts and the world is "grounded in perceptual simulations that prepare agents for situated action" (Barsalou 1999a, 77). If you can't run any models in your head—and you can't if all you have is verbal, dictionary-like information—you can't really understand what you are reading, hearing, or seeing. That's how humans are built. And, note, by the way, that this means there is a kinship between how the human mind works and how video games work, since video games are, indeed, perceptual simulations that the player must see as preparation for action or failure.

Conclusion

When we think of games, we think of fun. When we think of learning, we think of work. Games show us this is wrong. They trigger deep learning that is itself part and par-cel of the fun. It is what makes good games deep.

For those interested in spreading games and game technology into schools, work-places, and other learning sites, it is striking to meditate on how few of the learning prin-ciples I have sketched out here can be found in so-called educational games. "Non-educational" games for young people, such as *Pajama Sam*, *Animal Crossing*, *Mario Sunshine*, and *Pikmin*, all use many of the principles fully and well. Not so for

many a product used in school or for business or workplace learning. It is often said that what stops games from spreading to educational sites is their cost, where people usually have in mind the wonderful "eye candy" that games have become. But I would suggest that it is the cost to implement the above principles that is the real barrier. And the cost here is not just monetary. It is the cost, as well, of changing people's minds about learning—how and where it is done. It is the cost of changing one our most change-resistant institutions: schools.

Let me end by making it clear that the above principles are not either "conservative" or "liberal," "traditional" or "progressive." The progressives are right in that situated embodied experience is crucial. The traditionalists are right that learners cannot be left to their own devices, they need smart tools and, most importantly, they need good designers who guide and scaffold their learning (Kelley 2003). For games, these designers are brilliant game designers like Warren Spector and Will Wright. For schools, these designers are teachers.

REFERENCES

American Educator. 2003. Spring Issue. http://www.aft.org/pubs-reports/american_educator/spring2003/index.html.

Barsalou, L. W. 1999a. Language comprehension: Archival memory or preparation for situated action. *Discourse Processes* 28:61–80.

Barsalou, L. W. 1999b. Perceptual symbol systems. *Behavioral and Brain Sciences* 22:577–660.

Bereiter, C., and M. Scardamalia. 1993. *Surpassing ourselves: An inquiry into the nature and implications of expertise.* Chicago: Open Court.

Chall, J. S., V. Jacobs, and L. Baldwin. 1990. *The reading crisis: Why poor children fall behind.* Cambridge, MA: Harvard University Press.

Clark, A. 1989. *Microcognition: Philosophy, cognitive science, and parallel distributed processing.* Cambridge, MA: MIT Press.

Clark, A. 1997. *Being there: Putting brain, body, and world together again.* Cambridge, MA: MIT Press.

Clark, A. 2003. *Natural-born cyborgs: Why minds and technologies are made to merge.* Oxford: Oxford University Press.

diSessa, A. A. 2000. *Changing minds: Computers, learning, and literacy.* Cambridge, MA: MIT Press.

Elman, J. 1991a. Distributed representations, simple recurrent networks and grammatical structure. *Machine Learning* 7:195–225.

Elman, J. 1991b. *Incremental learning, or the importance of starting small.* Technical Report 9101, Center for Research in Language, University of California at San Diego.

Gee, J. P. 1992. *The social mind: Language, ideology, and social practice.* New York: Bergin & Garvey.

Gee, J. P. 2001. Progressivism, critique, and socially situated minds. In *The fate of progressive language policies and practices,* edited by C. Dudley-Marling and C. Edelsky. Urbana, IL: NCTE, pp. 31–58.

Gee, J. P. 2003. *What video games have to teach us about learning and literacy.* New York: Palgrave/Macmillan.

Gee, J. P. 2004. *Situated language and learning: A critique of traditional schooling.* London: Routledge.

Goto, S. 2003. Basic writing and policy reform: Why we keep talking past each other. *Journal of Basic Writing* 21:16–32.

Glenberg, A. M. 1997. What is memory for. *Behavioral and Brain Sciences* 20:1–55.

Glenberg, A. M., and D. A. Robertson. 1999. Indexical understanding of instructions. *Discourse Processes* 28:1–26.

Kelly, K. 1994. *Out of control: The new biology of machines, social systems, and the economic world.* Reading, MA: Addison-Wesley.

Kelley, A. E., ed. 2003. Theme issue: The role of design in educational research, *Educational Researcher* 32:3–37.

Shaffer, D. W. 2004. Pedagogical praxis: The professions as models for post-industrial education. *Teachers College Record* 10:1401–1421.

Mark J. P. Wolf

On the Future of Video Games

This essay looks at the uses of video games in the past and then extrapolates these uses into the near future, speculating on where current directions might take them. It offers a typology of several different ways in which games are used, including the video game as entertainment, as education, as simulation, as art and experience, as narrative, as communication (for example, in MMORPGs), and as examples of Tolkienian sub-creation (the building of consistent imaginary worlds).

After forty years of existence, the video game is finally beginning to receive scholarly attention, gradually carving a niche in media studies in much the same way that film scholars in the early 20th century had to convince the academy that film was an art and not merely a novelty, passing fad, or vulgar plaything of the masses. This is partly due to a generation of scholars who grew up with video games, who know them, and their history, intimately, and perhaps who have the skills necessary to explore the games thoroughly enough to write about them. And of course, the availability of walk-throughs and cheat codes also helps.

Certainly the video game holds an important place in our cultural history. It was the public's first encounter with computers, in the form of arcade games in the early 1970s, and the first computer appliance to find its way into the home, beginning with the Magnavox Odyssey in 1972. And games also helped introduce the home computer as a recreational device, and encouraged their spread in the late 1970s and early 1980s. Even today their advances provide a reason to upgrade systems and benchmarks to measure them by. The video game was also the first medium to combine moving imagery, sound, and real-time user interaction in one machine, making them quite different from other media.

Today, video games are a multibillion-dollar-a-year industry, taking in more money than the film industry. Video games use the same actors, sets, and special effects as films do, and the video game competes at all the same locations where film and television can be found—in movie theaters, video rental stores, and on television sets as well. There's

even competition at the Academy Awards, beginning with the 1998 nomination of an animated sequence from the game *Oddworld: Abe's Exoddus* for Best Animated Short. Like film and television, the video game is just another media outlet for any given franchise.

Before we consider what future the video game has, let's first consider its origins. As a medium of entertainment, the video game found its way to the public through the arcade. There, the video game joined a long line of coin-operated machines reaching back into the 1880s: strength testers, slot machines, card machines, racing games, and other "trade stimulators," as well as the coin-operated mutoscopes and kinetoscopes that paved the way of the cinema. Probably the most well-known arcade games before video games were pinball games, which developed in the 1930s and enjoyed a golden age from 1948 to 1958. Several companies that produced pinball games, like Bally and Gottlieb, became producers of arcade video games. And, not surprisingly, many early home video-game systems featured some sort of "video pinball" among their games.

Unlike most other arcade games, however, the video game, from early on, often placed its action in some kind of narrative context, making the media akin to film and television, which were also typically narrative-based. From the 1970s onward, dozens of movies and TV shows were adapted into video games, despite the weak resemblances early games could provide due to graphical limitations. As games developed visually, more and more cinematic conventions used for storytelling were adopted by video games, including camera moves and cutting, conservation of screen direction, editing such as is found in cut-scenes, and even opening sequences and end credits. Today more than ever, games are narrative-based and have even become source materials for films.

While narrative games dominate the market, the cause-and-effect sequences in some games, like *Sim City, Railroad Tycoon, Sid Meier's Civilization,* or *The Sims,* are so open-ended that they are unlike the predetermined narratives of cinema and more like computer simulation. Computer simulation was an impetus for the development of computer graphics. In 1949, the mainframe computer *Whirlwind* became the first computer to use a cathode-ray tube (CRT) as a display. In a 1951 episode of Edward R. Murrow's *See It Now* television program, *Whirlwind* was used to demonstrate a bouncing ball program and the calculation of a rocket trajectory. The earliest video games took simulations of bouncing balls and spaceships reacting to gravity and let the user interact with them, often giving them a narrative context in the process.

Since the simulations contained in video games are interactive, the possibility for education exists. While the video game as educational tool has been somewhat slow to develop, instances of supposedly educational video games can be found even in some of the early home systems, although many of them were often educational programs given weak game premises that tried to make their learning fun, or games with rather weak educational content, perhaps designed to attempt to convince parents that their kids were doing more than just having fun and that video games really weren't all that bad.

Another context that the video appeared in was the convergence of art and technology that took place in the late 1960s and early 1970s, which valued experimentation and emphasized the idea of art as an experience rather than as merely just an object. Stylistically, video games' limited computer graphics coincided with the minimalist art movement of the period, with use of points, lines, simple geometric forms, and color fields, all animated to electronic sound effects similar to those found in electronic music of the time. Experientially, video games could literally depict events on-screen in a way that the Action Painters like Jackson Pollack could only attempt to suggest through the processes they used to create their art. Other event-based art, like Allan Kaprow's

Happenings, the Fluxus festival, light shows, performances that incorporated randomness as an essential element, and especially interactive artwork that required some input from the user, provided a context in which video games could seem at home, and to some degree, video games can be seen as an outgrowth of these artistic concerns.

As hardware and software improved, new experiences became available to the video game player. In the late 1970s and into the 1980s, home computers became linked together through Bulletin Board Systems (BBSs) and through the growing Internet. Real-time chat rooms, combined with the idea behind text adventure games, led to the rise of Multi-User Dimensions or MUDs, and other forms of online gaming in which multiple people could play together over phone lines. Video games, then, became a form of communication, a trend that increased dramatically with the development of avatars and player personae through which players interact with one another.

As video games, especially home video games and online games, grow larger and more complex, the diegetic worlds their characters inhabit also expand in breadth and detail, joining the pantheon of imaginary worlds found most commonly in fantasy and science fiction. Video games, then, are just one of the latest media for the building of imaginary worlds, or what J. R. R. Tolkien called "sub-creation," seeing as it is a form of creation that takes place within and under God's creation. And unlike books, films, and other older media, the imaginary worlds found in video games allow user interaction, drawing the player inward and giving him a stake in the events occurring on-screen.

To sum up, then, and speculate as to what the future of the video-game medium might be, we can extend and extrapolate the directions in which the video game has already been moving, looking at the video game as *Entertainment*, as *Narrative*, as *Simulation*, as *Education*, as *Art and Experience*, as *Communication*, and as *Subcreation*.

Video Games as Entertainment

Although it need not be their only purpose or function, video games have been primarily made and used for entertainment to an even greater extent than theater, film, or television, or almost any other type of media. The dominance of entertainment as the main use for the medium has obscured other possibilities, and perhaps this has been possible because of the rich vein of possibilities existing within this one function. For example, the number of venues for video games keeps increasing. Arcade games appeared outside the arcade in bars, restaurants, movie theaters, shopping malls, and almost anywhere that vending machines might be found. The video game can also combine entertainment with exercise; for example, the game *Dance Dance Revolution* is full-body aerobic exercise, and one California school has even added it to its physical education program, since the game teaches such things as balance, timing, and coordination (Smith 2003).

Other forms of games appeared in the home, first on television sets and later in hand-held units and on home computers (even within operating systems themselves), and today even on personal digital assistants, watches, and cell phones. In the future we can probably expect to find games on any interactive electronic device that has a screen. Future scholarship in this area should include a look at how the medium was adapted to each particular venue, and how its usage fits into larger studies of cultural consumption. Other speculation might include possibilities for new venues. Currently, games with larger numbers of players are found online, but other configurations are possible, for example, people playing as contestants on a television show via their cell phones. Large

gatherings of physically present players could also be explored; imagine, for example, an IMAX theater with game controls for every seat in the theater, each controlling an avatar in a larger projected screen image, allowing several hundred people to play at once, all on the same screen.

Another way the video game fits into a larger cultural framework is its role as an outlet for cross-media franchises, including tie-ins to movies, television shows, board games, card games, table-top games, novels, and so forth. Today, instead of developing works specific to a single medium, it is not unusual to find franchises developed for a range of media all at the same time. For example, the *Enter the Matrix* video game was developed at the same time as the second and third *Matrix* films, and incorporates the same actors and storylines, effects, and a budget of $20 million, far in excess of most video-game budgets. Often an entire series of games is produced, as in the *Star Wars* and *Star Trek* franchises. Questions for study in this area could examine the cross-media and merchandising strategies used, the integration of the storylines, characters and ideas between media, and the ways they might become even more tightly interwoven in the future. For example, as game graphics improve and grow more photorealistic, and film imagery becomes more and more computer generated, the appearance of both media continue to converge. Other scholarship in this area could examine audience reception and the different degrees of commitment to franchises, and how marketing is designed to reach these different levels of fandom.

I suspect that entertainment will remain the dominant use of the medium, just as it has for film and television. And, just as it is in film and television, the dominant form of that entertainment will likely remain narrative.

Video Games as Narrative

While most video games are either narrative in their organization or frame their action within narrative contexts, the adaptation of narrative to an interactive medium in which players act and make decisions has both placed limitations on storytelling as well as opened up new possibilities. In some cases, techniques little-used in literature are better suited to interaction. Second-person narration, for example, was the typical mode of address found in text adventures. Most games are oriented as first-person experiences, where the player's avatar functions as the main character in the story presented, the outcome of which depends on the player's actions. Story events, then, range from predetermined and unchanging sequences (like many events found in opening sequences), to conditional events (depending on what the player does), to randomized events (for example, the appearance of attackers or obstacles).

Writing for video games means dealing with contingencies, which at first resulted in simpler narratives or games with a low degree of interactivity. Games with low interactivity, such as games in the genre known as Interactive Movies, have typically been unpopular, allowing simpler storylines to win out. Arcade games, whose success is determined by the number of quarters per hour they take in, will probably always trade complicated storylines for fast action and state-of-the-art graphics, so it is in home games where we find narrative innovation.

Home games have expanded narrative potential through the growth in capacity of the storage media used, which moved from cartridges to floppy diskettes to CD-ROMs and now to DVD-ROMs, resulting in better pre-rendered game imagery, more narrative pathways, and a larger diegetic game-world. Other advances have overcome limitations

imposed by contingencies through the use of computer-controlled characters driven by algorithms and artificial intelligences with complex conditional behaviors, or by having large numbers of characters controlled by players, as in massively multiplayer online role-playing games (MMORPGs). Both allow for a greater variety of game events, as well as open-ended games that can go on indefinitely (like *SimCity* or any online game).

An interesting question to consider, then, is how increasing narrative possibilities will impact the scholarly study of the games themselves. Increasing amounts of time will have to be spent exploring narrative possibilities, with no guarantee that everything has been seen or experienced. Many games already are designed to take forty hours or more to complete, compared to the two-hour or so time slot that most movies fit into.

The moral and ethical worldviews that one often finds inherent in narratives like novels can also be present in video games, in the ways that actions and consequences are connected, and through the demands placed on the player that are required to keep the game from ending. The effect on the player is stronger, not only in terms of hours spent, because the player is directly involved in the decision making, unlike the passive spectator in the cinema. The effects that extended video-game playing can have on a person's worldviews and outlook is also something requiring further study.

As artificial intelligences and other game structures generate narratives through the use of algorithms, games move into another realm, that of computer simulation, which is where the future of interactive narrative will be found.

Video Games as Simulation

Although many early games had simplified simulations of physical phenomena such as gravity or ricochets, during the 1980s, games began to appear in which simulation was given a central role. Games like *M.U.L.E.* were management simulations in which players had to allocate limited resources while balancing competing needs, modeling simple economic principles. The most successful of these games appeared in 1989: Will Wright's *SimCity*, and launched a still-ongoing series of *Sim* games. While simulation-based games have objectives, like building a successful city or expanding one's empire, the overarching objective from one playing to the next is the understanding of the underlying principles and algorithms governing the simulation. Simulation games, then, can simulate systems, institutions, and even the ideologies behind them.

The study of these games should ask what kinds of ideology are operating within them, and look at how they relate not only to gameplay, but how closely they resemble the real-world systems they are intended to simulate. As simulations grow increasingly complex, a wider variety of phenomena can be modeled. *The Sims*, for example, has moved the genre from economic or political phenomena into the realm of psychology, albeit in a simplified form. Since players may play the games without consciously analyzing what kinds of worldviews are embodied in the underlying rules governing the game, the design of the game may be imparting ideas and ideologies that are subtler than those found in surface representations (for example, those of race, gender, ethnicity, and so forth). Such implications may take many hours of gameplay to substantiate, but they are likely to be central to any in-depth analysis of a game.

We might also speculate as to what ever-more-detailed kinds of systems or institutions will be simulated. Already one can play God (in *Black & White I* and *II*), create a world like Earth (in *SimEarth*), become a Latin American dictator (in *Tropico*), build theme parks, railroads, towers, ant colonies and ancient empires, or conduct war campaigns.

Perhaps someday we will see games simulating HMOs, public-school systems, nonprofit organizations, or other areas that could potentially help give some indication of the intricacies involved in social or political problem areas. Future scholarship in the area of game design should ask how such entities might be reasonably simulated within the context of a game. The more simulation is able to capture the working of real-life systems and institutions, the more video games move in the direction of education.

Video Games as Education

Even the early home game systems, including the Magnavox Odyssey and the Atari 2600, had cartridges purporting to be educational for children, though their content was fairly simple. In the home computer, educational software bridged the gap between utility software and games. Some were even spin offs of games, such as *Mario Teaches Typing*. The closest arcade ever got to being educational were several puzzle games, quiz games, and a modified version of *Battlezone* that the military wanted to use for tank training.

Today, the video game is being seriously considered as a means of education. The Games-to-Teach Project, a partnership between the Massachusetts Institute of Technology and Microsoft, is exploring ways of teaching math, science, and engineering through the use of games. They already have a set of conceptual frameworks for games, several of which are being developed into prototypes that they hope will become marketable products. Among these are *Supercharged*, which teaches principles of electromagnetism and charged particle physics, and *Environmental Detectives*, a game involving environmental engineering investigation and played on handheld PCs. Other proposed games include puzzles in optics, the effects of mass and velocity on levers, pulleys, strings and gears, and engineering principles. Still others involve psychology, viruses and immunology, history, design, architecture, and terraforming. The project also plans to look at educational networked gaming environments.

The Digital Media Collaboratory, an initiative of the I. C. Squared Institute at the University of Texas at Austin, is also working on video games as education. Two of their projects, EnterTech and Career Connect, involve simulated work environments that are used for the training of individuals entering the workforce who have not had the opportunity for education or the necessary skills for the workplace. The program has been running since the year 2000 and has been successful, and according to an article in *Syllabus*, "more than 67 percent of EnterTech graduates found jobs or enrolled in future education" (Syllabus.com 2003). Another project at the institute, "Valuation Matrices for Learning/Educational Content in Popular Games," is researching "the potential for commercially situated computer games to demonstrate educational utility" (I. C. Squared 2003).

Future research in the area of video games as education will no doubt examine what can be taught and how it can be taught through games, but it should also consider the larger cultural context, which may limit the games' effectiveness, due to the way it defines exactly what constitutes "fun." Also, how do existing video-game conventions and player expectations impact the design of educational games? As video-game technology expands into areas of virtual reality and augmented reality, new educational possibilities will also appear, and online gaming communities are another area of potential. Another question to ask is, "Who is doing the educating?" Advertisers who want consumers to learn about their products are already producing *advergames*. According to *Wired* magazine,

an *advergame* is "A downloadable or Web-based game created solely to enable product placements" (Branwyn 2001). The ideology behind the design of a game may be hidden in the code and less obvious than, say, the ideas described in a textbook. A game based on the way the economy functions or the way social groups interact will be based on theories that will vary greatly depending on the politics and beliefs of the group designing the game. Anything used as a tool of education has the potential to become a political or ideological tool as well. Of course, this can also be done covertly or overtly, and the video game can be used for artistic expression and become a form of experiential art.

Video Games as Art and Experience

Perhaps because entertainment has been the dominant function of the video game throughout its entire history, the potential function of the video game as art and experience has been the most overlooked. Earlier I described a number of artistic movements and concerns that coincided with the emergence of the video game, which the video game could be seen as extending. As a time-based visual medium, the video game possesses great potential for artistic expression. Although the medium has arguably already been used for artistic expression, the art has almost always been subject to commercial concerns, leaving much of the artistic potential untouched. An important question for future development of video games, then, is how to make the means of production more available to artists and make the technology user-friendly enough for the artist to work directly in the medium. Similar barriers were encountered when artists first began using computer technology, and it seems inevitable that they will soon begin creating video games as well.

Another area of great untapped potential lies in the graphics of video games. By definition, the video game is a visual medium, and one that combines information processing and interaction, often in such a way that one relies on the speed of the other. A large part of playing a video game involves reading and interpreting the graphics of the game, for navigation and other goal-oriented activities such as collecting or using objects and interacting with the right characters, and so on. Since the earliest games, a tension between abstraction and representation has existed in video-game graphics, resulting in games of varying difficulty as far as reading the graphics is concerned. Even the early games, with their severe graphical limitations, usually attempted to be as representational as possible. Games with deliberately abstract graphics were occasionally produced, but their numbers grew smaller throughout the 1980s and 1990s, as the representational power of the medium grew, with 1989's *Tetris* perhaps the last well-known success in the genre.

Recently, some abstraction has reappeared in video games, in the textures used for texture-mapping, although even this is arguably a representational use of abstract patterns. As for abstract games, *Rez* for the Sony PlayStation and *Tron 2.0* are perhaps a sign that the industry is slowly realizing the possibilities for fresh designs that abstraction has to offer. Games can be abstract not only in appearance but also in behavior, requiring players to learn specific rules and how to interpret events in order to play a game successfully. Abstraction, then, in both appearance and behavior, is a major area of potential for future video-game design, and one in need of further study and exploration.

In general, the function of the video game as art and experience has been little explored, perhaps because the industry has been slow to see such possibilities as commercially feasible. Artists, too, must be more willing to explore what the medium can com-

municate, and how it can be used to express ideas and experiences. Taking this a step further, we can also consider ways in which the video game is becoming a medium of communication.

Video Games as Communication

Once we admit the use of the video game as representation, simulation, and education, we can see that the medium can also be used to communicate moral and ethical worldviews as well, either deliberately or inadvertently. The video game does not merely *show* us things, it asks us to *do* things, to participate, to play. The nature of that play, however, can demand different things: aggressive behavior or cooperative behavior, quick reflexes or contemplation, problem-solving ability or hand-eye coordination, navigational ability, suspicion, strategic thinking and so forth. The different degrees to which a game requires certain actions and abilities, and how they are combined, will result in certain attitudes being encouraged over others within the game. How players are rewarded or punished for what they do, and the way causes are connected with effects, and actions are connected with consequences, will likewise suggest values for behaviors and suggest moral and ethical worldviews based on those valuations. Also, the presence of level editors and other authoring tools allow players to modify games to personify the messages they embody. Questions for future study, then, might be, "What kinds of values are most reinforced in current video game culture?" and "How can positive values be introduced into gameplay?" Considering that the audience for video games ranges from adults to young children, we might also ask how video games influence and are perceived by different age groups.

In addition to the one-way communication described above, the video game has also become a two-way means of communication, in the form of massively-multiplayer online role-playing games (MMORPGs). All of the above elements involving morals and ethics are even more influential on a player's thinking when that player is a part of a huge community of players all operating within the same gameworld subject to the same rules. In MMORPGs like *Ultima Online, EverQuest, Asheron's Call,* or *Star Wars Galaxies*, community building is a major part of play, as players make friends and enemies, forming alliances and guilds, and competing against each other individually and in groups. Many people form strong friendships with people they will never meet in person, although many online friendships do result in real-world ones, even marriages occasionally. At the same time, the many hours spent in online play may take a person away from real-world friendships and activities.

Little serious scholarly work has been done regarding life in these online communities, and represents a growing area for future research and study of the medium. As online worlds grow in detail, depth, and attractiveness, and as the real-world is perceived by many to be more dangerous and unsafe, one might expect social shifts in which online venues grow in importance and begin to have greater influence and effects on real-world events. At present, theorizing about how such online worlds function has yet to catch up to the growth of those worlds. In order to catch up, video-game theorists will have to look at MMORPGs as not just games, but as subcreated imaginary worlds.

Video Games as Subcreation

In 1939, J. R. R. Tolkien proposed the notion of "subcreation," the idea that human beings recombine concepts and elements from the universe of God's creation, "creating

under" or "subcreating" to make imaginary worlds of their own. Tolkien's own Arda, in which lies Middle-Earth, is an example of this, and examples in other media include the galaxies of *Star Wars* and *Star Trek*. These worlds are more than simply stories in that they involve their own geography, history and timelines, cultures, languages, and even their own flora and fauna, resulting in imaginary worlds that are as complete and internally consistent as the author wishes to make them.

Several large-scale video games and especially MMORPGs are moving in this direction; some online games already have more than one-hundred-thousand players, and the games take place in persistent worlds, which means they continue 24 hours a day, seven days a week. The geography of these worlds can be enormous: *Ultima Online*, for example, is said to have "more than 189 million square feet" which "would fit on approximately 38,000 17-inch monitors, roughly the size of a football field" (Ocampo 1997). Within these worlds, the buying and selling of objects has blossomed into economies, with the sale of some virtual objects and characters even occurring outside the virtual world on eBay. One researcher looking at Norrath, the kingdom in the online game *EverQuest*, has concluded that "The creation of dollar-valued items in Norrath occurs at a rate such that Norrath's GNP per capita easily exceeds that of dozens of countries, including India and China" (Castronova 2002, 3). As these virtual economies grow, they will no doubt have an increasing impact on real-world economies.

Seeing video games as subcreated worlds is one way that future scholarship will be able to regard the complexity, depth, and sheer size of these kinds of video games, as well as other games that take place in the same subcreation, such as the *Myst* series of games, or the *Star Wars* games. As the object of study grows in size, it will also be necessary to devise new ways of studying video games, and current scholarship has a long way to go to catch up to this quickly expanding medium.

In conclusion, video games represent one of the fastest-growing, and I would argue, one of the most interesting areas of media studies. The great potential variety of uses and functions of video games is already beginning to be explored, and scholarly study is struggling just to catch up to the existing games, much less the future directions they may be heading. For many players, video games represent the greatest percentage of media usage in their everyday life, and for a growing number of online players, these games have become a way of life. However one wishes to speculate about the future of media in general, it is clear that the video game is certain to play an increasingly important role.

REFERENCES

Branwyn, G. 2001. Jargon watch. *Wired*, October. http://www.wired.com/wired/archive/9.10/mustread_pr.html.

Castronova, E. 2002. Virtual Worlds: A First-Hand Account of Market and Society on the Cyberian Frontier. *CESifo Working Paper* Series No. 618, January 14.

I. C. Squared. 2003. http://www.ic2.0rg/main (accessed September 2003).

Ocampo, J. 1997. *Company announces release of Ultima Online.* http://cdmag.com/articles/005/012/uo_ships.html (accessed September 2003).

Smith, T. 2003. Video game that's good for you. *CBSnews.com*, October 6. Available at http://cbsnews.com/stories/2002/06/13/earlyshow/contributors/tracysmith/main512169.shtml.

Syllabus.com. 2003. University of Texas at Austin: Simulated workplace builds skills, confidence. *Syllabus*, July 16. Available at http://www.syllabus.com/article.asp?id=6594.

Jennifer Stromer-Galley
& Rosa Leslie Mikeal

Gaming Pink

Gender and Structure in The Sims Online

The Sims Online is a massively multiplayer online game that allows players to design avatars with recognizably human bodies, to play within houses, and to develop relationships with other players. The game offers a complicated environment for feminist social critics. On the one hand, the game reproduces feminine standards of politeness and community support and reinforces traditionally stereotypic images of female bodies and female roles. On the other hand, it invites the possibility to subvert traditional notions of patriarchy that situate woman as powerless. It is within this complicated gaming environment that women both reproduce domestic lives and shift those lives into something new.

The Sims Online—the dynamic, online game where players create avatars, build houses, make friends, and find lovers—is a problematic game for feminist social critics. The game can be dismissed as a "pink game," a game with feminine characteristics and female appeal. The avatars women play tend towards the unachievable beauty of the super model. The world they play in is a house—their own house and others' houses—that contains and structures all game play. The female players generally play the game for social interaction, flirtation, and pretend marriages with male players. Such play is reminiscent of the dollhouse play so many American women grew up with.[1]

Gender is inscribed in *The Sims Online* (as it is in all games). It is structured in the software code and is represented in the symbols that comprise the game, and players interact with that structure in gendered ways. Female players interact with the familiar metaphor of the house and generally confirm and conform to gendered roles. At the same time, the domestic sphere is the only sphere of game play and, as a consequence, privileges women's roles and communication patterns.

In the pages that follow, we dig into the gender construction in this game. We first provide background literature on girls, women, and gaming, then offer a brief exposition of the game *The Sims Online*. We then offer our ethnographic observations of the bodies and the houses that structure the game and the player's interaction with that environment. We conclude by briefly discussing the complicated, gendered environment *The Sims Online* provides.

Girls, Women, and Video Games

In this essay, we approach gaming as a constructed social practice. We examine the game environment's structure and analyze how players interact with that structure. This approach is similar to that adopted by Yates and Littleton (1999) and Webb (2001) in their studies of gaming culture. They argue that gaming research should be mindful of the interaction among the game's players, the norms and expectations they bring from their offline lives, and the structure of the gaming environment. Current research on gender and video games in particular urges examination of not only the game environment but also of the preferred readings of games-as-texts and how players *play* with the game-as-text (Humphreys 2003; Yates and Littleton 1999).

Our focus in this paper is on female players and female avatars. *The Sims* and *The Sims Online* have been noteworthy because of their popularity among female players. A Microsoft press release reports that more than 60% of *The Sims* players are female, although they comprise only 40% of all Microsoft Windows platform game players (Microsoft 2004). We ask: Why does this particular game environment draw female players?

Prior research on gender and video games has found that boys and men are much more likely to play video games than girls or women (AAUW 2000; Greenfield 1994; Subrahmanyam and Greenfield 1994), that game producers and developers are largely male (Cassell and Jenkins 1998), and that nearly 90% of video game magazine readers are male (Kinder 1996). Although this trend has reversed somewhat in recent years, a significant gap between male and female players persists. The Entertainment Software Association reported in 2003 that women and girls comprised 38% of the gaming population.

Some research suggests that many gaming environments, especially those with high levels of violence, fail to appeal to girls and women (Funk and Buchman 1996). In his study of games and entertainment among college students, Jones (2003) suggests that women might find video games less appealing in part because, "video games are also often rigid in their game options and narrative structure . . . and gender roles are stereotyped and exaggerated" (6). Other scholars point to issues like game control (Grodal 2000), social censure of game play (Funk and Buchman 1996), and even biological sex differences in game-relevant skills like mental rotation exercises (Lucas and Sherry 2004) to explain why girls and women have less interest in video games.

Other scholars point to the games themselves as aggressively marketed toward, designed by, and stereotyped for boys and men. A content analysis of 33 of the most popular video games for the Nintendo and Saga Genesis consoles suggests that in 41% of the games there were no female characters, and in 28%, female characters were portrayed as sex objects (Dietz 1998). The "save the princess" theme in many old-style, popular video games, such as *Mario Brothers* and *Donkey Kong*, are heterosexist (Consalvo 2003), emphasize a male gaze (van Zoonen 1994), and portray roles for females in a narrowly proscribed fashion (Banks 1998). Even games with female heroes, like Lara Croft in *Tomb Raider* (Subrahmanyam and Greenfield 1994) or the teenaged Buffy in the *Buffy the Vampire Slayer* video game, frequently present characters with exaggerated sexuality and "promote the martial and masculine values of domination and destruction" (Labre and Duke 2004, 152).

Perhaps women and girls are not finding what they seek in video games, in spite of tepid attempts to design and market games like Barbie *World* for girls. A study by the

AAUW Educational Foundation (2000), found that middle- and high-school girls looked for games that "allow role playing, identity experiments, and simulations to work through real-life problems" (30), and that have "ample opportunities for communication and collaboration" (32). Unlike the unsuccessful Barbie games or Nintendo's "Gamegirl," *The Sims* franchise may be appealing to girls and women because it offers those very identity experiments, role playing, and opportunities for social interaction and collaborative play.

The play that occurs in *The Sims Online* happens within a feminized environment, however. The system of interconnected meanings implicit in creating, maintaining, hosting and visiting "houses" taps into the domestic socialization familiar to many girls and women raised in the United States. The house metaphor of *The Sims Online* (TSO) structures game play and invites gendered role enactment that facilitates both in-game and player-created goals around collaborative projects, social networks, and aesthetic environments. Girls who grew up playing with Barbies, EZ-Bake ovens, and miniature tea sets find familiar themes in *The Sims* franchise; the game allows women a chance to play "house" again.

Much like designing, decorating, and populating an elaborate dollhouse, player activities in TSO are principally concerned with creating and experiencing an active social space. Thus, the game environment itself invites and structures interactions that are governed by normed and gendered expectations of behavior that girls and women grew up with. Although much game play fits squarely into traditionally feminine roles and duties, the actively social context seems to appeal to women and girls. Even if they are still making beds and washing dishes in the game, players are doing so with the possibility of meeting a stranger, gaining his/her favor, or flirting. The real pleasure received from interacting and building a sense of connection to other people cannot be easily dismissed (see T. L. Taylor 2003 for a discussion of the specific pleasure of social interaction for female gamers). Before explaining in more detail the implications of this gendered structure and culture in TSO, some background on the game is necessary.

The Sims Online

In December of 2002, *The Sims Online* appeared on the computer gaming scene. Referred to as "TSO" by players, *The Sims Online* is the massively multiplayer online version of the most successful video game ever created, *The Sims* (C. Taylor 2003). The original video game, played on personal computers, offered a life-simulation in which players create characters—human-like avatars called "sims"—that they direct and control. Players build and design houses, guide their sims through careers, romances, flirtations, marriages, and having children. Sims also need the care a player provides: food, rest, play, socializing, cleanliness, and empty bladders. The official Sims website describes the game this way: "Create your sims, build their homes, run their lives, or ruin them."

Electronic Arts, the makers of *The Sims Online*, took this concept and moved it onto a networked environment where multiple players could play in the same city and interact with each other in real time. Players have an avatar, or "sim," they design and guide to make money, acquire skills, and build a house where they can invite other players to join them as roommates or as guests. Sims travel among houses within a "city" via a hyperlinked map to live, work, and play.

A player or her sim can talk publicly with others. Such talk appears as dialogue bubbles over the sim's head. Players also can send private messages in a separate window—much like standard AOL or Yahoo! Instant Message functions—to players anywhere in

the city. Active players might have several private conversations going with players whose sims are in different houses while they engage in public chat within the house where their sim is building skill or making money.

Along with the public and private chat options, players can use their sims to provide additional context cues nonverbally. A player can use her sim to wave, vomit, throw a temper tantrum, blow smoke out of her ears, or primp. A player can use his sim to interact with another sim by giving a hug or a backrub, slapping another sim, poking him in the eyes, or giving him a pile drive. These avatar interactions supplement the chat functions; a visitor can be greeted with a text welcome and a sim handshake, adding an expressive dimension to traditional online text interactions.

Although the structure of *The Sims Online* includes basic motivations for players to make money and create successful homes, the resulting environment is less a game and more a social experience. Electronic Arts, the makers of *The Sims* and *The Sims Online*, have created the environment, but the players must define for themselves the objectives of the game. Much like an elaborate digital dollhouse, TSO calls for considerable player initiative and cooperation to generate exciting or unique events, goals, or activities.[2]

We engaged in systematic ethnographic participant observation for three months, from June 2003 until September 2003, on *The Sims Online*. Prior to this period, we were avid players of the game since its release in December 2002. We took detailed field notes of player interaction within and structured by the gaming environment. We played in two towns on TSO: Alphaville and Blazing Falls. In Blazing Falls, Rosa Mikeal played as Belladonna "Bella" Nightshade and Jennifer Stromer-Galley played as Kindra Garten. In Alphaville, Mikeal played as Belladonna "Bella" Hemlock and Stromer-Galley played as Arabella Moon. In our discussion of findings, we have changed the names of the sims involved to protect player identities.

The Gendered Body/The Gendered Self

There are now quite a number of massively multiplayer online games (MMPOGs) that involve the use of a digital avatar for game play. Players create a representation of their character, including species, gender, race, stature, and clothing in many different games. In *The Sims Online*, however, this representation is particularly influential. In contrast with typical fantasy video games, *The Sims Online* is populated almost entirely with human characters who look very much like "regular people." They wear recognizably human clothing and do not have special powers or magical natures. As a sim, players must select a gender (with the exception of two non-human options), a face/head, a skin tone (pale, medium, and dark) and an outfit. Sims are generally treated as the gender they select. Importantly, sims in TSO have a far wider range of actions and interactions than other games permit, lending an even more humanlike quality to these digital avatars. Sims are designed to be familiar, human characters, and, as such, players tend to treat them that way.

We observed that players generally construct their avatars to represent their own biological sex. Female players' avatars generally were designed to represent an idealized vision of women's bodies. The body is one of the first cues others use to determine how to behave and what the appropriate norms of interaction should be. Thus, the sexy, female avatars that populate TSO establish an environment suggestive of traditional gender roles where women play eye candy and compete for men.

Although the game allows for departure from traditional gender alignments—female

sims can propose marriage to one another, for example—most players reinforce gender expectations. Many interactions focus heavily on dating and building heterosexual relationships, following traditional norms for male and female interaction. For example, male sims produce cat-calls if two female sims kiss one another ("Cool! Two chicks kissing!"), and female sims will often hesitate to kiss males sims they do not know ("I don't kiss on the first date."). It is far less acceptable for a male sim to request a kiss from another male sim. The game structure also precludes certain gender play. For example, male sims have only one option to wear a dress, and female sims cannot wear a tuxedo.

In our game play, experiences between half and three-quarters of avatars in a given house were female. Almost all avatars had bodies that conform to traditional notions of feminine beauty (slim, curvy, and long-legged). Although a player can create an old or an overweight avatar, very few players chose those designs among the over-50 options available. Stepping into a sim "home," players are surrounded by digital representations of buxom young women wearing midriff-revealing shirts and jeans or a short skirt with sumptuous, flowing hair (of the sort featured in shampoo commercials). One of the most popular female avatar heads we called the "Farah Fawcett" head: the face was racially white, had conventionally attractive features, large eyes and lips, and a small nose. The hair was long and wavy with long bangs, and a player could choose the color of blonde, red, black, or a glittery, streaked purple. The pervasiveness of this head choice was such that when Kindra dropped in on a house specializing in cooking skill, 8 of the 10 female avatars had the "Farah Fawcett" head. Although players could subvert traditional expectations of femininity in the gaming environment by creating non-idealized body types, female players tended to select sexy bodies in line with stereotyped notions of what would please the male gaze (see, for example, Berger 1972; van Zoonen 1994).

During our research we met many types of women. These included college students, artists, professionals, entrepreneurs, and retirees. Some of the people who played most often and for the longest periods of time were housewives and stay-at-home moms. One player with whom we developed a friendship was a young mother of two small boys. "Tully" lived on the West Coast with her husband, who was in the military (she was one of the many women players we met who were military wives). Tully had enjoyed *The Sims* offline game and wanted to experience the online version. She integrated TSO into her daily routine, playing the game while her sons napped and after they had gone to bed. She would interrupt her late-night game play to tend to her youngest son when he would wake in the night needing comfort or feeding.

Many of the players we encountered had avatars that were either rough approximations of their physical bodies or sexually idealized versions of their own bodies. One player-built fan website, Realsimsonline.com, allowed TSO players to create personal pages that featured both their Sim avatars as well as pictures of their "real" selves. Both of us created personal pages, selected photos of our "real" selves, and described our TSO avatars. This website allowed us to check up on the avatars we interacted with to see photos of the player behind the avatar. One evening, Stromer-Galley spent considerable time looking up players on Realsimsonline.com whom she encountered in her game play. Two avatars she observed with attractive, but older representations, were nonetheless behaving in ways she thought to be quite immature. Much to her surprise, their descriptions and photographs on Realsimsonline.com confirmed that they were indeed players in their 50s.

House and Home

The Sims Online establishes the house as the digital environment in which players act and interact. There, they build the skills that allow their characters to grow, maintain their avatars, and interact with each other. The sim home, as the center of activity, shapes the nature of sim interaction in part because it is the principle mechanism players have to demonstrate success and the only place avatars can interact.

Although the game offers few incentives for play, one that seems to motivate players is creating a house that is popular enough to get listed in the "Top 100." Houses on this list are the most heavily trafficked by non-resident sims. A successful sim property, by this measure, must supply ample opportunities to both maintain sim health and engage in advertised activities. Property residents must be present for other sims to visit, and hosts have certain norms of hospitality they generally work hard to fulfill.

The house creates a metaphorical space in which players use real-world notions of expected behavior to guide their actions as hosts and visitors. The role of "host" invokes images of the *Good Housekeeping* wife: polite to a fault, greeting visitors warmly at the door, inviting them in to sample the just-baked treat, to sit around the coffee table and chat, or walk through the backyard garden enjoying the fruits of her labor.

In the game, such a stereotypic image is not far from the mark. A polite host will generally call a text greeting to visitors as they arrive. When a host fails in her task, perhaps because she is busy with other activities and fails to see the arrival of new guests, apologies are offered for not properly greeting sooner. Many hosts will try to remember visitors who have been there before, greeting them not simply with a "hello," or "welcome," but "welcome back." A visit by a close acquaintance or friend might even warrant halting activity to bring a sim to the door for an avatar greeting. Similarly, hosts frequently say goodbye to sims who announce they are leaving, seeing off closer friends with avatar interactions, like a kiss or hug. Sim players, male and female alike, will offer admiring comments on design or décor, and enthusiastic hosts will give friends and visitors tours of the house's special features like courtyard swimming pools, disco floors, or newly decorated bedrooms. This extra attention is a key way that hosts make visitors welcome and encourage them to spend time on their property. The game is designed to reward sims who generate high traffic with cash bonuses and higher house rankings. Performing as the model host(ess) is thus virtually required for the most successful game-play.

A vital component of host etiquette is providing services, especially maintaining food supplies for active sims. If the food has run out, hosts will hurry to cook or buy more, and apologize profusely when the delay for food is too long. Keeping bathrooms clean, beds made, and objects in good repair are also expected by guests. We observed female sims cleaning and preparing food more often than male sims, even among mixed-gender members of a single household.

Female players will even take up the role of host in others' homes. As visitors to a skills property hosted by a male sim, we witnessed a female guest who took it upon herself to do a significant amount of cleaning. The host insisted she did not need to bother, acknowledging that it was his job. When she continued to clean, he rewarded her. He used his avatar to approach her and give her a hug, then followed up with an entertaining jitterbug dance. These nonverbal interactions, with their gentle hint of flirtation, served as a reward to the generous guest for her work. Her reaction was text "laughter" and a joyous, "I should come here to clean all the time!" (Perhaps, that was what he was hoping for.)

The role of host is also one of social mediator. Hosts typically intervene when conflict arises between guests in the house. Conflict does not arise as frequently as one might expect in this anonymous environment. When it does occur, it is often dealt with through textual sanctions.[3] For example, at a skill house a player named Private Sally entered the property and was greeted by the owner of the house, Suze. Sally began demanding that the other players in the game do 100 push-ups, calling them "maggots," and declaring that they were now part of her army. Players ignored her, but after a few rounds of Sally demanding players do push-ups, Suze said, "This house isn't an army." When Sally walked over to the pool table and demanded that a "maggot" come play pool with her, Suze said, "I thought we said please in this house." When the rest of the visitors continued to ignore Sally, she left.

Suze's gentle interventions and the rest of the players' avoidance of the situation serve as an example of the gentle sanctioning that hosts often exact when players have overstepped the bounds of propriety, reminiscent of the classic stereotype of the scolding mother chiding a child who has forgotten her manners. Sally's behavior might have been particularly puzzling and annoying to players because of its strong departure from gendered norms of appropriate female behavior. Players studiously ignored Sally's attempt at role play, taking her commands literally instead of accepting them in the spirit of imaginative amusement. Although we did not see male sims playing this kind of military role, other, more gender-appropriate attempts at role play—like holding male-female weddings, males performing as DJs, or males engaging in exchanges of avatar "strength" demonstrations—received far more welcome.

The environment created by the metaphor of a house thus structures the types of interactions that occur within its walls. It is within a house's walls that women were confined and were expected to remain in U.S. society before the first woman's rights social movement of the 19th century (Flexner 1975). The house served symbolically as the private sphere within which women were the primary caretakers (Welter 1966). Contrasted with the wage-generating public sphere of post-industrial-revolution American society, the woman's household domain was constructed as less valuable and devoid of power (Reid 1934).

In TSO, the house is the only sphere within which activity can occur. Sim houses, even those that offer commercial activities, must have a "living space" with beds, toilets, showers, and a kitchen for resident and visitor sims to care for their sim's needs. This structure places *all* game activity within the traditionally female domestic sphere, and presents intriguing opportunities for women's control and power within that sphere. As a result, the game's structure complicates a critical feminist read of the game. Instead of being constructed as a marginalized, devalued contrast to the economically valued, masculine, and productive public sphere, the home is the *only* sphere. It can be constructed as the primary locus of power.

The structure of the game thus creates and reworks symbols associated with women's oppression. Houses, to which women traditionally were restricted, and bodies, which are crafted to comply with traditional notions of femininity and sexuality, comprise this environment. Yet, because the house is the only sphere of activity, it could be constructed by players as a source and site of power. Women's notions of their traditional role as homemakers might even provide advantages in game play for some female players. The question then is: Do players interact with this environment in traditionally feminine ways? In the next section we address this question more explicitly.

Behaving Like a Lady

Early research on social interaction channeled over the Internet suggested that social norms that govern behavior would be less influential online because the anonymous quality of the interaction liberates people from social strictures (Hiltz and Turoff 1978; Kiesler, Siegel, and McGuire 1984; Postmes and Spears 1998; Sproull and Kiesler 1986). Such effects might even mitigate traditional gender roles (Michaelson and Pohl 2001). In spite of this hope, however, considerable research on gender in online contexts has found stereotypic differences in male and female communication. Scholars point to differences in conversational style, including the tendency for males to talk more (Savicki, Lingerfelter, and Kelly 1996), favor more task-oriented and adversarial interactions (Herring 1993), and use more abusive or aggressive language (Savicki, Lingerfelter, and Kelly 1996).

In the strongly gendered spaces of TSO and its avatars, Michaelson and Pohl (2001) observe that the "weakening" of gender roles is not apparent. However, the relationship between player power and traditionally feminine behavior is unclear. Indeed, in spite of the presence of traditionally gendered norms in conversation, the online environment of TSO privileges feminized speech and style over masculinized ones in many cases. The implications of gendered interaction in this game depart somewhat from suggestions that male *dominance* is reproduced in online contexts. Instead, we observe some in-game dominance derived from traditionally feminine role enactment. In the next two sections, we detail our observations to illustrate the prevalence of feminized speech.

Social Interaction

Public conversation is the mainstay of entertainment in *The Sims Online*. Because fulfilling the in-game goals of skill building or money making is slow and monotonous, lively conversations within a house can evolve, and players get to know each other as their sims lift weights or take naps. Field notes from game play underscored how boring we both found much of our time on TSO. To ease the tedium of watching one's avatar reading a book or making preserves, public chat with other players passed the time.

In *The Sims Online*, where women seem to outnumber men, the predominant conversational style is a feminized one. Herring's (1994) research suggests that women and men exhibit distinct communicative habits when communicating through Internet-mediated channels. She argues that "women and men have different communicative ethics—that is, they value different kinds of online interactions as appropriate and desirable" (1). She explains that women consider the needs and wants of the person with whom they are communicating and work to make conversation partners feel liked.

Herring (1994) also observes that those who are the non-dominant gender in the communication environment will adopt the communication patterns of the dominant gender. She writes, "It is tacitly expected that members of the non-dominant gender will adapt their posting style in the direction of the style of the dominant gender." This occurs in part, she explains, because "[users] must adapt in order to participate appropriately in keeping with the norms of the local list culture" (4).

The feminized style of interaction among players (both men and women) that we observed in TSO served some important functions in the game space. It helped players to save face, build popularity, and negotiate a social environment in which most players are strangers to one another. We also noted that feminized style was made manifest in the communication pattern of politeness. As Bonvillain (2002) notes, "women typically

use more polite speech than do men, characterized by a high frequency of honorific . . . and softening devices such as hedges and questions" (139).

In TSO, expectations of politeness are strong guides for appropriate and inappropriate behavior. The notion of polite behavior among sims is reinforced largely with sanctioning, and sometimes with criticizing behavior. The politeness standards in TSO were also clearly visible in player profiles and were more prominent among female than male sims. Profiles from female sims included comments like "please be polite" or "Dislikes: Rude people." When sims acted in ways that fit with notions of politeness, they were more quickly accepted, praised, and thanked for their actions. When sims acted contrary to these norms, they were occasionally scolded, kicked out of properties, or even got into avatar-to-avatar fights. Players seemed to use real-world standards of politeness to determine which behavior fits or counters these norms, and new players could integrate themselves into these environments by drawing on notions of politeness from the real world. Players' abilities to comply with these norms influenced not only their enjoyment of the game and engagement with social activities, but also contributed to their performance on in-game measures like group money-making.

As an example, Kindra was in a money house making telemarketing phone calls. Two sims, a male and a female, were sitting across from each other at the telemarketing table. The male sim started teasing the female sim, demanding that she swear and talk dirty to him. She refused, and was clearly annoyed by his aggressive approach. The homeowner intervened, telling the male sim to "be nice." After another, more gentle round of teasing, he backed off. When he asked the female sim if she was mad at him, she said that he had been "mean" to her. He then apologized.

Players that transgress norms of politeness too far might even be removed or banned from a house. For example, one male sim visitor moved among players in a money house, turning them into enemies with the violent action of ripping out their sims' hearts. Repeated demands that he stop were met with explanations that "it was fun to do" and "just a joke." The offending sim was eventually kicked out and banned from the house.

Because the structure of TSO made cooperation with other players virtually a necessity for game play, politeness influenced how successful a player was in her endeavors there. Players that subverted notions of polite behavior, even within imaginative role play, found they were not welcomed or valued.

Flirtation and Sexuality

Much interaction in TSO focused on flirtation and sex, perhaps because the interaction occurred within a house—the sphere of reproductive activity. Game play within a house invites behaviors appropriate and expected within the house, including building and maintaining social as well as sexual relationships. Indeed, many of the options built into the game for avatar interaction are sexual in nature, from innocent pecks on the cheek to sexy dances and hot kisses. The environment also provided the necessary accoutrements for courtship—including hot tubs, the dance floor, restaurants, and the love bed—and for marriage—from cake to bridal dress to priest costume—so that players can role-play fantasy relationships.

In general, players chatted and flirted quite a bit with one another. Avatars were used to shift the meaning of comments, and were used when players were interested in getting to know each other better. For example, in a skill house, one sim approached our avatar after a brief text exchange of humorous quips. The interested sim bowed and danced for Bella, and followed up his actions with the comment, "A bit of fun for the

lovely lady?" After Bella responded, "Why thank you, sir!" to indicate approval of this comment, he then used the "Sexy Wiggle" action and commented, "More fun, perhaps?" His sexy action shifted this comment from a benign one to a flirtation.

Social interaction in TSO is largely influenced by offline social norms that identify boundaries between appropriate and inappropriate sexual comments and behavior (Mikeal and Stromer-Galley 2003). From our observations, female sims had considerable leeway in flirting with one another, while male sims studiously avoided the appearance of homo-erotic play. Female-female flirtations, however, seem to hold a significantly different position in TSO. We frequently observed and participated in sexualized avatar interactions and comments with other female sims—actions that generated no negative comments at all, even among sims obviously uncomfortable with male-male flirtation. For example, Bella was greeted by a sim friend with a "hot kiss" upon entering a house, prompting an admiring comment from a male sim, "Ooh! Girls kissing! Lol."[4] Later, that sim was involved in a public discussion of how it was "gross" when male sims kissed each other.

This gendered difference in flirtation norms parallels the presentation of lesbian scenes in mainstream imagery as commodities for heterosexual male consumption (Reichert, Maly, and Zavoina 1999), but unlike that in traditional media content, female-female eroticism in TSO is under complete control of the women themselves. Although from this initial study we cannot conclude the extent of women's sense of power or control in this context, these patterns suggest that women feel some freedom to play, subvert, and counter expected gender roles surrounding flirtation.

The Thin Pink Line Between Virtual and "Real"

Sometimes the lines between offline and online relationships became blurred. One evening at a cooking-skills house, we overheard a conversation between guest Sasha and host Suzanne. Sasha explained that she was going to divorce her husband, because she had learned he was cheating on her with another woman. At this point, it seemed the conversation was about their offline lives. Then, Sasha explained she knew he was cheating because she received private messages from three different sims asking her why she was with their man. From this point, it was clear Sasha was talking about a sim husband. Sasha explained that she had confronted him about the situation, and that he had become defensive. He told her their relationship wasn't real, she explained. He would not date her if they knew each other offline, because she was deaf. Suzanna replied that his comment was rude. Sasha agreed and then said she wasn't looking for anything with him either because she was engaged to be married in real life. Their conversation ended at that point.

This exchange reveals the thin boundaries between in-game and out-of-game relationships. From the actions of the avatar, one would not know that the player navigating it was deaf. Sasha's in-game husband and she had enough interaction to have acquired detailed, personal information about each other. Sasha seemed to have developed a real bond with her sim-husband. Her discovery of his infidelity triggered real anger and pain, and she confronted him. Their role-playing as sim-husband and sim-wife was shattered, and the grounds of their interaction shifted from pretend to real when he said he would not date her if they had met outside of the game context.

Such interactions, especially with roommates or sim-lovers, move easily between game encounters to e-mail, instant message, or face-to-face encounters. One player shared a story of meeting another sim, getting married, creating a house together, and then splitting up. She and her sim-husband began e-mailing outside of the game after

their sim-marriage, then telephoning weekly to talk. She found herself growing increasingly attracted to this man, and she decided as a consequence to end the sim-relationship because it was starting to interfere with her relationship with her husband. She confided that they planned to meet in person in the near future, though she was earnest in stating they were meeting "only as friends."

Some women played TSO with their husbands. The dynamic of game play with a spouse complicated their interactions both in the game and out of it. When Kindra Garten first entered the town of Blazing Falls in TSO, she was quickly enticed to become roommates at a house with a real-life husband and wife team. Eon and Heather, who used their real names as their avatar names, were trying to build a "100 Most Popular" house. As a roommate, Kindra was required to keep the house "open" for visitors when they could not be there. Kindra found that one of them was usually there. During the game play, Kindra learned a great deal about her two roommates. Heather was a housewife, Eon worked in computers. This was their second marriage. Eon had a son from a first marriage who lived with his ex-wife, and he and Heather had an 8-year-old daughter who would join them in the game periodically.

The dynamic of a husband and wife team in a game environment in which people can flirt and have pretend sex in the "love bed" proved complicated. Eon flirted mercilessly with the sexy avatars (and the players behind them) when Heather was not around. When Eon was at work and Heather was in-game, she complained to Kindra about Eon's philandering. At one point, she had decided to stop playing, because she could not handle her husband's flirtations with other avatars/players. She found it stressful, and it was affecting their relationship when they were not playing the game. She did not quit, though. Instead, she and Eon had an argument about it, and she urged him to stop his flirtatious ways. He promised to do so. After Kindra had moved out to start a house with Bella, she stopped by the old house. Eon was there flirting with another sim. He asked Kindra to keep his flirtations a secret as his avatar went upstairs for a romp in the love bed.

The boundary between the domestic house and the sim house was thin for some players. Women, such as Heather, cleaned houses and cooked for guests, worried about the actions of their husbands, and wished for acknowledgement and appreciation offline and online. If part of the seduction of games is the escape from daily life, it can be hard to imagine why some women retreat to a place that reproduces much of their daily lives. On the other hand, the vitality and prevalence of strong social connections—extending even to well-organized sim dating services—makes relationships crucial to successful and entertaining game-play for many players. In this arguably traditional woman's world, where social connections are the life-blood of social power, the blurred line between simulated and real relationships may well contribute to women's feelings of control over their lives.

Conclusions

The gendered sim bodies and the game play within the confines of the house structure the roles women enact in *The Sims Online*. The game environment invites and rewards interactions that are governed by normed and gendered expectations of behavior found in offline contexts. Moreover, one can see that the metaphor of the house shapes how players interact with the game environment and with each other. Players generally structure their interactions to align with appropriate behavior as visitors or hosts.

Although the gaming environment reproduces a largely traditional domestic environ-

ment, there are exceptions. Some players invert traditional activities and behavior to create contexts that break with mainstream gendered norms. For example, we attended weddings that started off as familiar, traditional affairs, but then ended as pile-drive wrestling free-for-alls among priest, bride, groom, and guests. Our house resided near a gay "neighborhood" within which lesbian and gay players created environments supportive and celebratory of alternative sexual and gender identities. We participated in and witnessed female-to-female sexual encounters. Norms of politeness, especially those surrounding visitor and host behavioral norms, often require both male and female players to behave in more feminized ways to be successful players, and frequently women excel in TSO. Although politeness is a strongly reinforced norm in this space, it is unclear whether a wide range of traditionally gendered norms apply and whether traditional norms result in the male dominance found in other gaming contexts (Herring 1993).

Thus, The Sims Online serves as a problematic case for feminists. It is similar to the problem of romance novels (Radway 1984), and soap operas (Ang 1985; van Zoonen 1991), two cultural products that reproduce stereotypes and cultural themes potentially destructive for women that also provide pleasure to the women who consume them. Similar to romance novels or soap operas, the environment of The Sims Online could be read critically as reproducing a stereotypic environment for women, and could be tossed into the "pink game" category—a game that is geared towards feminine sensibilities (T.L. Taylor 2003). Worse, we could declare women players as ideologically duped into co-participating in a sexist system. Our research suggests, however, that although TSO is a highly feminized space, it may also offer alternative avenues for self-expression and power for women.

From our observations, it is clear that TSO players understand the symbols of the house, the domestic role that entails, and the traditionally sexualized bodies as parts of an acceptable, normal reality. To borrow Radway's (1984) words, "they accept patriarchy as given, as the natural organization of sex and gender" (10). However, perhaps as a result of the strong norms governing polite interaction and sexuality and the intrinsic game-generated value of the household, women in TSO seem to have a very real sense of power. The environment of the home places all game play in the household domain, traditionally the one where "woman rules the roost."

This initial investigation into gender in TSO suggests, on the one hand, that the game reproduces feminized standards of politeness and community support and reinforces traditionally stereotypic images of female bodies and female roles. On the other hand, it invites the possibility to subvert traditional notions of patriarchy that situate woman as powerless. In TSO, woman is powerful. It is within this complicated environment that the game occurs, pink though it may be, for women to both reproduce domestic, offline lives, and shift those lives into something new.

NOTES

1. It is important to note, however, that *The Sims* franchise, especially the offline version, is the top-selling game of any kind, across all video-game genres (with the exception of games like solitaire or Tetris, generally not included in this category). Women and men alike have made this game overwhelmingly popular.

2. TSO has not been as successful as *The Sims*. Approximately 125,000 people bought the game and paid the $9.95 per month access charge to play the game in 2003 (Pham 2003), which is many fewer players than Electronic Arts hoped for.

3. We were only able to witness public sanctioning, although we learned through an interview that some

hosts prefer to sanction inappropriate behavior privately.

4. The "lol" is used here to signify laughter, usually good natured. It stands for "laughing out loud."

REFERENCES

AAUW. 2000. Teach savvy: Educating girls in the new computer age: AAUW Educational Foundation Commission on Technology, Gender, and Teacher Education, http://www.aauw.org/member_center/publications/TechSavvy/TechSavvy.pdf.

Ang, I. 1985. *Watching Dallas: Soap opera and the melodramatic imagination.* London: Methuen.

Banks, J. 1998. Controlling gameplay. *M/C: The Journal of Media & Culture* 1 (5). http://journal.media-culture.org.au/9812/game.php.

Berger, J. 1972. *Ways of seeing.* London: British Broadcasting Corporation.

Bonvillain, N. 2002. *Language, Culture, and Communication: The Meaning of Messages.* 4th ed. Upper Saddle River, New Jersey: Prentice Hall.

Cassell, J., and H. Jenkins. 1998. Chess for girls? In *From Barbie to Mortal Kombat: Gender and computer games,* edited by H. Jenkins. Cambridge, MA: MIT Press.

Consalvo, M. 2003. It's a Queer World Afterall: Studying *The Sims* and Sexuality. New York: GLAAD Center for the Study of Media & Society.

Dietz, T. 1998. An examination of violence and gender role portrayals in video games: Implications for gender socialization and aggressive behavior. *Sex Roles* 38 (5/6):425–442.

Entertainment Software Association. 2003. Game players are a more diverse gender, age and socio-economic group than ever, according to new poll. http://www.theesa.com/8_26_2003.html.

Flexner, E. 1975. *Century of struggle: A woman's rights movement in the United States.* Rev. ed. Cambridge, MA: Harvard University Press.

Funk, J. B., and D. D. Buchman. 1996. Playing violent video and computer games and adolescent self-concept. *Journal of Communication* 46 (2):19–32.

Greenfield, P. M. 1994. Video games as cultural artifacts. *Journal of Applied Developmental Psychology* 15:3–12.

Grodal, T. 2000. Video games and the pleasures of control. In *Media entertainment: The psychology of its appeal,* edited by P. Vorderer. Mahwah, NJ: Lawrence Erlbaum Associates.

Herring, S. 1993. Gender and democracy in computer-mediated communication. *Electronic Journal of Communication* 3(2). http:www.cios.org/www/ejc/v3n293.htm.

———. 1994. Politeness in computer culture: Why women thank and men flame. In *Cultural Performances: Proceedings of the Third Berkeley Women and Language Conference,* edited by C. Hines. Berkeley: Berkeley Women and Language Group.

Hiltz, S. R., and M. Turoff. 1978. *The network nation: Human communication via computer.* Reading, MA: Addison-Wesley.

Humphreys, S. 2003. Online multi-user games: Playing for real. *Australian Journal of Communication* 30 (1):79–91.

Jones, S. G. 2003. *Let the games begin: Gaming technology and entertainment among college students.* Washington, D. C.: Pew Internet and American Life Project.

Kiesler, S., J. Siegel, and T. W. McGuire. 1984. Social psychological aspects of computer-mediated communication. *American Psychologist* 39:1123–1134.

Kinder, M. 1996. Contextualizing video game violence: From Teenage Mutant Ninja Turtles 1 to Mortal Kombat 2. In *Interacting with video,* edited by R. R. Cocking. Norwood, NJ: Ablex.

Labre, M. P., and L. Duke. 2004. "Nothing like a brisk walk and a spot of demon slaughter to make a girl's night": The construction of the female hero in the Buffy video game. *Journal of Communication Inquiry* 28 (2):138–156.

Lucas, K., and J. L. Sherry. 2004. Sex differences in video game play: A communication-based explanation. *Communication Research* 31 (5):499–523.

Michaelson, G., and M. Pohl. 2001. Gender in email based on co-operative problem-solving. In *Virtual gender*, edited by A. Adams. Amsterdam: John Benjamins.

Microsoft. 2004. *Women get in the game*. 8 January 2004 (accessed 29 November 2004). Available from http://www.microsoft.com/presspass/features/2004/Jan04/01–08WomenGamers.asp.

Mikeal, R., and J. Stromer-Galley. 2003. The digital dollhouse: Normative behavior in *The Sims Online*. Paper read at Association of Internet Researchers, at Toronto.

Pham, A. 2003. Electronic Arts' Focus on Fewer, Profitable Titles Pays Off in Sales, Earnings Gains. *New York Times*, May 7, 2003, 1.

Postmes, T., and R. Spears. 1998. Deindividuation and antinormative behavior: A meta-analysis. *Psychological Bulletin* 123 (3):238–259.

Radway, J. A. 1984. *Reading the romance: Women, patriarchy, and popular literature*. Chapel Hill, NC: University of North Carolina Press.

Reichert, T., K. R. Maly, and S. C. Zavoina. 1999. Designed for (male) pleasure: The myth of lesbian chic in mainstream advertising. In *Sexual rhetoric: Media perspectives on sexuality, gender, and identity*, edited by M. G. Carstarphen and S. C. Zavoina. Westport, CT: Greenwood Press.

Reid, M. G. 1934. *Economics of household production*. New York, Wiley and Sons.

Savicki, V., D. Lingerfelter, and M. Kelly. 1996. Gender language style in group composition in Internet discussion groups. *Journal of Computer-Mediated Communication* 2 (3). http://www.ascusc.org/jcmc/vol2/issue3/savicki.html.

Sproull, L., and S. Kiesler. 1986. Reducing social context cues: Electronic mail in organizational communication. *Management Science* 32:1492–1512.

Subrahmanyam, K., and P. M. Greenfield. 1994. Effect of video game practice on spatial skills in girls and boys. *Journal of Applied Developmental Psychology* 15:13–32.

Taylor, C. 2003. Reinventing *The Sims*: Will Wright hopes to erase some bad memories with a new version of the best-selling computer game. *Time.com*, August 31, 2003. http://www.time.com/time/covers/1101030908/xgames.html (accessed September 11, 2003).

Taylor, T. L. 2003. Multiple pleasures: Women and online gaming. *Convergence* 9 (1):21–46.

van Zoonen, L. 1991. Feminist perspectives on the media. In *Mass media & society*, edited by J.Curran and M. Gurevitch. London: Edward Arnold.

———. 1994. *Feminist media studies*. Thousand Oaks, CA: Sage.

Webb, S. 2001. Avatarculture: Narrative, power and identity in virtual world environments. *Information, Communication & Society* 4 (4):560–594.

Welter, B. 1966. The cult of true womanhood: 1920–1860. *American Quarterly* 18 (66):151–174.

Yates, S., and K. Littleton. 1999. Understanding computer game cultures: A situated approach. *Information, Communication & Society* 2 (4):566–583.

C. Shawn Green & Daphne Bavelier[1]

The Cognitive Neuroscience of Video Games

We examine the perceptual and cognitive consequences of day-to-day experience with video games. A burgeoning literature indicates that video game play enhances perceptuo-motor skills and may also be beneficial to some aspects of cognition. This research opens new doors for practical applications such as in the rehabilitation of neurological patients in slowing the cognitive decline associated with normal aging, or in the enhancement of performance in specialized professions. However, existing research also demonstrates that not all video games are created alike and that finding the optimal training strategy is critical. The challenges that lay ahead for translating basic research into everyday applications are reviewed.

The Atari video game platform was released in the 1970s. Nintendo was born in the early 1980s. Since then, the percentage of Americans who play video games has grown at a rapid pace. This explosion has been spurred on by advancements in both hardware technology and software development that allow a more intense and realistic gaming experience. In addition to these improvements in graphical capability, advances in online gaming now allow users to play with sometimes hundreds of other players, which is slowly changing the perception of video game play from a solitary to a social activity. The Entertainment Software Association estimates that around 60% of Americans—around 145 million people in all—currently play some type of video game, and despite the common view of video games being "for kids," the average age of a video game player is actually around 29 years old. Unsurprisingly, both popular and scientific interest in the potential consequences of game play has been driven by this dramatic surge in video game use. Recently, researchers have begun to address the effect of video games on the fundamental question of how people see the world.

The Perceptual and Cognitive Consequences of Video game Play

In a 1984 book chapter, Patricia Greenfield outlined many of the aspects of video games that could make them interesting in the study of perception and general cogni-

tion (Greenfield 1984). In addition to the obvious point that spatial and sensory motor skills are at a premium in video games, Greenfield remarks that the level of cognitive complexity (in the case of Pac-Man discriminating among the different color "ghosts," learning their behavior and thus developing optimum strategies) was far beyond her expectations. She was therefore among the first researchers to suggest that perhaps video game play is not necessarily a "mindless" activity and that video games could be used to develop both visuo-motor and cognitive skills.

To a reader not familiar with the field of cognitive science, and more specifically with the field of perceptual learning, many of the studies that will be described may seem obvious in what they are testing and what we would expect to find in video game players. On the surface it may seem intuitive that playing a video game would improve hand-eye coordination, hasten reaction time, or benefit peripheral vision. However, one of the more enduring findings about visual learning is that training on one visual task rarely leads to improvement on anything other than the specific trained task (Fiorentini and Berardi 1980; Karni and Sagi 1991). There are cases in which if subjects are trained in one part of the visual field, only this specific area shows a benefit: for instance, if subjects are trained with one eye, only that eye shows a benefit, etc. Such specificity of visual learning has been a major obstacle to the development of efficient rehabilitation methods for visually impaired individuals, such as amblyopes. In this context, it is actually quite surprising that playing a video game could affect skills as widespread as visuo-motor or cognitive skills (Drew and Waters 1986).

The Effect of Video Games on Reaction Time and Visuo-motor Coordination

One of the first issues addressed by researchers investigating the effects of video games was the question of visuo-motor control. Anyone who has played a video game or seen someone play a video game realizes the premium put both on reaction time and hand-eye coordination. In one of the earliest studies on the effects of video games, Griffith and colleagues examined the difference between video game users and non-users on a test of eye-hand coordination (Griffith et al. 1983). Using a rotary pursuit unit (essentially a wand), subjects were required to track a light stimulus that moved at various rates (from 1 to 50 rpm) and in different patterns (circular, square, and triangular). Video game users far outperformed their non-user counterparts on this task, particularly at high speeds, clearly demonstrating that video game users have superior eye-hand coordination than non-users. However, this particular experiment simply demonstrated a correlation between video game experience and superior eye-hand coordination. Given these data, another equally valid hypothesis could be that people with inherently better eye-hand coordination are drawn to play video games, whereas people with naturally poorer coordination tend not to play. In this case, the true causative factor would be natural ability and not video game play. The only way to fully demonstrate causation is to train a random sample of non-gamers on a video game and measure changes in their performance. If non-gamers demonstrate similar improvements following video game training, one can infer the relationship between video game play and the effect in question is indeed causative. In general, we will tend to focus on studies that have included a training aspect in order to assure a causal role for video game play.

Another common measurement of visuo-motor skill is the simple reaction time. Orosy-Fildes and Allan (1989) performed a study in which 20 subjects were given a reaction time pretest (press a button when a light turns on). After the pretest, half of the sub-

jects underwent a 15-minute practice treatment on an Atari 2600 video game system. All of the subjects were then post-tested on the reaction time test. Those that received the video game experience showed a reduction in reaction time of approximately 50 milliseconds, which was not observed in the control group that received no game experience. Such a change of this magnitude after only 15 minutes of training is noteworthy. Researchers have reported that the simple reaction time in children is also decreased by video game experience (Yuji 1996) and similar results will also be discussed in the elderly in a later section on practical implications of video game play (Drew and Waters 1986; Clark, Lanphear, and Riddick 1987).

So how could an increase in hand-eye coordination or a reduction in reaction time be beneficial in one's day-to-day life? Improvements in hand-eye coordination could be advantageous in a wide variety of professions that require manual labor, but a more obvious benefit of reduced reaction times is in braking in front of an obstacle while driving. Anyone who has ever had an animal cross directly in front of them while driving might attest that 50 milliseconds could make the difference between a hit and a miss.

The Effect of Video Games on Spatial Skills

Another "obvious" potential change in video game users would be in the ability to gather and manipulate spatial information; many researchers have indeed examined the effects of video games on spatial skills (Lowery and Knirk 1982; Sims and Mayer 2002). Dorval and Pepin (1986) measured the ability to determine the three-dimensional structure of an object presented in two-dimension, and how the same object would appear if rotated in space. They asked if this ability could be improved by training on the video game *Zaxxon*. In *Zaxxon*, the player controls a spaceship in simulated three-dimensional space (*Zaxxon* was actually one of the few games at the time that simulated three-dimensionality) and attempts to shoot enemies and to avoid obstacles while avoiding being shot by enemies. Subjects in the experimental group underwent eight sessions of *Zaxxon* play, while a matched control group received no video game experience. Following training, the video game trained group showed significantly higher spatial-skill scores than the control group, indicating that spatial visualization is trainable with video game play. A study by Gagnon (1985) also reported comparable enhancements in measures of spatial skills in video game trainees, while McClurg and Chaille (1987) demonstrated that children trained on video games demonstrated improved scores on The Mental Rotations test.

In 1994, Subrahmanyam and Greenfield performed another video game training study using children. Sixty-one fifth graders were first pretested on three tests of dynamic spatial skills. One such test required subjects to view three movies, each containing a small square moving across the screen. The trajectory of the square either in the first or in the third movie did not match that of the square in the second movie and subjects were required to report which movie did not match. Following the pretest, half of the children underwent three 45-minute sessions with the spatially demanding game *Marble Madness*, while the other half played the word game *Conjecture* (control group). Following training, the children who received the *Marble Madness* training showed significant improvements over the control group.

Not all authors have observed significant effects of game playing on spatial skills. Sims and Mayer (2002) studied the effect of playing the game *Tetris* on mental rotation capabilities. While highly skilled *Tetris* players demonstrated better mental rotation skills than unskilled players, *Tetris* novices trained on *Tetris* did not show greater improvements than

control subjects following training (both groups actually improved by a large amount). The authors therefore argued for a genetic difference between the skilled and unskilled *Tetris* players that led to the observed results.

This study not withstanding however, the improvements noted by the authors in this section have numerous potential practical implications. The most noteworthy is that these tests measure capabilities needed by many professions. For instance, the ability to infer the three-dimensional structure of an object from a two-dimensional representation is critical for architects and engineers. Performance in other professions, including pilots, mechanics, machine operators, and draftsmen, could similarly be aided by increases in spatial skills (Gagnon 1985). Thus, video game play could potentially enhance performance in a number of professions.

The Effect of Video Games on Visual Attention

In order to fully explain visual attention, we would likely require far more pages than contained in this entire book. However, the general idea is likely intuitive to most people. First, it is important to state that visual attention is relatively distinct from the concept of "attention," as in the ability to pay attention in class. At a very simple level, visual attention can be thought of as a "gate" to perception. There is far more visual information available to us than we are capable of processing, and thus visual attention is the mechanism through which some items are selected for further processing while others are left unnoticed. For instance, although you are currently reading this book chapter, there are other things you can "see." Perhaps a desk, a coffee cup, a chair, etc? Although they have physically been present the entire time, it is likely that while reading you don't really "notice" them. In this case, the book chapter would be said to be the focus of visual attention and thus the other peripheral items were not attended to. In all, when items are attended to, they are generally processed more quickly, more efficiently, and to a greater degree than when items are left unattended. Thus, one could argue that what really matters for human vision is not necessarily what a person can "see," but to what they can attend.

Greenfield and colleagues (1994) demonstrated the effect of video games on the ability to divide and switch attention. In their study, subjects were told they should press a button as soon as they saw a briefly flashed target stimulus. They were further told that the stimulus could only appear at two locations, A and B. They were also warned that in 80% of the trials it would appear at location A and that it would only appear at location B in 10% of the trials (in the remaining 10% of trials the stimulus appeared on both sides). By manipulating the probability of occurrence at each location, subjects become biased to allocate more attention to the high-probability location and less attention to the low-probability location. Accordingly, subjects are generally faster to respond to high-probability targets and much slower to respond to low-probability targets, which is taken to reflect the difference in attentional allocation.

In an initial experiment, Greenfield et al. (1994) pitted expert video game players against non-players on this divided attention task (along with a control condition in which the stimulus appeared at each location equally often). First, replicating previous findings in the video game literature, video game players were found to have an overall faster reaction time than non-gamers. Also, as is consistently reported in previous attentional literature, Greenfield et al. found that non-players responded faster to stimuli presented at the 80% location and slower to stimuli presented at the 10% location compared to their

reaction times when the probabilities were equal (which represents an even division of attention). Interestingly, while the expert video game players showed a benefit (decreased reaction time) at the 80% location, unlike non-players, their reaction time for the 10% location was the same as during the control condition. This finding indicates that the efficiency with which attention is divided is greatly increased in video game players. In a follow-up training study, a group trained on a video game showed a reduction in reaction time for the 10% location that was not seen in a control group, thus demonstrating the causative role video games play in the effect.

A real-world example of this type of task can again be seen in driving. It is usually the case while driving that the majority of attention should be allocated to the road ahead. However, this necessarily implies that items in the periphery will be processed less efficiently because they receive less attentional benefit. Video game players seem to show a markedly reduced cost of divided attention and thus theoretically could be better at detecting peripheral items (for instance, detecting a child chasing a ball toward the street) while driving.

In our own work, we have further attempted to characterize the aspects of visual attention that are modified by video game play. We have recently demonstrated that video game play enhances the overall capacity of the attentional system (the number of items that can be attended to), the ability to effectively deploy attention over space, and the temporal resolution of attention (the efficiency with which attention acts over time).

We tested video game players and non-players in several experiments, each of which was designed to tap one of these relatively distinct aspects of visual attention (Green and Bavelier 2003).

We measured the capacity of the visual system using the multiple object tracking paradigm (Pylyshyn and Storm 1988). This task measures the maximum number of moving items that can be successfully tracked within a field of distracting moving items. The number of items that can be tracked is thought to provide an index of the number of items that can be simultaneously attended to, and therefore of the capacity of the visual attentional system. Video game players were able to track approximately two more items than non-players, suggesting there is a definite increase in the number of objects that can be attended to by video game players.

To assess the efficiency with which gamers and non-gamers distribute their attention over the visual field, we used a task initially developed to assess the driving fitness of elderly citizens. One interesting fact is that safe driving is not well correlated with visual acuity (the bottom line you can read on the eye-chart at the optometrist), but rather with the ability to successfully monitor a cluttered visual world (Ball et al. 1988). In our version of the UFOV task, a subject is asked to localize a very briefly presented target (only 7 ms) at eccentricities up to 30? Again, video game players far outperformed non-players. This suggests that video game players can more readily identify what they arc looking for in a cluttered scene.

Finally, we measured the temporal resolution of visual attention by using the attentional blink paradigm. In this task, a stream of quickly presented letters is flashed on a computer screen. Subjects are asked to identify the white letter and decide whether an X has been presented or not. For most subjects, when the "X" is presented very close in time to the white letter, it is often missed. The hypothesis for this is that because the subjects are "busy" processing the identity of the white letter, they are unable to process any new information until they are finished. Therefore, if the "X" appears while the subjects

are processing the white letter, it will be missed. Video game players show a much shorter "blink." This finding suggests that video game players can process a rapid stream of visual information with increased efficiency as compared to non-players.

We found similar results in each of the three paradigms in non-players trained on an action video game. After action game training, subjects improved their scores more than a group that played a control game. Therefore, action video game play appears to increase the efficiency with which attention is divided, enhances the spatial and temporal characteristics of attention, and leads to an overall increase in attentional resources.

The potential day-to-day benefits from these enhancements in visual attention seem quite obvious. To use driving as an example once again, drivers who are able to monitor more objects at once, over a broader range of the visual field, with greater temporal resolution, will have information at their disposal that might allow them to be safer drivers (although we will leave it for others to speculate whether changes in personality could potentially cancel out these benefits from vision).

How Video Games May Change the Brain

As cognitive neuroscientists, we are interested not only in the perceptual consequences of a training regimen, but also the neural factors involved in learning. A group of researchers in Britain sought to understand the neurochemical consequences of video game play (Koepp et al. 1998). These researchers measured the amount of dopamine released when subjects played an action video game (in this case, maneuvering a tank through a battlefield and destroying enemy tanks). Dopamine is one of many chemicals in the brain called neurotransmitters that allow the modulation of information passed from brain area to brain area. Dopamine is of particular interest because it is thought to play a role in a wide range of human behavior including pleasure, addiction, and learning. For instance, most drugs of addiction produce pleasure by increasing the amount of dopamine in the brain. Using a form of brain imaging (Positron Emission Tomography, or PET), the researchers were able to determine whether playing a video game increased the amount of dopamine released by the brain. A substantial increase in the amount of dopamine released in the brain was indeed observed during video game play, particularly in areas thought to control reward and learning. The level of increase was remarkable, being comparable to that observed when amphetamines are injected intravenously.

The role of this surge in dopamine and its implications are not currently well known, but work in rats suggests that dopamine may be important in the modification of the brain following perceptual training. Bao and colleagues (2001) conducted a study in which for one group of rats they paired the presentation of a particular tone (9 kHz) with stimulation of dopamine neurons, while another group received the tone alone. Following training, they observed an expansion of the part of the brain devoted to the tone only in the rats that had dopamine neurons concurrently stimulated (Bao, Chan, and Merzenich 2001). They therefore hypothesized that the dopamine neurons play a critical role in the learning that results in neural reorganization. One could imagine that the large surge of dopamine observed when individuals play a video game acts similarly, leading to faster and more widespread learning. Understanding the neuroanatomical and neurochemical substrates of video game play and of the learning it induces will be one of the major challenges in the years ahead.

Practical Implications for Video game Training

While the research outlined in the previous section has been mainly theory driven, the potential practical implications are numerous. Two main areas where the impact of video game training has been examined are in the rehabilitation of individuals with diminished perceptual or cognitive functioning (such as the elderly) and in the training of individuals whose professions require enhanced perceptual capabilities (such as military personnel).

Video Games to Rehabilitate the Elderly

While there are some circumstances in day-to-day living that would benefit from increases in perceptual ability, in general, most humans survive quite well with only "normal" processing capabilities. However, in many cases, the elderly suffer from natural declines in these abilities. In general, the elderly suffer from a number of processing deficits, e.g., in reaction time, manual dexterity, hand-eye coordination, response selection, and general cognitive abilities such as short-term memory and reasoning (Welford 1977; Drew and Waters 1986; Whitcomb 1990). While this decline is generally thought to be a natural consequence of aging, it is still an open question as to whether appropriate training could stall or reverse this trend and thus allow for a return to a more normal life.

Drew and Waters (1986) demonstrated that video game play could increase not only hand-eye coordination but also scores of general and verbal intelligence. Thirteen elderly subjects (ages 61–78 years) were trained on an Atari video game called *Crystal Castles* for two months (one hour of training per week). A control group received no game training. Before and after, training groups were tested on the WAIS-R (general intelligence), the Purdue Pegboard (manual dexterity), and the Rotary Pursuit task (hand-eye coordination). The researchers found that the results of video game training were quite significant for each measure. Furthermore, the seniors reported that following training they were more careful in daily activities and had fewer mishaps around the house. Therefore, this appears to be a case in which the video game training not only countered the age-related decline, but may also actually have reversed it, with subjects attaining much higher levels than their control counterparts.

However, some caution must be taken in interpreting these results. While at first sight one may be tempted to conclude that video game play enhances not only visuo-motor skills, but also intelligence, an alternative is that measures of intelligence most commonly used, such as the WAIS-R test, are heavily dependent on speed of processing. Many tests of intelligence place a premium on speed of processing, and it has been shown that such intelligence tests strongly correlate with speed of processing measures. Therefore, video game experience may increase the ability to make speeded choices without affecting other aspects of intelligence such as analytical skills or creativity. Whether or not this should constitute an increase in "intelligence" is a matter of some debate.

Clark and colleagues (1987) examined the possibility that video game training could reverse the age-related decline in performance on speeded tasks. Seven subjects with a mean age of 65 underwent a 7-week video game training treatment. Prior to and after video game training the subjects (as well as a group of control seniors) underwent a reaction-time test composed of two blocks. The seniors were seated in front of two lights, under which were two buttons. In one block of trials, the seniors were to press as fast as possible the button below the light that went on (this is called the compatible condition).

In the second block, they were to press the button beneath the light that did not go on (this is called the incompatible condition). "Normal" individuals are generally much quicker when the response is compatible with the cue (press the button under the light that goes on) than when the response is incompatible (press the button under the light that didn't go on), and the difficulty of incompatible trials is particularly magnified in the elderly. This is taken to reflect a difficultly in response selection (mapping a stimulus onto an appropriate action). During the seven weeks of video game training, the seniors in the experimental group practiced action games (*Pac Man* and *Donkey Kong*) for at least 2 hours per week. The effect of this video game training on reaction time was indeed significant as the experimental group's average reaction time dropped around 25 milliseconds in the compatible condition and an even more impressive 80 ms in the incompatible condition, while the control group did not improve. The authors argue that because the largest improvement was in the incompatible condition, the video game experience led to enhancements particularly in response selection, in addition to the widely reported decreases in simple reaction time. Superior response selection could theoretically aid seniors in any task where the stimulus and response are not naturally mapped (e.g., when you see an animal in the road, you should press the break pedal).

Although the results from these studies suggest that video game experience could be a powerful tool in slowing, stopping, or even reversing the age-related declines in perceptual, motor, and cognitive capabilities that the elderly population faces, it should be noted that these experiments were lacking in adequate controls for arousal, engagement, and motivation, which, as will be discussed later, could conceivably play a substantial role in the effects of video game experience. Although in these elderly individuals, video game experience was found to be beneficial as compared to no video game experience, it is unknown whether similarly challenging and cognitively engaging tasks (word puzzles, playing golf or chess, for example) would lead to similar benefits. Therefore, while we can conclude that video game play may be sufficient for enhancements in perceptual and cognitive functioning in the elderly, it is difficult to determine which aspects of video game play are necessary to induce changes.

Video Games to Aid Children

Human beings are among the least precocious of all animals. Perceptual, cognitive, and motor skills develop throughout infancy, childhood, and adolescence, and often take many years to reach "adult levels." While there is evidence that proper experience can be used to retrain capabilities lost through the natural aging process, another open question is whether video game experience can augment the normal development of these systems in children. Continuing research in our own lab suggests that children who play video games show similar benefits as adults on many measures of visual attention (Dye and Bavelier 2004). Dunbar, Lewis, and Hill (2001) have suggested that the attentional skills of children are linked with their behavior as pedestrians. They tested the ability of children of various ages to switch attention and concentrate using a simple video game and also observed the same subset of children crossing roads. Children who were better at the game, and thus more able to effectively switch attention, were more likely to show awareness of traffic when about to cross a road and crossed the road in an overall safer manner. One should definitely note, however, that this was another purely correlational study. Hasdai, Jessel, and Weiss (1998) also report that training on a joystick-controlled computer game can assist children learning to operate a motorized wheelchair (children with progressive muscular dystrophy or cerebral palsy). Therefore, although the work is

in a very preliminary stage, from a purely perceptual and motor-development standpoint, young video game players may indeed reap the same significant rewards from video game experience as those observed in adults.

Video Games to Improve the Abilities of Military Personnel

We now move from populations with below "normal" perceptual and/or cognitive capabilities to individuals who would benefit from enhancements in these capabilities. Military personnel in general, and aircraft pilots in particular, are one population for whom enhancements in perceptual and cognitive processing could lead to critical differences in job performance (which, in the case of the military, can often mean the difference between life and death).

By the early 1980s, the military had begun to examine the effect of video game playing on its personnel (Jones, Kennedy, and Bittner Jr. 1981; Kennedy, Bittner Jr., and Jones 1981; Lowery and Knirk 1982; Lintern and Kennedy 1984). Several studies by Kennedy, Bittner, and colleagues demonstrated the effect of the Atari game *Air Combat Maneuvering*, which was found to be an excellent candidate for a performance-test battery. They suggest that sonar or radar operators could reap large benefits from such training.

In addition to the interest shown by the U.S. military, the Israeli military has also investigated the possibility of training personnel on video games to increase their performance. Gopher and colleagues, working in collaboration with the Israeli Air Force, conducted a study to determine whether the benefits of video game play could be relevant to flight skills in Israeli Air Force cadets (Gopher 1992; Gopher, Weil, and Bareket 1994). They argue that video games increase the efficiency with which attention is managed, particularly when the task load is high, and that these enhanced abilities could be of great benefit to pilots.

In their experiments, Gopher and colleagues compared the flight skill of individuals that either had or had not been trained on the video game *Space Fortress*. Cadets given video game experience performed significantly better than a control group that received no game experience on various measures of flight performance. A second study found that game training led to an increased probability of program completion. In fact, this game was so successful that the authors note that the game had been incorporated into the regular training regimen of the Israeli Air Force. In addition to pilots, one can imagine many potential military personnel who could benefit from greater attentional capacity, control, and spread of attention, as well as more efficient response selection.

Video Games to Train Surgeons

Another group that has been shown to benefit from video game training are laparoscopic surgeons. A recent report by Rosser and colleagues (2004) suggested that video game players may in fact be better laparoscopic surgeons than non-gamers. Laparoscopic surgery is a minimally invasive form of surgery, in which a camera and operating instruments are introduced into the body via small incisions. The surgeon then conducts the surgery by maneuvering the instruments based on viewing the images from the internal camera. Visual attention, manual dexterity, and hand-eye coordination are of even more importance than in normal open surgery. Rosser and colleagues found that surgeons who played video games more than three hours per week committed fewer errors, were faster at laparoscopic drills, and were better at suturing tasks than non-video game playing sur-

geons. Using a multiple comparison analysis, the authors found that a surgeon's video game experience is a better predictor of surgical skill than number of years of practice or number of operations completed. The authors suggest that video games could be used as an important "warm-up" for laparoscopic surgeons or that the development of surgeon-specific video games could greatly enhance surgical aptitude.

The Difficulties of Video game Research

While the work reviewed in this chapter presents a rather rosy picture of the effects of video game training, in practice it is not that simple an endeavor. Several difficulties exist that make the study of the effect of video games challenging. One major difficulty is that no two video games are created exactly equal, which means that the perceptual and/or cognitive effects one can expect from each are not necessarily easily comparable. As our own particular interest is in visual attention, we tend to use first-person shooter (FPS) video games. These games require effective monitoring of the entire screen (enemies often first appear in the periphery), high temporal precision (the speed of the game often far exceeds the speed of day-to-day life), and high attentional capacity (many enemies often appear simultaneously). The requirements of other types of games are often similar, but distinct enough that it is difficult to predict their perceptual consequences. In practical terms, this is a real limitation when retooling video games for training purposes. The same game that may be very helpful to patients with hemineglect, a rather common deficit in visual attention after right parietal lobe damage, may not be of much use to patients with poor vision, such as amblyopes.

Another difficulty is that training can be more or less efficient depending on how it is administered (Linkenhoker and Knudsen 2002). We have often observed that the difficulty of the video game is critically important in the amount of learning that occurs. For maximum learning to occur, the game difficulty must be such that it is "just barely too difficult" for the subject. If the game is too easy or too hard, learning appears to be less efficient. Therefore, we actively monitor the progress of our subjects and increase the difficulty of the game as they progress, always pushing them to reach a goal just beyond what they can attain. This makes intuitive sense: putting subjects in a video game environment far beyond their abilities may teach them primarily how to restart when the computer kills them. Unfortunately, while the fact that the wrong training schedule would be detrimental to learning is highly intuitive, determining what the correct training schedule should be is far from intuitive, and is, as of now, as much an empirical question as a theoretical one. The "right" training schedule is likely to be a function of the game, the skill you hope to modify, the age and current perceptual skills of the subject (should you use the same schedule to train a stroke patient as a child?), as well as many other variables that have barely been considered so far by researchers (such as motivation, arousal, and the like).

In this endeavor, there are also other confounds that we are only in the very early stages of considering. For instance, basic metabolic phenomena appear to be altered when playing particular video games: heart rate, respiration, etc. One might imagine that playing competitive games could also be accompanied by increases in adrenaline. In our own work, we have often observed that action-game trainees seem more physically aroused than control-game players. Is this a critical component of the learning that occurs?

Because of these myriad factors, it is critical that the reader not believe that it is "easy"

to induce perceptual or cognitive changes through video game experience. It is certainly not the case that any type of experience with any type of game will change any perceptual, motor, or cognitive skill.

Conclusion

Video games currently play a substantial role in our culture, as more than half of all Americans play some type of video game. The available research in the perceptual and cognitive domain indicates that such activity is likely to alter a wide range of perceptual, motor, and cognitive traits. Video game play has been shown to dramatically enhance visuo-motor skills. In particular, video game players have been shown to possess decreased reaction times, increased hand-eye coordination, and augmented manual dexterity. Video game play has also been shown to improve spatial skills such as mental rotation, spatial visualization, and the ability to mentally work in three-dimensions. In addition, video game play has been shown to enhance numerous aspects of visual attention, including the ability to divide and switch attention, the temporal and spatial resolution of visual attention, and the number of objects that can be attended to. The possibility that video games provide a medium that facilitates learning, and thus promotes changes in performance and brain organization, has led some to propose that video games are the teaching tool of choice of the 21st century. The surge in new video games being developed to enhance one particular trait or another is probably the best testimony of the level of excitement in this new field.

Whereas the benefits of video games to some aspects of cognitive and motor skills seem undeniable, this work is still truly in its infancy and many questions of great theoretical and practical importance remain to be addressed. On a practical level, in order to efficiently use video games to train a particular function, we need to first determine what characteristics a game should possess to maximally benefit the skill in question. We also need to determine the most efficient training schedule, as poorly designed training regimens are likely to lead to null results. Finally, one needs to ensure that for all the gain, there is no major loss in performance in other areas of cognition or at the emotional and social level. On a theoretical level, video game research is opening a fascinating window into the amazing capability of the brain and behavior to be reshaped by experience. Understanding the mechanisms that unleash such widespread plasticity is one of the many challenges facing this field.

NOTES

1. The authors would like to thank Nina Fernandez for her comments on earlier drafts, as well as acknowledge grants from the Office of Naval Research and the Training Grant T32 MH19942 from the University of Rochester.

REFERENCES

Ball, K., B. Beard, D. Roenker, R. Miller, and D. Griggs. 1988. Age and visual search: Expanding the useful field of view. *Journal Optical Society of America* A. 5 (10):2210–2219.

Bao, S., V. T. Chan, and M. M. Merzenich. 2001. Cortical remodelling induced by activity of ventral tegmental dopamine neurons. *Nature* 412 (6842):79–83.

Clark, J. E., A. K. Lanphear, and C. C. Riddick. 1987. The effects of videogame playing on the response selection processing of elderly adults. *Journal of Gerontology* 42 (1):82–85.

Dorval, M., and M. Pepin. 1986. Effect of playing a video game on a measure of spatial visualization.

Perceptual Motor Skills 62:159–162.

Drew, D., and J. Waters. 1986. Video games: Utilization of a novel strategy to improve perceptual motor skills and cognitive functioning in the non-institutionalized elderly. *Cognitive Rehabilitation* 4:26–31.

Dunbar, G., V. Lewis, and R. Hill. 2001. Children's attentional skills and road behavior. *Journal of Experimental Psychology: Applied* 7 (3):227–234.

Dye, M. W. G., and D. Bavelier. 2004. Playing video games enhances visual attention in school children. Paper read at Fall Vision Meeting, at Rochester, NY.

Fiorentini, A., and N. Berardi. 1980. Perceptual learning specific for orientation and spatial frequency. *Nature* 287:43–44.

Gagnon, D. 1985. Videogame and spatial skills: An explatory study. *Educational Communication and Technology Journal* 33:263–275.

Gopher, D. 1992. The skill of attentional control: Acquisiting and execution of attention strategies. In *Attention and performance XIV*, edited by D. E. Meyer and S. Kornblum. Cambridge, MA: The MIT Press.

Gopher, D., M. Weil, and T. Bareket. 1994. Transfer of skill from a computer game trainer to flight. *Human Factors* 36 (3):387–405.

Green, C. S., and D. Bavelier. 2003. Action video game modifies visual selective attention. *Nature* 423:534–537.

Greenfield, P. M. 1984. *Mind and media: The effects of television, video games, and computers.* Cambridge, MA: Harvard University Press.

Greenfield, P. M., P. deWinstanley, H. Kilpatrick, and D. Kaye. 1994. Action video games and informal education: Effects on strategies for dividing visual attention. *Journal of Applied Developmental Psychology* 15:105–123.

Griffith, J. L., P. Voloschin, G. D. Gibb, and J. R. Bailey. 1983. Differences in eye-hand motor coordination of video game users and non-users. *Perceptual and Motor Skills* 57:155–158.

Hasdai, A., A. S. Jessel, and P. L. Weiss. 1998. Use of a computer simulator for training children with disabilities in the operation of a powered wheelchair. *American Journal of Occupational Therapy* 52 (3):215–220.

Jones, M. B., R. S. Kennedy, and A. C. Bittner Jr. 1981. A video game for performance testing. *American Journal of Psychology* 94 (1):143–152.

Karni, A., and D. Sagi. 1991. Where practice makes perfect in texture discrimination: Evidence for primary visual cortex plasticity. *Proc Natl Acad Sci* 88 (11):4966–70.

Kennedy, R. S., A. C. Bittner Jr., and M. B. Jones. 1981. Video game and conventional tracking. *Perceptual and Motor Skills* 53:310.

Koepp, M. J., R. N. Gunn, A. D. Lawrence, V. J. Cunningham, A. Dagher, T. Jones, D. J. Brooks, C. J. Bench, and P. M. Grasby. 1998. Evidence for striatal dopamine release during a video game. *Nature* 393:266–268.

Linkenhoker, B. A., and E. I. Knudsen. 2002. Incremental training increases the plasticity of the auditory space map in adult barn owls. *Nature* 419 (6904):293–296.

Lintern, G., and R. S. Kennedy. 1984. Video game as a covariate for carrier landing research. *Perceptual and Motor Skills* 58:167–172.

Lowery, B. R., and F. G. Knirk. 1982. Micro-computer videogames and spatial visualization acquisition. *Journal of Educational Technology Systems* 11:155–166.

McClurg, P. A., and C. Chaille. 1987. Computer games: Environments for developing spatial cognition. *Journal of Educational Computing Research* 3 (1):95–111.

Metalis, S. A. 1985. Effects of massed versus distributed practice on acquisition of video game skill. *Perceptual and Motor Skills* 61:457–458.

Orosy-Fildes, C., and R. W. Allan. 1989. Psychology of computer use: XII. Videogame play: Human reac-

tion time to visual stimuli. *Perceptual and Motor Skills* 69:243–247.

Pylyshyn, Z. W., and R. W. Storm. 1988. Tracking multiple independent targets: Evidence for a parallel tracking mechanism. *Spatial Vision* 3 (3):179–197.

Rosser Jr., J. C., P. J. Lynch, L. A. Haskamp, A. Yalif, D. A. Gentile, and L. Giammaria. January 2004. Are video game players better at laparoscopic surgical tasks? Paper read at Medicine Meets Virtual Reality Conference, Newport Beach, CA.

Sims, V. K., and R. E. Mayer. 2002. Domain specificity of spatial expertise: The case of video game players. *Applied Cognitive Psychology* 16:97–115.

Stanney, K. M., K. S. Hale, I. Nahmens, and R. S. Kennedy. 2003. What to expect from immersive virtual environment exposure: Influences of gender, body mass index, and past experience. *Human Factors* 45 (3):504–520.

Subrahmanyam, K., and P. M. Greenfield. 1994. Effect of video game practice on spatial skills in girls and boys. *Journal of Applied Developmental Psychology* 15:13–32.

Welford, A. T. 1977. Motor Performance. In *Handbook of aging*, edited by J. E. Birren and K. W. Schaie. New York: Van Nostrand Reinhold.

Whitcomb, G. R. 1990. Computer games for the elderly. ACM SIGCAS *Computers and Society* 20 (3):112–115.

Yuji, H. 1996. Computer games and information processing skills. *Perceptual and Motor Skills* 83:643–647.

John L. Sherry

Would the Great and Mighty Oz Play Doom?

A Look Behind the Curtain of Violent Video Game Research

While many professional organizations (e.g., AMA, APA, etc.) have decried video games for their potential negative effects, the research in this area is not particularly strong. This chapter refutes these claims by explaining and interpreting what is meant by overall effect size, closely examining the research methods used, and looking at trends in violent crime in the United States. Recommendations are given for more fruitful paths for future research.

Although less research has been done on the impact of violent interactive entertainment (video games and other interactive media) on young people, preliminary studies indicate that the negative impact may be significantly more severe than that wrought by television, movies, or music.

Joint Statement by the American Academy of Pediatrics, American Medical Association, American Psychological Association, American Academy of Child and Adolescent Psychiatry, American Academy of Family Physicians, American Psychiatric Association (2000)

Playing violent video games has been found to account for a 13% to 22% increase in adolescents' violent behavior; by comparison, smoking tobacco accounts for 14% of the increase in lung cancer.

Statement of American Academy of Pediatrics, Committee on Public Education (2001)

My research colleagues are correct in claiming that high exposure to media violence is a major contributing cause of the high rate of violence in modern U.S. society.

Craig Anderson, Ph.D. Chair, Department of Psychology, Iowa State University

Video games are murder simulators which over time, teach a person how to look another person in the eye and snuff their life out.

David Grossman, Ph.D., military training expert (Claymon 1999)

Epidemiologists studying factors associated with violence, including poverty, racial discrimination, substance abuse, inadequate schools, joblessness and family dissolution, found that exposure to violent media was a factor in half of the 10,000 homicides committed each year.

Michael Rich (2000), MD, MPH, FAAP, for the American Academy of Pediatrics

Based on the pronouncements of experts, video games would appear to be a major health hazard in the United States. Experts claim that these "murder simulators" and other violent media are a "major contributing cause of the high rate of violence in American society" and are a factor in 5,000 homicides each year. In fact, video games' "negative impact may be significantly more severe than that wrought by television, movies, or music." Further, it would appear from the experts' statements that the question of whether video-game violence causes players to be aggressive is settled. But upon what evidence are these conclusions based? This paper peels back the curtain of academic discourse to reveal the research the claims are based on. It is my hope that translating the research, from academic language into a form in which people outside the academic world can understand, will allow the discussion of the consequences of these findings to proceed more fruitfully. In this paper, I attempt to make the literature clear, to tell exactly what research has been done and how.

What Exactly is the Literature Telling Us?

In this section, I will attempt to demystify the statistics and methodology underlying scholarly claims, and to communicate the consequences of game play as it applies to behavior effects in everyday life. Before taking a close look at the research, it is important to understand the research process and the philosophy underlying social scientific inquiry. To that end, I will examine three ways that are commonly used by researchers to speak to different aspects of the relationship between game play and aggression: association (Pearson's product moment correlation coefficient), difference (Cohen's d as a measure of effect size), and comparative epidemiological evidence.

In the course of this article, I will make reference to two studies in particular, both meta-analyses of the violent video-game literature (Anderson and Bushman 2001; J. L. Sherry 2001). Meta-analysis is a statistical method used to summarize overall findings across a large literature. Rather than looking at the results of an individual study, which could be misleading, meta-analysis combines the findings from all studies on that topic. This allows us to determine the overall effect and to find trends within the studies that could be important for theory building. Overall, Anderson and Bushman found an association of $r = .19$, while I found an association of $r = .15$ (more on the meaning of these numbers will follow).

On Method: Some Cautionary Notes

In many ways, research on human behavior is more difficult than research in the hard sciences such as physics, chemistry, and biology. The main difficulty in doing social-science research is that the subject of the research, human beings, cannot be manipu-

lated as easily as molecules or photons because of ethical considerations. We can design perfect experiments to understand human behavior, but we cannot always execute these experiments. One colleague speaks of an imaginary island on which we can perform any experimental manipulation of people we want. On this island, we could run the ideal experiment to understand the relationship between cigarette smoking and cancer. Groups of a few thousand randomly chosen individuals would need to be taken from their daily life and randomly assigned to one of several experimental conditions: smoking 10 packs of cigarettes a day, smoking five packs a day, smoking one pack a day, or no smoking. After 10 years of enforced smoking, we could see whether people in the heavy smoking conditions had more cancer than those assigned to the non-smoking condition. Fortunately for the people who were forced into the heavy smoking condition, the island remains imaginary.

Because we don't have the ability to control all aspects of our experiments, social scientists must approximate the types of laboratory control that those in the hard sciences enjoy. Participants are recruited to come to a lab on campus and act out situations that occur in real life, such as group interactions, persuasion attempts, or interactions with media. Most often, the participants in these experiments are college students, because they are most easily and inexpensively available. In the case of video-game research, the participants come to the lab to play video games. An obvious problem is that game play in a university laboratory is not very similar to game play in real life. In the lab, there are researchers directing behaviors, including what game to play and how long the game is played. Thus, media use becomes a forced rather than voluntary activity. Typically, media are used with friends, but friends are not allowed in the lab. In fact, game play often occurs with no other person in the room.

One way to get around the artificiality of the lab is to conduct field research. Field research takes the researcher out of the lab and into the real world where people are interacting. There are a number of ways to do this. The most common type of field research that has been done on video games is the survey. Surveys attempt to find trends among large numbers of people by having them respond to a series of questions. In this way, they are able to report everyday behaviors and preferences. The disadvantage of surveys is that the researcher loses control over a number of factors that are under control in the laboratory. First, the researcher loses control of time order. Even if there is a relationship between violent video-game play and some form of aggression, it is difficult to establish whether: 1) video-game play causes individuals to act aggressively, 2) aggressive people like playing video games, or 3) some other factor (e.g., personality) causes both violent video-game play and aggression. Second, there are any number of other variables that could affect the way that participants respond to questions. In the lab, the researcher can control time order (have the participants play the game before measuring aggression) and other variables (by excluding them from the lab).

Key to the research process is clear definition. Words such as "violence" or "aggression" can mean a number of different things to different people. In fact, "violence" and "aggression" are commonly used interchangeably in common conversation. For the social scientist, these words have very different meanings, with "violence" often connoting a more extreme form of aggression, such as murder, physical assault with or without a weapon, or rape. Therefore, we would never conduct an experiment in which we expected the subject to act violently. Instead, we use a variety of measures of aggression or the willingness to hurt others. These measures include paper and pen assessments of aggressive feelings, simulated aggression such as willingness to administer electric shock

or a noise blast, positive or negative ratings of a research associate, and verbal or physical aggressiveness during free play. Further, the researcher must be clear about what is meant by "violent media." For example, some past video-game researchers have used *Missile Command* or *Centipede* as the violent game, while others have used *Mortal Kombat*. Certainly, there are a number of factors that may be included in the definition of "violent media," such as the type of violence, use of weapons, amount of violence, type of victim and perpetrator, and graphicness of the violence. A game like *Mortal Kombat* depicts two humanlike creatures fighting martial-arts style with weapons such as swords, while *Quake* features a first-person perspective as the game player hunts human characters with high-powered weapons such as rocket launchers and machine guns.

Statistical Relationships—Association

Pearson's correlation coefficient is a measure of linear association between two variables. In this case, we are looking at the extent to which more violent video-game play is associated with greater amounts of aggression. The correlation metric ranges from 0, meaning no relationship at all, to 1, meaning a perfect association. The relationship can be positive, meaning that as one variable gets larger, the other one also gets larger, or negative, meaning that as one variable gets larger, the other one gets smaller. Therefore, a correlation of–1 means that there is a perfect relationship: as one variable gets larger, the other variable gets smaller.

Often when dealing with measures of association, scientists will speak of something called "the percent of variance explained." Variance explained is often misinterpreted to mean the contribution that one variable makes to the other, particularly in an individual case. Certainly, this appears to be the type of argument being made by the AAP when they say that video-game play " . . . accounts for a 13% to 22% increase in adolescent violent behavior." With a correlation coefficient, variance explained is calculated by squaring the correlation.

Statistical Relationships—Difference

Much experimental research focuses on behavior that results from the introduction of a stimulus. We compare a group of people who are exposed to the stimulus to a separate group who are not exposed. The difference observed is referred to as an increase or decrease associated with exposure to the stimulus. Experts have claimed that exposure to violent video games increases violent behavior by 13% to 22%.

In experiments, we test whether exposure to the treatment condition will cause an increase or decrease in the outcome measure as compared to the treatment condition. For example, let's say that we have conducted an experiment in which one group of children is randomly assigned to play *Doom* for twenty minutes and a second group of children watches a pleasant documentary about flowers. Children who play *Doom* are said to be in the "treatment condition" because they are exposed to the stimulus that we believe will cause increased aggression. Children in the documentary group provide a comparison, or "control" group to determine the average amount of child aggression without exposure to violent media. After exposing the children to different conditions, we allow them to freely play in the school yard, where we count the number of aggressive acts they perform. The number of aggressive acts is referred to as the "dependent variable" or "outcome measure." A common statistic for calculating the size of the difference is Cohen's *d*.

The formula for Cohen's *d* is quite simple: subtract the average aggression score of the people in the violent video-game treatment condition from those in the control condition. In order to put both groups on a common metric for easier interpretation, we divide by the average standard deviation (*s*).

Cohen (1988) provides a guideline for understanding magnitude of effect size in terms of small (*d* = .20), medium (*d* = .50), and large (*d* = .80) effects. An example of a small effect that Cohen provides is the difference in average height between 15- and 16-year-old girls. By comparison, a medium-effect size is found in the average difference in height between 14- and 18-year-old girls. Converting the overall effect size of video-game play on aggression in the Sherry meta-analysis into Cohen's *d* metric translates to an effect size of *d* = .30, while Cohen's *d* for the Anderson and Bushman meta-analysis is *d* = .39. For comparison, Paik and Comstock (1994) arrived at an effect-size estimate for the effect of television violence on aggression of *d* = .65. Anderson and Bushman (2001) dispute the Paik and Comstock figure and place the effect size for television at *d* = .43.

What does a .30 or .39 effect size mean in terms of behavioral consequences resulting from game play observed in the experiments? Table 20.1 provides details of experiments that showed the greatest behavioral effects of playing violent video games. Excluded were studies that showed small behavioral effects (Brusa 1988; Cohn 1995) or negative behavioral effects (Austin 1987; Graybill et al. 1987; Walker 1984; Winkel, Novak, and Hopson 1987). An example in the average-effect size range is Anderson and Dill's (2000) experiment (*d* = .32). In this experiment, Anderson and Dill had college students play one of two games: either *Wolfenstein 3D*, a first-person shooter game in which players navigate a castle, killing Nazi guards with knives, automatic weapons, a revolver, and a flame thrower; or *Myst*, a first-person perspective puzzle solving game. Immediately after playing the assigned video game for 15 minutes, participants took part in a competitive reaction time test in which they tried to push a button faster than their competitor. They were allowed to set a "noise blast" level and duration that their competitor would receive upon losing. Participants who had been in the violent video-game condition set the noise blast duration for 6.81 seconds, while those who had played the non-violent game set the noise blast duration for 6.65 seconds. This difference is approximately the same as the average effect size found across all violent video-game studies.

Study	ES (d)	Violent VG	Aggression Measure	Control	Treatment
Anderson & Dill	.31	Wolfenstien 3D	Noise blast duration	6.65 sec.	6.81 sec.
Ballard & Lineberger	.45	Mortal Kombat	Cold pressor task	4.62 sec.	5.77 sec.
Bartholow & Anderson	.90	Mortal Kombat	Noise blast intensity	4.60	5.97
Cooper & Mackie	.61	Missile Command	Play with violent toys	46.48 sec.	82.13 sec.
			Bad buzzer	n.s.	
Irwin & Gross	.65	Double Dragon	Free play aggression-others	.85	1.3
	.74		Free play aggression-objects	4.4	9.9
Schutte et al.	.65	Karate	Free-play aggression-others	.00	1.2
	.16	Karate	Free play aggression-hit toys	4.75	7.13
Silvern & Williamson	.32	Space Invaders	Free-play aggression	5.31	9.44

Table 20.1. Effect sizes of the violent video-game experiments

Bartholow and Anderson (2002) found a larger effect than anyone else in their experiment (see Table 20.1). Using the same protocol as Anderson and Dill, but different games, they found a large difference in the intensity of noise-blast settings assigned by those who played the violent video game (*Mortal Kombat*) compared to those who played the non-violent game (*PGA Golf*). They did not report a measure of duration of noise blast in their study. Other measures that have been used to show aggression include (see Table 20.1) a cold pressor task in which violent game players punished a confederate longer by holding their hand in cold water (5.77 seconds vs. 4.62 seconds), counts of the number of aggressive acts during free play aimed at others (Irwin and Gross 1995; Schutte et al. 1988; Silvern and Williamson 1987) or at inanimate objects (Irwin and Gross 1995; Schutte et al. 1988), and number of seconds playing with violent toys during free play (Cooper and Mackie 1986).

Statistical Relationships—Epidemiological Comparisons

In order to help average Americans understand the extent of the threat posed by video games, researchers have provided epidemiological comparisons that most people can relate to. Epidemiology is the scientific study of the causes, distribution, and control of health threats that affect a large population. Epidemics show up as aberrations from normal health trends. The American Academy of Pediatrics claims that the relationship between playing violent video games and aggression is greater than the relationship between cigarette smoking and cancer, and that violent media are a factor in half of the murders committed each year. It is not clear where these statistics came from, as both meta-analyses of the literature place the average effect size much lower than that claimed by the AAP.

A frequently used method for examining epidemiological data is to plot the introduction of the suspected cause (in this case, violent video games) against a time-series trend in some variable of interest (e.g., violent crime). This allows us to trace the impact of the cause on society. This technique has been used in the past to investigate the causes of violence. For example, Anderson and Anderson (1996) were able to show that heat is a causal factor in violent crime by comparing crime reports with temperatures in a number of cities in the U.S. Because experts are claiming that the introduction of violent video games is a clear and present health hazard because of its effects on violent behavior, we might be able to see an increase in violent crime following the introduction of various highly popular violent video games such as *Mortal Kombat* and *Tekken*, first-person shooter games such as *Doom* and *Quake*, and violent action games such as *Tomb Raider*.

Figure 20.2 plots the violent crime trend in the U.S. in the time since the introduction of highly graphic, violent video games. The crime data are from the U.S. Department of Justice Bureau of Crime Statistics National Crime Victimization Survey (NCVS). Each year since 1973, the DOJ surveys 8,000 randomly chosen Americans to determine their experience of crime victimization. The NCVS is considered a more accurate measure of actual crime than the FBI Uniform Crime Report, because the FBI only records crimes that are reported to authorities (Rand and Rennison 2002). The NCVS contains instances of crime that were not reported to police. The only exception is the crime of murder, which the victim obviously cannot report. Therefore, the crime trend data in Figure 20.1 includes the NCVS estimates of simple and aggravated assault, rape, and robbery, and the FBI Uniform Crime Report statistics on murder.

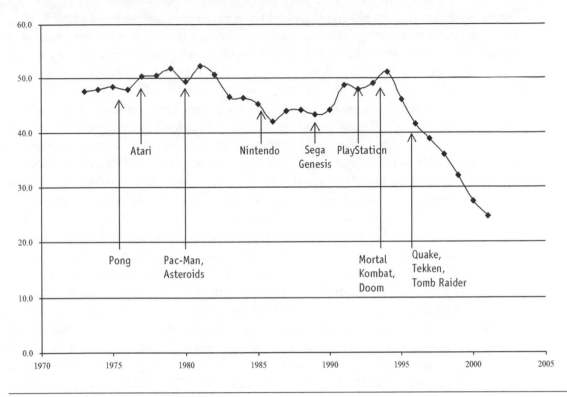

Figure 20.2 Trend of violent crime in the U.S., 1973–2001

As can be seen in the data, there is a pronounced decrease in violent crime in years subsequent to the introduction of violent video games. There are at least three conclusions that can be drawn from these data: 1) that video games have little or no effect on natural trends in crime, 2) that the presence of video games caused a decrease in the amount of violent crime, or 3) that crime would be even worse if video games were not introduced. It is impossible to know the answer with complete certainty because there is no possible comparison group.

Assessment and Recommendations

The data are presented here in hopes that readers can make their own assessment of the claims made by experts. I'd also like to provide my own assessment of these claims, the state of the literature, and future directions that researchers may want to pursue.

To date, researchers have tried, with limited success, to create experiments that demonstrate a relationship between playing violent video games and subsequent aggression. While the experiments were well conceived and conducted, they do not show a consistently clear and powerful effect. (Remember that Table 20.1 excludes studies that found negative or no associations.) Undoubtedly, scholars will continue to refine their methods in order to demonstrate the expected effect. But perhaps the time has come to try a different approach as well, taking off from Karl Popper's (1968) well-known falsification criterion. Instead of trying to show that a relationship does exist, Popper suggests that scientists try to disprove it. The extent to which the relationship stands up to repeated attempts to falsify it, the stronger the relationship. Take as an example the testing of a highway bridge over a deep river. Engineers could test the bridge by: 1) trying to show it will

hold the weight of a car, or 2) trying to show it won't hold the weight of a car. The first test could be satisfied by placing the weight of a car at the strongest part of the bridge. However, the second test, falsification, can only be accomplished by placing weight at the weakest point in the bridge under extreme conditions such as during heavy winds. The extent to which the bridge does not break under these circumstances is the extent to which the bridge is strong. Which bridge would you rather drive over?

This same logic could be applied to video-game research. Rather than continuing to try to prove that video games cause aggression by creating extreme conditions in the laboratory, it may be time to try to falsify the notion that video games cause aggression. The extent to which the relationship holds up in ecologically valid tests is the extent to which the relationship between violent video games and aggression is something that we should be concerned about. What would such a test look like? In order to understand that, we need to think about some plausible explanations for the relationships seen in the lab and compare those to real life. First, researchers to date have been working in a dose-response model. That is, they have made the differences between conditions extreme in order to see if they could create the effect. In order to find an effect, they use games that are very different, isolate players from all other distractions, and use measures that are highly sensitive to any type of aggression. But the fact that you can find aggression in the lab does not mean it is a threat in daily life. For example, lab tests on mice showed that the artificial sweetener saccharin, given in very large doses, leads to bladder cancer in male rats. Subsequent studies on human populations have failed to show that saccharin use is a risk for humans (National Cancer Institute 1997). Just because a negative effect can be created in a lab does not mean that it presents a threat in the real world.

As further evidence on these matters, consider a recent experiment by Sherry, Curtis, and Sparks (2001). We assigned college students to one of three groups: a violent video-game condition in which they played a popular fighting game (*Soul Calibur*) on a highly graphic system (Dreamcast), a non-violent game-playing condition (*Bass Fishing*), and a control condition in which they read an article about Internet infrastructure. After playing the game, all participants watched an eight-minute film featuring the types of violence that has been shown to cause an aggressive effect in many lab studies. After the film, we measure participant hostility using the Multiple Affect Adjective Checklist, a commonly used measure of aggressive feelings. We did not find a difference between the three groups on level of hostility. Physiological data that we took during the experiment showed an initial arousal effect of violent video-game play that disappeared by the end of the movie. It is possible that the aggression reactions that researchers have been finding may be related to arousal, which dissipates rapidly after game play.

In addition to the questions raised by physiological arousal and playing modalities, future research will need to address issues of ecological validity or how well the research mimics real-world situations. Laboratory research will need to recreate the game-playing experience by allowing participants some choice in whether to play a violent video game or not. What are the conditions under which an individual may choose to play a violent game? Zillmann and Bryant (1996) have pursued this line of research with television; a similar research line needs to be opened with video games. Once we understand who chooses to play violent video games and why, we will be able to better appreciate the conditions under which persistent aggression effects may (or may not) occur.

Another way to increase the ecological validity of violent video-game research is to step out of the lab and conduct field research. Research in the "real world" is difficult

and expensive. It is not possible to gain the level of control that researchers in the lab enjoy because of complicating factors in the environment. As indicated earlier, one method of studying effects in the real world is to employ epidemiological data, such as tracking crime rates over time or examining the aftermath of unusual events. Taking an unusual event as an example, we could look at the aftermath of the recent QuakeCon event in which thousands of gamers came to Dallas on the weekend of August 14–17, 2003, to play violent networked games in a large tournament. This year's event featured the unveiling of Id Software's most intense and graphically violent game to date, *Doom 3*. If expert predictions were correct, the event would have been a particularly dangerous situation with thousands of frequent players, desensitized to violence by games, and with activated hostile thoughts in their minds, jammed together in a hotel. Contrary to any such expectations, there were no reports of any unusual increase in crime resulting from the conference.

Another option is to conduct experiments in the field using quasi-experimental techniques (Shadish, Cook, and Campbell 2002). Field studies attempt to recreate as many of the laboratory controls as possible in a real-world setting. Such research demands a greater amount of creativity (and funding) from the researcher in order to control extraneous variables, but the pay off is a greater sense of how people behave in the real world. Field studies use a variety of proven methods, such as multiple non-random comparison groups, matching of participants within groups, and time-series designs. They often try to take advantage of naturally occurring events as manipulations. For example, Id Software is scheduled to release *Doom 3* around Christmas time. This unique event allows for data collection before and after the release of *Doom 3* to track whether the introduction of the new violent game has an effect on actual behavior. In order to conduct valid research, we will need *a priori* knowledge of a number of factors such as: who are likely players, why they are likely players, how frequently they might play and under what conditions, and in what type of actual aggression we are interested. Knowledge of such factors informs our choice of participants for this kind of research and guides us in the design of valid measures.

One field study failed to find an increase in aggressiveness after a month of playing a violent online game. Williams and Skoric (2003) recruited 521 participants to take part in the study. Participants in the treatment condition were given a copy of *Asheron's Call 2*, a violent, massively multiplayer online role-playing game, and told to keep track of the amount of time they spent playing during the month. The control group did not receive the game, but were promised the opportunity to win prizes if they stayed through the month. After a month, there were no significant differences between the treatment and control groups on physical aggression, verbal aggression, or aggressive cognitions.

Other Behavioral Effects

If we abandon the *a priori* assumption that violent video games are necessarily bad and instead try to study games from a more neutral starting point, then we can posit a number of other possible effects that might be worthy of investigation. For example, might it be possible that violent video games actually have a role in reducing violent crime on the streets? Could it be the case that individuals, some whom are inclined to act violently, may prefer to stay indoors and play out their violent fantasies in ways that are not possible in the real world? Because male street fighting is often more about establishing dominance than inflicting pain, video games give individuals an outlet for demonstra-

tions of dominance. Games such as *Quake* allow players to engage in heavily armed combat against the computer or against other players. It is certainly a safer form of contest than street fighting.

While no one has directly tested the notion of video games as surrogates for dominance displays, there are data supporting such a notion. Kestenbaum and Weinstein (1985) conducted a survey of adolescent males in which they concluded that adolescents use violent video games to manage feelings of anger (cast by the researchers as a Freudian Oedipal conflict). My own focus group and survey research suggests that games are frequently used to live out competitive fantasies against both friends and strangers (Sherry and Lucas 2003). Certainly, the QuakeCon tournament and the forming of professional video-game playing leagues provide a safe opportunity to demonstrate dominance.

Video games have been shown to provide an outlet for control for players (Sherry et al. 2003). As such, they may play a useful role in helping children manage difficult developmental situations. I was struck by this possibility recently while talking to a 6-year-old boy who is a very avid game player. He plays video games as often as possible and has memorized the personalities of all the characters in the virtual worlds he plays in. While he plays, he blocks out everything that is going on around him. Normally, such seemingly addictive behavior would have bothered me. But I talked to the child and asked him why he likes playing video games; his response was so that he could be strong. This child lives in a chaotic situation. His parents are divorced and he lives with his inconsistent mother during the week and spends weekends with his emotionally disturbed father. He is the youngest child in the family and is seldom listened to. His mother is getting married soon and he will be forced to integrate with a new family where he will remain on the bottom of the pecking order. Video games seem to allow him to escape into a world where events are predictable and controllable, and where he has the ability to dictate behavior. Those opportunities simply do not exist in the real world for him.

There is some systematic evidence that children may indeed use video games to manage difficult developmental situations. We have come to a similar conclusion based on a survey of fifth-grade children's game-playing habits (Sherry, Desouza, and Holmstrom 2003). We looked at the temperament of children who report liking violent games categorized as "fighters and shooters." While boys who like violent games have outgoing temperaments, girls who like violent games were typified by less social, more controlling temperament types. The games seemed to be a channel through which they could gain control of their world and perhaps enact violent fantasies in a safe environment.

Online gaming has expanded friendship networks for gamers. A recent AP story on QuakeCon described the event as a type of family reunion in which people who formed online gaming "clans" were able to meet each other in person (Slagle 2003). A surprising aspect of the event was the growing popularity of the game among girls and families. Online games allow players to communicate with one another during game play and to form groups who meet at set times during the week to play together. Who might be interested in these gaming communities? What gratifications do they provide for players? Might this be a different group of game players from those who play other genres, such as those that are limited to one player?

Those who wish to find negative effects of violent video games may want to cast their attention toward ethical behavior learned via video-game play. The video-game world consists of rule-based competition with fuzzy borders. A highly proficient player can not only play within the rules of the game, but also figure out how to get around the rules of the games. Often times, these techniques are made available on Internet "cheat sites," or even

on game-maker sites. Playing around the rules may send the message to developing adolescents that rules are flexible and only apply to those who are not smart enough to learn how to evade them.

The powerful effects-claims advanced by some experts may appear considerably weaker when subjected to careful scrutiny. There has been an inclination to blame media for social problems throughout the 20th century (Wartella and Reeves 1985). However, it is the responsibility of scholarly researchers to act on fact, not opinion. At a minimum, the experts have jumped the gun by claiming powerful effects before evidence for these effects exists. Perhaps future ecologically valid research will show that these games are indeed a serious threat. When the data as they exist today are examined, the case for violent video games causing aggression is less than overwhelming.

REFERENCES

American Academy of Pediatrics Committee on Public Education. 2001. Media violence. *Pediatrics* 108 (5):1222–1226.

Anderson, C. A., and K. B. Anderson. 1996. Violent crime rate studies in philosophical context: A destructive testing approach to heat and southern culture of violence effects. *Journal of Personality and Social Psychology* 70:740–756.

Anderson, C. A., and B. J. Bushman. 2001. Effects of violent video games on aggressive behavior, aggressive cognition, aggressive affect, physiological arousal, and prosocial behavior: A meta-analytic review of the scientific literature. *Psychological Science* 12:353–359.

Anderson, C. A., and K. E. Dill. 2000. Video games and aggressive thoughts, feelings, and behavior in the laboratory and in life. *Journal of Personality and Social Psychology* 78:772–790.

AMA, APA, AP. 2000. Joint statement on the impact of entertainment violence on children Congressional Public Health Summit (accessed August 10, 2003) http://www.aap.org/advocacy/releases/jstmtevc.htm.

Austin, L. 1987. The effects of playing video games with aggressive features. PhD. diss., Fielding Institute, 1987. *Dissertation Abstracts International-B, 49/11,* 5013.

Ballard, M. E., and R. Lineberger. 1999. Video game violence and confederate gender: Effects on reward and punishment given by college males. *Sex Roles* 41:541–558.

Bartholow, B. D., and C. A. Anderson. 2002. Effects of violent video games on aggressive behavior: Potential sex differences. *Journal of Experimental Social Psychology* 38:283–290.

Brusa, J. A. 1988. Effects of video game playing on children's social behavior (aggression, cooperation). PhD. diss., DePaul University, 1987. *Dissertation Abstracts International-B, 48/10,* 3127.

Claymon, D. 1999. Video game industry seeks to deflect blame for violence. *Miami Herald,* July 2, 1999.

Cohn, L. B. 1995. Violent video games: Aggression, arousal, and desensitization in young adolescent boys. *Dissertation Abstracts International, 57,* 2-B, 9616947.

Cohen, J. 1988. *Statistical power analysis for the behavioral sciences 2nd ed.* Hillsdale, NJ: Erlbaum.

Cooper, J., and D. Mackie. 1986. Video games and aggression in children. *Journal of Applied Social Psychology* 16 (8):726–744.

Graybill, D., M. Strawniak, T. Hunter, and M. O'Leary. 1987. Effects of playing versus observing violent versus nonviolent video games on children's aggression. *Psychology: A Quarterly Journal of Human Behavior* 24 (3):1–8.

Irwin, A. R., and A. M. Gross. 1995. Cognitive tempo, violent video games, and aggressive behavior in young boys. *Journal of Family Violence* 10 (3):337–350.

Kestenbaum, G. I., and L. Weinstein. 1985. Personality, psychopathology and developmental issues in male adolescent video game use. *Journal of the American Academy of Child Psychiatry* 24 (3):329–337.

National Cancer Institute. 1997. Cancer facts: Artificial sweeteners (accessed August 18, 2003). http://cis.nci.nih.gov/fact/3_19.htm.

Paik, H., and G. Comstock. 1994. The effects of television violence on antisocial behavior: A meta-analysis. *Communication Research* 21:516–546.

Popper, K. 1968. *The logic of scientific discovery.* New York: Harper & Row.

Rand, M. R., and C. M. Rennison. 2002. True crime stories? Accounting for differences in our national crime indicators. *Chance* 15 (1):47–51.

Rich, M. 2000. Public health summit on entertainment violence, Washington, D.C. http://www.aap.org/advocacy/rich-mediaviolence.pdf.

Schutte, N., J. Malouff, J. Post-Gordon, and A. Rodasta. 1988. Effects of playing video games on children's aggressive and other behaviors. *Journal of Applied Social Psychology* 18:451–456.

Shadish, W. R., T. D. Cook, and D. T. Campbell. 2002. *Experimental and quasi-experimental designs for generalized causal inference.* Boston: Houghton Mifflin.

Sherry, J. L. 2001. *The effects of violent video games on aggression: A meta-analysis.* Human Communication Research 27:409–431.

Sherry, J., R. Desouza, and A. Holmstrom. 2003. *The appeal of violent video games in children.* Broadcast Education Association Annual Convention, Las Vegas, NV.

Sherry, J., R. Desouza, B. Greenberg, and K. Lachlan. 2003. *Relationship between developmental stages and video game uses and gratifications, game preference and amount of time spent in play.* International Communication Association Annual Convention, San Diego, CA.

Sherry, J., and K. Lucas. 2003. Video game uses and gratifications as predictors of use and game preference. International Communication Association Annual Convention, San Diego, CA.

Sherry, J. L., J. Curtis, and G. Sparks. 2001. Arousal transfer or priming? Individual differences in physiological reactivity to violent and non-violent video games. International Communication Association Annual Convention, Washington, D.C.

Silvern, S., and P. Williamson. 1987. The effects of video game play on young children's aggression, fantasy, and prosocial behavior. *Journal of Applied Developmental Psychology* 8:449–458.

Slagle, M. 2003. Video game conference drawing more girls, families (accessed August 17, 2003). http://www.beaufortgazette.com/24hour/technology/story/971161p-6812894c.html.

Walker, M.R. (1984). The effects of video games and TV/film violence on subsequent aggression in male adolescents. PhD. diss., University of Southern Mississippi, 1985. *Dissertation Abstracts International,* 46, 2082.

Wartella, E., and B. Reeves. 1985. Historical trends in research on children and the media: 1900–1960. *Journal of Communication* 35 (2):118–133.

Williams, D., and M. Skoric. 2003. Massively Mulitplayer Mayhem: Aggression in an Online Game. Association for Education in Journalism and Mass Communication Conference, Kansas City, MO.

Winkel, M., D. Novak, and H. Hopson. 1987. Personality factors, subject gender and the effects of aggressive video games on aggression in adolescents. *Journal of Research in Personality* 21:211–223.

Zillmann, D., and J. Bryant. 1994. Entertainment as media effect. In J. Bryant and D. Zillmann (Eds.), *Media effects: Advances in theory and research* (pp. 437–461). Hillsdale, NJ: Erlbaum.

Annie Lang

Motivated Cognition (LC4MP)

The Influence of Appetitive and Aversive Activation on the Processing of Video Games

This essay approaches the issue of how people interact with video games from a dynamic, embodied theoretical framework. The premise is that underlying all conscious and cognitive activity is a very basic motivational system consisting of an appetitive (or approach) and an aversive (or avoid) system. These two systems are conceived of as operating simultaneously and independently. Many stimuli, and in particular, the high-arousal positive and negative stimuli that exist in video games, automatically and differentially activate these systems. This chapter discusses how the various contents and structures of video games engage the appetitive and aversive systems, which, in turn, mediates the player's physiological, cognitive, and emotional responses, experiences, and behaviors. The chapter also considers how individual variation in resting motivational activation may be a factor in who plays games and which kinds of games they play.

This paper applies a specific theoretical approach that focuses on the influence of primitive nervous-system responses on how people interact with mediated messages to understanding video games. It considers how the oldest parts of the human brain interact with the newest forms of mediated communication.

A familiar chart of significant events and ages since the creation depicts all of human history as a single day, and thus the last, and most technologically dizzying, century as a single second. When considering how human brains deal with modern media technology, it is well to keep this thought in mind. We should seriously consider that the evolution of the human brain encompassed several "hours" and was completed many "hours" before the single second in which we are living. Technology changes very quickly and brains change very slowly. The human brain of the 21st century does not differ from the human brain of the 19th century, the ninth century, or even the ninth century BC. The human brain did not develop to deal with mediated messages.

The human brain developed to deal with the real world. Real things, moving through real environments, pursuing goals related to living, of which the primary goal is to live.

From the simplest single-cell organism to the complex human being, the primary goal must be to survive. Survival requires behavior calculated to sustain and protect the physical body. The twin goals of sustaining and protecting are often conceptualized as basic motivational systems. Those systems are colloquially referred to as the approach system and the avoidance system. In this chapter, we will speak of them as the appetitive (related to appetite) and the aversive (related to aversion) system. The appetitive system exists to sustain the individual organism and the species, to search for food and opportunities for procreation. The aversive system's function is to protect the organism from harm to locate, avoid, or remove danger.

These two systems are the yin and the yang of motivation. Their effects can be seen in the simplest single-celled animals and the most complex mammals. They function automatically, without conscious thought, and they cannot be eliminated by conscious thought. When the environment is safe, the appetitive system is in charge. When danger threatens, the aversive system is in charge. When the environment is moderately safe but danger is possible, both systems function simultaneously to sustain and protect.

Our goal is to consider how the structure and the content of video games automatically and differentially activate the appetitive and aversive motivational systems in the human being, and how that differential activation impacts higher order emotional and cognitive processing. In order to do this, it is necessary first to lay out three basic theoretical perspectives: 1) a theoretical perspective on "thinking," 2) a theoretical perspective on motivation and emotion, 3) a theoretical perspective on media. Following this background material, the paper applies these theoretical perspectives, in concert, to four basic questions: 1) How and when do media activate underlying motivational systems? 2) How does activation of the motivational systems impact emotional response? 3) How does the activation of underlying motivational systems impact thinking? 4) How does motivational activation, as an individual difference, affect media use and mediated message processing? Each of these four questions is considered first in general, as related to any medium, and then in the context of playing and designing video games.

Theoretical Perspectives

A Theoretical Perspective on Thinking

People think. They can't help but think. We think automatically, by which I mean that it happens without conscious volition and you cannot stop it, though you can, to some extent, control it. In this chapter, thinking is conceived of as being "embodied." What this means is that brains are located in bodies and they are inseparably a part of those bodies, closely linked by millions of chemical, physical, and neuronal ties. Nothing happens to the body that is not reflected in the brain. Conversely, nothing happens in the brain that is not reflected in the body.

Further, the brain-body system is dynamic, moving through both space and time. The state of the system at this second is having an impact on the state of the system in the next second, which is having an impact on the state of the system in the next second, and so on. The system both responds to and initiates actions. Those actions begin, grow, optimize, and recede. The system operates in parallel, multiple responses and initiations occur in concert, at different speeds, for different purposes.

The basic model used here is the Limited Capacity Model of Mediated Message Processing (LC3MP) (Lang 2000). In this model, thinking is conceptualized as requir-

ing mental resources of which people have a finite limited supply, which are allocated to the processes involved in thinking. Those processes include (but may not be limited to) encoding, storage, and retrieval. These three processes occur simultaneously.

Encoding is the process of creating a mental representation of the environment. It functions continuously to build up, over time, a representation of the outside world. It is important to recognize that the process of encoding is not thought to be veridical, i.e., what is encoded is not an exact representation of what is there. The mental representation is conceived to be an inexact and idiosyncratic copy of the world. At any given time, the mental representation of the environment is multiply determined by the salience of aspects of the environment, the goals and experiences of the person perceiving the environment, and the interaction between the two, including the length of time the interaction continues. Items in the environment that are motivationally salient (food, sex, danger), structurally salient (movement, novelty, change, etc.), or personally salient (goal related, learned signal, etc.) are more likely to be selected and encoded into the mental representation. Over time, less salient information may also be encoded and the mental representation may become more detailed and more complete. Thus, the initial mental representations of an environment are likely similar from individual to individual in terms of motivational and structural items, but different in terms of items of relevance to individuals. The similarity amongst mental representations is likely to increase over time. This process of encoding requires mental resources.

Storage is the process of linking recently encoded information with previously encoded information. Once information has been encoded, it exists in some form in the brain. At the point that information is being encoded, or is being thought about, it is conceived of as being active. Information that is active simultaneously becomes linked. Information that is strongly linked to existing information is better stored than information that has few or only weak links. The process of creating links, or storage, also requires mental resources.

Retrieval is conceptualized as the process of activating previously stored representations. The better stored a representation is, the more likely it is to be retrievable. Also, the easier it will be to retrieve. The process of retrieval also requires mental resources.

As all these processes require resources, and all are ongoing, the thinking being is continually allocating and reallocating his/her finite supply of mental resources to the simultaneously occurring processes of encoding, storage, and retrieval. While all of these processes function automatically, their functioning can be inhibited or improved through intent.

Resource allocation is conceptualized to occur as a result of both automatic and controlled processes. Resources are automatically allocated to stimuli that are novel, motivationally salient, or are learned signals (i.e., the person has learned that the stimulus signals important or relevant information). These types of stimuli elicit orienting responses. The orienting response is an automatic resource-allocation mechanism and consists of a set of physiological and behavioral responses that are thought to increase the ability of the organism to take in (or encode) information from the environment. When a stimulus elicits an orienting response, resources are automatically allocated to encoding the stimulus.

Controlled resource allocation varies with the intentions and goals of the organism. When people want to remember something, they can increase the allocation of resources to storage, and therefore increase the likelihood that they will be able to retrieve information at a later date. Similarly, when searching the environment for a specific item, they can increase the resources allocated to encoding.

The system has only a limited supply of processing resources. Therefore, unlimited resources cannot be allocated to all three processes, meaning that processing is nearly always necessarily incomplete. When the exigencies of the processing task exceed the resources available in the limited capacity pool, the state arises that is called cognitive overload. At the point of cognitive overload, all processing resources have been allocated to the various processes, but more are required to complete the ongoing processing task. When this happens, processing suffers. Depending on the requirements of the processing task, cognitive overload may occur for a single process (such as encoding) or across processes.

A Theoretical Perspective on Motivation and Emotion

The perspective used here combines research on motivation and emotion, and is based on a dual-system model proposed by Caccioppo (Caccioppo and Gardner 1999; Caccioppo, Gardner, and Bernston 1999). This model views emotion as functional: the assumption being that emotion developed to help organisms to avoid danger, overcome obstacles, and find food and mates.

In this approach, emotional space is conceived of as having two primary dimensions. The first of these, valence, corresponds to whether an emotion is positive or negative. This dimension ranges from extremely negative to extremely positive. The second dimension is called arousal. This dimension indexes the intensity of the emotional response and ranges from very calm to extremely aroused (P. J. Lang, Bradley, and Cuthbert 1997; P. J. Lang, Fitzsimmons et al. 1996; P. J. Lang, Gilmore et al. 1996; P. J. Lang, Simons, and Balaban 1997; P. J. Lang et al. 1993).

Lang theorizes that the experience of emotion, and in particular whether the emotion is positive or negative, is related to activation in the underlying appetitive and aversive motivational systems. In other words, positive emotions correspond to appetitive activation and negative emotions correspond to aversive activation. The arousal dimension is indicative of increasing activation in the underlying motivational systems. Thus, the experience of positive emotion corresponds to appetitive activation while the experience of negative emotion corresponds to activation of the aversive system.

Recent work by Cacioppo builds on this approach. However, Cacioppo adds to the mix the concept of *coactivation* (Caccioppo and Gardner 1999; Caccioppo, Gardner, and Bernston 1999). Traditionally, it has been assumed that the motivational systems were reciprocally active. That is, one or the other was active at a time. Cacioppo argues that this conceptualization is not correct and that we should conceptualize the appetitive and aversive motivational systems as independent of one another. While the two systems *can* activate *reciprocally*, as has traditionally been thought, there are also three other possible modes of activation: both systems can be inactive, the systems can be activated in a completely unrelated way, which is called *uncoupled*, and both systems can be simultaneously active, called *coactivation*.

Cacioppo further proposes that in addition to being independent, the two motivational systems are characterized by different activation functions. The appetitive activation system is theorized to be more active than the aversive system in a neutral environment. This provides the impetus for the animal to leave the nest and explore the environment in search of food and mates in a neutral environment. If the aversive system was more active, the animal would never leave the nest. Cacioppo calls this appetitive activation advantage the "positivity offset." Though less activated in a neutral environment, the the-

ory proposes the aversive system responds more quickly to potentially relevant stimuli than the appetitive system because danger can occur quickly and slow response may mean death. Cacioppo calls this faster speed of response the negativity bias.

Thus, in a neutral environment humans are slightly appetitively motivated. As stimuli enter the environment, automatic pre-attentive mechanisms identify them as primarily neutral, positive, or negative. Negative stimuli activate the aversive system, while positive stimuli further activate the appetitive system. The closer, or the more arousing, the stimulus is, the greater the corresponding activation in the associated motivation system. In addition, a single stimulus might be both positive and negative, or multiple stimuli might be present, some of which are positive and some of which are negative. When this is the case, the theory posits that both systems will increase in activation, resulting in coactivation.

In addition, positivity offset and negativity bias appear to vary across individuals and can be measured using the Motivational Activation Measure (MAM), which indexes an individual's positivity offset and negativity bias (A. Lang, Shin, and Lee 2005; Wang, Bradley, and Lang 2004). Positivity offset is related to the sensation-seeking personality trait, to risky behaviors like drug and alcohol use and abuse, and to attention to media. Negativity bias is related to substance use, sensation seeking, and startle enhancement, or "potentiation." MAM can be used to identify four basic groups of people called *risk takers* (those who have a high positivity offset and a low negativity bias), *risk avoiders* (those who have a low positivity offset and a high negativity bias), *inactives* (both low), and *coactives* (both high) (A. Lang, Shin, and Lee 2005).

This work suggests (though little data is yet available) that resting activation in the motivational systems, as described by positivity offset and negativity bias, likely impacts how individuals process their environments (i.e., what information they encode and retrieve, and how well that information is stored) and, as a result, how they process mediated messages.

A Theoretical Perspective on Media

Over time, communication researchers have defined media in numerous ways. Common conceptualizations are to consider media by technology (e.g., print, broadcast, digital media, etc.), by genre (e.g., news, drama, comedy, sports, advertising, etc.), by content (e.g., sex, violence, politics, etc.), and by intent (e.g., educational, entertainment, persuasive, etc.). Certainly, all of these conceptualizations have value and lead to different perspectives on how to study media. In this chapter, mediated messages are considered from a psychological point of view. Mediation is conceptualized as the set of structural features imposed on a message by the message producers' choice of medium (McLeod and Reeves 1980; Reeves, Thorson, and Schleuder 1986; Reeves 1989; Reeves and Geiger 1994). Examples include channel of information presentation (visual, audio, audiovisual, tactile, smell), control of information presentation (onset, offset, rate, access, etc.), and structural features associated with production such as camera effects, visual effects, sound effects, movement, color, etc. Messages are conceptualized by psychologically and motivationally relevant content features such as familiarity, difficulty of information, emotional valence and arousing content, narrative structure, relevance, etc.

Using this view of media, one can examine across media and within a medium how various structural and content features of messages impact media users' cognitive, emotional, and motivational systems, and how media users' cognitive, emotional, and moti-

vational systems affect their use and response to mediated messages. The same theoretical conceptualization of processing, emotion, and motivation can then be applied to all media by defining the medium under study in terms of its structural features and defining the message under consideration in terms of its psychologically relevant content features.

This is the conceptualization of media used in the LC4MP (and its precursor the LC3MP). Research using this model has examined how user goals interact with the content and structural features of various media (including television, computers, and radio) to affect the encoding, storage, and retrieval of the content of mediated messages.

Within this model, mediated message processing is conceived of as an interaction between the media user, the medium, and content of the message (Lang 2000). Media users are characterized by personality characteristics, motivational type, previous knowledge, goals, interests, experience with the medium, and a myriad of other individual differences that may affect message processing. The media, through their individual structural features, dictate in some measure the automatic allocation of processing resources to specific aspects of the message, as well as the level of resources required to process the content. Finally, and obviously, the content of the message plays an enormous role in both how the message content is automatically processed (through content features such as emotion) and on how media users allocate their control processing resources (as a function of interests, goals, etc.).

In the rest of this chapter, we will examine how the combination of these three theoretical perspectives in the LC4MP, the limited capacity model of *motivated* mediated message processing, can be applied to media in general and video games in particular.

Application of the Theory

How and When do Media Activate Underlying Motivational Systems?

Traditionally, we view media use as a conscious choice made by rational human beings. As with other representational forms and entertainment media, from storytellers to theater to books to television to the World Wide Web, we are prone to think that as we engage in an interaction with a not-real message we suspend our disbelief. Yet, as Byron Reeves and Cliff Nass explain in their book *The Media Equation* (1996), that argument does not make sense from an old brain perspective. There is no reason why the brain should have some kind of switch that allows it to recognize stimuli as *not* real. When the brain was evolving, stimuli were real, and detecting their presence was a motivational imperative. Certainly, newer parts of the brain have evolved that are able to distinguish between a mediated and a real message. The initial response to messages and stimuli, however, which occurs within the first 1,000 milliseconds of encountering a message, is not under the control of the "new brain." Instead, it is controlled by the "old brain." In the first 1,000 milliseconds, the older parts of the brain engage in object recognition, and differentiation of neutral from positive and negative stimuli. Automatic protective, and attentional responses designed to protect the body from intense or fast onset stimuli are triggered within milliseconds of stimulus onset, before the object has been recognized, and long before the conscious brain can think, "This is not real." This means that when people sit down to a mediated message, they do not say, "I will pretend that this message is a real message, even though I know it is not." Rather, the interaction that occurs involves the higher order areas of the brain inhibiting the responses of the lower levels of the brain.

Thus, media elicit orienting responses, startle responses, and perhaps even defensive responses. They elicit activation in the motivational systems along with the accompanying physiology that prepares the organism for a fight, flight, or approach. What the conscious brain does is inhibit the size and ramifications of those automatic responses after they have occurred. Thus, when you know something bad is going to happen, and then the dark figure jumps out from behind the building, you still have a startle response. You blink, you jump, your heart speeds up, your palms sweat, your processing is briefly interrupted. Your body is ready to avoid the sudden occurrence of a possibly negative stimulus. There is nothing you can do to eliminate that response. It will occur. It is reflex. You can, however, after the initial reflexive jump, sit back in your chair, laugh at yourself, and go back to watching the movie or playing your game. But that conscious response to an imperative reflex is the new brain at work, inhibiting the old brain, which is responding to the movie or game as if it were real.

Many people consider that with the onset of new digital media and virtual reality, people will experience a greater sense of presence. They will be even more "taken in" by the media than they were before. This is an interesting idea to contemplate from the old-brain perspective. First, from this perspective, there is no difference in "reality" between a black-and-white image on a TV screen and the most up-to-date virtual-reality stimulus. The old brain responds to both of them as real stimuli. The difference, to the extent it exists, is in the new brain. The new brain knows that both of them are "not real." However, the extent to which a mediated stimulus has a greater match with the real world will likely elicit a greater coterie of automatic, physiological, and perhaps even behavioral responses. Therefore, the task of inhibiting the old brain and the old body may be a bigger job. Indeed, virtual reality might become so indistinguishable from reality on a conscious level that the task of convincing the new brain that the virtual experience is not real might become almost overwhelming, resulting in a significant decrease in the level of inhibition imposed on the old body/brain system.

So, under LC4MP, how do media activate the "old brain" and what is the "new brain" doing? Mediated stimuli activate the motivational systems almost instantly, certainly within 150 milliseconds of onset. The effects of the emotional content of a stimulus can be seen in the modulation of the startle response beginning 100 milliseconds after stimulus onset (Graham 1979). During the first 600 milliseconds after a stimulus appears, startle responses are slightly inhibited for both positive and negative stimuli compared to neutral stimuli. Thus, stimuli that are likely to have motivational relevance modulate what is essentially a protective reflex. After 800 milliseconds, a different pattern of modulation is seen—startle reflexes are smaller for positive stimuli and larger for negative stimuli compared to neutral stimuli (P. J. Lang, Bradley, and Cuthbert 1990, 1997).

One explanation for these findings is called motivated attention (P. J. Lang, Bradley, and Cuthbert 1997). The startle response has physiological, behavioral, and cognitive consequences. The behavioral response is the classic full-body jerk associated with being startled, which includes a protective eye blink. This likely functions to move the body out of the path of danger. The physiological response includes heart rate acceleration and increased skin conductance, which are associated with preparing the body for action. The cognitive response is thought to function as a processing interrupt. If a stimulus is fast enough to elicit a startle response, then it must not be ignored. However, if a stimulus that elicits an orienting response (associated with the intake of information) occurs 250 milliseconds before a stimulus that elicits a startle response, the startle response is inhib-

ited. Theory suggests that this is due to the protective function of the orienting response. Thus, though processing is still largely interrupted, the stimulus that already had elicited an orienting response receives protective processing, i.e., is not interrupted, for 250 milliseconds, about the time required to identify the stimulus. This inhibition of the startle response, caused by an orienting response, is larger when the orienting eliciting stimuli is motivationally relevant (i.e., emotional). Thus, even in the presence of a startle eliciting stimulus, motivationally relevant stimuli receive protected processing up to the point of stimulus identification.

After 800 milliseconds, the emotional foreground (in other words, whether the environment is generally positive, negative, or neutral), as opposed to the emotional content of the orienting eliciting stimuli, is what modulates the size of the startle response. In a positive or approach environment the startle is somewhat inhibited. In a negative, aversive environment the startle is enhanced or potentiated.

It is likely that both protective inhibition and motivationally relevant modulation are going on when the old brain meets a mediated stimulus. Thus, if a sudden onset (a fast-moving person, a gunshot, etc.) occurs during a positive message a startle is elicited, but should be inhibited. Similarly, in a negative message, the startle is potentiated. At the same time, if the startle eliciting characteristic occurs very shortly after a scene change, or other orienting-eliciting structural feature, processing of that feature may be protected, in particular if it is emotional.

How does this theoretical approach, focused on the interaction amongst the medium, the content, the old brain, the new brain, and the body, apply to the use and design of video games? First, the old brain is responding to the video game environment as if it were real. In a negative environment, that is, one containing threats that must be responded to, you should get automatic aversive activation. Because media are not real, however, and the new brain knows that they are not real, there's always a certain amount of appetitive activation that accompanies media use. Media use, or the intent to use media, should result in an approach set. This likely means that, at least for negative video games, the experience of playing them is coactive, providing both appetitive and aversive activation.

Further, while all mediated environments will be perceived by the *old* brain as real, the greater the verisimilitude of the virtual environment, the more work the *new* brain will have to do to remember that it is a not in a real environment, which is likely to reduce inhibition of old-brain responses.

If this is so, it seems sensible to design video games to play on the old brain's reflexes. In particular, the onsets and offsets of scenes and characters can be designed to vary in their emotional valence and speed of onset. That is, some objects might appear with slow rise times resulting in orienting responses, while others might appear with fast rise times and elicit startle responses. By using the medium to regularly trigger these automatic responses, you're likely to maintain attention towards and interest in the game. The careful positioning of orienting eliciting stimuli can be used to help direct novice users in ways that will speed their learning of the game. Many aspects of video game play (such as learning controls and mastering aspects of the interface) are repetitive and lend themselves to becoming automatic. The initial performance of these actions requires the allocation of resources (or mental effort) but, with practice, these actions become automatic or effortless.

Further, the size and impact of startle responses can be altered through the placement of startle and orienting-eliciting stimulus onsets either close together or far apart,

or within positive or negative emotional foregrounds. For example, the startle response could be doubly inhibited by a positive foreground and an immediately preceding orienting response, reducing the size of the startle and the severity of the processing interrupt. Similarly, use of a negative emotional foreground and a fast-onset negative stimulus can maximize the size of the startle response. All of these responses can be further magnified by having a more lifelike virtual environment.

Playing video games is likely to be a coactive experience. By creating games with lifelike environments and varying the valence and speed of onset of characters, one might create an experience that elicits a great deal of old-brain activity, and reduces new-brain inhibition, creating more physiological responding, which should create an experience and memories that are also more "real" because the responses of the body are more like what they would be in a real setting. In other words, presence is higher when the body's "old brain" responses are larger.

How does activation of the motivational systems impact emotional response?

The answer to this question depends in part on how one separates emotion from motivation, a question that is certainly theoretical and may indeed be philosophical. LC4MP conceptualizes motivation as activation of the underlying appetitive and aversive motivational systems. Emotion, on the other hand, is conceptualized as the experience of emotion, or the feelings people have. Thus, motivation is the very beginning of a causal chain of responses that leads from a stimulus to an emotional feeling or experience. If that stimulus is motivationally relevant, it will elicit activation in the appropriate motivational system. That activation will in turn cause physiological and behavioral responses designed to increase the ability of the organism to survive. Eventually (say, after 600 to 750 milliseconds), the motivational activation and its corresponding physiological and behavioral activity begin to affect conscious experience of both the environment and the emotional feeling.

This would suggest that the greater the motivational activation elicited, the greater the emotional response. During media use, where the new brain is inhibiting the motivational and physiological responses of the old brain, emotional experience may also be somewhat inhibited.

How would this apply to designing or experiencing video games? Take the proposition that the experience of emotion is increased when either or both aversive and appetitive activation are increased. LC4MP suggests numerous ways in which the emotional foreground of the game, the speed of onset of the characters and objects, and the valence of those characters and objects, could be combined to maximize either positive or negative emotional experience. The emotional foreground of the game might vary from positive to negative. At times the player may be engaged in very pleasant activities in what appear to be safe and pleasant environments, at other times the environment may be actively negative and the player may be engaged in active avoidance or aggression. The variation in the valence and arousing content of the foreground will increase the associated motivational system's activation. Depending upon that emotional foreground, the use of slow- or rapid-onset negative and positive stimuli can again be used to elicit orienting or startle responses. These will also differentially activate the motivational systems, with orienting responses increasing appetitive activation and startle responses increasing aversive activation, and also lead to variation in the associated physiological responses and the eventual emotional experience of the user.

For example, if the foreground is positive (a lovely forest glen), and a positive stimulus appears with a slow onset (a magical feast), an orienting response will occur. The orienting response will briefly increase appetitive activation and provide a zone of protection for recognition of the recently appearing stimuli. If shortly after the zone of protection a fast-onset stimulus occurs, it will elicit a startle response. The startle response will be somewhat inhibited by the positive foreground, and could be yet more inhibited if the onset is within 250 milliseconds of the slow-onset stimulus. This fast-onset stimulus could be either negative (a spider dropping down over the table) or positive (the Fairy Queen's appearance at the head of the table). If it is positive, then the old brain will experience a positive foreground, a positive stimulus-eliciting orienting response, both of which should increase appetitive activation, followed by a positive stimulus that elicits a startle response causing a brief increase in aversive activation, followed by another increase in appetitive activation. This sequence of events should greatly increase positive emotional experience, and the presence of the startle response, with its associated aversive activation, is likely to result in a greater increase in the experience of arousal than would be caused by the positive stimuli without the startle response, which should also increase the experience of positive emotion. Similarly, one could design the foregrounds and onsets to maximize negative activation and the experience of negative emotion.

How Does Activation of Underlying Motivational Systems Affect Thinking (Cognitive Processing)?

If thinking is an embodied activity, motivational activation should affect thought. Thinking involves the recognition of environmental stimuli, contemplation of the consequences of encountering those stimuli, choices about actions to be taken to either avoid or engage with those stimuli, and remembering relevant aspects of the stimulus for future use. It evolved to further improve the organism's ability to survive. In a neutral environment where motivational activation is low, thinking can occur in a leisurely fashion. This situation might most closely resemble the kind of rational information processing that has been studied by cognitive psychologists for the last 40 years. However, when the environment demands some kind of action related to survival, it makes sense that the thinking process should be modulated by those demands.

First, motivational relevance should increase the likelihood of the stimulus being encoded (P. J. Lang, Bradley, and Cuthbert 1997). Motivational relevance can be determined by both structural (speed, intensity, novelty) and content (negative, positive, signal) aspects of stimulus.

Thus, motivationally relevant stimuli increase the allocation of processing resources to encoding and more information can be encoded. Initially, this increase in resources occurs for both positive and negative stimuli. As time goes on, however, the allocation of resources to encoding is modulated by whether the activation is aversive or appetitive.

During appetitive activation the cognitive set of an organism is one of information intake. As appetitive activation increases, resources allocated to encoding should continue to increase, resulting in a positive relationship between appetitive activation and resources allocated to encoding. Aversive activation, on the other hand, is more likely to be associated with action (e.g., protection, avoidance, and flight). Thus, once the negative stimulus has been identified, further information intake may be unnecessary. Rather than allocating additional resources to encoding details about the bad guy, resources are likely allocated to other processes associated with selecting and implementing an appro-

priate protective response. Thus, at lower levels of aversive activation, there will be some increase in resources allocated to encoding, but increasing aversive activation will cause a decrease in resources allocated to encoding (A. Lang, Dhillon, and Dong 1995). The same relationships should hold when engaged with a mediated stimulus. As a result, recognition for positive messages (an index of encoding) should be greater than recognition for negative messages. Similarly, for negative messages, recognition increases at lower levels of aversive activation and then decreases at high levels of aversive activation (A. Lang, Potter, and Bolls 1999; A. Lang et al. 2000).

Motivational activation also affects storage. It makes sense to remember motivationally relevant stimuli in order to find them again if they are positive or avoid them if they are negative. Similarly, the storage of a successful response to a stimulus will enable that response to be used again. LC4MP theorizes that motivationally relevant stimuli elicit an automatic allocation of resources to storage (A. Lang et al. 1999; Potter and Lang 1996).

In the case of mediated messages, this would mean that positive or negative messages should result in an increase in the storage of information contained in the message. Further, as motivational activation increases, resources allocated to storage should increase.

This explanation is also congruent with both research on and the experiences of people giving eyewitness accounts of emotionally negative events. In general, people have very strong memories of the event, its general properties, and important structural aspects, such as when and where it occurred. When pressed for details, however, people are often unable to remember what might seem to be obvious things, such as type of clothing, hair style, color of the car, etc.

What happens to retrieval as motivational activation increases? In general, organisms are constantly retrieving information in order to make sense of the environment. Thus, what is already known has an impact on the ongoing encoding and storage processes. Similarly, already held information affects the signal properties of environmental stimuli. Primary motivationally relevant stimuli are likely hardwired into the motivational system. Thus, evolutionary predators, food, and members of the opposite sex automatically elicit the appropriate motivational activation. Similarly, stimuli that are not evolutionarily relevant, but which one has learned are motivationally relevant (such as restaurant signs that signal food and weapons that signal danger), also elicit motivational activation.

When a motivationally relevant stimulus is present, additional resources are allocated to retrieval in order to maximize the information available to the organism when making a decision about approaching or avoiding the stimulus. With increasing activation, both for appetitive and aversive stimuli, additional resources are likely allocated to retrieval to enable the organism to consider all that is known about both the stimulus and already learned responses to it. This likely reduces the resources available for encoding and storage. Thus, in cases where activation is high and possible responses are many, people may encode and store less information about the environment.

In the case of mediated messages, a certain level of ongoing retrieval is necessary to understand the message. The level of retrieval required by the message is a message characteristic. Some messages, in particular well-crafted chronological narratives, may require little retrieval of information in order to be understood. Other messages may require a great deal of information retrieval in order to be understood (A. Lang et al. 1995).

If, as theorized above, motivational activation automatically allocates additional

resources to retrieval, then motivational activation will result in more competition for resources. During appetitive activation there will be automatic calls for resources to be allocated to encoding, storage, and retrieval. During aversive activation there will only be automatic calls for resources at storage and retrieval after initial identification. Thus, competition for resources and the possibility of cognitive overload are increased for appetitive activation.

Again we can consider how this impacts the design and experience of playing video games. First, the complexity of the video game environment needs to be considered. How many resources are required by the game for basic understanding of the environment and possible responses and actions? This is important, because at optimal levels of resource allocation, media users experience greater enjoyment and demonstrate optimal performance. When users are overloaded and unable to perform well, they experience less enjoyment. Similarly, when media stimuli are overly simple, boredom results and enjoyment is again reduced.

Obviously, the level of resources required varies as a function of experience. A novice game player will need more resources to play. Further, the novice players will be allocating most of their resources to encoding and storage, since they do not have already stored knowledge of the game. The experienced player is likely allocating resources primarily to encoding (to keep track of what is happening in the game) and retrieval (to use already built-up knowledge).

In addition to being related to experience, however, the resources required will also be a characteristic of the game. Difficult and complex games will require more resources than simple ones. To the extent that a video game elicits cognitive overload, performance will suffer. This means that novice users playing complex games are likely to experience severe cognitive overload, play the game very badly, and perhaps get little enjoyment from the experience. Experienced players, should have less cognitive overload, play these games well and enjoy them.

While this may seem obvious, it does suggest some things for the design and marketing of video games. First, games with multiple levels are likely to be most successful with novice game players. Initial levels should be designed with low difficulty and low complexity. More particularly, stimuli important to learning and succeeding at the game should be presented so as to automatically elicit orienting responses, thus increasing their likelihood of being selected and encoded. Appetitive activation should be kept at a relatively high level in order to facilitate storage and positive emotional experience. This combination of factors will increase automatic allocation of resources to relevant characteristics of the game, it will increase storage of information about how to play the game, and it will increase positive emotional experience, which should increase the amount of time people play the game, which will increase the automatization of the skills required to play the game and significantly reduce cognitive load.

As the game player masters each level, increasing difficulty and complexity can be added. At a complex level, irrelevant stimuli may be introduced that elicit automatic attention responses, and relevant stimuli may be introduced in such a way that they do not elicit automatic responses. Further, irrelevant stimuli may be introduced using startle-eliciting structural features, causing an interruption in the processing of relevant stimuli. In this way, the production and presentation of elements of the video game can work against the processing system to increase the difficulty of the game as the user becomes ready for a greater challenge. In addition, increasing amounts of aversive activation

might be added to the game, again making encoding more difficult and increasing arousal and emotional experience.

How Does Motivational Activation, as an Individual Difference, Affect Media Use and Mediated Message Processing?

In addition to considering how media-elicited motivational activation may influence interaction with mediated messages, it is also worth considering how individual variation in motivational activation influences individuals' media choice, media use, and preferences for various types of content. People with strongly activated appetitive systems, for example, would be more likely "to explore, to seek out new life and new civilizations, to boldly go where no one has gone before." Those with a strongly activated aversive system would be quicker to avoid negative or dangerous stimuli compared to those with more weakly activated aversive systems. Starfleet would not be their best career choice.

This perspective also suggests that individuals make choices about media partially as a function of individual levels of motivational activation and that their online processing of mediated messages is impacted by their personal level of appetitive and aversive activation (A. Lang, Shin, and Lee in press).

How is appetitive and aversive activation as an individual difference likely to affect choice of media and choice of media contents? Those who are high in appetitive activation (regardless of their level of aversive activation) are more likely to use more media, and perhaps more types of media, compared to those low in appetitive activation. Further, they are likely to use more new media, since they are more likely to seek out and explore new and different stimuli in the environment.

Aversive activation also plays a role here, though it may play a role more in media content choice, than in choice of medium. Thus, for example, those high in aversive activation may seek out positive messages and actively avoid negative messages. That may be particularly true for messages that are highly arousing. This line of reasoning would suggest that motivational activation, as an individual difference, might play a very significant role in how people choose both to entertain themselves and to search for information. One might predict that *inactives* would tend to use older media in a functional manner and be relatively unaffected by high-sensation value production, while *coactives* would be the reverse. The high appetitive activation of the latter might lead them to seek out high levels of stimulation and to try out many types of media, including new media. Within a medium, they will likely avoid arousing negative and seek arousing positive content. The *risk seekers* would also seek out many and new media, and prefer stimuli that are high on arousal regardless of valence. Finally, the *risk avoiders* would probably be the lowest media users, tending to use older media with which they are comfortable, and staying far away from arousing, and in particular, arousing negative messages.

This suggests that those high in appetitive activation are most likely to use new media and play video games. Further, they are more likely to play video games that are more stimulating and novel. Those low in appetitive activation, to the extent that they play games, are likely to play games for functional reasons and to play games that are lower in novelty and stimulation. Thus, they may play a video version of a game that they already know and like (e.g., solitaire or Scrabble) because it is more functional in its digital form. In contrast, those high in aversive activation are likely to avoid negative games and in particular, arousing negative games. Those low in aversive activation are likely attracted to games that are extremely arousing and often negative.

The combination of activation also likely matters. The risk takers probably play highly arousing, complex, novel games regardless of valence. The risk avoiders may be least likely to play games, and when they do, to play only games that are positive and low arousal. The coactives are likely attracted to novel, complex, arousing *positive* games. Though negative consequences that are not arousing would not be off-putting. The inactives would be likely to play fewer games, but when they did play games they might very well play games that were negative or positive and arousing.

Finally, individual levels of motivational activation are likely to influence the online processing of mediated messages and of video games. People high in appetitive activation may do a better job of learning information in neutral messages, while people high in aversive activation may actively avoid activities with negative consequences. This may be most important when designing simple levels of games that function to teach the game to novice players. It seems likely that those low in appetitive activation and high in aversive activation will be the least likely to exert effort to learn to play games. For these people, the use of structural features that increase appetitive activation and reduce the effortful processing required to learn the game should be maximized. Similarly, initial levels of the game should keep negative consequences and activation to a relatively low arousal level so as not to turnoff people with high negativity bias. Once the game has been learned, if it is sufficiently enjoyable, these people may continue to play at higher levels of difficulty, where the negative episodes might be allowed to become more arousing.

Conclusion

LC4MP, which thoroughly integrates motivational activation into mediated message processing, provides a broad theoretical explanation for who uses what media when and to what effect. The object here has been to demonstrate how this perspective can be used to make predictions about who will play what games and how to design games that appeal to different types of people. It is interesting to note that much of what we know about who plays video games and the types of games that they play is consistent with this perspective. For example, the sensation-seeking personality trait, which is related to motivational activation, also has a relationship with gender and age. Younger people are higher on sensation-seeking than older people, and males score higher, in general, than females. Further, as females age, they decrease in sensation-seeking at a faster rate than males. Using our previous analysis of who should play games and what sorts of games they might play, this would suggest that those high in appetitive activation (young people and in particular, young males) should play the most video games. Those lowest in appetitive activation (older women) should play the fewest video games. These predictions are consistent with the demographics of video game play. In addition, those low in appetitive activation (older women) are more likely to play traditional games online (e.g., solitaire) and games that have relatively low emotional, and in particular, negative emotional, experience (e.g., *The Sims*), while those high in appetitive activation (young males) are more likely to play negative, arousing, complex games. Again, this is consistent with what we know about game choice and demographics (Schneider et al. 2004).

The LC4MP provides a broad framework that is consistent with current cognitive and emotional psychology within which one can ask questions about video game use, video game design, and the experience of playing video games. It provides testable predictions about who plays, what they will play, and how they will feel while playing. Similarly, it can be applied to other media (new and old) to help us learn how to use media to craft

better messages. This should lead to the crafting of "messages" (including video games) that are easier to learn from, more enjoyable, more persuasive, or in some other way more effective.

REFERENCES

Caccioppo, J. T., and W. L. Gardner. 1999. Emotion. *Annual Reviews: Psychology* 50:191–214.

Caccioppo, J. T., W. L. Gardner, and G. G. Bernston. 1999. The affect system has parallel and integrative processing components: Form follows function. *Journal of Personality and Social Psychology* 76 (5):839–855.

Graham, F. K. 1979. Distinguishing among orienting, defense, and startle reflexes. In *The orienting reflex in humans*, edited by H. D. Kimmel, E. H. Van Olst, and J. F. Orlebeke. Hillsdale, NJ: Lawrence Erlbaum Associates.

Lang, A. 2000. The limited capacity model of mediated message processing. *Journal of Communication* 50 (1):46–70.

Lang, A., Paul Bolls, Robert F. Potter, and Karlynn Kawahara. 1999. The effects of production pacing and arousing content on the information processing of television messages. *Journal of Broadcasting and Electronic Media* 43 (4):451–475.

Lang, A., Kuljinder Dhillon, and Qingwen Dong. 1995. The effects of emotional arousal and valence on television viewers' cognitive capacity and memory. *Journal of Broadcasting and Electronic Media* 39 (3):313–327.

Lang, A., Robert F. Potter, and Paul D. Bolls. 1999. Something for nothing: Is visual encoding automatic? *Media Psychology* 1 (2):145–163.

Lang, A., Mija Shin, and Seungwhan Lee. In press. Sensation seeking, motivation, and substance use: A dual system approach. *Media Psychology.*

Lang, A., Mija Shin, and Seungwhan Lee. 2005. Sensation seeking, motivation, and substance use: A dual system approach. *Media Psychology* 7:1–29.

Lang, A., Patricia M. Sias, Patty Chantrill, and Jennifer A. Burek. 1995. Tell me a story: Narrative elaboration and memory for television. *Communication Reports* 8 (2):102–110.

Lang, A., Shuhua Zhou, Nancy Schwartz, Paul Bolls, and Robert F. Potter. 2000. The effects of edits on arousal, attention, and memory for television messages: When an edit is an edit can an edit be too much? *Journal of Broadcasting and Electronic Media* 44 (1):94–109.

Lang, P.J., M. M. Bradley, and B. N. Cuthbert. 1990. Emotion, Attention, and the Startle Reflex. *Psychological Review* 97:377–395.

Lang, P. J., M. M. Bradley, and B. N. Cuthbert. 1997. Motivated attention: Affect, activation, and action. In *Attention and Orienting: Sensory and motivational processes*, edited by P. J. Lang, R. F. Simons, and M. T. Balaban. Hillsdale, NJ: Lawrence Erlbaum Associates.

Lang, P. J., J. R. Fitzsimmons, M. M. Bradley, B. N. Cuthbert, and J. Scott. 1996. Processing emotional pictures: Differential activation in primary visual cortex. Poster presentation at the 2nd annual functional mapping of the human brain conference, Boston, MA.

Lang, P. J., R. Gilmore, B. N. Cuthbert, and M. M. Bradley. 1996. Inside picture processing: Emotional modulation of ERPs from the cortical surface. Paper to be presented to the Society for Psychophysiological Research, October. Toronto, CANADA.

Lang, P. J., M. K. Greenwald, M. M. Bradley, and A. O. Hamm. 1993. Looking at pictures: Evaluative, facial, visceral, and behavioral responses. *Psychophysiology* 16:495–512.

Lang, P. J., R. F. Simons, and M. T. Balaban. 1997. *Attention and orienting: Sensory and motivational processes.* Hillsdale, NJ: Lawrence Erlbaum, Inc.

McLeod, Jack, and Byron Reeves. 1980. On the nature of mass media effects. In *Television and Social Behavior: Beyond Violence and Children*, edited by W. a. Ables: Erlbaum.

Potter, Robert, F., and Annie Lang. 1996. Arousing messages: Reaction time, capacity, encoding. Paper presented to the Association for Education in Journalism and Mass Communication.

Reeves, B. 1989. Theories about news and theories about cognition. *American Behavioral Scientist* 33 (2):191–198.

Reeves, B., and S. Geiger. 1994. Designing experiments that assess psychological responses to media messages. In *Measuring psychological responses to media messages*, edited by A. Lang. Hillsdale: Lawrence Erlbaum, Inc.

Reeves, B., E. Thorson, and J. Schleuder. 1986. Attention to television: Psychological theories and chronometric measures. In *Perspectives on media effects*, edited by J. Bryant and D. Zillmann. Hillsdale, NJ: Lawrence Erlbaum Associates.

Reeves, Byron, and Clifford Nass. 1996. *The Media Equation: How people treat computers, television, and new media like real people and places.* Stanford, CA: CSLI Publications.

Schneider, E. F., A. Lang, Mija Shin, and S. D. Bradley. 2004. Death with a story: How story impacts emotional, motivational, and physiological responses to first person shooter video games. *Human Communication Research* 30:361–375.

Wang, Zheng, Samuel Bradley, and Annie Lang. 2004. Measuring individual variation and motivational activation: Man, mini-MAM, YO-MAM. Paper read at International Communication Association, at New Orleans, Louisiana.

New Digital Media

From Virtual to Real

Jeremy N. Bailenson

Transformed Social Interaction in Collaborative Virtual Environments

Over time, our mode of remote communication has evolved from written letters to telephones, e-mail, Internet chat rooms, and video conferences. Similarly, collaborative virtual environments (CVEs) promise to further change the nature of remote interaction. CVEs are systems that track verbal and nonverbal signals of multiple interactants and render those signals onto avatars, three-dimensional, digital representations of people in a shared digital space. In this chapter, I describe a series of projects that explore the manners in which CVEs can qualitatively change the nature of remote communication. Unlike telephone conversations and videoconferences, interactants in CVEs have the ability to systematically filter the physical appearance and behavioral actions of their avatars in the eyes of their conversational partners, amplifying or suppressing features and nonverbal signals in real-time for strategic purposes. These transformations can have a drastic impact on interactants' persuasive and instructional abilities. Furthermore, through using CVEs, behavioral researchers can use this mismatch between performed and perceived behavior as a tool to examine complex patterns of nonverbal behavior with nearly perfect experimental control and great precision. Implications for communications systems, interpersonal influence strategies, and behavioral science research will be discussed.

Introduction

In this chapter, I first plan to briefly discuss definitions of immersive virtual reality. Next, I focus specifically on the idea of digital-human representation in virtual reality, in particular the manners in which avatars are constructed and currently utilized during social interaction. I then present a theoretical paradigm called Transformed Social Interaction (TSI), a research paradigm that explores the ways that VR allows people to interact in ways not possible face-to-face, and review a number of published studies examining TSI as well as some new pilot data. I conclude by discussing what the future looks like in regards to the next step in VR in research and applications, and discussing poten-

tial ethical problems with TSI.

What Is Immersive Virtual Reality?

A video game powered by a joystick is an extremely simple form of virtual reality. Both are digital environments in which a user can interact. However, there are a number of major distinctions between immersive virtual reality and a video game. We discuss two of them here.

The first distinction concerns *user tracking*. In a video game, a user's behavior and form are tracked in an extremely unnatural manner. In the game, behaviors such as walking, running, and arm movements occur as a result of an abstract action such as a button push or a joystick movement. The user's form is arbitrary and bears little resemblance to the actual face or body of the user. On the other hand, immersive virtual reality simulations employ naturalistic tracking. Sensitive equipment typically utilizing optical, magnetic, or mechanical sensors track a user's behaviors. In other words, if a user wants to walk through an immersive virtual world, instead of moving a joystick, she just walks through the physical world, and the system then renders (i.e., projects an image or sound of that behavior) that walking behavior in the physical world. Another way to express the idea of naturalistic tracking is that there is a one-to-one mapping of the user's movements in the physical world and the user's movements through the virtual world.

The second major distinction is the concept of *immersion* and immersive displays. Immersive virtual reality surrounds the user perceptually with sensory input (most commonly visual and auditory information). Instead of hearing sounds from a source localized in a single place, sounds emanate from various places in the digital environment. Likewise, visual input is rendered from anywhere in the user's visual field, as opposed to having to look at a computer monitor in a single place. Immersive virtual reality systems utilize equipment that renders sensory information stereoscopically (i.e., different information reaches each individual eye and ear) and spatially localized from anywhere in the user's sensory field.

Many social scientists are using immersive virtual reality to study human behavior (see Blascovich et al. 2002 or Loomis, Blascovich, and Beall 1999 for a review). In addition, a number of scholars are seeking to examine the concept of presence, the degree to which users feel they are in the virtual world as opposed to the physical world (see Lee 2004 for a recent review of this work). This paper, however, will focus on the use of immersive virtual reality to join individuals from remote physical locations into the same virtual world.

Collaborative Virtual Environments

Collaborative Virtual Environments (CVEs) are simply virtual environments that contain more than one user simultaneously. Users in CVEs interact with *avatars*, digital representations of one another (see Bailenson and Blascovich 2004 for an explication of this concept). As Person A moves in Chicago, the tracking equipment measures all of his movements, gestures, expressions and sounds. Person B, in New York, already has a digital environment that contains the digital information necessary to render (i.e., create an on-the-fly digital representation) a three-dimensional model of the avatar of Person B as well as the information necessary to render whatever specific digital environment their avatars inhabit at that point in time. Person A's equipment then sends all of the tracking information over a network to Person B's rendering machine, which then renders all of those move-

ments onto Person A's avatar. This bi-directional process—track the users' actions, send those actions over the network, and render those actions simultaneously for each user— occurs at an extremely high frequency (e.g., 60 times per second).

Compare a CVE to a traditional videoconference, depicted in Figure 22.1. In a videoconference, a camera records each user and then sends that stream of information over the network directly into the display of the other user. In other words, the brunt of the work is being performed by the network, which automatically sends every piece of information that each of the two cameras record.

Videoconferences tend to be relatively taxing on users for a variety of reasons, one of which is the classic inability to orient eye contact with traditional videoconferences. As Figure 22.1 demonstrates, a user can either look at the image of the other user (as A is doing) or she can look directly at the camera (as B is doing), but it is impossible to accomplish both of those tasks at once. The inevitable result is a feeling of disconnectedness due

Figure 22.1: A schematic of a simple videoconference

to the inability to match eye contact and other gestures. For example, in the above figure, Person A sees Person B looking right at his eyes. However, Person B cannot see the image of Person A, because she is looking at the camera, and even if she could, she would see an image of Person A looking at her nose, not her eyes. In this example, there are only two people and disconnectedness occurs. The problem only becomes exacerbated in videoconferences that involve members of three or more separate locations, for obvious reasons. There have been some notable attempts to correct this gesture-disconnect problem in videoconferences (see Yang and Zhang 2002 for a review of these solutions), however, these solutions typically involve some type of behavior tracking and digital rendering, similar in concept to a CVE.

In addition, even with high-bandwidth connections, there tends to be a delay between performed behavior and received behavior across the network. This is due to the system repeatedly sending every piece of information via an analog-like information stream. In other words, even if two people stand frozen like statues in a videoconference, the system still sends the same amount of information as if they were both talking, moving, and gesturing. Consequently, there are inherent delays in videoconferencing systems, and these delays can be extremely disruptive to the conversational flow and interactional synchrony (Kendon 1977) in a conversation. Even as bandwidth increases, this problem is unlikely to be solved due to the corresponding increase in image resolution and sound quality.

Figure 22.2: A schematic of a simple CVE

On the other hand, consider the CVE depicted in Figure 22.2. On the left panel of the diagram, three users in remote physical locations are being tracked and rendered. The right panel demonstrated the digital configuration in which the three users see and hear one another. Each of the users has a digital image of the other two stored locally in their CVE system. The CVE receives digital tracking information about movements, gestures, and other actions from the network. This information is a tiny fraction of the size of analog-like image and sound information. Consequently, there is virtually no delay at all in the transmission, because the only information that needs to be sent is a small stream of numbers that represents the current behaviors of each user. Furthermore, in a CVE, it is trivial to ensure that users receive the proper eye contact and connect on other gestures because the system can use algorithms to adjust incoming tracking information to keep the configurations set in the desired manner. Consequently, the disconnect problem depicted in Figure 22.1 occurs extremely infrequently in CVEs.

Transformed Social Interaction Theory

Given that CVEs render the world separately for each user simultaneously, it is possible to break the normal physics of conversation and to render the interaction differently for each user at the same time. In other words, each CVE user sends the other users a particular stream of information that summarizes his or her current state of actions. However, that user theoretically can alter his stream of information in real-time for strategic purposes. The theory of Transformed Social Interaction (TSI) (Bailenson, Beall, Loomis, et al. 2004; Bailenson and Beall 2004) examines the possibilities that these real-time transformations raise. TSI explores three dimensions for transformations during interaction.

The first dimension of TSI is transforming *sensory abilities*. These transformations complement human perceptual abilities. One example of this transformation is to render "invisible consultants," either algorithms or human avatars who are only visible to particular members of the CVEs. These consultants can either provide real-time summary information about the attentions and movements of other interactants (information that is automatically collected by the CVE) or can scrutinize the actions of the user herself. For example, teachers using distance-learning applications can utilize automatic registers that ensure they are spreading their attention equally towards each student.

The second dimension is *situational context*, transforming the spatial or temporal

structure of a conversation. For example, each user in the CVE can optimally configure the geographical setup of the room. Using the distance-learning paradigm, every single student in a class of twenty can sit directly in front of the virtual blackboard and perceive the rest of the students as sitting behind him. Furthermore, by altering the flow of rendered time in a CVE, users can implement strategic uses of "pause" and "rewind" during a conversation in attempt to increase comprehension and productivity.

The third dimension of TSI is *self representation*, the strategic decoupling of the rendered appearance or behaviors of avatars from the actual appearance or behavior of the human driving the avatar. Because interactants can modulate the flow of information dictating the way their avatars are rendered to others, that rendering can deviate from the actual state of the user. In the distance-learning paradigm, it could be the case that some students learn better with teachers who smile while some learn better with teachers with serious faces. In a CVE, the teacher can render himself differently to those students, tailoring his facial expressions to each student in order to maximize their attention and learning.

In sum, using TSI, users can strategically alter aspects of the conversation. Previous work has discussed the ability of people to use limited forms of TSI during face-to-face interaction (Bailenson and Beall 2004), such as applying makeup, plastic surgery, and automatic nonverbal mimicry such as "the chameleon effect" (Chartrand and Bargh 1999). However, there is no doubt that the advent of CVEs allows for a plethora of TSI strategies on a much larger scale. In the following section, we review empirical work that has examined TSI in CVEs.

Empirical Investigation of TSI

Multilateral Perspective Taking

A CVE is rendered from scratch 60 times per second for each of the interactants. Normally, this is done by determining where each interactant is standing and looking, and rendering the scene appropriately given that information. However, an interactant in theory can render her sensory point of view from any single place in the room. In other words, it is possible for Person B to disconnect her area of perception from the area in which Person A perceives her. Figure 22.3 illustrates this transformation.

In Figure 22.3, Person B is implementing a multilateral perspective. Specifically, she is choosing to adopt the sensory perspective of Person A during the conversation. In other words, she has left her own point of view and become a passenger to Person A, by rendering not a digital world that is contingent on her own movements, but instead a digital world that is contingent on Person A's movements. As a result, she sees herself in real-time from behind the eyes of her conversational partner. Either by shifting her entire field of view to the spatial location of other avatars in the interaction, or by popping up "field of view windows" in corners of the virtual display, an interactant can unobtrusively occupy the home space of any avatar in the CVE.

Current research (Gehlbach et al. 2004) is examining multilateral perspectives in a negotiation scenario inside a CVE. Previous work has used either role playing (Davis et al. 1996) or observational seating arrangements (Taylor and Fiske 1975) to cause subjects to take on the perspectives of others in a conversation, demonstrating more efficient and effective interactions. Equipping an interactant with the real-time ability to see one's avatar from another point of view should enhance these previous findings. In our cur-

Figure 22.3: Person B takes on multilateral perspectives: she can experience the CVE her own perspective and the perspective of Person A at the same time.

rent work in progress, we are predicting to find more cooperative solutions in simulations in which negotiators can occupy the field of view of their opponents.

We also are currently utilizing this perspective-shifting tool as a way to better implement diversity training. The general idea is to create some type of simulation that depicts a diversity-related interpersonal event, and to then use the simulation to put subjects in the perspective of all parties involved in the diversity event. Recent work by Yee and Bailenson (2004) utilizes the "virtual mirror." In these studies, subjects arrive into the lab, enter into an immersive virtual-reality simulation, and walk around a simulated room. The main feature in the simulated room is a virtual mirror, which shows the reflection of their avatar. The avatar moves and gestures in the mirror as the experimental subject moves and gestures in the physical room. However, this is not a normal mirror in the sense that we can render their mirror image in whatever form we choose—skin color, gender, height and attractiveness are all flexible parameters in the virtual mirror.

Our research paradigm entails having subjects stand and gesture in front of the virtual mirror for about ninety seconds, watching their reflection, which is an image of their opposite gender or race. Next, they turn around from the mirror and interact with two other avatars that have entered the CVE. We then measure their behavior towards the other avatars: the amount of personal space they leave between themselves and the others in the CVE (Bailenson, Blascovich, Beall and Loomis 2003), the amount of direct eye contact they make with others in the CVE, the amount of time they spend talking in the interaction, and a number of subjective measures concerning the subjects' overall confidence and task performance when they are seen by others as wearing a mismatched avatar. Allport (1954) is most credited with the "contact hypothesis," the notion that putting people from different social groups together reduces prejudice. Using the virtual mirror, we are exploring the "hyper-contact hypothesis," namely that being forced to wear the face and body of a member of the opposite social group should produce an even further reduction of prejudice.

Non-Zero-Sum Gaze

Another TSI tool is *non-zero-sum gaze* (NZSG): directing mutual gaze at more than a single interactant in a CVE at once. Previous research has demonstrated that eye gaze

is an extremely powerful tool for communicators seeking to garner attention, be persuasive and instruct (see Segrin 1993 for a review on this topic). People who use mutual gaze increase their ability to engage an audience as well as to accomplish a number of conversational goals.

In face-to-face interaction, gaze is zero-sum. In other words, if Person A looks directly at Person B for 65 percent of the time, it is not possible for Person A to look directly at Person C for more than 35 percent of the time. However, interaction among avatars in CVEs is not bound by this constraint. The virtual environment as well as the other avatars in the CVE is individually rendered for each interactant locally. As a result, Person A can have his avatar rendered differently for each other interactant, and appear to maintain mutual gaze with both B and C for a majority of the conversation, as Figure 22.4 demonstrates.

NZSG allows interactants to perpetuate the illusion that they are looking directly at each person in an entire roomful of interactants. Three separate projects (Bailenson, Beall, Blascovich et al. 2004; Beall et al. 2003; Guadagno et al. 2004) have utilized a paradigm in which a single presenter read a passage to two listeners inside a CVE. All three interactants were of the same gender, wore stereoscopic, head-mounted displays, and had their head movements and mouth movements tracked and rendered. The presenter's

Figure 22.4: A schematic illustration of non-zero-sum gaze. Each interactant on the right perceives the speaker on the left gazing directly at him or her

avatar either looked directly at each of the other two speakers simultaneously for 100 percent of the time (augmented gaze) or utilized normal, zero-sum gaze. Results across those three studies have demonstrated three important findings: 1) participants never detected that the augmented gaze was not in fact backed by real gaze, 2) participants returned gaze to the presenter more often in the augmented condition than in the normal condition, and 3) participants (females to a greater extant than males) were more persuaded by a presenter implementing augmented gaze than a presenter implementing normal gaze.

NZSG should be a powerful tool in future computer-mediated communication. Walther (1992) describes how interactions conducted via digital representations can be *hyperpersonal*: more intimate and intense than face-to-face interaction. The current findings extend the notion of hyperpersonal interaction to the nonverbal realm. For applications such as distance education, sales, online chatting and dating, utilizing computer-guided gaze should have a high impact on social interaction.

Digital Chameleons

Previous research on face-to-face interaction has shown that people are highly influenced by others who mimic their language (van Baaren, et. a.l 2003) or their gestures (Chartrand and Bargh 1999) during social interaction. In this latter study, an interviewee who mimicked the posture and sitting position of the interviewer during the interaction was seen more favorably than one who did not perform the mimicry. Moreover, recent research has extended these findings to computer agents: voice synthesizers that mimic vocal patterns (Suzuki et al. 2003) as well as embodied agents in immersive virtual reality that mimic nonverbal behavior (Bailenson and Yee 2005).

In the study by Bailenson and Yee (2005) a realistic looking *embodied agent* (i.e., virtual human in a CVE that is controlled by a computer algorithm, not by another human) administered a three-minute verbal persuasive message. For half of the subjects, the agent was a digital chameleon, in that its head movements were an exact mimic of the subject's head movements at a four-second delay. For the other half, the agent's head movements were a playback of another subject's head movements. Results demonstrated three important findings: 1) participants rarely detected their own gestures when those gestures were utilized by the agents, 2) participants were more persuaded by the agent and liked the agent more in the mimic condition than in the recorded condition, and 3) participants actually looked at the agent more in the mimic condition than in the recorded condition.

In CVEs, as well as in many other forms of computer-mediated communication, people interact with one another through digital representations. Consequently, the potential for implementing digital chameleons in a variety of media remains a distinct possibility, one that is in many ways more powerful than face-to-face mimicry. For example, in computer-mediated communication, algorithms can be indiscriminately and constantly applied to mimic peoples' behaviors. Once mimics are utilized on an algorithmic level, the potential to utilize more fine-grained strategies such as probabilistic mimics (e.g., Person A's avatar mimic's Person B's actions for only part of the time), rule-based mimics (e.g., Person A's avatar mimic's Person B's actions only when Person B is talking), and scaled mimics (e.g., Person A's avatar's head movements only move half as much as Person B's movements during the mimic) become almost trivial to employ. Such a systematic application of various levels of mimicry is difficult to implement in face-to-face conversation. Consequently, CVEs provide unique potential for social scientists to study contingency and mimicry during interaction, for example, systematically exploring notions of interactional synchrony (Kendon 1977).

Conclusions and Implications

In sum, the prevalence of research on TSI is growing steadily over the past five years. Across studies, two general patterns of results have been consistently emerging. First, TSI strategies are detected surprisingly infrequently during social interaction. Second, avatars that utilize TSI gain unique social influence in the interaction compared to avatars that do not utilize the transformation strategies.

In future work, we plan on exploring TSI phenomenon more thoroughly, including TSI in non-immersive, non-virtual settings. We have recently completed a series of studies examining *identity capture* (Bailenson, Garland et al. 2004). We presented undergraduates with an image of an unfamiliar political candidate who was ostensibly running for office in California. The two-dimensional photograph of the candidate was either mor-

phed with a photograph of the undergraduate filling out the questionnaire about the candidate or not. Results demonstrated that, under a variety of conditions, candidates that captured aspects of the specific subjects' facial structure gained advantage and was more likely to receive the subjects' votes. This result is not surprising, given that a variety of research indicates that people show affinity towards things that resemble themselves (see Baumeister 1998 for a review). However, the truly surprising finding was that less than five percent of the subjects detected their own face in the photograph, even when the morphs captured up to 40 percent of the subjects' original photographs.

The fact that TSI can be effective in non-immersive settings is somewhat alarming. When people enter an immersive virtual-reality simulation, the expectation or at least the accepting of some degree of foul play in terms of veridical rendering of other people's behavior is most likely inevitable. However, when viewing two-dimensional video feeds, images on websites, voices enhanced by digital algorithms on cell phones, other players in online video games (Yee 2004) and text in chat rooms, we may not be so rigorous in our skepticism concerning the authenticity of form and behavior. The potential for using TSI for abuse in all forms of digital communication certainly warrants attention.

The Orwellian themes behind this research paradigm are quite transparent. TSI tools such as identity capture, augmented gaze, and digital mimicry certainly would be better left out of the hands of advertisers, politicians, and anyone else whose may seek to influence people. On a more basic level, not being able to trust the very pillars of social interaction—what a person looks like and how they behave—presents interactants in a difficult position. On the other hand, is TSI fundamentally different from plastic surgery, makeup, self-help books and white lies?

Certainly the potential ethical concerns of TSI largely vanish if one assumes that all interactants in a CVE are aware of the potential for everyone to rampantly use these transformations. However, then the possibility becomes that TSI will cause CVE technology as a whole to become completely useless. Why bother to use a communication device in which it is not possible to trust any of the actions of the other interactants? As computer-mediated communication becomes more advanced and prevalent, it will be fascinating to monitor the progress of TSI strategies as well as technology designed to detect and foil the non-veridical rendering of appearance and behaviors. In the meantime, TSI and CVEs present spectacular opportunities for social scientists studying nonverbal behavior, computer-mediated communication, and digital human representation.

REFERENCES

Allport, G. 1954. *The nature of prejudice.* Reading, MA: Addison-Wesley.

Bailenson, J. N. and A. C. Beall. 2004, in press. Transformed social interaction: Exploring the digital plasticity of avatars. In *Avatars at Work and Play: Collaboration and Interaction in Shared Virtual Environments*, edited by R. Schroeder and A. Axelsson, Springer-Verlag.

Bailenson, J. N., A.C. Beall, J. Blascovich, J. Loomis, and M. Turk. 2004. Non-zero-sum gaze and persuasion. Paper presented in the Top Papers in Communication and Technology session at the 54th Annual Conference of the International Communication Association, New Orleans, LA.

Bailenson, J. N., A. C. Beall, J. Loomis, J. Blascovich, and M. Turk. 2004. Transformed social interaction: Decoupling representation from behavior and form in collaborative virtual environments. *PRESENCE: Teleoperators and Virtual Environments*, 13 (4):428–441.

Bailenson, J. N., and J. Blascovich. 2004, in press. Avatars. *Encyclopedia of Human-Computer Interaction*, Berkshire Publishing Group: 64–68.

Bailenson, J. N., J. Blascovich, A. C. Beall, and J. M. Loomis. 2003. Interpersonal distance in immersive

virtual environments. *Personality and Social Psychology Bulletin,* 29:1–15.

Bailenson, J. N., P. Garland, S. Iyengar, and N. Yee. In press. The effects of morphing similarity onto the faces of political candidates. *Political Psychology.*

Bailenson, J. N., and N. Yee. 2005, in press. Digital chameleons: Automatic assimilation of nonverbal gestures in immersive virtual environments. *Psychological Science.*

Baumeister, R. F. 1998. The self. In *Handbook of social psychology 4th edition,* edited by D. T. Gilbert, S. T. Fiske, and G. Lindzey. New York: McGraw-Hill.

Beall, A. C., J. N. Bailenson, J. Loomis, J. Blascovich, and C. Rex. 2003. Non-zero-sum mutual gaze in immersive virtual environments. Proceedings of HCI International 2003, Crete.

Blascovich, J., J. Loomis, A. C. Beall, K. R. Swinth, C. L. Hoyt, and J. N. Bailenson. 2002. Immersive virtual environment technology as a methodological tool for social psychology. *Psychological Inquiry* 13:146–149.

Chartrand, T. L., and J. A. Bargh. 1999. The chameleon effect: The perception-behavior link and social interaction. *Journal of Personality and Social Psychology* 76:893–910.

Davis, M. H., L. Conklin, A. Smith, and C. Luce. 1996. Effect of perspective taking on the cognitive representation of persons: A merging of self and other. *Journal of Personality and Social Psychology* 70:713–726.

Gehlbach, H., J. N. Bailenson, N. Yee, and A. C. Beall. 2004, draft in progress. Perspective taking and negotiation in collaborative virtual environments.

Guadagno, R. E., J. N. Bailenson, A. C. Beall, A. Dimov, and J. Blascovich. 2004, draft in progress. Non-zero-sum gaze and the cyranoid: The impact of non-verbal behavior on persuasion in an immersive virtual environment.

Kendon, A. 1977. *Studies in the behavior of social interaction.* Bloomington, Indiana: Indiana University Press.

Lee, K. M. 2004. Presence, explicated. *Communication Theory* 14:27–50.

Loomis, J. M., J. J. Blascovich, and A. C. Beall. 1999. Immersive virtual environments as a basic research tool in psychology. *Behavior Research Methods, Instruments, and Computers* 31 (4):557–564.

Segrin, C. 1993. The effects of nonverbal behavior on outcomes of compliance gaining attempts. *Communication Studies* 44:169–187.

Suzuki, N., Y. Takeuchi, K. Ishii, and M. Okada. 2003. Effects of echoic mimicry using hummed sounds on human-computer interaction. *Speech Communication* 40:559–573.

Taylor, S. E., and S. T. Fiske. 1975. Point of view and perceptions of causality. *Journal of Personality and Social Psychology* 32:439–445.

van Baaren, R. B., R. W. Holland, B. Steenaert, and A. van Knippenberg. 2003. Mimicry for money: Behavioral consequences of imitation. *Journal of Experimental Social Psychology* 39 (4):393–398.

Walther, J. 1992. Interpersonal effects in computer-mediated communication. *Communication Research* 19:52–90.

Yang, R., and Z. Zhang. 2002. Eye gaze correction with stereovision for video-teleconferencing. Proceedings of the Seventh European Conference on Computer Vision (ECCV 2002), Copenhagen, Denmark.

Yee, N. 2004. In press. The psychology of MMORPGs: Emotional investment, motivations, relationship formation, and problematic usage. In *Social Life of Avatars II,* edited by R. Schroeder and A. Axelsson. London: Springer-Verlag.

Yee, N. and J. N. Bailenson, Identity transformation and behavioral confirmation in immersive virtual reality. Manuscript in preparation.

Margaret L. McLaughlin

Simulating the Sense of Touch in Virtual Environments

Applications to Learning in the Health Sciences

Haptics involves the modality of touch and the sensation of shape and texture an observer feels when virtually "touching" a digital object with a force-feedback stylus, instrumented data glove with exoskeleton, or other robotic device. The researchers at the Integrated Media Systems Center Haptics Lab at USC have been studying how to use desktop robotic devices in such application areas as medical training, in collaboration with researchers at Keck School of Medicine; visualization for the blind and visually impaired, in partnership with Foundation for the Junior Blind; mutual touch over the Internet; and museum display, in collaboration with USC's Fisher Gallery and the Natural History Museum of Los Angeles County. In this chapter we report on two promising applications in the health care arena. With an interdisciplinary team from the Departments of Plastic Surgery, Educational Technology, and the USC Program in Multimedia Literacy we are developing a surgical simulator for training in arterial catheter insertion. Haptics is used in the simulator to provide realistic force feedback to guide the trainee in a difficult insertion task where an inappropriate insertion trajectory can have serious consequences for surrounding tissue and organs. A second application that we describe in the chapter is the use of haptics for rehabilitation training during recovery from stroke. We will report on the technical innovations we have developed that are important for medical training and rehabilitation applications. Finally, we report on our techniques for extending haptics to Web-based environments. We have created methods for collaboration between users of haptic devices who are physically separated by many miles, such that it is possible, for example, for a therapist to guide the hand motions of a rehabilitation client over the network, even from a remote location. This "hand-over-hand" guidance capability creates a sense of immediacy and presence in virtual training environments.

Haptics involves the modality of touch and the sensation of shape and texture an observer feels when virtually "touching" a digital object with a force-feedback stylus, instrumented data glove with exoskeleton, or other robotic device. The researchers at the Integrated Media Systems Center Haptics Lab at USC have been studying how to use desktop robotic devices in such application areas as medical training, in collaboration with researchers at Keck School of Medicine (Grunwald et al. 2004); visualization for the blind and visually impaired, in partnership with Foundation for the Junior Blind (McLaughlin 2002); mutual touch over the Internet (McLaughlin, Sukhatme, Peng et al. 2002, 2003); and museum display , in collaboration with USC's Fisher Gallery (Ascheim et al. in press; Lazzari et al. 2003; McLaughlin et al. 2000a, 2000b).

In our lab we have employed such devices as the PHANToM, a 6DOF force-feedback stylus, to enable users to explore the surfaces and textures of virtual objects and "palpate" deformable models of soft tissue in a medical simulator. We have also developed techniques for using a haptic stylus to "paint" on three-dimensional virtual objects, and for assisting visually impaired users to maintain orientation in virtual environments. Most recently we have begun to develop strategies for more commonplace haptic devices, such as the Synaptics TouchPad, to enable us to predict user frustration with computer-based tasks from the user's patterns of application of force to the pressure-sensitive input device (Jung et al. 2004; McLaughlin, Shahabi et al. 2004).

Below I describe what the user experiences when exploring a virtual environment with a haptic device, and then talk about some of the application areas we have examined prior to settling on medical simulation and training as a primary field in which to use haptics to enrich and extend the sensory immersion of virtual learning environments.

Haptic Devices

Everybody who has used a laptop or played with a joystick during a computer game has had experience with a haptic device, perhaps without recognizing it as such. You are probably accustomed to the idea that when you slide the mouse across your mouse pad to "pick up" and move an icon that the motion is not unlike what would you would feel if you pressed down on a piece of paper with your fingertips and slid it across your desk. When you become frustrated with a computer application that won't perform as you want it to, or responds too slowly, it's likely that you might jab your fingertip into the Touchpad a little more forcefully as if to bend the machine to your will. We know from research in the area of gaming that when users interact with a game they grip the joystick or press buttons on a game-pad more vigorously when they are excited or challenged or frustrated by the game, just as they might grip the arms of a chair while watching a thrilling athletic competition or frightening movie on television, or pound an elevator button repeatedly when the lift fails to arrive quickly enough. So in many respects, these simple input devices and the ways in which we use them to interact with digital media bear a close resemblance to the way our hands interact with our physical environment. And that is the basic idea as well behind some of the more advanced kinds of haptic devices that we use in our lab.

One of the devices that you would find in our lab is the CyberGrasp. This is the term used to describe a pairing of an instrumented data glove, which looks a great deal like an Isotoner, with an "exoskeletal" device, which has a network of tendons that fit on top of the gloved hand. If you were wearing this apparatus while sitting in front of a computer display of a virtual environment that contained, for example, a three-dimensional

model of a ball or a soda can, you could "reach" for the ball or can, and the tracker that works with the glove would detect the location of your hand and fingers inside the virtual environment and sense when you were in contact with the object (that is, that the model of your hand was in contact with the model of the ball or can), and as you grasped the object, the tendons on the exoskeleton would exert grasp forces on your fingers that would make you feel as if that object was resting in the palm of your hand with your fingers curled around it. You could pick it up and put it down just as if it were the real object rather than a digital illusion.

Another device that you would find in our lab is the PHANToM. In fact we have three of these, of varying degrees of sophistication. They each have a stylus that you can think of as a sort of pen-shaped 3D mouse, such that when you use the pen to stroke the surface of an object on the screen (e.g., a digital teapot), you will feel its interesting shapes and textures, the empty space between the handle and the body of the pot, and the indentation where the lid rests, because when the "collision" of your digital fingertip with the teapot in the virtual environment is detected, force is communicated back to your finger as if you were touching that object in the real world.

Some of the objects that people have felt in our lab have been digitally concocted ones, such as a two-sided eyeball with a concave iris that was made for us by a graphic artist. If you pressed your PHANToM stylus into the center of the eyeball you would feel a sort of viscosity rather than a firm surface. This feature was added because the art project for which the sculpture was developed was designed to be enjoyed by the blind and visually impaired, and this difference in feel helped to mark-off parts of the digital object that could not be apprehended visually by the user. Sometimes we have digitized objects on a rotating turntable, capturing their images at 6-degrees angular separation all the way around with a video camera until we had enough data to create a full three-dimensional model. We have done this with various collections in the southern California area, including a collection of embossed and highly decorated daguerreotype cases from the Natural History Museum of Los Angeles County.

We have used haptics for visualization as well. One of our projects involved creating an earthquake simulator using data from 66 seismic recording stations around the Los Angeles area that was captured during the Northridge quake. A person using our simulator, which was also designed for the visually impaired, could speak aloud the name of a location (e.g., Newhall, California), and his hand holding the stylus would be guided automatically to a location on an earthquake map, where the quake would be "replayed" at his fingertip, reproducing the ups and downs of the seismic data for precisely the duration of the original shaking.

And finally, we have enabled people to experience a rudimentary sense of mutual touch over the Internet. In one of our experiments we had a person in a location that was remote from our own use a PHANToM to "touch" the fingers of a person wearing a CyberGrasp in our lab. The CyberGrasp wearer was able to detect which of his fingers was being touched over the Internet with about 90% accuracy. We also found in this study that not only are people able to feel the touch of their remote partner, but they make attributions about the partner's personality and character based on the way in which they are touched. These examples illustrate the variety of potential applications of "haptic rendering," the process of translating information about the contact between the model of the user's hand and an object in the virtual environment.

Using Haptics to Learn About the User

Although applications in which haptics is used to help the user learn more about objects continue to be of interest, we are putting much of our energy currently in using haptics to find out more about the user. Haptic devices, from the costly and complex CyberGrasp down to the ubiquitous Synaptics TouchPad, have the capability of being programmed to keep track of how they are being used. For example, it is possible not only to capture and log a time series of where your finger goes on the Touchpad (its position in terms of a Cartesian coordinate system) but also the degree of pressure you exert with each contact. And this data is susceptible of statistical analysis, which can be used to obtain information about your activity in the midst of playing a game, or working on a term paper, or creating a spreadsheet, and using that information to make the game more exciting or making the application a little easier with a helper or "agent" who can provide tips or advice when you become frustrated. Below I describe some of our work with capturing user frustration from TouchPad data, and then describe the role of related work with more sophisticated haptic devices in medical simulation and training.

Capturing Haptic Data from the Frustrated User

Although there has been considerable work on recognition of signs and gestures from pen-based or instrumented data-glove input, there has been very little research on using data from haptic devices for recognizing when the user is excited, challenged, or experiencing difficulty, in short, in a condition other than normal or "baseline." A study by Mentis and Gay (2002), however, is one of a few exceptions. They found that differences in subjects' fingertip pressure on a Synaptics Touch Pad were significantly greater before and after frustrating "critical incidents" in a word processing task than they were during comparable control incidents without frustrating episodes. Findings of this sort suggest that haptic indicators may provide unobtrusive mechanisms for recognizing and responding to negative affective states of the user.

Mentis and Gay emphasized that frustrating episodes were relatively infrequent, resulting in a small sample of data points. They argued for the use of more controlled data-collection environments (e.g., deliberately inducing problematic situations) to study implicit user cues. Further, they note the importance of obtaining baseline measures on individual users if one wants to study how people change under frustrating conditions. The study by Mentis and Gay and a related paper by Qi, Reynolds, and Picard (2001) have generated interest in the use of pressure-sensitive input devices to measure variations in muscle tension related to the experience of frustration in learning tasks. Qi, Reynolds and Picard found that simple mouse-pressure data could reliably discriminate between episodes that frustrated users and those that proceeded smoothly.

Sykes and Brown (2003) studied pressure applied to buttons on a game console as an indicator of user emotion in the context of video gaming. In a variation on *Space Invaders*, Sykes and Brown created three difficulty levels that were presented in random order to the player. They found that as the difficulty level increased, so also did the pressure applied to the gamepad buttons. Sykes and Brown noted certain defects in previous methods of assessing the user's state while playing games, such as the Galvanic skin response, whose measurements can be confounded by things like heavy perspiration or muscle tensing by the user. They note that GSR is not suitable for fast gaming, which requires rapid and dexterous finger movements, but mousepad pressure seemed to be a very useful indicator of the gameplayer's state of mind.

Our approach differs from these earlier efforts in several significant ways. Rather than leaving frustration as an uncontrolled variable and inferring its presence from subjects' retrospective recollections, as in the Mentis and Gay study, or assuming that emotional arousal is the same thing as task difficulty, as in the Qi et al. study, we are building frustration into the design of our experiments by providing the subject in the "frustration" condition with a deficient set of materials for carrying out the assigned task, which necessitate time-wasting task support functions (a help page, online assistant), and then we are following up with a post-task validation of the experimental manipulation; that is, finding out if we actually succeeded in frustrating the user.

Our study design is currently being pilot-tested in the lab with a task of building a particular LEGO assembly within a six-minute time limit, with a clock icon on the instruction manual counting down the time remaining. Additional frustration inducers include an incomplete set of instructions and an insufficient set of resources (LEGO pieces) to complete the task. Our approach is to capture Touchpad pressure data from the user every 10 ms in both frustrating and baseline task conditions, as well as keep a videotape record of subjects' facial expressions and verbalizations. Our goal is to perfect our acquisition techniques for observing and logging the user's patterns of haptic interaction with computers and integrating what we learn into an adaptive user interface that adjusts task difficulty and/or offers help functions dynamically when problematic user states are recognized from the user's input.

Using Captured Haptic Data in Games and Simulations

The capabilities of a low-cost input device like the Synaptics TouchPad can be extended to permit a natural, intuitive haptic interface to be added to the structural features of games and simulations, by taking data that is normally discarded (the user's pressure on the touchpad and the location of the user's fingertip at a particular point in time) and putting it to use. The information captured in this way can be used to control various elements and actions in games and simulations. For example, to advance to a next stage a user might have to exert a certain degree of pressure, or move the cursor at or beyond a particular rate of acceleration. To make or create things within the game, the user might employ varying levels of pressure to represent the amounts or quantities of properties or objects that should be combined. If there are objects that can be deformed or reshaped, greater pressure on the touchpad can create greater deformation. More complex tasks or more difficult questions can be represented by icons that have to be pressed more firmly. When simulations are used to visualize the relationships in scientific or economic data, "drilling down" from higher-order categories to molecular level data can be mapped to changes in level of pressure. Similarly, variation in pressure on an input device can be used to communicate desired actions by the learner in a collaborative environment, such as pressing harder to light up a signal or communicate a more urgent request.

Haptics in Medical Simulations

The haptics group at USC has been involved in several projects in the area of medical training and surgical simulation. Our first venture into this area was the development of a prototype system for training physicians in clinical breast examination, which permits self-paced learning (McLaughlin, Jordan-Marsh et. al. 2003). A haptic device tracks the hand and finger movements of the user as she/he explores a deformable model of the breast and axilla on the computer screen. The haptic device, a 6DOF PHANToM,

communicates forces back to the trainee's fingers that are like those that would be experienced in a similar "real world" examination. The user's hand is represented in the workspace of the digital breast as a three-fingered hand model, so that the final force and torque feedback can be calculated according to the "collisions" between the three fingers and the breast model.

The system when fully realized will include a database of breast models with wide coverage of sizes and shapes of breasts, location, and size of tumors, relationship of the lump to neighboring tissue, and tissue density. Models can be retrieved from the database and explored at leisure, feedback can be provided at every step, including successful location of lumps and "detection" of lumps where none exist. The user's exploration path can be captured and compared to an expert's. Significant deviation into unproductive areas can be gently corrected with prompts from an intelligent coaching agent or "guidebot."

Text-to-speech generation and synthesis will complement and supplement the information provided by the haptics system. In a "tutorial review" mode, the system can take the initiative in explaining specific details of the touch experience being currently rendered (using the haptic output). Spatial context information (e.g., the specific region of the breast currently in focus) is provided to the system by the haptic input. On the other hand, in an "exploratory" mode the user can take the initiative and make a verbal inquiry, such as "have I already explored this area?" All dialog between the user and the system is logged and available for analysis dynamically, or after the trainee's session. Video techniques that capture the trainee's facial expressions and gestures are combined with haptics and spoken language cues to monitor user state (e.g., user frustration) and trigger appropriate interventions as needed.

Breast models can be explored in three ways: free exploration (no guidance), guided exploration (force feedback is applied to the user's fingertip to reinforce the correct path), and remote collaborative guided exploration ("hand over hand"), where the tip of the user's PHANToM can be captured and guided by a user at another location. The exploration pattern recommended for clinical breast examination consists largely in the user pushing into the breast model with the PHANToM stylus at three successively greater levels of depth (shallow, medium, and deep), following a circular pattern roughly the size of a dime at each level, and then moving the stylus vertically to the next locus of palpation. The boundaries of the critical areas of the breast model relative to the previous location of palpation can be specified quite precisely, as can the degree of force required for the user to push into the model at the appropriate depth, and it will be possible to recognize the user's actions as intended to situate the haptic probe properly with respect to location and depth of palpation, following the instructions for assuring systematic and thorough coverage of the whole area. It will also be possible to recognize the user's attempt to follow a circular pattern of pressing at each successive level of depth, from a superficial pressure to pressing all the way down to the chest wall.

A second application area has been in the use of haptics for rehabilitation training during recovery from stroke. There are several recent reports of research in which haptics has been studied for its potential in post-stroke rehabilitation. Broeren, Georgsson, Rydmark, and Sunnerhagen (2002) used a 3D computer game to promote motor relearning in a patient suffering from a left arm paresis. The treatment was delivered through the ReachIn VR platform, which features stereoscopic visualization and force feedback with a PHANToM haptic device. The subject's performance was evaluated on a specific hand-function task—striking a virtual ball to knock over bricks in a pile. Grip force,

endurance, and the pattern of arm movement showed improvement after treatment. Connor, Wing, Humphreys, Bracewell, and Harvey (2002) tested the efficacy of haptically guided errorless learning (EL) with a group of patients with post-stroke visuoperceptual deficits. In the errorless-learning condition, unproductive or incorrect approaches to objects within a virtual environment are prevented by applying a counter-resistive force when the patient moves in the wrong direction.

Connor et al. found that errorless learning training with haptic guidance benefited some patients, but not all. Boian, Deutsch, Lee, Burdea and Lewis (2002) developed a prototype virtual reality-based rehabilitation environment using a haptic device called the "Rutgers Ankle." The patient navigates a virtual environment with a PC host that puts him or her through a series of exercises, using the Ankle as a foot joystick. Boian et al. reported some gains in gait speed and muscle strength for study participants.

We have recently teamed with collaborators from Cell Neurobiology, Computer Science, Psychology, and Physical Therapy, and with the support of the National Institutes of Health will be working on a project to develop virtual therapeutic environments for post-stroke recovery. The technical capabilities that we have developed in the Haptics Lab are very useful in this regard. First, we have created robust techniques for recording and playing back the activities of the user during a haptics-enhanced VR session regardless of the type of device employed. This playback capacity is useful in training applications where a trainee is attempting to carry out a series of skilled movements in the manner of an expert trainer, and it also facilitates assessment of improvement in motor relearning over time, where the hand/finger coordinates and joint angles between the fingers can be treated as time-series data and compared before and after various interventions. Second, we have implemented algorithms that allow us to anticipate incorrect movement trajectories by the user and head off errors before they occur, a technique that may be useful for "errorless learning." Third, we have developed a spoken-dialog system fully integrated with our haptic systems that permit voice control of the interface, input devices including force feedback devices, and access to the help system. This feature allows the user to navigate the interface without fine or gross motor control and leaves the hands free to concentrate on the training exercise. Fourth, we have created modifications that make it easier for the user to locate objects in the virtual environment and to remain "in contact" with them, such as "sticky" object surfaces and "snap-to" features that move the haptic cursor to digital objects with voice commands. And finally, we have created methods for collaboration between users of haptic devices who are physically separated by many miles, such that it is possible, for example, for a therapist to guide the hand motions of a rehabilitation client over the network, even from a remote location. This "hand-over-hand" guidance capability creates a sense of immediacy and presence in virtual training environments.

The virtual rehabilitation environments that we will design will serve stroke patients in the subacute phase who are currently receiving therapy at a neuro-rehabilitation service in the greater Los Angeles area. Patients will range in age from their mid-twenties to their late-seventies. Our role is to develop task-specific virtual exercise environments that will trigger and reinforce the compensatory brain mechanisms that facilitate recovery from stroke. Behavioral experience (motor skills training tied to specific tasks such as making coffee) is believed to accelerate these neuroplastic processes. We will also create environments that will allow testing the effects of mere visualization (watching the motor skills tied to a specific task being enacted, as opposed to actually performing them).

Recovering stroke patients will engage in interaction within a simple virtual environment consisting of a background and one or more three-dimensional objects, some of which may be "rigid-body" objects like a 3D model of a coffee pot, and others of which are "deformable" or change shape upon haptic input from the user, like a virtual rubber ball. The patient will interact with the objects through one of two types of devices in our laboratory. The first of these is the 6 DOF (degrees of freedom) PHANToM, which permits simulation of single-fingertip contact with virtual objects through a stylus, as described earlier. This particular PHANToM not only tracks and delivers force feedback based on the coordinates of the user's fingertip and its contact with the virtual object, but it also is able to haptically render torque, so the patient will be able to feel effects such as turning a knob or opening a jar.

In some of our virtual scenarios, more than one PHANToM will be used; for example, the patient will be able to "toss a salad" with virtual tongs. The other class of device we will use is the CyberGrasp, which was described above. The patient is fitted with the CyberGlove/CyberGrasp, which is then individually calibrated. On screen she will see a three-dimensional, rigid-body model of a soda can. She will be instructed to "reach" for the can, "grasp" it in her hand, and pick it up from its current resting place. If performed correctly the patient will feel the sensation of a solid cylindrical object inside her palm. She will then be instructed to "pour" from the can by completely inverting it and holding this position for ten seconds. Then the patient will be instructed to place the can back in its original resting place. In the visualization condition, the patient will either: 1) watch a video of this exercise, or 2) wear the CyberGlove/CyberGrasp and be passively taken through the motions as a previously recorded "pouring" session is replayed. The user interfaces will require minimal input from the user, and will be completely navigable with voice commands (e.g., "result," "next task," "repeat," etc.).

From experience gained in our research on Internet-based mutual touch and collaborative environments, we have developed strategies that will allow the patient's activities to be guided by a rehabilitation therapist at a remote location, so that the therapeutic regimen can be free of some of the normal constraints of time and place.

There is a lengthy list of tasks that can be simulated, with varying degrees of difficulty, inside a haptics-enhanced virtual environment. They include CyberGrasp tasks, such as throwing a ball, grasping a moving object, or batting down objects as they pop up, and single PHANToM tasks, such as tracing the surface of an object, rotating an object clockwise or counterclockwise, turning an object upside down, picking an object up and putting it back down, painting or drawing on an object, turning an object to make it fit into a slot, rolling a ball or marble between two fingers, and pressing a deformable shape (for example, buttering bread) or palpating it to feel firmer tissue inside (for example, taking a pulse). Two PHANToMs can be combined to simulate the effects of holding tongs or scissors, and can be used with deformable models to simulate the effects of holding food while cutting it.

Finally, I will mention briefly an ambitious undertaking with an interdisciplinary team from the Departments of Plastic Surgery, Educational Technology, and the USC Program in Multimedia Literacy to develop a surgical simulator for training in arterial catheter insertion. Haptics will be used in the simulator to provide realistic force feedback to guide the trainee in a difficult insertion task where an inappropriate insertion trajectory can have serious consequences for surrounding tissue and organs. As a precursor to this very complex simulator, we have partnered with a major maker of medical simu-

lators to develop interface enhancements and a training regimen based on cognitive task analysis (2004) for a "needle stick" simulator that uses haptics to simulate the resistance encountered during procedures such as drawing blood or inserting an IV.

Looking To the Future:
Multimodal Integration of Cues to User State

One of our long-term goals is to integrate haptic data with video and speech data for "multimodal user state sensing" (Chai et al. 2002). Because some of our newer projects such as the rehabilitation exercise environment require the presence of a trainer alongside the patient, at least initially, we have begun to pay attention to the impact that social factors (e.g., the presence of another) might have on the seemingly straightforward task of integrating user data from touch, video, and speech. When social goals are present the task of detecting the user state becomes exponentially more complex (Buck and vanLear 2002; O'Keefe 1988). In the most straightforward case the mere presence of a human trainer may increase the richness of communication and hence the range and complexity of the cues displayed, and simple additive models of how cues combine may not be adequate. Cues in one modality that supplement or modify cues in another may be comparatively more separated in time (e.g., follow at a longer interval) when there is an audience for the patient's behavioral output. In some cases cues may co-occur temporally but seemingly conflict with one another. For example, there may be more cue "leakage" as indicators of arousal states manifest themselves in restless or nervous leg or arm activity even while the user is making a conscious effort to control her facial affect display for the benefit of the trainer. There may be deliberate ambiguity: for example, the patients' language may be polite and non-intense and he may deny having difficulty, but a "pseudo-spontaneous" (Buck and vanLear 2002) frown, grimace, or falling intonation pattern conveys his frustration and, suitably interpreted, could procure a desired intervention from an intelligent agent or help system without the user's having to ask for it. Such inconsistencies among cues require special handling from an "intention recognizer," a software component that is trying to read the patient's behaviors and respond accordingly. Our future research efforts are directed to understanding the complexity and subtle nuances as indicators of touch, speech, and vision combine to provide a look inside the user.

REFERENCES

Aschheim, D., M. Lazzari, M. McLaughlin, P. Zirkle, N. Chelyapov, J. Jaskowiak, and W. Zhu. In press. Touch and connectivity: Metaphors for the networks of humans and technology. *New Architecture*.

Boian, R. F., J. Deutsch, C. S. Lee, G. C. Burdea, and J. Lewis. 2002. Haptic effects for virtual reality-based post-stroke rehabilitation. Proceedings of the Eleventh Symposium on Haptic Interfaces For Virtual Environment and Teleoperator Systems, Los Angeles, CA

Broeren, J., M. Georgsson, M. Rydmark, and K. Stibrant Sunnerhagen. 2002. Virtual reality in stroke rehabilitation with the assistance of haptics and telemedicine. Proceedings of the 4th International Conference on Disability, Virtual Reality and Associated Technology. Veszprém, Hungary.

Buck, R., and C. A. vanLear. 2002. Verbal and nonverbal communication: Distinguishing symbolic, spontaneous, and pseudo-spontaneous nonverbal behavior. *Journal of Communication* 52:522–541.

Chai, J., S. Pan, M. Zou, and K. Houck. 2002. Context-based multimodal input understanding in conversational systems. Proceedings of the Fourth IEEE International Conference on Multimodal Interfaces.

Connor, B. B., A. M. Wing, G. W. Humphreys, R. M. Bracewell, and D. A. Harvey. 2002. Errorless learning using haptic guidance: Research in cognitive rehabilitation following stroke. Proceedings of the

4th International Conference on Disability, Virtual Reality and Associated Technology. Veszprém, Hungary.

Grunwald, T., D. Clark, S. Fisher, M. McLaughlin, S. Narayanan, and D. Piepol. 2004. Using Cognitive Task Analysis to facilitate collaboration in development of simulator to accelerate surgical training. Proceedings of the 12th Annual Medicine Meets Virtual Reality Conference, Newport Beach, California.

Jung, Y., N. Park, W. Zhu, M. McLaughlin, and S. Jin. 2004, under review. Utility of haptic data in recognition of User state. Proceedings of the 11th International Conference on Human-Computer Interaction.

Lazzari, M., A. Francois, M. L. McLaughlin, J. Jaskowiak, W. L. Wong, M. Akbarian, W. Peng, and W. Zhu. 2003. Using haptics and a "virtual mirror" to exhibit museum objects with reflective surfaces. Proceedings of the 11th International Conference on Advanced Robotics.

McLaughlin, M. L. 2002. Haptic museum. National Science Foundation Project Report, Integrated Media Systems Center, University of Southern California, Los Angeles.

McLaughlin, M. L, M. Jordan-Marsh, L. Hovanessian Larsen, and S. Narayanan. 2003. Haptic interfaces for improving the detection of breast cancer. Conference on Virtual Learning in Health Communication. University of Southern California, Los Angeles.

McLaughlin, M. L., C. Shahabi, N. Park, W. Zhu, and B. Navai. 2004. Recognizing user state from haptic data. Proceedings of the International Conference on Cybernetics and Information Technologies, Systems and Applications (CITSA 2004), Orlando, FL.

McLaughlin, M. L., G. Sukhatme, J. Hespanha, C. Shahabi, and A. Ortega. 2000a. Touch in immersive environments. Proceedings of the EVA 2000 Conference on Electronic Imaging and the Visual Arts, Edinburgh, Scotland.

McLaughlin, M. L., G. Sukhatme, J. Hespanha, C. Shahabi, A. Ortega, and G. Medioni. 2000b. The haptic museum. Proceedings of the EVA 2000 Conference on Electronic Imaging and the Visual Arts, Edinburgh, Scotland.

McLaughlin, M. L, G. Sukhatme, W. Peng, W. Zhu, and J. Parks. 2002. An experimental study of performance and presence in heterogeneous haptic collaboration: Some preliminary findings. Proceedings of the Seventh Phantom User's Group Workshop. Santa Fe, New Mexico.

McLaughlin, M. L, G. Sukhatme, W. Peng, W. Zhu, and J. Parks. 2003. Performance and co-presence in heterogeneous haptic collaboration. Proceedings of IEEE VR 2003.

Mentis, H. M., and G. K. Gay. 2002. Using TouchPad pressure to detect negative affect. Proceedings of the Fourth IEEE International Conference on Multimodal Interfaces.

O'Keefe, B. 1988. The logic of message design: Individual differences in reasoning about communication. Communication Monographs 55:80–103.

Qi, Y., C. Reynolds, and R. Picard. 2001. The Bayes Point Machine for Computer-User Frustration Detection via PressureMouse. Proceedings of the 2001 Workshop on Perceptive User Interfaces (PUI 01), Orlando, Florida.

Sykes, J., and S. Brown. 2003. Affective gaming: Measuring emotion through the Gamepad. CHI 2003: New Horizons.

Jeffrey Huang

Inhabitable Interfaces

What happens when communication media instead of physical walls begin to define the spaces our bodies inhabit? Although the virtual world is not supplanting the physical one, the Internet is becoming an increasingly essential conduit for many everyday activities. Few elements of physical architecture are left unaffected. As networking infrastructures become increasingly part of our built environments, physical and virtual elements merge in many ways, leading to new kinds of spaces with components of both the physical and the virtual realm. What happens when websites become inhabitable, and buildings in turn become human-computer interfaces? What happens when physical spaces can expand seamlessly into remote places with different time zones, dialects and rituals? This essay explores these questions at the center of the nexus where physical and digital media meet, by discussing a built, inhabitable interface that operates in everyday life: the Swisshouse. The Swisshouse is a large inhabitable interface prototype, conceived and built to connect the geographically scattered community of Swiss scientists, and "reverse brain drain." The Swisshouse illustrates a shift of how we view the computer: from a stand-alone word-processor, drawing machine and number cruncher, to a device that is essentially social and spatial. Accordingly, architecture is no longer seen as a passive place where computing happens, but as an active communicative vector, as an inhabitable interface itself. Numerous graphical illustrations, plans, sections, three-dimensional diagrams, and photographic materials of the built inhabitable interface are used to provide evidence of the increasing spatialization of digital media and communication, and discuss the related design issues, challenges, and opportunities.

With the recent advances in computer and networking technologies, there is a growing interest in how the expanded functions and interconnectivity of digital media will change human-to-human communication. Much of the current discussion focuses on the effects and opportunities raised by "virtual" architectures, such as found in online communities, game environments, and instant messaging. In the excitement of these

technologies, the impact of such innovations on the "physical" architecture—the physical spaces where human communicators physically stand, sit, and talk to each other—has been widely neglected. What are the possibilities for physical architecture to embrace and integrate new digital media for communication? To what extent can architectural elements in which we live, such as walls, ceilings, floors, doors and furniture, act as an interface between virtual and physical everyday activities?

To explore these questions, this essay presents a case study of an inhabitable interface for communication and knowledge exchange: the Swisshouse. The Swisshouse is a prototype for a new generation of spatial communication interfaces that addresses the dynamic interplay between physical, face-to-face communication and technology enhanced collaboration, discussion, and community formation. It redefines human communication interfaces in ways both familiar and new, traditional and innovative, physical and virtual—and overall may represent a harbinger of more such hybrids in the future.

The Swisshouse

Officially called the Swiss Consulate for Science and Technology, the Swisshouse is a prototype of a physical and virtual consulate for knowledge diplomacy.

Background

The project started in 1999 as a response to a problem identified by the Swiss Government as "the brain drain problem." By that the Swiss meant the problem referring to the thousands of researchers and scientists whom they sponsor every year to spend time abroad, typically through a grant from the Swiss National Science Foundation, and who end up not returning back to the mother country, because they find other opportunities in the host country. There is a drain of intelligence from Switzerland to other countries, especially to the U.S., U.K., and increasingly, Asia, and this diaspora of Swiss intelligence is growing every year. Over the years, the Swiss officials have tried to contravene brain drain in all sorts of ways. They instituted policies, such as the J1 exchange visa, obligating the young researchers to return after two years of stay in the foreign country. But of course, since these young researchers are typically fairly brilliant people, they usually find ways around it. Finally, after much drainage, the Swiss authorities began to realize that the only effect that most of these policies had was not regaining but alienating their own researchers.

In 2000, we (the author in collaboration with architect/artist Muriel Waldvogel) proposed an alternative. The fundamental idea was to create a new kind of diplomatic space that combines physical and virtual technologies into an inhabitable interface. This new diplomatic space would do two things: 1) it would foster the creation of a virtual community for the Swiss scientists and researchers, enabling them to get to know each other, network, and feel a sense of belonging to something greater, and 2) it would provide a network of physical nodes in strategic places that the dispersed communities of scientists could visit and use to virtually transfer their knowledge back ("reverse brain drain") without having to physically leave the country. Each node therefore was conceived as an inhabitable interface where researchers could physically walk in and turn it into a portal or gateway to exchange knowledge and collaborate with people and places in Switzerland and scientists located in other nodes.

The proposed location for the nodes was determined by the present concentration

of Swiss scientists in specific geographic locations (such as Boston) and anticipated future exchange between a location and Switzerland (such as Beijing). The initial list of proposed network nodes included Boston, San Francisco, Chicago, Singapore, London, Paris, Hong Kong, Seoul, Beijing, Shanghai, Johannesburg, Sidney, Bangalore, Taipei, Sao Paolo, and Cairo.

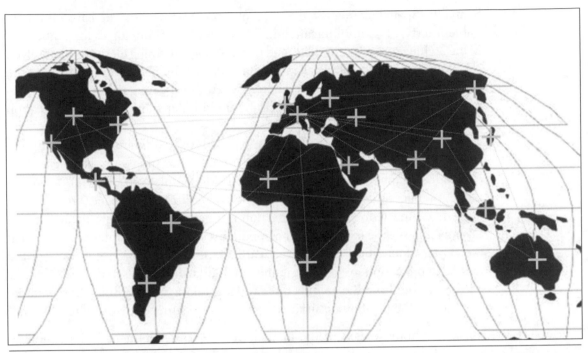

Figure 24.1: Network of Swisshouse nodes around the world.

To our own surprise, the proposal received very positive reactions from Berne (the Swiss capital usually known as being rather conservative), and the Swiss accepted to sponsor the building of a first prototype node in Boston, Massachusetts, where some of the major attractors of brains were located.

Physical/Virtual

The prototype Swisshouse node in Boston is a large, inhabitable interface that seamlessly integrates physical and virtual architectures. Rather than as an afterthought, the design of the interface elements and software—the "virtual" architecture—are developed in conjunction with the design of the physical environment, i.e., the "physical" architecture.

As a convergent physical/virtual architecture, inhabitable interfaces are complex. They are essentially a dynamic balance among three parameters: 1) the configuration of the physical space, including size and height of the space, typology layout, materials used, circulation, etc., 2) the design of the hardware interface elements embedded into the building elements, including input devices such as sensors, cameras, microphones, RFID interrogators, etc., and output devices, such as rear and front projectors, loudspeakers, ambient visualization devices, plasma screens, computer controlled LEDs, etc., and 3) the programming of software, including building operation systems to operate audio-visual control systems, lighting and climate, video-conferencing software, streaming software, meeting capture software, data-driven visualization software, etc.

Wired Loft

An existing abandoned brick building on Broadway in Cambridge, Massachusetts, built in the 1950s, served as a basis for the Swisshouse architecture. The building was transformed from a closed, dark, grocery and wash-and-dry store, into an open, wired loft, following four design guidelines:

1. Spatiality. Spatial elements rather than object elements form the basis for inhabitable interfaces. Communication input and output technologies are embedded in the architecture of the building and become space-defining elements themselves.

2. Adaptability. Both the physical and virtual architecture define the flexibility of the space in order to accommodate different, even unexpected, communication scenarios, by enabling different spatial configurations depending on communication needs.

3. Translucency. The boundaries between "on" and "off" communication are blurred. Rather than confronting participants with an either/or situation—between either complete communication transparency ("on") or complete opacity ("off")—inhabitable interfaces make the transition seamless and informal. Spaces are in a state of "semi-connectedness," full connection is triggered by physical interaction.

4. Distractedness. The technological components of inhabitable interfaces are not at the center of attention in the space. Participants are only passively aware of the devices at the periphery. The distribution of interface elements in the space follows a logic derived from the architecture of space, taking into consideration parameters such as the location of surfaces, orientation of surfaces, size and resolution.

In an almost homage-like analogy to modern computing architectures, the inhabitable interface features a similar expandable design, characterized by a structural division of its components into a basic shell and modular plug-and-play modules.

The basic shell (the wired loft envelope) acts as a gigantic, inhabitable motherboard containing the basic infrastructure and connectivity (16x16 matrix switch, CAT5 output grid, powergrid). Into this motherboard, various plug-and-play modules can be inserted, substituted, arranged, as "digital walls," "knowledge cafes," "kinetic arenas," "nomadic workspaces," and "guest book walls." The following figures illustrate this concept.

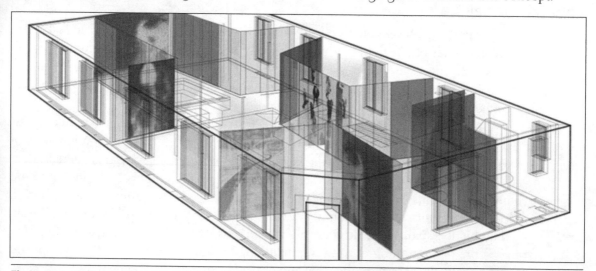

Figure 24.2: Bird's-eye view of a node as an "inhabitable interface." The building acts as a large communication interface. The digital walls extend the spaces to remote locations.

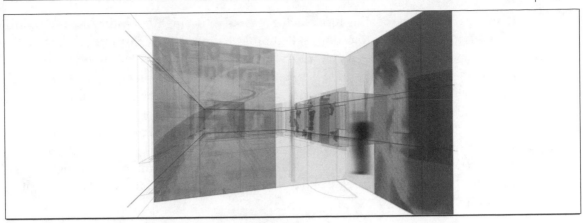

Figure 24.3: 3D computer simulation of entrance situation.

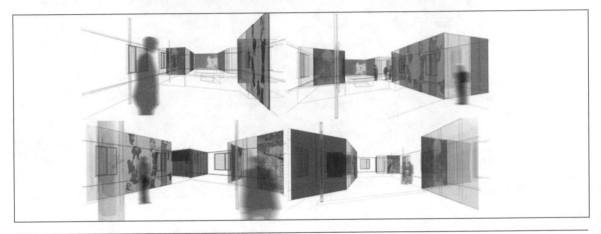

Figure 24.4: 3D walkthrough animation used to design spatial configurations and location of interface elements for communication.

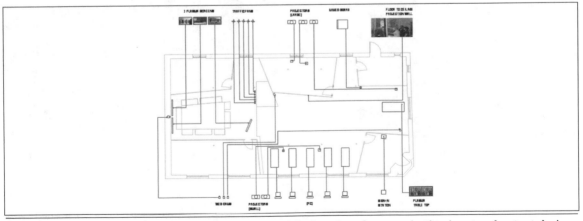

Figure 24.5: Floor plan of the building with indication of the location of communication input and output devices.

Digital Walls

Half-inch-thick tampered, specially coated digital-glass walls that run from floor to ceiling define the wired loft space. The glass for the digital-glass walls is structural and self-supporting: it is clipped in the floor behind the wooden planks and in the ceiling behind the gypsum board. Without any visible framing structure, the glass appears to float

in space. The special coating turns each glass wall into a high-resolution floor-to-ceiling screen for rear or front projection. When projected upon, the glass loses its materiality and the spatial boundaries are blurred by the projected images. Communication media instead of physical walls begin to define the space. Different places, virtual worlds, artificial environments appear on the surrounding glass transforming the boundaries, program, and ambience of the space.

The glass walls are positioned at a slightly off-orthogonal angle to give the loft space a continuous flow and maximize viewing at any given spot in the building. Architecturally, the space features richly textured wooden planks and large amounts of natural light, counteracting the coldness of the glass and technology, and fostering an energetic and creative atmosphere.

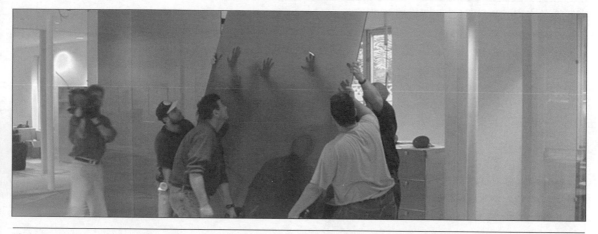

Figure 24.6: Installation of the film-coated 6- by 10-foot digital-glass panels.

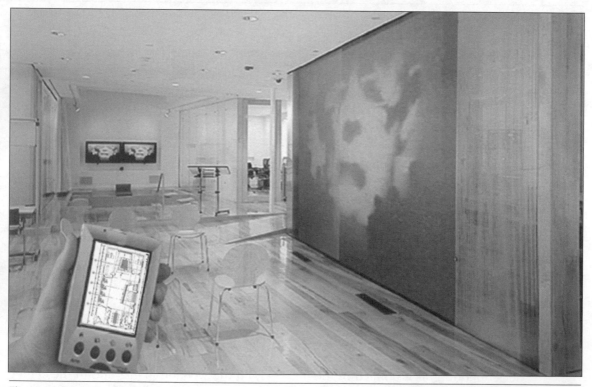

Figure 24.7: Interior shot of the completed building with mobile and embedded communication interfaces. Mobile devices control the digital-glass walls.

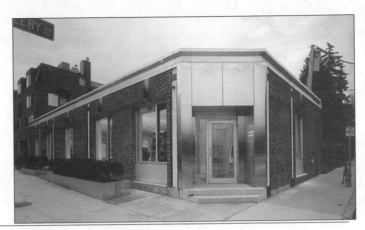

Figure 24.8: Exterior shot of the completed building.

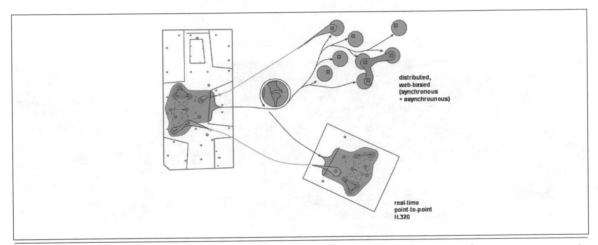

Figure 24.9: Communication diagram. Bottom right: Point-to-point communication connecting two or more remote spaces. Top right: One-to-many communication connecting one Swisshouse node with distributed participants via Web-based streaming.

Figure 24.10: Interactive wallpapers: Visualization of the presence of others.

Communication Scenarios

Typical activities happening at the Swisshouse include virtual cocktail parties, scientist happy hours, remote lectures, multi-party conferences, brainstorming sessions, cultural exhibitions, a virtual career desk, and visits of scientists and researchers. Each activity is recorded and blogged (for details see http://www.creativeswitzerland.com).

What is happening physically in the Swisshouse node is apparent on the virtual site, and vice versa. A digital guestbook wall captures visits of physical and virtual users and displays the identity, location, and time zones of visitors as icons on the guestbook wall. For example, whenever visitors log into the virtual site to follow an event, their presence is visualized as icons on the digital walls in the physical building.

Alternatively, a visitor entering the physical space in Cambridge is captured and transmitted to the sites around the world in real-time. Each member of the Swiss scientist community has a personalized Swatch watch containing a passive RFID tag. The RFID tag has a unique ID that points to the data entry with information about the scientist on the Swisshouse database server. Whenever a scientist walks into the Swisshouse with the RFID Swatch, his presence is sensed by the building and displayed on the guestbook wall.

The following pictures illustrate sample scenarios.

Figure 24.11: Sample scenario usages: (left) Reception area with RFID reader and public guestbook wall, (middle) Brainstorming session with real-time ambient information, (right) Discussion with remote participants in the main space.

Figure 24.12: Virtual cocktail. Participants engaged in informal social interaction with a remote audience.

Related Work

The idea of inhabitable interface or architecture as an interface is not a new one. Architecture and architectural surfaces as interfaces for communication have been known and used throughout history. From the cave paintings to Plato's cave, to the rich and iconic illustrations on the walls of temples and churches, architecture always enjoyed a role as interface for communicating stories and beliefs.

Beyond passive surfaces that carry images and stories, buildings have also played a more active role as inhabitable interface since the Renaissance. In the mid 17th century, for example, Athanasius Kircher, the Jesuit savant, proposed what could be seen as precursors of today's digital inhabitable interfaces. His projects include buildings in which acoustical and visual interfaces were seamlessly integrated. A particularly illustrative example is the "Klangschnecke," a building proposed around 1650, in which walls and ceilings operate as sonic interfaces: spaces are connected by winding acoustical interfaces. Standing in a side chamber, hiding behind a statue, one may overhear a conversation happening in the adjacent big hall, or spread gossip by whispering secrets into the ceiling interface.

The advent of digital media changed the notion of inhabitable interfaces in the 20th century. "Think," the IBM Pavilion in New York designed in 1965 by Ray and Charles Eames, provides a good example of an attempt to merge information, digital media, and architecture into an integrated structure. Later dubbed the "information machine," the pavilion remains an important precedent for a new kind of architecture that results from a deep concern with information organization, retrieval, and use of information.

Outside architectural design, the idea of communication interfaces that have a spatial dimension was taken up by researchers in the human-computer interface (HCI) field. There are a number of precedents in HCI that have looked at what role communications media can have within physical environments. Media spaces, for example, have existed for a number of years and to varying degrees have used technology to connect two or more spaces via videoconferencing technology. For example, the Cavecat system from the University of Toronto, built in 1990, examined the integration of video, audio, and networked computing in a simple office environment with the objective of studying the impact of such a system on the collaborative work process. The Cavecat project is situated within a trajectory of work on video-mediated spaces, starting with the seminal work of Engelbart and English in the late 1960s, the Xerox PARC experiments around "video-places" in the mid 1980s, and Hiroshi Ishii's Clearboard projects at NTT in the early 1990s. A variation of media spaces is the Shared Workspaces project, which combines a synchronous speech channel with shared visual material such as documents or graphics. More recent work related to the integration of media elements into architectural elements include roomware systems and cooperative building concepts proposed by the German research institute GMD, and augmented surfaces pursued by Sony Research in Japan.

What distinguishes inhabitable interfaces from media spaces and other research conducted in the HCI field is their focus and origin in architecture. Inhabitable interfaces fundamentally rethink the architectural basis, and transform the given architectural environment that is taken as a point of departure for media integration, rather than simply looking at what technology systems and furniture could be developed to fit into an existing architectural layout.

Questions

The Swisshouse is an early example of a large, inhabitable interface for human communication deployed in the context of knowledge diplomacy, brain drain, and a geographically scattered diaspora. People in and friends of the Swiss community visiting the Swisshouse can experience different levels of presence and embodiment as they virtually and physically interact with the space. Some members of the community may be physically present and visible, while others may be physically in the space but invisible, hiding behind translucent walls. A third group may be only virtually present, and only to a certain degree. Now and then we may see glimpses of their digital selves wandering about from node to node, shifting their attention to us and then, to something else.

The inhabitable interface of the Swisshouse expands the notion of physical space, provoking new experiences of community, closeness, and proximity. The Swisshouse attempts to create new, different qualities of presence in the space, by connecting local spaces with distant places, collapsing geographic distance and collocating different dialects, time-zones, and rituals in one space.

While the prototype node in Boston revealed the potential of inhabitable interfaces, it also raised several theoretical and practical questions.

Questions of Typology

When finished, the Swisshouse will feature a network of twenty small, interconnected, inhabitable interfaces distributed around the globe. Across traditional architectural typologies—offices, bank buildings, universities, museums, retail stores—a slow but relentless redistribution of building mass can be observed: a shift from centralized typologies to radically decentralized, networked architectures.

Consider the University of Phoenix: a networked university with an online learning space and 151 connected campuses in the U.S. This is radical departure from the traditional one-campus university typology, epitomized by the typical American campus such as Thomas Jefferson's University of Virginia. The networked typology allows Phoenix University to grow at multiple ends, and consequently extremely fast. As of the writing of this text, it is adding 1,000 students every week across its decentralized campuses. With more than 240,000 students, Phoenix University is already by far the largest private university in the U.S., approximately six times larger than the second largest private university in the U.S., New York University (NYU).

Are buildings evolving from large, centralized typologies to networks of smaller interconnected architectures? If so, what are the potential for new architectural typologies that combine physical and virtual technologies?

Questions of Obsolescence

Introducing new technologies that radically alter existing architectural typologies (the typology of the "office" or the "consulate" in the Swisshouse example) always runs the risks of sacrificing benefits that have been established over generations. In other words, by disrupting the incremental evolutionary path of a given architectural typology, there is always the risk of consciously or unconsciously abandoning some of the inherent benefits associated with that given existing typology.

The convergence of new technologies and traditional building materials raises some concerns related to the notion of obsolescence. How can inhabitable interfaces deal with

the discrepancy between the durability of architectural materials and the rapid obsolescence of technologies, both of which are integral part of their architecture? What happens to floor-to-ceiling video walls in three to five years, when the technology has fundamentally changed? This question, albeit a mostly pragmatic one, is certainly justified, since most of the current interface technologies have an increasingly short half-time that is a fraction of the corresponding half-time of physical architectural elements. For example, the half-time of typical wall materials are approximately: twenty-four years for concrete walls, two-hundred twenty-three years for stone wall, thirty-five years for metal sheet, one-hundred and five years for laminates, and seventy years for glass. Now consider the equivalent numbers for the technology elements, hardware and software, that are dictated by Moore's law. How can inhabitable interfaces be broken down into interchangeable layers that can grow with time to bridge this obsolescence gap?

Questions of Flexibility vs. Coherence

Another question concerns the elusive attempt to design spaces that fit all possible functions without sacrificing a certain architectural coherence and the role hardware and software design plays. When a new typology of space is introduced, it is difficult to foresee how the space will be used because typological changes come from how people inhabit and modulate the space according to their needs over time. Having new methods for inhabitation, people do not know or can only guess how they will change their work habits. A current demand for the design of inhabitable interfaces may therefore be that of maximal flexibility.

However, maximal flexibility is difficult to achieve and may even be not desirable as we are speaking of inhabitable interfaces. Opting for flexibility in architecture usually comes at the sacrifice of construction quality and aesthetic coherence. The challenge therefore is to balance flexibility with architectural integrity within predefined parameters. In the Swisshouse project, we decided to operate with fixed hardware and introduce flexibility through software. The position of the glass walls, for example, is fixed and cannot be moved. They are positioned at an off-orthogonal configuration in relation to the condition of the site (the entrance situation, the view to the park) and the desired free-flowing "feel" of the space. The walls are interfaces for the projections but at the same time, they act as space-defining elements, carving out private spaces, such as the consul's office, the restrooms, etc. They have to remain fixed. On the other hand, software gives the space flexibility. Different software changes the spaces for different events, users, and atmospheres. For example, for a videoconference event, the wall shows the remote users. For a music concert, the wall is decorated with a digital wallpaper that defines the mood of the room, and for a brainstorming session, the walls are covered with knowledge cards. One possible challenge for the future concerning the question of flexibility is: How to find the right balance between hardware and software determinacy?

Questions of Privacy

There are a series of questions to consider, related to privacy, especially when walls start to hear and ceilings begin to see. Two interesting questions are: 1) virtual eyes—how to deal with the feeling of surveillance due to the presence of Webcams and the associated latent suspicion that someone may be watching from a remote location, and 2) physical ears—how to balance the desire to create an open, fluid space with the potential problem of a resulting space that is acoustically uncontrollable and in which conversa-

tions are too easy/difficult to overhear? One way to approach these concerns is by telling people about, and making them aware of, the problems of eyes and ears, and empower them to be in control of their privacy. Architecturally, the challenge will be how to design an architecture that gives control of privacy to the physical users, and how to use the sheer physical mass of architecture to protect people from information intrusion.

Questions of Forms

The final question concerns the formal aspects of inhabitable interface. Can inhabitable interfaces be interpreted as a radically new typology in need of a radically new formal expression and thereby abandoning the comfort of known forms, or can the function of inhabitable interfaces be simply superimposed onto existing forms and architectural objects and thereby sacrificing the chance of a new formal language? An example of the latter is found in prototype projects originating in technology oriented research labs. Here we find doorknobs, pinwheels, and light bulbs that are used as communication interfaces (for example, pinwheels turn to indicate Web traffic, lights that shine brighter depending on stock market information, or doorknobs that heat up to indicate the level of occupancy in a room). These "new" interfacial objects appear to be awkward and irritating, since what they do is high-jacking the original meaning of the architectural objects onto which their functions are mapped. No longer sure whether a doorknob actually opens a door or indicates traffic, or whether a light actually gives light or reflects the NASDAQ, an irritating double-mapping results, leaving users in a strange state of ambivalence and uncertainty about what the objects do.

Geri Gay

The Role of Social Navigation and Context in Ubiquitous Computing

The ability to detect context seems especially relevant to mobile and ubiquitous computing systems that may be used in a variety of different locations, by different users, and/or for different purposes. In this chapter, we examine a number of issues that need to be considered as these pervasive devices become part of our everyday environments. A number of themes emerged from our studies on the use of ubiquitous devices in context including: relevancy, social constructivism, critical mass, functionality, accuracy, and trust.

Powered by the vision of pioneers like Mark Weiser, John Seeley Brown, and Paul Dourish (Weiser 1991; Weiser and Brown 1996; Harrison and Dourish 1996), there is currently a great deal of interest and development work in ubiquitous computing. Computation is now available in a variety of devices. With the proliferation of personal computers, cell phones, PDAs and other electronic products, computing and telecommunications are becoming more embedded in our everyday environments. The wave of smart appliances and ubiquitous computing will continue to alter the nature and quality of communicating and interacting via e-mail, instant messaging, voice, and video (Weiser 1991; Munro, Hook, and Benyon 1999). These embedded computation and communication capabilities have dramatically extended the social and informational resources available to people anytime and anywhere.

Research in ubiquitous computing deals with a variety of novel interaction schemes very different from the "one user, one computer model" most usability research is based upon. Ubiquitous computing systems often include the use of computers or sensors embedded in the user's environment. Computers in these settings can be much larger or much smaller than the typical desktop and often serve a more specialized purpose. They may be fixed to a specific location, or they may be mobile (Weiser 1991). Many researchers are currently studying the technical problems related to coordinating and implementing these embedded and mobile computing environments (Dey and Abowd 2000), however, it is vital that research is also conducted to determine what new prob-

lems these types of environments pose to users. How do users understand and use these systems? What types of user applications and scenarios will be the most successful?

Our research has looked at two new models of computer usage that pertain specifically to mobile, networked devices. The first model is *context-aware computing*. This is a networked environment where information is made available to a user dependent upon specific environmental factors. These factors can include location, time, user and device type. Our second model encompasses *social navigation*. Social navigation describes a phenomenon in which a user's navigation through a physical or virtual space is guided and structured by the activities of others within that space (Dourish 1999). In unifying these two models, a connected device can make visible what is invisible in the user's environment by drawing upon the collective knowledge of previous users. This knowledge is made available to indicate what is relevant and interesting about the physical space or the task at hand.

Context-Aware Computing

Context-aware computing is a subcategory of ubiquitous computing research that deals with systems that detect aspects of the user's context of use. Contextual elements the system may detect include location, identity, activity, and the date/time. Once detected, the system provides services or information relevant to that context. The idea behind context-aware computing is that the users' environment, including where they are, who they are with, and what they are doing, can inform the computing device. This added knowledge results in a changed interaction between the user and device. Individuals associate places with events and activities so the information and tasks presented to the user can be filtered for their location (Mark 1999).

Most of the existing research in context-aware computing has focused primarily on the problem of sensing and interpreting context (Spreitzer and Theimer 1993), creating a clear definition of context and context awareness (Dey and Abowd 2000), describing the design of various context-aware systems (Dey, Abowd, and Salber 2001), and the ability to attach information to a physical location that begins to move the user's interface away from the device itself to the physical environment (Abowd et al. 1997). One of the most well known context-aware systems is the Xerox Parctab project that provides services such as call forwarding and interaction tracking in a corporate campus environment (Want et al. 1995). Several researchers have created location-aware tour guides that use GPS coordinates, infrared transceivers, or object detection to determine the user's location. Location-aware guides have been designed for city tours (Cheverst et al. 2000) and frequently for museums (Broadbent and Marti 1997; Woodruff et al. 2001). A series of similar systems usually grouped under the term "augmented reality" rely on elaborate head-mounted and wearable displays (Feiner 2002; Rekimoto and Nagao 1995). A few researchers have even begun exploring the idea of incorporating content created by users into these location-aware guidance systems (Espinoza et al. 2001; Burrell et al. 2002; Pascoe 1997).

A number of proponents of context-aware computing suggest that a system that can take into account the context of use can cater more specifically to its users. Location, time, identity, and activity have been proposed as the primary elements of context (Dey, Abowd, and Salber 2001; Greenberg 2001). The ability to detect context seems especially relevant to mobile and ubiquitous computing systems that may be used in a variety of different locations, by different users, and/or for different purposes. The concept of

attaching notes to contexts has been proposed to create a tour of Disneyland (Pascoe 1997). We have previously created a system that associates Web URLs with locations (Burrell and Gay 2000). Other work has been done in using context-awareness to assist fieldwork in archaeology (Pascoe 1998). This body of research has made great efforts towards exploring a variety of scenarios of use and exploring the technical issues involved in implementing a context-aware system.

Context, before now, enjoyed a relative static, stable, characterization. The desktop workspace, whether at home or the office, kept context chained to a single location frequented usually by a single user. Context-aware applications challenge our traditional conceptions of space as just a "place," as well as expand our imaginations for what activities might be applied to these new tools in the varied physical contexts in which they may be used. Places are "spaces invested with understandings of behavioral appropriateness, cultural expectations, and so forth" (Harrison and Dourish 1996, 71). People infer assumptions about social processes in spaces and places. Spaces, the objects within them, and the events that transpire there, all encourage and afford certain behaviors (Gibson 1979). The design of the real or virtual spaces should suggest the type of activity or interaction associated with the space. People orient to these affordances and they tend to adapt practices from the physical world to the affordances of electronic space.

Developing relevant-aware applications then requires us to redefine context as a multidimensional construct with overlapping layers that interact to varying degrees. Thus, it must include not only the external physical context, but also the context the individual brings to the situation, the context of the tool/device, the information context, and finally, the context created by the activity itself. Defining these levels, the levels within each level, and how they overlap with one another provides us with an understanding of how well the tools' intended purpose get translated to the individual vis a vis how the individual interprets these concentric layers of context.

The same space may connote different interpretations of appropriate behavior at different times, such as an arena used for sports or musical events. Harrison and Dourish (1996) caution that spaces that don't clearly provide a "sense of place" may adversely affect communication and behavior. It is a notion of space that is socially meaningful so computer applications should concentrate on supporting a sense of place. Attempts have been made to outline prescribed, generic definitions of these contextual layers (Dieberger 1999). While such attempts underscore the importance of identifying contextual features, they have typically only focused on location and identification attributes of context. In addition, they fail to recognize the dynamic nature of contextual influences.

Social Navigation

Social navigation extends context-aware computing to the world of computer-mediated communication. A goal of social navigation is to "utilize information about other people's behavior for our own navigational decisions" (Dieberger 1999, 35). Amazon.com was one of the first online companies to use a social recommendation system for recommending books similar to the book the reader is ordering. The recommender system involves using the preferences and advice of others to help determine what is relevant about the information currently being dealt with. This information can be the user's current location, documents they are looking at, whom they are with, etc. Individuals may encounter they same context at different times, but if information about these encounters can be recorded, the history of interaction can be used to inform

future users and help them make decisions about their own activities (Dieberger 1999).

Social navigation can be used in any networked system where multiple users are interacting with their environment, and this information can be recorded in some way and used to share information. Combining social navigation with context-aware computing can result in location-mediated communication, document-mediated communication, or event-mediated communication. This ties the invisible usage of objects in the environment with their history of use to the benefit of users.

The idea of collectively gathering information from users and using it to influence and guide other users was inspired by research in social navigation (Dourish 1999). Most researchers studying social navigation use these ideas to open up networked information spaces (often Web resources) to dynamic user-created content. However, it has been pointed out that we can witness social navigation both in the real worlds and in the virtual worlds of information spaces (Munro, Hook, and Benyon 1999). In the physical world, people observe the behavior of others all the time to determine where to go or what to do. You see this every time people follow a crowd to see what's going on, follow a hiking trail, or even follow someone's gaze to see what they are looking at. However, without the presence of other people or the traces they leave behind, users cannot benefit from what others have done. Our research, in context-aware computing, involved creating an information space of user behavior and comments layered on top of physical space and to make these traces visible for an extended period of time. A system that includes social maps and annotation of space with notes allows users to leave traces in a physical space that would otherwise have no record of who was present and what went on before.

User Research in Context-Aware Computing

The concept of ubiquitous computing takes a giant step away from a user sitting at a desktop computer. And similarly, we can expect the usability issues to be very different as well. Some proponents of ubiquitous computing suggest that usability problems will be solved merely because these systems are integrated into the physical environments we interact with effortlessly every day. We argue that usability problems with computing technology do not disappear simply by integrating that technology into the physical world. Don Norman's book *The Design of Everyday Things*, showed that even something as innocuous as a doorknob can pose real problems to people (Norman 2002).

One major usability concern relates to the fact that ubiquitous computing systems are often designed to be supporting players in what is essentially a user experience based on interaction with the physical world. That experience could be a guided tour, a classroom lecture, driving a car, answering the phone, or any number of other activities. Once you embed computing technology into the environment, the individual can no longer attend exclusively to a computer interface, whether this interface is something tangible (like a knob, toy, or telephone) or a more traditional computing device (like a computer screen or keyboard). This leads to an important question: when should the computing system blend into the background and when should it somehow capture the user's attention?

In 1998 we began to design and develop a suite of integrated library tools for use in a wireless environment (Burrell, Treadwell, and Gay 2000) and are currently researching the use of wireless technologies in museums (Burrell and Gay 2002; Gay and Hembrooke, in press). In 1998, we began brainstorming ideas for developing a context-aware application. We had several initial goals for this tool: first, we wanted to develop an application for use in an educational environment, and second, we wanted the tool to incorporate not

only location awareness but also allow users to communicate with each other around objects and places. By extending the context-aware model to include social navigation we felt we would be capitalizing on this natural proclivity. In addition, we thought that by providing a consensual interactive space, we might facilitate the interpretation of context and relevancy in a relatively novel application (Burrell and Gay 2002).

Our studies focused less on approaching the technical problems of context detection and system design, and more on evaluating user's reception to a system of this type in real-world use (ibid.). We wanted to address some usability questions related to context-awareness. In particular, we were interested to see what type of information users associated with their context of use, whether or not they had problems understanding location-awareness, and if they could find interesting and novel uses for location-aware systems. With these questions in mind, we introduced the notion of context-aware computing for campus tours and museum guides to enhance museum visits.

In our recent application (Burrell et al. 2002), museum patrons are given color PDAs with wireless access and are free to browse various exhibits. Works of art throughout the exhibit have infrared tags placed nearby, in front of which a patron can wave the PDA. The "beacon" broadcasts a unique exhibit ID, which is read dynamically by the PDA. This ID is then sent by the PDA to a central server over the wireless network. The server then responds back, with information about the exhibit. This information is provided as a rich mixture of audio, graphics, and text.

Our wireless handheld applications, for both the campus tours and museum visits, are able to detect the user's location (Gay and Hembrooke, in press). A list of relevant text notes are displayed based on the user's location and identity. In all our applications, users were only able to view the notes associated with their current location. The applications also allowed users to create notes and associate those notes with specific locations on the wireless network. In other words, users could virtually "tag" a location with information they chose to contribute. Later on, other users could encounter these tagged notes and potentially benefit from the shared information. Again, the idea of collectively gathering information from users and using it to influence and inform other users was incorporated to foster social interaction. In the next section, we will discuss emergent issues in designing and using context-aware computing and social navigation.

Meaning Arises Through Use

The affordance of a technology is not inherent in the technology, but rather arises as the technology is used. Many of the participants used the context-aware systems like a chat client, such as IM or ICQ. It seems that what we hit up against here is what Norman (1983) refers to as the distinction between the conceptual and mental model of a system; the former relates to the designer's intent for the system, and the later expresses how the user thinks about the system. In the case of one of our earlier applications, E-graffiti (a precursor to both the CampusAware and MUSE systems), to make the interface as intuitive and easy to use as possible we tried to tap into users' mental model of e-mail. Many users were frustrated because they felt the technology did not do what they thought it should do. Users also had difficulty orienting themselves while using these devices.

In this early application, each note had a small envelope icon next to it to indicate whether it was new or old. In actual use, these small features were more overpowering than we expected and many students came to see E-graffiti as another form of e-mail. As a result, they saw the location-tracking feature as irrelevant or as a limitation because it

prevented them from getting e-mail to its appropriate recipient. One user commented that she did not use E-graffiti much because, "notes left for me at one location can't be picked up from another."

It is not surprising that users latched on to the e-mail model and ignored the location-aware aspects of the system. Their previous experience with communication technologies dictated a model where an item of information goes from one individual (the sender) to another (the recipient). Location awareness is not a standard capability for the computers these users had encountered, so a conceptual model must be chosen carefully when designing context-aware systems so that it does not limit the users' concept of how to use the system. In the case of E-graffiti, a better method might have been to use a map of campus to organize the notes and to support attaching notes to locations on the map interface. The map would emphasize the location-aware aspect of the system and a conceptual model suggesting annotation, rather than e-mail. By removing the private note functionality, the temptation to resort to known communication models may have been lessened further.

Relevancy

Research in the field of computer-supported cooperative work has looked at the problem of motivating users to contribute, particularly in groupware systems. One problem results from the "disparity between those who will benefit from an application and those who must do additional work to support it" (Grudin 1988). Alan Cooper (1999) calls this the principle of commensurate effort. This principle states that users are willing to work harder when they feel they will be rewarded. Applying this principle to social navigation where users share information to guide each other, a virtual community consisting only of consumers will not be successful (Dieberger 1999). Furthermore, when users are short on time or competing against each other, people may be unwilling to contribute (ibid.). Trying to create a balanced, active virtual community with both information creators and consumers was one of our concerns in designing and evaluating our applications. Since users seemed so willing to contribute notes to the system, we wondered what motivated them to do so given that there was no obvious benefit? Analysis of the posted notes and survey results we gathered point to several possible answers.

Primary among the findings from our studies was that the notion of "aware" technology is ambiguous for most users, and unless the context is highly specific, users have a hard time understanding the relevancy of the functionality and don't use it (Burrell and Gay 2002). When the context is relevant, users' responses were generally very positive, as indicated by their motivation to interact with other users and provide information to the system. Content analysis of the information left by users indicated that they liked this functionality, they enjoyed more informal contributions to the system versus "official" information posted by administrators, and that much of the motivation for contributing to the system was almost driven by a sense of "duty," to inform other users of necessary information (Burrell et al. 2002).

Use of our campus-tour application suggested that being in the relevant environment jogs the user's memory, almost compelling the user to contribute based on this personal expertise. As one student commented, "If I saw something not on the program, I added it." Another example is a note a user posted reading, "Don't park on the road here. Tickets are $45.00." Seeing the location where the incident happened reminded the user of the parking ticket and they posted a note about it as a result.

Above all, users seemed most compelled to contribute when they thought themselves experts. One user noted, "I thought I had some interesting point of views and additional info to contribute." Another stated, "I felt it was important that others should be aware of certain things." In fact, when asked why they left notes, over half of the participants answered that they felt they had information that was missing from the system or they thought their views would be useful to future users. It seemed to be this desire to express an opinion or help others out that drove these users to contribute (Burrell et al. 2002). Users are motivated to contribute when there is a pay off or when it is very easy to do. As we noted in the previous section about user reaction to posted notes, users found value in the information posted by other experts, so this was one pay off for them. They also seemed to have benefited from feelings of altruism and expertise resulting from contributing notes to help out others. These experts were willing to create notes even though it was difficult to do on handheld PDAs.

Critical Mass

Fulk (1993) demonstrated that social influences impact behavior and attitudes towards technology. We observed this in both how the context-aware systems were used as well as the frequency with which they were used, or rather, not used. It seems that once a few users started using the handheld devices as a direct communication tools, others adopted that behavior. Initially, in the earlier applications, people were at a loss on how to use the devices. As soon as a few people started to use the "leave and read" messages, others quickly adapted. So, the use of the context-aware applications as a chatting tool spread through social influence. We attempted to influence use socially in a similar way to encourage users to take advantage of the location-aware functionality by posting notes affiliated with the location or objects at the location.

Initially, there seemed to be a general lack of motivation to use the context-aware note features. In one questionnaire, twenty-three users responded that the reason for not using the handheld was that too few other people were using it. One user summed it up saying that the location-aware program "didn't seem like it was very useful since it wasn't very popular." It is difficult to understand the specific mediating factors in this effect: was it the lack of critical mass borne from an imbalance in people that could make useful contributing notes (Grudin 1988), or a byproduct of the way they conceptualized the system as a chat/communication tool? In either case, it is important for researchers to attend to issues of critical mass and users' interpretation of a particular technology.

Aggregate Behavior

One interesting aspect of social navigation is the aggregation feature. Computer systems have the capability to bring together information from a number of individuals and present it at the same time as when it is being gathered or at some later time. In the case of the CampusAware program, aggregate reports can be presented not based on the opinions of one individual but based on the observations of a number of tourists. The map takes aggregated user behavior or very simple user feedback (such as voting on the desirability of various campus locations) and maps this information onto physical spaces. Simple social mapping systems as part of a tour guide application can help users get to interesting information.

Social maps can be presented to users and provide dynamic feedback at a point and time when people need the information. These displays can be used in different public

spaces, such as museums and offices, to encourage reflection and conversation on collective or aggregate movement, activity, and emotion. In the museum context, for example, we are building a dynamic feedback application that functions both as tool and art itself. As tool, it serves as a navigation guide allowing visitors to track their path and the paths of others over time. As art, it represents the current and historical social presence, and encourages reflection on each individual's effect on the museum experience.

Accuracy and Trust

Participants were also very concerned about the role of experts in the context-aware environments. Most visitors to the museums and campus wanted cues provided about the identity of the contributors. Participants suggested that the design of the note systems would be improved if the experts' comments were displayed in bold or in a different color from the surrounding text in order to provide them with greater "visual authority" and to distinguish them from those of the novices. While they liked the feature of having anyone contribute notes, many suggested that experts could help keep people focused by providing discussion questions and other interesting bits of information. For obvious reasons, people were worried about the credibility of the information from others online and the trustworthiness of the sources of the information.

While participants indicated that being able to discern experts' comments from other users' comments would enhance their confidence in the accuracy of posted information, they also appreciated notes contributed by unofficial sources, such as students or insiders. In fact, unofficial posts were valued more by these users than the official factual notes that were posted by the designers. These notes were primarily informal, sometimes opinionated, and often humorous. One user commented, "Notes that kind of gave an 'insider's' perspective were quite interesting." Another user said, "I found the other personal insiders' notes from other students useful and informative." A third user stated, "I think when people come on a tour, the thing they are looking for is not only information about the school, but real advice from the students who go there." This evidence provides some justification for opening systems to this type of user feedback. The content becomes qualitatively unique and is well received when it is created by other users.

Incorporating user-contributed information into a context-aware tour guide is a valid way to generate useful content. In our studies, users were willing to contribute their knowledge and also found value in the content created through this process. Similarly, when users posted inaccurate information other users posted corrections, and when users posted questions other users answered them. The self-maintaining nature of our system is encouragement for designers of similar systems who are concerned about the quality, quantity, and accuracy of unmoderated content created by users.

Conclusion

As computing devices recede further and further into the background of our existence (Norman 2002), we find ourselves asking different questions about relevancy, functionality, accuracy, and most of all, the context in which these devices will be used. First, the context of use must be highly relevant. People communicate best with these devices when they continuously represent and refer to objects or things to help them achieve some level of common ground or understanding. The intent needs to be apparent in order for the user to be able to derive function or contextual affordance. This was dramatically demonstrated by the way the intended use of E-graffiti was reappropriated as a chatting tool.

Second, when the context is highly relevant, by including a channel for communicating users will readily contribute contextual information to the system. User-created content gives users more power over the system, allowing them to steer its use toward their own needs and interests. As more users contributed notes, contextual relevance and tool acceptance spiraled. It is important to keep in mind, however, that the content users contribute is likely to be qualitatively different from the factual information an institution like a museum or university administration would develop. The creators of GeoNotes, a location-based social information system, were thinking along these lines. They note that the social, expressive, and subversive qualities of content created by users may be more interesting than content created by administrators, which tends to be serious and utility oriented (Espinoza et al. 2001).

Third, accuracy is one of the open issues for social navigation. While a recommendation from an expert might be more valuable, it may be more difficult to obtain that information. When a system becomes open to the users, there is the risk that the information may be inaccurate or of low quality. Notes of low quality can potentially turn users off.

There are several social navigation systems that can be used to resolve accuracy issues. The useful role of moderators emerging from the general group to aid, improve, and guide the use of the system has been documented in other research (Okamura et al. 1994). Allowing users to vote on the usefulness of notes themselves is another possible solution to this problem. Various websites such as Slashdot, Amazon, and E-bay provide similar capabilities.

Finally, most would agree that supplanting the real-world experience would not be an appropriate use of context-aware technology. However, we believe that context-aware systems with a social element are often more dynamic and reflective of users' concerns. Using the conversational tools and logging maps provided by a carefully designed online environment can provide a more authentic reflection of the space being examined. The context-aware application should be used to supplement rather than replace the experience of viewing an original work of art in person or visiting a particular location. All the participants felt that both applications opened up new conversational and informational channels for understanding objects or spaces around them. The reciprocal relationship between context, users' goals, and activities is fundamental to the success of these ubiquitous tools.

REFERENCES

Abowd, G. D., C. G. Atkeson, J. Hong, S. Long, R. Kooper, M. Pinkerton. 1997. Cyberguide: A mobile context-aware tour guide. Wireless Networks: Special issue on mobile computing and networking. Selected papers from *MobiCom 96* 3 (5):421–433.

Broadbent, J. and P. Marti. 1997. Location-aware mobile interactive guides: Usability issues. Proceedings International Cultural Heritage Informatics Meeting. Paris, France.

Burrell, J. and G. Gay. 2000. Designing for context: Usability in a ubiquitous environment. Proceedings of CUU 2000: ACM Conference on Universal Usability, Arlington, VA.

Burrell, J. and G. Gay. 2002. E-Graffiti: Evaluating real-world use of a context-aware system. *Interacting with Computers, Elsevier Science*: 54–60.

Burrell, J., P. Treadwell, and G. Gay. 2000. Designing for context: Usability in a ubiquitous environment. Proceedings of CUU 2000: ACM Conference on Universal Usability, Arlington, VA.

Burrell, J., G. Gay, K. Kubo, and N. Farina. 2002. Context-aware computing: A test case. Proceedings of Ubicomp, Finland.

Cheverst, K., N. Davies, K. Mitchell, A. Friday, and C. Efstratiou. 2000. Developing a context-aware electronic tourist guide: Some issues and experiences. Proceedings of CHI, The Hague, Netherlands.

Cooper, A. 1999. *The inmates are running the asylum: Why high-tech products drive us crazy and how to restore the sanity*. Sams: Indianapolis, IN.

Dey, A. K., and G. D. Abowd. 2000. Towards a better understanding of context and context awareness. In Proceedings of the CHI 2000 Workshop on The What, Who, Where, and How of Context-Awareness, The Hague, Netherlands.

Dey, A. K., G. D. Abowd, and D. Salber. 2001. A conceptual framework and toolkit for supporting the rapid prototyping of context-aware applications. *Journal of Human-Computer Interaction: Special Issue* 16 (2):97–166.

Dieberger, A. 1999. Social connotations of space in the design for virtual communities and social navigation. In *Social Navigation of Information Space*, edited by A. J. Munro, K. Hook, and D. Benyon. New York: Springer-Verlag.

Dourish, P. 1999. Where the footprints lead: Tracking down other roles for social navigation. In *Social Navigation of Information Space*, edited by A. J. Munro, K. Hook, and D. Benyon. New York: Springer-Verlag.

Espinoza, F., P. Persson, A. Sandin, H. Nystrom, E. Cacciatore, and M. Bylund. 2001. GeoNotes: Social and navigational aspects of location-based information systems. Proceedings of the International UbiComp Conference, September. Atlanta, GA.

Feiner, S. 2002. Augmented reality: A new way of seeing. *Scientific American*, April.

Fulk, J. 1993. Social construction of communication technology. *Academy of Management Journal* 36 (5):921–950.

Gay, G. and H. Hembrooke. In press. *Activity centered design*. Boston: MIT Press.

Gibson, J. J. 1979. *The ecological approach to visual perception*. Boston: Houghton Mifflin.

Greenberg, S. 2001. Context as a dynamic construct. *Journal of Human-Computer Interaction: Special Issue* 16 (2):257–268.

Grudin, J. 1988. Why CSCW applications fail: Problems in the design and evaluation of organizational interfaces. Proceedings of the Conference on Computer-Supported Cooperative Work, Oregon.

Harrison, S. and P. Dourish. 1996. Re-Place-ing Space: The Roles of Space and Place in Collaborative Systems. Proceedings of the Conference on Computer-Supported Cooperative Work, Oregon.

Mark, W. 1999. Turning pervasive computing into mediated spaces. *IBM Systems Journal* 38 (44).

Munro, A. J., K. Hook, and D. Benyon. 1999. *Social navigation of information space*. Berlin: Springer-Verlag.

Norman, D. A. 1983. Some observations on mental models. In *Mental Models*, edited by D. Genter and A. L. Stevens. Hillsdale, NJ: Lawrence Erlbaum.

———. 2002. *The design of everyday things*. New York: Doubleday.

Okamura, K., W. J. Orlikowski, M. Fujimoto, and J. Yates.1994. "Helping CSCW Applications Succeed: The Role of Mediators in the Context of Use," *Center for Coordination Science Technical Report #171*. http://ccs.mit.edu/papers/CCSWP171/CCSWP171.html (Accessed March 24, 2005.)

Pascoe, J. 1997. The stick-e note architecture: Extending the interface beyond the user. Proceedings of the 1997 International Conference on Intelligent User Interfaces.

———. 1998. Enhanced reality fieldwork: The Context-aware archaeological assistant. In *Computer Applications in Archaeology*, edited by V. Gaffney, M. van Leusan, and S. Exxno. Oxford: Tempus Reparatum.

Rekimoto, J., and K. Nagao. 1995. The world through the computer: Computer augmented interaction with real world environments. Proceedings of UIST.

Spreitzer, M. and M. Theimer. Dec. 1993. Providing location information in a ubiquitous computing environment. Proceedings of the Fourteenth ACM Symposium on Operating System Principles, Asheville, NC.

Want, R., B. Schilit, N. Adams, R. Gold, K. Petersen, D. Goldberg, J. Ellis, and M. Weiser. 1995. An overview of the ParcTab ubiquitous computing experiment. *IEEE Personal Communications Magazine* 2 (6):28–43.

Weiser, M. 1991. The computer for the 21st century. *Scientific American* 9:94–110.

Weiser, M. and J. S. Brown. 1996. Designing calm technology, PowerGrid Journal, v 1.01. http://power-grid.electriciti.com/1.01 (Accessed July 1996).

Woodruff, A., M. H. Szymanski, P. M. Aoki, and A. Hurst. 2001. The conversational role of electronic guidebooks. Proceedings of the International Conference on Ubiquitous Computing, Atlanta, GA.

Cory D. Kidd

Human-Robot Interaction

Recent Experiments and Future Work

Human-robot interaction is a recently emerged area of research that is working to understand how to build robots that are better at successfully navigating social interactions with people. Recent work has shown that people respond differently to robots than to animated characters, that the physical embodiment of a robot is important in an interaction, and that social behavior on the part of a robot helps in conducting interactions. Several future uses of sociable robots are considered, along with the challenges that must be overcome in the process of creating these robots.

Human-robot interaction is a recently emerged area of research that is working to understand how to build robots that are better at successfully navigating social interactions with people. This paper presents an overview of the field and a review of recent work of the author in three parts. The first part introduces the reader to the topics of human-robot interaction and sociable robotics. This is followed by a discussion of current applications of interactive robotic technologies. The second portion of the paper presents recent work by the author in the field of human-robot interaction. The final section presents a series of ideas on future applications of socially interactive robots.

What Is Human-Robot Interaction?

The field of human-robot interaction is still a new area of research, although there are a growing number of people interested in this topic. HRI stems from several existing fields of inquiry, primarily human-computer interaction, robotics, and artificial intelligence. It also draws on, albeit to a lesser extent, other areas of work such as psychology, embodied conversational agents (animated agents), and communications theory. The work presented in this

paper will acknowledge work in several of these areas and it is becoming easier to find research that ties together these and other fields of investigation.

Although human-robot interaction is a new field, researchers are addressing a number of interesting questions and have identified many more issues that need to be answered. A short list of some of the interesting questions explored in my and others' work include:

- What social skills must a robot be capable of and how do these make a difference to a human with whom the robot is interacting?
- Does the physical appearance of a robot make a difference in an interaction? What impact does its physical form have regardless of its physical presence?
- Should a robot act like a human? When is this desirable and when might we want to avoid it?
- Should a robot have a human-like appearance? Should it at least be easily mapped onto a human body? Does its intended use affect this?

This is clearly not an exhaustive list of the interesting questions that come up when we begin to consider the possibility of an intimate interaction between people and robots. These are several questions that will be discussed in the work presented here.

Sociable Robotics

Before continuing into a discussion on the details of human-robot interaction in sociable robots, it will be useful to define what we mean by that term. Cynthia Breazeal has delineated several types of social robots in her recent paper on the topic (Breazeal 2003). She charts the range of robots as they increase in their ability to interact with humans in more natural ways for the human—through more complex understanding and exhibition of social cues that humans normally use in communication.

This starts with *socially evocative* robots, robots that are created in such a manner as to encourage people to treat them as animate objects. Examples of this kind of robot are toys that are designed to draw people in to an interaction, but do not go further in engendering a social alliance.

Next come robots described as having a *social interface*. These are robots that can exhibit social cues that a human would recognize. Alongside this category are *socially receptive* robots. These are robots that can comprehend social cues that are displayed by people with whom the robot is interacting. An important feature of these robots according to Breazeal's definition is that they should be capable of learning from this social interaction and benefit from this level of understanding.

Finally, we have the category that we are most concerned with in the current work, that of *sociable robots*. These are robots that are capable of fully engaging in social situations and have motivations of their own for being involved in these types of interactions. This type of robot will be capable of embodying the traits described in all types of robots above, as well as interacting on a social level that humans are familiar and comfortable with, thus allowing these interactions to take place naturally and easily.

Current Commercial Applications

The most notable current use of robots is in entertainment. Most people have seen or are somewhat familiar with Sony's AIBO, Hasbro's My Real Baby, or the numerous other robotic toys for children. Another use of robots in entertainment is as a robotic actor

in a movie. Although these applications appear on the surface to be vastly different than some of the future applications discussed in the last section of this paper—such as a robotic astronaut or a healthcare assistant—there are actually a number of similarities across these applications in how the robot must be able to comprehend and react to a human with whom it is interacting. A good overview of many of the aspects of human-robot interaction and the uses of social robots can be found in a recent review by Fong, Nourbakhsh, and Dautenhahn (2002).

The commercial success of creature-like robots such as the Sony AIBO dog and the multitude of less expensive (and less-abled) toys that the AIBO inspired suggests that the ability to make a toy with true social interaction capabilities could create an even more compelling and better-selling toy. If we look at AIBO as one example of a current robotic toy, we can see how quickly many people become attached to this toy. The work of Sherry Turkle and others (Kahn, Jr., et al. 2002; Turkle and Daste 2003) has shown a number of examples of both children and adults developing an attachment with one of these "pets." While this emotional attachment to a robot may not always be desirable, it may promote the robot's effectiveness in certain situations, such as a robot designed to assist a child in her school lessons or one that is meant to help an autistic child adapt to life in the real world (Scassellati 2000). This willingness to patiently teach and assist a robot will clearly be an asset when interacting with the first generations of consumer-focused robots that will inevitably need a great deal of human hand-holding to learn how to perform its tasks around the home or office. This patience will also be a virtue when robots make mistakes—not many of us feel a lot of patience for our computers, which leads to frustration and even a desire to hit or kick them on occasion (Pertemps.co.uk 2002).

There is also a strong interest from the Hollywood entertainment industry. There is already a great use of robots on the silver screen (for example, the *Jurassic Park* series and the *Terminator* movies). The challenge in directing the current generation of robots on a film set comes from the complexity of their design. Most robots are composed of dozens of individual motors (or degree of freedom, abbreviated DOF), which must be controlled in real-time by several people, usually the engineers that built the robot. Because each person is limited in how many DOFs they can control (typically 8–10 per person), this leads to the need for a team of people to control an individual robot. This set of issues causes two problems that are inherent in this kind of setup. The first is that it is challenging for even an experienced controller to get realistic movement out of a robot. Designers have discovered that it takes on the order of ten DOFs around the mouth to get movements that are believable-looking as speech. This means that one person must control all of these DOFs at once, which is not a simple task. A controller spends weeks, if not months, perfecting his technique to be able to produce realistic-looking speech.

Apart from the complexity of one person controlling movements to make their part of the robot appear realistic, comes the challenge of choreographing up to eight people controlling a single robotic character's performance at one time. Among the people who control these robots on the set, it is known as a challenging problem to do things well that we find trivial for ourselves, such as keeping a character's eyes fixed on a point (another actor to whom he is speaking, for example) while turning his head. This is because typically a different person will be controlling the eyes than the person who is operating the overall head and neck. If the robot had the ability to perform this kind of skill on its own, the complexity of the control problem would be reduced and the performance could be closer to the ideal of the single-minded human actor.

A robotic character on a set also provides an advantage to the actors who must per-

form opposite them when the alternative is a blue- or green-screen performance. (In this situation, the actor performs in front of a solid blue or green wall and the other "character" is digitally added into the scene in postproduction (Winston 2002).) Actors, and indeed all of us, typically find it easier to respond to someone or something that is in front of us instead of only in our minds. The same argument can be made for the character knowing how to perform natural social responses, such as orienting to the person who is talking to it or to be able to share visual attention cues with their co-star.

My Work

Two years ago, I set out to explore several aspects of how people relate to robotic characters. In this time, I have carried out three studies that address some of the interesting questions that were posed earlier in this paper. While these studies address only a small portion of what we need to know in order to successfully create robots that can effectively interact with humans, they begin to give us an idea of what aspects we can influence when building sociable robots in the near future.

Robots Compared to Animated Characters

Purpose

The first study was designed to understand differences between individual's reactions to robots and animated characters. In this study, we wanted to explore how similar interactions with characters in different media would affect perceptions of social characteristics of these characters. Perceptions of the character's fairness, reliability, credibility, and informativeness were measured, as well as a measure of how enjoyable the interaction was. The results were then compared across the three characters used: a robot, an animated character, and a human.

Study Design

The study was a within-subjects design in which each participant interacted with each of the three characters in a randomized order. Following the interactions, participants completed a questionnaire composed of the aforementioned scales.

During each of the interactions, participants were seated directly across a table from the character with which they were interacting. Everything but the character's eyes was covered in order to make each character seem as similar to the others as possible. Between the person and the character were three colored blocks on the table. The interaction consisted of requests by the character[1] to the participant to manipulate particular blocks. Requests included, "Please pick up the blue block so I can see it," and "Hold that block up to my left," during which the character would look at a particular block.

Results

We hypothesized that the robot would be rated more highly than the animated character, but lower than the human. On most of the scales, this was indeed the case, the only exception being how enjoyable the interaction was, where the human was ranked below both robot and animated character.

We performed a within-subjects, repeated-measures ANOVA to examine how participants perceived the three characters. What we found is that they perceived the robot to be only slightly different than the human overall, but significantly different from the animated character (condition $F[2,2304] = 25.7$, $p < 0.0001$; robot vs. person contrast F =

2.7, p = 0.10; robot vs. animated character contrast F = 27.4, p < 0.0001).

The Importance of the Physical Being

Purpose

The first study showed that there were differences in participants' reactions to the animated and the robotic characters. There are two explanations for why this is the case. It is possible that the difference is a result of the robot being a real, physical thing, while the character is simply something that is drawn on the screen, a fictional thing. The second explanation is that there is no perceived difference in how real the two characters are, but that the robot is physically proximate, while the animated character is viewed as being distant because it is displayed on the screen. Thus we designed a second study to test these two hypotheses and see which of these factors is the one that causes the difference in participant perceptions.

In this study, we again gathered participant reactions on scales measuring sincerity, informativeness, dominance, likeability, reliability, openness, trustworthiness, and engagement. Results were then compared across the conditions within this study and between this study and the previous one.

Study Design

This experiment was a between-subjects design with two factors that varied between conditions. The first was the presence of the robot: it was either directly across the table from participants or in the next room with a television immediately in front of the person. In both cases, the robot responded in the same way to the participant's actions, the only difference was the placement of the robot. The other factor that varied was the type of task that participants completed with the robot. One task was very interactive and required cooperation between the person and the robot, while the other required the participant to simply sit and listen to a lesson spoken by the robot and verbally respond to a series of questions at the end. At the conclusion of either experiment, participants completed a set of questions about the experience.

Results

With respect to answering the open question from the first experiment, we began with the null hypothesis, that there would be no difference in participant responses with respect to the presence of the robot. Our analysis showed that indeed there was no difference in perceptions of the robot between the present and remote situations.[2] This leads us to the conclusion that the actual presence of the robot is not what is important to people. Rather it is that they perceive the robot to be a real thing with a physical presence, whether or not that thing is actually present in front of them. This is clearly something that an animated character cannot attain.

The other question addressed in this experiment was whether the level of interactivity in the task that participants carried out with the robot affected their perceptions of the robot. In this case, we hypothesized that there would be an effect across all scales. What we found is that there was an effect for five of the eight scales: sincerity, informativeness, likeability, openness, and trustworthiness.[3] What is interesting is that not all of the differences are in the same direction. We find that in the more interactive task, participants rate the robot higher on scales of sincerity and openness, but in the non-interactive task, they perceive the robot as being more informative, likeable, and trustworthy.

Social Behavior in Interaction

Purpose

We have recently begun to explore another aspect of social interaction, that of a robot performing gestures that we expect from humans in a social interaction.[4] The question of interest in this experiment was whether three types of gestures—deictic, beat, and gaze—would increase a person's evaluation of the experience. Humans use all of these gestures in face-to-face interactions to facilitate conversation.

Deictic gestures are those in which the speaker uses a gesture when referring to an object. An example of this in our experiment was when the robot initially referred to the table next to him, he looked and pointed in that direction. Beat gestures are non-specific gestures that reinforce what a person is saying. These are the gestures that we see when a person emphasizes the start of a new sentence or phrase with their hands and the gesture doesn't mean anything specific (Cassell, Vilhjalmsson, and Bickmore 2001; McNeill 1992). Gaze can be loosely interpreted as a type of gesture, as we are referring in this case to gaze as the movement of the robot's head to track the person with whom he is interacting.

Study Design

In this experiment, we had a robotic penguin named Mel giving a demonstration of another technology. This demo was of an instrumented cup and table that allowed the table to sense how full or empty the cup was. The details of this system are not important, what is relevant is that the interaction included the participant in the experiment to fill and empty the cup when requested by Mel. Thus there was both a physical interaction by the person as well as sensing in the environment that allowed the robot to know what was taking place.

There were two versions of the demo that were run during the experiment. These were what we called "normal Mel," where the robot made all of the gestures described above in the best way that we knew how. This interaction was modeled after videos of a human giving the same demo to visitors to the lab. The other version of the demo was "wooden Mel." Wooden Mel made none of the gestures as described. In fact, the only movement that he made was flapping his beak when he talked. This version was quite different than the normal Mel giving the demo.

The experiment was a between-subjects design where participants were pre-assigned to one of the versions of Mel with which they would be interacting. The experiment was videotaped so that we could later record information about behavior as well as show the video to the participant as part of a post-experiment interview. Each participant also completed a questionnaire that contained scales asking about their knowledge of the technology being shown, their confidence about that knowledge, their liking of the robot, their level of engagement in the interaction, the reliability of the robot, and the appropriateness of the robot's movements.

Results

The entire interaction with the robot was only about four minutes long, so we did not hypothesize that there would be much of a difference in the scales. What we did expect to find was a difference in tracking time. We defined tracking time as the percentage of time during the interaction in which the participant's gaze tracked that of Mel. Thus when Mel was looking at the participant and the participant was looking back, they were tracking. The participant was also tracking the robot if both were looking at the same object, which happened when Mel described different parts of the demo. At any other

time, such as when the robot would look at the participant while the participant was look-ing at the demo, this was noted as not tracking.

The videotapes of the interactions were coded for this tracking time and we found a significant difference in tracking time between the normal and wooden conditions. In the normal condition, participants track Mel over 51% of the time, while in the wood-en condition, they track only 36% of the time.[5]

As expected, there were no statistically significant differences in the data for knowledge of the demo, confidence of knowledge, liking of the robot, or even engagement. However, we did find differences in the case of reliability and appropriateness of movement. While we will not discuss the reliability finding here, the appropriateness of the robot's movement is relevant to the previous result. We asked subjects about their perceptions of the robot's movements (or lack thereof): whether they happened at appropriate times, were conveyed effectively, were like a person would make, or were confusing. Subjects reported that the normal Mel's movements were more appropriate than wooden Mel's.[6]

Summary

We have learned several things about socially interactive robots through conducting and analyzing these experiments. First, a robot has an impact on people that a charac-ter on the screen does not. This is because the robot is a real, physical thing. This effect occurs regardless of whether the robot is actually physically present. The level of inter-activity between a robot and a person is important. As reported above, several factors are affected in different ways depending on the interactivity, so this should be considered when designing a robot for a particular type of interaction. Finally, a robot that can per-form natural gestures during a conversation allows an interaction with a person to occur more naturally.

Future of Human-Robot Interaction

Challenges: Speech, Vision, Sensing, and More

Some of the greatest difficulties faced in building robots that interact with people in natural, social ways are those inherent in building any kind of multi-modal interface. In order to have a robot that interacts naturally, we expect it to be able to see us, hear us, have a sense of touch, and understand everything coming at it through all of these sens-es. This is a tall order given the current state of many of these areas of research!

The fact that all of these are still areas of research, rather than solved problems, is what makes this such a demanding problem. When we build a sociable robot today, we assemble a physical robot with its motors, hardware drivers, and software controls for gen-erating movement, a computer vision system that gives us some idea of what is going on around the robot, a speech recognition system that passes the words it recognizes into a speech understanding system that tries to make some sense of it semantically, and some software system that ties all of this together and gives the robot some semblance of a "mind," allowing it to carry out its tasks or complete its interactions as intended. It is easy to see that it takes a team of people versed in these different specialties to be able to cre-ate a successful sociable robot.

Our group at the MIT Media Lab, under the direction of Dr. Cynthia Breazeal, is currently building a sociable robot by the name of Leonardo. Leonardo is a very com-plex, 61 degree of freedom robot, with just over half of those in the face, giving him a

range of expressions that nearly rivals a human. Work is currently underway on all of the computational systems described above, but the ultimate goal for this robot requires much more work than has been completed so far. In the following section, I address one of the most challenging aspects of this work: constructing a theory of mind for the robot.

Constructing a Socially-Aware System

The most foreboding challenge that must be addressed in creating a sociable robot is developing a computational model that serves as the basis of its interactions. The concept that we are working towards has been called "theory of mind" (Gopnik and Meltzoff 1997), "naïve psychology of action" (Heider 1958), and "folk psychology" (Greenwood 1991) by various researchers. It has been described as "the conceptual framework that helps people perceive, explain, predict, and change human behavior by reference to mental states" (Malle and Knobe 2001). Essentially, this is what will allow the robot to interpret human actions, respond in an appropriate manner, and learn new knowledge or behaviors when necessary. For purposes of discussion, I will refer to this as theory of mind.

It is hypothesized that theory of mind is what allows us to relate to other people in our daily interactions (and that the lack of theory of mind is what causes childhood autism) (Elman et al. 1996). If we want a robot to be able to navigate these kinds of social interactions, it follows that we must build into the robot some form of theory of mind or some way to develop one. We are currently working with the former goal in mind, that of building in a theory of mind.

There are two imposing challenges in this endeavor. First, the way that the human mind works in this respect is not yet fully understood. Second, even with what we do know now about the human abilities to comprehend other people's intentions and actions, we are not sure how to implement this in a robot. As psychologists elicit more of an understanding of the human abilities, we (among others) are working to implement a model of this system in the computer and use it in our robots.

While this is only one of the challenges facing designers of sociable robots, it is currently one of the more difficult problems that we face. As we continue the quest to build more socially capable robots, we are proceeding in steps towards this goal. Let us now turn to some of the potential applications of robots that we can begin to construct.

Future Commercial Applications

The more compelling and interesting applications are further away and somewhat more challenging to achieve. The science-fiction-inspired vision of the personal robot for performing our mundane household chores will be a difficult one to achieve without the advances sought after through sociable robotics. Imagine trying to explain to another person how you clean your kitchen or fold your laundry using a traditional graphical interface. Even if it is not impossible, it hardly seems desirable.

There are other approaches to this problem that have been suggested, such as a system that simply learns by observation without providing feedback. We believe, however, that the robot's ability to understand and display social interaction cues with a person is an important feature that will allow this kind of robot to be more successful in conducting interactions. If a person feels that the robot is trying to communicate with them and learn from them, they will be more inclined to help it succeed. The rest of this section presents several visions of sociable robots and how they will be a part of our lives in the coming years.

Human-Robot Teams for Scientific Exploration

A near-term project of this type of robotic assistant is the Robonaut project that is currently in progress (NASA 2002). Researchers at the National Aeronautics and Space Administration in the United States (NASA) are currently working with a number of other research groups to build a robot that will assist astronauts with various tasks in space. The purpose of this robotic astronaut is "to develop and demonstrate a robotic system that can function as an EVA [extra-vehicular activity, or space walk] astronaut equivalent" (NASA 2001).

Another key design feature of this robot (and for social robotics in general) is for the robot to be able to learn through natural interaction with a human. The Robonaut proposal gives three important reasons why these capabilities will make the system easier to use and more successful. The first concerns the cognitive load that would be placed on an operator trying to control a 47 degree-of-freedom robot. This is an immensely complex task that requires the operator to wear a virtual-reality immersion helmet for visual feedback and sensing the position and orientation of the operators' head, gloves for sensing the position of each finger, and an exoskeleton for determining the positions of other body segments. The visual feedback received by the operator through the display in the helmet is the only feedback that is received, so the operator must be very attentive to what is being displayed. The combination of the equipment that is required to be worn and the constant, careful attention needed of the operator means that one person can only effectively control the robot for a short period of time if it is to be teleoperated.

The second reason that social interaction capabilities are desired is that training the robot will be simpler from the human teacher's perspective. Similar to the problem of controlling each of the degrees of freedom on this robot, programming the robot can be equally challenging. A particular type of social interaction that would be useful here is learning by imitation or other forms of social learning. If the robot is capable of this type of learning, rather than having each joint programmed for each activity that the robot is to perform, it can watch a human perform the task and then imitate that action. The human trainer can then correct aspects of the robot's action if necessary

The final reason for implementing social interaction in this robot is that "the social aspects [of] human pedagogy will allow the robot to learn more effectively from fewer examples and generalize better." This aspect of learning takes the example of imitation learning a step further. Instead of learning particular actions and then being told when and where to carry out those actions, the robot could learn higher-level goals concerning the type of work that it is supposed to conduct. For example, the robot could learn that it should look for anomalies in particular systems and then correct them whenever they occur.

Both the second and third issues are discussed further in Breazeal's 2002 book on designing sociable robots (Breazeal 2002). Clearly this kind of robot could provide great benefit to human endeavors in space and will best be achieved through the application of the principles of human-robot interaction.

Human-Robot Teams for Search and Rescue

Another currently developing use of robotics is in search-and-rescue missions. In these scenarios, we can think of a robot in much the same way as we would a dog. Dogs are commonly used as search-and-rescue teammates because of their intelligence and ability to be trained. We want two things from these dogs: they should be able to follow commands and general guidelines that let them know where they should go and what kind

of things they should do (search for people and alert human rescuers, for example). They must also have the intelligence to carry out this search on their own without constant direction by a human, moving completely throughout a space that may be too hazardous or too small for a human to search (Casper 2002).

This application of robots blurs the distinction between viewing the robot as a tool or as a partner. In some sense, it is simply a tool that we are using to complete a particular task that may not be desirable or even possible for a human to accomplish alone. However, the partnering aspect of this task—where the robot takes orders and autonomously carries out a search—is clearly an important aspect contributing to the success of these robots. In an urgent, highly stressful situation such as search and rescue, it is vital that these robots be able to quickly, easily, and reliably interact with humans in as natural a manner as possible so that the desired outcome is achieved.

Household Robots

Although there are no existing robots that fall into the category of social household robots, there have been attempts to create commercially viable, but simpler, robots that assist with household tasks. The most recent of these is the Roomba vacuum cleaner robot from iRobot (iRobot 2003). According to the iRobot website, the Roomba "is the first automatic vacuum in the U.S. It uses intelligent navigation technology to automatically clean nearly all household floor surfaces without human direction." While this robot does not demonstrate the viability of the ideas presented in this thesis, its commercial success does show that there is a growing acceptance of robots as a household assistant.

With the capabilities that social interaction can provide, it will be possible to create robots that perform more complex tasks around the house than vacuuming the carpet. One of the limiting factors of the current generation of vacuuming robots is that they have difficulty knowing where to and where not to vacuum. This is because the input to them is usually limited to a switch that turns them on and off. It is then up to the robot to figure out where to go based on algorithms that must be pre-programmed when the robot is designed and constructed. If the robot had the capability to quickly learn where and when to do its job, the resulting product would be much more satisfying to the consumer.

Informational Robots

One type of robot that is being studied but does not yet have a good name is robots that interact with people in public spaces and convey information. One example of this could be a robot that greets visitors in an office building or lab and gives directions or other information. Another example that has been implemented by a team of researchers at Carnegie Mellon University is a robot that guides visitors around a museum and tells them about the exhibits (Fong, Nourbakhsh, and Dautenhahn 2002). This robot, called Sage, wanders around the exhibits in Dinosaur Hall at the Carnegie Museum, telling visitors about the exhibits that they are near and helps direct them to other displays.

Social interaction is clearly important here because these robots will be in situations and locations where they will be interacting with many different people. In a controlled lab setting, users can be trained to interact with a robot in a way that the robot can interpret. In a public setting, the robot must understand how to interact with people in a very social manner. This includes things such as moving through crowds (something that the aforementioned robot, Sage, does), conversing at appropriate times, and understanding and conveying information that is appropriate to its audience.

Communicative Robots

Many technologies have been developed to enable, support, and extend communication capabilities between people. The telegraph, telephone, television, and e-mail are all examples of these kinds of technologies. Each has its benefits, but there are also limitations to each of these means of communication. If we concentrate on two-way interaction between individuals, two of the most widely used of these technologies are currently the telephone and e-mail. The greatest difficulty encountered in interactions across either of these media is the lack of non-verbal channels of communication. There is extensive research showing that these channels (such as facial expression, body posture and movement, and eye gaze) are extremely important to engendering trust, liking, and other factors that are greatly important in any social task and important, albeit to a lesser extent, in non-social interactions (Argyle and Cook 1976; Bradner and Mark 2002; Burgoon et al. 2002; Cary 1978; Latane 1981). Another difficulty is an obvious one: the inability to physically share the same space and manipulate objects or even point at some object between the participants in an interaction.

For many years (more than 75 years, in fact) people have thought of using videoconferencing as a solution to these problems. The belief has been that the ability to see the other person (or people) involved in a conversation would open up these other, non-verbal channels of communication for use in a conversation. However, there are a number of shortcomings to this potential solution, many of which are discussed by Hannes Vilhjálmsson in his recent dissertation (Vilhjalmsson 2003). He points out that turn-taking is difficult because it relies on gaze direction, which is generally not supported in video communication systems. Assessing a conversation partner's focus of attention is also challenging, side conversations cannot take place in groups because everyone is sharing the same communication channels, and pointing to or manipulating physical objects is difficult. There are obviously difficulties that must be overcome in order to create an acceptable technology for communication at a distance.

One means for achieving this type of communication may be through robotic avatars. These avatars would serve as the remote embodiment of a person participating in an interaction. There are several advantages to this system over a videoconferencing setup. Gaze direction would be much simpler to interpret when there is a physically present character representing the other person (or people) in a conversation. (This is shown in the first experiment presented in this thesis.) This would help to alleviate the first two problems mentioned above: turn-taking regulation and determining focus of attention. Pointing and manipulating objects may also be possible depending upon the construction of the robot.

Control of these robots would of course be an issue. However, if we take advantage of some of the same ideas presented in the previous sections on robots for scientific collaboration or search and rescue, it becomes a simpler problem. We can imagine utilizing technology to allow the robot to synchronize its facial and gestural movements with the speech of the person it is representing. Manipulation of objects could be achieved through currently available means of telepresent operation or through similar mechanisms to those described in the scientific collaboration section, allowing a person to provide the high-level direction for the robot and leaving it to the robot to manage the detailed movement.

This kind of interaction certainly holds promise for the future of remote communication and collaboration. There remains a great deal of work to achieve these goals, but more research should be focused in this direction to understand not only what is possi-

ble, but what is desirable and beneficial in using robots for this kind of mediated communication.

Educational Robots

Another very important application of sociable robotics is in education. There are currently a plethora of computer-based tutorials for students on a wide range of subjects. An important aspect of the mentor-student relationship is the shared reference through cues such as directing attention, mutual gaze, pointing, and displaying and reading facial expressions—features that computer-based tutorial systems do not currently possess. These social aspects of the mentor-student relationship are an important part of the learning process, so understanding how to create these as a part of an interaction with a robot is an important step toward creating robots that will successfully fill this kind of a role. When it is not possible to have a human mentor, or when the human mentor is at a distance (such as in remote learning scenarios), a robot may prove to be more engaging and easier to interact with than a computer-based tutor because of the shared physical space.

Healthcare Robots

No less important than employing robots in education is their potential use in health care. As the population of the world is aging (UN 2002), the number of elderly needing regular attention is growing. With the shrinking number of working-age caregivers available, robots are a logical alternative for providing some portion of this care. There are a number of projects that seek to address this problem (Baltus et al. 2000; Camarinha-Matosa and Vieira 1999), and our work contributes to an understanding of the characteristics that these robots should possess to make the interactions rewarding, or at least palatable, to their patients. A key feature of a robot in this domain is the ability for the person needing care to maintain a feeling of independence and not feel as though they are a burden to a caretaker, rather, they can have a robot act as an extension of themselves or as an assistant to aid them in their everyday tasks. It is also important to have a robot that a human feels they can trust, is useful, and has their best interests in mind.

A different aspect of health care related to robotics is the use of robots in pet therapy. The idea behind pet therapy is that people are happier, healthier, and recover faster from ailments when they have the company of a pet (Raveis et al. 1993; Allen et al. 1991). One problem with a typical situation in which a pet might be beneficial is that the person who might benefit from the pet has difficulty taking care of a pet, either because of difficulties keeping a regular schedule, because of health reasons (allergies, etc.), or because their care environment does not allow pets (hospital or nursing home, for example). In these cases, it may be beneficial to have a robotic pet that could be cared for by the person. It may still be possible to make the emotional attachment that is desirable in this kind of relationship without some of the detriments that come with a living pet, especially in a clinical environment. There are already examples of companies trying to create and market this kind of robotic pet. A leading company in this respect is the Japanese company Omron with its NeCoRo pet (Omron Corporation 2003). The development of improved interaction capabilities could make this kind of robot more beneficial to its intended recipient and allow those who cannot have pets to attain the benefits that doing so would give.

Conclusion

Much work has been accomplished in the few years since human-robot interaction has become a cohesive discipline. There is, however, much more that must be done before this is a mature field. This paper has presented only a few of the recent research findings that will contribute to the creation of more successful sociable robots in the coming years. As we continue to work to make our vision of the helpful types of robots presented here a reality, we must overcome both the research and integration challenges that were discussed. The pace of progress is promising and we hope to see some of these systems successfully built in the coming years.

NOTES

1. The voice was a prerecorded female human voice. This choice was made for clarity in the interaction. For further discussion of this and other aspects of the experiment design, see my M.S. thesis available at http://web.media.mit.edu/~coryk.

2. Analysis was done using a between-subjects, repeated-measures ANOVA. Results showed a significant difference only for the sincerity scale: $F[1,77] = 5.4$, $p < 0.05$.

3. Using a between-subjects, repeated-measures ANOVA, we get the following: sincerity, $F[1,77] = 3.8$, $p = 0.06$; informativeness, $F[1,76] = 4.4$, $p < 0.05$; likeability, $F[1,77] = 5.6$, $p < 0.05$; openness, $F[1,77] = 7.9$, $p < 0.01$; trustworthiness, $F[1,77] = 7.8$, $p < 0.01$.

4. This work was conducted at Mitsubishi Electric Research Labs in conjunction with Candy Sidner and Chris Lee.

5. Normal $X = 51.1\%$. Wooden $X = 35.9\%$. Single-factor, between-subjects ANOVA gives: $F[1,35] = 8.34$, $p < 0.01$.

6. Normal $X = 4.99$. Wooden $X = 4.27$. Single-factor, between-subjects ANOVA gives: $F[1,35] = 6.60$, $p < 0.05$.

REFERENCES

Allen, K., J. Blascovich, J. Tomaka, and R. Kelsey. 1991. Presence of Human Friends and Pet Dogs as Moderators of Autonomic Responses to Stress in Women. *Journal of Personality and Social Psychology* 61 (4):582–589.

Argyle, M., and M. Cook. 1976. *Gaze and mutual gaze*. Cambridge: Cambridge University Press.

Baltus, G., D. Fox, F. Gemperle, J. Goetz, T. Hirsch, D. Magaritis, M. Montemerlo, J. Pineau, N. Roy, J. Schulte, and S. Thrun. 2000. Towards personal service robots for the elderly. Paper read at Proceedings of the Workshop on Interactive Robotics and Entertainment (WIRE), Pittsburgh, PA.

Bradner, E., and G. Mark. 2002. Why distance matters: Effects on cooperation, persuasion and deception. Paper read at CSCW '02, New Orleans, LA.

Breazeal, C. L. 2002. Designing sociable robots. *Intelligent robots and autonomous agents*, edited by R. C. Arkin. Cambridge, MA: The MIT Press.

———. 2003. Toward sociable robots. *Robotics and Autonomous Systems* 42:167–175.

Burgoon, J. K., J. A. Bonito, A. Ramirez, Jr., N. E. Dunbar, K. Kam, and J. Fischer. 2002. Testing the interactivity principle: Effects of mediation, propinquity, and verbal and nonverbal modalities in interpersonal interaction. *Journal of Communication*: 657–677.

Camarinha-Matosa, L. M., and W. Vieira. 1999. Intelligent mobile agents in elderly care. *Robotics and Autonomous Systems* 27 (1–2):59–75.

Cary, M. S. 1978. The role of haze in the initiation of conversation. *Social Psychology* 41 (3):269–271.

Casper, J. 2002. Human-robot interactions during the robot-assisted urban search and rescue response at the World Trade Center. Master's thesis, University of South Florida.

Cassell, J., H. H. Vilhjalmsson, and T. W. Bickmore. 2001. BEAT: The behavior expression animation toolkit. Paper read at International Conference on Computer Graphics and Interactive Techniques (SIGGRAPH 2001), Los Angeles, California.

Elman, J. L., E. A. Bates, M. Johnson, A. Karmiloff-Smith, D. Parisi, and K. Plunkett. 1996. *Rethinking innateness: A connectionist perspective on development.* In *Neural Network Modeling and Connectionism,* edited by J. L. Elman. Cambridge, MA: MIT Press.

Fong, T. E., I. Nourbakhsh, and K. Dautenhahn. 2002. *A survey of social robots.* Pittsburgh, PA: Carnegie Mellon University Robotics Institute.

Gopnik, A., and A. N. Meltzoff. 1997. *Words, thoughts, and theories (learning, development, and conceptual change).* Boston, MA: MIT Press.

Greenwood, J. D. 1991. *The future of folk psychology: Intentionality and cognitive science.* Cambridge, UK: Cambridge University Press.

Heider, F. 1958. *The psychology of interpersonal relations.* New York: John Wiley and Sons.

iRobot. 2003. *Official Roomba Home Page.* (accessed March 13, 2003) http://www.roombavac.com.

Kahn, Jr., P. H., B. Friedman, and J. Hagman. 2002. "I care about him as a pal": Conceptions of robotic pets in online AIBO discussion forums. Paper read at CHI 2002, Minneapolis, MN.

Latane, B. 1981. The Psychology of Social Impact. *American Psychologist* 36 (4):343–356.

Malle, B. F., and J. Knobe. 2001. The distinction between desire and intention: A folk-conceptual analysis. In *Intentions and intentionality: Foundations of social cognition,* edited by B. F. Malle, L. J. Moses, and D. A. Baldwin. Boston, MA: MIT Press.

McNeill, D. 1992. *Hand and mind: What gestures reveal about thought.* Chicago, IL: University of Chicago Press.

NASA. 2001. *Robonaut.* National Aeronautics and Space Administration. (accessed March 13, 2003) http://vesuvius.jsc.nasa.gov/er_er/html/robonaut/robonaut.html.

———. 2002. Instructing robotic assistants to acquire autonomous behaviors; Acquisition of autonomous behaviors for robotic assistant through instruction. Houston, TX: NASA Johnson Space Center.

Omron Corporation. 2003. *OMRON NeCoRo cat-like robot.* (accessed May 5, 2003) http://www.omron.com/news/n_161001.html.

Pertemps.co.uk. 2002. *Office staff get close to violence.* Pertemps 2002. (accessed March 13, 2003) http://www.pertemps.co.uk/newsju12002.shtml.

Raveis, V. H., F. Mesagno, D. Darus, and D. Gottfried. 1993. Psychological consequences of pet ownership of terminally ill cancer patients. New York: Memorial Sloan-Kettering Cancer Institute, Department of Social Work Research.

Scassellati, B. 2000. *How robotics and developmental psychology complement each other.* Lansing, MI: Michigan State University.

Turkle, S., and O. Daste. 2003. *Aibo and my real baby interactions with elderly people.* Boston, MA.

UN–United Nations Population Division. 2002. World Population Ageing: 1950–2050. New York: United Nations.

Vilhjalmsson, H. H. 2003. Avatar augmented online conversation. Ph.D., diss., Cambridge, MA: Massachusetts Institute of Technology.

Winston, S. 2002. Personal communication.

Sherry Turkle, Cynthia Breazeal,
Olivia Dasté, Brian Scassellati

First Encounters with Kismet and Cog

Children Respond to Relational Artifacts

Kismet and Cog, humanoid robots developed at the MIT Artificial Intelligence Laboratory, are "relational artifacts," designed to present themselves as having "states of mind" affected by their "social" interactions with human beings. During the summer of 2001, sixty children, from ages five to thirteen, were introduced to Kismet and Cog. The children's first encounters with the robots provide a window onto how such objects—and in particular, the "sociable" robots of the future—may enter into how children think about life, intentionality, friendship, and what is special about being a person.

Traditionally, researchers in artificial intelligence concentrated on building engineering systems that impressed through their rationality and cognitive competence—whether in playing chess or giving "expert" advice. The past decade has seen the development of new kinds of computational objects that Turkle (2001, 2004a, 2004b) has characterized as "relational artifacts." These are objects that present themselves as having "states of mind" that are affected by their interactions with human beings, objects designed to impress not so much through their "smarts," but through their sociability. The humanoid robots Kismet and Cog, designed in the late 1990s at the MIT Artificial Intelligence Laboratory, exemplify such objects (Breazeal 2000, 2002; Scassellati 2002). They are explicitly designed to relate to people in humanlike ways, to "detect stimuli that humans find relevant . . . respond to stimuli in a humanlike manner . . . [and] have a roughly anthropomorphic appearance" (Scassellati 2002, 49).

In the summer of 2001, roboticists Cynthia Breazeal and Brian Scassellati and clinical psychologist and ethnographer Sherry Turkle—all of MIT—introduced a group of sixty children to Kismet and Cog, observed their play, and talked to the children about their experiences.[1] This work was not experimental, but exploratory and qualitative. Our goal was to better understand children's first impressions of this novel form of social intelligence. This essay suggests that even first encounters provide a window onto children's styles of anthropomorphizing relational artifacts and children's evolving discourse about

the "aliveness" of "sociable" robots. Beyond this, relational artifacts are new objects-to-think-with for asking the question, What is an authentic relationship with a robot? [2]

Overview of Relational Artifacts

Relational artifacts include complex research robots such as Kismet and Cog, as well as a wider set of objects that have found their way into the consumer market: virtual creatures, robotic pets, and humanoid dolls. At varying levels of sophistication, these objects give the impression of wanting to be attended to, wanting to have their "needs" satisfied, and being gratified when they are appropriately nurtured. [3]

American children first met relational artifacts with the 1996 introduction of the Bandai Corporation's Tamagotchi, a small virtual creature whose screen is housed in egg-shaped plastic. The instruction book included in every Tamagotchi's packaging presented a narrative that stressed the creature's need for nurturance:

> There are a total of 4 hearts on the "Happy" and "Hunger" screens and they start out empty. The more hearts that are filled, the better satisfied Tamagotchi is. You must feed or play with Tamagotchi in order to fill the empty hearts. If you keep Tamagotchi full and happy, it will grow into a cute, happy cyberpet. If you neglect Tamagotchi, it will grow into an unattractive alien. [4]

The Tamagotchi requires that its user determine whether it needs to be cleaned, fed, or amused by assessing its state on a small screen display. If the user, usually a child under twelve, successfully reads and responds to the digital creature's state of mind, the toy will be "happy." It will flourish and survive.

In the toys that were produced for the Japanese market, the penalty for not caring adequately for a Tamagotchi was the creature's death. In some versions, the dead Tamagotchi could be uploaded to a virtual graveyard. In the United States, the manufacturers decided on a less harsh resolution: a neglected Tamagotchi became an "angel" that was "uploaded to its home planet" and the user could hit "reset" and be presented with a new Tamagotchi. Even with this opportunity for multiple chances, from a child's point of view, every relationship with a Tamagotchi was centered on accepting the role of caretaker. Bandai's website provided moral instruction that linked nurturance and responsibility:

> Tamagotchi is a tiny pet from cyberspace that needs your love to survive and grow. If you take good care of your Tamagotchi pet, it will slowly grow bigger, healthier, and more beautiful every day. But if you neglect your little cyber creature, your Tamagotchi may grow up to be mean or ugly. How old will your Tamagotchi be when it returns to its home planet? What kind of virtual caretaker will you be? [5]

Furbies, the toy fad of 1998–99, are small furry creatures with large, prominent eyes and the ability to "speak." Like Tamagotchis, Furbies are presented to children as visitors from another planet. This explains why they only speak Furbish when they are first brought to life—it is the mother language of their planet. In the case of Furbies, a child's caretaking responsibility is centered on teaching. In the course of play, Furbies "learn" to speak English. In fact, this learning reflects the unfolding of a program that evolves the Furbies' speech pattern from "Furbish" to a set of simple English phrases. (In other words, no matter what language a child speaks to a Furby, that Furby will begin to speak English.) For most children from five to nine, the illusion works: children come to believe they are teaching their Furbies English by interacting with them. Children also come to believe that a lack of attention to their pet Furbies will have a negative impact on their inner state. Neglected Furbies will feel sad or lonely (Turkle 2001, 2004b).

My Real Baby, introduced by Hasbro in 2000, continues the theme of child-as-parent and presents itself as having inner "emotional" states that a child needs to decipher in order to appropriately nurture the toy. My Real Baby does its part—the toy signals its state with baby sounds, cries, words, and facial expressions. My Real Baby was a descendent of Bit, a robotic doll first developed at the iRobot Corporation. Rodney Brooks, the director of the MIT Artificial Intelligence Laboratory and founder and director of iRobot, describes Bit in terms of its inner states:

> If the baby were upset, it would stay upset until someone soothed it or it finally fell asleep after minutes of heartrending crying and fussing. If Bit . . . was abused in any way—for instance, by being swung upside down—it got very upset. If it was upset and someone bounced it on their knee, it got more upset, but if the same thing happened when it was happy, it got more and more excited, giggling and laughing, until eventually it got overtired and started to get upset. If it were hungry, it would stay hungry until it was fed. It acted a lot like a real baby (Brooks 2002, 109).

Although more sophisticated (and more expensive), Sony's AIBO home entertainment robot, first introduced in 1999 in the shape of a pet dog, participates in the basic narrative of connection through caretaking that characterizes Tamagotchis, Furbies, and My Real Babies. AIBO responds to noises, makes musical sounds to communicate and express different needs and emotions, and has a variety of sensors that respond to touch and orientation. AIBO develops different personalities depending on how it is treated by its user. Newer models have facial and voice recognition software that enable it to recognize its "primary caregiver."

Cog and Kismet, the humanoid robots used in our study, are highly evolved examples of relational artifacts. Cog is an upper-torso robot, with sensors for sight, touch, and movement. It can detect people as well as objects that it has been programmed to consider salient, turn and point toward visual targets, differentiate between animate and inanimate motion, and perform simple tasks of imitation. Kismet is a robotic head with a vision system, winsome in appearance, with small, mobile ears made of folded paper, mobile lips made from red rubber tubing, and heavily lidded doll eyes ringed with false eyelashes. Its ability to move its head and display a range of facial expressions compels human attention. Kismet's behaviors and capabilities are modeled on those of a pre-verbal infant (Breazeal and Scassellati 1999, 2000; Breazeal 2000, 2002). It gives the impression of looking into people's eyes, and to a limited degree, it can recognize and generate speech and speech patterns.[6] In general, Cog engaged children by turning its body, looking in their direction, and copying their arm motions, while Kismet engaged them through its seeming to make eye contact, its facial expressions, and its response to language with utterances of its own.

The Study

We brought children from ages five to thirteen to spend an afternoon at MIT to interact with the robots and to speak with us about their experience. The children were drawn from the MIT community and from Boston- and Cambridge-area summer after-school programs and community organizations.[7] After a brief introductory conversation, each child met individually with one of the robots. Our approach was to interfere as little as possible in these encounters. If children asked for guidance or seemed anxious, a researcher might provide a supportive question (e.g., "What do you notice about Kismet right now?") or, if necessary, a more directive request (e.g., "Can you try to get Cog to wave at you?"). Stuffed animals were available in the areas around both robots and chil-

dren were told that they could use them if they wished. In general, children had about twenty minutes alone with the robot and were told when they had five minutes remaining in their sessions. After their encounter with the robot, children had a conversation with us about their experience.

Finally, children came back for a second session with the robot of about thirty minutes (usually involving other children) during which they were encouraged to ask any questions on their minds.[8] With the robot Cog, this second session included a special "debriefing" during which Scassellati explained Cog's inner workings. This debriefing presented an opportunity to test the limits of the children's perseverance in their "animation" of the robot. Indeed, one of our most striking findings is that children persevered in their animation and anthropomorphization of the robots even when they failed to operate properly and even when there was a determined effort to "demystify" the machines. Children continued to imbue the robots with life even when being shown—as in the famous scene from the *Wizard of Oz*—the man behind the curtain.

Here we report on three major themes that emerged from our study of first encounters, all related to children's desire to see the robots as appropriate for relationships. Children displayed perseverance in their efforts to communicate with the robots, and expressed this perseverance through a range of personal styles. A similar range of styles marked children's ways of anthropomorphizing the robots. For the most part, children came to see the robots as "sort of alive" and felt social connections with them, using different strategies to overcome disappointments and system failures. Finally, children's stake in preserving a sense of relationship with the robots was so strong that children actively resisted attempts to demystify them. With few exceptions, children were uninterested, indeed unwilling, to approach the robots in terms of underlying mechanism.

Perseverance in Communication

Kismet and Cog are research robots in a university laboratory environment. In the course of our study, laboratory members were continually working on them. Thus, at various points during our study, Kismet had difficulties tracking eye movement, responding to auditory input, or vocalizing. And one of Cog's arms was inoperable for the duration of the study, limiting its abilities to imitate motion. Despite these limitations, children persisted in trying to elicit speech from Kismet (with the greatest focus on getting Kismet to say its name) and in trying to make Cog imitate their arm movements.

Heather, seven years old, is energetic and vibrant. Before meeting Cog, Heather informs the researchers that if she could take a robot home she would treat it "just like a pet." It would sleep outside and she would give it bones to eat. When she is alone with Cog, Heather performs what she calls "an experiment" where she tries to have the robot raise its arm to model her pointing gesture and then attempts to place a stuffed animal on Cog's raised arm.[9] Heather's goal is to have Cog balance a stuffed animal on its raised arm. With each attempt, Heather raises her arm and instructs Cog to do the same. In a typical interchange, Heather speaks to the robot directly: "Up. Up. Up. Like you are pointing at me. Up! . . . now steady. . . ." and rushes to place a toy on Cog's lifted arm. Each time she succeeds in balancing a toy, Cog's arm drops. Undeterred, Heather tries again: "Now let's try that again. Up. Up, robot. Uuuuuuuuup! Thank you. Now steady. . . ." Heather's tone ranges from commanding to pleading as she tries a range of toys, seeming to believe that one or another might better hold the robot's attention. She refuses to give up and continues her "experiment" until the very end of her time with Cog (Session 17, S52).

Heather's perseverance was typical; most children set a goal for the robot they were visiting with and spent most of their time trying to get the robot to accomplish it. Although the robots' performance frustrated expectations, most children believed that the robot with which they were engaged had the ability to perform to their expectations. Children had different styles of persevering, reflecting individual personality. Aggressive children become angry when the robots had difficulties; children with gentler natures responded with sympathy.

Perseverance through Nurturance

Many children saw Kismet as a very young child and took parental roles in its company. They tried to coax Kismet to speak and attempted to reward it with kind words or a gentle touch. When Kismet did interact with them, children took this as a sign that the robot was enjoying their company; children made it clear that they wanted this acceptance and they wanted to feel needed:

> When she first meets Kismet, Trisha, five years old, refuses to approach it. After receiving some reassurance, she takes a step toward Kismet and asks, "Are you a nice robot?" A few silent moments later, Trisha says, "Hello. My name is Trisha." Kismet is silent. Trisha tries again, slowly and gently, "Tri-sha. . . . What is your name?" Trisha looks intently into Kismet's eyes, speaks to it gently, and caresses its eyebrows, neck, and base. Finally, Kismet makes a cooing sound and Trisha smiles. Encouraged, Trishsa returns to her questions, repeats them softly, pronouncing every syllable, while continuing to caress Kismet. Trisha shows Kismet the color segments on a stuffed toy caterpillar, and coaches, "Green . . . Blue . . . Orange . . . Purple . . . Red . . . Orange . . . Yellow . . ." Kismet is silent. Trisha pets the space between Kismet's "eyes" and says, "Don't be scared." Before she leaves, Trisha gives Kismet a hug (Session 10, S30).

> ■ ■ ■

> Marianne, ten years old, is quiet and thoughtful. She appears removed from the boisterous, atmosphere generated by the two boys also attending the session. When she sees Kismet, Marianne is immediately engaged: "How are you doing?" she asks. Kismet does not respond; Marianne is undeterred. She gently repeats her original question, "How are you doing?" Again, Kismet is silent. Marianne tries again and again, until Kismet finally speaks. Kismet's vocalizations are not comprehensible; Marianne says apologetically, "I'm sorry, I didn't hear you" and returns to her questions. With each attempt Marianne leans in closer, placing her ear near Kismet's mouth. Now she asks Kismet "What is your name?" and when she gets no answer, says, "I'm sorry . . . What are you looking at?"

> As the session continues, Marianne does not give up or show any sign of frustration. Instead, her voice remains gentle, coaxing Kismet to play with her. She asks her questions in a singsong way, as if talking to a baby. She asks, "Can you sing for me? Do you want to sing the ABC's? Can you sing it?" Marianne sings the alphabet softly. She plays Peek-a-Boo, covering the robot's eyes and then removing her hands and saying "Boo!" Her behavior conveys her belief that the robot is more likely to respond if she nurtures it (S47, Session 15).

Children tended to see both Cog and Kismet as sentient, but most saw Cog as a playmate and Kismet as a child to nurture. When children played with Kismet, they often urged the robot to pay attention to them, to listen, to try harder.

> Mandi, nine years old, says that what she enjoys most is "bothering" her three older siblings and playing with her baby sister. She asks Kismet, "What is your name?" then, "Do you have parents?" Encouraged by a vocal response from Kismet, Mandi asks, "Do you have brothers and sisters?" Kismet does not respond and Mandi repeats her question three times. As the session unfolds, Mandi increasingly speaks of Kismet as a female, treating the robot like a little girl. Mandi thinks Kismet has a birthday, that the robot was born, and has parents as well as brothers and sisters. Mandi asks Kismet, "Do you like ice-cream?" Kismet says something incomprehensible. Mandi responds, "I think she said yes." And then to Kismet, "What flavor do you like?" Mandi asks Kismet about her favorite color, if she goes to school, and if she has any toys. Then Mandi tries to engage Kismet by dangling toys in front of its eyes.

"I think that she [Kismet] is a baby because these toys look like little baby toys." Mandi has a six-week-old sister and likens Kismet to the child.

Mandi says that Kismet is a little bit older than her sister because Kismet speaks better. Mandi says that Kismet might get sad like a baby even if she can't cry. "If you made arms for Kismet she would scribble over the pages of a coloring book and put things in her mouth." Mandi believes that Kismet learns to speak better with every child who comes to visit. She says that "[Kismet] is still little, but it grows up. It looks little, but it still grows up." Mandi believes that Kismet will continue to learn and will mature "inside" even if we might not be able to tell from "outside" (Session 16, S49).

Many children believed that they had "taught" Kismet something. The act of teaching, a form of nurturance, reinforced the bonds between children and robot. It also reinforced children's belief that Kismet thinks, remembers, and is sometimes in more of a mood to learn than at other times. The confidence Mandi expressed in Kismet's internality, a common assumption, supported her identification with the robot's learning process. To children, Kismet was like them and although it was having difficulty, it seemed to be "trying." Some children were pleased that Kismet trusted them enough to learn from them. Children were openly affectionate with Kismet, showering it with hugs and kisses, making efforts to entertain it with stuffed animals and rattles. Some tried to amuse it with favorite childhood games and songs. In one case, a child made clay treats for Kismet to eat. Poignantly, one child told Kismet that he was going "to take care of it and protect it against all evil."

Perseverance through Belligerence

Some children showed no less determination to stick with Kismet and Cog in spite of the robots' frustrating behavior, but persisted with anger rather than nurturance.

Adam, six years old, is rather small, but very energetic and articulate. Before the beginning of the session, Adam's father tells us that his son had two questions: Could he take the robot home afterwards, and did it have weapons? According to his father, Adam has been getting into "fighting games" at school, likes rough play, and to be "in charge."

When he first meets Kismet, Adam asks the robot, "Can you talk?" When Kismet does not answer Adam repeats his question with increased urgency. When Adam cannot understand Kismet's response, Adam becomes very frustrated. After a series of "What?" "What?" "What?" Adam tells Kismet to "Shut up!" Adam forces various objects in Kismet's mouth, first a metal object, then a toy caterpillar saying, "Chew this!" He becomes increasingly angry at Kismet for not paying attention to him and for not being comprehensible. At no point does he disengage from the robot (Session 27, S27).

▪ ▪ ▪

Jerome, twelve years old, visits the robot lab with his two younger brothers and is very aggressive towards them. Finally, he turns to Kismet, and half-heartedly asks the robot, "What's your name?" When he does not receive an answer, Jerome covers Kismet's cameras and orders, "Say something!" After a few more minutes of silence he shouts, "Say shut up! Say shut up!" Seeming to fear reprimand, Jerome continues with a brusque tone but less hostile words: "Say hi . . ." "Say blah!" Suddenly, Kismet says "Hi" back to him. Jerome, smiling, tries to get Kismet to speak again, but when Kismet does not respond Jerome forces his pen into Kismet's mouth and says, "Here! Eat this pen!" Though frustrated, Jerome does not tire of the exercise. The robot is as worthy of aggression as are his siblings, at least for a while (Session 20, S58).

Perseverance through Resourcefulness

Children had very different styles of coping with the robots' lack of responsiveness. Some children nurtured, some cajoled, others reached for alternate means of communication. What seemed constant was the children's assumption that the robots could do

better if they tried harder. So, for example, some children tried to "speak Kismet" language back to Kismet, repeating the babble they heard from the robot, while others acted hurt and tried to make Kismet feel guilty about not speaking to them. Others tried speaking foreign languages with Kismet, interpreting its difficulties as those that might be encountered by any alien.

> Chi, six years old, is a small quiet boy who refers to Kismet as a "she" throughout his session. Kismet's microphone is broken and Kismet is making incoherent sounds. Chi says that he cannot understand what Kismet is saying but he knows it isn't English. Chi asserts that even though he doesn't know Thai, he is sure that Kismet is speaking Thai. He says that he wishes Kismet could speak English so that she could speak to him about herself (S29, session 9).

■ ■ ■

> Roanne, twelve years old, is very eager to speak with Kismet, but the robot is not answering her questions. Roanne patiently tries to engage Kismet. She asks, "Do you sing? Do you sing? [slower, more articulated speech] Do you sing? Say yes . . . I think he speaks French. Do you sing? Do you sing? [Kismet speaks] He said he trusts me! OK!" When it is time to end the session, Roanne says "Adios" to Kismet. Roanne decides that Kismet spoke to her in Spanish. When asked what she thought Kismet might be saying, Roanne replies, "All it said was, I can't remember, but he said 'get lost' stuff like that, and I can't remember the other words. The other words he said in Spanish." The researcher asks, "Do you think when you said 'Adios' it understood that?" Roanne answers, "Yeah" (S25, Session 8).

Some children tried to cope with the robots' limitations by turning to sign language. In the case of Cog, the logic for using sign language was impeccable: since Cog can only "see," signing would be the appropriate language for a "deaf" robot just as it would be for a deaf person. And although Kismet was deemed able to "hear," on several occasions there were technical problems with its microphone and it was rendered "deaf," again leading children to make the case for signing.

> Mort, five years old, has difficulty accepting that Cog does not speak. He is affectionate and curious about the robot, but resolute in his belief that Cog both "thinks" and "wants to talk to me." When he and his friends speak to Cog, they want an answer. When Cog's only response is to raise his arm, Mort offers, "I think he is doing sign language." Mort's friend asks, "Why doesn't he talk?" Mort tells her, "I think he is talking right now. I think he's talking in sign language" (S42, session 14).

■ ■ ■

> Heather, the seven-year-old earlier described, was also convinced that sign language would be a good way to communicate with Cog. When Cog fails to follow her instructions she suggests, "Maybe he understands sign for things." After her session with Cog, Heather says that she would like to take Cog home with her where she would teach it sign language. Further, she explains that she would teach it by having it watch a special video made especially to teach people sign language. Heather demonstrates her knowledge of signing, including the signs she know for "house," "eat," and "I love you" (S52, session 17).

Perseverance through the "ELIZA Effect"

Children want the robots to be responsive. When the robots did not respond appropriately, children went to great lengths to "cover" for them and their limitations. Even when they were told that the robot with which they were playing was broken or that a particular function was not working (in other words, when they were given "mechanistic" explanations for robot problems) children created explanations that preserved their image of the robot as both generally competent and genuinely caring in its relationship with them.

The tendency to work around a computer's relational limitations has long been part of our understanding of computer-human interaction. Joseph Weizenbaum's ELIZA (or "Doctor") program was designed to respond in the manner of a Rogerian psychothera-

pist (it mirrored a statement—"I'm angry at my mother" and turned it into a solicitous reply: "Why do you say you are angry at your mother?"). The program was seductive, even Weizenbaum's graduate students who "knew" that the program could not "know" or "understand" wanted to converse with it and confide in it. They wanted to be alone with it (Weizenbaum 1976). Weizenbaum himself became indignant, insisting that he had written the program as a joke and was troubled that people wanted to converse seriously with what he estimated to be little more than a parlor trick.

In her studies of people's relationships with ELIZA, Turkle observed that people "helped" ELIZA to seem more intelligent than it actually was. People using ELIZA refrained from asking questions that might confuse it and specifically asked it questions that would ensure a humanlike answer, going to considerable lengths to protect the illusion of a relationship with the program (Turkle 1984, 40). In *The Second Self*, Turkle describes how five-year-old Lucy took an early computer toy, Texas Instrument's Speak and Spell, and used the "ELIZA effect" to maintain the sense that she was having a conversation with it, even though the toy had no interactive capability. Lucy did this by tailoring her demands of the toy to exactly match what the toy was able to do. We saw many examples of this "helping" behavior in our study. When all evidence pointed to broken or malfunctioning robots, children rationalized their failings in other ways. So, for example, when Kismet did not speak, children said: the robot is deaf, it is too young to understand and respond correctly, it is ill, it is not responding because "he doesn't like me," it is speaking another language, it is very shy, and it is sleeping. What seemed at stake was not just an image of Cog and Kismet as intelligent. Children's excuses and "helping" behavior also preserved their sense that the robots cared about them.

> Samantha, six years old, is excited to meet Kismet and has great expectations. She asks Kismet to speak and when she learns that Kismet is having technical problems, she becomes increasingly active in her efforts to maintain her involvement with the robot.
>
> First she sings "Happy Birthday" to Kismet and pretends to make Kismet eat a clay birthday cake she has sculpted in its honor. When Kismet doesn't answer her questions, such as "Was it good?" she simply answers for the robot, "Yep!" Her first comment when hearing Kismet vocalize is, "He likes me!" Kismet babbles, Samantha ascribes meaning to its vocalizations, and then engages in a conversation based on her ascription of meaning. Samantha says that Kismet is speaking English "just fine" and that she can understand perfectly well what it is saying to her. Samantha says that Kismet is answering all her questions. Before leaving Kismet, she tries to have the robot say, "I love you" and "Samantha." She kisses it gently then hugs it goodbye (Session 18, S54).

■ ■ ■

> Jonathan, eight years old, tells us that his two older brothers' favorite pastime is "to beat him up." Although he claims to be afraid of them, he is talkative and displays great enthusiasm about being at the lab. He tells the researchers he wishes he could build a robot to "save him" from his brothers. He would like to have a robot as a friend in whom he might confide.
>
> Jonathan is sure that Kismet will talk to him and when he meets Kismet, he says, "You're cool!" Kismet vocalizes random sounds, but Jonathan hears what he wants to hear. First he interprets Kismet as saying "What are you doing, Harry [one of his brothers]?" and then, "I'm going to kiss you." Kismet continues babbling, but Jonathan smiles and says again, "You're cool!" with a thumbs-up. Jonathan suggests a list of words for Kismet to say and although Kismet does not repeat any of them, Jonathan turns to the researchers and says, "See! It said cheese! It said potato!"
>
> Jonathan says that Kismet is learning, saying the words he is teaching it to say, making explanations for Kismet's apparent incoherence. When Jonathan presents a dinosaur toy to Kismet and it says something like "Derksherk" Jonathan says, "Derksherk? Oh he probably named it [the toy]! Or maybe he meant Dino, because he probably can't say 'dinosaur.'"
>
> When Kismet stops talking completely, Jonathan suggests, "Maybe after a while he gets bored." Jonathan tries to use Kismet's toy to get its attention; when this fails he explains the failure by explaining that the toy probably "distracts" Kismet. When Jonathan is showed Kismet's voice

recognition display, which displays what Kismet is "hearing," Jonathan tries to speak "Kismet language," repeating what he sees on the monitor. When this strategy doesn't prompt a response from Kismet, Jonathan insists, "I don't think it's hearing me so good." Towards the end of his session, Jonathan concludes that Kismet has stopped talking to him because it liked his brothers better (Session 20, S60).

Anthropomorphization

The tendency for people to attribute personality, intelligence, and emotion to computational objects has been widely documented in the field of human-computer interaction (see, for example, Weizenbaum 1976; Nass et al.1997; Kiesler and Sproull 1997; Sproull et al. 1996; Parise et al. 1999; Reeves and Nass 1999). In "Computers are Social Actors: A Review of Current Research," Clifford Nass, Youngme Moon, and their co-authors review a set of laboratory experiments in which "individuals engage in social behavior towards technologies even when such behavior is entirely inconsistent with their beliefs about the machines" (1997,138). Even when computer-based tasks had only a few humanlike characteristics, the authors found that participants attributed personality traits and gender to computers and adjusted their responses to avoid hurting the machine's "feelings." The authors suggest that "when we are confronted with an entity that [behaves in human-like ways, such as using language and responding based on prior inputs] our brain's default response is to unconsciously treat the entity as human" (158). And that the more we "like" the object, the more this is likely to "lead to secondary consequences in interpersonal relationships (e.g., trust, sustained friendship, etc.) . . ." (138).

These laboratory findings are consistent with Turkle's ethnographic and clinical findings about anthropomorphization in children's interactions with computational objects. Turkle began working with children and computational objects in the late 1970s. The first objects of her investigation were the first generation of computer toys and games: Merlin, Simon, Speak and Spell (Turkle 1984). In those cases, even a minimum of interactivity in the toys and games provoked children to imagine them as sentient others. Recall that in the case of relational artifacts such as Kismet and Cog, the machines do a great deal to encourage their anthropomorphization. Their ways of being interactive include the ability to locate people and objects and to maintain their focus on things that are moving, colorful, and in Cog's case, animate. Cog moves its torso, is able to point, and orients its gaze. Kismet moves its neck and head, exhibits facial expression, as well as prosody in its speech. Its doll eyes give the impression of direct eye contact. Rodney Brooks writes, "Between people, gaze direction and gaze-direction determination are crucial foundational components of how we interact with each other" (Brooks 2002)[11].

Therefore, it is not suprising, that children imbue Kismet and Cog with humanlike traits. More striking is the range of styles of anthropomorphization enabled by the robots' sociable design.

Children not only saw Kismet and Cog as intelligent but imagined them with emotions and feelings, basically equipped for friendship. Children, and not just the younger ones, asked Kismet and Cog, how they were feeling, if they were happy, did they like their toys? Children asked if the robots loved them and provided a profusion of detail about the robots' inner lives.

> Imani, nine years old, loves to talk about hip hop and rap music; she wants to be a model and a doctor when she grows up, "just like the ones I've seen on TV." Even before meeting Kismet, Imani is convinced that a robot could be a perfect friend. When she first meets Kismet, which she address-

es as a "he," Imani says hello, introduces herself, and offers Kismet some candy. Imani asks Kismet, "Are you a robot? Can you say robot?" She asks Kismet, "Do you have friends," and reports that "Kismet would make a great friend if he spoke to people nicely." Imani explains why Kismet is not moving: "He is sleeping, just like when a person is sleeping."

Imani thinks that Kismet understands her and said her name. With little objective evidence, Imani believes Kismet to be "definitely alive" because "he talks and moves like a person." Imani says that if she took Kismet home she would take good care of it. "I would make Kismet his own room where there would be a television for Kismet to see other robots so it won't miss its family and friends."

After her session with Kismet, Imani draws a picture of a robot. She uses bright colors to draw a robot that wears roller-skates and has multi-colored hair tied up with a ribbon. When asked about the robot, Imani says that the robot is a girl robot and "she" is her friend. Her robot sings and raps, mainly about its mom and about being "different." The girl robot has a family of robots who look exactly like "her" and it knows other little robots outside "her" family. Imani adds that the little girl robot only speaks to herself and her mom because other people make fun of her. The girl robot is her friend and ally. Imani has made a robot into what she most needs: a protection against loneliness (Session 7, S23).

■ ■ ■

Fara is eleven years old and is direct in her efforts to engage Cog. She asks, "What do you want?" "What do you like?" and then, tries to startle Cog. She sneaks up to the robot, jumps out loudly, and noticing Cog's lack of reaction, says, "You don't get scared, do you?"

Fara tries to get Cog to imitate her by raising her arms. After a brief delay, Cog responds. Fara blames the delay on Cog's mind, on mental "slowness." Addressing Cog she says, "You are kind of slow, aren't you?" and then turns towards the others in the room, "He's slow—it takes him a while to run through his brain." She says this sympathetically.

Fara wants to have Cog as a friend and thinks that the best part of being its friend would be to help it learn. She adds that in some ways Cog would be better than a person-friend because a robot wouldn't try to hurt your feelings. She adds, "It's easier to forgive in a way because it doesn't really understand." She says that she could never get tired of it because "it's not like a toy because you can't teach a toy, it's like something that's part of you, you know, something you love, kind of, like another person, like a baby" (Session 1, S2).

Children generally thought that the robots were "sort of alive," a category that captures the increasingly blurred boundaries between what is animate and what is not. Thinking about the "sort of alive" gives children an intellectual space to elaborate the dimensions of a new way of being alive that stands between an "animal kind of alive" and a "human kind of alive." The "sort of alive" category has evolved in the context of successive generations of children responding to successive generations of computational objects (Turkle 1984, 1995, 2001).

When the Swiss psychologist Jean Piaget studied how children reasoned about the question of aliveness, he found that they gradually came to define life in terms of autonomous physical motion (Piaget 1960). Things that moved on their own accord were alive. Gradually, children refined the notion of "moving of one's own accord" to mean the "life motions" of breathing and metabolism.

In the 1970s and early 1980s, computers and first-generation electronic toys and games such as Merlin, Simon, and Speak and Spell disrupted this classical pattern. When children spoke about the aliveness of these new computational objects, their conversation turned to what they perceived as the computer's psychological rather than physical properties. The computer's increased "opacity" encouraged children to see computational objects as psychological machines. A computer toy's ability to "know" the rules of a game, "solve" puzzles, or even to "cheat" was what made it seem alive.

In the 1990s, children's discussion of aliveness in the presence of computational objects became more complex. Simulation games introduced children to characters/enti-

ties/avatars that moved and "lived" on the screen, but that could not be touched. Some, for example, the objects that inhabited games such as SimLife, were able to "evolve." Children were thus faced with a new, in-between category of more than imaginary and less-than-biological beings and used the category of "sort of alive" as one strategy for managing the new boundary objects. In developing new rationales for why computational objects of the 1990s were "sort of alive," children were not constrained either by the physical explanations they had used when classifying "traditional," that is, non-computational objects, or by the psychological criteria they had used when classifying the early electronic toys and games. They approached complex computational objects in the manner of theoretical tinkerers or "bricoleurs," constructing passing theories to fit prevailing circumstances. They "cycled through" various notions of what it took to be alive, saying, for example, that creatures from the game of SimLife were not alive, but almost-alive; that they would be alive if they spoke or if they traveled; that they were alive, but not "real"; that they were not alive because they don't have bodies; that they were alive because they can have babies (Turkle 1995).

Not surprisingly, when relational artifacts came on the scene in the late 1990s, children put objects such as Tamagotchis and Furbies in the "sort of alive" category. However, even very primitive relational artifacts changed the discourse about the category. Relational artifacts put a new focus on the quality of the child's relationship with the objects rather than on what the objects can do. So for example, a child of six says, "My Furby is alive because it loves me. It wants to sleep with me. Something this smart should have arms. It wants to hug me" (Turkle 2001). This "relational effect" was heightened in the case of first encounters with Kismet and Cog.

Clearly, Kismet and Cog didn't "move of their own accord." In the study reported here their power sources were in view at all times, yet this did not seem relevant to how children discussed their aliveness. What did seem relevant were the robots' gazes and the quality of their expressions and gestures. When children felt the robots were making eye contact and were responding to the children's gestures, they saw the robots as not only alive but as sentient and caring. What mattered most for the discourse of aliveness was the degree to which children felt in relationship with creatures that cared.

In studying previous generations of computational objects, Turkle has described the computer as a Rorschach, as a relatively neutral screen onto which people are able to project their thoughts and feelings, a mirror of mind and self (Turkle 1984). Today's relational artifacts make the Rorschach metaphor less useful than before. Relational artifacts do more than invite projection. They demand engagement (Turkle 2004b), creating a sense that the user and artifact have a mutual connection.

In the past, the power of computational objects to act as relatively neutral screens meant that children could project their own meanings onto them. Relational artifacts take a more active stance. With them, children's expectations that their computational objects want to be hugged, amused, or loved do not only come from children's projection of desire onto inert playthings, but from such things as digital dolls crying inconsolably or even saying: "Hug me!" or "It's time for me to get dressed for school!" Such behavior on the part of dolls inhibits projection—something that has implications for the kinds of psychological satisfactions that children can obtain from playing with digital dolls (and presumably the more advanced robots of tomorrow)—but unquestionably increases children's sense that they are in specific relationships.

In our summer 2001 study, children spoke about feeling a sense of mutual connec-

tion with Cog and Kismet. Unprompted, children expressed the importance of being recognized by the robots and being liked by the robots. Unprompted, children made it clear how important it was to show the robots affection. Children spontaneously kissed Kismet and hugged Cog. Children sang to the robots and put on dance shows. When Kismet successfully said one of the children's names, there were comments (even by some of the oldest children) that this was evidence of Kismet's affection. If one child was trying to get Kismet to say his or her name and Kismet said another child's name, this was sometimes taken as evidence that Kismet preferred the other child, often causing hurt feelings. When either Cog or Kismet were unresponsive, children were more likely to experience this as personal rejection than as broken mechanism.

> Eugene, eight years old, wanted to bring his remote control car to the robot session so he could ask the engineers at MIT how it works. Eugene is excited about getting to play with robots. He seems surprised to learn that Kismet's parts are made and not grown. Eugene thinks that Kismet's cables are its hair. When Kismet has some technical difficulties, Eugene asks many questions: What is the robot made of? How long did it take to build?
>
> Eugene sees Kismet as male and says that Kismet is not broken but "just sleeping . . . He's sleeping with his eyes open just like my dad does." Eugene places his arm around Kismet and declares, "He will make a good friend." Eugene says he can tell Kismet will be a good friend because of its smile. He says that Kismet "looks like a normal good friend." Before leaving Kismet for the first time, he hugs the robot and tells it, "I will see you soon."
>
> Eugene and his sister, six, are asked what they would do with Kismet. Eugene says, "play baseball" and "eat ice-cream together." His sister simply says, "Love it." Eugene says that Kismet would enjoy playing video games and would probably beat him.
>
> When it is almost time to leave, Kismet is babbling nonsense syllables and Eugene is trying to teach Kismet to speak. Eugene says: "Say I love you. Kismet, say I love you." With patience, Eugene tries again. Kismet is silent; Eugene is sad. A few minutes later, Kismet speaks and Eugene says with relief, "He said 'I love you.'" Eugene and his sister then try to teach Kismet to say their names and are overjoyed to report success. When it is time for them to go, they hug and kiss the robot goodbye and each says "I love you" (Session 18, S53).

■ ■ ■

Jazmyn, nine years old, is bubbly and enthusiastic. Jazmyn's favorite extracurricular activity is dance; she says that she takes step, hip-hop, jazz, and Latin dance classes. Brian Scassellati is there with her when she meets Cog and they have the following conversation:

Scassellati: What have you seen the robot do so far?

Jazmyn: Look at me and raise his hands. Maybe it's trying to shake my hand or something.

Scassellati: Did you try shaking its hand?

Jazmyn: Yeah

Scassellati: What did it do?

Jazmyn: Shook my hand.

Later, Jazmyn asks Scassellati if he is planning on making a mouth for Cog. She says that Cog probably "wants to talk to other people . . . and it might want to smile." In these comments we hear Jazmyn's wish that Cog make contact with her. Their conversation continues:

Scassellati: What do you think the new version of Cog should be able to do?

Jazmyn: Dance.

Scassellati: Should it just dance for you or should it be able to dance with you?

Jazmyn: Dance with it! [she starts to dance]

Scassellati: Do you want to dance with the robot?

Jazmyn: Yeah!

Scassellati: What kind of dancing would you do?

Jazmyn: Any kind!

Later, speaking with another researcher, Jazmyn comments about Cog: "If his other arm could move, I think that I would teach him to hug me." Jazmyn talks about wanting to take Cog home where they could play together, dance together, talk together, and eat dinner together. Later she dances for Cog and says that Cog enjoyed her performance. She adds, "I liked that the robot was at first by itself and that it looked at me when I was dancing. I liked that the little circles and squares followed movement while I was moving" [The circles and squares are representations of Cog's attention pattern on a visual display] (Session 13, S41).

Children gave evidence of feeling in a mutual relationship by the way they showed pleasure when Kismet said a particular word or Cog imitated a particular gesture. Children's responses to the robots' successes were akin to parental pride—in reference to the robots, children spoke of a "job well done." And as children assumed the parental role in relation to the robots, they also made it clear that their encouragement of a robot had been decisive in that robot's success. When a robot did well, it was not uncommon for children to take this as evidence that their patience had borne fruit or that a particular learning strategy had worked. They made the robot's success into their success.

Resistance to Demystification

Even in their very brief first encounters with Kismet and Cog, children were drawn into interactions that seemed to matter to them: the robots' behavior seemed to affect the children's state of mind and self-esteem. Our research team explicitly discussed the ethics of the encounters we were facilitating and the possibility that the development of children's feelings toward the robots should be tempered by presenting children with a "realistic" or "engineering" perspective on the robots' behavior.

In our study, we explicitly experimented with demystifying the robots, with the idea that this might make the relationship between person and machine more authentic in a certain sense. We used strategies for making the robots "transparent" to the children (by giving some sense of underlying mechanism) with both Kismet and Cog, but were most systematic in addressing this issue with Cog. Scassellati has a particular interest in developing responsible pedagogy in the field of robotics. At the time of our study, he was committed to showing children the machine behind robotic "magic," not wanting children to leave the laboratory under the illusion that Cog was an animate creature. Thirty children had an individual play session with Cog, followed by a session with Scassellati during which he took children through a real-time demonstration of how the robot processes information. Children were shown the computers that ran Cog and the monitors that demonstrated what Cog "saw." Scassellati demonstrated how Cog's program works and how its different functions could be turned off. Finally, children were allowed to "drive" the robot. This meant that they had a chance to control the robot's movements and behaviors—to be the robot's "brains."

When Scassellati first suggested giving children this "reality check" by putting them in touch with the robot as a transparent mechanism, there was considerable discussion within our research team about how the demonstration might alter children's view of this and other robots. Turkle has studied people's relationships with increasingly opaque computational objects and charted a trajectory from a culture of calculation (in which the computer is understood in mechanical terms) to a culture of simulation (here, the computer itself disappears—the user interacts with an opaque screen to be taken "at interface

value" (Turkle 1995, 1997). As the focus shifted to interaction with an opaque surface, people increasingly related to the machine as a psychological entity. Now, we were intrigued by the possible effects of didactically insisting on a transparent view of an otherwise opaque robot. Would the robot, now presented as mechanical, systematically stripped of its extraordinary powers, and perhaps more relevant, of any illusion of autonomy, seem less worthy to serve as a companion, seem less worthy of relationship?

In these sessions, our didactic presentation of a transparent, mechanical Cog had almost no effect either on children's attitudes toward the robot or on their feelings of being in a relationship with it.[10] It seemed akin to informing a child that their best friend's mind is made up of electrical impulses and chemical reactions. Such explanations (on a radically different level from the one at which relationships take place) are treated as perhaps accurate but irrelevant. They might be helpful in explaining a friend's bad mood just as Scassellati's debriefing might be helpful in explaining why Cog might be having a bad day. His explanation was not necessarily unwelcome; it was received as interesting—some children even found it compelling. But it did not interfere with children's sense of being in a relationship with Cog. This result from Scassellati's formal debriefing with Cog is similar to what we observed less formally when Kismet and Cog malfunctioned during a play session. At those times, children did not treat the robots as broken mechanisms but as ailing social creatures. It seems that once children feel that these robots are capable of sociability, the machines are treated as social creatures no matter what their current state (on, off, not in working condition). Once defined as social, any lack of particular competencies is taken as an unfortunate disability for which the robot deserves sympathy. The following vignette illustrates how children communicated that understanding the mystery behind the machine was irrelevant to their concerns:

> Blair, nine years old, is assertive, indeed, sometimes aggressive in her dealings with the other children in her group. When she meets Cog, she says she believes that Cog can be her friend and says that taking it home would be "like having a sleepover!" She believes that robots, like people, can dream and have nightmares.
>
> Alone with Cog, Blair says that she thinks Cog "trying to greet her" and that it is "happy now" because "it keeps moving its arm up and down." She thinks it is exploring its toys: "It's trying to see what this thing is [a stuffed toy]. It keeps looking at it. It seems like it really likes this toy because it keeps looking at it." When asked what she thinks of Cog, Blair says that the robot is "cool" and "happy to meet so many new kids."
>
> Scassellati shows Blair how Cog works. He turns on the LCD that corresponds to Cog's cameras and has Blair try to determine what Cog will "look at" next. Blair is very excited about her discoveries, especially when she correctly guesses that Cog is looking at her because of her brightly colored shirt. She then controls Cog's different movements from one of the computers. Blair has strong opinions about the debriefing session: "I liked it better when I got to control it [Cog] because I got to see what I could do when you got to control it by yourself." But the session takes little away from Blair's sense of Cog's inner life. She speaks of Cog's broken arm: "I bet it probably hurt when it noticed (that its arm was broken)." A researcher responds (inadvertently introducing the pronoun "him," which Blair then picks up without comment), "You mean it hurt him like it felt bad or that it hurt?" "No. Like it hurt his feelings. Like, why did you have to take my arm off?"
>
> We ask Blair, "Do you think Cog is alive?" Blair says "Yes." There is a conversation about the apparent contradiction. "What made it alive this time since you said before that it was alive because it moved on its own? This time you were moving it." Blair's reply illustrates that her beliefs about aliveness are not as related to formal categories as much as they are to her sense of being in a relationship with Cog, a relationship that was not compromised when she was put in temporary control of Cog's functioning. She replies, "This time [when she was in control of the robot] it felt more alive. . . . maybe because this time I got to move it. It just felt more real." Blair's sense of Cog's aliveness was actually strengthened by controlling Cog, despite the fact that she based her first assertion of Cog being alive on its being able to move on his own (Session 13, S38).

Blair's story illustrates that the experience of being with a relational artifact was more important to children than any intellectual understanding of what stands behind the robot's behavior. No matter how much we showed children the "insides" of a machine, if they felt a connection to a robot as a sentient and significant other, that sense of relationship remained intact and at times seemed even strengthened.

What is a Relationship?

With both Kismet and Cog, children try to understand the robots' states of mind in order to better communicate with them. When children sensed the robots were vulnerable (since they could not perform so much of the time), children tried to understand their states of mind in order to better take care of them. Thus, at the heart of the "holding power" of both Kismet and Cog is that they call forth the human desire for communication, connection, and nurturance. Kismet and Cog had this in common with each other, and with all relational artifacts. At the same time, Kismet and Cog are very different in their abilities and thus their appeal. Cog, with its large motor responses, tended to encourage more physical give and take; children related to it as a friend and protector. Kismet, with its emphasis on the modeling of affect and speech, encouraged children to treat it as a baby or a small creature to parent. Children seemed to feel very deeply recognized when they felt Kismet had spoken their names or they had taught it to say its own.

Cog, with its large size, visible steel-rod structure, and silent demeanor, seemed to children the more "masculine" robot whereas Kismet, with its high-pitched vocalizations, attractive features, and smaller size, seemed more "feminine." Boys preferred Cog, describing it as cool and quickly associated it with Robocop and Battle Bots. If needed, children incorporated imaginary weapons into their play with Cog. Kismet, more doll-like and requiring "teaching" in order to speak, had more appeal for girls, although girls found much in Cog to nurture, referring to the robot, which had lost one of its arms prior to our study, as "wounded."

In the case of both Kismet and Cog, children felt part of social encounters even when the robots were not functioning optimally. It is notable that Kismet and Cog signal the capacities they would be able to have if fully functioning. Children understand these signals as indicating the robots' capacity for relationship. Children were able to look at the body of the "wounded" Cog and appreciate how it was supposed to move and they were able to look at the face of the "deaf and dumb" Kismet and appreciate something of how it was supposed to relate emotionally. As already noted, even when the robots are not at their best, children do not treat them as broken mechanisms but as disabled creatures.

Put in more general terms, when children face a relational artifact that does not have a particular human capacity, children seem willing to attribute what is missing in the artifact to its being temporarily indisposed or temporarily incomplete in its design.[1] So, for example, faced with Cog's inability to respond to speech, Fara, eleven years old, does not question that Cog is "smart enough" to hear or speak, but sees him as disabled the way a human might be. She says that being with Cog felt like being with a deaf or blind person "because it was confused, it didn't understand what you were saying, and like a blind or as a deaf person, they don't know what you are saying . . . (Session 1, S2).

Children were tenacious in their efforts to obtain a humanlike response from the humanoid robots we studied. They anthropomorphized Kismet and Cog with extravagant "back stories" and developed a range of novel strategies for seeing the robots not only as "sort of alive," but as capable of being friends and companions. Children went to great

lengths to maintain the sense that they were in a mutual relationship with the robots, preferring to see them as disabled creatures in need of nurturance than as broken machines in need of repair.

In the warm welcome that children extended toward the robots, there were some expressions of reticence about how far the relationships could go:

> Steven, thirteen years old, says, "I have two tight friends, my girlfriend and my dog." Steven seems very engaged with Cog, and reports that Cog was reaching out to him and trying to say "hi" when Cog was lifting his arm toward him. Also present during Steven's encounter with Cog are Steven's camp counselor, Rory, nineteen-years-old, and Steven's friend, Philip, twelve. Rory, the counselor, says that he would like to have a robot as a friend, if it was smart enough. Steven immediately expresses his own reservations about a robot as a friend, "It wouldn't have as strong feelings (as a human friend) because it doesn't have a heart and so couldn't feel pain. I'm sure you could make it feel bad, but say it had a girlfriend and breaks up with its girlfriend, it might feel bad but it doesn't have strong emotions. It could be a friend but not a good friend." Philip has been listening and agrees, "Yeah, it could have a broken eye, but not a heartbreak" (Session 12, S37).

It is notable that in this encounter, Philip is willing to grant that the robot might have a certain form of biology—the kind of broken eye that might be painful for a robot. But what the robot will not have is the kind of pain that comes from broken emotions. Only human beings can have a broken heart.

Turkle has noted that since the beginning of children's immersion in the computer culture through their involvement with electronic toys and games, computational objects have been an essential element of how children talk about what is special about being a person. The computer appeared in the role of "nearest neighbor"—people were distinguished by what made them different from the machines. Through the mid 1990s, in large measure, children made these comparisons between computers and people by focusing on what computers could and could not do. In contrast, in the company of Kismet and Cog, when children spoke about what was special about being a person, they focused not on what the machines could do, but on the machine's potential for relationship. In this study, children often reflected that one thing that made people special was their imperfections. This study of first encounters offered poignant testimony to how a certain vulnerability, even frailty, can become valued as defining traits for people. A ten-year-old girl who has just played with Kismet says, "I would love to have a robot at home. It would be such a good friend. But it couldn't be a best friend. It might know everything but I don't. So it wouldn't be a best friend." She further explains that a robot is "too perfect" and that it might always need to correct her. Friendship is easier with your own kind.

Our look at first encounters between children and relational artifacts made it clear that in the not-distant future, children will consider themselves in relationships with computational companions, relational artifacts that will provide a sense of mutual connection. However, these involvements will invite new and complex questions, perhaps most centrally, "What is a relationship?"

NOTES

1. This research was funded by a NSF ITR grant "Relational Artifacts," (Turkle 2001) award number SES-0115668 and by the Mitchell Kapor Foundation through its support of the MIT Initiative on Technology and Self. Any opinions, findings, and conclusions or recommendations expressed in this material are those of the authors and do not necessarily reflect the views of the National Science Foundation, nor of the Mitchell Kapor Foundation. Breazeal, Scassellati and Turkle participated in data collection, discussion of the findings, and oversight of the summer project; Turkle and Dasté took responsibility for the analysis of the data and redaction of this text. Study participants also include

Jen Audley, research coordinator during summer 2001, and research assistants Robert Briscoe, Anita Chan, Tamara Knutsen, and Rebecca Hurwitz. A version of this paper was first presented at Humanoids 2004, Santa Monica, California, November 10 2004.

2. Olivia Dasté, Turkle's research assistant, joined the project in September 2001, at the beginning of data analysis.

3. Indeed, at MIT, there is an "affective computing" research group that undertakes to develop computers capable of assessing their users' emotional states and of responding, in turn, with appropriate "emotional" states of their own. Group leader Rosalind Picard, writes: "I have come to the conclusion that if we want computers to be genuinely intelligent, to adapt to us, and to interact naturally with us, then they will need the ability to recognize and express emotions, to have emotions, and to have what has come to be called 'emotional intelligence.'" (Picard 1997, x)

4. Bandai instruction booklet, "Happiness and Hunger Status Check." http: //virtualpet.com/vp/faq/instruct/-tam2.gif. Accessed 10/1/2001.

5. Tamagotchi Planet, "General Tamagotchi Information," quote from Bandai http://www.mimitchi.com/html/q1htm. Accessed 10/1/2001.

6. Kismet's "cuteness" is not accidental. In Kismet's design, Breazeal took into account Eibl-Eibelsfeld's "Kindchenschema" or Baby-scheme, which established that there is a biological explanation for human responses to "cuteness," meaning big eyes, round head, small bodies, big floppy ears, with caring and tender behavior. Breazeal notes: "For our purposes as robot designers, it seems reasonable to construct a robot with an infant-like appearance, which could encourage people to switch on their baby-scheme and treat it as a cute creature in need of protection and care" (Breazeal and Foerst 1999). Kismet, from the onset of its design, was meant to draw out a nurturing response. On this point, see also DiSalvo and Gemperle 2003.

7. The research team posted invitations to participate in a study about what children think about robots; families interested in the study initiated contact with us. Participants represented a wide range of socio-economic and ethnic backgrounds, including children of African American, Iranian, Haitian, Korean, and French ethnicity. All the participants' identities are disguised.

8. While not an experiment, our study had a formal structure: When participants arrived at MIT, usually in groups of four, they were directed to a conference room and given a brief description of what they would do and see during their time with us: a group introduction to a robot would be followed by a private session with the robot, a conversation about the experience, and then a final visit with the robot. The conversation with each participant was used to encourage each to talk about anything relating to the experience while also gathering information on a standard list of issues, including those raised by the following questions:

> Is there anything that you would like to change about the robot? Why?
> Was there anything about the robot that was different from what you expected?
> Would you like to have this robot at home? Why?
> Do you think this robot is alive? Why?
> Could this robot be a friend? Why?

In all cases, we were more interested in the child's conversation about an issue than the child's "yes or no" opinion about any question. At least one ethnographer and one roboticist staffed each encounter between child and robot. Interactions with the robots were video recorded and a combination of audio and videotapes were used to document the remainder of the child's time in the laboratory. For thirty children who visited with Cog, the final visit included a "debriefing" about Cog's inner workings.

During the one-on-one visits with the robot, participants were told that they could do whatever they wanted as long as it was not harmful or dangerous either to themselves or the robot. Participants were asked to wear a wireless clip-on microphone, which the researchers explained was being used to assist in recording their conversation in the noisy laboratory room. In addition, Kismet actually used this audio signal to detect word choice and vocal prosody. Cog did not use this information.

9. The toys given to the children to play with Cog included a stuffed bear, a slinky, a stuffed frog, a stuffed caterpillar, Beanie Babies, and a Mickey Mouse sorcerer. Heather tried each one of these in turn with Cog when carrying out her experiment.

10. Certainly, the few children who initially related to Kismet or Cog structurally, as an object to be understood, were reinforced in their stance when Scassellati unveiled the robot's structure and mechanism.

11. When children met both Kismet and Cog, they sometimes fantasized about hybrid species, in particular grafting Kismet's head on Cog's body. Children felt that Kismet would be "happier" with arms, but they were more focused on Cog not having "the head it deserved." This was perceived as the more immediate need.

RESOURCES

Breazeal, C. 2000. Sociable Machines: Expressive Social Exchange Between Humans and Robots. MIT Ph.D. Dissertation, MIT. Department of Electrical Engineering and Computer Science.

Breazeal, C. 2002. Designing Sociable Robots. Cambridge, MA: MIT Press.

Breazeal, C., and A. Foerst. 1999. Schmoozing with robots: Exploring the boundary of the original wireless network. Presentation at the Third International Conference on Cognitive Technology, CT.

Breazeal, C., and B. Scassellati. 1999. How to build robots that make friends and influence people. IEEE/RSJ International Conference on Intelligent Robots and Systems (IROS-99), Kyongju, Korea.

Breazeal, C., and B. Scassellati. 2000. Infant-like Social Interactions Between a Robot and a Human Caretaker. Adaptive Behavior 8:1.

Brooks, R. 2002. Flesh and machines: How robots will change us. New York: Pantheon Books.

Disalvo, C., and F. Gemperle. 2003. From Seduction to Fulfillment: The Use of Anthropomorphic Form in Design. Proceedings of DPPI '03: Designing Pleasurable Products and Interfaces, Pittsburgh, PA.

Kiesler, S., and L. Sproull. 1997. Social responses to social computers. In Human values and the design of technology, edited by B. Friedman. Stanford, CA: CLSI Publications.

Nass, C., Y. Moon, J. Morkes, E.Y. Kim, and B. J. Fogg. 1997. Computers are social actors: A review of current research. In Human values and the design of computer technology, edited by B. Friedman. Stanford, CA: CSLI Press.

Parise, S., S. Kiesler, L. Sproull, and K. Waters. 1999. Cooperating with life-like interface agents. Computers in Human Behavior 15:123–142.

Piaget, J. 1960. The child's conception of the world, trans. by Joan and Andrew Tomlinson. Totowa: Littlefield, Adams.

Picard, R. 1997. Affective computing. Cambridge, MA: MIT Press.

Reeves, B., and C. Nass. 1999. The media equation: How people treat computers, television, and new media like real people and places. Cambridge: Cambridge University Press.

Scassellati, B. 2002. Foundations for a theory of mind for a humanoid robot. Ph.D. diss MIT.

Sproull, L., R. Subramani, S. Kiesler, J. Walker, and K. Waters. 1996. When the interface is a face. Human-Computer Interaction 11:97–124.

Turkle, S. 1984. The Second Self: Computers and the Human Spirit. New York: Simon and Schuster, 2nd edition MIT Press, Cambridge, MA, 2005.

Turkle, S. 1995. Life on the screen: Identity in the age of the Internet. New York: Simon and Schuster.

Turkle, S. 1997. Seeing through computers: Education in a culture of simulation. The American Prospect 31.

Turkle, S. 2001. Relational artifacts. Proposal to the National Science Foundation SES-01115668.

Turkle, S. 2004a. Whither Psychoanalysis in the Computer Culture. Psychoanalytic Psychology, 21, 1 Winter.

Turkle, S. 2004b. Relational Artifacts. Final Report on Proposal to the National Science Foundation SES-01115668.

Weizenbaum, J. 1976. Computer power and human reason: From judgment to calculation. San Francisco: W. H. Freeman.

Contributors

JEREMY N. BAILENSON ("Collaborative Virtual Environments") is an Assistant Professor in the Department of Communication, Stanford University, and the Director of Stanford's Virtual Human Interaction Lab (http://vhil.stanford.edu). His work has been published in *Cognitive Psychology, Psychological Science, Personality and Social Psychology Bulletin, PRESENCE: Teleoperators and Virtual Environments*, and other journals, and his research is funded by the National Science Foundation, Stanford University, and various industry sources.

LEMI BARUH ("Music of My Own? The Transformation from Usage Rights to Usage Privileges in Digital Media") is a Ph.D. candidate at the Annenberg School for Communication, University of Pennsylvania. His research focuses on privacy, framing of privacy rights in the mainstream media, digital rights management systems and tensions that exist between privacy rights of individuals and digital rights management systems.

DAPHNE BAVELIER ("The Cognitive Neuroscience of Video Games") is an Associate Professor in the Department of Brain and Cognitive Sciences at the University of Rochester. Her work focuses on brain plasticity and examines the role of experience in shaping the functional organization of the human brain as well as in pushing the boundaries of behavior. She studies populations with altered experience such as deaf individuals, video game players or individuals using a visual rather than a spoken language (e.g. users of American Sign Language), and asks basic questions such as: Do deaf individuals see better? What is the impact of video gaming on vision and cognition? How does the use of a visual, rather than spoken language, change the cerebral organization for language?

SIDNEY E. BERGER ("The Future of Publishing in the Digital Age") is a Professor in the departments of Communications and English at Simmons College. He has been Curator of Printed Books and then Curator of Manuscripts at the American Antiquarian Society in Worcester, Massachusetts, Head of Special Collections at the University of

California, Riverside, and Director of the California Center for the Book. He has taught bibliography, medieval codicology, the history of books, and many other book-related and literary topics for more than thirty years. He runs his own handpress, makes paper, casts type by hand, and publishes and speaks extensively on literary and book-arts topics.

CYNTHIA BREAZEAL ("First Encounters with Kismet and Cog: Children Respond to Relational Artifacts") is an assistant professor of Media Arts and Sciences at the MIT Media Lab where she is director of the Robotic Life Group and holds the LG Group career development chair. She is a pioneer of the areas of human-robot interaction and sociable robotics. Her research interests focus on the scientific pursuit and technological innovation necessary to create machines that understand and engage people in social and affective terms. Particular areas of interest include multi-modal communication through speech, gesture, facial expression and touch, collocated human-robot teamwork, and social learning. Her first book, *Designing Sociable Robots*, is published by The MIT Press (2002). She received her B.S. (1989) in Electrical and Computer Engineering from the University of California at Santa Barbara. She received her S.M (1993) and Sc.D. (2000) in Electrical Engineering and Computer Science from the Massachusetts Institute of Technology.

MARK J. BUTLER ("'Everybody Needs a 303, Everybody Loves a Filter': Electronic Dance Music and the Aesthetics of Obsolescence") is an Assistant Professor in the Department of Music at the University of Pennsylvania. His publications have appeared in journals such as *Theoria, Music Theory Online*, and *Popular Music*. He recently completed a book entitled *Unlocking the Groove* (forthcoming from Indiana University Press), which explores the rhythmic organization of electronic dance music through field research with musicians and musical analysis.

OLIVIA DASTÉ ("First Encounters with Kismet and Cog: Children Respond to Relational Artifacts") graduated with a B.A. in Sociology from McGill University and is currently a Ph.D. candidate in that department. From 2001 to 2004, she worked at MIT as Professor Sherry Turkle's research assistant, focusing on the study of robotic creatures as they are experienced by children and the elderly.

ADAM FINKELSTEIN (cover art) is an Associate Professor of computer science at Princeton University.

GERI GAY ("Role of Social Navigation and Context in Ubiquitous Computing") is Director of the Human-Computer Interaction Group and Professor in the Department of Communication and Information Science at Cornell University. Current research projects include: CAMPUS AWARE (a campus tour system utilizing Palm Pilots and GPS), MUSE (an effort to bring handheld computers into the museum as a navigation and social collaboration tool), NOMAD (a project that studies wireless computing in the classroom), CIMI Handscape (evaluation of the implications of handheld technology for a consortium of cultural heritage institutions), AIDE (investigating the future role technology will play in facilitating distributed, collaborative work groups), and K-MODDL (which aims to facilitate the teaching of the principles of kinematics through digitization of a collection of 19th-century kinematic artifacts). She has served as a consultant for DARPA, IBM-Japan, and Intel, and is the author of *Activity Centered Design: An Ecological Approach to Designing Smart Tools and Usable Systems* (MIT, 2004, with Helene Hembrooke).

JAMES PAUL GEE ("Learning by Design: Good Video Games as Learning Machines") is a Professor in the Department of Educational Psychology at the University of Wisconsin–Madison. His books include *Sociolinguistics and Literacies: Ideologies in Discourse* (Taylor and Francis, 1990; Second Edition, 1996), *The Social Mind: Language, Ideology, and Social Practice* (Bergin and Garvey, 1992), *Introduction to Human Language: Fundamental Concepts in Linguistics* (Pearson, 1993), *The New Work Order: Behind the Language of the New Capitalism* (Westview, 1996, with Glynda Hull and Colin Lankshear), *An Introduction to Discourse Analysis: Theory and Method* (Routledge, 1999), and *What Video Games Have to Teach Us About Learning and Literacy* (Palgrave Macmillan, 2003).

C. SHAWN GREEN ("The Cognitive Neuroscience of Video Games") is a Ph.D. candidate in the Department of Brain and Cognitive Sciences at the University of Rochester, New York. He is affiliated with Dr. Daphne Bavelier's Brain and Vision Laboratory, where he is currently conducting a project on the effects of video game playing on visual skills and other cognitive functions.

JEFFREY HUANG ("Inhabitable Interfaces") is Associate Professor of Architecture at the Harvard University Graduate School of Design, in the area of digital media and information technology. His research, "Internet and Architecture," explores the vision of bringing the physical and virtual environments together. As part of this research, he recently completed the Swisshouse project, a prototype Internet-based consulate for Switzerland (in association with the architect Muriel Waldvogel). The physical building of the Swisshouse, located in Cambridge, MA, is a large interface for knowledge exchange between Switzerland and the U.S. and will serve as a test bed for studying issues related to telepresence, remote brainstorming and distance learning.

ALEX BRYMER HUMPHREYS ("The Past, Present and Future of Extractive and Immersive E-books") is the Director of Technology for Project TORCH (The Online Resource Center for the Humanities), an Oxford University Press sponsored scholarly e-book initiative, funded by the Mellon Foundation.

LEE HUMPHREYS ("Photographs and the Presentation of Self through Online Dating Services") is a Ph.D. candidate at the Annenberg School for Communication, University of Pennsylvania. She is currently working on her dissertation about social interactions and digital technology in public space.

CORY D. KIDD ("Human-Robot Interaction: Recent Experiments and Future Work") is a Ph.D. candidate in MIT's Media Lab. He works in the Robotic Life Research Group and is involved in projects on Human-Robot Interaction, looking specifically at applications of sociable robots in health care.

ANNIE LANG ("Motivated Cognition: The Influence of Appetitive and Aversive Activation on the Processing of Video Games") is a Professor of Telecommunications and Director of the Institute for Communications Research at Indiana University. Her research focuses on viewers' behavioral, psychophysiological, cognitive, and emotional interactions with media. She is a widely recognized authority on viewers' interactions with media and on the measurement of physiological responses.

KWAN MIN LEE ("Phenomenological Understanding of Social Responses to Synthesized Speech") is an Assistant Professor at the Annenberg School for Communication,

University of Southern California. Lee specializes in psychological impacts of new communication technologies, human-machine interaction, and speech-user interfaces. His research has been published in major journals in communication, computer science, education, and psychology. His research findings have been covered by The Washington Post, BBC News, and other major international news agencies. He received two top paper awards from the International Communication Association (ICA) and four fellowships (including three endowed fellowships) from Stanford University. His current research focuses on the design and evaluation of computer games, human-computer interfaces, and home robots.

PAUL LEVINSON ("The Hazards of Always Being in Touch: A Walk on the Dark Side with the Cell phone") is Professor and Chair of the Department of Communication and Media Studies at Fordham University. A prolific, award-winning writer of science fiction, he has published four novels and numerous short stories. He also is the author of *Mind at Large: Knowing in the Technological Age* (JAI, 1988), *The Soft Edge: A Natural History and Future of the Information Revolution* (Routledge, 1997), *Digital McLuhan: A Guide to the Information Millennium* (Routledge, 1999), *Realspace: The Fate of Physical Presence in the Digital Age, On and Off Planet* (Routledge, 2003) and *Cellphone: The Story of the World's Most Mobile Medium and How It Has Transformed Everything!* (Palgrave Pacmillan, 2004).

MARGARET L. MCLAUGHLIN ("Simulating the Sense of Touch in Virtual Environments: Applications in the Health Sciences") is Professor of Communication at the Annenberg School for Communication, University of Southern California, and a key investigator at USC's Integrated Media Systems Center, a National Science Foundation Engineering Research Center. Her current research focuses on the design and evaluation of haptic (tactile) interfaces to the WWW and desktop virtual museums and related applications. She has written or co-edited a number of books, including Touch in Virtual Environments: Haptics and the Design of Interactive Systems (Prentice Hall, 2002), Network and Netplay: Virtual Groups on the Internet (AAAI/MIT Press, 1998), Explaining One's Self to Others: Reason-Giving in a Social Context (Erlbaum, 1992), The Psychology of Tactical Communication (Multilingual Matters, 1990), and Conversation: How Talk Is Organized (Sage, 1987). She is a former president of the International Communication Association. McLaughlin's work on the Interactive Art Museum and Touch in Virtual Environments has been featured recently on CNN, KABC, KNBC, and TechTV, and in articles in Time Asia and Technology Review. Support for her research has been provided by the Annenberg Center for Communication, Hitachi America, the National Science Foundation, the Ford Foundation, and the National Institute of Health.

PAUL MESSARIS ("Viewers' Reactions to Digital F/X in Movies") is the Lev Kuleshov Professor of Visual Communication at the Annenberg School for Communication, University of Pennsylvania. He has directed three feature films and is the author of *Visual Literacy: Image, Mind, and Reality* (Westview, 1994) and *Visual Persuasion: The Role of Images in Advertising* (Sage, 1997).

ROSA LESLIE MIKEAL ("Gaming Pink: Gender and Structure in The Sims Online") is a PhD candidate at the Annenberg School for Communication of the University of Pennsylvania. Her research examines gender, information-seeking, and self-presentation

in online contexts. She is currently looking at women's internet job-search techniques and experiences, and the intersection between social and economic identity formation.

JULIANNE H. NEWTON ("Influences of Digital Imaging on the Concept of Photographic Truth") is an Associate Professor at the School of Journalism and Communication, University of Oregon. A distinguished artist and journalist, she is the author *The Burden of Visual Truth: The Role of Photojournalism in Mediating Reality* (Erlbaum, 2000).

DAVID PERLMUTTER ("Hypericons: Famous News Images in the Internet-Digital-Satellite Age") is an Associate Professor at the Manship School of Mass Communication, Louisiana State University, and a Senior Fellow at the Kevin P. Reilly Center for Media and Public Affairs. A registered columnist in the Knight-Ridder Progressive Media Project, he has published opinion and editorial articles on a wide range of domestic and international topics, and he was the first academic appointed to the board of directors of the American Association of Political Consultants. He edits LSU Press's politics@media book series and is the author of *Photojournalism and Foreign Policy: Framing Icons of Outrage in International Crises* (Greenwood, 1998), *Visions of War: Picturing Warfare from the Stone Age to the Cyberage* (St. Martin's, 1999), and *Policing the Media: Street Cops and Public Perceptions of Law Enforcement* (Sage, 2000).

STEPHEN PRINCE ("The End of Digital Special Effects") is a Professor in the Department of Communication at Virginia Tech. He is President of the Society for Cinema Studies and the author of *Visions of Empire: Political Imagery in Contemporary Hollywood Film* (Praeger, 1992), *Savage Cinema: Sam Pekinpah and the Rise of Ultraviolent Movies* (Texas, 1998), *The Warrior's Camera: The Cinema of Akira Kurosawa* (Princeton, 1999), *A New Pot of Gold: Hollywood under the Electronic Rainbow, 1980–1989* (Scribner's, 2000), *Classical Film Violence: Designing and Regulating Brutality in Hollywood Cinema, 1930–1968* (Rutgers, 2003), and *Movies and Meaning: An Introduction to Film* (Allyn and Bacon, 2004).

BRIAN SCASSELLATI ("First Encounters with Kismet and Cog: Children Respond to Relational Artifacts") received his doctorate from the Artificial Intelligence Lab at MIT and is an Assistant Professor of computer science at Yale. His research focuses on the construction of humanoid robots that use normal social cues to interact with people. His research group uses these robots both as tools to evaluate models of how infants acquire social skills and to assist in the diagnosis and quantification of disorders of social development (such as autism).

JOHN L. SHERRY ("Would the Great and Mighty Oz Play Doom? A Look Behind the Curtain of Violent Video Game Research") is an Assistant Professor in the Department of Communication at Michigan State University. His research on violent video games has been reported widely in the news media. Sherry's current research focuses on cognitive predictors of gender differences in video game use. His work on video games has been published in the journals *Communication Theory*, *Human Communication Research*, and *Communication Research*, as well as the upcoming book *Playing Computer Games: Motives, Responses, and Consequences*, edited by Peter Vorderer and Jennings Bryant.

JONATHAN STERNE ("What's Digital in Digital Music?") teaches in the Department of Art History and Communication Studies and the History and Philosophy of Science

Program at McGill University. He is author of *The Audible Past: Cultural Origins of Sound Reproduction* and numerous essays on media, technologies, and the politics of culture. His next book explores mp3s, the sound of music, and digital culture. He is also an editor of *Bad Subjects: Political Education for Everyday Life*, the longest continuously running publication on the Internet.

JENNIFER STROMER-GALLEY ("Gaming Pink: Gender and Structure in The Sims Online") is an Assistant Professor in the Department of Communication, University at Albany, SUNY. Her research interests include: the social uses of and experiences with new communication technology, mediated political campaign communication, and deliberative democracy. Her work can be found in the *Journal of Communication, Javnost/The Public, PS: Political Science and Politics*, and *Journal of Computer-Mediated Communication*.

TIMOTHY D. TAYLOR ("Music and Digital Culture: New Forms of Consumption and Commodification") is an Associate Professor in the Departments of Ethnomusicology and Musicology at the University of California, Los Angeles. He is the author of *Global Pop: World Music, World Markets* (Routledge, 1997), *Strange Sounds: Music, Technology and Culture* (Routledge, 2001), and numerous articles on various popular and classical musics.

SHERRY TURKLE ("First Encounters with Kismet and Cog: Children Respond to Relational Artifacts") is Abby Rockefeller Mauzé Professor of the Social Studies of Science and Technology in the Program in Science, Technology, and Society at MIT and the founder and director of the MIT Initiative on Technology and Self. Dr. Turkle received a joint doctorate in sociology and personality psychology from Harvard University, and is a licensed clinical psychologist. She is the author of *Psychoanalytic Politics: Jacques Lacan and Freud's French Revolution* (Basic Books, 1978; MIT Press paper, 1981; second revised edition, Guilford Press, 1992); *The Second Self: Computers and the Human Spirit* (Simon and Schuster, 1984; Touchstone paper, 1985; second revised edition, MIT Press,2005); and *Life on the Screen: Identity in the Age of the Internet* (Simon and Schuster, November 1995; Touchstone paperback, 1997). She has received fellowships from the Rockefeller Foundation, the Guggenheim Foundation, the Spencer Foundation, and the Mitchell Kapor Foundation. She is a graduate and affiliate member of the Boston Psychoanalytic Society and Institute and a licensed clinical psychologist. She received her B.A. from Radcliffe College and her Ph.D. in Sociology and Personality Psychology. Dr. Turkle has been exploring questions about human development given the most recent developments the computer culture. She is focusing on two areas: first, the development of computational objects as they become increasingly "relational," that is, designed to exhibit affect and respond to human emotions in an effort towards developing "sociable" and nurturant connections with people. These objects include "affective" computer programs, humanoid robots, and robotic dolls and pets. Second, Dr. Turkle is Principal Investigator on an NSF-funded study of "Information Technology and Professional Identity: A Comparative Study of the Effects of Virtuality," a collaborative effort at the Initiative which looks at the impact of using simulation technologies on a range of professions including architecture, medicine, and nuclear weapons design. Dr. Turkle is currently editing an essay collection, *Evocative Objects: Things We Think With and Completing Intimate Machines*, which she considers the third of her "computational trilogy" on people's increasingly engaged relationships with "identity technologies."

BARBARA WARNICK ("Rhetoric on the Web") is a Professor in the Department of Communication at the University of Washington. A former Editor of the *Quarterly Journal of Speech*, she is the author of Critical Literacy in a Digital Era: Technology, Rhetoric, and the Public Interest (Erlbaum, 2002).

RODNEY WHITTENBERG ("Using Computers to Create Music") is President of Melodyvision, Inc., a multi-media production company in Philadelphia, PA. An award-winning composer, Mr. Whittenberg has several film and television scores to his credit, including music for two Hollywood films, two segments of A&E's Biography series, and an HBO program. He is currently working on a series for New York Times Television, and has received a commission from the Philadelphia Orchestra Percussion Ensemble.

MARK J. P. WOLF ("On the Future of Video Games") is an Associate Professor in the Department of Communication, Concordia University, Wisconsin. His books include *Abstracting Reality: Art, Communication, and Cognition in the Digital Age* (University Press of America, 2000), *The Medium of the Video Game* (Texas, 2001), *Virtual Morality: Morals, Ethics, and New Media* (Peter Lang, 2003), *The Video Game Theory Reader* (Routledge, 2003), and *The World of the D'ni: Myst and Riven* (forthcoming in 2005 as a part of the *Ludologica* book series funded by Libera Università di Lingue e Comunicazione (IULM/Cariplo Foundation)).